LINER NOTES FOR THE REVOLUTION

LINER NOTES

FOR THE

REVOLUTION

THE INTELLECTUAL LIFE OF

BLACK FEMINIST SOUND

DAPHNE A. BROOKS

The Belknap Press of Harvard University Press

CAMBRIDGE, MASSACHUSETTS LONDON, ENGLAND 2021

LIBRARY OF CONGRESS CATALOGING-IN-PUBLICATION DATA

Names: Brooks, Daphne, author.
Title: Liner notes for the revolution : the intellectual life of
black feminist sound / Daphne A. Brooks.
Description: Cambridge, Massachusetts : The Belknap Press of Harvard
University Press, 2021. | Includes bibliographical references and index.
Identifiers: LCCN 2020030775 | ISBN 9780674052819 (hardcover)
Subjects: LCSH: African American women musicians. | African American
women—Music—History and criticism. | African American women—
Intellectual life. | Musical criticism—United States—History. |
African American feminists.
Classification: LCC ML3556 .B74 2021 | DDC 780.82/0973—dc23
LC record available at https://lccn.loc.gov/2020030775

In Memory of Lodell Brooks Matthews
In Honor of Juanita Kathryn Watson Brooks

and

for Matthew Frye Jacobson

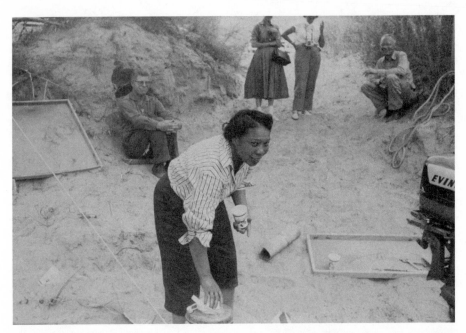

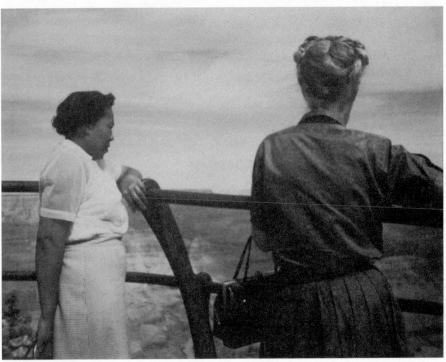

The author's aunt, Lodell Matthews, at the Colorado River circa 1956

Lodell Matthews and Margaret Marston
"take in the Points," circa 1956

CONTENTS

AUTHOR'S NOTE

Throughout this book, I use the terms *African American* and *Black* interchangeably. Readers will note a variety of texts which I cite that do so as well. I also make use of a number of other works which use *black* for this same point of reference. All of these variations refer to people of African descent, and my decision to turn back to capitalizing *Black* is done so in the spirit of emphasizing a core principle framing this book's aims: to reveal and explore the shared sociohistorical and cultural conditions of various peoples of African descent resulting from systemic subjugation across space and time. P. Gabrielle Foreman's invocation of nineteenth-century journalist T. Thomas Fortune's resoundingly emphatic reasoning for this practice, quoted in her own "Note on Language" (in *Activist Sentiments: Reading Black Women in the Nineteenth Century* [Urbana: University of Illinois Press, 2009], xv), is instructive, and so I reference it here as well and with great thanks to Foreman for setting yet another example for me. Says Fortune in his 1906 speech entitled "Who Are We," "I AM A PROPER NOUN, NOT A COMMON NOUN."

Two hundred and forty-six years of outward submission during slavery time got folks to thinking of us as creatures of task alone. When in fact the conflict between what we wanted to do and what we were forced to do intensified our inner life instead of destroying it. We developed turtle shell. So when folks come feeling around they find something smooth and round and simple on the outside. Like the six blind men who felt all over the elephant. But if more had been known about us, this mistaken simplicity never would have got abroad.

—ZORA NEALE HURSTON, "You Don't Know Us Negroes"

INTRODUCTION

Quiet as it's kept, Black women of sound have a secret. Theirs is a history unfolding on other frequencies while the world adores them and yet mishears them, celebrates them and yet ignores them, heralds them and simultaneously devalues them. Theirs is a history that is, nonetheless, populated with revolutionaries: turn-of-the-century vaudevillian Muriel Ringgold rocking her "entirety" in full costume as "the sea"; blues trailblazer Mamie Smith breaking the era of modern records wide open all crazy in Stagolee-style love; opera ingénue Anne Brown rewriting "Bess" to Gershwin's "Porgy"; High Priestess Nina orchestrating a Brecht and Weill tempest aimed at overturning Jim Crow; and slinky Afrocosmopolitan Eartha staging her own geopolitical cabaret. It's a history wide enough to encompass rebel-with-her-own-cause rock and roller Etta James in a fast car out on the open road and folk historian Odetta going deep into scholar, thinker, rule-breaker Zora's precious vault so that the real work (songs) can begin. It's teen Aretha in shimmering sequins attacking Al Jolson's "Swanee" and those glam ambassadors, the Supremes, pointing us toward "Somewhere" one day after a King had been slain. It's the body and soul of a grown-ass musician building bridges over troubled water for her listeners; the electric kinetics of Anna Mae Bullock breaking free from domestic tyranny; funk philosopher Betty Davis inventing her own erotic lexicon; and intergalactic trio Labelle delivering Afrofuturist theory all up in the club. Theirs is a history of the utopic and the transformative, the strange and the strategically unruly: Diana reaching out and touching the hands of the multitudes in the Central Park rain; Afropunk Godmother Grace driving Atlantic World nightlife right to the edge while Poly Styrene and Skin work on burning the whole house down. It's Whitney's melisma lighting up post–Civil Rights America, and it's Ms. Hill with her renegade contralto scoring a thousand turn-of-the-century sorrow songs for

the hip hop generation. It's a hardworking, H-town, new millennium storm system performing radical Black pop feminism to fight catastrophe, and it's her avant-garde genius baby sis staging a Blackest-of-Black uprising right in the center of the lily-white Guggenheim. Theirs is a history of game-changing art that stands as an affirmation of our past as well as the unrecorded future of sound, that which is booming in the not yet, the place where all those sisters of the yam are running us straight into the dawn.

"Shake That Thing": The Secret & the Subterranean Dimensions of Black Women's Sounds

Liner Notes for the Revolution tells the story of how Black women musicians have made the modern world. It is the first extensive archival interrogation of what ethnomusicologist Christopher Small has famously referred to as the "musicking . . . extending in all directions in our world" made by women who have been overlooked or underappreciated, misread and sometimes lazily mythologized, underestimated and sometimes entirely disregarded, and—above all else— perpetually undertheorized by generations of critics for much of the last one hundred years.[1] These critics and tastemakers, collectors, and far too many scholars have engaged in a long game, one that involves oversimplifying, simplistically romanticizing, and, at key moments, rapturously "cry-me-a-river" sentimentalizing the complexities of Black women musicians' work. It is the problem of their hold on the narratives about Black women's sonic artistry that constitutes a significant portion of this book.

But make no mistake. They are not the stars of this show. Rather, it is the remarkable sisters who both have made and have been thinking and writing about Black women's music for over a century now. They are the ones who stand front and center in this study, and they are the ones who have so fundamentally reshaped structures of feeling and expressive cultural forms in the popular domain since the dawn of the twentieth century that one would be hard-pressed to imagine an American culture without their influence. But do we even know some of these sisters' names? These women, this book argues, are culture *makers* who often labor right before our very eyes and ears without our recognition of the magnitude of their import. And the revolution that they waged was one in which the articulation of "more life" could, for a dispossessed people, be sounded out in many registers and tied to the core meaning and vision of liberation itself. Implicit in so much of their work is the stirring and glorious declaration once made by Zora that "you don't know us Negroes."[2]

Black women's musical practices are, in short, revolutionary because they are inextricably linked to the matter of Black life. Their strategies of performance perpetually and inventively philosophize the prodigiousness of its scope. But also—and quite crucially—Black women's musical practices are revolutionary because of the ways in which said practices both forecast and execute the viability and potentiality of Black life. This is not, I argue, a pessimistic operation, though the book does throughout take seriously the ways that various artists have wrestled with the ongoing crisis of precarity hanging over Blackness and its conditions of possibility. As we shall see, the performers and their accompanying scribes and theorists who populate *Liner Notes for the Revolution,* the sisters who were getting it all down for the record, are in this together, and they are "busy," as the literary lioness Toni Morrison might say, "busy being original, complicated, changeable—human."[3] Theirs is a revolution in intellectual labor. I use the term "labor" here very self-consciously so as to reference Black radical tradition theorist Cedric Robinson's classic observations about the way that Black work matters in relation to modern life. He insists that we "pay close attention to what Du Bois was saying: slavery was the specific historical institution through which the Black *worker* had been introduced into the modern world system. However, it was not as *slaves* that one could come to an understanding of the significance that these Black men, women, and children had for American development. It was as *labor.* He had entitled the first chapter to *Black Reconstruction,* 'The Black Worker.'"[4]

The profound urgency of Black women's culture work cannot be overstated, and it is perhaps best conveyed by simply suggesting that one consider just how "riotous" an act it was for Mamie Smith to break the sound barrier in the anti-Black recording industry on August 10, 1920, one year after America's "red summer" had told Black folks that no "new deal" with democracy was on the table for them following the First World War.[5] Smith's "Crazy Blues" effectively blew up the segregated pop cultural scene by seizing hold of modernity's new sonic technologies, the kinds that had been used to continue the centuries-old tradition of turning Black cultural labor into forms of capital for which they were systemically denied the returns. If white folks had controlled the conditions of Black folks' sonic reproduction since the origins of the modern recording age (looking at you, Victor Emerson, New Jersey Phonograph Company everyday hustler), and if white folks had also effectively colonized the blues, a Black vernacular form that white artists raced into the studio to record before them (looking at you, Marion Harris, Sophie Tucker, and a parade of your peers), then Smith's breakthrough was a rejoinder to all that. And yet, it was also more. If Black thought, Black rage, Black desire had few free and unhindered channels

for expression in the age of Jim Crow terror, "Crazy Blues" was a missive sent out to Black publics who bought her joint in droves. It said to them that all that feeling, all those strategies for living, could be improvised in the music, in sonic performances that bucked convention, mixed and made new forms, and expressed the capaciousness of Black humanity. Everyone from Frederick Douglass to Angela Davis has told us this truth.[6]

Liner Notes for the Revolution enters into this awesome, generations-spanning tradition of meditating on the insurgency of Black sound in three ways. First, it lays claim to the idea that modern popular music culture would cease to exist in the ways that we've come to know it without Black women artists. The book builds on landmark Black feminist scholarship produced by Davis and other pioneering critics to mount this case. I make a point of turning to lesser-known figures as well as dearly beloved icons, all of whom curate sonic performances that not only push the boundaries of musical experimentalism and invention but also produce daring and lyrical expressions of Blackness and womanhood that affirm the richness of their lifeworlds. These Black women artists refuse the terms of being scripted as objects. Instead, they choose to design their own mischievous and colorful, sometimes brooding and rage-filled, and always disruptive and questing definitions of a self that is intent on living a free life.

Second, this book takes seriously the notion of the archive—both the documentary record preserved by institutional powerbrokers and the faded pages we might imagine stored in an elderly sister's trunk—as a crucial, culture-making entity that Black women musicians and critics have had to negotiate in relation to their own artistic ambitions and to the problem of Black historical memory more broadly. Black women artists have played crucial roles *as* archives, as the innovators of performances and recordings that stood in *for* and *as* the memory of a people. Though often trivialized and minimized for their import, their cultural acts have amounted to a potent and forthright response to the class in control of libraries and universities, the publishing apparatuses and the awards councils, the film industries and the television industries, which saw fit to merely use up and dispose of the sounds created by Black people—to say nothing of the cycles upon cycles of "love and theft" that resulted in the obliteration of the history from whence these sounds first came. As archives, these Black women artists have operated through their music as the repositories of the past. Just as well, however, they have often engaged in active projects to archive their own creative practices, to document the intellectual and creative processes tied to their music, all of which, as we shall see, amounts to a Black feminist intellectual history in sound that has thus far gone unmarked and unheralded.

Third, *Liner Notes for the Revolution* excavates a counterhistory of popular music criticism, that deeply undertheorized form of critical writing that for several pivotal decades of the twentieth century was closely entangled with the social and cultural economy and sustainability of popular music culture. No surprise to most that this school of criticism has long marginalized African American women's role in popular music history, resulting in a grossly skewed understanding of their place at the center of modern music innovation. Obscuring or misreading the depths of their importance in this regard amounts to nothing short of a crisis in our collective cultural memory. But this book seeks to push up against this machine. It counters by detailing the ways in which Black women have long been, themselves, fugitive thinkers, critics, and theorists of sound. If we are willing to shake up the standard perceptions of who makes culture and who gets to think and write about it, if we are willing to cross the putative racial and gender boundaries that divide critics and artists, we might yet see and hear the myriad ways that Black women have labored in and through sonic culture, from its margins to its white-hot center, and they've done so in all sorts of roles—as creatives and intellectuals, as musicians, journalists, and celebrated essayists, as independent critics and marvelously nerdy and obsessive feminist collectors, as indie record label owners, as visual artists and poets, and above all else as dreamers who laid claim to music as a site to wrestle with crucial ideas about themselves and the world. To understand this, I argue, we must listen hard to the ways that all of these Black feminist publics who live on the lower frequencies have been insisting to us for over a century and in a multiplicity of ways that Black women's music—made by many and not just the exceptional few—profoundly matters in spite of what the gatekeepers continue to say.

Ahead, then, I read against the grain of dominant critical perceptions of Black women's sonic culture that, for instance, are quite comfortable mourning Aretha but are less interested in probing the long tradition encapsulating the historical, social, political, and material conditions from whence she came, and the racial, gender, class, and sexual politics that framed the conditions of her being. And this is to say nothing of the Black women artists who came both before and after her. The readings in this book are meant to help us think in microspecific ways about the uniquely transformative aesthetics and performance strategies of Black women musicians developing their artistry in different social and cultural spaces and at different moments in time from the eve of the birth of the recording industry to our present day. Like the literary critic Valerie Smith, who is interested in drawing connections between the ways that Toni Morrison's work resonates with other African American women writers, so, too, does this study recognize and remain interested in the shared expressive strategies and

experiments forged by women whose country gave them nothing and who, in return, gave the country the defining popular art of the twentieth century. To think of them as engaging in a shared aesthetic affinity "means," as Morrison herself puts it, "that the world as perceived by black women at certain times does exist."[7] *Liner Notes for the Revolution* is by no means, a comprehensive or an encyclopedic study. But it does affirm and extend Morrison's thinking by cutting a wide swath across multiple popular music genres and intellectual and cultural practices in order to explore the kind of meaning that Black women artists have made, as well as how their labor has evolved alongside, is entangled with, and sometimes has played a hand in generating and responding to historical events, social and political phenomena, and material, social, and cultural life in America from the late nineteenth century through the first two decades of the new millennium.

The inspiration for this sort of an effort arises, in part, from the liner notes genre that emerged in the early to mid-twentieth century, and which evolved along parallel lines with the birth of the long-playing record. What began as a line of advertising designed to promote the artist or the recording in question (on the very "lining," the sleeves for the records) gradually transformed into a sphere that held the potential for literary and analytic experimentation. At the peak of their cultural and critical influence and sophistication in the 1950s, 1960s, and 1970s, album liner notes served as a site where writers might spin complementary metanarratives and expansive discursive meditations on a sonic work in question, ideally opening up the conceptual universe of a record to listeners as they settle in to absorb its multiple layers of meaning.

By way of an essay that either anoints an artist and a musical object as being of value and thus calibrates the taste of the listener (think of the trenchant work of Leonard Feather, Nat Hentoff, or *Rolling Stone* cofounder Ralph J. Gleason) or serves as a discursive space wherein the musician might expand on, complement, complicate, and subvert the accompanying sonic text (think of those legendary, far-out notes produced by Sun Ra, John Coltrane, Bob Dylan, or Frank Zappa), liner notes hold out the possibility of operating as critical, fictional, or experimental works of writing in and of themselves. Conventional liner notes often walk a fine line between pedagogy and socialization, between sociohistorical and cultural reportage and heuristic conditioning (here's how and why to love the artist in question). The most ambitious notes strive toward the narrative realization, or the narrative reimagining, of a sonic collection of songs altogether. And there was a time when the notes had the potential to shore up the supposed import and ambition of a recording, amplifying its intellectual resonance by *writing* its value into the cultural imaginary. It should come as no

surprise that during the heyday of this now nearly dying form, whose viability has plummeted with the rise of the digital age, women and especially women of color artists and critics rarely had access to this sort of hustle.

The title of this book thus invokes a requiem for this oversight. These are the "notes" that I have tried my best to compile, to piece together, to reconstruct as recordings, as evidences of dreams manifest in sound, as an extended supplementary accompaniment—at its best, I hope, a discursive dialectical jam session—with the performances made by sisters who valued themselves through sound even when the world repeatedly told them that they were of no value at all. I offer these "liner notes," of sorts, for the artists and critics covered in this study—some of whom revolutionized the uses of popular music as forms of cultural memory and self-making, and others who gave us the language and conceptual vision to value the music itself.

This is a study that aims, in short, to "contextualize, to explain and describe, to provide a sort of discursive padding for the listener's approach to the music." Throughout all of my own journeys in sound as a fan, student, teacher, scholar, and critic, I have tried to write *beside* all of these sisters (as queer feminist thinker Eve Sedgwick would have it), to take "note" of and generate, as best I can, mindful narratives about their radical triumphs and lifelong labors in sound, to revel in the beauty of arresting prose made by my collaborators and coconspirators in music thought, and to likewise wrestle with some of the blind spots and missed opportunities in the oeuvres of some of my fellow critics.[8] This is my attempt to score an accompaniment to the "secret history" of Black women's sounds as well as the intellectual labor that engages their sounds, that which amounts to, in my opinion, a grossly unacknowledged revolution in culture and the making of modernity. This is my attempt to answer the question posed by historians Mia Bay, Farah J. Griffin, Martha Jones, and Barbara D. Savage, "[c]an we recover the intellectual traditions of thinkers who were often organic intellectuals and whose lives and thoughts are only modestly documented?" Above all else, it is my attempt to probe the reasons why it is that the dominant tales told by classic blues and "rock lit" and popular music criticism do not and cannot "imagine or include black women at their center," as Gayle Wald makes clear.[9] In the pages that follow, I've dedicated myself to instead turning our attention to the women artists and thinkers who have invented their own radical theories and tales and philosophies about sound, and who have innovated sonic aesthetics outside and beyond the center. Call it "running the world" while nobody was really seriously looking or listening, as Beyoncé once so famously proclaimed. Call it a revolution.

For this very reason, I propose that we add some different connotations to our traditional understanding of liner notes. There is, of course, the aforementioned

album-framing essay form, the kind of writing that captured my imagination in my teens and college years as I swam deep into the world of rock music writing. This book's "liner notes" are most certainly in conversation with that genre, but they are just as well dedicated to that which was born out of Black vernacular struggle and labor, the fierce and focused lining out, for instance, that one sees and hears in African American oral culture (discussed in Chapter 2). The book takes seriously the prodigious role of the lead vocalist in said culture, the figure instilled with the responsibility of clearing a path in a particular arrangement and charged with guiding and shaping the arc of a particular performance while shepherding an entire ensemble. Black women artists and the critics who look after them all emerge as heroes in *Liner Notes for the Revolution* as they tread into uncharted territories with their cuts-like-a-knife melismas and their sharp, analytic cris de coeur in print, as they push the culture in unexpected directions that upend our sensibilities. Like the Black folks and immigrant peoples who lined the nineteenth- and early twentieth-century railroad tracks across America, toiling away at building the industrial infrastructure of modernity's nation, a nation dead set against acknowledging their full humanity, these women built contemporary popular music culture by lining out sounds that altered and enlivened our relationship to time, the spaces that we inhabit, and our conceptions of community. This book aspires to listen to what they made with the ears of a fearless Florida anthropologist sister, and it is dedicated to lining out the stories of the women who, like said sister, laid down the deep-cut tracks of modern cultural life.

Doing this kind of work, getting down to this kind of *labor in listening,* requires grappling with a history that has no hall of fame, no landmark biopics, no Graceland pilgrimage sites, no *Hamilton*-size musical to memorialize the depth of its lasting impact. Such absences, blind spots, and silences—cultural manifestations of what Morrison famously refers to as "the disremembered and unaccounted for"—demand nothing short of a revolution, that which might bring Black feminist thinking and Black radical tradition study to the forefront of popular music criticism.[10] Such a move would, as this book seeks to show, allow for ways to (re)discover the heroics of a whole range of artists who have made music that repeatedly rejects the negation of Black life. In short, then, this book asks, What would we be without them, those everyday blues women who, for instance, invented an expressive popular lexicon that not only captured the vicissitudes of modern life but dreamed beyond such a life, folding both history and futurity into their sounds? What would we be without the women who galvanized the centrality of popular music as a popular art form in America? Without the ones who both upset and reinvigorated our conceptions of the modern world and who have given us myriad cultural tools to navigate that vol-

atile and violent world? Without the ones who set in play a throughline of radical sounds and sonic responses to said world that extend from before the time of Mamie to the present day of our Lady of *Lemonade*? That mammoth latter artist, as the Epilogue of this book insists, is the brilliant and mindful manifestation of all that history and, just as well, the spectacular sonic investment in Black futurity. Her work insists, like the figures in the second half of this book, that speculative music, art, and performance are the operations of our survival, the critical restoration of that which few monumental institutions have seen fit to call precious and care for.

This intellectual revolution in Black feminist sound is one that builds on a late twentieth-century experimental movement in form and content led by poets, Black feminist fiction writers like Morrison, and visual artists, who devised bold and brilliant new strategies for confronting history's opacities and dreamed up new methods for our survival. The arc of this book moves toward the recognition that such a movement's legacies are especially alive now in the world of the sonic and especially in the repertoires of a trifecta of risk-taking musicians who are disrupting and reinvigorating collective memory by offering up their own dense archives of sound. Like the insurgent musicking of the Black women artists who came before them, the speculative nuances of their often unpredictable, beautifully old-school-meets-new-school curatorial performances necessitate a kind of intellectual labor that might strive to keep time with them, that might try to approximate the kind of critical revolt waged by feminist thinkers in these pages who knew how high the culture stakes really were and who used their work, time and again, to cut through what legendary rock critic Lester Bangs once referred to as the "white noise supremacy."[11]

For the Record: Black Women Sound Modernity

Above all else, *Liner Notes for the Revolution* reads Black women musicians and performers as intellectuals—as figures who innovated sonic, visual, and kinesthetic styles that documented and served as catalysts for transformations in cultures of modernity and who, likewise, radically critiqued and questioned the forces of the modern. It is a study that considers the myriad ways that Black women artists crucially informed, questioned, and at times contested the evolution of modern structures of being and social and cultural formations for over one hundred years.

To recuperate this tradition, this book takes some of its inspiration from literary Afromodernism's insistence on emphasizing the scores of ways in which

Black individuals assert their complex, fluid humanity, face traumatic sociopolitical challenges, and harbor a range of intimate desires through musical practices. But like pioneering Black feminist cultural critic Farah Griffin, it questions the ways that classic literary scenes often mount such truths with limited regard for Black women's quests or desires. The (Black) modern moment in literature, as Griffin has brilliantly shown, so often depends on the masculine transcription of Black women's sounds, as well as the masculine translation of Black women's performative feeling into literary legend and romance.[12]

The rituals of sonic ensemble performances remain shrouded in masculinist legend in Black cultural imaginaries. Think of Sterling Brown's tender and yet quixotic memorializing of "Mother of the Blues," Ma Rainey, in his classic 1932 poem and the way that his poem figures an unnamed "fellow" as the one who conveys Rainey's ability to get "way down inside" of a migrant peoples' souls. Or think of James Baldwin's soaring denouement to his 1957 short story "Sonny's Blues," a lyrical meditation on improvisational catharsis forged between jazz men in the live set. They are the brothers who work it out, who sweat, toil, and sacrifice for a community that bears witness to the title hero's "ontological tonality" that gradually unfolds into a bridge for others to cross.[13] Stirring and stunning as these scenes are, and as much as they lay claim to the power of the sonic as a transcendent form of world-making for a subjugated people, such scenes of the Black radical marvelous nevertheless do little to remind us of the countless women who were listening to one another and who, in turn, transformed their experiences as listeners into aesthetic innovations that unsettle and vibrantly design and reconstitute modern life.

Such artists exist on the "edge," the "fringe," the "margin," where women who are all ears make sense of their worlds and each other in a kind of methexic reciprocity that envelops and yet also exceeds Sonny's bluest notes. These are the women who are both the records and the recorders, the phonographic subjects who produce but also pick up and interpolate the sounds of a new age into their repertoire, driving, influencing, changing, and disrupting a rapidly developing culture industry along the way. To imagine them playing for, with, alongside, in memory of, and as an answer to each other—as doing their own necessary and vital work in concert with one another—is to rethink the figure of the ensemble through a Black feminist conceptual lens, to imagine sisters who make music and the ones who listen to them in the round with each other and forging their own big, wide sonic universe of ideas.

Liner Notes for the Revolution aims to play along with this tradition, in part, by following the blueprint set by turn-of-the-century proto-Afrofuturist thinker Pauline Hopkins in that it explores the work of Black women musicians across

multiple spaces and times. Like the protagonists from Hopkins's 1903 diasporic music epic *Of One Blood,* this study moves cyclically among past, present, and occasionally future visions. And as in that novel, wherein Black self-formations are shaped, in part, by sounds performed both long ago and far away as well as up close and right in the moment, this book oscillates between worlds and epochs, sociopolitical crises and sociocultural trends, as it follows the sonic cartographies of Black women artists producing new knowledges about their worlds and the place of Black women in said worlds.

To get at the particulars of this tradition of sonic lives in motion, to draw out the polyvalence of these artists' performances as cultural forces that dialectically shape and speak back to the world, I draw on multiple modes of reading and making meaning out of their work. *Liner Notes for the Revolution* explores performances and recordings that bear witness to the labor that went into the art, biographical details that illuminate the complexities of the artist's aspirations, desires, and obstacles that they faced. It remains mindful of an attendance to historical, social, and political conditions that inform, deepen, sustain, and drive musical choices in multiple directions, and it keeps in the mix a recognition of the specificity of place and space in the production of sound.

In this regard, the panoramic sweep of this book takes some inspiration from Alex Ross's sprawling and majestic *The Rest Is Noise: Listening to the Twentieth Century.* Like Ross's work, each chapter "cuts a wide swath across a given period, but there is no attempt to be comprehensive: certain careers stand in for entire scenes, certain key pieces stand in for entire careers, and much great music is left on the cutting-room floor."[14]

But this story is about the sisters: the ethnographer rolling in her jalopy and collecting local songs for her recorder; the indie record label owner determined to revalue the blues queens; the iconoclastic songwriters and instrumentalists who transgressed genres and tore up the live set; the superstars as well as the (seemingly) minor figures and marginalized artists who posed questions about the meaning of intersectional citizenship and the category of the Human; the obscure rebels and the seasoned veterans who flirted with "criminal" forms of self-making; the early pop vocalist who, as Saidiya Hartman might put it, read the riot act through her music and ended up turning the record biz on its head.[15] It's also a story of the women who were critics, journalists, and quotidian fans who have insistently and incessantly immersed themselves in the music and sought to document, theorize, excavate, and analyze the work of these artists for over a century now, but whose voices are seldom recognized as crucial to the circulation of Black women's sonic cultures. I pay close attention to the observations of fellow artists in relation to each other, how they remember and

mount conversations with the work and ideas of other women, and I follow the paths of these visionary artists as they move through, to, and sometimes against the beat of sociopolitical and cultural histories while remaining in dialogue with a range of publics. Above all else, I take seriously the centrality of sound in Black women's lives as a foundation for developing and sustaining pivotal, profoundly meaningful world-making sociocultural networks and forms of intimacy with one another.

In this regard, then, *Liner Notes for the Revolution* pays homage to that which the grand dame of early Black music writing Pauline Hopkins long ago already knew. Honoring Hopkins's legacy means paying close attention to both the richness of individual Black women artists' work as well as the broader communities, social forces, and cultural landscapes that they navigated. This book sees each of its figures as historically provocative in her own right, each artist steeped in the cultural memory manifested in her work. It addresses lines of past affiliations, encounters, chance meetings, collaborations, and other forms of labor and sociality that bear on the music at hand. Some might call this approach "rhizomatic," meaning the apprehension of multiplicities as mapped out by those sexy academic Euro Marxist philosophers Gilles Deleuze and Félix Guattari. The comparison is, to an extent, apt and useful.[16] I do approach Black women's sonic cultures as "collective, nomadic," and as always entangled with multiple, imbricated histories.[17]

But my aim in doing so is to fundamentally recuperate a genealogical line of cultural theory and philosophy innovated by Black women intellectuals themselves. Generations of Black women improvisational musicians have woven together their own "fabric of the rhizome" with its "conjunction . . . and . . . and . . . and . . ." To say these women model for us "another way of traveling and moving: proceeding from the middle, through the middle, coming and going rather than starting and finishing" is to insist on a different theoretical point of entry for "exploring ourselves as subjects," as Barbara Christian so famously encouraged Black feminist scholars to do all those years ago when she reminded us of "what Celie knows that you should know."[18]

The phenomenon of their culture work centers on the historical, social, and political stakes and impact of Black women's musicianship on modern life. As such, "woman" as a social formation serves as the overarching gender rubric in this study, in short, because the majority of figures in the book identify as such; however, queer sociality undergirds the core spirit of this book's focus. Queer and gender-nonconforming artists are, as any number of scholars have shown, the backbone of Black sound, and the fugitive intimacies of and between Black women frame and fuel the alternative history of the blues proposed in the

second half of this book.[19] Just as importantly, the forces of migration give rise to the critical frames in which these musicians experiment with sounds that both generate and address shifting temporalities, spacialities, and communities.[20]

I see the cultural performers in this book not only as musicians but also as *listeners, arrangers,* and *curators.* To that first point, I not only pay close attention to the sound produced by the artists themselves (as Alexandra Vazquez does so brilliantly in *Listening in Detail*) but also *listen to the listeners listening*—to each other, to distant live performers, to beloved recordings, to nonmusical sounds, to ideas about other sounds composed in the privacy of their own vibrant imagination. Film theorist Giuliana Bruno would call this "an archeological intertextual approach," and to be sure, her mobile way of reading culture, her "kinetic analytic," has offered me a map for how to read Black women's aural worlds in this way, how to revel in and dissect the *sonic palimpsest* that these artists extend, explore, and respond to by way of their performances.[21] As Black women's cultural lives remain supposedly marginal as well as marginalized—even as their cultural labor shapes the backbone of (inter)national life—their sound performances tell a richer, if often fragmented, story of self-making and world-making than typically meets the ear and the eye. Listening to the sonic palimpsests, the layers of social and cultural memory embedded in their music, allows for ways to navigate the lacunae of histories that obscure Black women as the resourceful heroines of a pop culture industry that views them as irrelevant and disposable.

To the question of *arrangement* I ask this: If we pay close attention to Black sonic women's listenings, what more about the depths of their craft might we ultimately hear? This book suggests that, if we think of Black women as "adaptor[s], transcriber[s], orchestrator[s]," as the kind of "arrangers" that sound theorist Peter Szendy has in mind, we might better recognize the ways that their active forms of listening both produce and record modern life. For "the arranger," as Szendy insists, is "a musician who knows how to *write down a listening* . . . knows how, with any sonorous work, to *make it listened to as* . . ." The kind of arranging I am thinking of is performative, embodied, sometimes written down, but more often sung, played, (re)covered, spoken, and shared. It is a kind of arranging that holds the potential to be both loving and contentious, affectionate as well as combative. This kind of arranging, this kind of "plastic listening," as Szendy would have it, elasticizes our relation to sonic performances, opens up and reveals the multiplicity of roiling publics who come together to create musical work. This work—their work—shakes up presumptions about how we define sonic modernity and how it is (un)made.[22]

Still more, we might think about the importance of curation in relation to this singular form of Black women's culture making. This book asks that we imagine the labor of Black feminist sounds as often moving beyond arrangement and into the realm of *sonic curation,* an even broader conception of an endeavor that, in art and museum worlds, entails not only serving as a "caretaker charged with the safekeeping of museum objects" but also "deal[ing] with the orchestration of ideas, concepts, and happenings." The former pertains to the kind of "stewardship" of which Kara Keeling speaks, and the latter refers to the more recent turns in curatorial theory in the art world outlined by museum studies scholar Halona Norton Westbrook. These approaches, she points out, emphasize "interpretation," "storytelling," and "a reorientation toward audience acknowledgement and participation."[23] *Sonic curation* encompasses the reimagined terms of arrangement of which Szendy speaks, and yet it also calls attention to an even wider array of expressive and performance practices—visual, kinesthetic, and choreographic practices—but also, perhaps most importantly with regard to the artists in this study, it refers to practices that aesthetically engage and invoke the historical, social, and political ideas and conditions that inform the musical work in question. While arrangers lay claim to the dazzling work of producing a listening, operating as the bridge figure between a particular work of sound and the audiences who are ready to receive an artist's interpretation of said work, the sonic curator is pulling from a vaster reservoir of multiformalistic expressive modalities. She is arranging an experience that moves beyond the musical work itself, creating a sphere of alterity and possibility not unlike the best and most transformative exhibits that one might attend.[24]

Think of the distinction as being the difference between something like Beyoncé's moving (to some, polarizing to others) arrangement of that gospel song-of-songs, Thomas Dorsey's "Precious Lord," which she and her team prepared for a 2015 Grammys performance, and her history-making *Lemonade.* The first, in promotional videos that she released as supplements to the performance, documented her connections to the song as a memory tied to the maternal and her mother's recordings of Mahalia Jackson's version of the song, which she describes in the video as having captivated her as a young girl. Beyoncé's felt arrangement of "Precious Lord" here calls attention to her own inscription of listening to Mahalia in this moment; it opens up the connection to multiple publics, her household included, which are bound up with the song.[25] Conversely, *Lemonade,* her 2016 sonic, visual, multimedia Black feminist magnum opus, stands as the curatorial summation of the citational practices she has been honing for nearly two decades as a pop icon. The intel-

lectual and cultural sublimity of *Lemonade*'s form and content demands studious, multi-sensory immersion as it calls upon history, politics, and the radical scope and breadth of Black life to constitute its contours. As we shall see, artists in the second half of this book assert their own form of curatorial performances, but it's my belief that they are indebted to blues pioneers in this regard as well, women who pulled from all of the cultural aesthetics they had at their disposal to make popular music that was heterogeneously conceived and spoken in many aesthetic tongues. Theirs was a music whose voice was not one.

Let us listen, then, to the sisters who were listening to each other and making big things out of what they heard, making new arrangements for living and curating entirely new sounds out of their encounters. Let us take seriously, just as does Jennifer Stoever, the concept of "black performers and writers as theorists of listening." It is impossible, for instance, to understand the evolution of jazz, the "soundtrack to modern culture," without considering the lasting intensity of a preteen Mary Lou Williams's engagement with the live performances of "the lady pianist" Lovie Austin, a musician who captures Williams's imagination as she marvels over her sitting "cross-legged at the piano, a cigarette in her mouth, writing music with her right hand while accompanying the show with her swinging left!"[26] The particularities of Williams's lived experience as a young artist developing her craft and straddling cultural epochs in the process (growing up in the era of the blues, coming of age as a swing musician, pushing avant-garde categories so as to innovate bebop, and foraying even later in her career into religious musical experimentalism) tells us something about the ways that Black women musicians both responded to and ignited cultural change. Their work poses its own question: What happens to modernity when we hear it taking shape through the ears and voices and instrumentation of Black women?

Put differently, what is the transformative sonic "history from below" of artists like Esther Mae Scott, born in Warren County, Mississippi, in 1893, the seventh of fourteen children raised by sharecropping parents, a woman who would go on to accompany Leadbelly, Bessie Smith, and others on guitar? Scott's life and career is a story of the local and the mobile, the transregional and the community-oriented. It is a story of the multiplicity of ways that a sound life held out possibilities for Black women workers to reconstitute conventional notions of temporality, spatiality, and community so as to both steer and disturb the arc of the modern world they inhabited. Scott's journeys—from the Polk plantation, where she started playing music with her family at a young age, to her teen years hawking hair products in a traveling medicine show, to her

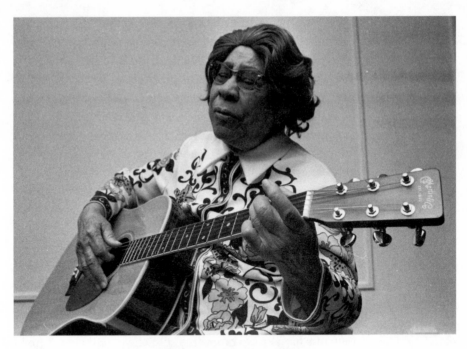

Esther Mae Scott, blues traveler

itinerant life as a guitarist while maintaining employment as a domestic worker, to her senior years as a Washington, DC, Civil Rights activist and folk musician—encapsulate the cultural heterogeneity of the lives of these women. As artists they formed a bridge between shifting eras, rapidly evolving technologies, and vastly diverse regions and peoples.[27] Scott's will to move is a blues woman's prerogative, as many a Black feminist critic has noted,[28] but what especially fascinates me about her story, and that of all the women in this book, is the way that her relationship to sonic culture complicates and ultimately transgresses the conventional material conditions in which historians and pop critics tend to read Black women musicians. The networks of cultural intimacy emerging out of Scott's commitment to and passion for her craft constitute the lost records in early pop music history, the unreleased tracks that remind us of all the unnamed sisters in the juke who make the blues. These were the women who utilized their own "modern ears" to enact prodigious forms of world-making. In their own "sonorous time," they invented "omni-dimensional" space for themselves, resonating in relation to one another.[29]

And they were plotting, strategizing, *listening, arranging, curating* by way of the sonic and devising ways of moving through the world against the tide of their perpetual subjugation. What these Black women musicians offer, in

short, is another way of hearing, reading, theorizing, *making* the modern. Black women of sound sign *and* sing themselves through their listening such that they reframe archaic philosophies of the "Self" born out of high Enlightenment thought that never had them in mind. At the forefront of the recording industry's first cultural phenomenon, the blues, they managed to both own the aesthetic innovations of that early scene and yet still disturb the conditions of their own commodification. The dialectic between production and consumption for them pushes beyond "the leverage point of capitalism," beyond culture *as* industry that stupefies the masses.[30] When I say that Black women artists make the modern world, I am signaling the ways in which we might acknowledge how their sonic innovations have shaped our social and cultural connections and intimacies through forms as varied as blues laments and sensual soul arias. Their sonic work is its own form of affective technology, and it is work that has shown the power to generate daring modes of artistic survival. Their music fundamentally disturbs the terms by which we define "modern life," the condition born out of dramatic shifts in perceptions of time, space, and collectivity. In the longue (and unfinished) durée of Black Emancipation, Black women musicians have innovated sounds that amount to essential fuel, the kind that keeps Great Migration peoples "flowin'" just as the aching restlessness of Ma's music would urge them to do. Their aesthetics both capture and anticipate those shifting terrains of power in our homes and out in the streets, from the "One Hour Mama" demands of sexually assertive Ida Cox to the forceful proclamations of our wholly realized selfhood voiced by Queen ReRe on the Civil Rights scene. Their art spans the range of, keeps time with, and makes history voiced by everyone from "I ain't about to be nonviolent" Nina flexing her Black Power to that Afrostarchild Solange who spots the "Cranes in the Sky" and sings us through our chronic weariness. Across epochs and through many changes, these women have done the work. They invented sonic maps of underground folk communities all fluent in intricate coded languages and hieroglyphs, that which Zora did her best to record. This is the musicking that serves as the cornerstone of cultural modernities. These are sonic ways of being that roll with, absorb, and even have the power to produce "the shocks and displacements of society reformulating its very experience" of the temporal and the spatial rhythm of life. These expressive practices were technologies of the body, emanating from the throats, the fingers, and joints of artists who invented sonic works through the complexity of their own exquisite performing selves, through their own "resonance chambers" and felt listenings that created conditions of possibility for the modern and that which exceeds the modern.[31]

"So Low You Can't Get under It, so High You Can't Get around It": The Blackness & Modernity Question

Only Black studies scholarship can show us the way to that subterranean realm, the place where Black women artists' aesthetic battles with and (re)invention of the terms of modernity are constantly unfolding.[32] "We the people who are darker than blue," as Curtis once so boldly crooned, have been scripted in the romance of the West as the wholesale "victims" of time and change rather than as the architects of such matters. Yet Black radical tradition scholars tell us otherwise. By now we know better than to assume that Black folks just rolled over—or got rolled—by modernity. More than three decades of Black studies scholars have wrangled over modernity's racial discontents and, likewise, wrestled modernity from its putatively hegemonic logic. From the very necessary Stuart Hall, who laid the framework for this critical intervention by way of his consistent interrogation of the very definition of the term, to Cedric Robinson's groundbreaking critique of the racialized structures of capitalism, *Black Marxism,* which set the terms by which we've come to recognize the central role that African peoples have played "in the creation of the modern and the premodern world," Black thinkers have illuminated the philosophical and cultural modes of opposition to the institutionalized negation of Black humanity.[33]

Black feminist scholars have long paved the way in making these points manifest in Black Studies, illustrating and painstakingly dissecting the ways that racial, gender, class, and sexual modes of power have figured as the tools of choice in the invention of the modern. And it makes all the sense in the world that they would play a decisive role in pushing forward these critical conversations since they bear the frontline legacies of the disaster that modernity hath wrought, the disaster that resulted in the acute horrors that Black women in particular faced as captives, as humans who were forced into the role of concubines and breeders in the iniquitous grammar of the Atlantic Slave Trade. What theorist Hortense Spillers told us in the early 1980s about the systemic and structural modes of defining Black women according to "a cunning difference—visually, psychologically, ontologically," the binary inversion of those in power, makes it ever so clear that they are *the route* by which the dominant modes decided the distinction between humanity and 'other.' . . ." Spillers's work and that of her generation of Black feminist scholars has, in short, been sounding the alarm on modernity for many years now and making possible the decades of Black thought on this topic that would subsequently follow.[34]

The crew that extended these ideas have posed different—if at times complementary—perspectives and questions about the where, the when, and

the how of modernity in relation to Blackness and Black peoples. *Liner Notes for the Revolution* is principally concerned with culture-making and modernity, and it is therefore in conversation with scholars like Paul Gilroy, who explicitly emphasizes the role of culture in Black Atlantic self-making practices. Black folks' very proximity to racial terror, he famously asserts, informs their ability to produce unique modes of expression shaped by and yet radically disturbing the conditions of forced migration and captivity. The sonic performative emerging out of these conditions is, he argues, one of the many "willfully damaged signs" that "partially transcend modernity, constructing both an imaginary anti-modern past and postmodern yet-to-come. This is not a counter-discourse but a counterculture that defiantly reconstructs its own critical, intellectual, and moral genealogy in a partially hidden public sphere of its own." He concludes by asserting that "[t]he politics of transfiguration therefore reveals the hidden internal fissures in the concept of modernity."[35] My work lights off, in part, from Gilroy's in its consistent presumption that this terror is the thing that Black women musicians have had to both negotiate and transfigure in their own art. But still more, I am insisting that the specifics of Black women's historical subjugation frame the conditions by which their sonic performances amount to "ironical grace," as Spillers refers to it.[36] These conditions form the grist of the radicalism endemic to their sounds.

The conversations that Gilroy reignited about Black culture as a revolutionary rejoinder to the terrors of the modern constitute some of the scaffolding for this book, but so does the work of the late and marvelous critical theorist Lindon Barrett, whose take on the predicament that Black folk face in relation to modernity remains instructive to my thinking about these kinds of questions. Barrett's work effectively lays bare the epistemologies that undergird racial capital and dominant definitions of "the human" and reminds us of the ways that Enlightenment philosophies invented and institutionalized a kind of "humanity" that was tethered to letters, literacy, discursive self-making acts, and "the singing voice," as he refers to it. If the New World dominant regime scripted Black captives as "excessive," illegible, without a voice of value and worth, "the singing voice" of African Americans, as he counters, is the means by which a "socially and psychologically tyrannized population" could "recor[d] and celebrat[e] individual lives as well as the life of their culture." If Western modernity invested a kind of foundational power in literacy, Black folks countered by singing their ontological presence and worth so as to "refus[e] . . . 'the basis of Western systemic thought.'"[37] Barrett's insistence on thinking through the violence of Atlantic World slavery and racial capitalism as it frames the terms of Black cultural value in the West has everything to do with this study's approach to reading the recording industry and

popular music culture more broadly as a terrain of fraught racial, gender, and class struggle. To modernity's Euro gangster theories of the Human which famously favor "the mind" and immaterial speech over the body, Barrett's bold and demanding work counters by calling for a reclamation of materiality and the "ludic corporeality" of the human voice. The African American singing voice, he argues, "disturb[s] the *presence*" of signification in New World philosophies of reason by interpolating a disruptive, embodied performative labor into civic as well as intimate modes of self-invention.[38]

And it is the singing voice, this prodigious tool capable of shaping narrative, conveying character, and delivering formidable and complicated feelings and ideas about self and world, that is the thing for which Black women musicians have been most often simplistically championed. Critics have casually glorified them as unparalleled innovators of popular vocalizing and yet rendered them unworthy of serious and sustained intellectual care for their creative labors. Historically, their music has been the source of critical elision, chronically devalued for failing to meet the masculinist cultural paradigms and standards—the virtuosic performances and craftsmanship in the form of instrumentation *other than that* of the workings of the human voice—that cause taste-makers to salivate. Barrett's ideas open up space to argue for, as I do here, the pivotal roles that Black women popular musicians have played in modern self-making practices.

I am not seeking to show how Black women are exhibits of the modern as much as I want to demonstrate that they redefine what we think modernity is and does. Alexander Weheliye's classic work on Blackness and modernity is, thus, instructive, particularly because of his expansive definition of these two mutually constituted categories. Weheliye reads against the presumed split between writing (the graph) and sounding (the phono). He insists that Black cultural practices and sound technologies intersect in the making of the modern; they are central to "this thing called life," as Prince might have it, this radically altered experience of our felt world and environs so particularly and dramatically emergent across the last one hundred years in the West. Black folks' culture makes this modern condition both possible and palpable, his work reminds. And this is why Black subjects, those uniquely complex individuals shaped by DuBoisean double-consciousness, "second-sight" superpowers, and positioned as the selvage of humanity, remain both "within and against Western modernity." They are critical to its formation, rather than merely "minor" or "counter" to it as the anti-Black philosophies of Jefferson, Hegel, and all 'dem good old boys might have it. The (re)production of Black sounds in the modern world— whether by human, embodied performance, musical instrument, or "modern information technologies"—generates "a series of compounded materiodiscur-

sive echoes in and around sounds in the West," argues Weheliye. And it is this "sonic Afro-modernity," in his terms, that "holds out more flexible and future-directed provenances of black subjects' relation to and participation in the creation of modernity."[39] In his account, Blackness and modernity are inextricably linked to each other, mutually constitutive of each other, held in tension with and dramatically generative in relation to each other. Or, as Black diasporic anthropologist David Scott puts it, "modernity was not a choice New World slaves could exercise but was itself one of the fundamental *conditions* of choice."[40]

Weheliye's work makes possible ways of considering how "black culture has utilized and created the technological innovations that now characterize sound technologies." But imagine, this study asks, what happens to our recognition of the cultural world as we presume to know it when we put Black women and their feminist allies—musicians as well as the critics who looked after them—at the forefront of modernizing endeavors. Such a reimagining might push up against the grain of how we experience structural power on a day-to-day basis as a zero-sum game if the next thing we say after answering June Jordan's light-the-fuse question ("Who in the hell set things up this way?") is this: "But we *made* this."[41]

The conversations and debates waged between Gilroy, Barrett, and Weheliye concerning Blackness and modernity are, of course, anything but settled.[42] And like these aforementioned thinkers, I remain so wary and weary of romanticizing modernity—especially when it hath wrought unprecedented disaster for Black folks and Black women in particular, as Sylvia Wynter, Toni Morrison, Hortense Spillers, Saidiya Hartman, and numerous other Black feminist scholars have so clearly spelled out for us.[43] Why should we think of Black women as having had a hand in this nightmare? But by sounding it, this study suggests, Black women produced a modern experience with a consistently forceful critique built into its very social structures and cultural landscape. The equipment for living produced by Black sonic revolutionary women informs modernity, is coterminous with it, and yet still evermore does battle with it. No one critic has shown the magnitude of Black sound's move-the-ground-beneath-you worth, struggle, and necessity more formidably and lyrically than Fred Moten. His work moves improvisationally in, through, and outside these meditations on Blackness and modernity by expanding, rearranging, and elasticizing the epistemic repertoire in which we think these concepts together with philosophical might and majesty, and he poses several undeniable facts, which are these: Black life is inextricable to the world as we know it today; it is a cosmically urgent force that has framed how the West defines what it means to be Human; Blackness remains a massively potent, ubiquitous, and beautifully ineffable phenomenon so fundamental to our conditions of being and structures of life that it

defies facile speech, thought, and study. Rather than thinking Blackness with modernity, or not, Moten improvises outside the narrowness of these categories and how one defines them altogether. His aim to tell "the story of how apparent nonvalue functions as a creator of value" and to also tell "the story of how value animates what appears as nonvalue" demands that we recognize Blackness as a radically capacious entity that exists before, as well as willfully, belatedly after, and also volatilely, mutually in relation to the philosophical apparatuses that produce the modern. Moten's versioning of Black studies shifts analytic focus and force so as to recognize the ways that "Western civilization is the object of black studies," and his epic exegeses and indispensable critical methodologies exhume the corpus of Western philosophical thought—Hegel, Heidegger, Kant, and friends—in order to dissect the Blackness that exists within and yet also exceeds and supersedes such thought.[44] Moten's commitment to tracking prodigiously complex Black ontologies expands the playing field of how we think and interrogate and pull apart race and modernity by working from within the framework of this massive, unregulated thing called the "Black condition."

Above all else, *Liner Notes for the Revolution* remains invested in following the paths of creatives whose Black feminist work radically cares for this condition. Moten's transformative vantage point enables us to see, as he famously argues, "what's at stake" in Blackness's "fugitive movement in and out of the frame, bar, or whatever externally imposed social logic—a movement of escape, the stealth of the stolen that can be said, since it inheres in every closed circle, to break every enclosure."[45] His theoretical explorations, which demand everything (ethical, political, imaginative) of us, arc toward the "air of the thing that escapes enframing . . . an often unattended movement that accompanies largely unthought positions and appositions." Having not only survived the conditions of captivity but also "escap[ed] the Hegelian positioning of the bondsman," Blackness is, according to our friend Fred, "perhaps best understood as the extra-ontological, extra-political constant . . . an ensemble always operating in excess of that ancient juridical formulation of the thing," a "dangerous supplement," a "special ontic-ontological fugitivity of / in the slave." This *thing* called "Blackness" is its own technology that enables Black subjects to perform under duress (and otherwise) and perpetually escape confinement by way of "exhausting" their own performative abilities.[46]

The sisters who are making the modern in this book have figured their sonic bodies as principal to modernity's equation, reminding us through the brilliant innovation of their work that, though Man's cruel steamroll of domination, annihilation, industrial expansion, and material consumption has hinged on the

long historical exploitation of their bodies as reproductive vessels in bondage and beyond, this was not the end of their embodied will to selfhood. Rather, their musicking is the massive rejoinder to being defined as "the source of an irresistible, destructive sensuality" and "reduced" to *being* for the captor . . ." as Spillers describes it.[47] Sound as archived, arranged, curated, and performed by these culture makers remains the way in which they put their own designs on modernity while remaining vigilant about exploding the entire game from within it.

Black Women's Sound Labor & the Art of Black Feminist Modernity

The rituals and aesthetics of Black sonic women are emphatic bodily acts, full-throated gestures behind the microphone, all-of-me inflections at the keyboard, willing and intimate connections made with a strapped-on guitar. Such statements of the musical everyday are keys to the subterranean blues that Black women perform in "the undercommons" of our modern world. They are the blues that create the conditions for the "sonorous time" that Esther Mae Scott initiates outside the labor contract that frames her domestic work, and they, likewise, lay the groundwork for the social intimacies of a boisterous nightlife culture in experimental sound, one that ultimately dazzles a young Mary Lou Williams, drives her aesthetic ambition, and sets her off on her own path towards achieving new heights of sonic innovation. As this book seeks to make clear, the music of women like Scott and Williams, the art of their blues and jazz, is the sound that "mov[es] inexorably in a trajectory and toward a location that is remote from—if not in excess of or inaccessible to—words." Their labor conveys depths of history and feeling consolidated and transduced into the felt guitar licks of, say, a sister who saw fit to live beyond and outside the boundaries of domestic time and another who, as Chapter 1 suggests, composed jazz piano works capable of cultivating jubilant Black space that could "continue the night beyond the closing time regulation enforced by the city."[48] As Black women, the very reclamation of their own bodies from being scripted as the "beached whales of the sexual universe, unvoiced, misseen, not doing, [and] awaiting *their* verb" is a bid to become instead their own instruments of wonder, orchestrating social and cultural transformations as a revolution of the first order.[49] And so across the century they sing, as did Bessie with depths of insight and sorrow, leaving it all on the floor for the ones facing a flood of devastation. They play, as did Aretha at the piano, shaking the foundations of the interracial rock and roll

Fillmore with the vivacity and conviction of her gospel vision. Generations of Black women's musicianship have repeated the quotidian miracle of artists like Scott who was improvising her own time and Williams who was making music of the juke, the music that "map[s] the spatiotemporal experience of afterhours." Their artistry attests to the many ways that Black women invented sonic alterities for themselves and for their brethren, designed a socio-cultural lexicon in sound, and expanded the articulation of what's possible.[50]

They used their own performing bodies to precipitate modernity's shock of the new, and they have shown a particularly meaningful ability to cultivate our sense of community, to "surrogate" our shared affinities, to invite us to imagine ourselves as a "we" by way of the seductive power of their sonic storytelling.[51] They are the ones who have laid down affectively and aesthetically sophisticated ways of *being with* each other through their sonic moves. Like Baldwin's Sonny, they are the ones who can call attention to the terms of our belonging and simultaneously forge new symbolic arrangements *to* belong.

Eccentric indie jazz vocalist René Marie often plays out this drama in her contemporary sets, swinging from left field in her daring performances that wend their way through the thickets of racial history, mixing and matching well-known compositions ("Dixie" and "Strange Fruit") in order to draw to the aural surface tensions between the mythical united state of the nation and the volatile experiences of the dispossessed. Her intricately arranged and much-discussed disturbance of state narrative and presumptions of the American collective in 2008 is a prime example of her style and strategy. Invited to sing the national anthem at Denver's mayoral inauguration that year, Marie delivered a now-infamous performance that unsettled the terms of civic propriety and pulsated with the concentrated energy emerging out of her brave and abrasive aesthetic choices. She made herself a world in that moment, closing her eyes and leaning into a measured, steady reading of two classic songs at once, interpolating the words of James Weldon Johnson's 1900 declaration of Black collective determination to "lift ev'ry voice and sing" into the fabric of "The Star-Spangled Banner." It was a feat that hinged on referencing and yet also dissolving the anthem's imperial bombast and simultaneously rendering precious the language of New Negro fortitude and uplift. Before a visibly bewildered audience, Marie turned the nation's song of itself into the O.G. African American battle cry with its insistence on facing the "rising sun" and "march[ing] on 'til" racial justice "victory is won." Her sonically curated historical drama altogether troubles the proper and disrupts "the common sense of 'the national anthem.'" It is a performance that makes audible the tensions between the stars and stripes "Banner" and the "Voice" of Blackness by, in part, calling attention to the op-

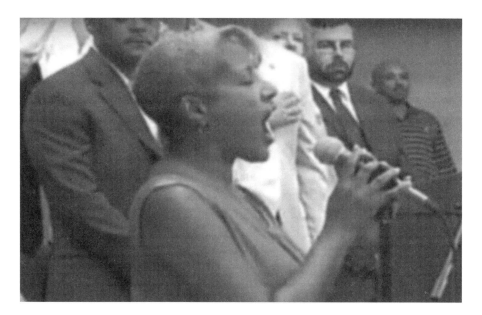

René Marie performs "Lift Ev'ry Voice and Sing" at Mayor John Hickenlooper's
State of the City address, Denver, July 2008

posing sensorial strivings of these two anthems. One hears in Marie's startling
double reading one song invested in selective sight ("O say can you see . . .") and
another predicated on a sound uprising, the call to raise voices so high towards
the "listening skies" that they might shake heaven and earth. It is Marie's keen
abilities as both arranger and musician, as Shana Redmond reminds, that frame
the terms by which she executes what amounts to an "a cappella experiment in
the practice of citizenship" and a refusal to "resolve the contradictory positions
and practices that define black women's citizenship."[52] Calmly, pointedly she
turns over each word of Johnson's while yet still holding down the composi-
tional blueprint of John Stafford Smith's English drinking song that white su-
premacist Francis Scott Key had cribbed for his ode to early American military
might. Carefully, she moves to merge these two songs as if both detonating one
bomb and preparing to set off another. Rhythmically, she displaces Key's lyrics
for Johnson's, enacting a triple reading—of Johnson's verse, Key's military vic-
tory song, and Johnson and composer brother J. Rosamond's musical conver-
sation with Key's work.[53]

Marie's performance amounts to more than mere arrangement as it both "dis-
turbs and questions the work (of the arranged as well as of the arranger)" and
depends on the Blackness of her embodied witnessing, her insistence on making
a scene out of the interfacing of two songs at dramatic odds with each other.

This is labor that amounts to sonic curation, radical "interpretation," fugitive "storytelling," and a commitment to hailing the audience in the renovation of this master song that was never meant for Black folks. This is her bid to amplify the sounds of those who tread the blood-stained "path" of the "slaughtered," those who toiled to reach the precipice of a "gleam[ing]" new tomorrow forecast by Johnson. She puts Johnson's anthem to work with surgical precision, interrupting and also slyly harmonizing with Key's hallowed yet hollow composition in a different register, turning up the volume on this Blackest of calls to "rejoice," come what be and though "stony the road we trod . . ." Marie is, here, the curator as well as acoustician, manipulating the soundscapes of Key, composer Stafford Smith, and the Johnsons' respective works, laboring over them so as to leave her own "acoustic signature" and, in the process, opening up their (public yet secret) relationship to one another.[54]

This is the anatomy of modern sonic culture of which Black women artists have been the architects—which is not to say that every sister rolling up on a microphone is crossfading colonial era patriotic cuts with postbellum uplift hymns. What Rene Marie exemplifies, however, is the particularity and poignancy of Black women musicians' consistent resolve to turn to sound as a form of historical recourse.[55] Armed with the "prostheses" of a "phonographic listening instrument" that is her own musical virtuosity, René Marie, the "transducer" of sounds, shares with her stunned audience a secret from the realm of the subterranean: that Black women have been radically recording, archiving, and rearranging the modern era right before our very ears.[56] They are the technicians and the designers of sounds that have been captured, mimicked, and reproduced by instruments of technology that constitute the making of our modern life. And they are also the authors of their own (exhausting) instrumentation that has actively produced that life, recording it, replaying it, and providing us with the means to listen to the rich and intricate complexity of their own survival. Their sounds are "not just the annunciation of modernity itself but the insurgent prophesy that all modernity will have at its heart, in its own hold, this movement of things, this interdicted outlawed social life of nothing." Theirs is "the antiphonal accompaniment to gratuitous violence—the sound that can be heard as if it were in response to that violence, the sound that must be heard as that to which such violence responds."[57]

No one would dispute the fact that the brothers—everyone from Satchmo, Monk, Miles, and Trane to Otis, Marvin, and Stevie—have actively participated in the making and fierce preservation of this tradition too, and the many cornerstone works in jazz studies, soul, R&B and hip hop studies attests to this—largely at the expense of paying greater attention to the exceptionalism of the

African American women on the frontlines of this cultural phenomenon. The question becomes, then, whether we might be able to imagine a pop (culture) life with Black women at its full-stop center rather than as the opening act, the accompanying act, or the afterthought? Can we be like Jayna Brown who, in her important study of Black women performers "in motion" in the early twentieth century, notes the critical role that these dancers and actors, comedians, and all-around entertainers played as they traversed the "shifting terrain" of the modern city armed with their resilient imagination and shaking up cultural life along the way. Like Brown, I care for and about the cultural work of Black women and tracing the accomplishments and wonders of their creative lives as well as the ways that they marked their experiences as modern subjects in active, sensorial relation to their worlds. We might think of the artists in this study, then, as akin to Brown's flaneurs who are wholly resourceful in their execution of vision and movement and in their navigation of changing sociocultural landscapes and socialities.[58]

I have set myself to listening to the Black women whose labor can be measured in sound, the ones who "pus[h] against the grain" and as Richard Iton would have it, innovate "potentially transformative" and "thickly emancipatory and substantively post-colonial visions . . . in their lower registers."[59] These artists, the revolutionary engineers of social and cultural modernity, repeatedly confound modernity's racialized and gendered tenets rather than "displacing" its tenets altogether. Black women musicians and Black feminist thinkers are, it would seem to me, the progenitors of sonic forms, aesthetics, and strategies, as well as *ideas* about the sonic that have destabilized and reordered our sensorial and expressive lives, and such a revelation demands that we account for how their imaginative and analytic practices have made massive contributions to the ways in which we cognitively and affectively make sense of our place in the everyday world and how we move through it. The women in this study disrupt modernity's negation and violent expenditure of Blackness and Black womanhood in particular.

I would add too that my own thinking on this topic takes seriously the drop-dead radical claims made by Black feminist poet and theorist Simone White. While I diverge from her important and iconoclastic criticism in significant ways, White's bold line of theorizing involves, in part, a wholesale reinterrogation of "the Black Music Juggernaut," as she refers to the criticism of Moten and poet-music theorist Nathaniel Mackey as well as Amiri Baraka and others, which I still find useful in this book. For White though, this "Juggernaut" is an often masculinist, overdetermined "aspect of thought that is of the devil—insofar as it describes the unobservable and unheard (of) and allows for communication

only via belief in a certain attunement to how it feels to be a problem." What she is after is an "alternative to the image of blackness as a sound, an archive of sound," for it is sometimes presumed in these authors to be wholly entangled with racial terror, with "the advent of modernity." She instead wants to think expressive practices beyond this moment, so as "to come into other existences, again and after, with modernity's ebb and flow," and she thus proposes the capacious figure of "the fold," a "metaphor" that can move us "toward understanding how life can begin to take place where black people are concerned; some whole understanding of the space inside which individual black life (continuously unfolding expression) can take place, not in defiance of opposing powers, but paying them no mind, remaining nonetheless attuned to their structuring presence."[60] *Liner Notes for the Revolution* searches for a similar place, but it significantly and obviously does so without letting go of the belief that the *practice of sound* and *sound performance* as made and executed by Black women in relation to power—as well as the writerly philosophizing of such sounds by women critics—remain a source of severe analytic neglect. Theirs is the kind of event that I am not yet ready to discard and move beyond, because there's so much information about this crisis stored up in this work of the sisters that we've yet to even sit with—let alone discover—whether in the vaults of Paramount Records or housed in the memories of my nonagenarian mother.

In other words, while White's work challenges us to think about the problem of the brothers who are writing toward, after, and alongside one another about Black music, it shouldn't take us away from the far-too-often-rendered-as-invisible women who make up "the chorus." I focus resolutely on the ones who, as Hartman makes so vividly clear, were engaging in disorderly "experiments in living free," those who were making music so as to offer "a fierce and expanded sense of what might be possible," those who were articulating "the ardent longing to live as one wanted."[61] Through their sounds, she argues in her symphonic meditation on this subject, "you can hear the whole world in a bent note, a throwaway lyric, a singular thread of the collective utterance. Everything from the first ship to the young woman found hanging in her cell. Marvel at their capacity to inhabit every woman's grief as their own. All the stories ever told rush" from the "opened mouth[s]" of these artists, who emerge as an ensemblic array of actors in the archive.[62]

Reckoning with their sounds reminds us that everything is possible. Their art is both the key to and the contestation of modernity. They make and store up the sounds that reflect new times, other places, other ways of imagining our connections to one another through their wholly influential, widely imitated, and felt expressive forms. As records (living archives) and recorders (archivists),

Black women sonic artists are, as I have stated throughout, listening, arranging, curating, performing, and, by way of these practices, scripting modernity. We might hear more clearly the way they are creating original works and, likewise, (re)arranging that which has already been created. They sing, sign, write, and rewrite in concert with one another's labor, designing works that comprise many voices and listenings. Their artistic and critical aspirations call on us to take note of the fact that they were always more than "object[s] of modern power and the subject of . . . modern life."[63] "Who else," Hartman asks,

> would dare believe another world was possible, spend the good days readying for it, and the bad days shedding tears that it has not yet arrived? Who else would be reckless enough to dream a colored girl's or a black woman's future? Devote even an afternoon musing about the history of the universe seen from nowhere? Or be convinced that nothing could be said about the Negro problem, modernity, global capitalism, police brutality, state killings, and the Anthropocene if it did not take her into account? Did not reckon with the disavowed geography of the world: the barracoon, the hold, the plantation, the camp, the reservation, the garret, the colony, the attic studio, the bedroom, the urban archipelagoes, the ghetto, and the prison? The chorus bears all of it for us.[64]

Like "literature," which, she observes, "was better able to grapple with the role of chance in human action and . . . illuminate the possibility and the promise of the errant path"—providing, that is, a break from coercive, disciplining societal norms that have policed and surveilled Black women before, through, and beyond the modern era—sonic performances are sometimes sumptuous, sometimes tempestuous forms of potentiality, dreaming, planning, negotiating, exorcising, proselytizing, and prophesying.[65]

Sound performances—that formalistic elixir of what Black radical tradition philosopher Sylvia Wynter refers to as "bios and mythoi"—are the means through which these artists forge a different epistemic relationship with the world, one that allows them "'to climb out of our present order of consciousness' . . . to know / think / feel / behave and subjectively experience ourselves—doing so for the first time in our human history *consciously* now—in *quite different terms*." The sound performances of the artists in this study enable us to think of Black womanhood as "hybridly human," as contesting the limits placed upon conceptions of the Human as defined by the West. Mary Lou Williams, Esther Scott, and René Marie are but three examples of artists who redefine their own modern condition by expanding it through sound, and by using sound to "detach themselves from

imperial knowledge and subjectivity." As Wynter scholar and collaborator Katherine McKittrick asserts, "the science of the word is writ large" in "music and music making." These are the forms and performance strategies in which "the physiological/neurological human being" who "assembl[es] creative texts . . . understand[s] and perceive[s] the world as necessarily connective."[66]

For this reason alone, the records matter. *Liner Notes for the Revolution* pays attention not only to the expressive singing voice in the making of the modern but also to the recorded expressive practices of Black women musicians and the ways in which said practices constitute innovations in modern, technological cultural production. Black women musicians are experimental mediators in the story that I'm telling here. They are figures who modulate and remix history—our felt and distinct relationship to specifically powerful conceptions of time and place, our identifications and disidentifications with community. And while it should be obvious that all sorts of gifted performers across any combination of expressive forms are privy to such skills, the "stakes is high" for those who've been historically deprived of determining and defining the experiences in and on their own time. Throughout this book's journey, Black women musicians use, manage, exploit, and reimagine sonic and visual technologies—the phonograph, microphones, cinematic and video production—in ways that both subtly and overtly push against prescribed notions of how Black women artists sound, look, and move in the popular music imaginary. And they use these devices toward their own exuberantly conspiratorial ends.

Think, then, of Black women musicians as the invisible media—or the "vanishing mediator," as Jonathan Sterne might have it—through which the West experiences itself as "new" and constantly, dramatically shifting, "evolving," becoming. As conduits of sounds that altered the sociocultural economy in the first half of the twentieth century and reshaped the political and affective meaning and utility of popular music in the second half of that century and into the new millennium, the performers in this study have turned to the sonic in the face of white patriarchal supremacy's structural negation of their personhood. As women who listen, who record and bear witness as distinct and often "noisy" records of racial, gender, class, and sexual specificity in the margins, they trouble the unspoken antitechnological romance of the "aura," that Benjaminian concept of aesthetic essence and presumptive inviolability so often attached to white masculine art in our cultural imaginary. That which is "authentic" and "original" is made by white men. That which is mimetic and lacks innovation is made by everyone else. So goes a tale that gained traction and power in the age of nineteenth-century blackface minstrelsy, but whose roots are, we know, centuries older.[67]

Benjamin's famous hand-wringing focused entirely on machines and modernity, the anxiety of what technology might do to the art object's "nature" as it dislodged that object from its original context and reproduced it for the masses. But the myth of aura shares much in common with the white masculine pop music canon in that both depend on a perception of the world in which dialectical exchange and "otherness" have no influence, no consequence, no potential to shape or shift existing ("white") objects of their putative essence. Black sonic womanhood unsettles this myth by calling attention, often in a curatorial mode, to the palimpsest, the networks of listening bound up in the act of performance, the presence of multiple voices, multiple histories, aural entanglements, cultural memories encapsulated in sound as the vital and innovative framework for art itself. To think of these women artists as modern media, as crafting performance practices that anticipate, reflect, and refract the practices of early sound reproduction, is to recognize the extent to which, like this media, their work sustains "recurring relations among people, practices, institutions, and machines." "The medium is the shape of a network of social and technological relations," argues Sterne, "and the sounds produced within the medium cannot be assumed to exist in the world apart from the network." He is referring here, of course, to "studio art," to early phonography, telephony, and radio and the range of sound-reproduction technologies emerging out of these inventions that informed and transformed "the messy and political human sphere."[68]

By focusing on Black women's sound labor, *Liner Notes for the Revolution* insists on thinking modernity in different terms. It aims to take us to a place where the artists themselves are mapping, singing, playing out, and curating strategies that call attention to the ways that Black folks—and Black women in particular—are figuring the Human as an ongoing, co-relational doing (from noun to verb). The musicians and thinkers in this book are each, in her own way, invested in imagining the fundamental condition of "being" as fluid rather than stable, changeable rather than fixed, and above all else, free—in spite of the external world's efforts to tell them otherwise. The category of the Human, for these culture workers, is powerfully and thrillingly mediated by art-making, by poetic, kinesthetic language, by the "science of the word" that "*feels and questions* the unsurvival of the condemned, dislodging black diasporic denigration from its 'natural' place through *wording* [and sounding] the biological conditions of being human."[69]

This art quests and questions; this art offers the performer/listener the chance to have a different epistemic relationship with one's environment and with one's autopoietic, genre-specific living system (the "status quo"); this art unsettles our perception and acceptance of "imperial Humanity" born out of

the locally realized, globally ordained Enlightenment West; this art demands that we redefine the terms of what it means to be "enlightened" altogether. It is art that both poses and sings a revolutionary response to this question: What does it mean to be modern when humanness is an ongoing, hybrid, improvisational praxis? What if, rather than assuming the role of being "conscripts to modernity" as an end point, Black women artists draw on the "conditions of possibility" emerging out of this situation to paradoxically affirm and articulate that which is in excess of the modern, that which goes not wholly against it but beyond it altogether? What kind of language might we use to lay claim to Black women's sound modernity and its ability to create new places, new times, new ways of being?[70]

What this book is after, then, is a way to talk about the entanglements of "modern life" and the sonic imagination of certain daring Black women artists. What I'm after here is a way to tell a story of modernity from the vantage point of those who have been excised and exiled from the foundations of the modern but who, nonetheless, invented performance languages and expressive modalities that have dramatically reinterrogated and reordered human experience. Black women's "sonic imaginations bring us to particular conjunctures and problems, but they also redescribe them from unexpected standpoints."[71] Theirs is a dense "cultural front," to borrow Michael Denning's formidable analytic formulation, and by virtue of Black folks' historical disenfranchisement and rejection from institutionalized power structures, they were always and already producing a kind of public culture that perpetually, in its structures of feeling, generates radical expressive forms and forges potent "allegiances and affiliations."[72] They have crafted an alternative archive of modernity that both is shaped by and accounts for the violence of their presumed invisibility in and dispossession from the body politic and yet exceeds that violence by evermore attempting to rehearse and record "a new set of social arrangements."[73]

My argument hinges on recognizing the ways that, at tremendously important junctures in time, Black women's sonic performances functioned like phonography, that modern technology that evolved into a medium. Sonic Black womanhood shatters the "aura" of white mythical sound practices and allows us to be privy to the polyrhythms of their fully realized lives. Their sounds, which respond to the maelstrom of Man, as Wynter might have it, ultimately run fugitive from Man. To be both record and recorder means not only to unsettle the terms by which we understand Man, it also signals the ways that Black women artists generate and store counterknowledges to those who deny their humanness altogether. As records and recorders, they manage and mediate both bios and mythoi, invoking embodied sounds that constitute and reflect the foun-

dations of their being as "homo narrans," that Wynter coinage that reminds us of our species' "storytelling" origins.[74] Through sound, they preserve and pass on stories of Black womanhood that exceed the script bequeathed to them by Man. Through music, they create electrifying networks for Black women to move through and use as a means to self-making, self-reinvention, and co-relational insurgency. Like the formidable and intrepid young Mary Lou, they are archivists digging for knowledge in the sonic work of other women, documenting, preserving, and disseminating the performances of others. Like Esther Mae Scott and René Marie, they are listening, (re)arranging, reframing, and curating the music that they carry inside them and pass on to others. Their multiple, intersecting publics constitute radical cultural networks of aesthetic rupture and transformation; their music is a kind of "musical criticism *in music*," and as critical, intellectual, and artistic forces, their practices, methods, and innovations insist to us the multiple ways that Black women musicians are the engines of modernity.[75]

"Everything Is Possible": Black Studies, Rock Criticism & the Feminist Hereafter

Think, then, of these boisterous vocal sisters as the "little women" who steer *Liner Notes for the Revolution* and subterranean blues study more broadly. For they are the kind of sharp and knowing figures who, like Ralph Ellison's trenchant figure in his classic essay "Little Man at Chehaw Station," lurk in the most unexpected places, observing and evaluating the broad American cultural scene. In that landmark work of cultural criticism, Ellison reflects on the sage advice that he receives from his Tuskegee music teacher, cosmopolitan classical pianist Hazel Harrison, who imparts the famous, transformative riddle to her young charge to "*always* play your best, even if it's only in the waiting room at Chehaw Station, because in this country there'll always be the little man behind the stove."[76] Her advice sets young Ellison on a journey to figure out, among other things, the meaning of performative virtuosity as well as the recognition of cultural hybridity in America.

Much critical attention has focused on the figure of the "little man" as a symbol of the listener who sits (quite literally) at "the crossroads" of Chehaw Station and who thus serves as a reminder of the importance of performing multilingually—playing, writing, singing in both classical and vernacular idioms (because you never know who might be listening). The little man is also, as Ellison sees it, a "connoisseur," a "critic," and a "trickster . . . a day-coach, [a]

cabin-class traveler. . . . Sometimes he's there, sometimes he's here." To El-lison, his cultural fluency and fluidity are signs of American democracy's open secret, of which he was a true believer: that "our 'Americanness' . . . creates out of its incongruity an uneasiness within us, because it is a constant reminder that American democracy is not only a political collectivity of individuals, but culturally a collectivity of styles, tastes and traditions."[77] Ellison's interest in America's "complex and pluralistic wholeness" is one that I share in this book. However, as cultural critic Nicholas Boggs points out, Ellison's focus on the "little man" has come at the expense of considering Harrison's critical role in guiding him toward an understanding of the meaning of cultural plurality in the first place. Few have taken note of Harrison's "sphinx-like" presence as the core interventionist figure who, through musical proverb, teaches her student a lesson not only about heterogeneous Black subjectivity in American culture but also about the critical meaning of Black womanhood in relation to that cul-ture. She is, Boggs suggests, the "little woman" who guides Ellison toward em-bracing the profundities of democracy's promise as well as the exigencies of sonic expression as the complex articulation of self.[78]

Ellison's own pedagogy on this score has guided me as well. As a Black femi-nist literary and cultural critic who grew up making regular pilgrimages to the now-defunct Tower Records and loitering at the magazine rack reading rock rags, I can see no other way of telling this story of Black women's sounds and intellectual culture without considering the criticism that shaped perceptions of these sounds. Given my own roots, it seems right to acknowledge what I have in common with the "little man" who, "*as a reader* . . . demands that the rela-tionship between his own condition and that of those more highly placed be recognized." The little man "senses," as Ellison points out, "that American ex-perience is of a whole, and he wants the interconnections revealed," as do I.[79] As a result, other kinds of thinkers—critics, novelists, playwrights, visual art-ists and their respective works—matter in the story that I'm telling here in that they create expressive forms or meaningful aesthetic dialogues with the artists in this book, as do other intimates and companions and public audiences—the crowds, the diverse publics whose competing desires and feelings for these art-ists often figure prominently, as both inspiration and antagonism, in the reper-toires of these women.

The point of these sorts of efforts is to, in effect, invite a motley bunch of readers—some of whom may find this work's prolonged engagement with ar-chival Black feminist figures foreign, illegible, or irrelevant to their interests, and others who may not recognize or care about the stakes involved in con-fronting white male–dominated rock and blues criticism at all—to reassess

their presumptions. In many ways, this book yokes together two seemingly disparate worlds—the alternative cultural arts criticism born out of the New Left and counterculture revolutions of the sixties and the illustrious line of African American radical thinkers who have long innovated profound theories about the meaning, purpose, and possibility of culture and its ability to reframe and reform the fabric of our lives. *Liner Notes for the Revolution* calls attention to what I see as the urgent need for rock lit and Black studies to "speak" to each other, to account for the overlooked and undertheorized value of Black women as cultural actors and innovators, and most importantly, to reckon with the lasting impact of a Black feminist intervention *in both fields all at once.* If the bold and ferocious analytic mischief of critic Greg Tate teaches us anything, it's that a crucial and unprecedented merging of these spheres of thought might serve as a touchstone for pushing the boundaries of both the language and the conceptual framework for reading pop culture with Black fantastic genius at its center. As Tate, the iconoclastic freedom-fighting brother from another planet of arts writing and theory puts it bluntly, "What I myself have really been intrigued by all along is something less quantifiable than Black Culture and even Black Identity and Black Consciousness, and that something is what my friend Arthur Jafa has termed Black Cognition—the way Black people 'think,' mentally, emotionally, physically, cryptically how those ways of thinking and being inform our artistic choices."[80]

Liner Notes for the Revolution is thus no "history" in any conventional sense of the word. Like critic Hazel Carby, who once famously distanced herself from the Black feminist theoretical impulse to rely "on a common or shared . . . experience" in exploring the work of Black women writers, I do not set my sights on excavating a "tradition" of Black women's musical aesthetics. I do, however, pursue the idea of Black women musicians and entertainers as sociocultural intellectuals and as archives of cultural memory. I focus on the ways that cultural critics, scholars, and collectors emerge as integral figures in the production of Black women's sonic cultures and their discontents. And I aim to tell a twofold story: of how an array of daring Black women artists engaged with historical memory and fragments of Black folks' sociocultural past through sound, and of how these same artists innovated their own distinct and innovative modes of critical practice *within* Black sound. The flipside of this story focuses on the ways that critics and record collectors have documented and produced divergent knowledges about Black women artists and devised very particular ways of reading their work. The juxtaposition of these two worlds—that of the musicians and that of the critics—is crucial here because at its heart, this book insists that Black women's popular music culture, sound archives, music critics,

and collectors are deeply entangled with one another and that Black women musicians have strategized myriad pathbreaking ways to navigate said entanglements. The story of these women cannot be told without paying attention to the white and mostly male critics and the archives that documented their lives and work but were just as prone to forgetting them.

While it may seem of little or no consequence in the third decade of the twenty-first century to address and treat Black women musicians and performers as thinkers, as artists with intellectual questions and formidable desires, and as figures whose work generates relevant and sometimes pivotal sociocultural commentary and is often rooted in some form of critical, transformative action, consider the following. Since Farah Griffin's landmark 2001 publication of *If You Can't Be Free, Be a Mystery: In Search of Billie Holiday,* the first scholarly book by a Black feminist critic that fundamentally reshaped and elevated critical conversations about Lady Day as a musician, full-length studies in this vein are still few and far between.[81] Instructive on this score is Brent Edwards, whose deeply eloquent meditations on the aesthetically and analytically adventurous role of the jazz musician as writer resonate with my approach to exploring the artists in this study. Edwards's razor-sharp focus on how the music of African Americans "contains not only emotional surges and rhythmic propulsion but also the 'character of cognition'—commentary, insight, and even lucid critical analysis" and, perhaps most powerfully for my purposes, his claim that "the music can provide the model for criticism because the music *already is* criticism—itself, autonomously, purely in the medium of the sound" inform my own thinking about Black women's sound practices.[82]

Yet here too we gently part ways—not only because of my interest in foregrounding gender (Edwards's magnificent *Epistrophies* includes only one chapter on a woman artist) but because I remain steadfastly focused on exploring Black women musicians' performance labor as encompassing a constellation of intellectual and historiographical practices.[83] Like Edwards, I am drawn to exploring what he refers to as this "ancillary" form of writing about music that has the power to "emphatically frame the way a recording is heard, whether by noting the stylistic trends it exemplifies, making an argument for its historical significance, pointing out its shortcomings, or sketching an alluring (or off-putting) 'persona'" of the artist in question.[84] To aspire to the level of writing or producing knowledge akin to liner notes is, for Black women artists and Black feminist sound critics, to intervene in the framing practices of others who have either denied or discounted their work. It is critical meditation that questions, contests, and welcomes improvisatory and experimental ways of

thinking, performing, and writing through and about the many meanings of Black women's sounds.[85]

As a result, *Liner Notes for the Revolution* takes seriously that which has been marginalized, trivialized, and disappeared in popular music culture and American culture more broadly. It remains mindful of Frankfurt School theory, that body of interwar European philosophy that wages a multifaceted critique of, among other things, capitalism and its culture industries, bourgeois consciousness, and ideologies emerging out of Western civilization on the whole. Rock star critics like Theodor Adorno, Max Horkheimer, and a dynamic cluster of other Weimer Republic thinkers who constitute the Frankfurt School were drawing on Marx, Hegel, and Freud to build a new philosophical radicalism. They were working out wide-ranging theories that, in part, dissected the failures of the social, the fallacies of material culture, and the crushing oppressiveness of cultural hegemony, the structures of domination produced by the ruling class. Adorno, in particular, appears in pointed cameos at various moments in this study, but he also remains an important foil. What his work tells us about music's ability to radicalize our senses, to disturb and reorder our consciousness, is a point of deep inspiration to me, but his infamous rejection of *popular* music as a manifestation of the culture industry's hold on the masses is a critique that leaves little room for the complexities of Black expressive emancipation. As Lindon Barrett famously points out, Adorno "completely misses the antagonistically transformative relations that jazz and the African American communities from which it arises have to Western market societies—that, upon examination, prove the actual objects of his denunciation."[86] The Germans, therefore, can only get us so far when it comes to tracing the explosiveness of Black folks' sounds and especially those made by Black women.[87]

Instead, this book insists on forging a different kind of path with a sound set of Black women and their feminist allies leading the way. It offers a self-consciously unfinished map for future users, a "subterranean" cultural cartography of Black women's musical innovations and performative aesthetics that both predates the meteoric emergence of the early twentieth-century Black women's blues era and tracks these cultural moves into the new millennium. *Liner Notes for the Revolution* listens along to a series of historically situated musical "events" and "happenings" that reflect, shape, and—sometimes quietly, sometimes at full volume—transform (sub)cultural scenes as well as public notions of "Blackness" and "womanhood" across the modern era. It draws its inspiration from a variety of sources and thinkers that include academics, outlaws, critics, and critical miscreants (with a few who are one and the same). Yet in its

insistence on recording the "secret" life of Black women and sound, it is most immediately in conversation with *Lipstick Traces* (1989), foundational rock critic Greil Marcus's swirling, mystic, phantasmal, and kaleidoscopic "secret history of the twentieth century," which presents an epic saga of punk and Free Speech, Situationists and Letterists, Johnny Rotten and Little Richard, and Adorno as (re)covered by the Sex Pistols.

Marcus, too, is wary of "tradition as arithmetic," choosing instead to go in search of a story that "disrupt[s] the continuities of a tradition, even the discontinuities of a smoky, subterranean tradition, with a certain simultaneity." As critic-turned-curator, he arranges a radical assemblage of cultural actors and traces a variety of sonic disturbances and socially disturbing gestures in order to illuminate a "history" that is "comprised of only unfinished, unsatisfied stories" that "carr[y] tremendous force." Repeatedly, Marcus seizes upon the "task," as critic, to encourage others to "stop looking at the past and start listening to it" so as to "hear echoes of a new conversation. . . . to lead speakers and listeners unaware of each other's existence to talk to one another." The job of the critic, he declares, is "to maintain the ability to be surprised at how the conversation goes, and to communicate that sense of surprise to other people." The "secret" for Marcus is one in which artists and activists, intellectuals and would-be criminals across time share a discontinuous yet undyingly passionate resolve to reject ideology, to make culture that revolts against and exposes "the whole received hegemonic propositions about the way the world was supposed to work . . . a fraud so complete and venal that it demanded to be destroyed beyond the powers of memory to recall its existence." More than two decades after Marcus published his molotov tome, its central hook remains seductive: "Nothing is true / everything is possible."[88]

Or, as Black Rock Coalition legends Living Colour might rephrase it, "Everything is possible / but nothing is real." At the risk of pushing the eighties thing a bit too hard here, I cue up the lyrics from that band's song "Type" in order to mark the Robert Johnson crossroads, in order to plant the flag at the point on the highway where Marcus and the Pistols' secrets cross paths with Black folks and where, just as well, Blackness holds many secrets of its own. "We are the children of concrete and steel," sings velvety crooning hardcore lead vocalist Corey Glover. "This is the place where the truth is concealed / This is the time when the lie is revealed / Everything is possible, but nothing is real." The godfathers of Afrometal assured us that they heard Marcus loud and clear on their Elvis-is-definitely-dead 1990 album *Time's Up,* but in their insistence on calling attention to an urban ("concrete and steel[y]") people's ability to "reveal" the "lies" and make "everything" possible in the third installment of the Reagan-

Bush regime, guitarist and songwriter Vernon Reid and his group were also staking a claim in the negationist game.[89] Living Colour reminds us that the Frankfurt School's negative dialectics, which fuel Marcus's potent intellectual shove, is already and has always been a Black operation,[90] as people of African descent's survival has always depended in part on negating the "truth" that's been fed them since their days in captivity, since before and after Frederick Douglass resolved to love everything his master hated.

When I bang my head in time to Living Colour as well as Marcus's *Lipstick Traces,* I'm left, then, with this question: What would it mean to put it all together and to put it in the service of the sisters? What if we could get everybody in the same room and around the same table to do some hardcore Black thinking, some mindful meditation on the capaciousness of Blackness, some deep listening to the sounds and performances that evade easy logic, and what if, still more, we could mix it up in the mosh pit with rock and roll criticism in order to tell a different story about popular music culture, one that takes seriously the women who made new sounds and, likewise, thought hard about how to go about writing down and recuperating the value of said sounds for the ages? Can we even imagine a history of popular music that regards as priceless the innovations of a different cast of lead characters from the ones so often deified? The possibilities are endless if we could only stretch our curiosity and imagination to, for instance, ponder the crossed-eye moves of a young Josephine Baker, a Parisian music hall sensation refusing the primitivist line; to expand the cultural lexicon in which we think about the queer blond hairdo and gutbucket vocals of on-the-verge Etta James, a New Frontier teen and former gangbanger finding her voice through the blues; or, as this book aims to do, to keep pushing our exploration of "dance or die" Janelle Monáe's early career in the guise of an android superhero composing her own epic, multimedia adventure.

Black women musicians show us myriad ways of doing "Black Cognition" through exhilarating and sometimes "cryptic" forms of artistry. To borrow a line from those rock crit darlings and riot grrl revolutionaries Sleater-Kinney, they "invent [their] own kind of obscurity." That white feminist legendary band, co-led by Walter Benjamin–fluent polymath Carrie Brownstein, speaks in these lyrics of a kind of poetic truth to power that shares affinity with Black studies thought as well, a point that further drives home the kinds of connections that this book insists on. In the world of Black studies, the "right to obscurity," as Fred Moten famously argues, "corresponds to the need for the fugitive, the immigrant and the new (and newly constrained) citizen to hold something in reserve, to keep a secret." Moten reminds us that, "The history of Afro-diasporic art, especially music, is the history of the keeping of this secret even in the midst

of its intensely public and highly commodified dissemination."[91] And to this, poet and critic Mackey adds that "one of the reasons" that black diasporic music "so often goes over into nonspeech—moaning, humming, shouts, nonsense lyrics, scat—is to say, among other things, that the realm of conventionally articulate speech is not sufficient for saying what needs to be said." It is the diasporic condition of a perpetually, sometimes utterly, other times subtly eccentric Black musicking that is, Mackey insists, "dialogical in quality," and it "can be heard in a number of different idioms and forms."[92]

Such wondrous forms, this book asserts, cannot be accounted for in straight-ahead history, per se. This is why, for instance, genius poets like Moten and Mackey have made such dazzling inroads in Black sound studies by altogether pushing the language that we use to talk about the prodigious complexity of Black music, the magnitude of its weight and depth. The field-altering work that Mackey and Moten have each executed by way of issuing what amounts to a series of poetically rendered correctives—about, for instance, the presumed "legibility" and tenacious resonances of Black sound—are crucial to any study of modern sonic culture because their work forces us to confront with, among other things, the long historical arc of Black phonic meaning that precedes, rivals, and runs parallel to the characters whose acts are "really happening" in Marcus's study. As Moten makes plain in his by now legendary *In the Break* opening conversation with Hartman, Marx, Freud, Derrida, and others, if we recognize the fact that Black subjects who are conscripted to the realm of commodities can speak, then we'll have to come to terms with the "commodity's powers" to also "break speech." This is "the always already belated origin of the music that ought to be understood as the rigorously sounded critique of the theory of value."[93] And still here, we might think of the ways that my dear brothers, too—as they would surely agree—follow a Black feminist model of formalistic philosophizing, the kind of which Morrison speaks when she talks of the importance of "getting language out of the way" in her approach to writing about slavery and its afterlives. The majesty and invention of her speculative prose revolutionized Black Studies thought as well as the style and content of said thought for the last half century. I, too, follow the Morrisonian path of the speculative at key points, drawing inspiration from Hartman and others as well so as to open up our relationship to the depths of the opaque Black sonic past.

Liner Notes for the Revolution suggests that the Black women from the way back to the right now, women who made this music as well as the women who saw fit to take note of it, are the revolutionary ones who expanded our notions of what's expressively possible, powerful, and humanly restorative in a world that never showed them enough love. If, then, as Patricia Ybarra makes clear in

her incisive rereading of Marcus alongside Adorno and the Rude Mechs Theatre Company's stage adaptation of *Lipstick Traces,* punk as a "performed," quotidian event is "performance as historical articulation," it is, indeed, a very old, new thing. And ain't nothing wrong with that. The thrilling part is, perhaps, to listen to all that noise, that "lost matter, lost maternity, lost mechanics that joins bondage and freedom" that one can hear when these secrets are put in the mix with one another.[94] Think, for instance, of Zora Neale Hurston challenging the Southern world order with her reco(r)dings of Black song, and Abbey Lincoln sitting on the edge of Mahalia and Ellington's "Sunday" dispensing her own sound knowledge. These two Black women artist-intellectuals, along with two white, Jewish feminist critics—one a vinyl archivist and the other a pioneering critic of rock and roll vinyl—add to the critical cabal that shapes the contours of this book. Each carries Peetie Wheatstraw's wheelbarrow of blueprints for what lies beneath the surface, in the subterranean realm where everything is possible.[95]

To get to that place, I'm drawing from the secrets of the thinkers already mentioned. This book asserts that to go to the site where blues and rock criticism can better handle, better care for the sisters making marvelous sound, we're going to have to lean hard into Black study. To better hear both the women at the bottom of the archive and those that sit at the top (yet beg for a different kind of attention), to better "think sound" and do some better "sound thinking" in relation to music criticism on Black women, we might surprisingly take a cue from Bob Dylan, the artist whose 1965 agit-prop lament "Subterranean Homesick Blues" is one of the sources of inspiration for my work and an artist who knew a thing or two about Black women's musical virtuosity and genius.[96] "They keep it all hid," declares our electric man; "better jump down a manhole." Dylan's would-be escape route is one that runs down to the place where you'd better "light yourself a candle" and not "wear sandals." His high-stakes folk blues rightly mistrusts this man's, man's, man's world of corrupt leaders and white supremacists holding the "firehose" and seeks, instead, cover in darkness, taking the leap that Ellison's masterpiece *Invisible Man* did some thirteen years before his song dropped. That writer's Afromodernist working-class hero is, however, anything but "homesick," discovering instead revelation and light in the underground, the place at "the end" that "is in the beginning and lies far ahead," the place where Satchmo and reefer upset time signatures and give way to the sounds of "an old woman singing a spiritual as full of Weltschmerz as flamenco" while yet another woman, "a beautiful girl the color of ivory plead[s] in a voice like" the protagonist's "mother's as she stood before a group of slaveowners who bid for her naked body."[97]

That great American novel's prologue whispers to us that, if we run the tunnel from the rock and roll Bard back through to Black literary modernism's patron saint on through to the sounds of subjugated Black womanhood, we reach the "fugitive spirit" that Mackey so influentially describes as a voice full of flamenco, that which is "a sound of trouble," as he refers to it, an "eloquence of another order." It is a voice as well of musical, existential supplication, an "unquenchable thirst" that is "a longing without object," a voice full of "Weltschmerz" that is escapist and alienated.[98] It is a voice that deserves its own set of liner notes. The women way down in the Ellisonian dreamscape are the architects of this "African American fugitivity," the ones who deserve a cultural criticism they can call their own. They are the ones designing "a mobile, mercurial noninvestment in the status quo" that is born out of forced migration and captivity and that gives body and soul to these spirituals. The maternal and the material body of Black womanhood, though often overshadowed by Louis Armstrong's "Black and Blue" "beam of lyrical sound" in readings of this novel's most famous scene, nonetheless anchors our hero's descent into the "blackness of blackness."[99]

Invisible Man's sonic women are the stuff of familiar Black literary mythologies, as Farah Griffin has so convincingly shown us, the kinds of "mythic tropes" that we've come to expect: "an old black churchwoman's voice, ghosts . . . nightriders. . . . This is the landscape," she argues, "that produced the blues," filled with the "'plaintive' 'haunting,'" and the "'achingly real'. . . . To hear the voice is to witness the history. To embody the voice, to play it, to represent it, is to bear witness to that history." Griffin makes plain the ways that these voices are the origins "of black male literary and musical productivity" stretching from Frederick Douglass to Miles Davis and beyond. Likewise, they are the "founding sound of the New World Black Nation." What does it mean to be so audibly recognizable, so fundamentally crucial to the self-formation of others? she asks in her game-changing essay. What does it mean for "that peculiar black voice" to be "in it but not of it at the nation's beginning"?[100] What does it mean to be the source of epiphany, the gateway to transcendence for others? To these questions we might add, What would it mean to reckon with the ways that Black women's voices are indispensable to modern sound?

Better to leave it to Edouard Glissant to tell us which way the wind blows. The late Caribbean poet, novelist, and critic repeatedly returns to the subterranean as a site that is loaded with counterhistorical meaning, the place where buried New World truths lie. I aim to follow and trace the music that comes from that very direction, the place where, at the bottom of the sea, we encounter the traumas beneath the traumas, "all those Africans weighed down with ball and chain and thrown overboard whenever a slave ship was pursued by enemy

vessels and felt too weak to put up a fight. *They sowed in the depths the seeds of an invisible presence.*" The subterranean is the repository of all that has been discarded yet remains with us at the very core of our everyday lives. It is the "invisible ink," as Marcus would say, the basement tapes of a Blackness born out of violent subjugation, denied yet stored up in the sediment of culture. For, as Iton reminds, "the excluded are never simply excluded. . . . [T]heir marginalization reflects and determines the shape, texture, and boundaries of the dominant order and its associated privileged communities." Glissant's subterranean is, still more, the sphere of the "spatially mobile," as postcolonial performance theorist May Joseph refers to it, the place "where the histories of those peoples once reputed to be without history come together."[101]

The subterranean blues of *Liner Notes for the Revolution* articulates how central Black women musicians are to modernity and, likewise, how modernity and its cultural archives repeatedly betray these artists, the conduits of "nurturing, healing, life and love giving for the majority culture," as well as their own legacies. For precisely these reasons, it might seem impossible for some to imagine their subcultural strategies of survival. How is it possible for Black women popular musicians (an Aretha, a Whitney, a Beyoncé)—some of the most widely imitated artists in the world—to exist simultaneously at the fringe and yet at the center of the culture industry? Perpetually they remind us that, as Nicki Minaj put it ever so plainly in her summer 2015 "Twitter beef" with Taylor Swift, it is high time that we reckon with "a system that doesn't credit black women for their contributions to pop culture as freely / quickly as they reward others. . . . We are huge trendsetters, not second class citizens that get thrown crumbs. This isn't anger. This is #information."[102] Minaj's wake-up call forces us to ask whether we have a language for these artists, the Ellisonian "little women," who both make and unsettle the means and ends of popular sonic production while perpetually being disappeared from it. Minaj's spitting-fire remarks force us to ask, Do we have a language by which to discuss the work of these women who "refuse that which was first refused to [them] and in this refusal reshape desire, reorient hope, reimagine possibility and do so separate from the fantasies nestled into rights and respectability"? Do we have a way of even beginning to tell the story of those women, the ones who, as the pioneering Black feminist pop music critic Danyel Smith, puts it, "have been overworked, underpaid, and underappreciated for too long . . ."? Like Smith, I, too, long for a story that amounts to "a pageant," one "that starts as far back as the women hacking sugarcane and threshing rice. . . ." How, then, to convey a history this "vast," one that takes account of "the world" that, as she reminds, Black women "nurtured and cleaned—and imprinted and built . . ."?[103]

The Birmingham School cultural studies critics, those germinal thinkers influenced by Gramsci—from Stuart Hall and Dick Hebdige to Hazel Carby and Michael Denning—have given us the tools to answer these questions for more than thirty years, showing how, for instance, class struggle plays itself out on the terrain of culture, how subcultures "continue to exist within and co-exist with the exclusive culture of the classes from which they spring," and how these subcultures "challenge the symbolic order" and yield "expressive forms" that sustain "a fundamental tension between those in power and those condemned to subordinate positions and second-class lives."[104] And *Liner Notes for the Revolution* is nothing if not cognizant of the dynamic subcultures that Black women have forged through musical experimentations and collaborations that did just this. Hazel Carby told us as much when she kicked open the door to this field of study by robustly and rigorously exploring the mobile insurgencies of blues women's culture coursing through the Harlem Renaissance era. She introduced us to a new critical lexicon for reading Black women's cultural work both alongside of and beyond the realm of literary culture. Add to this Mackey's, Robert O'Meally's, Griffin's, Moten's, and Brent Edwards's respective and lyrical theorizations of the "dislocating tilt of artistic othering" tactics performed by Black musicians who "accent variance [and] variability," "innovation, invention and change" in their work and one gets a better sense of how Black folks have been ghosting the machine through sound for some time now, centuries longer than punk's "critique of mass culture now paraded as mass culture."[105] This is, in fact, the subterranean secret of Black culture—that which has been perpetually co-opted and commodified and yet also repeatedly finds ways of disturbing (if not always unseating) its own market exchange.

In spite of all this, we have ignored the massive role (pace Minaj) that Black women artists across both time and the pop music spectrum have played in conceiving and shaping this invention and change, these "form[s] of Refusal" that constitute the "noise" that is "the flip-side to Althusser's teeth-gritting harmony." To listen for that, we'd have to start by acknowledging the existence of a vast Black women's sonic counterpublic, what Michael Warner calls an "odd social imaginary established by the ethic of estrangement [from the dominant order] and social poesis in public address." As this book suggests, although the majority of the women in the chapters ahead are crucial to multiple (r)evolutions in modern culture, and many (yet by no means all) aspire to reach the center of mainstream culture and multiple publics, they are also fascinatingly, defiantly, and unpredictably subcultural and counterpublic, and their performances hold the traces of rich and complicated histories that suggest the extent to which their sounds are "surface manifestations of long, and largely

unrecorded, histories. They do not tell those histories in (of) and by themselves, but, like footsteps in the dark, they alert us to be aware, to be on the lookout for things that may be all around us but not yet seen" . . . or heard.[106]

Liner Notes for the Revolution moves from a meditation on the importance of intellectual labor and Black women's sonic cultures (Side A) to an exploration of elusive Black women musicians and the critics and artists who have focused their attention on their legacies in a variety of ways (Side B). The Conclusion asserts the arrival of a new revolution in Black feminist archival and curatorial performances in sound. If Side A aims to recuperate the intellectual history of Black women's sonic worlds and to, likewise, excavate the language, methods, theories, and forms of imaginative writing that have been and that we might yet still innovate in order to care for and about this remarkable body of women's work, Side B is the "deep cut," so to speak, akin to the tracks that take flight during late-night studio jam sessions and are never intended for "regular rotation" airplay. Such "B sides" are often quirky and unexpected, and sometimes taboo. They are the kinds of tracks where Prince and Sheila E. bend gender and sexual mores into delicious soul avant-gardism (on "Erotic City"), or where Freddie Mercury could get his bandmates to sing along to an all-hyperbole stadium chant ("We Will Rock You"). B sides are sites of experimentalism, and so it seems fitting to shift the focus in Side B of this book to the importance of the speculative in Black feminist revolutionary sounds and sonic performances. This section thus zeroes in on a crisis in care for the lives and work of Black women musicians as well as the women who love them, and it pursues the multiplicity of ways that we might fundamentally transform the matter at hand. It comes in part, as I will argue, through identifying the means by which the artists themselves are able to push the sonic experience into the realm of what historian Robin Kelley has poetically dubbed the "freedom dreams" of those invested in "abolishing exploitation" as well as the "four-hundred-year-old dream of payback for slavery and Jim Crow."[107] This side of the record moves, then, towards flying with these women out the window and onto the speculative terrain of revolutionary possibility.

Chapter 1 explores the cultural labors of Black feminist artist-intellectuals who engage the politics and poetics of sound—from postbellum vocalist, journalist, novelist and all-around "polymath" Pauline Hopkins to twenty-first century Afrofuturist queer, Black feminist punk rebel Janelle Monáe; from transgenerational jazz pianist and composer Mary Lou Williams to Civil Rights–era experimental vocalist and activist Abbey Lincoln—in order to demonstrate how Black women artists disturbed the modern by figuring themselves

as records and record keepers of lost, elusive, and undertheorized Black sounds. Each of these women invokes sound as an epistemic tool to, in effect, ask how we know what we think we know about Blackness, womanhood, and the politics of freedom and self-making. Their music demands that we know more (and know different things in different ways) about each of these topics. Likewise, each of these women has sought recourse in critical projects extending beyond and yet also complementary of her sound performances. Hopkins's post-Reconstruction fiction and journalism, Williams's unpublished essays and letters, Lincoln's public lectures on the history of Black women's musicianship, Monáe's avant-garde liner notes are all key objects of inquiry in the chapter. Their distinct and daring cultural moves, I argue, complicate facile perceptions of the time and space and communities forged by and through the figuration of sonic Black womanhood.

Chapter 2 asks that we take seriously the idea of the iconoclastic Harlem Renaissance anthropologist, novelist, and playwright Hurston as a groundbreaking cultural critic whose theories of African American music, in particular, generated a new lexicon and unprecedented conceptual frameworks for interrogating Black sound during the height of modernist fascination with racial primitivism. Hurston's recalcitrant meditations on Black vernacular life and culture posited a dense and sophisticated oppositionality to dominant myths about Black otherness, and she rooted her theories in sound testimonies, Works Progress Administration recordings of songs collected out in the field and offered up as her own renditions, drawn from her own memory and delivered in her own unvarnished vocal stylings. This chapter travels with Hurston as she sets out in her legendary cars, traveling the Gulf States, and devotedly "get[ting] in the crowd" so as to absorb the music, the mores, and the history of Southern Black folk whose record of life was seldom deemed a thing of value. Her scholarly essays on what she saw as the specificity and distinctiveness of Black sonic expression do a dialectical dance with Hurston's performances preserved on tape. We might think of them as, in effect, liner notes for her own recordings as well as essays that ultimately constitute some of the most extensive critical theories of Black sound produced by a Black woman intellectual in the first half of the twentieth century.

Chapter 3 turns its attention to examining the labor of a sui generis blues record collector, record label pioneer, and second-wave feminist intellectual who dedicated her life's work to excavating "lost" Black women's sounds. Jewish New Yorker Rosetta Reitz's story plays a central role in this book because of the ways that her own voluminous archive of blues album liner notes, journal notes, epistolary exchanges, and intellectual marginalia serves as proof of the hidden

feminist intellectual counterhistory of modern popular music culture. This chapter, in other words, leads with the principle that critics—both African American and otherwise—have played a crucial role in shaping the cultural imaginary of Black women's sonic cultures. Reitz self-consciously situated herself and her historic blues women's record label, Rosetta Records, in opposition to pop music culture's white patriarchal hegemony, and along the way she innovated radically illuminating ways of writing about intersectional sonic performances.

Chapter 4 traces the trajectory of insurgent feminist music writing produced by pioneering journalist and essayist Ellen Willis, one of the most influential and aesthetically groundbreaking rock critics who ever lived. Yet another Jewish New Yorker, Willis, in her lauded column for the *New Yorker* magazine in the late 1960s and early 1970s (becoming the first critic to hold such a post at the publication), set a precedent for writing about rock during what has come to be known as the "golden age" of that genre of cultural criticism. But she is hardly associated with Black feminist cultural politics and rarely wrote about Black music or race throughout her long and storied career. Yet a single document in her own archive reveals the seeds of a generative—albeit passing—connection between a college-age Willis and the legendary queer Black feminist playwright and Black freedom struggle activist Lorraine Hansberry. This chapter is, in effect, an overt exercise in making these two seemingly far-flung fields of rock music criticism and Black radical tradition thought speak to each other in the service of illuminating what Hansberry's Black feminist intellectual history means to this form of white bohemian arts writing and vice versa. The chapter's framing foreshadows the speculative focus of this book's second half. It seeks to reveal the ways in which the politically potent desires and aspirations of both women manifested themselves in their respective radical writings. Taken together, like Reitz's work, the substance of their intellectual lives prepared the ground for the legacies of revolutionary music writing which inform the very foundations of this book.

Side B turns its attention to the most storied network of collectors and critics devoted to unearthing blues women's recordings. The hunt for Southern musicians Geeshie Wiley and Elvie Thomas, artists who released their exquisite six sides of oblique country blues on Paramount Records in the 1930s, spans from the era of the 1960s folk revival through the twenty-first century, and Chapter 5 traces that search, one that encompasses a striking combination of eccentric loner savants, powerhouse independent scholars and artists, devoted collectors, and feeling and inventive journalists, many of whom have hotly pursued the story of these two mysterious artists and the music they left behind. The

chapter explores the complicated subculture of critics and collectors whose obsessions with Wiley and Thomas have driven blues histories, cultural criticism, and mythologies for over half a century, and it rereads their presence as well as their alluring absence in the blues archive as a particularly queer problem as well as queer critical and aesthetic possibility.

Chapter 6 responds to the crisis of archival loss and the conundrum of the supposedly "missing" blues women by turning to recourse in the speculative. I first explore the experimental aesthetic work and critical fabulist moves of a pair of daring contemporary Black feminist artists: Jackie Kay, Afro-Scottish queer poet and biographer of Bessie Smith, and leading Black feminist visual artist Carrie Mae Weems. These two women offer meditations on Black women musicians' absence, disappearance, and invisibility in the cultural imaginary in their experimental and contemplative fiction and visual art. The form and content of their respective work invites us to critically speculate about the unspoken, obscure(d), the precarious and the ephemeral lives of Black women artists who elude critical capture. Weems's and Kay's methods of remembrance and radical forgetting amount to alternative forms of care for Wiley and Thomas. This chapter also extends such forms of care by moving the girlhood narratives and memories of regal Black women who came of age listening to and loving jazz and (rhythm and) blues culture in the 1930s and 1940s from margin to center in an effort to dream up alternative methodologies for rereading the "lost" blues women's archive. Here I consider the fiction of the formidable Toni Morrison alongside the reflections of my mother, Juanita Watson Brooks, and her memories of the vibrant sociality of her own teen girlhood spent with friends in record shops in Jim Crow Texas. This chapter ultimately calls for a reckoning with the deep and reverberating resonances of blues records in the lives of the African American women fans who loved them and the contemporary artists who continue to gain inspiration from them. Through all of these meditations and explorations, this chapter remains in pursuit of new ways of doing blues music criticism altogether.

Chapter 7 takes up the slim recorded archive of Wiley and Thomas's music—six sides recorded in the dead winter of 1930 at the legendary Paramount Records studio in Grafton, Wisconsin. The ethics of this chapter involve posing another method for reading the history and music of these two artists. It prioritizes their sounds rather than the racial and gender mythologies and romantic theories of Blackness projected onto them, and it listens to the dense history of the carceral state and Jim Crow subjugation that frames the conditions and lyrical content of one oft-overlooked recording, "Pick Poor Robin Clean." Drawing on the resourceful research of cultural critic John Jeremiah Sullivan,

this chapter mines the sonic details of Wiley and Thomas's improvisational blues duets, and it places their performances in conversation with the socio-historical worlds out of which we believe they likely came and through which they slipped out of view on their way to obscurity.

Side B closes out with a turn toward the efforts of contemporary Black feminist avant-garde artists who mine and repurpose Black archives of historical sound as provocative, boundary-breaking experimental curatorial performance. Chapter 8 traces the ways that these artists' works unsettle the seeming fixity of the archival past. It also moves through the repertoires of these artists as they center archival Black music and history in the form and content of their work. This is music that wrestles with problems of loss and ephemerality as points of departure, and it turns said problems into an occasion to open up the vaults of Black sonic historical memory. Here I look to Weems and her stirring collaborative performances with the late, great jazz pianist Geri Allen, as well as the opera singer-turned-bluegrass folk artist Rhiannon Giddens, the Tennessee-turned-Williamsburg Afro-Appalachian alternative blues folkie Valerie June, and the phenomenally original, upstart jazz vocalist Cécile McLorin Salvant in order to showcase the lively, the thrillingly diverse and daring repertoires of twenty-first-century artist-intellectuals who repeatedly blur the boundaries between their instrumentality, their archival and curatorial practices, and their eloquent strategies of cultural critique. They pivot us towards the future by way of keeping the courageous artist-sisters of the past oh-so-close.

"We Can Be Heroes"

Consider the scene: it's 1931 and we are riding high-water trouble with "Empress of the Blues" Bessie Smith and her ensemble of formidable seamen: Louis Metcalfe on cornet, Charlie Green on trombone, Clarence Williams on piano, and Floyd Casey on drums. Even before we hear the voice of the Empress, a tremulous muted horn announces that all is not calm out in these parts. Uncertainty hangs in the air as "Shipwreck Blues" opens with fits and starts before the band finds a pocket of smooth currents for our magnetic superstar to ride and make her entrance. This is the moment when our heroine executes the kind of undeniable authority that was, at that point in her career, synonymous with her name. She delivers crisp, clear-eyed orders to a "Captain" to whom she is not beholden, instructing him to "tell your men to get on board." We are made privy to the alluring force of her effortless control of this sonic space, the space of the blues that she dominated across the span of the 1920s. Bessie is past the

peak of glamorous superstardom, but she sings with the conviction of an artist who knows that she has changed the game, having led a cultural revolution that would forever transform pop. We envision her on board that ship as though she were dressed for the jook, strewn in her trademark feathers and jewels. I like to picture her leading her mates, like Washington crossing the Delaware but also holding it down at the mast while looking gravely out into the storm. Smith is seemingly with the crew but not of the crew. She is our beguiling and seductively singular figure, a formidable contralto whose genius as a blues storyteller enabled her to spin gripping yarns and draw startling truths out of plaintive laments. So seasoned at this stage of her career, she embraces her role as the adventuress with delicious and winking imperiousness. She surveys the scenery of the song—an ecological universe of imminent catastrophe—while also doing her damnedest to work with the band and steer her vessel toward those extra helping hands that she spots on shore.

Clever euphemisms abound as they do in all good blues numbers. But lest we get too cozy with these sexual metaphors of ships riding into dock, our heroine flips the script in the second verse, turning inward. "I'm dreary in mind," she croons, "and I'm so worried in heart / Oh, the best of friends sho' has got to part." This was Smith's trademark move in classics like "Thinking Blues" and "In the House Blues," jams that revel in the complexities—the affective ambiguities—of a Black woman's inner lifeworld.

Growling, fretting, mourning, tangling with loss and rupture—listen closely and we hear all this in those late recordings. The trills in "Shipwreck" Bessie's voice are signs of a veteran musician ever so loose and savvy and playful enough at this moment in her artistry to dance around the melancholic conventions she had helped to make madly popular throughout the Harlem Renaissance twenties. Now a veteran of the form she'd reimagined, she digs into the sly histrionics of her own storytelling abilities rather than depend on the conventions of heartbreak. She is not our Bessie, longing for jelly on her roll or sugar in her bowl—which is not to say that erotics have nothing to do with the struggle at the heart of her performance. The Empress lets us know that this emergency, this impending disaster in which a woman finds herself with "friends" no more, demands a captain to "blow his whistle" and give his men the signal that service is necessary and urgent, because the only thing as ominous as the nautical perils ahead is a despondent and unsatisfied woman.

Blues is the source of Bessie's agency and infinite transformations. She uses her power to be both heroine in distress *and* storm system, "shipwrecked" protagonist and the conductor of an ensemble that oscillates between supplying the sounds on the scale of a hurricane and the steady vessel that will ride this

rough water like a surfboard into port. Smith "rains" down on us in these final verses, sounding out a deluge at precisely the moment her lyrics suggest the tragedy of stasis. Signature Bessie, indeed—but also a Bessie whom we might imagine as the sonic analogue to Romare Bearden's rendering of the Greek god Poseidon, as Robert O'Meally maps out for us in *A Black Odyssey,* his luminous work on the artist's "Odysseus Series." Bearden's Poseidon, as O'Meally makes clear, is a god of "multiple identities . . . a god of multiple sea ports—African, Asian, and European—a traveler through seas and rivers, but also on horseback and by bullback: a power-figure across the land too . . . Poseidon is not only the Sea God but also the Earth-Shaker." So we might think of our "Shipwreck Blues" Bessie as an artist with the power to conjure her own sea god tale, as an artist capable of evoking a sea god's "insatiable anger and power" but also fully ready to step into the role of Odysseus, reincarnated as a prodigious adventurer, a woman of "numerous tropes," as O'Meally might put it, "an inventor of tales and new strategies for surviving a fast-shifting world."[108]

Our grand improviser Bessie, the woman whose sense of play and risk and "antagonistic collaboration" with her ensemble and the song itself reminds us too on this track and others that she will persevere in "moving from one role to another, without ever disappearing into any role." She "lands somewhere between self and persona," ultimately "calling the autobiographical *I* of the blues lyric—and the blues performer—into question."[109] Listen to her spectacular self-fashioning on, for instance, not just "Shipwreck Blues" but a song like the marvelously gothic "Blue Spirit Blues," how she forges the crucial bridge between silent film and talkies, filling in the historical pauses in these advances in modernity by inventively collaborating with stride piano legend James P. Johnson to perform a fantastical dreamscape. Smith travels like Odysseus to the Realm of the Shades—led by the devil way down to that "red hot land of mean blue spirits" that "stick [their] fork" in her as she navigates an opaque path, all the way to the netherworld. We ride with her on this road strewn with "fairies and dragons spitting out blue flames" and "demons with their eyelashes dripping blood," and out of this odyssey we are made new by way of the demons she slays for us. We are reminded of the fact that, though the Greeks had their epics, it's Black folks who gave us the teachings and philosophies of the blues. Listen closely to Johnson's instrumental refrain on "Blue Spirit Blues" for the way that she pushes past the clichés of vaudeville villainy and even early horror film cues in order to signal that terror is on the rise. Johnson collaborates in that final verse with Smith to forge an escape route out of the nightmare, kicking up the tempo as Smith's protagonist "run[s] so fast / till someone wake[s] her up." Like Odysseus, our heroine has traveled to the dark side and

now returns to the land of the living, awakened, enlightened, and bearing witness to a social death relegated to the realm of slumber rather than her waking world.

To speak of the "heroic," as I often do in this book, is to call attention to the everyday and yet nonetheless epic obstacles that these performers faced pursuing their art in a changing public sphere that has, quite often and across many epochs, read Black women musicians as inscrutable and yet alluring, lewd and yet desirable, unseasoned and yet virtuosic, unimportant and yet captivating, amateurish and yet otherworldly. It is a testament to their bravery, perseverance, and an investment in their own vision that has enabled so many of them to find their own rhythm in the face of such a dizzying array of presumptions, biases, and demands placed upon them. The heroes of this book are the artists who have weathered all of this drama and still revolutionized the popular. They're also the sisters-in-the-struggle writers who cared deeply about recognizing and recording the importance of culture as a life-saving and life-giving phenomenon.

Heroism in sonic culture is a thing of risk, chance, and play, as choreographer Ralph Lemon reminds me. It is the act of pushing the boundaries of what's expected in a performance, walking to the edge of a cliff, throwing caution to the wind, and leaping into the aesthetic abyss. Heroism is, in effect, a question of the improvisational, as elder statesman jazz critic Albert Murray tells us. It is

> play in the sense of competition or contest; play in the sense of chance-taking or gambling; play in the sense of make-believe, play also in the sense of vertigo, or getting high, or inducing exhilaration; play also in the direction of simple amusement or entertainment—as in children's games; and play in the direction of gratuitous difficulty—as in increasing the number of jacks one catches or the height or distance one jumps, or decreasing the time one runs a given course; gratuitous difficulty also in the sense of wordplay; or play in the sense of sound—as in a Bach fugue.[110]

The heroine who takes up this charge in popular music culture is a stone-cold warrior, a "breaker of chains" who liberates us with each surprising turn of phrase like Aretha, our lady of grace, singing a congregation "through many dangers" in her reading of the gospel classic "Never Grow Old" in 1972 at the New Temple Missionary Baptist Church in Los Angeles; like glorious Nina burning through "hundreds of songs" on the piano late into the night at an Atlantic City bar for hours on end.[111] Or the heroine comes to us in the form of rap battle–ready Lauryn Hill, ferociously digging the archive in her 2012 new millennium pro-

test anthem, "Black Rage," a song that captures the melancholia of racialized state violence, a song that in that year simultaneously forecast and galvanized a modern movement on the verge of altering the nation's consciousness yet again, a song that addresses the value of Black life.

Hill the hero flexes her flow, burrows deep into history, and wades into the densest form of play in a performance of this song that she began performing in public in 2012, after the slaying of Trayvon Martin. Captured on tape in Houston, Texas, in October of that year, she stands onstage rooted like a tree in front of her band in an oversize denim jacket, her trademark short-cropped 'fro, and a pair of magnificent hoop earrings. She goes to work, storming the barricades of a musical theater classic in order to make new and urgent meaning. Hill's "Black Rage" draws on the seductive sonic blueprint of Rodgers and Hammerstein's "My Favorite Things," transforming that classic and, more broadly, its iconic parent, *The Sound of Music,* into an unlikely yet profoundly stirring manifesto for the souls of twenty-first-century Black folk. She sifts through a musical theater treasure turned bebop jazz standard so as to draw to the surface its sad, bold beauty, so as to mourn the "lost," "brood" the departed, contemplate the crisis of her beloved brethren.[112]

If the original "My Favorite Things" finds Julie Andrews's (and before her, Mary Martin's) bewitching novice-turned-nanny character relying on melody as a form of fortitude to calm the von Trapp children's nerves on a thunderous night, Lauryn Hill fashions herself as this generation's Afro-Maria (post her own turn as a musical nun in *Sister Act 2*). She is here to sing the Black masses through this our present storm by calling out the shibboleths of anti-Black neoliberalism. "Free enterprise / Is it myth or illusion," asks Hill, as she runs through a litany of perils that "forc[e] you back into purposed confusion":

> Murder and crime
> Compromise and distortion
> Sacrifice, sacrifice
> Who makes this fortune?
> Greed, falsely called progress
> Such human contortion
> Black rage is founded on these kinds of things.[113]

We travel with her through a 1959 Broadway smash, through its even more famous 1965 cinematic sibling, and frenetically on through John Coltrane's 1961 classic-in-its-own-right version of the song.[114] Coltrane scholar Salim Washington reminds that Trane's version of "My Favorite Things" "includes solo

sections that are completely liberated from the harmonic form of the tune." Each soloist is given the opportunity to "heroically" improvise. Trane's version, he argues, takes us to a place where "temporality is truly obliterated. No more cadences to march to, and no more four bar phrases to nod to, unless you want to. Functional tonality becomes irrelevant. . . . Trane dispenses with keeping the progression of the tune pretty much altogether . . . except as bridging material."[115]

Hill draws on Coltrane's radical use of time so as to trace for us the origins of a Black rage emerging out of power structures that nurture "self-hatred," that "threaten your freedom," that tell you to "stop your complaining / poison your water / while they say it's raining / then call you mad / for complaining / complaining." We cycle with her through history's traumas, move with her toward the brutal revelation that "black rage is founded on two-thirds a person / rapings and beatings and suffering that worsens." These are lyrics meant to sting, startle, disorient—so much so that, in footage from her Houston performance, Hill takes another round of delivering her words acapella and without the band's tempestuous din. Slowing down her tempo, leaning in to her emphasis on lyrics that bespeak the weight of history's "unspeakable things" and yet still insisting on a litany for survival, she turns an unreleased concert joint into a sermon, a testimony, an occasion to bear witness. She is here before the crowd to insist on a requiem for this ugly, unvarnished truth that has fueled some of the most consequential modern music known the world over: the fact that "black human packages tied up in strings" are the source of Black folks' righteous fury and sorrow. Yet to know and acknowledge such a thing, Hill the preacher tells us, is to also to fight the power of this chronic violence. To know such a thing is to get to the point where, when the threat of "dog bites" and "beatings" weighs so heavily on our spirit, we "don't *fear* so bad."[116]

Hill's sound of music is the sound of Black being and dense memory joined up with revolution in song. It is the sound of the Black archive and the matter of Black life, and it remains an extended, long-playing, remixed record of the very world that the heroines in the pages ahead have devoted their lives to capturing and conveying in their own many tongues, in an endless array of arresting registers and captivating gestures, and from as many felt, furious, and fabulous vantage points necessary for not only their own survival but ours as well.

Side A

For much of the last century, pop music writers and the latter-day institutions that support and promote their claims have been anything but kind to Black women musicians. Plenty of people would argue otherwise—citing, for instance, the long-running tendency of pop music writers to think in hagiographic terms about the "mothers" and "empresses," the "queens" (so many queens!) and "high priestesses" who have dazzled and destroyed audiences from one generation to the next and who have belted out the soundtrack to our interior lives as we've faced the uncertainty, the volatility, the exhilaration as well as the sorrows of modern times. And they'd be right to call our attention to the ways that these sisters, so beloved the world over, are worthy of monarchical metaphors. They built kingdoms of sound for the people who remained largely unseen or mis-read, vilified, and unloved for much of the four-hundred-year crawl that con-stitutes this singular and more than a little bit terrifying experiment that would come to be known as America. Yet these sonically electrifying worlds are ones that were and still remain largely controlled and engineered by a marketplace that they've never run. It's an operation that made their sounds available to the masses and gave wide, technological access to others to mimic and enjoy them.

At the same time, it was not a phenomenon built to last—which is to say that in spite of the mass(ive) exposure and circulation of popular music made by Black women, in spite of the varying instances of intense and sometimes rabid adoration, the kind that fosters fan "hives" and all sorts of obsessive idolatry,

(Left) Tina Turner graces the front page of *Rolling Stone*'s second issue, November 23, 1967

(Right) Rolling Stone, November 1, 1969

history reminds us that, until quite recently with, say, the death of an unprecedented icon here and the release of a watershed album there, theirs has always been a culture marked as disposable, as less worthy of serious intellectual regard, writerly love as it were, and institutional recognition. Such circumstances, small and culturally benign as they may seem to some, have real consequences, and the stakes could not be higher. They have everything to do with a grand culture of forgetting who actually invented the music that you just can't get out of your head, who first designed and put down for the record those dangerous vocal phrasings that bespeak suffering and revolutionary survival, who first composed those rhythms that conjure nightlife abandon and juke joint self-making. This was music that was deemed precious, a fungible commodity that would fuel the luxurious and glamorous life of the "masters" (the ones who "own" you in the recording industry, as Prince Rogers Nelson famously made clear). And ultimately, it was a writers' class—music critics, but also fans, collectors, and scholars—

that sprang up and eventually got caught up in the game too, championing and looking after what they defined as valuable, what they claimed spoke to them, what they couldn't live without, while often missing the broader and complex meaning, the urgency and origins of these sounds. Sometimes, too, they missed deeply important artists altogether.

They were doing a kind of intellectual labor that rarely receives attention for being what it is: a corrosive, quotidian power play whose common-parlance description, "taste-making," masks the fundamental and systemic ways that this writing about music created the conditions for new institutions—archives and museums—to further codify common presumptions about cultural belonging, who matters and who "made" things that we all supposedly value and believe to be worthy of care. In brief, they told tales to the pop world about who gets to appear in history and how. And all of this is the reason why I can't look away from the Rock and Roll Hall of Fame's annual induction ceremonies, the reason why I've attended said festivities on more than one occasion, enduring lengthy, score-settling speeches by the likes of Jon Bon Jovi and multioffense induction speeches by the likes of shock jock Howard Stern. It's the reason why I've walked through the hall's shining Cleveland, Ohio, shrine with a combination of incredulity and contempt. I've wandered through its exhibits as a Black feminist music fan and critic, still weary after all of these years and still wary of and obsessed with the power of this machine, the one that others may regard as a harmless exercise in pure white male boomer nostalgia, the kind that gives Little Steven Van Zandt his six minutes a year to wax on about the 45s that he adored in his "born to run" youth.

The for-profit, media-driven Rock and Roll Hall of Fame's years-long slog toward admitting epoch-altering artists like Rosetta Tharpe and Nina Simone into its pop pantheon in 2018 is simply the most high-profile example of the unsurprisingly chronic and widespread marginalization and often wholesale negation of Black women's aesthetic work in the historical imaginary. But it's also more. The Rock Hall's nexus of cultural preservation and culture canon building is symbolic of the ways that (hallowed) music archives and music criticism have worked in tandem with one another to generate, manage, sustain, and control pop culture knowledge and power.

The T-Rex of rock music criticism and worshipful sonic patriarchy, *Rolling Stone* magazine, took root under the leadership of celebrity cofounder and executive editor Jann Wenner. The product of University of California, Berkeley, dropout Wenner and music journalist Ralph Gleason's Bay Area counterculture dreams and aspirations, the magazine has been peddling ideas about excellence and relevance in popular music culture since its inception in 1967.[1]

With the invention of the Rock and Roll Hall of Fame Foundation in 1983, the subsequent first slate of inductees announced in 1986, and the 1995 opening of its Cleveland museum site, a gleaming, I. M. Pei–designed glass edifice (akin to Pei's Louvre Pyramid), Wenner and others, such as the well-meaning Atlantic Records luminary Ahmet Ertegun, advanced their vision of elevating the status of the nearly all-male and largely white roster of artists they'd been championing in four-star reviews and glamorizing by way of iconic magazine covers for decades.[2] Talismanic memorabilia—boots and guitars, leather jackets and sequined pants—are housed in glass display cases, the debris of an aging musical form born out of midcentury, racially miscegenated (and yet nonetheless segregated) musical youth culture, enshrined by a hegemonic consumer class forever obsessed with its own "hope I die before I get old" (im)mortality.

By building an edifice to complete the closed circuitry between print criticism and archive, the *Rolling* Rock Hall crew were, in effect, mobilizing a corporate pop version of the kind of "instituting imaginary" of which postcolonial critic Achille Mbembe speaks. They were "granting . . . a privileged status to certain . . . documents," certain artists, certain conceptions of aesthetic quality and virtuosity while "refus[ing] . . . that same status to others, thereby judged 'unarchivable.'" Adds Mbembe, it is

> through archived documents [that] we are presented with pieces of time to be assembled, fragments of life to be placed in order, one after the other, in an attempt to formulate a story that acquires its coherence through the ability to craft links between the beginning and the end. A montage of fragments thus creates an illusion of totality and continuity. In this way, just like the architectural process, the time woven together by the archive is the product of a composition. This time has a political dimension resulting from the alchemy of the archive: it is supposed to belong to everyone. The community of time, the feeling according to which we would all be heirs to a time over which we might exercise the rights of collective ownership: this is the imaginary that the archive seeks to disseminate.[3]

And we see it time and again—the ways that cultural institutions flex their uniquely seductive ability "to formulate a story that acquires its coherence through the ability to craft links between the beginning and the end." These pop music stories (about the "greatness" of certain artists, certain albums, certain forms of "genius") gain legitimacy and eminence, in part, through their archival preservation but also by way of the pop culture pomp and circumstance, red carpet promenades, awards show glitter, and taste-making regimes that obscure

generations of racial and gender exclusion and rejection of women of color artists from canonization and prestigious prizes. Pulitzers for music remain elusive. Grammy awards for best album are few and far between. Left out of the community of rock and roll time as key players (save for their prodigious abilities to keep time as the backup crew), Black women musicians have had to make time for themselves.

And often enough, it's been up to the sister fans—women of color as well as white—to look after them. While few have even bothered to pay them much mind at the show, at the shop, or sitting with affection at the turntable, they've been out there, you know, those passionate women and girl listeners—and not just in the bleachers swooning in euphoria, swimming in ecstasy over their Liverpool crushes. Those aforementioned girl-fans from the era of early rock and roll on through to our present day have had strong and confident ideas and tastes of their own that have long been overlooked and disregarded as trivial and visceral rather than lofty and cerebral, as Ann Powers has pointed out.[4] Alongside those women and girls who held on passionately to their pop world tastes, there were women journalists who covered the early pop beat and a few who eventually sought to fuse their feminist politics with readings of rock and roll that might refuse the casual and incessant sexism of this counterculture, one that rolled on alongside a genre of writing that strove to roll with it, maturing in sophistication and gaining prominence in the 1960s and 1970s. It is no surprise that these women listeners and fans, critics and collectors have dwelled in the shadows of an evolving canon of rock and pop music criticism invested in reproducing a familiar set of origin tales about lone blues outlaws, devils at the crossroads, and white men with hips that just won't quit.

According to Robert Christgau, the "self-proclaimed 'Dean of Rock Music Critics,'" we can trace the history of rock criticism back to the emergence of the "locally beloved nationally obscure Jane Scott, who was 45 on September 15, 1964, when she reviewed a Beatles concert, commencing a long, effusive career at the *Cleveland Plain Dealer*."[5] Scott was, of course, not alone in her efforts to write critical examinations of popular music performances that were directly connected to Black cultural forms. Many Black writers, from W. E. B. Du Bois, Langston Hughes and Ralph Ellison to the upstart LeRoi Jones (who would publish his *Blues People* one year before Scott began her journey into rock writing), were, across the twentieth century and especially by the mid-1960s, actively grappling with how to write critical narratives about popular music performance and how to interrogate its sociopolitical meaning and importance in the context of radical historical change.[6]

But it was the dailies such as the *San Francisco Chronicle,* the alternative weeklies like the *Village Voice,* highbrow magazines such as the *New Yorker,* and of course the countercultural publications like *Rolling Stone* and *CREEM* where an assortment of youthful, often college-educated, almost always white and male writers cultivated an aesthetic and codified a particular kind of ideological apparatus for writing about a musical form whose inventers were African American.[7] As Christgau astutely observes of the evolution of the field, "Canons of artistic quality, critical vocabulary, historical overview and cultural commitment quickly asserted themselves. The aesthetic was hell on pretension and in love with authenticity, excitement and the shock of the new. Although it valued formal imagination over technical skill, it expected tuneful songwriting and regularly got hot for strong tonsils or slippery fingers deployed in the service of form, authenticity or both. . . . Blues-and-country-had-a-baby and *Sgt.-Pepper-*begat-the-concept-album proved handy origin myths." And above all else, he suggests, "rock criticism embraced a dream or metaphor of perpetual revolution. . . . Worthwhile bands were supposed to change people's lives, preferably for the better. If they failed to do so, that meant they didn't . . . 'matter.'"[8] What this kind of writing did so well, however, was to inscribe into cultural memory a particular kind of historical narrative, a remembrance of past musical innovations that was suffocatingly narrow. It also created a lexicon of taste that would perpetuate that narrowness for years to come.

This is "rockism," an ethos, an ideological perspective, a method of writing about popular music performance that, as wily *New York Times* trickster critic Kelefa Sanneh famously defined it, means "idolizing the authentic old legend (or underground hero) while mocking the latest pop star; lionizing punk while barely tolerating disco; loving the live show and hating the music video; extolling the growling performer while hating the lipsyncher."[9] Clearly, the rockism erupting out of acid-dropping cultural arts journalism generated a cult of "taste and authenticity that infected writing about" pop performance for some time.[10] "Rockism" treated rock as "normative" programming, and as critic Douglas Wolk points out, "the way people write about music" ultimately made "it harder to understand any other kind of music on its own terms" and "chained artists," audiences, and critics "to an ideal rooted in a particular moment of the past, in which a gifted lyricist is by default a 'new Dylan' (not even a new Charley Patton, not a new Bill Withers, and especially not herself)."[11]

As I've argued elsewhere, for those of us concerned with historical memory and popular music performance, the challenge is to disturb these critical paradigms, to take a midnight train (with Gladys), as it were, through the thicket of guitar-god clichés that, for so long, privileged a focus on the slowhand axe man

at the expense of tracing the wild and provocative history of modern pop as it emerged out of the interracial sounds of pioneering women entertainers, be it African American stage diva Mamie Smith slinging her vaudeville imperson-ations to Jewish Tin Pan Alley songstress Sophie Tucker dipping deep into the blackface playbook.[12] These were artists who created the conditions for re-corded pop's culturally heterogeneous aesthetics and set in motion the kinds of recorded mimicry and appropriation struggles and spectacles that live on in our pop world today. But their breakthroughs are the stuff of arcana rather than common critical knowledge. A wider expanse in which to consider modern pop's past would leave room to consider the fact that an entire universe of in-dustrious, everyday, hoofin' it, Black women performers in particular were making the leap into recording the blues following Smith's "Crazy Blues" rise to fame, in the years between 1921 and 1922, that window between her hit and the emergence of the stars who would dominate this era. Imagining a retelling of modern popular music history that trains its attention on the archival details of creative risks and experiments on stage and in the studio taken by the likes of Gertrude Saunders, Edith Wilson, or male impersonator Jeanette Taylor—to name but a few artists from this moment—gets us a little closer to not only righting the genealogy of pop, itself, but recognizing and rethinking the meaning of modern pop as a Black (women's) thing and coming correct about the fact that the sisters were front and center in the birthing of it.[13]

This is the spirit of the journey that *Liner Notes for the Revolution* traces, and it is one that demands a critical re-attunement. To "go to the territory" (as Ralph Ellison might put it), I'm committed to circumventing conventional presump-tions about what counts as "criticism," "artistry," and "archives," about who counts as a "critic" or an "artist," and where and how we read the conflicts as well as the intimacies emerging between these two sets of culture workers. The urgent need to disrupt and expand these categories in the world of pop music culture could not be more apparent when esteemed rock writers like Jonathan Lethem and Kevin Dettmar observe in reference to the history of "great Amer-ican writing on rock and pop" that the "relative paucity—especially in earlier decades—of voices of color offers an especially bitter irony, given the primacy of black music in this tradition." They point out that, "If the situation is some-what improved today, it's hardly repaired."[14] Perhaps, however, Lethem and Dettmar have drawn a circle so small around what qualifies as "great rock writing" that they've overlooked the kinds of criticism and performance prac-tices produced by people of color and women that generate their own alterna-tive, world-making ideas that amount to thrilling forms of epistemological intervention.

Side A is therefore interested in pursuing a more nuanced approach to tracing the history of modern writing and critical thought about popular music that pushes back against Rock Hall amnesia and its dependence on certain sounds and certain voices. It follows the important path set by Evelyn McDonnell and Powers with their landmark 1995 *Rock She Wrote* volume, a work that boldly set out to traverse pop music writing's nagging gender divide by bringing to the fore women's voices in the genre.[15] The story that still needs telling, though, is one that explores the intellectual labor of a whole host of women artists and thinkers who devoted themselves to writing and lecturing about music as a freedom project—for themselves, for Black folks, for women. This is a largely unaccounted-for phenomenon, Side A suggests, in spite of the fact that a culture of Black feminist music writing has existed since the dawn of the twentieth century and the writing of key white feminists about sound and popular music culture also, it should be noted, absolutely flourished at the apex of the countercultural revolution.

The latter is evident, for instance, in a pair of sometimes quirky and ambitious and at other times earnest and pioneering full-length works by women music critics that have either received scant or fleeting attention or they've flown beneath the radar altogether. Take, for instance, Sandra Shevey's *Ladies of Pop/Rock,* a focused attempt to chart what she reads as a feminist sea tide in the early 1970s recording industry. Released by the young adult educational press Scholastic Book Services in 1971, Shevey's "hear me roar" study opens with a dedication to the then-recently-deceased Janis Joplin and pursues an ardent engagement with "Women's Lib." Shevey makes her critical methodology clear: her work aims to explore "the female singer" who "is 'doing her own thing' and has begun 1) to question woman's social role, 2) to emerge as a committed social thinker, 3) to become ethnically conscious, [and] 4) to develop as an artist, not a star."[16] This is feminist music criticism that joyously wears its politics on its fringed sleeves and bellbottom pants.

Shevey's work is hard to find in histories of popular music writing, but Lethem and Dettmar's anthology of seminal pop music prose does make room for another instance of feminist music writing evocative of this period, Australian rock critic Lillian Roxon and her sui generis, "monumental" tome, *Lillian Roxon's Rock Encyclopedia,* which they note for its stunning breadth and its "discriminating, opinionated, witty, and compellingly readable style."[17] Published in 1969, just four years before her untimely death, Roxon's *Encyclopedia* includes a dustcover that boasts its historicity: the "most complete rock book ever assembled" and "the only reference book on the phenomenon that has become the most important influence on the young generation of the sixties." Over five hundred entries strong, it toes the line between reference volume and analytic

supersource featuring compressed readings of counterculture artists and high-lights from their oeuvres that would anticipate Christgau's voluminous and now-legendary *Consumer Guide* record review columns. What stands out about Roxon's work in a crowd of late 1960s masculinist rhetoric about the rock and roll form is the determined, if sometimes old-school second-wave feminism (which evolved as she forged friendships with activist intellectuals like Germaine Greer) that she brought to her readings of women of color artists' musicianship in particular, from that of Aretha's work ("Respect, You Make Me Feel Like a Natural Woman, Satisfaction—they are all a great big raucous shout for women's rights, looking for love, getting it and suffering when you lose it, but always how good it is when you've got it. The suffering is important") to that of Tina's ("all skintight glitter and sequins and long hair whipping about in primitive frenzy, [she] is making the definitive statement about what it means to be a woman").[18] Roxon treats these musicians with a combination of fascination and admiration, though her white feminist-oriented fetish for the hippie "primal," no doubt, occasionally lapsed into predictable racial clichés.

As is the case in the work of her US contemporary Ellen Willis, whom I discuss in Chapter 4, the women are often ferocious in Roxon's rock and roll world, part of the sexual revolt against patriarchy in which white women's rights agitators stormed the barricades to take back their bodies and celebrate the potency of their own autonomous eroticism. Without a doubt, this kind of writing had its blind spots too, we now know for sure with half a century of intersectional hindsight at our disposal. For even as Roxon is able to marvel over Janis Joplin as "a whole new experience for everyone. . . . She controlled the entire audience with her body, her hair, her stamping feet, her jewels and her breasts," it's clear that what counted as "new experience" for some women was nothing of the sort for others whose surveilled and controlled relationship to their bodies was a charged and vexing fact of life. Feminist rock critic pioneers were not there yet with recognizing how the public eroticism of rock and roll was no simple game for Black women performers who, in particular, were navigating their own historically steeped peril, the hundreds of years of what Toni Morrison refers to as being deemed "easy prey" that made them forever woke about their Western embodiment.[19]

Roxon's short, crisp, matter-of-fact readings of these artists' repertoires rarely dive too deep into any sorts of contextual complexities such as these, but there is a bluntness to her prose that often couples with shrewd commentary on the diversity of Black women entertainers' skills. This is especially apparent in her sharp observations about the Supremes in which she identifies the representational tightrope that the group was forever having to walk. "You always get the

feeling," she muses, "when you're reading the newspaper interviews with the Supremes . . . that they are keeping a secret. The talk is always about clothes and wigs and families. Never about their music or their feelings."[20] In her preface to the *Encyclopedia,* Roxon sets out her converse aims in the book—to try to "get the rock world to keep still long enough for me to take its picture. . . . Too many people blinked when I clicked the shutter—but then, isn't this restlessness exactly what rock is all about? The madness and desperation and constant shifts of power. I wanted to record the facts without losing the feelings."[21]

The "facts," as delivered from the perspective of people in the margins, and the "feelings" of women critics and especially women of color critics are still the exception rather than the rule in arts journalism, and this is clearly the case as well in the "House of the Holy" that Jann Wenner literally built in the second half of the modern century as a fortress for his kings—not queens—of rock and roll. For these reasons alone, Lillian Roxon's work should remain important to anyone interested in exploring which critics were questioning the boundaries of rock and, long before that, folk, blues, jazz, and other forms of popular music criticism writ large. The ambition of her work is also something of a late twentieth-century touchstone for the various forms of experimental intellectual labor that Side A of this book excavates and explores. This is a kind of feminist intellectual labor emerging in 1900 and stretching all the way to our present day. From the out-there-on-her-own, postbellum novelist and journalist Pauline Hopkins to the sisters on the arts beat in the 1960s and 1970s, from the liner notes of new millennium Janelle Monáe to the on-the-ground music theory of Mary Lou Williams across the mid- to late century, from the lectures and sonic mood philosophies of jazz experimentalist Abbey Lincoln during the height of the Civil Rights freedom struggle to the phonographies that Zora Neale Hurston laid down during the Cultural Front era, Side A insists that there's a different way to write, perform, and capture the fugitive vibes of a popular music history whose women architects still await their own monuments. As the radical work of blues collector, critic, and entrepreneur Rosetta Reitz, feminist rock critic Ellen Willis, and her dream interlocutor, the wondrous Black feminist queer artist Lorraine Hansberry, all make clear as well in this first section, many of these artists/thinkers/critics/curators/planners saw their charge as nothing less than revolutionary. They set out to narrate culture on their own terms, seizing claim to a kind of intellectual labor taken up by few others, embracing sounds both old and new, known to many and fascinatingly obscure. They made this music matter in languages all their own. They are out there, you know . . .

1

TOWARD A BLACK FEMINIST INTELLECTUAL TRADITION IN SOUND

Black feminist music criticism takes flight with a voice—one that is perched on the edge of the modern era, one that manifests the turbulence of postbellum dislocation and pre-Harlem Renaissance fanciful aspiration, one that is both here and elsewhere, soaring and subterranean, thick with the sounds of its own opaque eccentricities yet simultaneously reaching into the registers of a diva soprano's ethereal upper regions—all at once. Black feminist music criticism takes flight in 1903 when agit-prop, sci-fi, Pan-Africanist, antilynching novelist, journalist, historian, and former vocalist Pauline Hopkins navigates her nearly tragic mulatta heroine Dianthe Lusk through the thickets of racial, gender, and sexual exploitation by way of a voice that both archives and exceeds the horrors of slavery and its aftermath.

Much has been written about the moment in Hopkins's last and most alluring epic when Lusk alters the mood of an all-white parlor with a rendition of "Go Down Moses" that cuts through Progressive Era cultural amnesia by conjuring the socially repressed histories of captivity and its fugitive discontents. Interrupting the sanctity of the salon with "a weird contralto, veiled as it were, rising and falling upon every wave of the great soprano, and reaching the ear as from some strange distance," Lusk's voice ignites recognizance of a past—one that is both individual and collective, one that is corrosive and yet vibrantly alive, one in which children born out of the sexual subjugation of the captive woman's body disperse, become estranged from each other as well as themselves, and

"Yours for humanity"—Pauline Hopkins,
editor of the *Colored American Magazine,* May 1901

ultimately reunite. It is a voice that sounds out the record of Black "twoness" that Hopkins's Boston rival would drop that same year in his *Souls of Black Folk.*

What interests me most now about this memorable scene is the fact that *Hopkins* (and not Douglass, Paul Laurence Dunbar, Du Bois, or James Weldon Johnson—four African American literary pinnacles of early Black music theory) wrote this meditation on music and that her conceptualization of Black women's vocality as mythical in its reach, polyvalent in its depth, capacious and unruly, "foreign" and yet familiar, draws on more than a century's worth of discursive accounts of "black musical presence" by mostly white and sometimes Black lis-

teners. It is a passage that catalogs a voice that, to quote Ron Radano, "excee[ds] the controlling grip of the figurations of placelessness and noise" and articulates "a sonic order that challenged white containments." In her last novel, Hopkins was doing her own version of Radano's "critical dreamwork," mining the resonances of the "forgotten but not gone" in the "socioacoustic matrix" by way of a woman's voice that gives "material significance to a people under siege."[1] She was also shifting the terms by which Black women can and do enter into these dominant debates and discourses about African American women's musical performances.

This chapter figures Lady Pauline as the progenitor of style and theory about Black women and modern sound, and it asks why so few have ever uttered her name in relation to the history of music criticism in America. To answer this question, it turns to the ideologies and mythmaking emerging out of late twentieth-century writing about popular music culture, as well as the lesser-known women arts writers who either turned their attention to Black women's musicianship or, as Black women writers themselves, interpolated their perspectives into the growing discourse of popular music criticism in the 1960s and 1970s. It then turns an eye to a cluster of Black women artists who have, across the century, offered their own robust paradigms and theories for how to think about their own repertoires or popular music history more broadly. As we shall see, Hopkins's work anticipates more than a century's worth of Black women artists' intellectual discourse *about* Black women's sonic cultures and the ways such artists mediate (and modulate) said cultures through their own aesthetic strategies. Transgenerational genius pianist composer Mary Lou Williams kept it correct as a theorist of her own artistic practice; Civil Rights activist and jazz musician Abbey Lincoln took to the stage as a Black feminist music historian and critic on the scene in the 1960s to set the record straight; and twenty-first-century time-traveling Afrofuturist feminist Janelle Monáe comes to us as an archivist and a phonographer dead set on disturbing the boundaries between musicianship and intellectual invention. Each of these artists is a critic in her own right. And each has taken advantage of different cultural platforms at vastly different moments in time in ways that publicly interrogate and intricately catalog and affirm the social value of Black sonic life.

These women navigated the popular realm with rigorous and felt analytic viewpoints. Even foremother Hopkins was an omnivorous culture maker who made use of mainstream literary forms (the sentimental novel, the gothic, serial sensation fiction) to convey her ideas about Black liberation. While the influential legacies of institution-building women such as Ella Sheppard, Maud Cuney Hare, E. Azalia Hackley, Nora Holt, and Eileen Southern are undeniable,

it's worth noting that these were sisters who were situated in academic and classical settings.[2] They were holding it down in the most elegant and elite corners of intellectual life, and God bless them. But the story I'm telling is out to catch a glimpse of a different kind of thinker. I'm interested in the ones who transgress the often narrowly defined borders between the popular and the intellectual. Their respective bodies of work, when read alongside those of even lesser-known Black women critics who wrote about music history, sonic culture, and theories of sound, constitute a wholly overlooked line of ambitious and often gloriously experimental intellectual work by African American women.

Turning our attention to them means also acknowledging that we've been listening to a very particular record collection for too long in the broad field of what some now call sonic studies—a field that, in part, encompasses Black music studies, rock criticism, performance studies, and popular music studies more generally. So much of the intellectual labor that informs the schools of thought about Black sound depends on, draws on, wrestles with the landmark theories and exegeses of our formidable, scholarly Black bards, ones who have driven my own imagination for sure—from Frederick Douglass telling us about all of the tones that are testimony to Black survival to Du Bois carrying forward the memory of diasporic sound, from Ellison's jazz navigation of racial invisibility to Baldwin's brother of Sonny telling us in a moment of revelation "all [he] knows about music." They have emerged as something like founding fathers to a field that has yet to center ideas emerging out of Black feminist thought.[3] The rock criticism side of the game, as the introduction to this book points out, has been shaped, in part, by a desire to ascribe the highest value to what Greil Marcus reads as the long and "secret history" that ties, for instance, punk rock to Dada. I am the child of all of that thinking and writing, but I am also suggesting we now work toward the deep cuts and spin the long-playing record that starts with Pauline Hopkins, moves back and forth across the postbellum era, and travels into the modern centuries so as to capture the genius of Black women artists theorizing their own sound work in and through their precious bodies, the kinds of bodies that were forced to literally play the role of the gateway to the so-called New World.[4] I am suggesting that we use a different needle to listen to the ruptures, interventions, and complexities of the music all around us made by Black women cultural actors but seldom heard in high fidelity, seldom listened to with deep, rich faith in their own wisdom.[5]

Ahead, then, this chapter bobs and weaves across a century's worth of intellectual labor. It begins by exploring the wholly unacknowledged culture of Black women's arts journalism. Looking back at the landscape of rock music criticism, it excavates some of the pivotal if oft-forgotten feminist voices who

used a different analytic lens from that of their "white noise" counterparts and, in so doing, fundamentally challenged gender norms and systems of value in the field.[6] The chapter moves out into the scene with the sisters who were covering live shows, reviewing records, and writing feature profiles during the advent of the soul, R&B, and rock revolutions that transformed the recording industry in the 1960s and 1970s. It then turns the clock back to trace the longer, secret history of Black women generating knowledge about the meaning and importance of music cultures. It considers the improvisatory Black music criticism of a post-bellum I'm-every-woman thinker, the everyday theorizing of a mobile jazz historian, and the radical lectures, essays, and archival practices of a pair of experimental musicians, one who was perched at the height of Civil Rights struggle and the other who emerged in the early years of the twenty-first century. As I suggest, the formidable creativity and critical thought of the pioneering musician-intellectuals Hopkins, Williams, Lincoln, and Monáe are worth taking seriously. Each of these women has radicalized perceptions of Black music culture and called attention to the urgencies linked to the sounds they cared for deeply, the genres that they both revered and sought to transform, and each has openly embraced the sociopolitical meaning of Black sound. Remarkably, too, each of them achieved some version of stardom, notoriety, and public adulation in her own time, and yet each of these artists has been largely overlooked as a stone-cold critic, a thinker who is capable of producing knowledge of weight and import about culture that matters. They've been at the bottom of the public intellectual bin, but the history of their labor in the margins is a tale worth telling.

Into the Black "Pluriverse":
Phyl Garland & the Sisters on the Music Beat

They were out there. The sister journalists who were turning in sharp, rich copy and covering rock, R&B, and soul sounds alongside white feminist critics like Lillian Roxon, Sandra Shevey, and Ellen Willis. To rephrase a poignant proclamation made by Pulitzer Prize–winning *New York Times* arts critic Wesley Morris about the inevitable racial and gender biases that these writers faced, they "were never supposed to show up" there. And so they "showed up there every day." Seldom recognized in any major way for their music criticism, Black women arts journalists of the sixties and seventies were nonetheless working the beat, covering the shows, reviewing the albums, booking the interviews with pop stars major and minor, and cranking out vivid, probing work that no doubt helped to shape the culture of their communities—from

major-market urban enclaves like Chicago and New York to the national Black pop scene that was rapidly accruing higher media visibility as Civil Rights agitation turned into fleeting Black Power glory.[7] Journalists like Cynthia Dagnal-Myron, Lorraine O'Grady, and especially Phyl Garland each produced work that in and of itself is an invaluable marker and clear documentation of Black women's active presence out in the field. They were listening closely to their own contemporary scene: Dagnal-Myron had her ear cued up to the stadium rock phenomenon of the 1970s in particular, hanging with the members of The Who and Aerosmith in pursuit of her stories; O'Grady was listening carefully to the new sounds of the popular emerging out of scrappy punk clubs and reverberating across the Black diaspora; and, most notably, Garland was subtly yet consistently reminding her readers of popular music's relationship to African American history, a people's freedom dreams, and her steadfast belief that Black folks should be the ones to speak with authority about the meaning of their own art.

Of this group of pioneers, the self-described "lone wolf and wild woman" of the counterculture era, Dagnal-Myron, is an example of a writer who thrived on the everyday hustle and the adrenaline that comes from being in the thick of covering popular music as a source of basic pleasure and wonder. The musical event was for her a life-affirming force worth noting and upon which she might make inspired comment. The first Black woman rock critic for a "major metropolitan daily," she cut her teeth at the *Chicago Sun-Times* in the 1970s after publishing what she refers to as "some audacious little articles for local alternative newspapers and magazines . . . and *Rolling Stone* and *Creem* too." Dagnal-Myron took up the rock beat in Chicago "believing that reporting was 'writing,' based on the amazing OpEd pieces and reviews and 'creative nonfiction' that [she'd] read by seasoned vets like the venerable Herman Kogan." As she puts it, "They wrote about life, love, places they'd been and places in the heart that we all knew about but couldn't put into words the way they did. I wanted to do *that*."[8] Like her predecessor Roxon, Dagnal-Myron was chasing a form that could capture a feeling as much as a sound and pursuing a line of writing that folds together affective experience with aesthetic encounter. It is a form of journalism that presumes and is driven by the taste subjectivity of the critic herself.

Legendary Black feminist conceptual artist Lorraine O'Grady was writing right beside her. Known and revered for her bold performance art experimentalism, a young O'Grady spent time as well in the 1970s working as a rock critic and writing for the *Village Voice* and *Rolling Stone* before turning her attention in full in the 1980s to radical art-making.[9] She was one of the first critics to review Bob Marley and the Wailers, who appeared as the lead-in act for Bruce

Springsteen and the E Street Band in 1973. It was a piece originally intended for the *Village Voice* but was famously rejected by her editor, who stated that "it was too soon for these two." O'Grady's style is a fluid mix of on-the-beat reportage and sage cultural observations about the performances of two not yet superstar acts. While holding high regard for the way that Springsteen's lyrics have the ability to take "his audience on a tender odyssey through a decaying city," she's quick to observe the flagged energy of a band with all eyes on them at Max's Kansas City that night. The suspense that she builds is in watching and conveying, as all of the strongest concert reviews do, the evolution of the performers' full arsenal of strategies, the beauty of what their sounds conjure or the tragedy of what their art fails to fulfill. "The carefully orchestrated, line to line mood-changes in 'Circus Song,' from pathos to gaiety, were amazing. If you can picture Todd Brown's [sic] Freaks," she ventures, "laced with gentleness, then you have an idea of what I mean. By the time Bruce introduced a new number, 'Zero and Terry,' as being 'sort of a West Side Story,' the band was on electric." Just as assured is her take on the then little-known Island Records artists the Wailers, for whom O'Grady, the daughter of Afro-Caribbean immigrants, offers a mixed reading filled with curiosity and speculation. "Reggae is rooted in the calypso tradition of political commentary," O'Grady explains. "But in reggae we have rounded a bend . . . from innuendo to polemic. Too bad. The sly ingenuousness of calypsonians like the Duke of Iron and Lord Kitchener may be gone forever, replaced by today's thing: black power. . . . But it's complicated. When the Wailer's [sic] sing, 'We're burning and looting tonight . . . We're burning all illusion,' it's hard to connect the message to the monotonous beat. Reggae is ganja as much as politics; you can get high just dancing to it." She invites you to wrestle with the conflicting energies of the upstart sounds of both acts, two groups who were on the verge of mammoth fame yet still green behind the ears and working out their sets for an unpredictable downtown crowd.[10]

They were in that crowd, these sisters of sixties and seventies pop music journalism, sitting on the front lines of a journalistic culture that was maturing and reaching wider audiences as hippie, funk, and disco publics crossed into the slipstream of mainstream imaginaries. One of the most accomplished and longstanding figures in this group of pioneering critics was Phyl Garland, an associate editor and the regular music critic at *Ebony* magazine from the mid-1960s through the late 1970s. Born in Pennsylvania, Garland earned a BS in journalism from Northwestern University and followed in the footsteps of her mother, Hazel Garland, who served as editor in chief at the *Pittsburgh Courier* from 1974 to 1977. Phyl Garland worked as a reporter at the *Courier* before moving to *Ebony* in 1965, where, among other things, she launched a record review column,

A young Lorraine O'Grady at work in her apartment at 55
Wildersgade, Christianshavn, Copenhagen, 1962

"Sounds," which ran from 1972 to 1977.[11] Her feature writing for that publica-
tion was formidable and varied in terms of its topical focus. From writing cover
stories on the King assassination one month after that catastrophe in May 1968
to covering Fannie Lou Hamer and "the black women new builders of the south,"
Garland was a leading reporter and critic at the Johnson family empire's flag-
ship magazine.[12] Her specialty was music writing and, in particular, celebrity
profiles on a wide range of artists—from the opera icons Leontyne Price and
Jessye Norman to jazz luminaries like Satchmo and Trane and upstarts like
Wynton Marsalis. She covered the Nixon White House's birthday celebration
for the Duke and wrote much-cited stories on the High Priestess Nina and press-
averse Queen Aretha.[13]

In many ways, Garland's criticism set a new standard for the quality, preci-
sion, detail, and imagination of music journalism that any serious contemporary

critic might strive to match in her own writing about Black popular music artists and especially the work of Black women artists. Her tender profile of the stunningly original R&B vocalist Esther Phillips is exemplary in this regard. "A Coast to Coast Comeback" charts the aching vicissitudes of a singer whose career saw many highs and just as many lows. Garland traces Phillips's evolution from 1950s child star "Little Esther" to that of a breakthrough vocalist whose hypnotic reimagining of the Beatles' "And I Love Her" had the band summoning her to appear on the BBC. Her feature weaves these familiar markers of success together with the story of her debilitating drug addiction, which, at that point, had nearly cost Phillips her life.[14] While elements of Garland's story follow the blueprint of the canonical *Ebony* celebrity profile—and particularly the tales of doomed women entertainers "made new" again through the tropes of heterosexual coupling and domestic bliss—Garland's study of Phillips's gifts as an artist and the ways in which those gifts resonate in multiple contexts reveals the larger ambitions of her writing style, how it was often aiming for deeper, more nuanced, and more complicated studies of professional Black women's musicianship.[15]

Before the de rigueur images of Phillips snuggling with her boo as he coaches her to play golf, before the shots of her decorating her home, Garland's multifaceted article situates us in the crowd, "midnight at Philharmonic Hall in New York's Lincoln Center," where our post-rehab artist is taking to the stage, greeted by a receptive and movingly supportive audience who are "emoting with her, understanding, at least in part, the intensity of a struggle against heroin addiction that has nearly torn her asunder during many of her 36 years." That this profile begins in a resolutely Black space, that of Black Power cultural intellectual Ellis Haizlip's 1972 Soul at the Center summer festival, is indicative of the ways that Garland's work is especially attentive to shifting the critical viewpoint in pop music criticism so as to affirm the value of Black perspective and the totalizing presence of Black folks both on the stage and holding space as the congregation in popular culture. This place where "'froed and flamboyant sisters and brothers converge on coolly sculptured caverns where the Bernsteins and Boulezs ordinarily hold sway" is also the site where an artist like Esther Phillips might yet get her groove back and thrive again.[16]

Together, Black musicians and Black audiences might disrupt the cultural status quo, Garland's work asserts, and rattle the presumed solemnity of white patriarchal institutions that previously were loath to acknowledge their worth. This is writing that is, on the one hand, steeped in the cultural nationalist language of the moment, which, among other things, apotheosized the arrival of a "black aesthetic" rooted in self-determination, communally focused dialogue, and celebration.[17] Yet it is also journalism that is mindful of gender power

dynamics and the crucial symbolism of Esther Phillips's poise and tenacity as an artist, as well as her gripping complexity as a vocalist, insisting that "she doesn't count on previous recognition to get her point across, for she lets it all hang out in her singing. Hers is not a comfortably sweet sound. It has a teasingly acid edge that challenges as much as it cajoles. She is sensual, contorting notes into compelling bedroom squeals and grunts. She is, in short, a black woman unashamed to let others know that, baby, she's for real."[18] Garland leans into the eccentricities of Phillips's timbre and phrasings, and she calls attention to the ways that the singer uses them to great effect—to stir, to tease, to unsettle, and to render an affective experience that seductively reorders the attention of onlookers and listeners, directing them to take note of her own desires. Above all else, "A Coast to Coast Comeback" sets out to rehumanize a musician on the other side of her nadir. It refuses the cultural and critical cliché of the tragic blues woman, so often misogynist, so often dismissive of the scope of a woman artist's greater lifeworld, choosing instead to present a biographical sketch that highlights the control she exerts over her journey in healing (her rise to becoming, for instance, the first female "tribe leader" in the Synanon rehab program) and her lasting indebtedness to a devoted female mentor, her idol Dinah Washington ("She told them people to give me my money. . . . And she *got* my money for me," Phillips tells Garland, recounting the veteran artist's entertainment world protectiveness of her). It is the kind of profile that consistently and matter-of-factly rejects the familiar showbiz tropes of female competition, female frivolity, female professional failure and ruin. Phillips, in this snapshot, in this moment in time before the tragedies that would later befall her yet again, is on the trajectory toward winning. Garland's feature unabashedly roots for her.[19]

Arguably Phyl Garland's crowning achievement as a critic, though, was the publication of her beautifully audacious 1969 book *The Sound of Soul,* in which she sets out to explore "how deeply . . . soul music [has] penetrated the cultural core of modern America" and asks, how "did it all come about?" Unabashedly aligned with Black cultural nationalist thought, the legacies of the Black press, and the work of African American studies' leading critics and scholars of her time—LeRoi Jones, Marshall Stearns, and Lerone Bennett Jr., as well as Charles Keil (author of the book *Urban Blues*) and Gwendolyn Brooks—Garland developed a kind of radicalism as a Black woman pop music writer that was unprecedented. "At this, the very beginning," she announces in her introduction, "I must state that I, as a black woman writing from out of my own experience and that of so many others, have not attempted to adopt a pose of Olympian objectivity. My perspective is a black one, and I have concentrated on the work of

black musicians simply because I believe them to be the most vital factor in the development of modern music."[20]

Published six years earlier, LeRoi Jones's *Blues People* is a clear and specific touchstone for Garland's book. *The Sound of Soul* aligns itself with Jones's philosophies, positing that "anyone who wishes to understand the black man's music should first know his history." It is a work that ultimately seeks to extend the *Blues People* theory of what she refers to as "the black man's peculiar role in the shaping of modern music," applying it to her contemporary moment and the emergence of the soul phenomenon. Just the same, her invocation of the masculinist language of Jones's Black Arts movement is nonetheless tempered by her self-awareness as a Black woman writer and her interest in engaging a wide array of cultural references and figures to develop her theories of soul. As "the poet Gwendolyn Brooks has shown me, by her accomplishments," Garland declares in her preface, "a black woman living in the strife-torn world of today can still become a full and creative human being." The book moves from a sweeping analysis of soul's contemporary cultural permeation in the work of everyone from the heavyweight architects—James Brown, Otis, Aretha—to the white artists—Elvis, the Beatles—whose work was indelibly shaped by the genre's key aesthetics. But *The Sound of Soul* is interested in an exploration of the music's ubiquity and cultural impact that's seemingly even more profound. Garland hears its reach in the improvisational utterances of José Feliciano's rendition of the national anthem at 1968's World Series, the psychedelia of Hendrix, the "gravel-voiced" cry of Joplin, who, to her, recalls Mildred Bailey, "'the white soul sister' of the late thirties and forties."[21]

Clearly, Garland's archive of sonic knowledge is wide and long. It is rooted in and informed by the historiography of foundational works of Black music history such as Marshall Stearns's *The Story of Jazz* which she uses in order to mount a genealogical trace of these sounds with roots extending from "the gutsy cry of a blues singer standing in a smoke-dimmed room" to Mahalia "vocally embrac[ing] the phrase 'Lord o-of lo-o-ove'" to the wholly influential and thoroughly overlooked godmother of rock and roll Willie Mae Thornton. But her study is not limited to the paradigms set out for her by previous cultural criticism. Instead, one finds her suturing together concepts and contextual points to create a critical language that can speak to her present pop moment. To illuminate the intimacy of soul, Garland laces her study with elements of memoir, reflections on the music that "saturated" her upbringing and was shaped, in part, by her father's work as "a trombonist turned businessman" and her mother's aspirations as "a singer-turned-journalist who once dreamed of trailing Lena Horne into the Cotton Club chorus line." She turns to James Baldwin as

Phyl Garland and Isaac Hayes together at the book release party for Garland's
The Sound of Soul, New York, December 4, 1969

a pivotal voice on Black music's sociocultural and spiritual value and urgency, building a case for her holistic approach to her readings of soul in the context of the "sensual." In Garland's hands, Baldwin sits alongside Jackie "Moms" Mabley, "the matriarch of black comediennes," as a figure of wisdom who espouses "sex without shame" in her routines.[22] Her book, which is teeming with culture references to pop music across the twentieth century, finds room as well for dense, historically rooted explanations of Black musical practices and aesthetics (the importance of the antiphonal in diasporic performance, the polyrhythmic structures of West African sounds), framing these insights in relation to renowned anthropologist Melville Herskovits's influential theories of diasporic

cultural continuity and retention. Fundamental to *The Sound of Soul* is Garland's commitment to honoring "black music fans," "the black listener to the music." The book addresses why and how soul, the outgrowth of centuries of suffering and survival, ultimately shapes their worlds, makes manifest their history, and serves as the bedrock of late twentieth-century popular music culture.

These were ideas that would remain a constant in Phyl Garland's work. But what would turn out to be her most captivating and sensationally forthright commentary on the necessity and responsibility of the Black music critic would also find her breaking from the philosophies of her beloved Baraka in crucial ways. A frequent public speaker in the years both during and following her time at *Ebony,* Phyl Garland entered the academy, first assuming a post at the State University of New York at New Paltz, where she taught from 1971 to 1973, and later joining the faculty at Columbia University's School of Journalism, where she earned tenure in 1981 and served as a professor until her retirement in 2004, two years before her passing in 2006. Her archival papers include a manuscript draft of an undated lecture, one she seemingly composed during her time at New Paltz and while working at *Ebony,* and one that amounts to something of a manifesto for the contemporary Black pop music critic. "As a lifetime lover of all music and a former student of this art," Garland ventures,

> I became aware, several years ago, of the fact that practically everything that was written or said about Black music came from out of the mouths and minds of whites. There were a few examples of Black scholarship in this field before 1960, most notably Maude Cuney-Hare and Alain Locke whose contributions dated from 1936, but their books were out-of-print until recently. Furthermore, this slim and difficult-to-find supply of Black materials had a negligible impact on public taste when compared with the constant barrage of white writing on Black music to be found in white publications readily available to the public.[23]

For Garland, questions of institutional control and gross racial inequities in cultural arts journalism have everything to do with not only who generates the narrative about Black music and how the broader story of that complicated and wondrous music—with all its promise and beauty and purpose—ultimately gets told but also who stands to profit from the telling. She pulls no punches when, for instance, skewering *Downbeat* magazine, "the so-called 'bible' of jazz which," as she reminds, "is fundamentally a black music. <u>Downbeat</u>, I knew, even in the days when I read it religiously, was white-owned, white-written and its entire history had employed but one Black staff writer—and he didn't remain with it

for long. Certainly, it was bad enough that whites owned and controlled the whole Black music business in the country with an iron fist, reaping enormous benefits from the exploitation of Black genius." In short, the whale that she goes after is the industry in its entirety. Root and branch, the whole of it is bound up in a much revered and trusted magazine that, nonetheless, to her reflects white supremacist structural power that fundamentally shapes conversations about Black sound and has long made a killing off of it.[24]

These kinds of claims, along with her freedom struggle–era belief in what she refers to as "the Black mystique" in music and the "essence" that cannot be imitated, cannot be co-opted, are time-stamp indicators of Garland's lasting alliance with the Black Arts movement that *Blues People* helped to inaugurate. This is the language of Black Power in all its idealistic, culturally rehabilitative yet narrowly conceived glory. In the years that followed, a number of African American intellectuals would move away from such concepts as the post-Soul era unfolded.[25] But the Garland of this lecture, circa 1971, is an earnest acolyte of this epoch, which championed the immanent specialness of Black expressiveness as a thing to be identified and protected, and clearly LeRoi Jones / Amiri Baraka's philosophies on this subject had much to do with Garland's thinking. She is quick to express a deep indebtedness to this towering literary revolutionary for having "created an awareness on the part of many of us who have followed in his footsteps," adding that "he is the spiritual daddy of us all." But Garland takes pains to critique the ways that, from her standpoint, the movement that he helped to spark was neither interested in nor fully capable of accounting for the power and potentiality of popular sounds. "To my deep regret," she argues, "his recent article in *Black World* (July, 1971) was a monumental put-down of the Black popular music loved by the masses." His embrace of avant-garde jazz at the expense of soul is "where Jones (Baraka) and I part company," says Garland. Because "while Sun Ra, Archie Shepp and Pharoah Sanders say something in their way, Aretha Franklin, James Brown, Marvin Gaye, Curtis Mayfield, Smokey Robinson and many other artists who happen to be commercially successful are whipping down some powerful messages to millions of brothers and sisters and their popularity is proof of their validity as purveyors of true Black art. Any analysis that excludes them is representative of a precious and elitist attitude that puts Black folks back in the same old bag of imitating white folks."[26] Garland's lecture casts a wide net as it sets out to address the popular pleasures of the Black masses with focus and sincerity, and her assertion that "we must overlook the debasement" of the "commercial commodity" for "we have other greater things in mind" is a clarion call to Black music critics to expand their imagination and their conceptualization of what

a wide range of sounds can do for a people. This fugitive music that "might elude the white Ph.D. attempting to decode our thing" is also the stuff of poetry and full of not only wide and varied information about past, present, and future longings but "an ineluctable fire that feeds our spirits." These are sounds that reverberate as well with the dynamism of African diasporic music of which she recounts witnessing up close for the first time in all its energy and vitality during a life-changing trip to Ghana to cover the historic Soul to Soul concert festival. This music is Black folks' cosmic chance for her. It represents the source of "cultural exchange" that might tend to "wounded kinship," mend ruptures across time and space.[27] "Let us listen to a few of these musical messages," Garland proposes,

> as they reaffirm the linkage:
> African record from Ghana
> South American music
> Albany movement record with preacher
> Ray Charles on Drown in My Own Tears
> Aretha Franklin: Bridge Over Trouble [sic] Water[28]

Black sound technology moves, leaps from one side of the globe to the other, in this lyrical rendering of what Joseph Roach might call circum-Atlantic theory.[29] It follows the dispersion of peoples, scattered by a vicious trade, treated like capital and yet still refusing the wretchedness of their own condition and scoring a long countermelody. It moves like Langston's "Negro speak[ing] of rivers," flowing like a current from West Africa, on up through the Southern Hemisphere, into the heart of a Civil Rights revolution that tapped into the radical phonographic power of dissemination, on through into the prodigiously sacred-turned-profane soul of a man at the piano, on through to the place on the bridge where a virtuoso vocalist turns that errant music into hymnody once more. The DIY poiesis of Garland's theories, the formalistic and imagistic abandon in her jolting prose here, largely flew under the radar compared with that of her Black nationalist idols and her pop beat peers. But in her cultivation of a "Black pluriversal viewpoint," that which reaches for the broadest "appreciation and conception of what Black music is" on Black folks' "own terms," Garland was also, in this lecture, naming that energy in Black music that might elude commercial capture. She was searching for and inventing the tools to make sense of this insistent "groove" that "is our only guide," the one that might lead us "out of our constrictions." Ready or not, she was intent on delivering the word.[30]

(*l to r*) Marc Glassman, Cynthia Dagnal-Myron, Roger Daltrey, JJ Quinn

Cynthia Dagnal-Myron's, Lorraine O'Grady's, and Phyl Garland's respective, public-facing contributions to intellectual discourse about popular music culture in the second half of the twentieth century are anything but obscure. Yet their opinions and perspectives are rarely cited by others or identified as crucial to the cultivation of ideas about rock and roll, R&B, and soul and the artists who innovated these forms; their writing and the situation of their being in the field remain marginal events in the history of popular music criticism.

To recognize the knowledge production of women who are dedicated to exploring sonic wonder and who came before as well as after them—be they artists or critics—is to confront the utter importance of cultural arts criticism as being what *New York Times* film critic A. O. Scott sees as "far from sapping the vitality of art" and "instead what supplies its lifeblood; it is to take dead seriously the idea that criticism, properly understood, is not an enemy from which art must be defended, but rather another name—the proper name—for the defense of art itself." Scott's point is one that remains especially poignant for Black folks who have stayed on the front lines of defining and defending the value of their own expressive cultures and, by extension, themselves. If, as he contends, "it's the job of art to free our minds and the task of criticism to figure out what to do with that freedom," then critics and artists have dialectical, sym-

biotic roles to play with one another. Still more, as he points out, they are both "creators" engaging in "critical acts." "All art," Scott insists, "is successful criticism." And certainly, it's possible to consider the most stirring criticism as art. In both cases, an individual produces a cultural event or text that "reaches out beyond" her own time and place to touch, to sit alongside, to adore, pursue, reject, deny, or inquire about a work of art as well as that which has come before or made possible that work of art. It is the critic who has the opportunity to explore the conditions in which a cultural work or event arises. "All art that is recognizable as such," concludes Scott, "is in some degree about other art. Every writer is a reader, every musician a listener, driven by a desire to imitate, to correct, to improve, or to answer the models before them."[31]

In the history of popular music culture across the twentieth and twenty-first centuries, how often have we extensively imagined Black women in any of these roles? How often have we asked Black women musicians, critics, and fans about what they've been listening to and why or which records they bought (or downloaded!), which songs set them on a journey to write, perform, and record their own music? How often have we explored the politics as well as the pleasure that women derived from writing about sounds and performances that were meaningful to them? How often have we mapped out and examined the worlds created and inhabited by Black women artists who are also critics and feminist critics whose prose aspired to the level of art? And as to those women who were ensnared in other people's criticism or who were bound—for any number of reasons—to archives that often brutally or carelessly rendered them as objects rather than subjects of their own making, how often have we considered the ways that their music created the conditions for crafting other ways of inhabiting the world?

This, then, is what it all comes down to in this book: Who gets to tell the story of Black women who were both performing and producing thought about popular music culture, and how will this story be told? As Elizabeth Mendez Berry and Chi-hui Yang have trenchantly argued in a high-profile *New York Times* op-ed, such questions "matte[r] because culture is a battleground where some narratives win and conversation about our collective imagination has the same blind spots as our political discourse." Adds the venerable Black feminist culture critic Margo Jefferson, the "role of the critic of color is to unveil and unearth the structures that lie behind and underneath and propel these narratives which always star the same figures." Arts criticism is, in effect and as they suggest, ultimately world-making. It has the power to both reflect and expand a community's relationship to the expressive modes of being that saturate our quotidian lives and inform our communicative lexicons. Or, as Toni Morrison,

a colossally influential thinker who fundamentally informs this study from its beginning to its end, once put it bluntly, "as far as the future is concerned, when one writes, as critic or as author, all necks are on the line." Berry and Yang thus helpfully urge the public to "think of cultural criticism as civic infrastructure that needs to be valued not based just on monetary impact"—that is, which artists receive the most exposure and reap the most revenue (though this is important, too, in a world of institutional inequities)—but also based on criticism's "capacity to expand the collective conversation at a time when it is dangerously contracting. Arts writing," they contend, "fosters an engaged citizenry that participates in the making of its own story."[32]

With regard to music criticism in particular, what's at stake as well is how we think about the complexities and heterogeneity of the aspirational and, as Josh Kun would put it, the audiotopic, beloved community that American popular music culture has always had the potential to become, no matter how fraught and rife with danger and failure that world has been and will continue to be. If it is true that "some version of 'community' was implicit" in the rock and roll "artworks themselves" that Lethem and Dettmar have in mind, it is also true that their claim that this was a "community founded less on political axioms than on instantaneous recognition of sensory revelations" does not apply to the figures in *Liner Notes for the Revolution,* Black as well as white women art agitators for whom such a dichotomy would seemingly be unfathomable.[33] The women below (in every sense of that word) each recognize that, for minoritarian publics, "sensory revelations" are the key to social revolution, and each sounds out this theory in her own glorious register.

The work that I am doing here seeks to honor their legacies and constitutes an approach that we might think of as "subterranean blues," a kind of Black feminist underground study that commits itself to exploring Black women musicians' and thinkers' forgotten, overlooked, and undertheorized critical language and archives in such a way as to illuminate the relationship between race, gender, sexuality, and sound as well as the intellectual difference that these categories make in relation to one another. Each of the artists here is a pivotal architect in the making of Black feminist sound cultures, and each participates in the sounding of modernity while also questioning and contesting its structural tyrannies. One postbellum pioneer set out at the dawn of the twentieth century to record the radicalism of Black women's vocality on the page, conveying to the world the historical and diasporic value of Black women's sonic lifeworlds. Another translated the theories of her everyday conditions as a long-standing working musician of the blues, swing, and bebop eras into theory and compositional wonder and praxis. Yet another yoked together her emergent role as a

1960s public historian and her evolving sensibilities as a profoundly gifted jazz singer turned "mood critic" to pronounce a new epoch of Black liberation. And one new millennium artist has explicitly turned back to the liner note form as a way to invite contemporary listeners to think intellectual radicalism through Black feminist sonic futurity. As this last artist might put it, for some time now, they've each been waging a "cold war" to tell a bolder and more beautiful story of American music culture with Black women at its center.[34]

That "Weird Contralto": Pauline Hopkins and the Long-Playing Record

Let's plant one of the flags where feminist music writing begins here, with the mighty Pauline Hopkins, and watch how her work shakes up origin myths about modern music criticism. The importance of the Black. Woman. Music Writer—at any time in history, but perhaps most crucially in the era when Black folks were appearing in the public sphere up on stage in the long (and still ever-so-present) shadow of blackface minstrelsy—cannot be overstated, and yet continues to receive far too little attention from cultural historians.[35] But they are the ones who deserve our utmost attention since they are our *witnesses* in the Black music archives. They are the ones who first accepted the charge to absorb all of the dazzling details of the theatrical event—the artists' alluring gestures and singular choices, the eccentric micropolitics and poetics of a given performance, the memorable motions, the challenging risks as well as the potential failures of a choral concert, an instrumental recital, a spectacularly choreographed dance suite, a vaudeville extravaganza. They are our opinionated conduits to the *thing* unfolding on the stage, our eyes and ears who bring us closer to the traces of Black performance resonances. And ultimately, they are the ones who craft "an archive of the exorbitant" for us through their writing, "a dream book for existing otherwise" through the music itself.[36]

There is so much we still don't know about one of those first critics, Pauline Hopkins, the onetime "Favorite Colored Soprano" of Boston who turned away from her celebrated stage work in the 1880s to devote herself to writing insurgent fiction and arts journalism at the turn of the century.[37] Although Lois Brown's groundbreaking, monumental biography certainly has done more than any other study to fill in numerous nagging gaps in her life record, there are many details about Hopkins's quiet years in Cambridge, Massachusetts, after her departure from journalism to which we seemingly have no access, especially as the house fire that took her life in 1930 leaves us with few mementos and

objects to convey information about her late-life inner world, her hobbies, her passions, her obsessions.[38] The questions that linger are perhaps unanswerable, lost to history and the forces of brutal chance: Was she queer, as several critics have speculated and queried since her "rediscovery" by scholars in the late 1980s?[39] Did she ever contemplate returning to the concert hall stage once she made the transition to journalism, fiction writing, and Black radical tradition social agitation at the turn of the century? Did she continue to take delight in the music made by other Black women artists coming of age during her "dormant years" living in Cambridge as the Harlem Renaissance unfolded? Did she listen closely to them when she could, keep a record of what she heard? Did she continue to share her thoughts about a craft that once was hers as well? Did she own a phonograph?[40]

What did her *desk* look like? Was it strewn with books, notes, and letters from fellow grassroots-agitating sisters in struggle, like Ida B., or academic belles lettres powerhouses like Anna J., or others who may have caught her 1901 column article entitled "Famous Women of the Negro Race: Phenomenal Vocalists" in the *Colored American* magazine, the publication that she edited? Were there telegrams from the Black Women's Club network putting the urgency of the matter to her: that "another black man had been lynched today," and therefore her presence was needed to offer her indelible words of hope paired with righteous indignation and delivered to her fund-raising brethren, the ones who'd committed themselves to fighting the perpetual crush of anti-Black domestic terror? Were there invitations to tea with social reform women concerned about the Black woman's cause, ones like Victoria Earle Matthews, the activist who, as Saidiya Hartman reminds, had devoted her life to "rescuing" those "wayward" girls from the evils of the city?[41]

What kinds of vulnerabilities, conflicts, and quagmires did she face as a professional sister writer who clung to her principles as Black postbellum politics were all afire around her? One imagines the telegrams that she perhaps received from her adversary Booker T. Washington, the heavy who hated on her radical journalism and eventually had his powerful machine remove her from her editorial post. Her tiny archive of letters affirms the fact that she worked under severe pressure as the "colored editress" of an ambitious uplift magazine she dearly loved, one that she oversaw for a salary of seven dollars a week while caring for "a bedridden mother." She stood in the direct line of fire of "the white South, male and female against [her]" who sent her "insulting letters" on the regular. She, likewise, did her best to weather the schemes and manipulations of Washington and the men who worked with, for, and around him to kill the "literary" vision of the *Colored American* magazine and to censor its political

content. "It is not good to bother about lynchings in Ohio or being 'a proscribed race,'" advised John C. Freund, the British founder of the *Musical and Dramatic Times and Music Trade Review*. An expedient benefactor and ultimately an aggressive agent of Washington's, Freund obsessively circled Hopkins and her fellow staff in the winter and spring of 1904, seeking to woo them with his financial support and increasingly lobbying to steer the publication away from "theoriz[ing]" about "the colored issue." He offered his unsolicited critiques about the *Colored American*'s design, and he suggested to Hopkins that, "in the future, you do not put young colored women on the front page." In her lengthy letter of appeal to anti-Washington newspaper editor William Monroe Trotter, Hopkins writes candidly of Freund's professional seduction, a turn of events akin to her fictionalized plot twists. He "sent me a bouquet of Russian violets . . . the book Self-Help by Smiles, an expensive set of furs. . . . I was so dense," she muses with regret, "I did not for a moment suspect that I was being politically bribed."[42]

The turbulence that overtook Hopkins's career is also a reason to ask other questions about the contrasting fullness of her creative life as a writer who cared ever so deeply about Black art and music in particular. What were the sleepless nights like for her in this hostile and patronizing environment? How did she stay focused while trying to keep her publication afloat? Did she drink coffee or tea? Did she like to cook, knit, or ride a bicycle to ease her mind? Was writing a respite? A chore? A necessity? And *when* did she put pen to paper about the sounds that captivated her, the musicians and vocalists who dazzled her, the performances that stirred her to her core, that brought her to tears or maybe, occasionally, left her longing for something more substantial? Would she rise early to compose her thoughts while the teapot warmed her in the kitchen? Or did she prefer scribbling by candlelight in the tiny parlor of her house, or as she sat in bed where the moonlight shone, looking out the window into the New England night? Did she handwrite her drafts of material or get right to the business of pounding out her feelings, her visions, and her dreams about majestic Black art music performances on an old-school Crandall typewriter, spinning her meditations on the classical sisters, the ones who rocked the studiously higher and lower registers like her own aunt, Madame Annie Pauline Pindell, her famous namesake.

Hopkins is a soloist in every sense of the word, a woman who never married; a woman who chose to call one of her heroic characters who'd survived the traumas of slavery and concubinage Sappho; a woman who would later die tragically in that 1930 house fire. Her history leaves me hungry and wanting to know more not only about her but about the other sisters like her as well—the kind of

work that they did, the kinds of pleasures that they pursued, the kind of art that they loved, and how they wrote about said love. I am getting my hustle on here to pay tribute to, to recognize and yet not cannibalize, the privacy of the ones who sometimes *sang* and *also* wrote about what it felt like to open up their lungs and reach the masses, the ones who believed in the beauty and the seduction of Black women's voices lighting the universe and inventing other worlds forged on the other side of, and yet instilled with the heavy wisdom of, what it means to live through and to survive Jim Crow tyranny. My questions about Hopkins come as a result of Hartman's revolutionary method to "craf[t] a counter-narrative liberated from the judgment and classification that subjected young black women to surveillance, arrest, punishment, and confinement" and to instead "offer an account that attends to beautiful experiments—to make living an art—undertaken by those often described as promiscuous, reckless, wild, and wayward."[43] Hartman's masterful recalibration of vision about Black women's lives and pleasures encourages a different kind of emphasis on the stories that get told about Black women in the archive, and it executes a distinct form of speculative imagining that sheds light on the quotidian dimensions of forgotten women's cultural labor that this chapter seeks to pursue.

Maybe Hopkins sits in her office in Boston, all suited up in petticoat garments—just down the road and yet worlds away from her distaff Black uplift public intellectual competitor, dictee Du Bois, who neglected to give her a shout-out in his 1903 *Souls of Black Folk* masterpiece. She was no "wayward girl," as far as we can tell, unlike those whom Hartman follows through varying forms of social precarity and peril. She was clearly closer to Victoria Earle Matthews's race woman, who engaged in a respectability-laden class of activism. Circa 1900, we might think of her as hoofing it like late twentieth-century Minneapolitan Mary Tyler Moore, a working girl pursuing her aspirations, which, in Hopkins's case, involved nights at the concert hall soaking up the choral majesty of the Fisk Jubilee-ers and, perhaps, mornings after the recital, drafting essays of appreciation, think pieces, and reviews—prose that constitutes some of our earliest discursive critical thought about Black women's sounds. But the details of her daily commitment to writing about and theorizing the sonic world as a platform for radical Black agitation is a thing that we might ponder if we are to honor and carefully engage this work that has been wholly disregarded by arts-writing history.[44]

Hopkins is our first Black woman cultural intellectual to offer an extended meditation on the work of Black women's voices in the so-called New World. She had been crafting these kinds of theories in the public sphere as a performer and arts entrepreneur nearly two decades before the publication of

her last novel. Most provocatively perhaps, she had specifically foreshadowed her interest in theorizing Black women's vocality in print two years before the arrival of *Of One Blood* in a magazine column article titled "Famous Women of the Negro Race: Phenomenal Vocalists," which specifically documented the talents of Madame Annie Pauline Pindell, Hopkins's famous aunt, known to the classical music world as "the Black Nightingale."[45] Hopkins "placed [Pindell] squarely within the elite . . . group of African American women performers that included the legendary Hyers Sisters, Elizabeth Taylor Greenfield ["the Black Swan"], and Madame Marie Selika, who was known as 'The Queen of Staccato.'" Here in this article we see her grafting together Western philosophical ruminations on the relationship between music and ancient history, music and Enlightenment values, and—in yet another pre–Du Boisean move— music as evidence of the "Negro's right to be classed as a man among men."[46] Hopkins showcases her chops as a historian and archivist, offering detailed journalistic accounts of antebellum performances by these women. She also works as a biographer and a music theorist, providing keen insight into, for instance, "the compass of [Madame Pindell's] voice" by comparing it to "the Black Swan's" as it "embrac[es] twenty-seven notes, from G in bass clef to E in treble clef." Here she flosses with a bit of technical expertise to underscore the extent of Pindell's mastery—as well as her own. As a race woman activist of the highest order, she also flexes her undying commitment to promoting Black aesthetic culture as revolution and reform, refusing to shy away from conjoining art appreciation with radical polemics in her insistence that it "is profitable, too, for us to appreciate the fact that the women of the race have always kept pace with every advance made, often leading the upward flight. The work accomplished by these artists," she continues, "was more sacred than the exquisite subtleness of their art, for to them it was given to create a manhood for their despised race."[47]

"Famous Women of the Negro Race" would come to characterize Hopkins's Black nationalist ideological vision and formal aesthetics as a journalist and magazine editor who prioritized documentation, recuperation, and revisionist narrative in her work. But her virtuosity as an intellectual who remained focused on illuminating the merit of Black women's musical performances and, likewise, making bold, aspirational statements about the weight, power, and execution of Black women's sounds would come fully to fruition in *Of One Blood*. That narrative lays the groundwork for a Black feminist intellectual network of cultural criticism that not only reads Black women's sonic presence as a conduit of historical memory (alongside Du Bois and in anticipation of those other magnificent patriarchs of the blue note—Hughes, Ellison, Albert Murray, and

Baraka) but also presents us with a Black heroine who disturbs her own social subjugation (controlled at varying points in the text by battling "blood" brothers) by way of an alien(ating) voice that summons sounds "from a strange distance." Still more, the text figures the Black woman's voice as an archive of Black existential desire, the site of the "phantom limb," "the vibrational affinities" of "wounded kinship" of which Nathaniel Mackey writes so beautifully some ninety years after and yet right in time with Hopkins. "That weird contralto, veiled as it were, rising and falling upon every [sound] wave of the great soprano," reaches toward Mackey's "quality of a tone" in his jazz odyssey *Bedouin Hornbook* that "is a statement of its incompleteness, its will to completion.... Listening to music," Mackey's experimental musician N muses, "we are not first in one tone, then in the next, and so forth. We are always between the tones, on the way from tone to tone; our hearing does not remain with the tone, it reaches through it and beyond it."[48]

Of One Blood summons the tradition of Black male authors finding inspiration in the Black woman's voice only to render it subordinate to a larger vision of Black women's vocality as radical pneumonic and archival praxis.[49] As Griffin reminds in her landmark "meditation on black women's vocality," this tradition is a long one, and in their narratives, "the singing New World" black woman's "voice ... inspires cultural memory in the hearer and sets him on his own path of creative discovery." Whether it's Sterling Brown's reverential treatment of "Ma Rainey" or August Wilson's open indebtedness to Bessie Smith as a source of his own artistry as a playwright, this phenomenon is a storied one in Black letters, and Hopkins's novel forecasts this trend. Her tortured "race man" protagonist is without purpose or a people until he is seduced by the devastating profundity of Fisk soloist Dianthe's "sweet thunder."[50] But the voice of Hopkins's heroine Dianthe moves beyond merely serving the brother-man. Her epic moves beyond the realm of romance (though it is undoubtedly romantic, seductive enough to draw the Du Boisean doppelgänger Reuel out of his isolated stupor and toward the antiphonal beckoning of our heroine's hypnotic rendition of the spirituals). Voice, in this narrative, becomes the means by which Hopkins posits a theory of Black women's performative archival work. It is the terrain of alterity for our singer turned spiritualist medium, the vehicle that occupies both high and low registers, the instrument that, Hopkins tells us further, "drop[s] sweet and low" with an "echo following it." This is the moment when we can hear our novelist scoring "the generative force of a venerable phonic propulsion," as Fred Moten refers to it, "the ontological and historical priority of resistance to power and objection to subjection, the old-new thing, the freedom drive that animates black performance."[51]

Hopkins's theorization of a Black woman's "peculiar" voice that unfolds simultaneously in the soprano and contralto registers—on separate yet intersecting planes, rising up out of history and diving down into the underground in a resonating wave—is distinct from the Black male radical tradition of writers like Douglass, Dunbar, Du Bois, and Johnson. It is, for example, a departure from Moten's radical reclamation of the "inspirited materiality" of Aunt Hester's scream in Douglass's landmark abolitionist narrative, a "(re)sounding moment" that, he argues, records the captive's "objection to exchange." It moves in relation to but also in excess of the way that Dunbar's mysterious "Malindy sings" in his 1895 poem that celebrates "de nachel o'gans" of a voice that causes "robins" to "hides dey faces," "fiddlin' man to jes' stop his fiddlin'," and dogs to bark. It is a text that offers a more complex version(ing) of Du Bois's tale of his "grandfather's grandmother" singing "a strange song in a strange land" and foreshadows with a twist the condition of the Ex-Coloured Man of James Weldon Johnson's fictional "autobiography" who listens attentively to the "old Southern songs" his mother would sing "with all their pathetic turns and cadences."[52]

By contrast, Hopkins's text gives us a heroine whose voice cuts, mixes, loops, and crossfades all of these moments into what our narrator calls a kind of "divine fire" that holds an audience "spell-bound," and one that an audience member characterizes as "genius" (perhaps the first time this word is used to describe a Black woman's voice in fiction). *Of One Blood* disturbs the "myth" in Black letters that, as Griffin reveals, "situates a black woman's voice as the origin of black male literary and musical productivity," instead moving our sounding Black heroine into the meteoric spotlight—just long enough to script her as the Afrofuturist see-er in the text, the one who forecasts the novel's Ethiopianist finale when her suitor-turned-brother iconically guides the family's journey back to the "mothership."[53]

By figuring a Black woman protagonist who sings in "between the tones," Hopkins offers us a method for mining the archive by way of the Black woman's vocal body. The singing voice, the "fundamental means for African American populations to extricate themselves from harshly imposed and dehumanizing silences," as the late, great Lindon Barrett contends, emerges as a material tool that both preserves and unsettles the "partials" of an unrecorded past. Like the archive that art historian Charles Merewether sees as neither "one and the same as forms of remembrance, or as history," the vocal body of Hopkins's woman of song manifests "itself in the form of traces, it contains the potential to fragment and destabilize either remembrance as recorded or history as written." Yet it also challenges the very presumptions on which the power of the archive depends, the presumptions that the archive will "provid[e] the last word in the

account of what has come to pass."[54] "The changing same" of Dianthe's "veiled" voice is both the "last" and "first" word of history without a home but housed in the musical matter of a "genius" who sings across the diasporic range(s). Surely Hopkins's epic sounding is an antecedent to classic works by Toni Morrison and Gayl Jones at the other end of the century, but in arriving at the "dawn" of a new era rather than "dusk," it reminds us of the long and heretofore undertheorized legacies of feminist cultural workers writing about and theorizing Black women's musical performances and simultaneously doing archival work in the deep grooves of history.

"Drag 'Em": The Jazz Automotive Theory of Mary Lou Williams

The genius jazz pianist and composer Mary Lou Williams had much to say about said deep grooves, the roots and branches of Black history, and she would devote her life and remarkable career to making music that amounted to a kind of tree of Black artistic vitality and innovation, a record of where and how Black sounds keep evolving and flourishing in the face of tyranny. Such an endeavor— to get it all down in the music—was, in and of itself, a modern strategy, and Williams was, if anything, clear about her audacity as a musician interested in composing and performing dynamic sounds that encapsulated both where she came from as an African American musician and where she was determinedly headed with drive and inspired vision. Indeed, she once said, "I get my inspiration from modern things." According to Griffin, Williams counted the New York City subway as one of her artistic incubators where "musical ideas and sounds" were "delivered" to her while in motion. She was known, by the time she had reached her thirties and achieved great prominence and influence in the 1940s Harlem jazz world, as the kind of daringly spontaneous artist who could emerge from the underground, "arriv[ing] at the club 'with the complete arrangement worked out,'" resulting in a train anthem like "Eighth Avenue Express" to rival the Duke's love letter to public transportation.[55]

What we might yet consider though is the extent to which other forms of "modern" transport animated Williams's craft at a much earlier age and in a drastically different place, out on the dirt roads between Memphis and Oklahoma City as she traveled with mother-in-law and friend from one set of gigs to the next, as she would help to create and ride the wave of swing and the boogie-woogie next big thing with her then-band Andy Kirk and the Dark Clouds of Joy. What did it mean for Williams to "roll" from one blood-red state to the next at one of the crucial, early moments in her career as an avant-

garde jazz pianist who moved from innovating swing to bebop to orchestral experimentalism? More to the point, how did that movement perhaps inform and shape her experimental philosophies about music making, a subject she would explore in her written work and interviews at various points in her career?

Mary Lou Williams was born Mary Elfrieda Scruggs in 1910 in Atlanta, Georgia, but raised in Pittsburgh, Pennsylvania, where she showed signs of singular, "clairvoyant" musical talent as a toddler, laying down rhythms on the family's reed organ while accompanying her mother, rolling as a tween with her caring stepfather to juke joints where she studied the moves of Lovie Austin and Ma Rainey, revealing her gift of perfect pitch by high school, and taking to the Theatre Owners Booking Association (Chitlin') Circuit by her teens. From her earliest years, Williams was on the move, independent, "alone but not lonely," as Griffin puts it. She "knew solitude, welcomed it and the gifts it bore. [She] welcomed the rare chance to hear [her] own thoughts, before the city stirred," once she settled in Harlem for most of the 1940s.[56]

Known for her "spiritually driven" commitment to "racial and economic justice," Williams would treat jazz as a site for affirming Black culture's richness and depths of complexity as well as its long historical reach. As many critics have noted, the sonic was for her a vast and mighty tool of expression and one that, she believed, could serve as a crucial and necessary portal for Black peoples to commune with and convey the magnitude of their past. Williams's forays into writing about "black music as the deepest expression of black history" appear in both published and unpublished form, as experimental artistic arguments and as formalized essay tracts that document the evolution of musical genres from the time of captivity to her modern era. The "jazz tree" illustration that she commissioned artist and friend David Stone Martin to design is a well-known example of the extent to which Williams turned to other forms to articulate her beliefs about Black music emerging as a direct product of the conditions of Black life and as a salve for Black sorrow. On many an occasion, she set to writing—informally in unpublished essays and letters but also at times in public forums—in order to elaborate on the ways in which her own "modern music" was both a statement in aesthetic "progress" and yet, likewise, constitutive of old forms.[57]

Williams was a jazz historian, to be sure, but as Brent Edwards notes, her "efforts at recorded jazz history...are posed as something like performative metonyms, in which [that] history inhabits and is remembered in the resonant fingerings of a singular body and the shifts of [Williams's] individual corpus." In other words, she prominently figured herself as the archive but, more still,

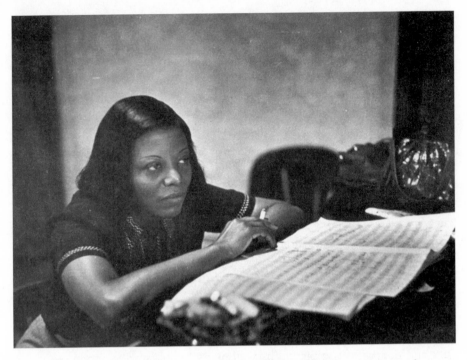

Mary Lou Williams listens to playback of one of her own recordings she's just made

saw fit to theorize the exigencies of this role in her written work, recorded projects, and interviews. Williams's prominence as a formidable jazz intellectual throughout her sixty-year career is, thus, undisputed.[58] Frequently and notably and with a kind of steady consistency across her career, Williams wrote about the Black music tradition as historical phenomenon, born out of suffering and yielding "the greatest and only true art . . . in the world": that of the spirituals and that which came after. Likewise, she often returned in her writings and interviews to the charge of the jazz musician to uphold that tradition through a combination of "feeling," "natural ability," and just enough instruction and mentorship to set alight as a committed experimentalist. Williams proudly assumed this mantle (one self-authored essay boasts that "no one else has actually changed and developed along with the music through all its history") and extolled the gospel of this truth in typewritten manuscripts with titles like "Don't Destroy the Roots," "Has the Black American Musician Lost His Creativeness and Heritage in Jazz?," and "Jazz Is Our Heritage." Such meditations sometimes bluntly ("the definition of a genius is one who does everything without being taught") and sometimes cheekily ("Mary Lou was flexing that manly privilege of experiment") addressed these topics in a contemplative and con-

Mary Lou Williams and David Stone Martin, "History of Jazz," 1977

versational style of prose that often mixed personal anecdotes with opinionated declarations about her artistic beliefs.[59]

Perhaps less discussed is the extent to which Williams held forth with a kind of antagonistic fascination about topics such as the rise of rock and soul, the recording industry's failure to appreciate the brilliance of Black art, and the fallacies of music criticism, which, at least in one searing essay, she ultimately likened to a racket dominated by jealous and expedient writers. By the time of the 1978 release of *Embraced,* the historic concert album that she recorded with avant-garde trailblazing fellow pianist Cecil Taylor, Williams was reflecting on the ways that she had wrestled for two decades plus with what she had previously felt to be "a perverted force . . . coming into the music" as a result of everything from "foreign composers" to "commercial rock." Before resolving that "one should play all forms of music," she acknowledges in the notes that she had, at one time, believed that these "forces" might "destroy the true *feeling* of Jazz." These were issues that Williams had been pondering for some time. In a fretful letter to Phyl Garland, who, in 1977, was working on an *Ebony* feature on Williams, the pianist worried about the need to "improvise new ways" of doing jazz so as to win back the youngsters who, she argues, "lost the heritage playing rock, avant garde [*sic*], black magic exercises . . . (Aretha & James Brown are the only real mccoys)."[60]

But in spite of her ambivalence toward the popular, Williams gave thought to other genres and particularly the ways that an unremarked-on Blackness drives these forms. "Rock," she argues, "is the new era of rhythm and blues and was created by Black Americans. . . . Even with the loudness of this music there was a great deal of soul (feeling). . . . When the commercial world grabbed it . . . it became amateurist [*sic*] and lousy." The exploitation of and disregard for deeply influential and imaginative Black artistic labor is a thing that Williams reads as endemic to the recording industry in ways that would foreshadow Nicki Minaj's Twitter philosophizing. In a letter to veteran jazz music critic Leonard Feather, she emphasized her point, insisting that the "black musician has been badly treated as far as grammys & awards. . . . We (blacks) could still be suffering for this. . . . The black musician became embittered because" the Black artist was "not getting enough credit for what was created thru his suffering."[61]

Her grievance toward the music industry establishment is perhaps most pronounced in an undated, handwritten essay in which Williams comes at the music critics, the writers who hold court about the merits of musicianship but, from her disdainful viewpoint, know little about the work of instrumental excellence and, particularly in the intimately connected world of jazz, are in pur-

suit of their own interests, their own cultural capital. These individuals, these "frustrated never[-]made[-]it critic[s] who once inspired [*sic*] to be a musician but had no ears so decided to write about it," are the bane of the music itself since that sort of "burning jealousy" will seemingly ruin the fellowship of jazz, which Williams promoted throughout her career. Just as threatening is "another kind of critic who doesn't know the history of anything" and is, therefore, easily seduced by weak talents and fads. "We still have another type [of] critic," she continues, "who knows good music of all brand," but "greed" and the pursuit of artists' kickbacks destroys his credibility. The dream of a critic "who listens to a record broadminded . . . as if he was playing it" is a praxis that Williams promotes as an alternative approach to *thinking* jazz, experiencing it on a vista that lets in all of the historical genres running through it.[62]

Yet it is the fact of Mary Lou Williams's own intellectual labor that I want to suggest we linger on, as we piece together these genealogies marking the presence and nature of Black women musicians at work, as thinkers who were consciously tinkering with the details and conditions of their own artistry. If, for instance, Edwards offers a compelling way in which to consider the curious practice of "*zoning* as something like a methodological principle at the base of her entire oeuvre" that privileges innovation and yet seeks to contain, manage, and "incorporate" the avant-garde into a system of jazz tradition, what more might we say about Williams's approach to the nuts and bolts, so to speak, of playing itself?[63] My point here is to suggest that we look to Williams's philosophies of her own artistry—that is to say, not just her discussions of what she saw herself as doing with and by way of her musicianship but also her ideas about the labor of her musicianship altogether—as extending through and beyond historical purpose and into the sphere of a kind of performance theory. If we take "theory" to be plainly, and at its most basic level, a "system of ideas," as the *Oxford English Dictionary* would have it, "intended to explain something," a "set of principles on which the practice of an activity is based," then Williams's theory, her aesthetic principles, and her ethical approach to her own performances reveal themselves to be intriguingly present in her reflections on her career and in aspects of the music that she made.[64] This we might do in order to continue to acknowledge her myriad talents as a critical as well as a performative force in jazz. This we might do in a bid to call attention to the Black woman musician as theorist of her own forms, as critic of her own aesthetic pursuits and innovations.

By "theorist," I mean here to underscore Williams's deft capacity to offer statements that reflect her principles and practices as a musician and composer. This is not to say that she published lengthy discursive tracts steeped

in (Western) philosophy as one often perceives of the standard-bearing theorist figures who have held sway at the center of the academy. And this is not to say that even her most basic ideas and arguments about jazz rose to the level of common parlance in critical circles about the music, a conventional sign of a theorist's currency and reach of influence in the social and culture imaginary of academe. Williams, we do know, was deeply beloved and revered by her peers and the players then and now who looked to her as a paragon of excellence and artistic endurance.[65] But "theory" is not a word that one associates with her. Consider this, though: Williams was a consummate storyteller about her long career, her many pursuits, the challenges and exciting turns that she embraced with passion at various moments in her life. These tales are the grist for her artistic practices, and they offer vernacular commentary on the meaning of life in motion. To call her a theorist, then, is to be reminded of Barbara Christian's revolutionary claim at the height of the 1980s academic canon wars that "people of color have always theorized—but in forms quite different from the Western form of abstract logic." She continues, "And I am inclined to say that our theorizing (and I intentionally use the verb rather than the noun) is often in narrative forms, in the stories we create, in riddles and proverbs, in the play with language, because dynamic rather than fixed ideas seemed more to our liking. How else have we managed to survive with such spiritedness the assault on our bodies, social institutions, countries, our very humanity?"[66] The "dynamism" of ideas is alive and well in the music, as well as the literary narratives that Christian cites here, made by women like Williams who remained determined to do more than survive, to create and compose a life of beauty and verve, risk and ever-insistent transformation. As will become clear shortly, the Mary Lou Williams of the jazz interview form and the one behind the piano is our theorist—not a "New Philosopher," as Christian refers to the old guard, a member of ye olde "literary elite," a "neutral humanist," but instead a woman who reveals herself at every turn as someone who was driven by the belief that Black music, like Audre Lorde's landmark poetry, "is not a luxury," "not only dream and vision," as Lorde puts it in the classic essay with which Christian closes her own work, but "the skeleton architecture of our lives . . . the foundations for a future of change, a bridge across our fears of what has never been before."[67]

So turn back the clock past her veteran days serving as mentor to many. Long before she became the grand dame whose uptown apartment served as the gathering ground for the likes of Duke and Dizz and Monk and numerous others, she was an eighteen-year-old member of Andy Kirk's swing ensemble, newly

married to fellow musician and bandmate John Williams and accustomed, from her years on the Theatre Owners Booking Association (Chitlin') Circuit, to the Bluespeople itinerary of a band on the run. With all that hustle under her belt, plus a dose of youthful, north-of-the-Mason-Dixon-line naïveté, she stared the perils of Depression-era, apartheid America back in the face with a startling insouciance that inevitably put her in danger on multiple occasions. As biographer Tammy Kernodle describes it, Williams, during her heady early years of touring, was prone "to forget[ting] how blacks were expected to act in the segregated South"—some of which had to have come as the result of her unusual experiences growing up as a musical prodigy first in Atlanta and then in Pittsburgh. Gigging with musicians in the fifth and sixth grades ("They'd come to Pittsburgh . . . come by and pick me up. . . . I went to all these little cities like Springfield, Ohio . . . Indianapolis . . ."), drawing crowds on her family's porch that even made fans of the neighborhood police ("I'd play a concert for them. If I was out late at night by myself, coming from a [show], they'd stop and bring me down in a patrol car to the house"), she developed something of a comfort level with risk and a kind of steely practicality undergirded by assertive artistic determination and everyday ambition—all of which came in handy when, for instance, at parties where she played, she encountered drunken boys emboldened by "their parents hav[ing] gone to Europe."[68]

Her touring life opened her up to both perilous and sui generis circumstances. From falling asleep on a streetcar in Memphis (where she and Kirk's band had set up shop for several months in 1928) and failing to make way for white passengers, to daring to gig in roadhouses where patrons threatened to lynch her, to eluding an overzealous "fan" who'd once plotted to kidnap her, Williams kept "rolling," as the title of one of her most famous tracks would have it. "I had . . . blood in me like a gypsy," she once declared, resorting to familiar ethnic caricature to sum up her transience. "I wanted to [get] out and play."[69] Even still, serious threats always hung in the air. It is well known, for instance, that Williams survived a sexual assault on her way to a recording session in Chicago, and just as known is the fact that the gritty Williams remarkably still, in the immediate wake of this horror, made her way to the studio on the very same day to record two of her first compositions, "Drag 'Em" and "Nightlife."[70]

Against this volatile and wretchedly brutal backdrop, our woman at the piano nonetheless continued to take to the road, and her intrepidness is spectacularly apparent in one of the most thrilling first-person accounts of a Black woman musician behind the wheel that we have for the record: in her epic

Melody Maker interview sessions published in 1954, Williams matter-of-factly carries us with her on the journey from here to there:

> I worked off the outstanding engagements, then set out to join John in Oklahoma City, 700 hard miles away. He had left our Chevrolet for me to make the journey in, and with John's mother and a friend I hit the highway. The Chev wasn't much of a "short" to look at. It looked like a red bath-tub in fact, but ran like one of those streamlined trains on the Pennsylvania railroad, and was the craziest for wear and tear. Unfortunately, we had miles of dirt and turtle-back roads to travel, and these excuses for highways were studded with sharp stones. To top all, it was August and hot as a young girl's doojie. Every 40 or 50 miles we stopped to change tyres or clean out the carburetor. As my passengers were strictly non-drivers and non-fixers, I was in sole command. We got along somehow, and after what seemed like weeks of blow-outs and fuel trouble we fell into Oklahoma City. Considering it was surrounded by every description of oil, well, the place was a beauty spot. But the smell of gas . . . wow![71]

Williams's relationship to the car clearly differs, in drastic ways, from that of the New Frontier warriors who would come long after her. Her narrative shows no interest in the cruise-with-me-baby braggadocio of Jackie Brenston and His Delta Cats' "Rocket 88," one of those early rock records from 1951 in which men find joy in the automotive object as the sign of "progress and compensatory prestige." And it likewise lacks Chuck Berry's "trickste[r] tactics of speed within a life understood as competition," both of which set the foundations for what Paul Gilroy sees as a modern crisis, in which "automobiles [are] serenaded and savoured in accordance with an aesthetic code that value[s] movement over fixity and [that] sometimes prize[s] public style over private comfort and security." Nor is Williams's description of life on the road that of a speed demon's intoxicating pursuit of escalating velocity that motors her toward oblivion.[72]

Instead, as she recounts it, she is eighteen and out on the Jim Crow frontier, accompanied by mother-in-law and friend (neither of whom has any driving or mechanic skills of which to speak), navigating "700 hard miles" through the dog days of summer, along the oh-so-unglamorous "dirt and turtle-back roads . . . studded with sharp stones" in a Chevy part clunker, part souped-up, versatile magic red bathtub bus contraption, weathering the unpredictability and the inefficiency of this modern object owned by the newlyweds. A "fixer," "a driver" in "sole command," Williams takes the nonescapist, pragmatic view of car travel that conveys compelling information about her relationship to questions of

freedom, movement, and adventure that likewise says much about her fundamental approach to music-making. One need only think of the ways that she figures her journeywoman language on her 1955 recording, *A Keyboard History*, in which she declares that "to bring this history to you [she] had to go through muck and mud," to get a sense of the ways that this kind of troping permeates her repertoire.[73] Outback travel laced with debris, thick with obstacles, the constant threat of catastrophe, risk enacted in the service of something greater than oneself, risk on behalf of the ensemble, this was Mary Lou's jam ethos performed on behalf of her sisters in the car with her and eventually and ultimately for the greater Black publics whose existence and worth she sought to articulate and honor by way of her musical life.[74]

Her reflections on the resilience and resourcefulness of her own road travel spirit are, of course, not without their own lexicon of romance. Yes, one detects a bit of the kind of erotics that Cotten Seiler describes in his provocative study *Republic of Drivers* wherein turn-of-the-century narratives of women drivers flirted with automobility's "transgressive," "sexualized" energies. In the early years of car culture, as Seiler points out, savvy, New Woman–era ad campaigns promoted car culture as holding out the promise for women to access a form of technology that was not (yet) a tool of domestic labor. In "using that technology," he observes, "many women derived a type of pleasure different in nature from the fulfillment of a gender imperative." For women of means (white and monied enough to have access to wheels), the car might serve as "an extension of the self—a sort of powerful prosthetic device,'" as well as a source of "both titillation and anxiety" on the part of patriarchy about female mobility. In this context, there were those critics who feared that cars might one day "supplant" men as "the object of female desire," that "cranking without effort" might serve as its own form of fulfilling autoeroticism.[75]

But Williams's tale is less about sex (notwithstanding her mildly ribald heat and hooch metaphors) and more about *craft,* that tremendously undervalued and undertheorized realm of the creative process when it comes to charting the histories and narratives of Black women musicians in particular (and Black women performers more broadly). Inasmuch as Williams's remarkable *Melody Maker* interviews return again and again to her "chops"—how she derived them; how she wielded them in late-night cutting sessions, besting her fellow musicians; how these chops gave her cred in a man's world from a young age forward—her driving anecdote showcases her own determined mastery of the instrument, her insistence on coaxing it again and again out of its sputtering, exhaustive state, her endurance, flexibility, adaptability in relation to the machine. It is a portrait of the woman artist as a high-wire-act problem-solver ever

so rarely rendered in a woman artist's own words, and her fearless engagement with technology, her full-on immersion in idiosyncratic forms—be they mechanical or instrumental—are a testimony to her wonkish genius and her virtuosic innovation. If, as Gilroy insists, Jimi Hendrix could take his instrument and "shif[t] and sculp[t] temporality itself so that his willing listeners were transported from one time to another," what could Mary Lou do with the piano? More to the point still, how did she theorize the cultivation of her own mastery?[76]

We know that, coming off of that journey, as she puts it, "out of [her] mind," Williams goes "without sleep to make the rehearsal the next morning" with what was then-bandleader T. Holder's outfit, the Dark Clouds of Joy (soon to become Andy Kirk's 12 Clouds of Joy). Here she marvels over the band's non-vaudeville-cooning "musicianship," their uncompromising "respectability," as she puts it. Moving with the Clouds to Kansas City in 1929, still the "unofficial member" with the boogie-woogie skills, the "boss piano player" fell into a musical scene that, as Kernodle reminds, "encouraged the utmost inventiveness and adventurousness among the players." And it was there in the Eighteenth and Vine "nightlife" of that city that Williams evolved into "a composer and an arranger."[77]

By 1930 when she recorded two distinct solo performances while in Chicago with the Clouds and, almost unfathomably, in the immediate wake of her attack, she had accrued the kind of turbulent knowledge of a blues traveler, composing two works that evoked the nature of life's lurching unpredictability: "Drag'Em," a slow rolling-through-the-streets minor anthem, and "Nightlife," a convivial ode to the joys of uptown nocturnal revelry "that highlighted her ability to improvise in the Harlem stride style."[78] Both tracks clock in at just under three minutes and both frame the question of movement around the assured work of Williams, who leads us, in the case of "Drag'Em," from the sound of measured, minor-tone playfulness to flirty, gradually ascending yet oh-so-tentative merriment. Williams called "Drag'Em" essentially a blues, but as she works the trills in the first thirty seconds of her performance, we are made privy to the ways that her itinerancy across the keys is its own form of commentary about the pleasures as well as the pressures of migratory experience. It is a track that dances listeners through fits and starts, through quick shifts in mood, through a Langston Hughesian "Weary Blues" spiral that weaves back and forth between sorrow and catharsis. If nothing else, it is an Ellisonian tale of looming catastrophe transformed by Williams's ability to swing us in the last thirty seconds of the track to the end of the line. In contrast, the hurly-burly of "Nightlife" finds Williams capturing a universe of moods associated with sociality in the dark—

rollicking encounters, bustling passages, quickened pursuits of delight—all of which escalate in anticipation as she frenetically climbs the scale in the first third of the track. At one minute and thirty seconds in, she introduces an arpeggio that opens the song onto another affective plateau, shifting us into another key of the life of the night, as if breaking through to another layer of subcultural energy.

Both tracks offer us a portrait of the Black woman artist as driver playing through the changes yet bucking the "apparatus" of automobility that Seiler rightly and trenchantly critiques. If the conventional driver is perpetually subject to neoliberal disciplining and the constrictions of governmentality, if in the early twentieth century "automobility emerged as a 'technology of self,' organizing a compelling mode of self-government anchored in liberal notions of freedom," if we construe the literal act of driving as hyperindividualistic, hypermasculine, as bound up with "sensations of agency, self-determination, entitlement, privacy, sovereignty, transgression, and speed," Williams's mobile compositions tell us something about the way that the automotive as an aesthetic, as a feeling, as a rhythm has a different kind of currency in relation to her jazz ethics, the codes by which, in part, a player recognizes the self as mutually constituted in relation to the ensemble. One might go so far as to suggest that, to rephrase an Edwards formulation, she was negotiating an "aesthetics of driving" that sounds out her style.[79]

Having already managed her way across dirt roads, confronting and repairing the hazards of the machinery at her disposal, she cultivated a framework for attacking obstacles that translated into her artistic approach to music-making. Mary Lou Williams took the energy and charged complexity of mobile life and turned it into the backbone of her early repertoire. In this way, we might think of her as having played her way through a rumination on the idea and ethics of her musicianship and the praxis of her own art on these two aforementioned compositions and tracks. Think of these songs, then, as Williams's own performative theories of her sound. From this standpoint, her use of auto themes and aesthetics held little in common with what would later become rock and roll coarchitect Chuck Berry and company's "'strong faith in mobility as a guarantee of dignity, democracy, pastoralism . . . equal opportunity,' and . . . African Americans' claim to citizenship."[80] Rather, we might think of her blues, her stride, her boogie-woogie, her swing, her eventual bebop, her figurative driving odysseys in sound as rejecting the "procedural participation" of 1930s standard road driving and the still-to-come Eisenhower interstates. Instead, Williams's roaming repertoire is the vehicle that carried jazz publics to new temporalities

and new, increasingly demanding sites of experimental possibility across the long arc of her career. Perpetually in motion, she was leaving dust tracks for her fellow—if ever so different—sister travelers just down the road behind her.

Keeping Score: Abbey Lincoln's Mood Criticism

The image of the female African-American in music is one of the responsible citizen. . . . [She is] the sophisticated woman who couldn't and cannot look away from injustice and degradation. To racist America, she has been a secretary, a record keeper, a positive catalyst. The school of hard knocks teaches her political and social awareness. Generously and artistically, she passes on the information as she sees it.

—ABBEY LINCOLN, "The Negro Woman in American Literature"

No two times singing is alike, so that we must consider the rendition of a song not as a final thing, but as a mood. It won't be the same thing next Sunday.

—ZORA NEALE HURSTON, "Spirituals and Neo-spirituals"

Ever the studious "secretary" of sound, ever the meticulous "record keeper," Abbey Lincoln slips gracefully and purposefully into the shoes of the Mary Lou Williams-style phonographer at an historic 1965 event well known to jazz heads yet less so perhaps to the vast majority of pop music critics and Black feminist scholars. There and then, Lincoln would take a seat on a panel at the New School in New York City entitled "The Negro Woman in American Literature" with novelist Paule Marshall, then-poet Sarah Wright, and playwright Alice Childress just one month after the release of the infamous congressional report on the "Negro family" (better known as the Moynihan Report) that targeted Black mothers as the central villains in the ostensible demise of that institution. In overt opposition to that document, her vivid, lyrical, and citational comments during the session would reanimate and make politically palpable the archival and performative legacies of Black women creatives through the concept of mood.

How is it that Lincoln ended up here? Born Anna Marie Woolridge in Chicago in 1930, Abbey Lincoln had initially traveled the road of the gorgeous pin-up girl, the screen siren, and the supper club chanteuse before evolving into a daring and visionary, avant-garde jazz vocalist and sociopolitical activist, as Griffin, Eric Porter, and other scholars have pointed out. Her commitment to

Abbey Lincoln, Black Power jazz icon, at the Harlem Cultural Festival, "Black Woodstock," Mount Morris Park, New York, June 29, 1969

Black communal politics and especially to promoting reparative relations between Black men and women in her music and in her activism was well known by the mid-1960s, but to be included in the company of a poet, a playwright, and a novelist may have read as a conundrum to some. "There are women among us who," Wright declares in her introductory remarks, "in spite of being in the condition of Afro-American enslavement, are both readers and writers. Some of these women you will meet today."[81]

Abbey Lincoln: both a reader and a writer. Curious titles, perhaps, for a woman whose writing, at least at this point, was emerging in bright yet limited sparks of lyrical wonder—see, for instance, her wise and whimsical version of Thelonious Monk's "Blue Monk," in which she draws out the

song's hermeneutic structure, its internal blues criticism of the blues, into the realm of thick and steady, measured and yet playful vocal wisdom. Thelonious Monk first recorded "Blue Monk" in 1954 and gave his blessing to Abbey Lincoln to write lyrics for the song in 1961, which she recorded for her album *Straight Ahead*. Porter observes that "the singer's voice provides a polyphonic statement of the melody" and that Lincoln's lyrics "pay homage" to an important jazz antecedent. Still more, Lincoln's version draws out an Ellisonian reading of the blues as "an autobiographical chronicle of personal catastrophe expressed lyrically" in Monk's standard by slowing down the tempo of the song and by delivering the lyrical equivalent of a blues *about* the blues as defined by Ellison. "Shallow or deep, nothing is cheap, measured by the dues that you pay," sings Lincoln. "It takes some doing, Monkery's a blue highway, measured by the dues you pay." Here she gives a name to the performance repertoire that masterfully navigates the catastrophic. "Monkery," that musician's virtuosic stockpile of jazz weaponry, is both the product of the blues and the equipment to manage it. It is, as Nat Hentoff points out in his liner notes for the album, "the act of self-searching, like a monk does." Lincoln's reanimation of "Blue Monk" lyrically bespeaks that which exists in the song itself, and in the wordless penultimate verse, a series of vocal utterances to match the melody, she adds the singer's instrumentality to the "monkery, the blues that you hear, keep on from year to year."[82]

Poetry and songwriting were lifelong sites of recourse for this regal musician, as evidenced by the dozens of notebooks, autobiographical tracts, journals, and writing files that she kept, which capture her expansive and meditative work on a variety of subjects ranging from African history and astrology to sorcery, voodoo, the origins of slavery, and the story of jazz. In ninety-nine-cent Woolworth's spiral notebooks, Lincoln stored reams of unpublished lyrics and verse that sometimes shared pages with freewriting about her state of mind, the quality of her spirit on a given day. In her archive as well, she kept copies of drafts of lectures, many of which seem to have been written after her New School speech and well into her veteran years as the first lady of avant-garde jazz. Such works, invited talks she had prepared for speaking engagements at university conferences and other events, show signs of recurring themes that held her imagination and drove her interests and sociopolitical passions concerning the state of Black masculinity ("The Man the African Man the European Man") and Black feminist critique. The latter topic surfaces in Lincoln's writings as early as 1962 in an early draft of her manifesto, "To Whom Will She Cry Rape?," which, in turn, became the 1965 lecture "Who Will Revere the Black Woman?," a talk so powerful that, as La Donna L. Forsgren points out, it made a lasting impression on young Black Arts poet Sonia Sanchez. This particular

Lincoln lecture electrified Black feminist circles, appearing in revised form in a 1966 issue of *Negro Digest* and gaining added visibility upon its reprinting in the 1970 groundbreaking Toni Cade Bambara anthology, *The Black Woman*. The forcefulness of Lincoln's intersectional vision in this classic work, in which she maps out the concatenate forms of transracial patriarchal power that result in Black women's "physical and emotional abuses," is a consistent characteristic in her public-facing writings. Lincoln the agitator is, in other words, a fully formed figure here, musing as to whether her fellow women should perhaps "get evil enough and angry enough" so that their men will "be moved to some action to bring [them] to their senses."[83]

That kind of rigorous voicing clearly carries through in her essays and lectures on Black culture and music in particular as well. Privately she documented her own autobiographical experiences in which she came to embrace the precious value of Black sound. "The best way I have found to remember," Lincoln ventures in her undated notes, "is through the arts[.] When I sat at [the] piano as a child I began to take refuge from my family life and found my own space." She circled back on several occasions as well to the trope of "unknown composers," jotting notes here and there before producing a burst of theories on the subject in her wide, roving Dillard University lecture from May 1999 entitled "There Are No Temples Here," a talk that examines and exalts "the African American musician" who "with a masterful understanding of the structures of chords and scales . . . constructs . . . a portrait of the human soul." A partial memoir of the artist's coming into Pan-Africanist consciousness and embracing her trademark Black Pride world ethos, "There Are No Temples Here" is also an ambitious tracing of the evolution of Black music in America as a form that "signals and documents the times and the social development of the nation. "It began," argues Lincoln, "with the contributions of the unknown singer/composer, whose experience and philosophy, as a victim of slavery, is documented through songs that will live a thousand years." Like that of her contemporary Phyl Garland, Lincoln's prose shows the influence of Jones/Baraka's reclamation of Black sound born out of captivity in *Blues People*. But similar to Garland as well, her insistence on squarely positioning herself as a Black woman listener, critic, and historian is hardwired into her opinions and perspectives of race and music and sits at the forefront of her work.[84]

This is the voice of Lincoln that comes across loud and clear in 1965 at the New School as well. By that year, her reputation in the world of jazz as a fearless interpreter of standards and as "a woman of her own mind, capable of defending herself and her artistic and political choices" was well known. At that point, she had already published her viewpoints, as Farah Griffin points

out, famously turning to the pages of *Down Beat* magazine in 1962 to do battle with jazz critic Ira Gitler over the political and experimental dimensions of her radical repertoire that she and her then-husband and artistic partner Max Roach had been developing. For her part, moderator and copanelist Sarah Wright would, on that day at the New School in 1965, aim to redirect the audience to this aspect of Lincoln's career, describing her as a "lyricist, singer-extraordinary" whose performances offer "a musical orientation about what is to be done in the freedom struggle."[85]

The New School event was pivotal for Lincoln, who had a series of musically sophisticated and politically minded jazz releases and print publications in the first half of that decade under her belt at that point. Perhaps more than any other program that she would take part in during that era of her career, the panel gave Lincoln a platform to "read" and "write" out loud Black women's musical histories and to instill the sound knowledge of a musician invested in (re)covering the complexities of Black sonic womanhood as civic activism. Whereas her formidable copanelists would largely use their time to pose pointed critiques of grossly problematic theatrical and cinematic representations of African American women (as does Childress) and the "use of the Negro woman" in literature "as an embodiment" of the country's "myths," its "fantasies," and its "repressed conscience" (as does Marshall), Lincoln's manifesto is, at its core, like "Monkery's the Blues," a hermeneutic one in which she offers a series of explications of Black musical women's critical interpretations of their quotidian world: reflections on fraught romance, self-worth, and socioeconomic autonomy (in Billie Holiday's "Don't Explain," "Billie's Blues," and "God Bless the Child") and observations about racial terrorism (in Holiday's "Strange Fruit") and class warfare (in Bessie Smith's "Poor Man's Blues").[86]

Lincoln is interested in capturing and (re)storing exquisite moments of high "Negro drama" that have been lost to history or—perhaps even worse—have not been properly heard, and her appearance at the New School appealingly turned into a moment for her to set a new mood, so to speak, in which to make audible the social and aesthetic resonances of music made by African American women. Mood is a multifaceted concept that Zora Neale Hurston would float on key occasions in her critical writing. It is, for her, the blues song genre itself (akin to "the class of moods set to strings which the ancient called lyric"), as well as the temperament of the vocalist that manifests itself formalistically in her varying readings of lyrics "repeated three times" and "walk[ing] with rhythm." Mood, for Hurston, is also a performance technique, an interpretative modality; it is a question of versioning, repetition with a signal difference, the insistence that the song will, in fact, not remain the same ("It won't be the same next Sunday").[87]

Lincoln's panel remarks emphatically underscore the crucial value and necessity of Black women vocalists as mood setters—both in the Hurstonian sense of the word and in the Heideggerian sense of the term as Jonathan Flatley has beautifully discussed in his cogent study of politically affective cultural modernisms. He reminds that, for Heidegger, "mood" (*Stimmung*) is the necessary context for affects to form in relation to objects. Moods are contextual; they yield perspective. For Flatley, they are also the conduits through which historical context manifests itself "in our affective attachments." The effects of this context surface in such attachments, and mood gives us a way to articulate this condition. As he puts it, "It is on the level of mood that historical forces most directly intervene in our affective lives and through mood that these forces may become apparent to us. Likewise, it is through the changing of mood that we are most able to exert agency on our own singular and collective affective lives; and it is by way of mood that we can find or create the opportunity for collective political projects." Mood is both the conduit through which historical forces shape our lives and the instrument that enables us to recognize and reckon with historical forces. But more still, Flatley suggests to us how mood can be changed, how mood offers us a way to "exert agency on our own singular and collective affective lives," and it is the means by which "we can find or create the opportunity for collective political projects."[88]

Lincoln's mood is that of the critic and sociopolitical activist who is also a ferociously intelligent musician, someone who will, on this day, call attention to her ability to set and change moods by way of song like her illustrious predecessors. Still more, she uses song to strike a new mood for her audience, one that resets the record of Black women's social and cultural worth in American culture. The "African-American woman," Lincoln declares, "is the most significant creative and widely imitated singer-artist . . . in the world today." Her words here encourage the audience to retune themselves so as to recognize the extant archive of Black women's cultural moves that unsettle the Moynihan script, and they remind us that "to be in a mood," observes Flatley, "is to 'be attuned,' an attunement that is foundation or starting place for everything else, the 'presupposition' for our 'thinking, doing, and acting,' the medium in which these things happen."[89] As the mood setter, Abbey Lincoln, a fierce and formidable, risk-taking artist, spins here a sonic-discursive and oratorical repertoire for her audience in the twinned role of musician and cultural critic. We might consider what it is that she is able to especially illuminate for us in the dual position of the vocalist and the critic whose own recordings and performances dialectically engage with her remarks. Lincoln invites her audience to "read and write" with her at the level of a vocalist-critic's "sensation and perception," and

she models yet another example of the intersecting "graphematic" and "phonic" technologies of Black women's musicality.[90] She does it all on a "Sunday."

As the finale for her presentation, Lincoln delivers the lyrics to Duke Ellington's "Come Sunday" from his 1943 epic "tone parallel" *Black, Brown and Beige.*

> Lordy Lord of love, God Almighty, God above
> Please look down and see my people through.
> I believe the sun and moon that shine up in the sky.
> When the day is grey I know it's clouds passing by.
> Up from dawn till sunset, men work hard all day,
> Come Sunday, oh come Sunday, that's the day.

We are invited to hear through her the "revered and beloved Mahalia Jackson['s]" 1958 "rendition of the great Duke Ellington composition" and to listen carefully to the mood that Lincoln strikes as she brings her presentation to a close.[91] In her treatise on the work of the Black woman vocalist, Lincoln's revisionist representation of Black womanhood takes aim at Moynihan's *Negro Family: The Case for National Action* without ever specifically naming it. What stands in the face of mythically negligent mothers and castrating wives are, in Lincoln's comments, the sounds of a Black woman voicing "love for her man," "the importance of economic independence," and the documentation of racial violence, poverty, and political corruption wreaking havoc on African Americans. She uses her time on the panel to demonstrate the myriad ways that "black music offered insight into the specifics of the marginal position of African American women in society and could be a site for black women's activism." By ending with Ellington's orchestral prayer, she reaches for the pinnacle of spiritual elevation in the figure of Mahalia, a resplendent "monument to black feminine virtue and morality" who, come "Sunday," negotiates the fate of her people through song. Lincoln, in the final moments of her address, picks up Mahalia's mood and reminds us of her own.[92]

To get to this moment, though, Lincoln has taken her audience on a journey rarely voiced circa 1965 and one that runs from Billie's multiple shades of blue back to Bessie's anthems of "desperation" and determination culled in the jook and out on the dance floor at rollicking Harlem rent parties. Her observations *about* Black women's observations in song take us all the way into the pulpit with Halie Jackson in order to demonstrate how, as she insists, this music is a kind of "equipment for living" that speaks to "the joy and pain of being black in racist America." This would be a stunning statement on its own if Abbey Lincoln had merely insisted on recalling Bessie's trenchant sociopolitical critiques

in "Black Mountain Blues" and "Poor Man's Blues" in the midst of the 1960s retro "roots music" revival when nary a Black woman cultural critic held sway as male musicians, journalists, and producers on both sides of the pond looked to veteran artists and old-school reissues as the source of inspiration for a new rock and roll era.

But Lincoln's work as a vocalist herself, one who by this stage of her career was placing the "collective sensibility" of African Americans at the forefront of her intersecting sociopolitical and artistic concerns, shapes her engagement with this material and models a kind of critical "record keeping" that Black women artists have had to do on their own and outside the shadow of institutionalization from one generation to the next. It is fitting, then, that she would end her time at the mic that day with a brief recitation of "Come Sunday" since it is a song that archives her own past performances as well as Mahalia's. As Porter observes, by "discussing songs she herself had recorded, Lincoln made sense of her own musical past and described the role that she could play in the political moment." Still more, we might think of her reading as a form of "mood criticism" that reminds us of Zora's insistence that "we consider the rendition of a song not as a final thing, but as a mood." Lincoln references Mahalia's luminous performance and challenges her audience to hear it in relation to her own rendition in order to make a larger statement about the kind of information stored up and disseminated in Black women's sounds. Catch the mood of Lincoln's "Sunday" in concert with Mahalia's and a panoramic tale of Black women's musical structures of feeling in the world becomes more audible to all who are open to hearing it.[93]

Lincoln's own version of "Come Sunday" appears on her 1959 album *Abbey Is Blue,* the last of her trilogy of Riverside recordings that signaled her transition from the supper club stage into the realm of jazz innovation. This cosmically iridescent recording stands out for several reasons beyond the beautifully measured power of Lincoln's vocals. It is the location of her voice, which sits far to the back of the track, and her self-consciously mindful tempo—gently hugging the silences here, pushing the melody along there—that set a subtly different mood from that of Mahalia's. We hear her quietly projecting into the microphone as though she were at a distance, as though she were lingering around the edges of the track, as though she were offering a stirring sermon in and from the margins of culture. This is her reverential dance with the Queen of Gospel.

Jackson superfan Ralph Ellison cared, however, little for Mahalia's "Sunday," calling it "a most unfortunate marriage [with Ellington] and an error of taste" that "made it impossible for Mahalia to release that vast fund with which the

Southern Negroes have charged the scenes and symbols of the Gospels." This is in no way her signature "art which swings," over which the writer marvels in his classic 1958 essay "As the Spirit Moves Mahalia."[94] This is not the "polyrhythmi[c]" and polytonal" matriarch of gospel whose eclectic musical arsenal "prepare[s] the congregation for the minister's message . . . mak[ing] it receptive of the spirit, and with effects of voice of rhythm . . . evok[ing] a shared community of experience." If, as Ellison observes, this "Sunday" fails to meet Ellington's aim to create the "moving *impression* of Sunday peace and religious quiet," it does close out with Mahalia humming, "accent[ing] the lyric line to reinforce the emotional impact" of this musical reading of Psalm 23. It is a gesture that brings the listener closer and draws her audience toward the core spiritual intimacy of the Duke's composition. Inviting the congregation to gather round, Mahalia delivers a supplication for her people and wordlessly moves them closer to the spirit.[95]

But catch the mood of Abbey's "Sunday" and contrast it with that of Mahalia's, and one hears a meditation on scale and perspective regarding the positioning of the Black woman musician in relation to her community. Lincoln's vocals are set against the haunting acoustics of what sounds like a spare room, accompanied by nothing more than a gentle four-piece band that steps lightly with and around her in the track. Lincoln the soloist and decidedly not the congregation leader stakes out a space of her own in the universe on her "Sunday" as she revels in the beauty of holy creation, "the sun and moon" that "shine up in the sky." Acoustically Lincoln's voice is both everywhere in the room and yet far away from us as she advises her listeners to "go to Him in secret / He will hear your every prayer." Distant and yet present, watchful and observant, absorbing a miraculous existential tapestry in her midst, the Abbey Lincoln of "Sunday" models in song the very cultural criticism that she performs at the New School.

Her performance itself reminds us of the ways that the Black musician, so often figured in literature as the man on the outside, the loner, the rebel, might assume the shape of a woman who, rather than being open, accessible, and readily available to harmonize for the masses, remains at arm's length and uses her position and perspective to hold up a critical eye to the world so as to administer wisdom.[96] Her Hurstonian mood shift at the level of interpretation yields the kind of Heideggerian mood shift of which Flatley speaks as well, that which creates a new "object of affective attachment" (shifting scale, spare acoustics) within her reading of Mahalia's song. It is a performance that is meant to evoke a "counter-mood" for her audience, "another world" in which to engage Black womanhood in 1965, a way for her progressive, pro-Black, and prowoman audience "to catch sight" and sound of themselves "in the *Stimmung* [they] are

in," to experience "the evocation of another *Stimmung*, one in which *Stimmung* and those with whom [they] share it have become themselves objects of interest and attachment."[97] Lincoln's "Sunday" knowledge sits in the grooves of the Mahalia recording, which she embraces and reveres as the culmination of her concise and rousing lecture, and it remains a blueprint for reading and writing Black women's critical new sound in, of, and for the modern era. Far ahead in the twenty-first century, another musician-turned-actor gathers up the legacies of the sisters before her. She is running toward the dawn in an epic of her own collaborative making with fellow travelers picked up along the way in her adopted home of Atlanta, and she is busy at work using myth as a form of critical commentary and artful cultural critique. As we shall see, her sprawling, ambitious, multimedia work demands much from us.

The Siren of Black Insurgencies

Halfway through her exuberant 2013 album *The Electric Lady*, it would seem that we, the listeners, are tied to the mast while Black space and future times heroine Janelle Monáe sings the Song of the Siren. "Look into my eyes," sings our far-out thespian in high histrionic mode, "Let them hypnotize / These eyes long to make you a perfect work of art." All awash in shimmering guitars and swelling strings, "Look into My Eyes" conjures up Italian cinematic mise-en-scène, ballroom kitsch, and shades of 007 intrigue as Monáe appears to assume the role of the classic femme fatale, beckoning a lover to succumb to her arresting and transformative powers: "Fall in love with me / Only then you'll see / What these eyes have been planning for you."[98]

Woman as sensuous seductress unleashes her sonic powers onto her betrothed in order to seemingly control and sexually dominate. It's a scene that Monáe's deliciously oblique, culturally heterogeneous liner notes for her album offer up as the stuff of myth by citing book 12 of *The Odyssey* and announcing that the song is "inspired by the temptation of the sirens." An odd move, for sure, for this critical and academic darling who's been hard at work with her ensemble of Wondaland arts collective collaborators, spinning a sprawling, multi-edition, Afropunk sci-fi opera that boldly traffics in Black freedom struggle politics. Because to figure herself as "the primitive natural forces" in Homer's epic, to assume the role of the destructive elements that everybody's hero Odysseus must withstand, would seemingly cast Monàe as the cliched villainess; it would put her at odds with the Black feminist theoretical underpinnings of her much-celebrated repertoire.

Beloved in countercultural circles in the years even before her mainstream breakthrough in recent years (which includes box office triumphs and a Grammy-nominated album), Monáe (dubbed in a raucous interlude on *The Electric Lady* as "our favorite fugitive") has, for some time now, been the stuff of "academic" (read: performance studies, Black studies, and feminist studies) dreams.[99] A dazzling and whimsical icon of Afrofuturist posthuman alterities, her stage persona is Black cultural studies manna from heaven, and she remains a musician–entertainer–performance artist who gives the gift that keeps on giving to a scholarly world that delights in unscrambling the alluring theoretical codes of her early career, core mythology narrative, a tale which features alt-ego Cindi Mayweather, an android on the run from the state who has brazenly broken the law regarding the limits of android intimacy and feeling. Think Ziggy Stardust crossed with Octavia Butler. Think Black abolitionists Henry Box Brown and the cross-dressing Ellen Craft all mixed-up ever so gloriously with Grace Jones and Labelle. Monáe's highly literary, cinematic, and sonic fugitive flight plan is inspired yet carefully conceived Afro "outsider art" for the twenty-first century. From her earliest EP in 2007, her fanciful outlaw mythology has drawn on dense cultural references and a voluminous number of citations (paying tribute to icons as well as deep-cut artistic visionaries). All of this referentiality is put into service by Monáe in her long-playing "emotion picture," as she refers to her repertoire. They are the tools of escape, the means by which her alt-heroine might get herself—and presumably all of us—free.[100] When she burst onto the scene in the early '00s, her epic adventure both consolidated and heroically reimagined more than fifty years of Black sonic memory and cultural innovations.[101]

To critics such as Francesca Royster, she is the androgynous artist who lives at the crossroads of glam rock, punk, funk, and soul genealogies, a poster child for dissident, post-Soul identity formations and Black eccentricities that disturb ossified racial authenticity politics: that Little Richard pompadour, that Godfatherly cape, those Wonder-inspired, empathic urban anthems, those Bad Brains body-slamming jams, that Jackson 5 baby Michael's angst-ridden crooning in the upper registers, the dazzling Sun Raian / George Clintonian spectacular futurity of her early live acts, recordings, and growing archive of cultural marginalia (visual art akin to graphic novels, thematically consonant film roles, and a historic 2018 coming-out multimedia extravaganza).[102] To cultural critic Shana Redmond, she is an artist who sustains "black diasporic arts traditions in which 'the cultural realm is always in play and already politically significant terrain.'" She "evidences an intelligent design," Redmond argues, "rooted in black feminist constructions that wed body to mind and experience to history."[103]

Janelle Monáe, August 2013

All of which makes the "siren song" reference all the more curious and intriguing. Frankfurt School heavyweights Adorno and Horkheimer would, of course, notoriously use the myth as, among other things, a way to contemplate "woman" as "representative of nature . . . in bourgeois society . . . an enigma of irresistibility and powerlessness." In turn, woman "reflects back," they argue, "the vain lie of power, which substitutes the mastery over nature for reconciliation with it." As Rita Felski and other feminist scholars have observed, the "repressed feminine of aesthetic and libidinal forces returns" in Adorno and Horkheimer, "in the form of the engulfing, regressive lures of modern mass culture and consumer society, which trades inauthentic pleasures and pseudo-

happiness for acquiescence to the status quo. . . . 'Masculine' rationalization" in the form of Odysseus's ability to withstand the song of the Siren "and 'feminine' pleasure are simply two sides of a single coin," in the *Dialectic of Enlightenment*. Together, Felski argues, "masculine rationalization" and "the feminine" produce a "seamless logic of domination that constitutes modern subjectivity through processes of subjugation."[104]

With seemingly no room in Adorno and Horkheimer's thesis for "the hermeneutic agency of social subjects and the polysemic richness of cultural texts," however, we should assume that the art-as-revolution aesthetic of Monáe is most likely ringing a different kind of alarm here.[105] For what may seem initially like clichéd feminine sexual danger in this performance turns swiftly into a hailing of a different order altogether. "You lift my heart when I fly," sings our valiant outsider, "Good morning, good night / It's a brave new world dawning, a lover's fantasy." As Suite IV of Monáe's grand epic comes to a gentle yet ominous close, the figure of the Siren transforms from Western myth into Black undercommons messianic heroine, the one who will lead not just her lover but presumably multiple disaffected publics (who are addressed across her range of recordings) out of the quagmire of dystopia by way of song and dance. Lushly she bids us to "fall in love with [her] / Cross the golden sand / There's a road winding up into sun rays."[106]

To "fall" for Monáe here is to fall for Black heterogeneous culture *as* Afroalienated revolution. And in this regard, perhaps the Siren trope is ultimately not so misplaced after all. For as feminist music theorist Barbara Engh has argued, what the femme fatale reading of the Odysseus myth "has forgotten entirely is the historical power of the Sirens," which Adorno and Horkheimer acknowledge as such when they contend that "the Sirens' song has not yet been rendered powerless by reduction to the condition of art" but rather contains the potential for "cognition" and "social practice."[107] Monáe sounds the Siren of social practice that is set to the beat of Moten, Mackey, Sylvia Wynter, and so many others—certainly Donna Haraway since Monáe offers a kind of Black feminist versioning of that scholar's classic cyborg manifesto, which celebrates "partiality, irony, intimacy and perversity."[108] Yes, we are living in a much-talked-about pop moment, one in which gendered artifice and spectacle rule and one in which an array of artists are working self-consciously conceived gender performances as a means to conveying everything from earnest and ardent political gesture to cynically-minded brand-burnishing (think everything from vintage Gaga and Katie, to Nicki, Cardi, and Megan, to the ever-changing Tay-Tay Swift circa 2019).[109] But Monáe's invention of her persona stands apart from that of her peers' because of its early stake in making use of inspired and

resourceful archival practices—that which draws on a deep and multifaceted trove of Black pop cultural artifacts and memories—and combining said practices with an intricate commitment to the poetics of writing sound. The countermythology that she and her coconspirators are weaving together is both a work of cultural criticism about the history and politics of her own music-making and a story of the archival immensity that informs her sound and style. As it rolls on with the velocity of a Mary Lou Williams after-hours composition, Monáe's very "moving picture" show provocatively calls attention to its own incompletion. It thrives on its own mysterious narrative opacity, and invites fans to follow and solve the cultural codes nestled like Easter eggs in her repertoire, to trace this queer sister rebel's inspirations, tastes, influences and desires made manifest in Monáe and her collaborators' acts of collecting and repurposing images, sound and material objects, cinematic moments and texts, disparate cultural iconographies, and ephemeral cultural incidents. This material, this ephemera that lives in the music and accompanying aesthetic texts of Janelle Monáe together make audible the critical sensations, complex perceptions, and intellectual labor of an artist who has embraced the role of the Black woman sonic culture worker.

As a masterful phonographer, the kind of artist who performs at the intersections of the sonic and the discursive, Monáe catalogs and critiques the material experience of Black folks' history by way of sound and her experimental liner notes. Her work reminds us of the critical force of Black women artists who often had little more than sound performances to rely on as sites of counter-(in)formation and self-making. Monáe is, then, a way into the way back, so to speak, the portal (she would no doubt insist "the time tunnel") through which we might imagine the future of Black feminist intellectual labor in relation to sound.

Monáe's fanciful, metatextual, intertextual Arch Android lore presents us with our first intergalactic fictionalized Black rock heroine of the twenty-first century, the likes of which we haven't seen since P Funk and glam rock's coinciding heydays when Black and white rock stars alike—Starchild and Major Tom among them—donned platforms and claimed monarchical titles and hefty, comic-book-size backstories for themselves.[110] Kansas City native Janelle Monáe Robinson is the performer who has assumed the persona of Janelle Monáe, human from the future (the year 2719). As the liner notes from her first full-length album describe it, in the vein of Philip K. Dick(ensian) pulp science fiction, she was "bodysnatched," "genoraped," "had her genetic code sold illegally to the highest bidder at a body farm, and . . . was forced into a time tunnel and sent back to our era." Out of the DNA grist of Monáe comes the (rogue) android Cindi Mayweather.[111]

The Monáe-Mayweather galactic adventure takes us to the place of fantastic split personas, a land where Black women musicians rarely ever have the luxury to reside (forced instead to adhere to the demands of representational transparency for conventional publics who insist on reading Blackness through a single lens). More than a mere soap opera twist, however, the duality of our heroine creates the conditions for broader meditations on Black women's relationship to history, futurity, and sound. The Arch Android mythology moves its dyadic heroine across space and time as she records, shares, and transmits arcane objects, ideas, and cultural memories between her past and future selves. Songs are the archive, the place where "historical knowledge and forms of remembrance are accumulated, stored and recovered," and they run the gamut from urban lamentations to battle cries, from dance manifestos to romance anthems, and they ultimately serve as revolutionary code, the weapons to fight the ominously titled "cold war" that human and droid are waging far apart and yet in simultaneity with each other.[112] It's an epic drama critically framed by the aforementioned liner notes, the form that illuminates the extent to which Monáe, the musician, and her close-knit arts collective are radicalizing the genre by showcasing and interpolating into the frame of her narrative the practices of collecting, archiving, and utilizing culture as critique.

Nearly an extinct form in mainstream pop recordings of today, liner notes are all but confined to the world of classic jazz and lavish box set reissues at this point (with some exceptions). But at the peak of their preeminence as a stamp of cultural credibility in the 1950s, 1960s, and early 1970s, these textual appendices to recordings sealed the chasm between "lowbrow" and "highbrow" music product, between pop commodity and "serious" music for aficionados. Having evolved in the early decades of the recording industry from basic discursive media on album inner-sleeve linings (hence the name) and jackets containing brief artist biographies and label ads to ambitious works of cultural criticism produced by music journalists and, on occasion, the artists themselves, liner notes emerged in the "golden age" of jazz criticism in the 1950s and the equally hallowed days of rock criticism in the 1960s and early 1970s as a canonizing form of popular music discourse.[113]

Most often, such notes have taken the form of an essay designed to elevate or reinforce the importance of an album or an artist or both (think of the trenchant work of Leonard Feather, Nat Hentoff, or *Rolling Stone* cofounder Ralph J. Gleason). This is writing aimed at nurturing the tastes of the listener, and in classic cases, the musician might step into this role in order to expand on, complement, complicate, or subvert the accompanying sonic text in question (think Coltrane, Dylan, Zappa). In all such cases, liner notes play along with the

music as the critical or the speculative or experimental extension of a work, as both its narrative excess and explanation.[114] "It is striking," observes Tom Piazza, "how often" a seemingly "minor literary genre" has the potential to contain much more than "glorified promotional copy . . . background on the musicians and the recordings, historical context, musical analysis, a window into the recording process, intimate anecdotes and personal views of the musicians that have . . . immediacy and warmth . . . setting the tempo, in a sense, for the listener's appreciation of the music."[115] Conventional liner notes often walk a fine line between pedagogy and socialization, between sociohistorical and cultural reportage and heuristic conditioning (as in, here's how and why to love the artist in question). The most ambitious notes strive toward the narrative realization or the narrative reimagining of a unified collection of songs. But the list of Black feminist critics who have engaged in the genre is small (novelist and critic Thulani Davis was the first to win a Grammy for her work in 1992 for Aretha's Atlantic Recordings box set), and the list of Black women musicians who have authored their own notes is even smaller.[116]

Into this idiosyncratic literary tradition enters Janelle Monáe, whose liner notes, like her songwriting, compositions, and studio production efforts, are consistently figured as ensemble endeavors between Monáe, creative director and co-songwriter / producer Charles "Chuck Lightning" Joseph, and composers Nate Wonder and Roman GianArthur. Their creative revival of the liner notes genre reimagines the conventions of the form. Not quite spiritual meditation (like that of Coltrane's 1964 *Love Supreme* notes) or stream-of-consciousness experimentalism (like Dylan's *Highway '61 Revisited* labyrinth), Monáe's notes are most akin to, for instance, Sun Ra's free-form poetry on *Space Is the Place,* which underwrites the alterity of his alien persona, and the oblique writings of controversial acoustic blues and folk guitarist John Fahey, a "sleeve writing pioneer in the 1960s" who used "liner notes to invent personas that blurred the boundaries between composer and listener, scholar and neophyte."[117] More still, her notes embody a kind of praxis that is fundamentally fugitive from the form itself. They exemplify the kind of methodology of which performance studies scholar P. A. Skantze speaks, the kind of notes that manifest "the wisdom of the margin, of marronage where secreted away we gather strength for the extended dance version of resistance."[118]

Monáe and crew use the space of the notes to launch the mythology (behold the story of "a loving hero turned into a runaway fugitive") but also to play with this idea of archival and performative exchange between the split heroine self. The album matter for her first two full-length recordings assembles fragments of documents—letters addressed to "the listener" from a narrator figure of

sorts, "Max Stellings, Vice Chancellor" of "the Palace of the Dogs Arts Asylum." Stellings's letters outline the exploits of Monáe/Mayweather and provide contextual suspense and narrative intrigue for each album's collection of musical material. "Is Janelle Monáe crazy?" Stellings asks. "Is she truly from the year 2719? Is she making music with apparitions? Is her direct clone descendent The ArchAndroid [Mayweather]"?[119] This mysterious character, who only appears in the notes, offers two "letters" that describe both albums as "the songs, text and images of Janelle Monáe, Palace of the Dogs Patient #57821." *The Electric Lady* album text pushes even further the suggestion that we recognize the circuitry between Monáe and Mayweather, human and droid. Monáe, now a fugitive herself, having escaped from the arts asylum, leaves behind "recordings" of "secret compositions conveyed to her" by Mayweather. She is thus machine cloned from woman *and* woman preserving and disseminating the machinely workings of her cloned, android self.

In this context, a gorgeous slow burn of a love anthem like "Victory" on *The Electric Lady* is, we are told in the liner annotations to each of the songs on her albums, "inspired by the life and times of Janelle Monáe." Likewise, the *Off the Wall*–era Michael seduction come-on "Can't Live without Your Love" is "inspired by the midnight dreams of Cindi Mayweather." The dizzying self-referentiality and citationality of the notes affirm a kind of alt sonic universe in which Black woman and femme 'borg presumably telepath sound to one another (for Mayweather performs in her own time as well) to protect, preserve, and exchange the exigencies of their respective felt experiences.

The Electric Lady is, then, itself a recording within a recording: Monáe is the phonographic archive, the performing repository of her future, (post)-human self, the media(tor) who toggles between the discursive citationality of the notes and the multidimensional resonances of her embodied performances. This is Black feminist phonography, a kind of performance practice that, pace Alexander Weheliye, "neither abandons the *graph* for the *phono* or vice versa" but "blends sensation" and "perception[,] and listens to the variety and intensity of their intermingling" in the articulation of "blackness."[120] More still, it is a musicking that arches toward the kind of hybrid humanness that comes after Man, as Sylvia Wynter imagines for us. The "emancipatory cognitive leap" of Janelle Monáe's liner notes project is such that it brings to the fore a "biomutationally evolved, hybrid species" of another order who rejects "being purely biological." Monáe's act instead brings to the fore a figure whose dual selves unseat the stability of selves defined as purely biological. Her work reminds us of what Wynter might call the "mythoi" that frames our cognitive perceptions of our entire—and not just biological—being. These

are the stories that we tell ourselves about ourselves that shape our ontological self-definition.[121]

The inspired pop artistry of Monáe's notes, however, moves beyond the standard work of the liner genre. The notes are crucial to a bigger and heavier act of hers, one that focused in her breakthrough days on promoting the mere idea as well as the critical importance of a Black woman artist's multiple metaselves. Her notes present songs as sites of declarative inspiration in and of themselves, and they celebrate the eccentricities of her own intimate cultural marginalia as extensions of her whimsical intellectual imaginary. They are notes that cue us to make associations between her music and a rich array of concepts and imagistic connections. Monáe invites us to use music as Black study and to study alongside her as she references high nerd pop arcana ("Princess Leia's cinnamon buns hairstyle," "Jack White's mustache"), the symbolism of global art house cinematic characters (such as that of Lil Ze in *City of God*), the treasures in the vaults of soul history (like "James Brown's cape"), the resonances of lyrical Black Power metaphors (like "the atomic bombs in Muhammad Ali's fists"). The notes tell us that her songs are inspired by performative gestures of the now ("a stage dive at the Bonnaroo Festival") or fleeting, subterranean moments on film ("the 'She's Crying. It's Backwards' scene in *Purple Rain,* the "Jeep sequence" in *Carmen Jones*). They also whisper to us imagined moments of the what might be ("the idea of Ennio Morricone playing cards with Duke Ellington") and synesthesian encounters with historical memory (such as the song "inspired by . . . hidden colors . . . and the burning big house in *Django Unchained*"). The follow-up to *The Electric Lady,* Monáe's 2018 queer liberation album, *Dirty Computer,* is even more pointed in its use of its notes as an archive of compressed intersectional aesthetics and political desires, dreams, and dissident declarations, tagging each song with dense cultural allusions that span the spectrum from the work of Toni Morrison to the cinematic phenomenon *Black Panther;* from the Bible to the art of Wangechi Mutu; from Gloria Steinem's tearful commentary in the Shirley Chisholm documentary *Unbought and Unbossed* to Barack Obama's oratory and the 1982 Black feminist anthology *But Some of Us Are Brave.*[122]

This is Monáe's kaleidoscopic archive that upends the form. Whereas the "efficacy" of conventional notes "depends on their capacity to accord with [the record's] contents and minimize any distortion that might flow from transferring between modes of 'meaning,'" whereas conventional notes tend to "only defer to what is contained in the record," the opacity and lyrical fragmentation of Janelle Monáe's cultural references demand that we read her notes in yet another way, as what Kevin Young might describe as a kind of Black cultural

"shadow book."[123] Young identifies "three kinds of shadow books" in the Black literary tradition: first, those books "that fail to be written" or completed (think Ellison's sophomore novel); second, those books that are the "shadow of the one that we have" (texts that call attention to their incompleteness—think Harriet Jacobs's *Incidents*); and third, those books that are altogether "lost."[124]

As a shadow book of the second order, Monáe's liner notes cite that which cannot be captured or contained in writing but which must be experienced through sound and other dimensions of sight, such as the cinematic, that which extends beyond the notes on the page. We, the "dear listeners" (hailed by Stellings), are invited to engage with the world via her archival sensory experiences. As *The Electric Lady* slides into track 2, the slinky Prince duet "Given 'Em What They Love," the record announces its burn-this-mother-down ambition. The quiet ferocity and tenacity of this track's lyrics, its menacing rhythm section and sinuous rhythm guitar, the reciprocating androgyny of Monáe and the Purple One's tense, powder-keg vocals are all elements of sound that call attention to the song's "shadow" of inspiration: that of a Tarantino plantation master's big house going up in flames. This phenomenon captured in the notes is what Skantze might call, building on the work of Ashon Crawley, "tones that are not simply moving towards resolution but are on the way to varied directionality—not simply in a linear, forward progression but also vertically down and up, askance and askew."[125] Their lean, "sharper than a switchblade" duet is the "askew" sonic analogue to the album's notes on fiery subterfuge and rebellion.

Vogel might call this a "sensuous" form of archiving, collecting, and assembling images that reference sight, sound, and touch, that juxtapose seemingly disparate figures and objects and fragments of memories that document a culturally vast world of experiences rooted in the senses and dialectically constitutive of Monáe's sonic repertoire. What her work presents us with is a way of reading the archive *as* repertoire, and most importantly, it exemplifies for us how Black feminist phonographies make this possible. We know, of course, oh so well by way of many a poststructuralist, psychoanalytic, or cultural studies theorist the extent to which the archive persists as an instantiation of institutional power on the one hand and marginalized longing on the other. It is the first and last word in history, the site of a kind of institutional violence that shelters, preserves, and presents itself as revealing even as it conceals histories of subjugation. Archives, we know by now, "contai[n] the potential to fragment and destabilize either remembrance as recorded, or history as written, as sufficient means of proving the [final say] in the account of what has come to pass."[126]

Diana Taylor's influential rejoinder here recuperates "the repertoire" of "embodied memory," the "live" that "exceeds the archive's ability to capture," and performance as the means for "transmitting communal memories, histories and values from one group [or] generation to the next. Embodied and performed acts," she insists, "generate, record, transmit knowledge." Taylor is also quick to point out that we needn't think in binaries that would lead us to presume that "the written and archival constitut[e] hegemonic power and the repertoire provid[es] the anti-hegemonic challenge. . . . We need not polarize the relationship between these different kinds of knowledge to acknowledge that they have often proved antagonistic in the struggle for cultural survival or supremacy."[127] But performance theorist Rebecca Schneider helpfully pushes beyond Taylor's work, arguing that "when we approach performance not as that which disappears (as the archive expects) but as both the *act* of remaining and a means of re-appearance and 'reparticipation' . . . we are almost immediately forced to admit that remains do not have to be isolated to the document, to the object, to bone versus flesh."[128]

Monáe's brand of phonography further unsettles these categories. Her synesthesian discursive texts and sonic recordings are mutually constitutive of one another; archive and repertoire run back and forth like a neon circuit. Her repertoire critiques and interrogates itself. Her media(tion) amounts to a kind of phonography that showcases the virtuosic sense perception of a Black feminist artist who transgresses the limits of time, space, and Man. It is a kind of mediation driven by her sono-discursive practices, which remind us of the extent to which Monáe's form of intellectual labor revolves around asserting this: that Black women artists like her have the power to operate as both the phonograph, itself, as well as the long-playing record.

What would it mean to think of Black women artists as akin to that late Victorian instrument, an Edisonian invention that, in its earliest incarnations, both recorded and played back sound? Adorno had his own ideas about the gendered politics of this device, asking of this machine in his infamous 1927 essay "The Curves of the Needle," What good is this thing to woman? Since, as he observes, "the female voice requires the physical appearance of the body that carries it . . . it is just this body that the [phonograph] eliminates, thereby giving every female voice a sound that is needy and incomplete."[129]

Many a feminist theorist has railed against this claim, and there is clearly much to say in opposition to such an observation (the ways that it perpetuates "the gendering of immanence and transcendence" concept which, as Engh points out, perpetuates the myth of "woman confined to the physical body"

while man remains "free" to exist in other spheres). But what if we were to interrupt this equation and take seriously the idea of the Monáe / Mayweather machine as a new millennium phonograph, one that revels in generating the sound of a mischievously "incomplete" voice that calls out to other forms and, moreover, that defies the kind of high-fidelity "abstraction" that Adorno fretted would lead to alienation? If the "gramophone," as he refers to it here, "needs to be complemented by specific sensory qualities of the object it is reproducing and on which it depends in order to remain at all related to that object," our electric dame and droid supply these qualities in the form of her badass notes, as well as her citational vocal body and compositions, her referential visual and sartorial aesthetics.[130]

Monáe uses her (split-self) body as the instrument of reproduction as well as the record itself, conduit of "archaic knowledge preserved for a later time," as our German friend refers to it in a later essay. "Through the curves of the needle on the phonograph record, music approaches decisively its true character as writing," argues Adorno. "Records," he contends, "transform the most recent sound of old feelings into an archaic text of knowledge to come."[131] The curves of her needle write sound and likewise generate sound writing that inscribes new Black feminist knowledges of subjectivity shaped and informed by musicking, that verb, that activity, that form of Black women's music making and doing in all of its dynamic manifestations.[132] In doing so, she shares the turntable with those who came before her. We might think of her as situated in the midst of a long, complex, and heretofore unheralded history of Black women figuring themselves as records and recorders, archivists and archives, sound and source, as phonographers who refuse the narrow sociocultural constructs assigned to Black women vocalists that Griffin has powerfully critiqued. If Black women's sonic work remains consistently vulnerable to being (mis)used as fuel for the engines of modernity (as material, for example, that shores up the nation-state—think Whitney at the Super Bowl; or as material that massively expands industrialized markets—think Mamie Smith and the advent of the blues record explosion), it has also been the site where they have improvised "new mechanisms of self-identity which are shaped by—yet also shape—the institutions of identity," as Anthony Giddens puts it.[133]

As the phonographer, Monáe and a line of Black women artists on the scene in the century before her emergence critically engage the sociocultural conditions of their own (re)production by way of mediating the phono *and* the graph. They record, replay, listen to, and (re)arrange the worlds that they feel compelled to traverse. They figure themselves as the medium, as the cultural main source around which "larger fields of economic and cultural relations . . .

extend, repeat, and mutate. . . ." Like Jean-Michel Basquiat's *Beat Bop* "Ear" which he painted for graffiti artist Rammelzee and MC K-Rob, like that visual revolutionary symbol that Josh Kun likens to an "inscribed black body of revolutionary black grooves," they are "the audiovisual conduit, the articulative node of human connection."[134] They inscribe the body in their graph projects and vice versa. They make Black womanhood audible, sensorily present as archive and as instruments of the repertoire. They interpolate gesture, vision, and affective "listening in detail" into their sonic and written performances as modes of sociopolitical and cultural critique. They figure themselves not simply as capable of reproducing the archival practices of modern technologies but as medium. Each of the artists in this book and her repertoire are the gateway to "a whole assemblage of connections, functions, institutions, and people." They sustain "modalities of interconnection and articulation."[135] They sustain, protect, at times nurture, and at other times critique Black life while supplying the soundtrack that insists on the perpetual necessity for more of it. The history is long, and many of the names have been either forgotten or largely disassociated from the intellectual politics and poetics of the popular music culture to which they contributed. Good thing that they left behind their own unique versions of notes that remain testimony to their meditations on craft and history and—like fast car Mary Lou—their incessant, lifelong artistic drive.

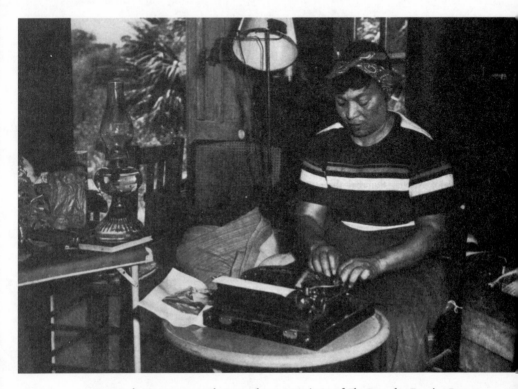

Zora Neale Hurston at work, December 8, 1951, issue of *The Saturday Evening Post*

"SISTER, CAN YOU LINE IT OUT?"

ZORA NEALE HURSTON NOTES THE SOUND

And in those days came the voice of the prophetess Ethel Waters, who
prophesied in Harlem and in Philadelphia and in divers other cities crying
["]hear, oh ye sons and daughters of Ham and Hagar, shake that thing. . . . ["]
And the multitudes hearkened unto the voice of the prophetess and
arose as one man and shook with many shakings.

—ZORA NEALE HURSTON, "She Rock"[1]

The little women lurk at the very heart of the modern, the place where Zora
Neale Hurston and her girl Ethel are keeping the beat. And of course, they were
friends, that Zora and Ethel. It may have taken some time to meet each other
"across the footlights," as Hurston put it in her memoir, but once they connected
through their mutual friend Carl Van Vechten, the bond between this untrained
singer and a woman referred to by some as "the Voice of an Era" was strong and
intimate.[2] Aesthetically too, they had more in common than one might think.
Born in Philadelphia and raised in a multicultural, working-class neighborhood
where, as Waters puts it, "whites, blacks, and yellows, were outcasts . . . to-
gether," she made use of an "elephant memory and gift of mimicry" in school.
As feminist blues archivist Rosetta Reitz contends, "It was this magnificent ear
and the awareness that there was authority in language, that gave Ethel Waters
an edge which she used to empower her life."[3]

Like Hurston, she mastered the art of multilingual colloquialisms and phras-
ings, assumed multiple personas in her vocal performances, and finessed the

art of deeply performative storytelling as she crafted a distinctly theatrical, vaudevillian style of blues singing that was magnetic and lasting. Only her peer, the passionately adored stage ingenue Florence Mills (whose 1927 premature death rocked Harlem), could match Waters in this regard, having ushered in the 1920s as "the agent of the modern spirit of unmasked feeling."[4] Of Waters, Hurston would marvel, "She is one of the strangest bundles of people that I have ever met. You can just see the different folks wrapped up in her if you associate with her long. Just like watching an open fire—the color and shape of her personality is never the same twice. She has extraordinary talents which her lack of formal education prevents her from displaying."[5] Listen to her burning up the scene with her slinky 1926 smash, "Shake That Thing," and you'll know what Hurston's talking about. Dolling out double entendres left and right, Waters shifts personas with the turn of a phrase. She's the swinging seductress one moment and the cool cultural observer the next. "Now it ain't no Charleston, ain't no Pigeon Wing," she assures,

> Nobody has to give you no lessons, to shake that thing
> When everybody can shake that thing
> Oh, I mean, shake that thing!
> I'm gettin' tired of telling you how to shake that thing!
> Oooh, oooh, with this kind of music, who wouldn't shake that thing?[6]

Ascendant as the queen of Black 1920s vaudeville, Waters knew how to work the drama and suspense in a jook-joint hot number celebrating the joys of carnal movement. Hers is an anthem that condenses the shifting energies of an epoch encapsulating mammoth change: migrated Black peoples spilling into northern cities, bursting with socioeconomic aspiration and artistic ambition, revolting against the norms that had historically sought to violently police their profit as well as their pleasures. In other words, all that "shaking" was evocative of the tumult in Waters's midst. As Saidiya Hartman points out, she "made music" out of the "noise" all around her in her adopted city of New York, soaking up and translating into her own sonic language "the sounds of life, the loving and fighting and laughter and suffering," all the while "describ[ing] the deprivation and vitality of cramped living from the inside" of her own Harlem flat.[7]

Both Ethel Waters and Zora Neale Hurston believed that the Black body, that their own kinesthetic bodies, could serve as prodigious and vital instruments in their musical endeavors. While Waters's massive breakthrough hit "Shake That Thing" (first performed in 1925 at the Plantation Club) would take the sexual energy of the jook (a realm Hurston refers to as the pinnacle of Black

Ethel Waters sings "Heat Wave," Music Box Theater, New York, 1933–1934

theatricality in her 1934 "Characteristics of Negro Expression" essay) to its ludic extreme, Hurston would also put her body to work not only as a narrative device, an instrument to convey big ideas about the dynamism of Black life, but as a form of performative epistemology called on to reference and revivify the cultural and historical memory of the work song archive. And crucial to this epistemology was an emphasis on the beautifully unpredictable idiosyncrasies manifest in her own voice both caught on tape and loudly leaving its imprint on her own indelible, discursive style. Like Hopkins before her, Hurston pursued the preservation and cultivation of voice—but in this case, it was her own rather than a literary character's that once again revolutionized Black sound writing as well as the relevance, meaning, and value of recording Black women's vocality.

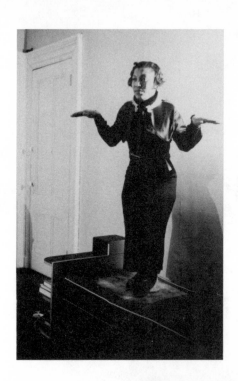

Zora Neale Hurston, poses from a Crow dance taken by Baxter Snark
(Prentiss Taylor)

That Hurston not only theorized the sounds in her scholarship and incorporated them in her folk concerts but also performed them herself makes plain the ways that she embraced the act of singing as an extension of her critical ethnographic work. Zora's singing traverses the presumptive boundaries between Diana Taylor's conception of the archive and the repertoire, "the archive of supposedly enduring materials (i.e., texts, documents, buildings, bones) and the so-called ephemeral repertoire of embodied practice / knowledge (i.e., spoken language, dance, sports, ritual)." Zora's singing intervenes in what she believed to be the so-called hegemony of Harlem Renaissance Black concert hall culture with its refined music, sounds that she abhorred for, in her opinion, watering down the voices of the folk.[8]

This chapter follows the sound of Zora, first turning to a reconsideration of her storied career through the prism of her creativity and innovations as a folklorist scholar, preservationist, and performer of diasporic Black vernacular music. It then explores the theories and methods that Hurston put forward in her pioneering essays on Black sound, which effectively inaugurated a new and unprecedented form of writing about African American sonic cultures and, likewise, were mutually constitutive of her vast and varied performance repertoire. From her scholarship to her rugged adventures recording out in the field of her homeland of Florida, the second half of the chapter lets Zora do the driving as it takes seriously her collecting practices, practices that were, in part, shaped by her infamous cars, the machinery that operated as practical sites of both efficiency and protection in her ethnographic pursuits. Her odysseys would take her through white and Black worlds, from federal circles of institutional power to the exhausting, back-breaking labor of railroad workers' daily lives. What's ultimately evident is how this Hurston of sound saw fit to exploit every modern instrument at her disposal—recording devices, automobiles, the conditions of the railway—to expose a fundamental truth: that the African American sonic is the key to (Black) life as well as the steadfast memory of its existence in all its witty, sensuous, sometimes truly dark, and always miraculous fullness. As we shall see, Hurston clearly believed that it was up to her to catch it all and sound it out before it vanished.[9]

The Zora Neale Hurston Mixtape: Retracing a Sonic Life

She cut for us a soundtrack that accompanies, complements, and yet also contradicts her critical writing. But be warned: Bessie Smith she was not. While no scholar in her right mind would dispute the fact that Zora Neale Hurston

revolutionized and revitalized the voices of Black folk in her beloved fiction, her less feted drama, and her still influential anthropological scholarship, you'd most likely be hard pressed to find anyone who would call her a "great singer." Most people, in fact, may not even know that the Harlem Renaissance rebel writer sang at all, let alone that during the late 1930s she readily and dynamically performed and recorded a colorful array of songs that she herself collected out in the field: on the open road, in her now legendary automobile Sassy Susie, at the boisterous leisure gatherings of Florida locals, and all along the railroad line where day laborers hammered out their sorrows, pleasures, and hopes and dreams in intricate, percussive melodies.[10]

The Zora recordings from this busy and prolific period of Hurston's career capture an artist and a scholar who was listening and likewise seeking to capture the music all around her. We hear her in full, authoritative mode, dialoguing with fellow ethnographers, narrating the thick local histories of various songs, and leaning in to sing the material herself in that unvarnished "second soprano" of hers. This Zora in the Florida Folklife from the WPA Collections, 1937–1942 is our woman of questioning adventure and ambition, one who clearly exudes a kind of veteran maturity, confidence, and knowledge at the tail end of a decade in which she had published multiple plays, novels, and critical essays while also amassing an impressive array of fieldwork material during her journeys across the global South.[11] Think of these "Zora mixtapes" as documentation of the documenter, the sonic traces of a scholar and a writer who was always also something of an actor-entertainer who drew on these various dimensions of her selves by way of sound endeavors. She emerges on these tracks as sly and playful, spirited and earnest, an everyday singer intent on letting her audience "know what real Negro music sounded like."[12] It was an aim that spurred her ethnographic work forward for much of the 1930s.

Numerous scholars have documented the complexities of Hurston's preoccupation with "realness" and Negro culture. Yet her singing perhaps presents something of a problem when it comes to reading her racial authenticity politics since it was a voice that fell so far outside Black popular music conventions, from the howls, growls, and shouts of the gospel tradition, to the "'dirty' tone, para-linguistic effects, and 'blue notes'" evolving out of the blues, to the elegant virtuosity of pioneering jazz singers from this era. Instead, Hurston's voice was, according to biographer Valerie Boyd, decidedly "limited. She could hold a tune in the shower, peck out a few bars on the piano and strum some decent chords on the guitar, but she was no maestro."[13] No maestra, indeed. In many ways, this Zora is a refreshing antidote to both the overdetermined literary and feminist icon of the past few decades and the perpetually romanticized figure

of the melisma-driven, Black woman singing diva.[14] Her technical imperfections are bold and pronounced in the realm of singing yet delivered with clarion confidence and simmering delight, like an amateur karaoke singer who revels in the song itself while ignoring the missed notes and turn-of-this-century singing competition "pitchyness" that our contemporary ears have become so trained to police.

In the event that is Hurston singing, we hear her shifting between "head and chest voice" and a steady yet raspy timbre. She taps into varied modes of vocality on these recordings, "allo[wing] the listener to imagine both soloist and responsive ensemble through a single vocal line."[15] That weird, quirky, piercing delivery of hers cuts a path through these songs, existing in the murky, charged space between Zora and the people she sets out to record. It is a space that she would examine and revisit again and again in her prose scholarship, innovating her own form of revolutionary Black study, the "signifying ethnography" of which Sonnet Retman refers, that method by which "her insider and outsider claims loop together like a Mobius strip to stretch the very limits of participant observation methodology." This move of Zora's "allows her to create a radically hybrid text that traverses the space between informant and ethnographer" and between personal and collective voice.[16]

What I would add to Retman's brilliant observation here is that we think, too, of the way that Hurston's specific brand of ethnography draws from the aesthetics of blues narratology—booming by the time that our adventuress was recording and writing extensively about Black sound—and how it just as well prefigures some of the core fundamentals that would come to the fore of modern popular music criticism in the latter half of the twentieth century. Although she was famously wary of the popular music form that dominated the Harlem that she would call home for much of the 1920s, blues aesthetics would nonetheless shape and inform the method of her musical analysis.[17]

Hurston's interrogation of blues aesthetics and cultural politics surfaces at key points in both her published and unpublished scholarship as she occasionally references the entanglements between the folkloric roots of secular and sacred Black musicking. Though she primarily focused her attention on what she firmly believed to be the inauthenticity of Black sacred song marketed to the white masses, her examination of, for example, the countercultural site of the jook reveals continuities between the preservation and evolution of Black folklore and the development of blues culture. The jook is, as the great Hurston scholar Cheryl Wall points out, the site of an "ethics" that has "given women far more personal freedom and power than the women on the store porch enjoy." In "its smelly, shoddy confines has been born the secular music known as the

blues," Hurston observes in "Characteristics," and like the vernacular folk songs passed between regions, jook songs such as the sly "Uncle Bud" "grow by incremental repetition as they travel from mouth to mouth and from Jook to Jook."[18] Her interest in the form of the blues is even more pronounced in her folklore and music chapter included in the manuscript for *The Florida Negro*. "The Negro blues songs," Hurston contends, "belong in the class of moods set to strings which the ancient called lyric because they were sung to the lyre. The form is a line indicating the mood of the singer repeated three times. It betrays the mood of the singer and it walks with rhythm. Contrast and imbellishment [*sic*] [are] obtained by stress and accent in the tune rather than a change of words."[19]

So too does Zora stand firmly in her writing about folkloric culture and Black sound. Hurston's prose "walks with rhythm" as it mediates the realm between being literally inside and outside the frame of analysis in question. Musical forms and performance techniques and methodologies cross-pollinate in Hurston's work as she wends her way through the Everglades, leaving trails of her own critical fortitude and invention for readers, listeners, and her sonic descendants to play with, against and through the changes. To follow her on that journey means relinquishing the romance of the guitar-slinging blues man as the singular sign and symbol of modern sonic genius and imagining a different kind of counterhero, one who moved effortlessly between expressive forms, wove phono with graph as a way to capture and affirm Black life's astounding immensity, its complexities, its sheer, everyday wonder. Hurston, as critic and musician, drew on the dissonance of the blues and folkloric storytelling as both a performance strategy and a critical knowledge tool. She was the genius who quietly and quirkily revolutionized modern sound writing practices. And she was in the crowd, up close and personal and also (not) of it as she belted out the music at the center of her Black study.[20]

> I just get in the crowd with the people and if they sing it I listen as best I can and then I start to joinin' in with a phrase or two and then finally I get so I can sing a verse. And then I keep on until I learn all the verses and then I sing 'em back to the people until they tell me that I can sing 'em just like them. And then I take part and I try it out on different people who already know the song until they are quite satisfied that I know it. Then I carry it in my memory. . . . I learn the song myself and then I can take it with me wherever I go.[21]

In many ways, this Zora of the crowd, so close, so casual, and yet so resolutely focused on sharing the fruits of her research labor, is flexing her stuff as a

confident ethnographer—flossing, if you will. She is right here in the room, urgent and immediate, and guiding her listeners in a master class on her methods. Her pedagogy is a thing of ease to her, matter-of-fact, pointedly effortless in its narration as it conveys her improvisational approach to fieldwork, her "I got this" engagement with "the people," the folks she lays claim to rolling with on the regular. To play along, to keep the beat with them, to acclimate herself to their lexicon and soundscape, she suggests here, requires nothing short of doing vocal double Dutch, figuring out when to leap into the center of a song, to ease into the language of it and sing it back to her discerning grassroots listeners and gain their precious approval. Two Zoras jump rope here and drive her intellectual labor—one who is as humble as she is shrewd, and one who is in absolute and utter control of the tale which she tells, the one in which she is the undisputed star.

What's clear as well is that we are worlds away from the hagiographic figure of the feminist 1980s and 1990s, when the image of our reclaimed queen of folk letters appeared every which way, affixed to buttons and tote bags as a distant symbol of the Harlem Renaissance ludic life.[22] This Zora, the one who here is a couple of years beyond having written her masterpiece of a novel, *Their Eyes Were Watching God,* makes music instead of fiction. Outside the market politics of a recording industry that thought it knew what a Black woman should sound like, she appears not to give a damn that she is no singer of any great vocal merit. Rather, the work that she is doing here in song and sound is a critical intervention in the ways that she steadfastly believed that Black life ought to be recorded. And as it would turn out, it is Hurston herself who provides us with some of the most fruitful and generative ways to theorize the sounds coming out of her mouth.

Having died in 1960 under the weight of poor health and poor finances, and with few in her life to care for her, Hurston had, at the time of her passing, slipped out of the public eye. Her tragic demise drew a sharp contrast from the era some three decades earlier when she'd been basking in the New Negro spotlight, holding court with other literary celebrities as a prolific, sharp-shooting, iconoclastic artist and scholar who toggled between many expressive and intellectual spheres—from fiction-writing and playmaking collaborations to the cultural anthropology social circles that she deftly navigated in her bid to document and broadcast to the world the intricacies of Black vernacular life.[23] That her fame would rise posthumously and to unprecedented heights in the wake of Alice Walker's storied pilgrimage to mark a resting place for her in 1973 is the stuff of Black feminist legend, the kind of public recuperation—both inside and outside the academy—that African American genius women (both

living and dead) have far too rarely enjoyed.[24] But in her own time, all bets were off as to whether Hurston would ever be unanimously revered. Tough-minded and unpredictable, adventurous and gregarious, she was an unusual sister of her Harlem Renaissance generation, a pathbreaking contrarian who was notoriously unafraid to go against the tide of high-profile African American cultural uplift campaigns that leaned hard into art-making that far too often, as she saw it, pandered to white folks by trafficking in forms that appealed to them and ones that were, as she often argued, "foreign" to the heartbeat of Black conviviality and survival. Her infamous beefs with a range of African American luminaries have long held the attention of literary historians and biographers, to say nothing of her public critiques of and debates with white artists and thinkers on questions related to racial representation.[25]

Like Abbey Lincoln, who followed in her footsteps, Zora Neale Hurston was especially interested in the way that Black sonic performances might serve as a repository for Black cultural memory. And like her forebear Pauline Hopkins, who was on the scene two decades before her, Hurston was an unabashedly multihyphenate artist. Born in 1891 in Alabama and raised in Eatonville, Florida, she too laid down early roots traveling through the world of theater (having worked in the service of the lead singer of Gilbert and Sullivan's company in the 1910s). At the height of her career, she cranked out short stories, critical essays, full-length novels, and multiact plays, as well as what would become influential ethnographies of Southern African American life that shaped scholarly studies of Black folk culture in pivotal ways across the twentieth century.[26]

In this latter regard, Hurston, the Howard-, Barnard-, and Columbia-trained scholar who'd racked up two Guggenheim fellowships as well as a Rosenwald grant, was a particularly unique individual, a sister with one foot planted in Ivy League academia and the other standing firmly in the realm of the quotidian African American culture that she tirelessly championed.[27] She was, in effect, an academic who experimented with a variety of artistic practices that reflected and extended her own research, and she was also a popular figure in Harlem cultural circles of the 1920s and 1930s, a figure who was interested in addressing, intervening in, and redefining the meaning and merit of aesthetic forms of Blackness as she saw fit to make use of them. In short, she was a thinker who was deeply invested in redefining the Black vernacular popular as what she saw as *rightly populist.*

Hurston's footprint in the world of music was always bound up with lofty ambitions and wider commitments to large-scale, (Black) democratic potentiality, and it is this aspect of her career that, until recently, has perhaps received the least amount of attention.[28] Yet on the other side of running with 1920s Black

literary crews (the members of which she sometimes derisively referred to as "the Niggerati"), she was laying down historic sounds on tape, making recordings in the shadow of her better-known career in the arts and in academia. She had spent the period from 1927 to 1932 collecting tales and dances and songs by way of funding from her wealthy white patron, Charlotte Osgood Mason (who owned and controlled the rights to this material), but by 1932, with Mason's patronage having come to a halt, she embarked on a period of creative experimentation with the music of African American folk at the core of her performative and scholarly projects. As she described it in a 1934 letter to Thomas E. Jones, president of Fisk University, upon returning from fieldwork that she had conducted from 1928 to 1931 in Florida, she "began to see the pity of all the flaming glory" of Negro folklore "being buried in scientific Journals" and instead turned her attention to live renditions of her findings.[29]

Her ambitious New York City concert production *The Great Day* (1932) would excavate and showcase the sound as well as the movement that sits at the foundation of the Black vernacular cultures that Hurston had been researching. "Seeing the stuff that is being put forth by over-wrought members of my own race, and well-meaning but uninformed white people, I conceived the idea of giving a series of concerts of untampered-with Negro folk material so that people may see what we are really like," she gushed in a letter that same year.[30] Conceived as a day in the life of a Florida railroad work camp community, *The Great Day* follows the path of musicality and expressive movement embedded in quotidian African American labor and leisure. As dance studies scholar Anthea Kraut has shown, *The Great Day* went against the grain of contemporaneous Black musical revues and Black folk dramas. Kraut points out that "*The Great Day* did not quite fit into any of these existing genres.... Hurston's concert... was dramatic without being a drama and musical (and dance heavy) without being a musical.... Audiences," for instance, "encountered spirituals as part of that community's religious practices—'with action,' as Hurston later put it—and not as an extracted and isolated art form."[31]

Hailed for its originality by critics as well as her contemporaries—from intellectual colleague, sometime mentor, and occasional adversary Alain Locke to music colleague and occasional adversary Hall Johnson—*The Great Day* transitioned Hurston into an era in which she quested to celebrate, cultivate, and make more audible to the masses the depth and complexities of Afrodiasporic sonic cultures. She was seeking, as John Szwed puts it, "to reclaim African American folklore from the grotesqueries created by white writers and artists, whether they be slumming modernists seeking primitivist thrills or old-school minstrel men grasping at yesterday's fantasies.... She was insisting that black

folk culture was already high art."[32] Throughout the thirties, Hurston applied for funding and dreamed big in her grant proposals, stating, for instance, in her Guggenheim application that she "hope[d] *eventually* to bring over a faculty from Africa and set up a school of Negro music in America. . . ." This, she believed, was crucial since "No Negro can remain a *Negro* composer long under white tutelage. . . . The better he is taught, the less there is left of his nativity." She supplemented her creative and academic research with teaching, bouncing between instructor positions at various colleges while she continued to develop, nurture, and present revised versions of her folk concert material, and by mid-decade she had entered into a complicated, on-again, off-again working relationship with select units of the Franklin D. Roosevelt administration's Works Progress Administration (WPA).[33] Her employment was unsteady, and she often struggled to pay the bills during this period. Yet her commitment to her field-work and especially to the project of recognizing and analyzing Black music as a field of critical inquiry was unwavering.

Hurston worked for a spell in 1935 alongside Orson Welles, John Houseman, and other theater professionals as a drama coach for the newly organized Federal Theatre Project (FTP). That same year, she embarked with folklorists Alan Lomax and Mary Elizabeth Barnicle on a journey through the South, starting in Eatonville and moving on to "record songs of Bahaman sugarcane cutters in the Everglades," then "proceed[ing] to the Georgia Sea Islands" before splitting up in the Bahamas and sending their findings to the Music Division of the Library of Congress. The trio's recording of "Bellamina" in Chosen, Florida, in 1935 and Hurston's high-pitched, ludic, sugar-sweet performance of "Bluebird" and "Bama Bama" recorded by Lomax in Petitionville, Haiti, on December 21, 1936, belie what was an undoubtedly fractious working relationship.[34] Lomax's admiration for Hurston's tactics in conducting ethnographic research was steeped in a combination of awe, incredulity, fascination, and perhaps just a bit of contemptuousness. He was, for instance, prone to emphasizing both her shrewd and intrepid strategies for procuring informants and simultaneously taking note of her gendered modes of manipulation. Hurston's WPA colleague Stetson Kennedy recalls Lomax observing that "in the field Zora was absolutely magnificent: She could out-Negro the best of them, and get anything out of anybody. She would honey-up to the men so they wouldn't ask us for money, and sometimes she overdid it to a point when she had to jump into her Chevy and flee for her life!"[35]

Her charged relationship with Lomax was but one in a series of adventures that Hurston navigated during this period of her life, a time when she continued to yoke together her interests in theater aesthetics, Black music, and ethnographic exploration. For stretches of time in the 1930s, she was getting her

hustle on with New Deal idealists, predominantly white WPA ethnographers, who shared with her one goal: documenting Southern vernacular sound on the brink of its supposed disintegration in the jaws of industrialization and mass Black exodus from the South. She addressed this topic on multiple fronts—as an ethnographer who collected cultural forms and sought to study and preserve them, as a performer who disseminated songs and tales in oral demonstrations recorded for the WPA archives, and as a critical writer who produced essays that pushed back against the dominant presumption that African Americans were bereft of cultural sophistication and elaborate expressive rituals. The remainder of this chapter explores this body of work by Hurston, in which she rehearses theories about Black culture by way of her own bold, idiosyncratic, scholarly essays, performances, and recording practices. As will become clear, it was Hurston who first saw fit to record the Black regional diaspora of her Depression-era world in her own voice and prose. She was working to, in effect, write an audible past as well as an "archaic text of knowledge to come" for the women who, like her, saw fit to wander.[36]

Characteristics of Negro Sonic Studies: Zora Neale Hurston's Sound Criticism

What Zora Neale Hurston ultimately did with the music she was encountering, documenting, and collecting was unprecedented, since no scholar, no cultural figure before her had ever made a pass at both sounding out the music in her own voice and writing about that music for an academic world that was reluctantly coming to terms with the idea that Black cultural life had any value whatsoever.[37] No Black intellectual figure before her—not Du Bois or J. W. Johnson and certainly not Alain Locke—had dared to literally rock the mic in the service of his own arguments about the intricacies of Black cultural forms. And while her onetime close friend Langston Hughes would go on to perform beautifully intricate readings of his poetry in collaboration with jazz musicians late in his career, Hurston was the sole Harlem Renaissance literary figure of note who doubled as an ethnographer and who both sang on tape and theorized in print about the poetics and social utility of Black song.[38] She was both the recorder and the record player, the woman who aimed to control the apparatus of documentation rather than acquiesce to getting played by it.[39] In her sonic and scholarly work from the 1930s, she figured herself as the line leader, the construction worker assembling and holding together the languages of Black vernacular musical traditions forged out in the field and under duress.

Nowhere is this more apparent than in the critical essays that Hurston produced in the 1930s as she continued the expeditions to research and collect elements of Black Southern culture that she had commenced the previous decade. But whereas she had pursued her projects of the twenties and early thirties under the watchful eye of wealthy white benefactress Charlotte Osgood Mason, her mid- to late 1930s work distinguished itself from that which had come before it in three crucial ways. First, with Mason's patronage having come to a halt in 1932, this new work marked the emergence of Hurston's independent vision and analytic focus, unfettered from the heiress who supplied her with approximately $15,000 over five years.[40] One could perhaps speculate, then, that it is for this reason that, second, her material from this period evinces a sharper and more commanding critical voice in its efforts to document, analyze, and theorize the function and merits of Black sonic styles and performances. And third, some of the most significant essays that Hurston wrote on sound during this period were closely aligned with and anticipatory of the WPA recordings she would ultimately produce. This last point is especially significant since it highlights the extent to which Hurston was unique among her contemporaries as a performer, a critic, and a phonographer.

As a vocalist, scholar, and archivist, Hurston would rerecord railroad workers by way of her own performances, and she would likewise publish scholarship in the 1930s that theorized the critical value of the sounds that she had been gathering up, cataloging, and performing. Her explanation of the preacher figure, for instance, in the 1934 essay "Spirituals and Neo-spirituals" discursively shadows and complements the sounds she was collecting one year earlier. "The well-known 'ha!' of the Negro preacher is a breathing device," explains Hurston. "It is the tail end of the expulsion just before inhalation. Instead of permitting the breath to drain out, when the wind gets too low for words, the remnant is expelled violently."[41] The art of the preacher's sermon echoes the aesthetics of the lining rhythms that she had been documenting. For her it conveys the richness of Black vernacular culture in all its action and studious extravagance. Shuttling between her vocal readings of folklore material and her written work in the 1930s, Hurston fluidly inhabits the dual roles of line worker and preacher—both of which draw on a panoply of expressive utterances in the service of executing their respective modes of performance labor. The rhythmic exhalation and exclamation not only mark time (the amount of time it takes to lay down heavy steel tracks *in* time with your fellow laborers, the amount of time it takes for a pastor to draw out the affective energy in a sermon's verse), but they also render audible the Black body *of* laboring force with energy and exertion.

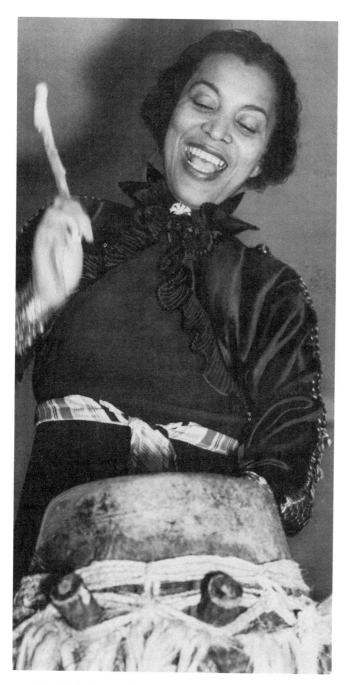

Zora Neale Hurston beats the hountar, or mama drum, 1937

Even the plaintive quality of what we might call Hurston's "mixtape renditions" finds explanation in her writing here. Though "Spirituals and Neo-spirituals" charts the intricacies of Black vernacular sacred performances, the essay serves as a kind of source piece for Hurston's performance practices, for her approach to interpreting the secular folk songs of the jook and elsewhere that she would go on to cover in some of her performances later that decade. "The real Negro singer," she proclaims in this essay, "cares nothing about pitch. The first notes just burst out and the rest of the church join in—fired by the same inner urge. Every man trying to express himself through song. Every man for himself. Hence the harmony and disharmony, the shifting keys and broken time that make up the spiritual."[42] Like the leader of a flock who turns music into speech for her followers, who translates "singing into saying," Hurston here lines out an aesthetic to which she herself responds five years later on tape in renditions of tunes like "Evalina," something of a folk song precursor to the King of Pop's "Billie Jean," which finds her delivering the refrain, "You know the baby don't favor me," with steadfast conviction. She is solo here, stripped of the busy, multitudinous voicings of the choir, but her plaintive vocals quietly reverberate with the informal, offbeat character of a musical protagonist whose wariness and casual moral conviction carries the song forward ("Evalina, Evalina don't you tell your mama that it belong to me / you know the baby don't favor me").[43]

What I want to suggest is that we take seriously the fluidity and cross-pollination of Hurston's music writing and her sonic performances and likewise that we consider her method of prose as a kind of discursive extension of the musical forms she sought to preserve. Just as "lining out, despite its European origins . . . became an early but seminal phase in the development of a modern identity for black music," just as "lining out first defined quasi-linguistic and musical terms by which a sequence of Anglo-American forms (religious, popular, and classical) would be imbued with African elements, structures and tendencies," just as *singing and saying . . . found a new cult of performativity*" in twentieth-century secular forms, so too might we consider Hurston's prose about Black sonic cultures, as well as her performances that stayed in conversation with that prose, as key turns in the development of modern writing about Black music.[44] Both "Spirituals and Neo-spirituals" and a second essay from 1934, the germinal "Characteristics of Negro Expression" (called by Dwight Conquergood the first Black performance studies essay), catalog her efforts to canonize Black sound in writing, to respond to what she clearly believed was the need to generate theories of Black sound that might deepen and enrich the scholarly public, to create dispatch notes that might encapsulate a lexicon and

innovate a language for African American vernacular sound that she would herself bring to life out in the field. The importance of her efforts cannot be overstated if we consider the scarcity of Black women who had the opportunity to seek recourse through writing in order to articulate the value of Black music.[45]

Hurston's efforts to craft a theory of Black sonic performance are most pronounced in the more famous of her two essays from Nancy Cunard's 1934 *Negro* anthology, "Characteristics of Negro Expression," a kind of compendium of and companion to the sounds that she'd been collecting and cataloging as a Columbia University student of pioneering anthropologist Franz Boas. Here in "Characteristics," Black performance is, for her, all in the details, as Vazquez would put it: the "drama" of a Negro girl's "slight shoulder movement that calls attention to her bust," the intricate ornamentation of "prayers and sermons . . . tooled and polished until they are true works of art."[46] In Hurston's published work, she was innovating philosophies and theories of Black life and culture—how, for instance, "every phase of Negro life is highly dramatized"—that she'd been contemplating for many years prior in her private and professional worlds.[47] Hurston drew on all of these aesthetic powers—of the pastor, the railroad line worker, and the Black church choir leader entrusted with the all-important task of lining out (the lyrics of a hymn) for the congregation—in her essay.

"Characteristics" finds her defining and exploring the significance of terms like "angularity" (that is, multiple, slanted postures in dance), "asymmetry" (the "presence of rhythm and lack of symmetry" in choreographic movement), and "adornment" ("embellishment" and a passion for the ornate) in Black cultural production. It is a work that manifests in form the content of the essay, turning the taxonomic, ethnographic, and ethnological "characteristics" of a people into a kind of writing that moves (enacting the "drama" and "action" that, Hurston contends, "permeates" the "self" of the Negro), collects and documents, sustains the rhythm it theorizes, the rhythm of Black life performances that, she insists, erupts in "segments. Each unit has a rhythm of its own," a "new tempo" to which the Negro "adjusts himself."[48] Further still, "mimicry," as Hurston outlines it here, is a vibrant repertoire, a storehouse of gestures that preserve and simultaneously revise cultural forms. Hurston the ethnographer calls attention to herself as the site where Black performative knowledge is (re)stored and perpetually restaged.

Her critical writing is testimony to the immensity and the fluidity of Black sonic life, the vast and expanding universe of Black sound as it amounted to a network of improvisational lyrics and tropings that took new shape each time it fell into new hands, new circles, new crowds, new times. Hurston saw fit to point this out often in the prefaces she gave before performing songs like "Uncle

Bud," noting the variegated topics and colorful specificity of new renditions of old numbers.[49] This music, she suggested, was epic in form, epic in content; it carried the tongues and tales of many people, many places. These songs are archives, her work proclaimed. Handle them with care. Write about them, if you will, but you best bring your A game; your knowledge; your experience; your recognition of structure, ritual, and whip-smart signifying codes; and a deft ability to rigorously dissect micro-elements of the everyday and tell a good story in the process. Hurston was the master of this kind of writing, a style that was reminiscent of the midcentury liner notes of "classical, ethnographic and jazz recordings" that "tended to instruct the listener in a didactic way."[50] It was prose characterized by forthright boundlessness and what would become her trademark "confidence and daring as an ethnographer and writer." This was style that would also pique the interest of twenty-year-old college student Alan Lomax. "What astonished him," observes Lomax biographer Szwed, "was the bravery with which she had gone beyond the rules of her anthropological training, becoming one of the folk, embracing their beliefs and dreams, then writing about it with elegance and high affect."[51] She

> represented to Alan what was possible for an intellectual of a certain type, and pointed the way toward how he, too, might come to write in a deeply personal and expressive style and still be an ethnographer and folklorist true to his subject. Though she was educated in the kind of careful ethnographic techniques and objective methods of anthropology that had the laboratory report and the scientific monograph as their models, to Alan "she was no reserved scientist but a raconteur, a singer and a dancer who could bring the culture of her people vividly to life. For she opened the way, with sure taste and a scientist's love of fact into the whole world of Negro folk lore."[52]

Even "if other anthropologists dismissed her results as too subjective, too literary," Lomax regarded Hurston's work as a brash formalistic endeavor that stressed immediacy and the critic's ability to cultivate deep context and compelling narrative in relation to the cultural object in question. Some of this, we might assume, came from Hurston's own dramaturgical leanings, her youthful immersion in theater culture at the age of twenty-four when she "landed a job as a lady's maid to the lead singer of a Gilbert and Sullivan repertoire company." Having tended to the skeletal framework of theater culture, she carried directorial vision as well as performance chutzpah into the realm of her written work on folk music. Lomax saw and heard the aesthetic and analytic invention in her

efforts to try "as much as possible to be both investigator and subject, participating in the singing, learning the songs as she listened, then singing along with the singers and writing it down later." He described her to American musicologist Oliver Strunk as "probably the best informed person today on Western Negro folk-lore."[53]

Yet Hurston's work also exceeds the conventions of the ethnographic form by not merely "framing" Black sound performances but also often discursively imbibing them with the kind of "magic" that late twentieth-century rock critics would chase in their prose. Robert Christgau would argue in one of his many joyously blunt treatises that contemporary pop music critics—journalists and academics alike—"can't capture magic [musical] moments in words. But we can surround them, approximate them, evoke them, open a window on them, open a window for them."[54] Think here of Hurston's invocation of folkloric parables as "illustrations" of performance aesthetics, her occasional fondness for metonymy and metaphor, her mastery of a kind of anthropological writing that, nonetheless, arched toward images and anecdotes that call attention to the elusiveness of the performance objects she sought to describe, and one hears hints of Lester Bangs's penchant for "mystifying grandly" lurking around the edges of that "protective layer of cynicism" in his Gonzo prose.[55] "Negro song," she argues in "Spirituals and Neo-Spirituals," "ornaments both the song and the mechanics. . . . I will make a parable to illustrate the difference between Negro and European." While her infamous racialization of sound in this provocative anecdote pits white house builder (out to "hide the beams and the uprights" in his edifice) against Black house builder (who favors the ornate), Hurston's parable bends away from technical documentation of the form in a bid to capture the figurative dimensions of sonic performance, to graft the literary onto sonic gestures of articulation, as she would do in her 1942 memoir, revisiting both the lyrics of "Let's Shake It" and the drama of the action emerging out of the song.[56]

The scene that Hurston spins in *Dust Tracks*, in a chapter entitled "Research," is one that ultimately prioritizes a study of Black song as both embodied and laborious art-making practice and, likewise, as a thing that is essential to the construction of America's modern infrastructure. Song that is made and moves amongst these railroad laborers does so according to the rhythm of rest and exertion, and Hurston, the intellectual who professes here that "[r]esearch is formalized curiosity . . . ," traces the beat of their sounds in her prose from their origins in Black work, the ways that, for instance, "the singing-liner cuts short his chant, the "[s]traw-boss relaxes with a gesture of his hand," and [a]nother rail spiked down. . . ." From these moments, however, she also limns with smooth lyricism the larger sacrifices of this exhausting physical work, how this everyday

sweat (indeed, a title for one of her early short stories) manifests itself as "[a]nother offering to the soul of civilization whose other name is travel."[57]

This style of writing differs from, say, that of her peer James Weldon Johnson, who, as Brent Edwards points out, seeks "musical recourse" in order to capture "the elusive quality in the vernacular he cannot notate."[58] By contrast, Hurston's is a kind of writing that does not merely "mediat[e] between forms" as Johnson would do in his storied essay prefaces to anthologies on Negro sermons and poetry. It also does not simply employ the method of "describ[ing] the similarly elusive nature of" the blues and poetry "from the perspective of the listener/viewer or reader" as Hughes would do in his upstart verse. Rather, her music writing asserts itself as a combination of both practices, a mediation between forms and a description of the "elusive nature" of Black sound, itself, from the perspective of the keen listener. Still more though, it is writing that self-consciously asserts itself as "a system of ideas," as carefully mapped out *theory* for Black folk expressive cultures heretofore unseen and valued in the public (published) eye by someone from the hood who spoke this language and loved it fiercely. Hurston's style of writing, the distinctive archness of her critical voice that infuses the conviction of her prose also lent itself to the sui generis vibe of her essays. This is work that remains as authoritative and yet as wide open and speculative as the object of inquiry in question. Paradoxically, she also stretches the limits of her analysis by offering her readers a cultural guide to that which cannot be mapped, lines to travel the spaces of unpredictability in Black sound, a playbook, if you will, to follow the "congregation" that is "bound by no rules."[59]

We might think, then, of her "Characteristics" and "Spirituals" essays as a record of Hurston's attempts to walk three lines at once: first, to line out a scholarly discourse that she beckoned her ethnographer colleagues to heed, one that would think critically and carefully about Black vernacular musical performance in ways that had yet to be written—attending to its intricacies and nuances, its vernacular internal structures and idiosyncrasies. Second, we might think of these two classic essays as doing the work of a lining rhythm, a beat that she was creating to sustain the necessary analytic work that desperately needed to be done to capture, preserve, and promote the sounds of Black folk culture in transit.[60] Third and most provocatively perhaps, I would argue that we might also read these two essays as a kind of liner notes for the yet-to-be-written sound texts of that which had yet to come, the "shadow book" of the first and second order for that which had yet to be recorded as well as that which is incomplete, remembered, and (re)arranged here by Hurston as she reports and interrogates her findings.[61] Like "the best liner notes," which, Tom Piazza argues, "have always provided something beyond facts," which "tell the listener,

in many subtle ways, what it means to be a . . . fan," and which "embody styles of appreciating the music, a range of possible attitudes toward it," her essays primed listeners for a way to culturally and critically value the tracks she would later lay down for the record.[62]

In the guise of the critic, this Hurston clears a path for and initiates a conversation with our sonic Zora, who travels through the archive of Florida folk music a few years down the road and leads us "in a high pitched but forceful voice" into the muck of Black women's musical alterity, challenging us to listen again to the form as well as the content of her angular ethnography, her scholarly work that sat restlessly askew from convention.[63]

Hustling (with) the Feds: WPA Days

Dear Miss Hurston: Under separate cover we are sending you Record No. AAFS 40 of <u>Folk Music of the United States from Records in the Archive of American Folk Song</u> (1943). In presenting you with these records in the making of which you have participated as a performer or collector, the Library of Congress takes this occasion to express its appreciation of your co-operation. Will you please sign, detach, and return the receipt, in the enclosed franked envelope?

—LIBRARY OF CONGRESS, August 9, 1945

I have received from the Library of Congress Record No. AAFS 40 of <u>Folk Music of the United States from Records in the Archive of American Folk Song</u> (1943). . . . Oh, I am so very grateful. To pay you back in kind, I will collect all the music I can on my Central American trip and send it along.

—Z. N. H.[64]

Yet another program housed under the WPA, the FWP, invited Hurston in 1938 to join the editorial staff of *The Florida Guide,* part of an "American Guide" series designed to "hold up a mirror to America." The gig provided her with the opportunity to sharpen her ethnographic game, and through her WPA activities and assignments, she began to move closer toward both recording and performing her folk music findings out in the field. According to her colleague Stetson Kennedy, she collected "fabulous folksongs, tales, and legends, possibly representing gleanings from days long gone by." She also drafted reports on the music of local church services and filed an essay on Florida folklore and music entitled "Go Gator and Muddy the Water." Hurston did all of this in spite of her

steadfast autonomy as a member—the only Black woman member—of the editorial staff (the lowest paid and yet, according to Kennedy, quite likely the most experienced). In this context, she emerged as the ideal candidate to participate in a statewide recording expedition organized by the FWP.[65] In the eyes of Ben Botkin, the FWP folklore program's new national director, "mere written transcriptions did not provide enough detail and ambience," and so he turned to Hurston and crew to turn up the volume in the wetlands. "When she first came on board and scheduled a visit to our (lily-white) state office," recalls Kennedy, "a staff conference was convened at which we were admonished that 'we would have to make allowances for Zora, as she had been lionized by New York café society, smoked cigarettes in the presence of white people,' etc. And so she did, and so we did."[66]

It was not a situation without stress for her. Writing in late 1938 to state FWP director Carita Doggett Corse, Hurston noted her personal battle with a "form of phobia," a crushing and incapacitating depression that left her unable to "write, read, or do anything at all for a period." Having assured her "Boss" in that letter that when she does "come out of" such spells, it is "as if [she] had just been born again," Hurston nonetheless was plagued at times with questions about how best to make sense of her inner turmoil in relation to her intellectual and artistic pursuits. In her letter to Corse, she ponders the reasons for her despair and notes that she finds that such spells are often "the prelude to creative effort."[67] By summer of the following year, she was rolling with the FWP crew and about to embark on some of her most fascinating and unique methods of research.

Some four years after the publication of what would become two of her most famous essays, folklorist Herbert Halpert and a crew of fellow WPA workers recorded Hurston on June 18, 1939, performing a range of rollicking vernacular songs down on the Florida peninsula in Jacksonville. Here she and her Florida guide colleagues had set up camp, among them Corse, "twenty-something" Halpert, and local student–turned–project supervisor Kennedy. On site in Jacksonville, Halpert had on hand a recording device "the size of a coffee table—the moving parts looked like a phonograph—and cut recordings with a sapphire needle directly onto a 12-inch acetate disk." For her part, Hurston had, along with her fellow Black FWP colleagues, rounded up "a group of railroad workers, musicians, and church ladies at the Clara White Mission on Ashley Street, a landmark institution in Jacksonville's Black community." There, Halpert "used his cumbersome recording machine to capture the voices of various informants singing, telling stories, and occasionally hamming it up for posterity."[68]

Catalog image of the SoundScriber machine

Hurston's approach to this whole operation was always distinct, always bent on both reproducing precious sounds through her own performance practices and yet still capitalizing on the quirks and the character of her own interpretative skills. This is Zora's form of phonography, that which loops together a zone in which she operates at the crossroads of the modern and the folk. On tape, one hears a forty-eight-year-old Hurston (who brashly claims for the record that she is thirty-five) both collaborating with and also facing off against Halpert's bulky, furniture-sized machine to offer her own definitive repertoire of Southern vernacular culture for the archive. A copy of Halpert's "Tentative Record Check List" from these sessions dated March 12–June 30, 1939, offers a detailed account of songs sung by Hurston and other local interlocutors (for example, "Beatrice Long (white) age 35"; "Rev. H. W. Stuckey, age 43, blind Negro preacher"). Both a playlist of sorts and an archival testimony to this sister's exhaustive performative dynamism, her mad flow, and her tireless and meticulous attention to the cultural eccentricities manifest in the songs themselves, Halpert's "record check" documents Hurston's instructive commentary and her magnetic presence on these expeditions. These are notes that follow the rhythms of her explanatory cues, the distinctions that she makes between, say, a "jook song" and a "lining" accompaniment, her references to her own ethnographic prowess ("Miss Hurston describ[es] how she collects and learns

songs (including those she has published)"). The labor of it all lurks in the parentheses as well, as in the bracketed moment when Halpert indicates that "Miss Hurston was tired (in part) and accidentally tacked songs together." This is the document of her marathon performances, her critical acuity in the realm of listening, performing, and, by extension, arranging the sounds that she encounters, stores, and "carrie[s] . . . in her memory" from the heart of the field right into the center of those scholarly circles awaiting her return.[69]

By way of Zora's phonography, we are made privy to *a listening to a listening:* Kennedy and Halpert and Corse and others lean in and pose questions as they strain to follow Hurston's musical cartography of folk songs, work chants, and blues and children's songs gathered up in the American South and the Caribbean diaspora, from the Bahamian "Crow Dance" to the swinging "Charleston rhythms" of "Oh the Buford Boat Done Come," music picked up by Hurston from a South Carolina Geechee country woman she met in Florida. She stands at the center of it all, shifting fluidly between the role of the folklorist and that of the informant, melding songs with communal lore, sketching out their sociocultural context and utility, and belting them out for a wonkish gaggle of folklore scholars, a captive audience who, nonetheless, prods her for details. Scholarly jostling ripples as an undercurrent in these sessions. But Hurston the pro brings all her swagger to these proceedings; she brings all of her skills to bear / bare in her vocal aesthetics of song, the means through which she might put the wonder and specificity of Black sonic art on the Florida map once and for all.[70]

Songs cover the landscape like regional quilts in Zora Neale Hurston's musical repertoire. As she lets loose on "Mule on the Mount," "the most widely distributed work song in the United States," we hear the varied shades and moods of Black regional experience as verses shift and change according to locality. Hurston's fascination with blues dissonance clearly undergirds her theories of Black performance, her liner notes for the recordings still to come when, for instance, she highlights the importance of both angularity (performances that stress the "angles" of bodily expression) and especially asymmetry ("the abrupt and unexpected changes. The frequent change of key and time . . ."). We can hear her working this blues aesthetic out in songs like "Mule on the Mount," that lining rhythm that we might think of as a Hurston, folkified version of "Wartime Blues" since, as is perhaps implicit in her prefatory comments, it shares moments of startling narrative discordance and social upheaval with that Blind Lemon Jefferson blues classic.

> HURSTON: This song I am going to sing is a lining rhythm, and I am
> going to call it "Mule on the Mount," though you can start with any verse

you want and give it a name. And it's the most widely distributed work song in the United States . . . it has innumerable verses and whatnot, about everything under the sun. . . . [Black folk] sometimes sing it just sitting around the jook houses and doing any kind of work a t'all. . . . Everywhere you'll find this song. Nowhere where you can't find parts of this song. . . .

HALPERT: . . . Is it a consistent song . . . as you hear it all over?

HURSTON: The tune is consistent, but . . . the verses, you know . . . every locality you find some new verses everywhere. . . . There is no place that I don't hear some of the same verses. . . .

HALPERT: Where did you learn this particular way?

HURSTON: Well, I heard the first verses, I got in my native village of Eatonville, Florida, from George Thomas.

HALPERT: And is . . . that the only version you're going to sing?

HURSTON: The tune is the same. I am going to sing verses from a whole lot of places.

HALPERT: All right.[71]

If the trope of the mule recurs in Hurston's literary and ethnographic writing most famously as a feminized beast of burden, in this song from "everywhere," it is the vehicle that the masculinist singer "rides . . . down" in the opening verse, replaced in the second verse by "a woman" who "shakes like jelly all over." "Mule on the Mount" is, by no means, a feminist revision of sexist vernacular culture, as it transitions into a stock tale of paranoia and betrayal ("My little woman, she had a baby this morning. . . . He had blue eyes"), alienation and revenge ("And I told her, must be the hellfire cap'n Ha! . . . I got a woman. . . . She won't live long, lawd, lawd, she won't live long"). However, it is a song that emerges in her research and performance as raw material that showcases the ways sonic folklore might serve as the connective tissue that ties dispersed Black peoples together through improvisational innovation, as well as temporally and geographically distant modes of collaboration.[72] Like the protagonist in Jefferson's ode to estrangement and wandering, the tragic hero of Zora's mule tale retold breaks by the fourth verse onto another plane, away from the arrival of the "blue-eyed baby," the product of probable betrayal and potential racialized sexual violation, away from "the hellfire," and turns instead toward the sound

of "a cuckoo bird" that "keep a hollerin' Ha! . . . It look like rain, lawd, lawd, it look like rain."[73] The pivotal fifth verse, and one that would become a signature line in Hurston's repertoire—"I got a rainbow wrapped and tied around my shoulder / It look like rain, lawd, lawd, it look like rain"—is the most telling break in the song, and it is the kind of rupture that Hurston would capitalize on in her role as a "signifying ethnographic" critic of Black sound. With that technicolor coat supplying crucial cover, the heroine of "Mule on the Mount" stands both outside and inside the song's wending, epic narrative. It may pour cats and dogs all around her, this song suggests, but she stays the course all bundled up in a mystical garment. Here in this place, caught in this storm and yet sheltered from it, she is traveling at her own angle against and through the elements. Moving to her own soundtrack, she possesses the equipment to stay in motion and keep the music alive. She wraps that "rainbow . . . tightly around [her] shoulder" and heads on out into the territory that is Black America, picking up exquisite sound, peculiar sound, vital sound all along the way.[74]

Driving While Zora: Sonic Collecting Practices

Oh de white gal rides in a Cadillac,
De yaller girl rides de same,
Black gal rides in a rusty Ford
But she gits der just de same.

—ZORA NEALE HURSTON, "Characteristics of Negro Expression" (1934)

That hour began my wanderings. Not so much in geography, but in time. Then not so much in time as in spirit.

—ZORA NEALE HURSTON, Dust Tracks on a Road (1942)[75]

Cars do time as sexual innuendo in the folklore that the trailblazing Hurston collected in the 1930s throughout her beloved southland. They surface in verses that mirror the blues man's standard go-to trope, the one in which sleek automobiles are likened to female bodies built to last, and they occasionally appear as metaphors in her work that reference the kind of gendered Jim Crow that Hurston herself would face as a traveling Black woman who had to make do with less than her white counterparts. But just the same, in Zora's world the car is also crucially entwined with the old, old-school phonograph in her ethnographic tool bag.[76] It is the instrument of mediation, the "mobile" media wherein Hurston both recorded—by her own memory (as she would proudly

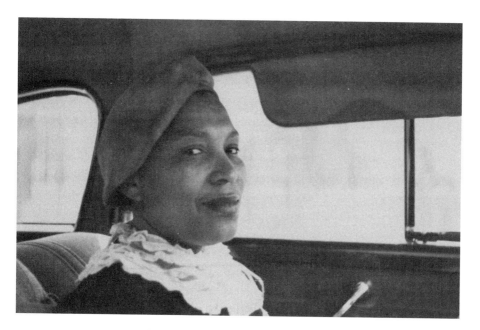

Zora Neale Hurston on wheels and out on the open road

and often declare)—and rehearsed and replayed the songs of her beloved Florida folk peeps whom she interviewed and with whom she rolled from house parties to juke joints. It is, for her, the location through which "a moving technology can create differential and contextual histories."[77] It is the laboratory by which she carries forward her all-important sound work.

Cars were, of course, a must for Hurston in order for her to participate in various recording expeditions. They were the modern forms of transport necessary for her and her team to traverse wide swaths of territory, gathering as much varied cultural data about the southland as they could find in song. One of the WPA's aims in its large-scale documentation of America was to "sho[w] a traveler on the ground what to expect at each road stop." It was an effort to generate vivid studies in local color, a kind of discursive soundtrack intended to accompany drivers traversing the Florida landscape. But Hurston's own recorded performances flirted with and challenged the limits of academic protocol—then as well as now.[78] She, for instance, thrilled in the execution of her own "playback" skills, performing the songs that she'd studiously learned while "in the crowd" to an audience of fellow field guide colleagues. On these rare, ragged, and intriguingly amateur tracks that she laid down while on the move, we hear her using her own voice as a technology of archival preservation, singing the songs of the people so as "not fade away" into Jean Toomer's

ominous *Cane* sunset.[79] As early as 1935 we have Hurston, for the record, singing delicate lullabies in Florida (in 1935) and ballads in Haiti (in 1936) on expeditions with Alan Lomax and Mary Elizabeth Barnicle that were less than sanguine. This is the fortysomething, seasoned Zora, veteran ethnographer, on the verge of dropping her classic *Their Eyes Were Watching God* for a public who would care little for that novel until long after her passing. This is the Zora who is both "the cartographer" and "the map," as Retman describes, a woman who, in her classic 1935 work *Mules and Men*, had already "recount[ed] significant moments of travel . . . reconfiguring the spatial and temporal contours" of her own fieldwork by way of the car, her Chevrolet once more, in which she, in part, "conducts her research" and in which she invites us to climb in alongside her to experience "the time and space of modernity."[80]

Hurstonian expedition was, no doubt, tied to the state—funded by the feds and reflective of phonography's "much-touted power to capture the voices of the dead," a project that, as Jonathan Sterne observes, was "metonymically connected to the drive to dehistoricize and preserve cultures that the U.S. government had actively sought to destroy only a generation earlier."[81] She makes spirited interventions in the field of anthropology, however, disrupting, for instance, the putative time lag between informant and ethnographer by enabling a "shared time" in the automobile and by pushing against the guide series' privileging of the car as "the space from which to view a stationary folk tableau vivant," instead transforming her auto into a recording studio where she and her informants, while bouncing from one party to the next, trade tales and songs. "I staggered sleepily forth," says Hurston, "to the little Chevrolet for Eatonville. The car was overflowing with passengers but I was so dull from lack of sleep that I didn't know who they were. All I knew is they belonged in Eatonville." "Her car," as Retman astutely points out, "becomes everybody's car in the production of a multilocale ethnography and field."[82] This is the kind of automotivity of which Adrienne Brown speaks in her Michael Hardt—and Antonio Negri–informed reassessment of "the specter of commonwealth and collective value lingering within" cultures of Afro-automotivity.[83]

Lest we get too warm and fuzzy imagining Zora behind the wheel with her crew though, we can turn to any number of scholars' accounts of vulnerabilities that she faced as a Black woman out on the road in the 1920s and 1930s South. "My search for knowledge of things," Hurston muses in her conundrum of a memoir *Dust Tracks on a Road*, "took me into many strange places and adventures. My life was in danger several times. If I had not learned how to take care of myself in these circumstances, I could have been maimed or killed on most any day of the several years of my research work." Still more, Carla Kaplan

makes plain in her edited edition of Hurston's letters how wary she is of "romanticiz[ing] Hurston with Model T and pistol, searching out 'the Negro farthest down' and 'woofing' in 'jooks' along the way." The "truth is," Kaplan contends, "that she worked hard under harsh conditions: traveling in blistering heat, sleeping in her car when 'colored' hotel rooms couldn't be had, defending herself against jealous women, putting up with bedbugs, lack of sanitation, and poor food in some of the turpentine camps, sawmills, and phosphate mines she visited."[84] But as she was prone to "wandering" in "spirit," if not always in "geography" and "time," as she would describe it in her memoir, the automobile proved useful as a source of refuge from Jim Crow danger on more than one occasion for her, particularly as "racially 'mixed' teams" of WPA field researchers "travelling together were virtually unheard of." For these reasons, her "beat-up Chevy" was, more often than not, always her most dependable shelter.[85]

These perils are always close at hand as Zora kept on the move out in the field. Still it seems worth lingering on the invention emerging out of her automotivity. As intrepid and determined as her fellow driving contemporary Mary Lou Williams, Hurston turned to her engine of modernity to gather up, cultivate, and disseminate songs that played with and through time and space and that called attention to the scale and depth of Black community. And her "commonwealth car" (as Brown might call it) shapes and informs the aesthetics that she brings to bear on the Black folks' songs that she collected and performed on tape, ones in which we hear Hurston's "second soprano" conjuring "a communal vocal experience as a solo singer," as voice theorist Marti Slaten describes it. The songs are the cars that she drives and the vehicles that carry her listeners into the "imagined cartographies" of Black migrants all at once, working out the politics of spirited togetherness as well as passionate longings and everyday dislocations as her vocal wheels keep turning. They are the sounds that stored up a kind of complex counterknowledge to that which irked Hurston, the seemingly knee-jerk rendering of southland Black life that defined it as steeped in suffering and nothing but.[86]

I heard "Halimuhfack" down on the . . . East Coast. . . . I was in a big crowd, and I learned it in the evening [in] the crowd. . . . I learned it from the crowd. . . . [Zora singing]: "You may leave 'n go to Halimuhfack, but my slow drag will bring you back. Well, you may go, but this will bring you back. I been in the country but I move to town. I'm a toe-low shaker from a head on down. Well you may go but this will bring you back. . . . Some folks call me a toe-low shaker, it's a doggone lie. I'm a backbone breaker. Well you may go, but this will bring you back. Oh you like my features but you don't

like me. Don't you like my features, don't you shake my tree? Oh well you may go but this will bring you back. Hoodo! Hoodo! Hoodo do working! My heels are poppin' . . . my toenails crackin'. Well you may go, but this will bring you back."[87]

You can hear Hurston relishing the wicked innuendos running amuck in "Halimuhfack," a jook song she'd "heard down on the East Coast" of Florida and one that exudes the "slow and sensuous" rhythms of the jook, that undercommons gathering place where, as she would famously insist, Negro theater originates, where "bawdiness" and "pleasure" erupt out of a smoldering elixir of song, dance, and inspired instrumentation.[88] All taunt and gentle seduction, Hurston the singer / interpreter gamely seizes on the mischievous wonder of a song that nonetheless documents and archives Black geographies in flux. It is a song that calls attention to the "imbrication of material and metaphorical space."[89] As Hurston would describe it in her "Folklore" manuscript chapter for the FWP, "Halimuhfack" is a "blues song" whose "title is a corruption of the Canadian city of Halifax. The extra syllables are added for the sake of rhythm."[90] Yet "extra syllables," the gateway to lyrical "corruption" here, are the beats that carry the song onto another plane of expressive recourse for African Americans managing the exigent pressures of Jim Crow life, the quest for equality, employment, and human sustenance. Like "Diddy-Wah-Diddy" and other "Negro mythical places" of Black folklore that she documents in her automotive guide writing, "Halimuhfack" is the site of the speculative, the not-here; it's the in-between world of mythical folklore and blues quotidian life.[91] Hurston's shrewd rhythmic elongation of a north-of-the-border place (a place where Black fugitives found shelter from those who sought to return them to US bondage) renders it unrecognizable, turns this place into something new, another site of Black flight with its own quixotic allure, matched only by the "slow drag" of a singer bold enough to try to seduce her lover to return.

"Halimuhfack" is a record of Florida Jim Crow life as it was lived in a felt relationship with space, place, and the land that our intrepid anthropologist crisscrossed by car. In her time working for the FWP—which, on the one hand, flexed its racism by hiring her "in a relief rather than an editorial-supervisory capacity" and yet, on the other hand, enabled her to "live and work out of her own home in Eatonville, a privilege extended to only a handful of writers nationwide"—Zora's taped performances exude the kind of adventurous independence that would ultimately inform the iconicity of her career.[92] Her recordings also stand as sound evidence of "different knowledges and imaginations . . . ," they are the kind of recordings that hold out the promise of "call[ing] into question the limits

of existing spatial paradigms and put[ting] forth more humanly workable geographies."[93] Hurston's rendition of the song encapsulates the driving and oscillating Zora, the woman who was both of and in the crowd as well as whimsically positioned outside of it. Reveling in the taunt, sass, and sly insinuations of this jook song's chorus ("You may go but this will bring you back"), she inhabits the playful ("Hoodo! Hoodo!") and the flirtatious energy of the tune while also wistfully stretching out the song's melancholic lyrics ("You may go but this will bring you back"), lyrics that signal lapsed love, abrupt departures, and the sting of abandonment. She translates into sonic feeling "geographic patterns that are underwritten by black alienation from the land."[94] As the twinned pressures of the Great Migration and the Depression continued on through the thirties, songs like "Halimuhfack" captured the entwined sounds of vibrant, ingenious, raucous communal sociality and movement; sober, individual despair; and a deep bone will to survive and thrive in the face of enormous socioeconomic and regional transformations. Inside the massive archive that is Zora's playlist, in the anatomy of each of these big, colorful and complex songs of the self, Black folks make their own time while the wheels keep turning round and round.

"Sister, Can You Line It Out?": Laying Down Tracks with the Brothers

The essence of Zora Neale Hurston's contribution is that she resolved to capture in writing and recorded sound the culture of black folk in America which had evolved and survived, and give it back to them and to all the world.

—STETSON KENNEDY[95]

She had an ear for that which was all around her, and she likewise had a voice that held on tightly to the melodies of her people that she feared might disappear. To her fellow researchers, she introduced and (re)inhabited "found" material with a delivery that was equal parts earnestness and performative mischief.

HURSTON: This song's called "Shove It Over," and it's a lining rhythm pretty generally distributed all over Florida. It was sung to me by Charlie Jones on the railroad construction camp near Lakeland, Florida.

HERBERT HALPERT: Bout how long ago?

HURSTON: Uh, I gathered that in '33. 1933. [*Clears throat, then sings:*] "When I get in an Illi-noise / I'm going to spread the news about the Florida boys / Shove it over, hey hey hey, can't you line it? / Ah shack a lack a lack a lack a lack a lack—mmph! / Can't you move there? Hey hey hey. A can't you try? / Eat him up whiskers, he won't shave / Eat him up a body, like ah he won't bathe / Shove it over. Hey hey hey, can't you line there / Ah shack a lack a lack a lack a lack a lack—mmph! / Can't you move there? Hey hey hey. A can't you try? Here come a woman, walking across the field / Her mouth exhausting like an automobile / Shove it over, hey hey hey a can't you try?"[96]

A vocal Hurston on tape in 1939 delivers the word of the absent Mr. Jones, and the message is clear: the secret of excruciating Black industrial labor as it was managed by workers who were laying down modern lines of transportation and who "lined out" lyrics for one another is a tenacious miracle of a thing. Listen, Hurston's performance suggests, to physical energy, effort, and exhaustion translated into sonic respite, into rhythms and rhymes that both sustained the beat of work ("When they say shack a lack a lack . . . they're getting ready to pull back, and when they say umph! they shove the rail," explains Hurston) and were just as prone to wandering away from the labor camp toward the elsewhere of places like "Illi-noise" ("Can't you move there?"). Hurston here stands in for Jones, but she is also something of a choir leader and preacher figure lining out for her congregation. In the tradition of African American hymn singing, "lining out" is crucial to the performance as it entails the act of leading and clearing a path for others. In antebellum culture, these hymns were often "intoned a line at a time—by someone who could read the text, and were then taken up by the congregation." It was a style of hymnody "infused with enduring vestiges of African musical forms [that] created the complex heterophony, subtle rhythms, and unhurried intricacies that became known simply as Dr. Watts."[97]

Hurston draws on her extensive knowledge of railroad labor and the songs emerging from that labor to "line out," so to speak, the intricate material history of Black work songs for her audience, to break down these songs to the nuts and bolts of their origins so as to hear the ways they came to life and to likewise breathe new life into this music as a hallowed form of American vernacular culture. "A rail weighs nine hundred pounds and the men have to take these lining bars and get it in shape to spike it down," she points out while introducing "Let's Shake It," another song in her repertoire. "And while they're doing that," she adds, "they have a chant and also some songs that they use the rhythm to

work it into place. And then the boss hollers 'bring me my hammer gang' and they start to spike it down."[98] The "gandy dancers," as they were called in the early period of the national railway system, "laid and maintained railroad tracks in the years before the work was done by machines," "using song to coordinate work. . . . Rhythm was necessary both to synchronize the manual labor and to maintain the morale of workers."[99]

HURSTON: This song, I got it at Talahand, Florida, which is the railroad center in the northern part of Florida.

HALPERT: When was this?

HURSTON: I got this in 1935. I don't remember the man's name who sung it to me, but I got it at Talahand. It's a railroad camp. . . . It's a chant for men lining. . . .

Ah, Mobile, ha!
Ah, in Alabama, ha!
Ah, Fort Myers, ha!
Ah, in Florida, ha!
Ah, let's shake it, ha!
Ah, let's break it, ha!
Ah, let's shake it, ha! . . . [100]

She entered into the spaces of men with ease, adapting their shared languages and sounds of labor, their penchant for blue banter as well as sometimes disturbingly casual tales of violent sexual conquest (see, for instance, the jook song "Uncle Bud," which, Hurston cautions, is "never" sung "before respectable ladies"). In these and other instances, Hurston figured herself as both the engineer, laying out the blueprint of these songs for the record, and the worker spiking down rhythms that would light up a map of Black labor movements across the global South. Songs like "Let's Shake It" reverberate with the latent foundational power of Black workers' energy sounded out to the beat of her own propulsive exhalations.[101]

Through her own curated playlist, Hurston sought to capture and convey the focused, disciplined energy of these sounds in her research and performances of lining rhythms. This music, her work suggests, remains evidence of the extent to which African Americans were (literally) the backbone of burgeoning industrial life in American culture. The sound of Black railroad construction that she aimed to get down on and for the record is, in other words, a sound

that mediates and documents the relationship between Black embodied practices and the aspirational sprawl of modernity. As Library of Congress archivist Archie Green observes, "each train" from this era "is directed and cared for by muscle and nerve. Hence, railroad lore fuses the sounds of machines with the emotions of workers. Right-of-way construction hands as well as operating and maintenance craftsmen perceive locomotives, cabooses, roundhouses, or track-sections as other mechanics view their own work sites. But a railroad is more than a place to earn a living. Precisely because a train is an artifact in culture which can be labeled 'iron horse,' it is a highly important symbol in folk tradition." To build a path for the "iron horse" and to manage that path, Black railroad workers drew on the mutually constitutive relationship between improvisational sound and physical strength to enable them to complete their tasks. They called on lining rhythms "to accompany and spur on labor" and to "express perfectly the communal nature of both work and music."[102]

The men in Charlie Jones's song are focused on the work at hand as well as the ways that this work ravages the body, and they are likewise wandering in and through this music into other realms of consciousness and perception, shaking something loose, catching a glimpse, for instance, of a motor-mouthed woman on her way to places unknown. "They sang it out," describes Toni Morrison of this tradition dating back to chain-gang slavery, "and beat it up, garbling the words so they could not be understood; tricking the words so their syllable yielded up other meanings. They sang the women they knew; the children they had been; the animals they had tamed."[103] Hurston's performance of Jones's tune conveys the rhythmic epistemology at the heart of the African American labor song born in captivity and still very much alive and necessary in the Jim Crow culture of her day. Every exhalation, every grunt, every vigorous and impassioned utterance catalogs the ways that Black folks used music as a tool not just to bear up under brutal conditions but to transform their stolen agrarian and (later) exploited industrial labor and lives. Together on the line, they transfigured that brutality into profligate expressive forms that transgressed the physical and spiritual misery of their material circumstances. Zora toed their line forward, held fast to their sounds, and committed her life to hitting the replay button for the masses and resolved to play it loud for as long as she could.[104]

Though her time with the FWP was short—lasting for a total of roughly eighteen months and over by August 11, 1939 (when she left the "now floundering" project, "packed up her car, and got out of town")—her work of art in the burgeoning age of mechanical reproduction illuminates the pivotal and momentous instrumentality of sonic Black womanhood. Hurston in these recorded

performances becomes the arranger who, as music theorist Peter Szendy observes, "signs" her listening. As the performer/arranger of these folk songs, she operates as "an adaptor, transcriber, orchestrator" who performs a record of what she has heard. Her performance doubly inscribes the self-making dreams and imagination of the Black collective whose voices she preserves, as well as her own present, active, independent reception as a woman with her ear to the ground and her voice on the wind. This is the work of a sister intent on cultivating a "sense of process to sound theory" in a way that has the power to, as Sterne might characterize it, "restore sociality and contingency to our theories of reproduced sound." Hurston's media(tions) "treat reproduction as an artifact of human life instead of as an ontological condition."[105] This is the grist of her intellectual life in sound.

Coda: "She Rock": Turning the Beat Around with Zora and Friends

A voice of the people. An archive of folk sound. The Zora who surfaces on these Florida Folklife recordings actively theorizes her own phonographic project, walking us through her dual ability to, like Edison's queer little late Victorian instrument, both record and play back the sound around her. This embodied sonic performance amounts to a combination of social survival strategy in the name of a people bereft of their own records. It is ethnographic inscription made by the instrumentation of her own body and aimed at putting Black voices on the (scholarly) record. This is Hurston's version of "sonic Afro-modernity," yet it differs from Alexander Weheliye's landmark definition of phonographies, where "the coupling of the graphematic *and* the phonic represents the prime achievement of black cultural production in the New World." The phono in her repertoire does more than "intermingle" with the graph in her hands. Rather it amplifies and worries it, and it speaks back to the crisis in the archive wherein Black folks—and Black women in particular—have, more often than not—supplied the sound without access to commenting on said sound. They have made music without much of a platform, a public, elevated site to mull over its meaning and value, with nary a place to share their own tales about its lingering power and resonance. Zora, the recorder, makes her own records and shakes up the scene. She puts us on alert, letting the world know by way of her own actions, her busy-ness, her multiplicity of projects and visionary, wish-list plans, that the work of Black women thinkers like herself was varied and complex. It is work that demands that we listen carefully.[106]

So watch her whirl through that stage of her singular career. She was intent on turning the beat around, keeping it in the mix of our cultural consciousness so as to prevent it from vanishing, so as to make it felt and heard across the course of a rapidly changing epoch. And as a result of this steadfast commitment to building a repertoire of ephemeral sounds and gestures, Zora Neale Hurston quietly paved the way for a figure like Civil Rights–era activist and musician Odetta, who would emerge on the folk music revival scene a little over a decade later with a similar kind of passion for excavating voices on the lower frequencies of history. If, as historian Matthew Frye Jacobson has shown, Odetta would assume the role of "a public *archivist*" through renditions of work songs, prison songs, and railroad chants, "delivering up to consciousness some long-suppressed historical sounds and scenes that might inspire" the Black folks "in her audience and accuse, remind, challenge, and prod the whites," Hurston, more than a decade before her, set the stage by rushing to preserve and care for this material, affirming its very existence for white listeners who were no doubt more (and perhaps only) familiar with Black music prepared for the concert hall.[107]

From Waters to Hurston to Odetta, the beat goes on. These were women who pounded out the rhythm of grossly neglected and mishandled material experiences and feelings, quotidian hopes, and transgenerational desires, and they did so through the stubborn exultancy of their own performing bodies. They took "the ethics of the jook and the blues" that Hurston so loved and valued as "true" to Black vernacular culture, ethics that "freed" all of them from "the constraints of ladyhood."[108] They carried this energy into (re)covering the music of the Black regional diaspora—and especially, in the case of Zora and her '60s counterpart Odetta, that of the masculine dispossessed. Hurston who did so most spectacularly and extensively, setting out on ethnographic recording expeditions that enabled her to inhabit the space of men at work and play in songs like "Georgia Skin," "Gonna See My Long-Haired Babe," and "Uncle Bud."[109] She utilized folkloric song as, in part, the medium through which to casually and yet emphatically transgress gender categories and expand the reach of her vision and sociality as a Black woman artist and scholar. And she turned the occasion of her own sonic recording practices into dynamic manifestations of Black archival memory and extensions of her own daring, inventive, and idiosyncratic 1930s cultural criticism.[110] Hurston was, it turns out, her own new media, her own "prophetess" who "arose" and "shook with many shakings," and her work from this era forecast a modern hermeneutic: Black feminist sound writing capable of secretly rocking the foundations of American culture.

3

BLUES FEMINIST LINGUA FRANCA

ROSETTA REITZ REWRITES THE RECORD

If there were any critic or collector who would have been an especially passionate steward of Zora Neale Hurston's historic recordings, it probably would have been the Jewish feminist activist, intellectual, and entrepreneur Rosetta Reitz (pronounced "RIGHTS"). The dynamic Reitz who proudly wore both such hats throughout her trailblazing career would have likely gone to great lengths to care for, study, protect, and preserve Hurston's sound scholarship. But Reitz's voluminous archive surprisingly shows little trace of Hurston's labors. Her absence from the feminist public historian's records perhaps says everything about the extent of Hurston's obscurity as a sound archivist in the 1970s since Reitz was a beast of a collector, a superwonk who, above all else, devoted her life to Black women's sonic cultures, and a woman who would ultimately produce some of the most extensive and trenchant critical thought and writing about Black women musicians that had ever been published. Born Rosetta Goldman on September 28, 1924, in upstate New York, the woman who would ultimately become a maverick in feminist blues record collecting, record producing, and Black feminist music programming managed the demands of single motherhood in the 1960s while bouncing through a series of jobs that often reflected her New Left, second-wave social and cultural sensibilities. From running her own 4 Seasons bookshop in Manhattan to writing a weekly food column for the *Village Voice* in the early 1970s to publishing *Menopause: A Positive Approach,* a Book-of-the-Month selection in 1978, Reitz sustained a multifaceted career for many years as a New York feminist activist and local cultural figure before settling on a line of work that became her passion and priority for the last three decades of her life. In the wake of completing *Menopause,* she turned in full to the world of blues women.[1]

The connection between that book and her dedication to African American women's music is one that she would highlight often in her many press interviews to promote the record label that she established in 1979 with $10,000 culled largely from "donations" provided by "women who kn[e]w and respect[ed] her work." "I was nurtured by these women and their music," Reitz told Black feminist journalist Jill Nelson in a 1980 interview. "I got courage, strength and wonderful energy back from them. . . . I almost feel as if I owe them a debt—they got me through." Reitz framed her commitment to promoting the import and legacies of blues women's work as, in part, a kind of feminist public service designed to broadly disseminate to other women the kind of nurturance that long-forgotten recordings had given to her. "I put their records on because here I was—a woman nurturing children, and on the job giving to the job and the bosses, and coming home and having to give. So who was feeding me? . . . These women fed me. I feel that I owe them something because I got so much from them." A self-avowed "feminist before the word feminist was even invented," Reitz articulated personal-as-the-political-as-the-cultural-as-the-professional narratives about the birth of her label, Rosetta Records.[2]

The first and only record label devoted entirely to specializing in women's blues and jazz music, Rosetta Records was the pinnacle of Reitz's achievements as a feminist historian and entrepreneur. In a career that spanned from the 1960s to her death in 2008, Reitz moved fluidly from running the label to teaching college courses at the New School in Manhattan, delivering campus lectures, and organizing full-scale concert events with artists whose work she lionized and for whom she fought hard to gain the critical and public recognition long denied them. As she explained in a letter to (of all people) Bessie Smith's adopted son, Jack Gee Jr., and his attorney, "I am a women's jazz historian who works hard to get more women written into the history of American music for their contribution to it. And written in [sic] with greater dignity and seriousness than is often afforded them when they are included."[3] That vision would drive Reitz to produce a total of nineteen album compilations (though she had been aiming to make twenty-six) ranging from commemorative collections of a single artist's work to thematic concept albums that focused on the pioneering contributions of musicians who were kindred in aesthetic spirit ("foremothers," "mean mothers: independent women's blues"), as well as subgenres of blues women's songs that focused on, for instance, the Great Migration ("railroad women's blues"). In what was arguably her greatest achievement as an archivist and producer, Reitz collaborated with the Library of Congress, regional librarians, a veteran historian of African American culture, and a Black feminist musi-

cian and activist to compile the first album anthology of women's prison songs, culled from the fieldwork of John A. Lomax and Herbert Halpert.[4]

While Rosetta Records served as the bedrock for her mission to recenter blues women's work in the national cultural imaginary, Reitz embarked on a campaign to institutionalize the music and iconicity of these artists in multiple contexts—leading the effort to, for instance, honor Bessie Smith with a commemorative postage stamp and to have her inducted into the National Women's Hall of Fame. At a moment when Black studies and women's studies academic programs were slowly yet determinedly growing in size and number at colleges across the country, Reitz worked the "outer rim," the spaces beyond academia, quotidian public and consumer cultures that neither prized nor even recognized the need for revaluing African American women's art of any kind. To Gee she pointed out, "[It] was I who badgered the NATIONAL WOMEN'S HALL OF FAME, from the time they started, to induct BESSIE SMITH. My feeling was, that would give her a dignity on the level of my other heroes, who were already in: Emily Dickinson and Eleanor Roosevelt. When I lecture . . . I speak of these three women in the same breadth [sic] and discuss how each, in a creative way, carved out her own life, using improvisation, illustrating how much they have in common as American women of achievement."[5]

Reitz's entrepreneurial and activist vision was all-encompassing in such a way that it extended well beyond the label and into the realm of live performance, "the functional part of this music" as she called it in a 1980 *New York Times* interview. "There are books that have . . . academic feeling" she mused. "I wanted to get into the action more . . . get involved with the women, become an intimate and [an] adviser of these women, particularly the older ones—Sippie Wallace . . . Edith Wilson and Adelaide Hall."[6] It was the liveness of two concert events that she curated and produced in 1980 and 1981, respectively, that provided her with a platform to valorize the central ideals undergirding her own love of blues and jazz women's music: its sensuality, its humor, its mode of nuanced social critique, its articulation of women's autonomy. With legendary jazz promoter and producer George Wein, Reitz organized concerts that enlisted veterans (Wallace, Big Mama Thornton) as well as younger upstarts (Nell Carter, Koko Taylor, and Carmen McCrae) to perform a repertoire of songs arranged in categories that, taken together, canonized the forgotten (with tributes to Bessie Smith and Lil Hardin Armstrong) and celebrated classic songs from across the century made famous by blues women (from W. C. Handy's "St. Louis Blues" to Taylor's 1978 "I'm a Woman," her self-penned, revisionist take on Bo Diddley's "I'm a Man"). As she declares in the program essay to 1981's "Wild Women Don't Have the Blues" concert, "We want to show that women didn't only sigh and cry when they

Rosetta Reitz with blues legend Sippie Wallace, preparing for
the *Blues Is a Woman* concert

sang the blues but shouted in defiance, too. They also gave instructions. The songs
where the women state what they want in an unequivocal way, instead of reacting
to what they get, are thrilling."[7]

Reitz's directorial spirit conveys the passion of a curator who felt the music
to the bone and who was determined to get others to feel it too. For her *Blues Is
A Woman* show, she made it clear that, "I want [show host Carmen McRae] to
groove to [Reitz's script]. . . . I want her to talk-sing some of it. . . . I want Doc
Cheatham to give out a clarion call on the trumpet everytime [*sic*] she says: 'And
there was . . .' I want Panama Francis to use the brushes gently but use the cym-
bals for names like Bessie Smith, Sippie W. etc. I want Vic Dickenson to do a
little church response AMEN on the trombone. . . . I want Carmen to help out
with this and make suggestions that she likes."[8] Reitz maintained a serious, pro-
fessional, and stirringly personal relationship with the music, the surviving
pioneers who made the music, and contemporary artists who were busy at work
keeping the music alive. At the same time, she was steadfast about assuming the
role of "the messenger" figure who could protect and promote extraordinary
legacies and precious archives of sound and, likewise, prove how enduringly rel-
evant the music remained.[9]

But arguably Reitz's greatest and heretofore unheralded legacy was in the realm of music criticism. As this chapter reveals, Reitz is one of our most formidable blues and jazz music critics, as well as a focused second-wave feminist critic, perhaps one of the only feminists of her generation to consistently and extensively champion the aesthetic work of Black women musicians as a vital and central component—the bedrock—of modern American culture. Her voluminous body of work, which includes dozens of meticulously crafted and heavily researched liner notes essays on women's blues and jazz, not only make her worthy of recognition but also illuminate the myriad ways that Rosetta Reitz fundamentally revolutionized intellectual discourse on Black women's musicality. No study of Black women and music should, in my opinion, overlook the groundbreaking critical methodologies and style of analysis that Reitz brought to her writing, since her work sought to change the playing field on which Black women musicians emerged as topics of interest and value among critics as well as fans. She cultivated a new critical language and new lens through which we might engage these artists and apprehend their often stunning, moving, and exhilarating artistic choices. Her cultural theories and critical strategies for affirming Black women of sound anticipate the sensual and improvisational moves and the archival impulses of Janelle Monáe. They also recall the performative intimacies, high affect, and collector's curatorial vision of Lady Z(ora); and Abbey Lincoln's recognition of Black women artists as social mood critics who are urgently attuned to the worlds in which they are situated. Reitz, the intellectual, brought all of these concerns together in her writing and left behind some liner notes to accompany Black women's subterranean sonic revolution.

Wild Women & Feminist Reform: Rosetta Records & the Politics of Grassroots Blues Activism

Where did she come from? How did she come to be—this intensely committed, white Jewish feminist music critic who was equally in love with women's liberation and Black women's sonic virtuosity? What are the roots of a woman who ultimately held fast to the idea that her feminist politics and her vast and sophisticated knowledge of blues and jazz histories and musical repertoires were deeply entwined with one another? Born decades before the flourishing era of the modern women's movement in the mid- to late 1960s, Rosetta Reitz came of age long before the concept of a feminist music critic and entrepreneur would have been recognizable—let alone viable—career options for college-educated women—even during the war years of her early twenties when

women's participation in the labor force opened up new opportunities for economic self-sufficiency and reinvention. But gender equality was a concept that no doubt gradually permeated the social and political landscape of her life in the long arc that stretched from a childhood in Utica, New York (as "the last and sixth child of immigrant parents" who owned a bakery), to teen years "doing the lindy hop" and listening to the *Saturday Night Hit Parade*, to "jitterbugging" her way through her 1940s college years (in Buffalo and then Madison, Wisconsin) to marriage and motherhood, and finally to living a life as a separated and single New York City career woman in the late 1960s. Both the formation of the leftist Congress of American Women, which "successfully linked women's issues, social justice, and peace with racial equality and economic justice," and the birth of the National Organization for Women in 1966, which "challenged American society to heed women's grievances" for equality and widespread social reform, created the conditions for women like Reitz to find their activist voices, and her involvement in these organizations were pivotal to her intellectual maturation as a feminist. Reitz's politics gained traction in concert with the long history of twentieth-century women's liberation spurred forward by old guard feminist activists like Betty Friedan and Gerda Lerner, bohemian cosmopolitan thinkers like Simone de Beauvoir and Alice Rossi, the journalist and public-facing force Gloria Steinem, and Civil Rights leaders like Pauli Murray, Ella Baker, and Fannie Lou Hamer. Three years younger than Friedan, Reitz would have likely felt some generational kinship with that icon, the housewife and former labor organizer whose 1963 book *The Feminine Mystique* would set off an unprecedented national debate about middle-class white women's gender oppression. One can imagine how Friedan's call to those women to question their conditions and "to live an examined and purposeful life" would have been heard by Reitz, who, by the end of the decade, had struck out on her own in the world to take up a series of professional odd jobs.[10]

There were signs all along that she would eventually sustain a life in writing, from her early, one-off culinary publication, *Mushroom Cookery* (1965), to her second-wave self-help book, *Menopause* (1977)—the project which she always referenced as the pathway to her complete and utter devotion to the blues—to her occasional articles in the *Village Voice*. Across these publications, she was cultivating a politics in her prose that would come to fruition while running her label. If *Menopause* revealed Reitz's interest in freeing women of the stigma associated with aging and empowering them with knowledge about their bodies (in the vein of other classic works from that era), the archives she venerated and protected and the critical discourse about her beloved musicians that she pieced together with craftsman-like, painstaking care reveled in the sexual as-

sertiveness and autonomy of blues women's music. The leap that she was making between these two projects effectively bridged the historical gap between early twentieth-century Black women entertainers and the mid- to late century ethics of modern feminism. Just as Alice Walker, Daphne Duval Harrison, Hazel Carby, Angela Davis, and numerous other Black feminist scholars would look to the blues as an intellectual genealogical touchstone that established a "discourse of sexuality" authored by Black women who "constructed themselves as sexual subjects through song" and who conceived of sexuality as "one of the most tangible domains in which emancipation was acted upon and through which meanings were expressed," so too did Reitz wage a campaign to theorize the feminist sexual politics of the genre in the late 1970s and early 1980s.[11]

Her archive reveals that she often rehearsed these theories outside of or in preparation for her finished essays. In her unpublished notes on the bluest of blues queens, Lucille Bogan, for instance, Reitz reflected on the ways that Bogan's frank eroticism bespeaks the effort to "try to love ourselves," to "not skip over any parts even if we have been taught our most important female place is smelly, dirty, shameful." This act of reclamation is a ritual enacted again and again by the women she admiringly referred to as "outlaws," women who, in order "to survive . . . had to give themselves power to transcend their reality." "What these women were trying to do," Reitz mused in her notes, "was to explore their genuine feelings, unorthodox as they may be, without the usual cultural guidelines, meaning without the prevailing male point of view or the male version of a woman's point [of view]" which men "may have written" for women to sing. The authority and integrity of the artist's performance and her interpretative powers remain central in Reitz's analyses and serve as the sturdy framework for articulating the complexities of sexual desire and pleasure. Like a speculative ethnographer of sorts, Reitz interrogated and tried to imagine the intimacies of blues women's lives and how those intimacies undergirded their repertoires. In her research files, she ventured that the "blues women[,] unlike feminists" of her own time, "didn't have to fight to be on top," and she quickly made a memo to herself to try to "find this out from some women how their sex was—did they get on top with no fanfare."[12]

Her frank and focused feminist principles merged with a clear recognition of long-standing debates in Black studies that centered on the question of African retentions and the survival of traces of African cultural lifeworlds in the wake of the Middle Passage and North American enslavement.[13] Peppered throughout her profiles of various musicians are references to their invocation of diasporic sounds. In Dorothy Donegan's performances, she traces a line of influence "underneath the sophisticated European technique" in which "lurks

the Pentacostal [sic] big Mama who has always swung the congregation and moved them by shouting her use of African rhythms." This was no caricatured figure to Reitz. Rather, church women, blues women, and jazz pianists like Donegan were equally united in their virtuosic fortitude and their ability to uniquely summon the cultural roots of Blackness that serve as the DNA for the blues, for musical modernity. The genius of Bessie Smith was, in Reitz's opinion, her ability to "change a folk expression into an indigenous art form by successfully blending African and Western modes of music." Her criticism insisted on affirming the continuities between "the development of this music" and the Black diasporic oral tradition.[14]

Well aware of the value of the blues as a force of sustenance, survival, and self-reckoning in Black folks' lives, Reitz kept notes for herself on her own gendered philosophy of the music. "Through their songs," she ventured, "these women show us their ways of being; their ways of comprehending the world; of making sense of their lives . . . synchronizing feeling with music into understandable order." Hers was a feminist reading of blues culture, quotidian and clear-eyed in its assessments of this music's utility and meaning specifically for, by, and about Black women. Her form of Black feminist blues study posed a critical alternative to 1980s Black poststructuralist rereadings of the music that posited similar arguments but that nonetheless and unsurprisingly continued the late twentieth-century trend of diminishing or altogether obscuring recognition of women artists as major architects of the tradition.[15] This was contemporary Black feminist blues theory in the making, a wholesale, intersectional interrogation of the form. Although sometimes prone to New Age hippie quirks and the occasional narrow claim or observation, Rosetta Reitz wrote criticism that was overwhelmingly robust, surprising, probing, and deeply and intensely committed to moving Black women back to the forefront of blues and jazz culture.[16]

"Mean Papa, Turn in Your Key": The Business of Feminist Institution Building

Rosetta Reitz's entire career in music collecting, the record business, concert promotions, and public history focusing on blues women's culture remains a startlingly unheralded rejoinder to the long-standing and persistent "generalizations about gender that get trotted out to explain the different ways men and women experience music fandom." Explains Amanda Petrusich, "There is the idea that women, temporarily incapacitated by unmanageable waves of passion, are incapable of comprehending how guitars work. . . . And that men, unsettled

by deep connections, need to reduce the experience of music to a series of facts and figures."[17] Men sort, collect, swallow up music trivia and spit it out like social assertion, as a form of bonding, drawing lines in the sand between fan tribes, so go such myths. Women, accordingly, nurse crushes and obsessions driven by "girlish" lust and frivolous wants. They may line up in their respective squads, these myths assert, but their interest in the music, if any at all, is led by body and not mind. No way that they'd want to spend time searching for sounds, studying an artist's body of work, imagining other worlds that said work might yet create for the listeners who love them.[18]

But a powerful combination of feminist vision and a passion for the blues was, for Reitz, the answer to these sorts of knee-jerk presumptions. She simply ignored the punditry that suggested that there was no place for women in record fan culture, in the record biz and in the growing subculture of blues record collecting and criticism that particularly flourished in response to the transatlantic folk revival. Throughout her career, she would highlight her own coming into consciousness as a critical listener and collector of the blues, calling attention to the gender homogeneity of that eccentric, subterranean network of blues and jazz record collectors that cultural historians Marybeth Hamilton, Petrusich, and others have documented in recent years. Recounting her time as initially the girlfriend who accompanied her beaus to record stores and who paid attention to their playlists, Reitz often emphasized her own gradual emancipation as an independent, fully attentive, and discriminating fan of jazz and blues, an evolution that spurred her desire to collect music for herself. A "record collector since 1940 when she was 15," Reitz would often cite her intellectual awakening as a feminist blues theorist as coinciding with her disentanglement from patriarchy. "When I had neither husband nor boyfriend who was telling me what to listen to," she states, "I started listening for myself. After having gone through the whole gamut—through Charlie Parker and John Coltrane and Ornette Coleman and Sam Rivers—I found great comfort and energy in these old blues women." Her own consistent collecting practices from her teens forward broke the mold of the standard—albeit oft-caricatured—profile of the 78 rpm record fiend. As Petrusich astutely observes, there "is a violence to the search" for rare records, "a dysfunctional aggression that vacillates between repellent and endearingly quirky. It's intimidating to outsiders, and it feeds on sacrifice." The need for family and community "ranked below the acquisition of new records. I wondered," Petrusich continues, "if women were unable (or just less likely) to make those kinds of choices."[19]

Reitz, however, defied the stereotype of the antisocial male record geek and instead managed to find a way to collect records, write about music, build a record

label, and raise a family. Guided by her sharp business acumen, she developed a career in music that drew on and was driven in equal parts by her youth culture intimacies and socialities with male music fans and her burgeoning political sensibilities. In her late-life personal memoirs, Reitz reflected on "dancing to a juke box" and the "number of boyfriends" she had while in college in Madison.

> They all brought me music. One was an Ellington fan, and one a Fats Waller fan and another loved Count Basie, especially Jimmy Rushing singing with him. I knew a math teacher who played Mozart Quintets for me and another boyfriend loved Wanda Landowska playing Bach on the harpsichord. I loved them all—the music, not the boyfriends.
>
> When I moved to Greenwich Village, the same pattern held. Men would bring me the music or take me to hear it on dates. In the world I lived in, it was taken for granted that music was a male thing.[20]

In a universe that was overwhelmingly dominated by men, Reitz would evolve into a feminist intellectual who embarked on a multidecade effort to recuperate, promote, disseminate, and champion the vast aesthetic, social, political, and cultural impact of blues women's work. Unlike many of her fellow contemporary collectors, her goal was not solely the acquisition and possession of lost records; her ethos did not merely deem "music as a thing to work for and revere and treasure and save, till death do you part."[21] Rather, she imagined her felt "kinship" with these recordings as valuable information about a woman's worth that she might pass on to other women and also send back as a corrective to a blues and jazz world that had, by the mid- to late twentieth century, neglected and rejected them. And so she put her connections to work. "At an informal collector's club called the Record Collector's Society, she met some of the most active of the researchers working in classic blues and jazz," including "Len Kunstadt who edited *Record Research Magazine* with his partner Bob Coulton." As Reitz recalls it, those gatherings were the spaces that allowed her to begin building her own collection, purchasing 78s by women artists from other members.[22]

When Reitz finally made the decision in 1979 to repair this thing that she felt had been "lost . . . the blues of 'women trying to really confront what they're living,'" when she decided to launch Rosetta Records with six years of learning about the basics of record production under her belt and a lifetime of facing nagging questions and problems ("So the 'real' blues," she once exclaimed, "had to be an itinerant beggar with a guitar—or maybe . . . somebody who wasn't even recorded!"), she both initiated the recuperative turn in Black women's blues and jazz studies and developed a specific kind of hermeneutics to explore with

Mean Mothers: Independent Women's Blues, Volume 1 album cover,
Rosetta Records, 1980

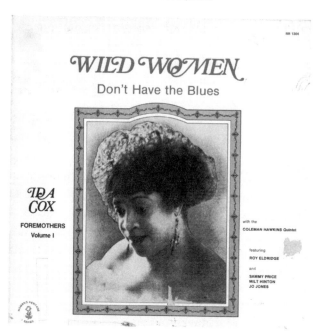

*Wild Women Don't Have the Blues: Ida Cox, Foremothers,
Volume 1* album cover, Rosetta Records, 1981

new fervor and originality the history of the music and the intricacies of the form.[23] Reitz, as we shall see, innovated a kind of critical, second-wave feminist music writing that takes seriously and rigorously conceives of Black women musicians as intellectuals, as producers of high art, and as agents of their own fully embodied self-making. The mammoth amount of critical work that Reitz produced in conjunction with her blues album reissues explodes all sorts of arbitrary, sexist dichotomies that devalue women musicians' intellectual and artistic thought—thought of any kind. Still more, Reitz's work established a revolutionary blueprint for feminist sound writing that demands far greater attention, and this chapter turns an eye to that writing in order to illuminate its pathbreaking significance. It traces her innovations as a critic and the development of a kind of cultural analysis that showcased her intimate dedication to the music and the musicians she openly adored and admired. This is work that embraced and paid close attention to the intricacies of craft, performance techniques, noteworthy style, and the historical, social, and political contexts shaping the form, as well as the specificities and significant details of artists' biographies. Her efforts were driven by quest and questioning. "When the women's movement got underway in the '60s," she would tell the *Chicago Tribune* in an interview in 1987, "I started asking myself, 'Why is jazz a man's domain? Where are the women?'" The answers to such questions emerged as a result of "locating the women and collecting their original recordings."[24]

"Sort of like an Archaeologist": History Reitz Itself

Perhaps more than any other postwar popular music critic, Reitz left behind extensive documentation of her own busy and assiduous growth as a critic who clearly and self-consciously worked at her craft as a writer and as a revisionist historian. Reitz's archive documents the lines of her research and her scholarly immersion in blues studies: her focused attention to cultivating a feminist critical voice that was knowledgeable and capable of speaking back to established canons of thought, as well as her intriguing forays into strategic forms of bricolage—cutting and pasting and suturing together the phrases and formulations of other critics into a language that best suited her analytic needs. This latter practice, of which her papers give us proof, is a complicated ethical dance; but as I argue later, we might ultimately look to Rosetta Reitz's discursive endeavors as an example of improvisational feminist sound studies, a critical hermeneutic that destabilizes the supposed boundaries between highbrow art criticism and popular music culture.

In her informal prose, notes, and personal letters, Reitz's criticism features a cluster of recurring tropes: critiquing jazz history and disassembling ossified gender myths about blues and jazz music culture; intervening in blues and jazz historiographies to offer feminist counternarratives; and recuperating the pioneering work of marginalized and forgotten blues and jazz women. First and foremost, Reitz sought through her writing to dismantle the most common and long-standing presumption about the blues and about blues women's music in particular: that the genre is inherently melancholic and that the canon of blues songs sung by women is a manifestation of Black women's wholesale and perpetual abjection. Reitz remained doggedly determined to obliterate these kinds of presumptions from the historical record, and her approach to doing so took the form of exhaustive research and hermeneutic analysis of blues criticism coupled with the cultivation of extensive, well-crafted revisionist prose. In the drafts upon drafts of notes that she kept for various projects, she rehearsed a variety of arguments as to why blues women's work was deserving of a rehearing in the court of cultural opinion. "Historic distortion," she mused,

> is too gentle a term for the violation that took place when men produced the race records for the white market. A system of editing was established, perhaps it was unconscious. Imagine the man in the record company office in New York decid[ing] on tunes. Will he pick "Men are like Street Cars" or "Pappa [sic] if you can't do better, I gotta another sweet papa who can" or will he pick, "I'll cry for you, I'll die for you, I'll be a slave for you"[?] Sometimes the blues women are not even mentioned in books on the blues. There is, I think, a volume devoted to them in The Blues Series published by Stein and Day with typical errors only a man would make. The author, Derrick Stewart-Baker titles a chapter about Ida Cox "Wild Women Get The Blues" when the tune she made famous and was a huge seller was called "Wild Women DON'T Get the Blues." He also mentions another equally arrogant tune "Mean Pappa [sic] Turn Your Key" which in fact was, "Mean Pappa [sic] Turn IN Your Key," the difference is as great as night and day and right and wrong.[25]

From the negligent to the conspiratorial, record executives, critics, and male fans of the music were guilty, according to Reitz, of developing and perpetuating a portrait of the blues woman as consumed by her own catastrophe, as passive and sexually dependent, as lacking sophisticated artistry. By forcefully reiterating the contention that blues women "celebrated their sexuality unashamedly," the dense, sometimes knotty, and always ardently conceived

personal notes informing her liner notes paved the way for a late twentieth- and early twenty-first-century renaissance in cultural criticism on blues women's music.[26]

Reitz cared most about dismantling the presumption that Black women musicians lacked professional and artistic autonomy, and her own personal archive reveals the extent to which she consistently and meticulously contested cultural historians' narratives about the Empress of the Blues in particular. In her critique of the *Notable American Women* encyclopedia's entry for Bessie Smith, for instance, she makes a point of flagging the careless description of Smith's rise as one in which "she gained confidence." Reitz acerbically points out that "this is an absurd statement to make about Bessie Smith. She had a lot of confidence when she was working in Atlanta at the 81 Theater for $75.00 a week, a lot of money before 1920 because already she was hiring the chorus line and the musicians and producing her own shows." Reitz continues her dissection of *Notable American Women*'s scholarship by noting that another line, which referred to the singer as being "plunged back into poverty," was "simply not so, the Great Depression effected [*sic*] everyone and she earned much less than in the high popularity years, but she continued to work and record at the Apollo Theater in Harlem. . . . [And] 1934 showed her as earning only $200 a week when 10 years before she was earning $2000." This sort of historical negligence fueled Reitz's sense of purpose and vision as a critic and an historian and served as the foundation for liner notes essays and articles in independent publications that she published in the wake of her success as a record label owner.[27] Reitz was constantly "keeping score" of antiquated and erroneous narratives and simultaneously developing new ways to tell and revise old stories of Black women and music. She also remained well attuned to the significant yet snail's-pace changes in cultural criticism of blues women, observing how, for instance, critics were "paying closer attention to Billie [Holiday] noting that they have begun to "sto[p] referring to her as 'girl'" and are beginning instead to address "'the severity and complexity of her musical mind . . .' and her 'independent musical intelligence.'"[28]

Hers was a recuperation project, one with depth, variation, and subtlety, and she maintained a tenacious and painstaking commitment to setting the historical record straight. Four kinds of figures receive the most attention in Rosetta Reitz's archive: the onetime greats who have fallen out of favor; the artists who were popular in their own time but were rarely taken seriously by the critical establishment; those blues adjacent performers who made their names in other areas of the entertainment world; and occasionally those average musicians who contributed to the fullness and ubiquity of blues and jazz culture. All of

"[L]isten to the wonderment of these women. Their ripeness and richness of spirit in the face of difficult odds, sometimes engulfed in blatantly dehumanizing circumstances and singing about it."

these categories were covered in Reitz's research for her label, and many of these types of artists were featured prominently on the albums that she compiled and designed and for which she oversaw engineering and production for all nineteen releases. Ida Cox and Valaida Snow were legends deserving of proper veneration, while 1930s and 1940s vocalist June Richmond had never received her due since, according to Reitz, "she wasn't pretty," was without "drama and drugs," and was overweight; thus, "she was dismissed." Others, like Dorothy Everett, were worthy of consideration as "everyday blues singer[s]" working "in an everyday black community" with "no frills, no feathers. . . . Because women like Dorothy Everett were the familiar, everyday homestuff," Reitz concludes, "the Queens could reign. . . ." In her mind, "without the thousands of local women . . . ," like Everett, "wailing the blues, the giants could not stand out in such bold relief. . . ." All of these women—the superstars and the everyday working musicians were astonishing to Reitz and worthy of our attention because, as she reminds, "[t]here was plenty of luck involved but there was also the hard work of an artist refining her craft. The big queens were very serious artists who persistently practiced preserving, refining their work and then embellishing with family finery." Just as well too, Reitz also voiced her investment in bringing to the surface the blues roots of Broadway entertainers such as Juanita Hall. In every case, she showed her chops as a digger and a collector who treated the recorded material of these women as evidence of a wider, more complicated and also more luminous history of Black women's cultural lives lived at the subterranean level—beneath the surface of hegemonic culture yet perpetually subtending it.[29]

Rosetta Reitz always remained hyperaware of the carelessness and indifference of the historians who'd gone before her, which only seemed to drive her resolve to engage in exhaustive research practices as well as a kind of detail-oriented writing that zeroed in on microgestures of style and specifics of socio-historical context. In her notes on Richmond, she reflects on how "there are many problems surrounding the retrieval of a fine singer like June Richmond because, the way the history has been written by men, she was not an important person in their scheme of swing. . . . But her 78rpm recordings do exist (with a lot of searching)[,] and we can hear her sound style." That style was quirky and dynamic, and Reitz focuses her attention on Richmond's "jokes, her comedy, her irreverent wisdom" as a vocalist. What is compelling here and elsewhere in her notes is how much *private* admiration she possessed for the artists for whom she wrote miles and miles of tributes and commemorations. This was love that constituted her entire lifeworld. Of Richmond she, for instance, writes both wistfully and whimsically about the ways that she was, to

her, "singing the dream of so many office secretaries stuck in their routine and portraying jobs where the highest form of self-expression was to correct a bosses [sic] poor English usage and get away with it."[30]

This kind of fanciful and yet earnest tone was not uncommon in her prose. Reitz frequently spun feminist narratives out of the music of these artists, pushing the limits of her own writerly imagination to translate into prose the feelings and scenes evoked by the sounds made by these women. It was a move that resembled "golden era" rock music criticism aesthetics of the 1960s and 1970s, but Reitz consistently coupled her emphasis on style with studious background on the music's relationship to time, space, place, and the specific material conditions of African American life that gave rise to the records. She was especially enamored with championing the 1920s, proclaiming that "this was a very special period, the only period when a group of women had power. . . . They were the women in charge. They had real estate, fur coats, fancy satin and velvet dresses, jewelry, Cadillacs." For her women's railroad blues album, which focused largely on that era, she lingered in her research on the historical resonance of trains in the modern world of Black migrants, echoing the theories of Black studies historians and observing that "trains represent power and speed. The sound of the train passing had a romantic beat. Train, a century before the radio, made democracy available because not only the very rich could travel for the price was within reach." Out of this mode of transportation and escape came, she deduces, the "rhythmic beat . . . of blues music." In the copious notes she took to prepare for the Dorothy Donegan album, Reitz produced extensive timelines of African American pianists that begin in the late 1800s, stretch through the 1950s, and include a diverse range of genres and performers—from ragtime stride to KC stride, from Scott Joplin and Will Marion Cook to James P. Johnson and Mary Lou Williams. These are notes that emphasize her strong interest in mapping genealogical legacies and influences. Reitz's experiments with album titles—"DOROTHY DONEGAN plays HISTORY, DOROTHY DONEGAN plays with HISTORY . . . DOROTHY ROMPS THROUGH HISTORY"—are evidence of a critic who recognized Black women musicians as deeply entrenched in the intellectual project of shaping and responding to their world by way of the sonic.[31]

Genealogies matter in Reitz's work. They stand as proof of women musicians' aesthetic relationships with one another. They represent their most intimate sources of artistic inspiration, their personal journeys of growth as musicians, their personally curated archival knowledge of music history, their apprenticeships, and their roles as mentors. For Reitz, these musicians are never without a past, never ahistorical, never to be regarded in a vacuum. Every artist, her work suggests, has a story steeped in the run of the historical. They are both

repositories of history and, likewise, always possessing the potential to become history-making. As she eloquently mused in her personal notes about Dinah Washington, "It is as though the humor and the theatricality of Ma Rainey had been filtered through the sufferance of Bessie Smith to nourish the number one blues singer of the whole America." This is the kind of critical riff in which she specialized—densely packed with sage-style references, vivid similes, palpable affective language. Her second-wave feminist spirit draws her to finding and venerating the figure of the foremother in this music just as she identifies her own ("I claim Bessie Smith as my foremother as much as I claim Eleanor Roosevelt"). Her criticism hammers home the fact that it is not enough to rewrite and renovate the value of already-legendary jazz and blues vocalists; it is necessary—and of downright urgent concern—to excavate the old-school roots, to suggest that no Ethel Waters means no Ella, no Billie, no Sarah. Just as much, her work insists that the relationship between Black and white vocalists will have to be uncovered. In her fierce assessment of Black cultural historian Donald Bogle's popular study *Brown Sugar: Over One Hundred Years of Black Female Superstars,* Reitz observes that he "doesn't mention that when Peggy Lee was singing with Benny Goodman in 1941 she heard Lil Green's 'Why Don't You Do Right?' with Big Bill Broonzy and copied Lil's phrasing exactly when she recorded it with the Goodman band."[32]

Reitz's work equally shows how Black women musicians, too, are sharp and innovative listeners, immersed in absorbing and translating the cutting-edge work of fellow artists. Sarah Vaughan, for instance, in her viewpoint, "learned . . . the lesson of her own inspiration, Charlie Parker, and [has] gone beyond it in self-preservation." Alongside her love of vocalists, she is especially drawn to "lost" legacies of women instrumentalists: "all-girl bands," mothers who beget daughters who follow in their footsteps as pianists, "women who accompany themselves: Lil Armstrong/Sippie Wallace/Victoria Spivey." These artists are, as Reitz's notes make clear, the most neglected in jazz and blues history despite the fact that many contributed to the foundations of the music, doing the loyal and dependable work in the rhythm section and taking on the compositional grunt work, in some cases, for iconic figures like Satchmo.[33]

What is perhaps most remarkable about Reitz's dedication to this work is that the act of resuscitating and recirculating old, out-of-print records stretched from her private life all the way into her public, present-day world of 1980s and 1990s Manhattan, where she used her growing clout as an indie label entrepreneur to locate living musicians whom she felt were additionally in need of their due. Marveled pianist Dorothy Donegan to the *Los Angeles Times* in 1992, "She is brave. . . . She puts her money where her mouth was. She's helped women who

Bessie Smith, postcard

would have gone unrecognized. She helped me. . . . She brought back things I had done during the 1950s that would have been lost." Donegan, like some of the surviving Sweethearts of Rhythm who worked closely with Reitz as she compiled the group's Rosetta Records anthology, maintained lively connections with the producer as the latter pitched her vision of an album that could capture Donegan's influence as a pianist, an influence that she was determined to affirm with the strength of her label. "I don't listen to [her label's] music every day," Donegan muses, "but I'm glad it's being unearthed. She's sort of like an archaeologist."[34]

"Outlaw women . . . what made them a group? . . . tho[ugh] they sang songs of sad love they also sang songs [of] fantasy and power."

She was also a steadfast believer in the greatness of her subjects as being equal to that of the so-called gods of the Western canon. No one before and no one since Rosetta Reitz has ever put so much energy and care into reconstituting the work of blues and jazz women in relation to this particular line of "high art." There are, of course, pros and cons when it comes to this sort of a move. Likening the "harmonic complexities" of the "Divine One," Sassy Sarah Vaughan, to "Bartok and Milhaud, the formality & dignity of Bach, and sometimes the lyrical romanticism of Debussy" enables other (largely monied, largely white folks') publics to potentially hear her genius, but it, of course, also threatens to render her value dependent on nonblack sources of cultural worth and excellence. Yet Reitz's criticism always strives to subvert this kind of myopia and to be as expansive and capacious as the forms she explores. Again, with regard to Vaughan, she lobbies for her readers to recognize the magnitude of her work, arguing that "at her best, when she is completely free & improvising she incorporates all of the elements I look for in music today; the rhythmic drive and energy of jazz, the passion and structure of the blues," all of this plus the kinds of mad skills that, for her, can easily go head-to-head with that aforementioned Euro foursome. "If this sounds excessive," Reitz continues, "remember, I am speaking of a giant of a woman who presents to her

audience filtered sensibility which has incorporated and refined a professional approach in an evolving jazz context for 32 years."[35]

In many ways, Reitz's own critical approach to reading her beloved women is probably closest to that of her contemporary Albert Murray, who, across his own prodigious body of cultural criticism on the blues, would increasingly gravitate toward comparative analyses that located the similarities between other aesthetic forms, such as literature and the music of African Americans. Murray found the throughline between Thomas Mann's title protagonist in his 1943 novel *Joseph and His Brothers* and "the fundamental qualities" of the "epic hero of the blues tradition, that uniquely American context of antagonistic cooperation. Joseph goes beyond his failures," adds Murray, "in the very blues singing process of acknowledging them and admitting to himself how bad conditions are." Reitz, too, set out to "convey something of the heroism and the majesty that [she] . . . felt from them." Majesty translates into "poetic imagination" in her work, the kind that drives Ma Rainey's "structuring of the blues," which runs akin, in her mind, to the work of Emily Dickinson. Majesty, laced with "courage, honor, integrity and an heroic attitude in life," manifests itself in the commanding vocality of the Queen of the Blues, Dinah Washington. Majesty is even lurking in the blue lyricism of Lucille Bogan's profane, obscenity-laden anthem, "Shave 'Em Dry," which Reitz insisted "is the same form of abstraction Matisse and Picasso were doing in the 1920s but this was poetry and music. [I]t is quintessential camp but above all it is self-confidence with pride & joy in femaleness."[36]

Majesty also manifests itself repeatedly in her study of the career of Bessie Smith, who "created a new art form, an American art that," as she argues, "required more than one person to perform it unless the singer was also her own piano player. . . . Bessie Smith set the example of the art of the blues, which by its seriousness and ambition successfully pressed the claim of the blues itself to be taken seriously in the world. She enlarged our concept of the blues [and] the limits of folk expression and showed us how a simple phrase like 'Woke up this mornin,' when sung by an artist, becomes a ritualistic symbolic action." Smith, a woman of vision and innovation, "an actress of the highest sort," is a recurring character in the epic that is Reitz's archive of writings. She is the foremother to Ella ("a genius who was musically radical, willing to take risks, with full knowledge of her artistic potential and of her limitations"), the mentee of Ma Rainey (who wrote blues songs that "contain some of the most exquisite poetry in the English language"), the progenitor of Billie Holiday, whom Reitz sought to liken to Gertrude Stein and, as she did many blues women, to visual artists—especially Matisse. In her notes, she compared what Matisse "said when talking about his art[,] 'My choice of colors does not rest on any scientific

Rosetta Reitz with the performers of the *Blues Is a Woman* Concert at the
Newport Jazz Festival *(standing, l to r):* Koko Taylor, Linda Hopkins,
George Wein, Rosetta Reitz, Adelaide Hall, Little Brother Montgomery,
Big Mama Thornton, Beulah Bryant; *(seated, l to r):* Sharon Freeman,
Sippie Wallace, Nell Carter

theory; it is based on observation, on sensitivity, on felt experience,'" to "Holiday's
statement about her art[,] . . . [']What comes out is what I feel.[']" Repeatedly
she returned to Matisse analogies to illustrate her claims about the ways these
women were architects of the form who used affective complexity as dense story-
telling strategy. When "Bessie or Dinah sings Jailhouse Blues because they so
convincingly talk to Mr. Judge," she reminds, "they are not really in jail[,] they are
singing about an abstraction. Matisse spoke to this point when he said: 'I do not
literally paint that table, but the emotion it produces on me.'" For Reitz, the scope
of what these musicians were capable of articulating in their work and the co-
gency of their observations amounted to socially and politically informed philos-
ophy, the kind of mood criticism that Abbey Lincoln executed in her singing.
Reitz drew on similar strategies and principles in her writing, observing of the
blues and jazz woman, in this case Lady Day, that the "existential lucidity which
came to [her] from surviving racial violence again and again found expression in
the way she communicated emotionally through her songs. Billie Holiday was
especially caught up in the historical misadventure that was American racism in

the 1930s and 1940s." The nightmare of antiBlackness was a thing that Holiday and her peers would reckon with through their music. Reitz made it clear in her work that these women knew terror and disassembled it through sound. For these reasons, she would always insist that this thing called the blues of Black women musicians "is an art of a profundity and breadth of vision that only mature artists who continually develop and grow are capable of."[37]

"You Can't Sleep in My Bed": Writing Virtuosity & Blues Women's Heroism

If there is a glaring weakness in her criticism, it is perhaps that her work was largely void of negative critique, of hard, clear-eyed assessments of failures as well as triumphs. In many ways, this was to be expected since her mission entailed restoring Black women musicians to the public cultural imaginary as a corrective to their long-standing dismissal by tastemakers and cultural historians. More than anything, these tropes remain consistent across her entire collection of work: for Rosetta Reitz, Black women musicians were archivists, masters of virtuosity, sonic artisans of indelible style, and mythic adventurers unmatched in their heroism. She understands musical virtuosity as the elegant realization of performative expertise and, likewise, as the valiant action initiated by artists who forge powerful affective bonds with their audiences. Reitz's intellectual labor as a critic hinges, in part, on highlighting this virtuosity. To come correct and honor them properly, her work essentially asserts, students of the feminist blues must mirror all of the intensity, the sensuality, the humor, the rage and the sadness, the social wisdom and masterful storytelling of the music itself. They must look to the historical and cultural memory of the artist and her aesthetic choices, she maintained, and focus on the innovative arrangements emerging out of that memory and out of a vast, immersive knowledge of genres and repertoires. Of pianist Lil Armstrong, she noted, for instance, that she greatly admired her resourcefulness as a historian in her own right. As she told it to *CAUSE* magazine, Armstrong "was the only musician to retrieve and retain many of the most famous blues numbers that Lovie Austin, Mazie Mullin and Jeanette James were singing at the time."[38] That curatorial impulse was, for her, evidence of the enormity of the work that these artists did among themselves, with and for one another, to preserve, sustain, and push forward traditions of sound made by their fellow musicians.

Like Albert Murray, who believed that the "most inventive, the most innovative jazz musician is also one with a very rich apperceptive mass or base, a

very rich storehouse of tunes, phrases, ditties, which he uses as a painter uses his awareness of other paintings, as a writer employs his literary background to give his statements richer resonances," Reitz, too, regarded the coupling of wisdom and invention as the foundation of improvisational genius.[39] Of Dorothy Donegan, for instance, she was dazzled by the way that artist could "tak[e] American history in her left hand to bounce out boogie-woogie bass lines making her sound like a blues orchestra," and she often remarked on the enormity of Donegan's "scope," how

> it covers the history of jazz and pop, going back to the turn of the century. It's hard to believe a single person can know so many songs; they seem to be as available to her as pressing a button on a keyboard. It's one thin[g] to have them stored in the brain's computer, quite another to be able to . . . put them in the right place. It's miraculous. . . . Her repertoire of European classical music is just as enormous and seems to be equally accessible. This is what I mean. She could be playing away, on one of those marvelous old standards—like AFTER YOU'VE GONE, just as great today as when it was written in 1918—and in parenthesis, give us a taste of a Goldberg Variation from Bach, played with the fearless panache one has come to expect from her. Then she might see me for the first time that evening, sitting on a low balcony at The Village Vanguard, up front near the bandstand, and take off on Earl Hines' ROSETTA in his trumpet piano style, adding a Rachmaninoff riff for fun, maybe even swagger through a chorus of AIN'T MISBEHAVIN. . . . Lorrain Gordon, who runs the Vanguard, could walk over and sit down with me, all smiles, touching my shoulder. . . . Now she's playing SWEET LOR-RAINE and using Nat King Cole's elegant touch. Dorothy knows I'm a boogie buff, so she'll roll the beat, Pine Top Smith style, at blazing speed, all the while maintaining her own persona, doing all of this as smoothly and naturally as though it were planned. Coolly, she'll retrieve the original tune which . . . is hanging in the air, and finish off with the melody of AFTER YOU'VE GONE, resolving everything. . . . That is the amazing thing about her imagination, it is relentlessly inventive. And she has the technique to ex-ecute that imagination. It's her magic, her genius, making the most dispa-rate music seem seamless in her hands. What could a Chopin Nocturne have in common with a Stevie Wonder soul song Dorothy will find it, just the right thing for transition too, that will make it work musically.[40]

Reitz's writing often strives to match, absorb, and convey the magnitude of what her artists accomplish in the compressed range of each of their specific perfor-

mances. Like Murray, she located greatness in the jazz and blues musician's ability to "engage in a dialogue or conversation or even argument . . . with his peers" and with "musicians in the world at large" and play through the changes, to adapt to the break, to inventively respond to rupture and disruption. "This is," as he famously reminds, the "moment of greatest jeopardy" and "greatest opportunity. This is the heroic moment. . . . It is when you establish your identity; it is when you write your signature on the epidermis of actuality."[41] Just as Donegan kept her familiarity with standards, signature songs, and the trademark aesthetics of veteran musicians in reserve, so too did Reitz craft readings of musicians like Donegan that played *along* with the artist in question, keeping up with the furious number of citations in her repertoire and tracing the anatomy of an improvisational performance by offering her own antiphonal riffs in prose. Her reading of Donegan's musical prowess here depends, in part, on her own active presence—as both audience member and critic—as she supplies the inspiration for the pianist's invocation of bebop legend Earl "Fatha" Hines's theme song for his band, her namesake anthem.

Ever the active and sophisticated listener, Reitz responds to Donegan's "call" and reads the fluid codes in her signifying address, weaving together "a Rachmaninoff riff for fun" with the "swagger . . . of AIN'T MISBEHAVIN," as both women acknowledge that that is exactly what she is doing—"misbehaving" and diverging from the gendered conventions of formality and restraint associated with women musicians. Reitz recognizes and keeps track of Donegan's audacious moves with her critical eye, even as she and fellow devoted female jazz fan and entrepreneur Lorraine Gordon, the legendary owner of the Village Vanguard, are hailed by the musician as audience members who are fluent in her language, who are capable of delightfully digesting the references as they fly their way: "SWEET LORRAINE" with a flourish of Nat King Cole, "AFTER YOU'VE GONE," the reference that "resolves everything" at the close of her musical conversation with Reitz and Gordon. Reitz's writing gives us a way to recognize the intimacy established between a musician and her ideal audience, an audience savvy enough to appreciate her deftness at "retrieving" sounds from the archive and shaping them into a seamless sonic tapestry, a quilt of music for everyday use. Reitz is with her as she digs deeper and deeper into the trove.[42]

Virtuosity, the kind that Donegan has by the boatloads, is a concept that looms large in Reitz's criticism. In her writing, she remains invested in heralding her artists' mastery of forms, their sheer and, as she seeks to convey, undeniably formidable skills of technique and interpretation as artists and performers. Of Donegan, she observes that the pianist possesses a "virtuoso's fire in her belly," and she often pays close, yet not exclusive, attention to the technical details

executed by a musician, the way, for instance, Sarah Vaughan had a list of extraordinary skills at her disposal when performing. In her own kind of free-style note-taking, one sees Reitz brainstorming descriptive words and phrases to articulate Vaughan's gifts: "flexibility [of] style, phrasing, breath control . . . purity of tones . . . controlled vibrato." She was, in her opinion, an "improvising musician . . . richly sensual . . . soaring aerial & unconfined," with a "variety of texture" and "the range of her over two octave voice," which can "display on the top delicacy of a coloratura soprano" as well as "a deep contralto."[43] Reitz seemingly saw her task as a critic as one involving drawing out of the margins the ways that Black women musicians—vocalists and instrumentalists alike—consistently demonstrated their genius at art-making as well as their deft ability to render great artwork in blues and jazz. Black women artists emerging out of these imbricated genres, she would repeatedly assert, had not only the skill but the aesthetic intelligence and sophistication necessary to turn their performances into simultaneous meditations on the content of the material that they were interpreting and the conditions of their own sonic will. Philosopher and pianist Thomas Carson Mark might call this phenomenon occasions in which these musicians execute virtuosity by generating the kind of work "in which the display of skill is made a central feature." Any artwork, Mark continues, that "qualifies as a work of virtuosity will stand as an *instance* of what it is about." It is art that "turns inward on itself, contemplating and exalting the necessary conditions of its own existence."[44]

Reitz's work insists that Black women's musicality operates in this universe, responding to "existential confrontation," as she calls it. "These women," she continues, "invented it. Gladys Bentley's growl on 'How Much Can I Stand?' is her own voice, not a trumpet, although she sounds like one. It is this human growling sound that trumpet players try to imitate. Here we have an early example of the female influence of the development of scat singing. Mary Dixon carries the growl-scat further on the opening of 'You Can't Sleep in My Bed.' These wonderful sounds were a common style in the blues singing of the twenties in the honkytonks and cabarets, but were not often recorded." Her assessment of the meticulous rigor and aesthetic of legends as well as lesser-known musicians is, in this regard, deeply akin to the ways that Edward Said reads the work of classical pianist and composer Glenn Gould, as actualizing a kind of virtuosity that is, at its heart, "a search . . . for new modes of apprehension . . . even a new system of mythology in Northrop Frye's sense of the term."[45]

Reitz recognized an artist's ability to convey aesthetic grandeur and complexity and to equally embody and personify imagination as clear signs of virtuosity. She remained interested in limning the meaning and uses and produc-

tion of iconic art by these performers, and she stayed the course throughout her career pursuing ways of approximating in her prose the alluring details of their sonic work—from technical skill to stylistic choices. These were details that evoked both capaciousness and intimacy and ones that, in short, she believed enabled each of the artists she showcased to hail multiple publics and nurture deep bonds with their fans. The ambitiousness of her critical arguments found her repeatedly seeking out canonical analogies to make these claims while occasionally wandering into sentimental hyperbole. Ella Fitzgerald was, for instance, "Miss America if there ever was one. When her voice came . . . over the radio it is 'America Singing' at it's [sic] best." Reitz argues, "Hers may not have been the voice Walt Whitman heard when he discovered America singing in 'The Leaves of Grass' but it certainly is the spirit. Joyous, buoyant, expansive . . . not defining any group or category . . . but representing all Americans." Reitz toggled between invoking the grandiosity of mythical language to describe Black women musicians and excavating the relationships forged between these artists and the audiences who wholly and passionately opened themselves up to their music. She found poetry in Dinah Washington's gift of "articulat[ing] (or enunciat[ing]) the love song in the mother tongue of our imagination" with her "kaleidoscopic" aesthetics. "For Dinah," Reitz points out, "the blues is the eloquent media through which she expresses experience—that is, its imaginative and emotional value—and it becomes a work of art."[46]

Not surprisingly, Reitz saved particular praise for Bessie, championing the way that she

> attains her solitary and special supremacy by dint of her capacity for intense vitalization . . . [and] the culminating gift of immediately projecting a living human being who is not only a human being, but also something much greater than any one person . . . impress[ing] her imagination straight upon ours. She does her business of delineating the life of Black women well; she ruffles her listeners with vehemence, disturbs them profoundly. The passions are known to her; she embraces that stormy sisterhood. She spells out female feelings that throb fast and full of life and the sentient target of death—this she embraces with grace and elegance.[47]

Reitz here, in her notes, rehearses Lincolnian theories of the blues woman's role as documentarian and ambassador of structures of feeling rooted in Depression-era Black women's material struggles. More still, however, interpreting this songbook of sentience does the dual work, she suggests here, of answering the Du Boisean question of "How does it feel to be a problem?"—to be born Negro

"As we try to love ourselves, we don't skip over any parts even if we have been taught our most important female place is smelly, dirty, shameful."

in America—but also what does it mean to be human? Reitz extrapolated the stylistic details of Black women's performances in order to build profiles of persona: Ella's "sense of humor" evident in "improvisatory embellishments," for instance. Her "courageous inner voice," she continues, "directed her to follow her instincts plus the miraculous creativity to express her ideas and her spirit."[48] The gift of being able to articulate the vastness of one's lifeworld in such a way as to affirm specificity and also invite listeners to couple their imaginations with that of the singer's is what Reitz seems to be after in her critical analysis of the ethics, values, and goals of blues and jazz women's musicianship.

"She Weaves Long Melodies": Rosetta Reitz and the Politics of Critical Maroonage

What is the proper language, what are the syntactical structures, the analytic allusions available to a woman critic intent on doing so much with the music, covering so much historical, social, and aesthetic territory in her prose? Rosetta Reitz's archive reveals that she consistently drew on and used published literary reviews, music journalism, and especially art journalism as a laboratory to cultivate her method of analysis, her critical lexicon, and the tenor of her own written

voice. This, for her, one might imagine, was a different type of feminist revolution in letters, one in which she effectively engaged in a kind of intellectual heist, occasionally lifting the language, strategies, and images of a cadre of men who wrote about art and who, nonetheless, had nothing to say about the art of Black women. Reitz studied her fellow (and nearly unanimously male) critics hard, keeping clippings of and notes on the work that irked her as well as the work she admired. She collected the outrageous: an obscure *American Arts* magazine clipping featuring a quote from Whitney Balliett, esteemed *New Yorker* critic, stating that "women don't have the grace and poise to play jazz," as well as the material that had been largely relegated to the footnotes of history: a 1961 *Record Research Issue* clipping describing how "Lil [Armstrong] spoke about her all girl orchestra . . . in 1932." She battled in the margins of her copies of books and articles by Bogle (he "is a sympathetic man but does not have a female sensibility. . . . One would hope for less generalization and more specific information about the women's contribution to American culture") and particularly Bessie Smith biographer Chris Albertson ("He writes from a weird point of view for it is as though he's a reluctant lover in the way he chooses to tell us about [blues women]. . . . I wonder why he doesn't ever truly show Bessie as a winner in her life, being happy . . . but [rather] always being sad").[49] She kept stacks of reviews and profiles and feature articles by jazz critics like Gary Giddens and Nat Hentoff, and *New York Times* music critics like Robert Palmer, Jon Pareles, John Rockwell, and Peter Watrous, taking care to underline lyrical sentences and phrases.[50] On occasion, she reached out directly to independent critics like jazz scholar Stanley Dance, whom she tapped as a resource and bridge figure who communicated with veteran musicians for her. Dance's connection to legendary pianist Earl Hines gave her the opportunity to gather information about trumpeter Valaida Snow that other critics had overlooked. "I wonder . . . if I could impose on you," she ventured,

> to ask him a few questions for me? Women care so much for this material. . . . It really is lost history . . . and I consider it a privilege to try to retrieve some of it. I'm trying to get a feel of [*sic*] her PERSONA, the kind of person she was. . . . There are things I'm trying to find out. . . . Is there a female voice (instrumentally)? Could you ask Earl, was her trumpet playing different from that of a man? Was she called "Little Louis" as a joke, or did people think she sounded like him? . . . Was she arrogant (or modest) about playing . . . ? Was she a friendly person, was she foxy, feisty, outspoken or shy? Was she what one would call <u>regular</u> or was she artificial? Did she practice the trumpet, a lot, a little or not at all? . . . Alberta Hunter says about herself that she was "dicty"—would one use that word for Valaida?[51]

Reitz is interested here and elsewhere in fleshing out and examining the complex identity formations that come to bear on a musician's sound, how she approached her instrument and how she negotiated space with her fellow musicians. "Persona," she suggests in this letter, is that which leaves an imprint on the music; it is an outgrowth of an artist's affective politics. Building whole female characters in her alternative history of the music was, at its core, a feminist endeavor that prioritized finding the lost women in the archive and making them legible and audible in multidimensional narrative registers.

This kind of digging, this kind of researching and writing, was its own form of critical virtuosity. It was complicated, painstaking, jigsaw puzzle–like prose-writing at the draft stage that followed its own rules. Reitz shows a tendency to make notes on article clippings in red or black ink, interpolating feminine pronouns, bracketing phrases, and underlining key words that, pooled together, constitute a storehouse of modifiers, metaphors, and similes that she dissected and consulted in the process of composing her own criticism. A 1985 Carol Muske review of iconic feminist poet Adrienne Rich's "The Fact of a Doorframe" provides the occasion for Reitz to collect and calibrate Muske's language and formulations and to translate and transport them to her own critical endeavors. Writing along the edges of the article, Reitz jots down words—"stamina" and "pluck"—and then to the side of the photo of Rich lurks an additional note, a kind of free-floating reminder to herself to "fully embrace these songs, suspend your own beliefs, and allow yourself to enter those of the singer." From the article itself, she pulls quotes that leave a map of her critical priorities (underlining "<u>unearthing a lost history</u>") and elaborations on Rich's poetics that speak to those of her blues women's repertoire ("Where love has grown disillusioned, and truth simultaneously more commanding . . ."). Reitz gravitates toward Muske's musical allusions in her review, locating the commonalities between poetry and song lyric, and finally adjusting the language of the article, bending it to meet her own analytic will. Muske's vivid, metaphorical description of Rich's technique, that it is like "dialectical fire" that "produces <u>poems of transcendent beauty</u>," becomes here "<u>songs of transcendent beauty</u>." Reitz further edits, "~~This~~ [These] remarkable ~~poet~~ [women] <u>whose passionate excesses,</u> whose brilliant ~~terrifying~~ leaps of faith ~~often~~ affect us more deeply than the[ir] ingrown success of our assemblage of 'approved' poets. [conventional songs]"[52] The poet and the blues woman meet up in her critical imaginary as twin innovators of intense, aesthetic innovation, as risk-takers who subvert and surpass convention. Muske's review was but one of many articles from the world of the arts that supplied Reitz with the discursive means to experiment with new ways of interpreting

and, in her mind, elevating the ways that Black women musicians' work might be regarded by the wider public.

Published concert and record reviews—especially covering the work of notable jazz musicians—were clearly of use to her in this project. We see Reitz grafting her own voice onto that of the critic John Wilson's in a review of jazz pianist Tony Tamburello's gig—"[s]he weaves long medleys made up of one or two choruses of melodies that [she] floats over a light and swinging beat"— before scrambling and rearranging another cut of the prose to read, "She lightly floats over the swinging beat." Call this invagination, call this critical maroonage, discursive subversion—perhaps even call it pure mimicry and analytic appropriation—but Reitz's intriguing method here conveys the efforts of a music critic at work, rehearsing style, searching for the voice that best suits her argumentative needs. In her preparation to write the *Dorothy Romps* liner notes in particular, one sees her looking to jazz and classical music reviews for inspiration and direct formulations to hammer out her ideas. A *Time* magazine profile of Russian pianist Vladimir Feltsman by Michael Walsh provides a phrase— "virtuoso's fire in his belly"—that she revises for gender and repeats for herself in separate notes, borrowing additional modifiers from Walsh's article. This is language that does not make it into the final, published version of the notes but appears to have worked as something like clay foundation for Reitz as she built the belletristic scaffolding for her own voice.[53]

But her most provocative resources were arguably reviews of visual artists in pop culture mainstay *Time* magazine. She was scrupulous about collecting these sorts of articles and mining them for helpful and provocative analytic angles. It is clear from her research notes that Reitz regarded the sonic as akin to the visual, as demanding a language that could capture what is not just heard but what can be seen in and through the music. She seems to have lived for a long time inside Robert Hughes's review of Irish-born painter Francis Bacon's landmark 1985 Tate exhibit, striking Bacon's name early in the article and replacing it with "blues" to read instead "lexicon of blues," underlining Hughes's contention that Bacon "breaks the chain of pessimistic expectation by taking his prototypes beyond themselves into grandeur," marking the ways that he reads Bacon's use of lines "like punctuation marks commanding one to focus and look," and pointing out how certain images in his work "shed their documentary purpose." Reitz hangs on to vivid phrases (circling "obstinate integrity") in the article, and her notes build toward a crescendo of consolidated energy around conjoining the painter's aesthetics with those of the blues woman as she edits Hughes's words to read that the "truth is that the Bacon one sees [hears] this time at the Tate has much more in common with old

masters. . . . This kind of ~~paint~~ [singing] surface is part of the work of delivering sensations not propositions, and it is neither idly sumptuous nor 'ironically' sexy." Reitz shows signs of searching for the appropriate way to say much more than what has been conventionally said about blues women's vocalizing by way of drawing analogies to Bacon's complex, sensual palette of images, a skein of "tensions and paradoxes that surround all efforts to ~~see~~ [hear], let alone to paint, [sing about] the human ~~figure~~ [condition] in an age of ~~photography~~ [flash ~~rock~~ disco].⁵⁴ She has invented for herself here in the privacy of her written notes a form of punctuation (strike-throughs and underlines) that is both "ludic" and "lived" in ways theorized by Black feminist performance studies critic Jennifer Brody. If, as Brody argues in her singular study on the topic, that "punctuation is the conduit that directs us to creation, the trace of an embodied act," the mark that "records / accords" "affect and feeling," Reitz's lines are performances of her relationship to the criticism in question, performance archives of feeling and critical formation. It is here that we see "the phantom limb" conjoining her writing with that of another, "stag[ing] an intervention between utterance and inscription, speech and writing, activism / activity and apathy, body and gesture. It is seen and unspoken, sounded and unseen."⁵⁵

It is here in these boxes upon boxes of notes and scribblings that Rosetta Reitz the improvisational feminist sound critic fully emerges, the woman who plays through and at the intersections of language and music, who takes chances and gambles with striking images and allusions, who is thrilled by and seeks a shared sense of exhilaration elicited by the blues, who pursues gratuitous and alluring difficulty in her prose about Black women's performances, who perpetually strives to translate "forms of raw (sonic) experience" into discursive style and musical story-making. Think of Rosetta the improviser, sometimes impulsively, sometimes with slow, pointed care, jotting down her thoughts on scraps of paper, a half envelope here, a stained piece of binder paper there, perhaps on the flip side of a *Menopause* manuscript draft page, freestyling a thesaurus of modifiers and predicates and actions for future use: "voluptuous, gumption, perception, to perceive, meaning conveyed, responsive . . . acuteness." Think of Rosetta keeping a map for herself of where she was headed in each of her projects ("this album is about women's feelings") and imparting crucial reminders to her future self to "listen to the wonderment." Think of her pushing her use of visual tropes (describing how Donegan "plays colors . . . on the palette of the keyboard from lyric . . . pastels to stormy vivid primaries with sweeping gestures") and marveling over a musician's "gesticular statements of spontaneity . . . mak[ing] it work aesthetically." Her archive holds the many traces of a critic, a scholar, a historian who was furiously and endlessly productive, making

Singing Within the Bloody Wood

At the Tate, a second celebration of Francis Bacon

All of a sudden, in a rush, the English know what they have got. "Surely the greatest living painter," wrote Alan Bowness, director of London's Tate Gallery. "The greatest painter in the world," claimed Lord Gowrie, England's Minister for the Arts, "and the best this country has produced since Turner." The artist is Francis Bacon, 75, whose second retrospective exhibition at the Tate (the first was 23 years ago) opened last month.

Some art is wallpaper. Bacon's is flypaper, and innumerable clichés stick to it over the past 40 years it has attracted extremes of praise and calumniation. There are still plenty of people who see his work as idly mannered, sensationalist guignol. He is the sort of artist whose work generates admiration rather than fondness. The usual evolution of major artists in old age, whereby they become civilly grand paternal figures, patting their juniors on the back and reminiscing in autumnal mellowness about their dead coevals, has not happened to Bacon, who is apt to dismiss nearly everything painted in the 20th century with blank contempt. He has gone on record as admiring Giacometti and Picasso; for a few others, a few words of respect, beyond that, the *sense of isolation is ferocious*. The motto of an aristocratic French family declared: *"Roi ne puis, prince ne daigne, Rohan je suis"* (King I cannot be; prince I do not deign to be; I am a Rohan). Shift the context and you have the epitome of Bacon's own view of his place in 20th century art.

The lexicon of Bacon's imagery is famous. Its most familiar component is the screaming Pope, smartly rising from blackness like carnivorous ectoplasm, his throne indicated by a pair of gold finials, the whole enclosed in a sketchy cage—homage to an original that Bacon firmly denies having ever seen, the Velásquez portrait of Innocent X in the Doria collection in Rome. There are the Crucifixion motifs, reflections of Grünewald and the Cimabue *Crucifixion* in Santa Croce that was partly destroyed by the 1966 Florence flood, whose sinuous and near boneless body Bacon once startlingly compared to "a worm crawling down the Cross." There are the bumping, grappling figures on pallets or operating tables; the twisted, internalized portraits, the stabbings, the penetrations; the Aeschylean furies

pinned against the windowpane; and the transformations of flesh into meat, nose into snout, jaw into mandible and mouth into a kind of all-purpose orifice with deadly molars, all of which aspire, in the common view, to the condition of documents. Here, one has been told over and over again, is the outer limit of expressionism: these are the signs of the pessimism and offer, as he puts it, "the sensation without the boredom of its conveyance." He once remarked: "An illustrational form tells you through the intelligence immediately what the form is about, whereas a nonillustrational form works first upon sensation and then slowly leaks back into the fact." The nub of the difference between Bacon's figures and those of expressionism is that his do not solicit pity. They are not pathetic and do not try to call you into their own space. Everything unwinds in silence, on the other side of the glass wall. (Maybe this is why Bacon insists on putting even his biggest canvases behind glass: it makes the separation literal, though sensations too literal. The glass becomes an element, even a kind of collage.) Art Historian Dawn Ades acutely notes in her catalog essay to the Tate show, there is a lot in common between Bacon's vision of human affairs and the neurasthenic, broken allusiveness of early Eliot—a cinematic, quick-cutting mixture of "nostalgia for classical mythology, the abruptness of modern manners, the threat of the unseen and the eruption of casual violence." Some lines from Eliot's "Sweeney Among the Nightingales" are quite Baconian:

> *The host with someone*
> *indistinct*
> *Converses at the door*
> *apart,*
> *The nightingales are*
> *singing near*
> *The Convent of the Sacred*
> *Heart.*
>
> *And sang within the*
> *bloody wood*
> *When Agamemnon cried*
> *aloud*
> *And let their liquid*
> *siftings fall*
> *To stain the stiff*
> *dishonoured shroud.*

That "someone indistinct" is, of course, a key figure in Bacon.

The real peculiarity of his figurative style is that it manages to be both precise and ungraspable, for its distortions of face and limb bear little relationship to anything that painters have done to the human body since Cézanne. Forms are governed by slippage: they smear sideways, rotating, not like the succession of displayed facts and transparent planes in cubism, but as though they had endured some terminal rearrangement by massage. Their shape retains an organic integrity, the precise result of a sudden movement. And by the early to mid-'60s, the time of the great triptychs, when Bacon decisively abandoned the "spectral," scumbled evocations of the face used in his Popes and caged business-

The artist in London
A ferocious isolation.

mistic alienation to which a history of extreme mass suffering has reduced the human image. The collective psyche has imploded, leaving only the blurred individual meat, hideously generalized. The paintings "reflect" horror. Their power is in their mirroring. They are narratives, though not always openly legible ones.

Bacon utterly rejects this view. He sees himself not as an expressionist but as a realist who nevertheless makes the outcome of his art on an opposition between intelligence (ordering, remembering, exemplifying) and sensation. His paintings do not strive to tell stories, but to clamp themselves on the viewers' nervous system.

Triptych May-June 1973: taking one back to the classical past, not to the morbies, but to the sacrifices

man, his figures had begun to embody an immense plastic power. Sometimes these creatures, knotted in contrapposto, seem desperately marooned; but there are other moments when the smearing and knotting of flesh, not so much depicted as reconstituted in the fizzy whorls and runs of paint, take on a tragic density closer to Michelangelo than to modernism. Among these artists who, in the past century, have tried to represent the inwardness of the body, Bacon holds a high place, along with Schiele, Kokoschka and Giacometti. He invokes the chain of pessimistic expectation by taking his stereotypes, he and themselves into grandeur. In earlier art there was a repertoire of classical emblems of energy and pathos, starting with the *Laocoön*, that painters could draw on for this operation. Bacon's starting point is less authoritative: the photographs of anonymous, hermetic white bodies in Eadweard Muybridge's *The Human Figure in Motion*, a snap of a baboon or a kitten in blurred motion, a wicketkeeper whipping the ball across the stumps, the bloodied face of the nursemaid of the Odessa Steps in Eisenstein's *Battleship Potemkin*, her spectacles awry. These and other images begin as chaos, holes in the social fabric, and are then worked up, gradually, into emblems. The elliptical format of the nursemaid's spectacles, for example, turn into bigger ellipses, without a face behind them, like punctuation marks compressing one to form and stick: they recur the pathos of the '70s. Muybridge's wrestlers become Bacon's signs for sexual battle. But the dead meat becomes its purpose, and in doing so, from the way to another dis-

course of figures. When impelled by strong emotion—as in the *Triptych May-June 1973*, which commemorates the suicide of his friend George Dyer in a Paris hotel two years before—the "shocking" images in Bacon are raised to the order of grand lamentation: they take one back to the classical past, not to its morbidities, not its marbles.

None of this would be possible without Bacon's mastery of the physical side of painting. Much has been made of his reliance on chance, but it seems to have affected his life (he is at an inveterate gambler, an addict of the green baize) more than his art. One could say the ejaculatory blurt of white paint in a painting like *Two Studies for a Portrait of George Dyer*, 1968, is chancy, but that kind of chance is easily manipulated with practice, and it rhymes suspiciously well with other curves in the painting (like the back of the chair in the picture within a picture at the left). The truth is that the Bacon one sees this time at the Tate has much more in common with old masters than with contemporary painting. The joint acquires a wonderful plenitude in becoming flesh. One thinks of the coruscated light, the Venetian red interstitial drawing, in Tintoretto. This kind of paint surface is part of the "work of delivering sensations, not propositions, and it is only their idly sumptuous not "ironically" sexy.

But the one thing it cannot feasibly do is fix the extreme disjuncture between Bacon's figures and their backgrounds. The content of the two—the intense plasticity of the figures, the flat stagings of the rooms and spaces in which they convulse themselves—is what gives rise to the charge of "illustration." It will not entirely go away, because Bacon only rarely manages to set up the whole of the canvas as a coherent structure, every part exerting its necessary pressure on the next. One looks at the figures, not the ground. Hence the theatricality of his failures. But, like his successes, these because the work of an utterly compelling artist who will do without bases. No one could imitate Bacon without looking stupid. But to ignore him is equally absurd, for no other living painter has set forth with such austere clarity the tension and paradoxes that nourished his art alone so aloof in an age of photography. He is an age of photography.

—*By Robert Hughes*

Study after Velázquez's Portrait of Pope Innocent X, 1953

The art of critical maroonage

pages and pages of lists of musician genealogies and challenging herself with large-scale riddles that she sought to solve ("In looking at this music I'm trying to find the answers to many questions that I raise & can't find the answer to . . . to bring to life the rhythms, the images, the sensuousness of a lost time"), pursuing queries that she was delighted to answer through her research and analysis: "What do you do with a paragon of creative invention . . . who refuses to be a prisoner of the decades she lives in?" Reitz presciently asks. Her own simple answer to this question sums up the fundamental ethos of all her efforts: "You sit and listen and enjoy!"[56]

Independent Label Notes for the Blues Revolution: Vision & Breakthrough on Rosetta Records

All of this research, all of this drafting and experimentation with regard to her critical voice and methods, manifested itself in the Rosetta Records enterprise, which Rosetta Reitz oversaw for nearly thirty years. The work that went into compiling, producing, packaging, and marketing each release was an exhaustive and all-consuming labor of love that Reitz relished and embraced as a feminist call to arms in the heady years of the 1980s culture wars. Against the backdrop of public debates about canons and college course curricula, about diversity in the media and cultivating inclusive histories, Reitz "did the research, wrote the liner notes, conceived of the record design, and produced each album," which, as ethnomusicologist Cheryl Keyes reminds, stands as "an important landmark in American traditional music scholarship." Her hands were in everything to get this project off the ground. She "supervised the remastering of records that were often severely damaged . . . designed graphics and found period photographs for the album covers" to accompany her essay-length notes. She adapted to the times, transitioning from producing vinyl releases to producing tape cassettes and finally CDs, and although much "of the music she recorded was in the public domain . . . she devoted time and energy to tracking down the rights to some songs and paying artists royalties when she could."[57]

The themes covered in the Rosetta Records catalog can, Keyes argues, be divided into three different categories: the Independent Women's Blues series featuring album collections entitled *Mean Mothers, Big Mamas,* and *Super Sisters* and focusing on songs that "shatter the notion that women who sang the blues wallowed in their discontent"; the Foremothers series, which is "comprised of nine multi-artist records representing the most influential blues and jazz women performers from the 1920s to 1950s," with volumes covering the music of Ida Cox,

Valaida Snow, Ethel Waters, Rosetta Tharpe, and others; and a third category that Keyes labels "miscellaneous" because of its diversity of topics, ranging from albums of boogie-woogie pianists to prison songs and all-female jazz bands.[58]

Throughout the years of the label's activity, Reitz refined her skills as a critic. Each of the albums showcases Reitz's singular gifts as a feminist music writer and as a scholar and archivist of Black feminist music history and culture. The liner notes document the evolution of Reitz's trademark analytic voice, the kinds of tropes and critical perspectives she frequently invoked in her work, and the rare problematic and racially unsophisticated observations she occasionally made (about, for instance, singer Lil Green's putatively "black" sound and her "slurring" speech, in contrast to Billie and Dinah, who "were singing white songs and articulating the words and syllables so they could be easily understood").[59] Particularly in some of the early releases, she wrote with an earnest, unvarnished inquisitiveness and straightforward declaration of her intentions as an archivist and as a feminist historian. Take, for example, the notes that accompany the 1982 Foremothers, volume 3, album, *Georgia White Sings and Plays the Blues*. Reitz frames her analysis of White's career in terms of speculative interrogation and conditional possibility while also keeping herself squarely in the narrative about the search for White's music and its impact on her. "Is Georgia White alive or dead?" she begins.

> Nobody seems to know. If she is alive she is living in obscurity and would be 80 years old. If she is dead, her death went unnoticed for there were no obituaries. I checked and double checked with people who might know. I've been looking for her. I would like to tell her how important I think she is, important to the history of American music (even though hardly anyone knows her name today). . . . I would tell Miss White that I love her music because she glorifies the human spirit. I value it so much that I am retrieving sixteen of her songs on an L. P. so that they will not be lost and so she will be remembered.

Her tendency to depend on feminist essentialist rhetoric occasionally overwhelms her reading of White's aesthetics, as when she imagines how White might respond to her queries: "She would probably smile at that and say, 'I was just doing what came natural.' And that is precisely why she knocks me out. She *is* natural, without artifice, without the self-conscious artistry of some of her contemporaries."[60] Yet Reitz's commitment to opening up a conversation with the lost and the forgotten in blues history would become a figurative and an ideological mainstay in her writing, and it was, as Side B reveals, a very different

approach from that of the men who were holding court as blues critics and historians.

Reitz loaded her notes with historical information about the lives of the artists, their sites of collaboration, and the origins of their craft. In the notes for the 1986 *Ethel Waters, 1938–1939: The Complete Bluebird Sessions,* she offers a broad, alternative context for rereading the blues, citing the 1920s as "the only decade women had power musically," when "the Classic Blues Queens . . . called the tune in every way. The musicians had to play *their* way. . . . Until 1927 while the women reigned, 278 black women recorded on the race labels' they were 76% of the blues record production." On the historic 1980 album *Sorry but I Can't Take You: Women's Railroad Blues,* she takes on origins tales in the genre, declaring that the "first blues song with the title 'Freight Train' that was written down was by a woman, Elizabeth Cotten, circa 1904." Similarly, in her liner notes for the 1988 Rosetta Tharpe collection, she offers revisionist histories of gospel women, the central musical role that women in the church have played "swinging in the congregations from the keyboards, the soloists, the choirs and the worshippers hallelujahing, that are the base," she argues, "the underneath it all, of America's music."[61]

Reitz turns to artists' biographies and their testimonies of influence and training to flesh out the development of aesthetics, citing, for instance, Ethel Waters's description of how her "elephant memory and gift of mimicry astonished teachers." She lingers on her early development of craft, Waters's absorption of multiracial performance skills as she moved to Harlem, her "graduate school," and spent "an afternoon in the peanut gallery . . . where she saw the popular white singers and the Negro acts." This is why, she suggests, one can hear in Waters's voice "the echoes of Bessie Smith, Louis Armstrong and Eva Tanguay, Sophie Tucker, Blossom Seeley and Al Jolson and Rudy Vallee. . . . Immaculate diction and a perfect sense of time and phrasing." Reitz continues with her dissection of Waters's dynamism as an artist, pointing out the intricacies of her bald-faced competition with other musicians, as well as the depth of intimacy found in her collaborations with her female pianist Pearl Wright. She cites Waters's candid meditations on her own style and invention, her reflections regarding the fact that she "'can't read music, never have. But I have almost absolute pitch. My music is all queer little things that come into my head. I feel these little trills and things deep inside me, and I sing them that way. All queer little things that I hum.' Pearl understood those queer little things." To Waters's alluring description, Reitz adds that she "could execute" said "queer things" on "the keyboard." She uncovers numerous unheralded instances of women musicians influencing one another

(Sister Rosetta Tharpe, she points out, adopts pianist Sister Arizona Dranes's "special rhythmic power in her worship").[62]

Watch her as she maps big adventures in the music. Watch her as she draws out the panoramic picture in her readings of artists' careers and illuminates their fundamental impact on popular music culture. Reitz, for instance, uses the milestones in Waters's career (as the fifth Black woman to record and the first to appear in an all-white show on Broadway) as a way to frame her meditations on her indelible style of mimicry that destabilized racial mythologies. She likewise takes Harlem ministers to task for critiquing Rosetta Tharpe's many secular triumphs, including her 1941 Apollo Theater concert, as an example of "fail[ing] to realiz[e]" the fact that Tharpe "was expanding the church doctrine," "creating a church without walls, preaching the gospel truth to thousands who would otherwise not hear it."[63] Their music sets the occasion for disturbing the logic of Jim Crow racial categories, in the case of Waters, and reordering the logic of Black spiritual publics, in the case of Tharpe. Perpetually, Reitz's writing about these sister musicians asks of her readers, what would we be without them?

Her strategy to make these sorts of points plain, clear, and immediate was to use her notes as a primer for the listener to recognize the extent to which these recordings are steeped in material history. "The early songs," she instructs, "require becoming familiarized with the sounds because of the primitive way they were made. The masters were literally cut on blocks of wax that were fragile and sensitive to heat. They were made acoustically; the women sang into a large horn. You may not get all the words in the first listening but you will get the thrust of the meaning and the feeling." Of Waters's indelible recording of "West End Blues," she hones in on the details of production, how the vocalist "sounds as if she is going to pronounce the word *today* but it comes out as *to way*. This is on the original 78 rpm record, a take that was chosen because it was so beautiful. . . . On the floor, stringy curls of wax accumulated in piles as the musicians worded. It is truly a wonder," she marvels, "that more than 50 years later we are lucky enough to be able to hear the original and learn how this music evolved."[64]

Perhaps her most significant and virtually unrecognized innovation as a music writer, however, was in the way that she mastered an attention to Black women musicians' achievements in style, their excellence and rigor as performers and artists of the highest order. No other critic, in my mind, has paid such close attention to such a wide-ranging array of African American women musicians in their cultural work and over such a sustained period of time. Part fangirl and part tastemaker, Reitz created prose that resonates with awe and affection for her subjects. Waters, she argues, "was the quintessential singer of

American popular song, bringing a new dimension to it by incorporating the music that came before her. . . . Her sweet bell-like clarity of tone and subtle use of nuance showed her innate taste and tireless invention." According to Reitz, she was an "archetype who invented herself by carving out her own life with style and class. She learned early that there was power in the use of language." Her use of similes is sharp and effective in her readings of style (of Waters again, she characterizes the ways that the vocalist "caress[es] vowels" as though "she had been brought up with the elegance of the eighteenth century prose style"). Of Tharpe she points out that she "was phrasing the material in a new way, stylizing it sometimes to the point of abstraction. Notice in the songs her way of accenting a word: lucky lucky lucky glory glory glory, never never never, using it musically as well." These are the kinds of inventive approaches to examining Tharpe's electrifying sound that pave the way for her twenty-first-century feminist biographer Gayle Wald and Wald's influential assessment of Sister Rosetta's work. Reitz is mindful of technique (Tharpe's "baroque embellishments" and "churchy riffs," her controlled vibrato) but consistently reads that technique as working in the service of higher interpretative powers (Tharpe's ability to exude "a quiet, mature passion" in her reading of "Motherless Child" in ways that eschew sentimentality). Of the blues foremother Ida Cox, she recognizes her skill at articulating joy, fantasy, hokum, and satire. She notes how blues singers make effective use of "the exultant I," which "sounds like a much longer word," comparing this form of improvisation to the poetry of Dickinson. She alludes to the complexities of metaphorical songwriting in lesser-known blues women's repertoires, the way, for instance, Rosetta Howard asks a "metaphysical question concern[ing] one's place in the universe, one's sense of sacral space," "Where do I belong?" on the 1980 *Red, White & Blues: Women Sing America* album. She listens for the expressiveness of the phrasing on pianist Georgia White's little-known queer confessional "The Way I'm Feelin'" and makes multiple comparisons to Georgia O'Keefe's floral imagery in her examination of blues women's narratives of women's sexuality on the 1982 collection *Super Sisters*. In other words, Reitz's citational game is strong, as she emphasizes, throughout her criticism, the ways that the blues was first and foremost the musical expression of women's inner lives.[65]

Reitz's writing showed rapid maturity and sophistication over an astonishingly short period of time. Just two years later she would pull her arsenal of critical skills together with the publication of her liner notes accompanying the fourth Foremothers volume in 1984, *Dinah Washington: Wise Woman Blues.* This is a work of writing that is full, vibrant, and rich, and it displays her precision and grace as a critic, as well as her principal concerns and values as a feminist

music writer. One sees in these liner notes what would become Reitz's trademark style of making audacious statements that sum up both the dense, affective qualities of the music and the power and incomparable talents of musicians whose work, in the case of Washington, "embodies the sensible, sensitive, sensory, sensational and sentimental along with the sensuous." Here she is also tough-mindedly conscious of extrapolating the larger truths emerging out of "Dinah's oeuvre" and showing how it "reflects the social patterns and ideological beliefs of American mythology. In her rugged individualistic way," Reitz argues, "she glorified the icons of commerce and the idealized patterns of the good life." At the same time, however, she is intensely reverential toward Washington's "ability to engage the listener as participant," contending that this "was part of her genius. She intensified and clarified the experience of the songs she sang, breaking down the barriers that divide us. . . . Her yearning becomes the listener's." Rosetta Reitz believed in blues women's commanding powers of surrogation, how their iconicity translated into them becoming conduits of desire and sustenance for devoted fans and impassioned blues and jazz communities. She insists, offering no less than a critical swoon, that Washington "can pierce chaos and exorcise our sadness, lovingly, authoritatively helping us through her confident vision." One feels the awe in her prose, the weight of what she locates for us in the music.[66]

We are all invited to sit in the round with her, listening, dreaming. This writing, which amounts to love letters to both the artists and their fans, is constantly striving to pull listeners, and especially if not exclusively women listeners, into this glorious circle of sound. Women listeners and women in the audience are central to Reitz's grassroots blues activism; they are the figures worthy of interpolation into the very meaning and significance of blues and jazz women's performances. She transports her readers, for instance, to Washington's legendary 1958 Birdland concerts, reconstructing a scene with women already in the room and at the forefront of the audience, a "1940s debutante crowd who had flowered into societies' matrons, who came with their escorts. . . . The women were Dinah's age and identified with her singing of life's incongruities, about independence and being bound. They felt her longing for personal freedom. Dinah was safely articulating it, passionately expressing their feelings, but upbeat, without being gloomy. She was adored by this classy crowd and adored too by the crowd in the balcony of the Apollo." In Reitz's feminist genealogy, Washington supplies a respite from the crisis of the "feminine mystique" two decades before Friedan would verbalize the problem for white middle-class housewives. Gender solidarity is born out of the affinities fomented by her sound practices, and Reitz's daring criticism sets its sights on drawing out

these interracial connections, the coalition that might be forged between Black women vocalists and white debutantes as well as those sturdy, already existing bonds between these artists and their reverential Black publics.[67]

Dinah Washington is, it should be noted, a particularly important figure in Reitz's intellectual universe. She invokes her as exemplary in her efforts to limn and delineate her beloved artists' relationship to the aesthetic past and in her bid to reveal how they actively turned to blues and jazz history as a training ground, a pivotal site for cultivating craft and their own sense of style. "Dinah," she points out, "uses the resources of the past to inform her own present and to project the future." Reitz basks in the wondrousness of Washington's deep trove of jazz knowledge. But at times, she is also not above fetishizing certain kinds of racialized code-switching and crossover performance politics in this essay. Her strong biases are apparent when she, for instance, applauds Washington for not making "the mistake of bringing the screams and shrieks of gospel into jazz and pop" or when she praises her ability to excise the "old blues device" of "slurring words with hums," which, as she puts it, allowed the artist "to embrace a wider audience." This, for Reitz, is worthy of laudatory praise and suggests a conservatism on her part when it comes to reading the fullness, the complexity and heterogeneity of Blackness as it manifests itself in blues women's aesthetics. Yet in making this claim, Reitz seems to be primarily interested in emphasizing the act of invention on the artist's part, restoring an attention to the microscopic details of Washington's techniques, how she "found another way to scoop, slide, stretch and bend notes, to anticipate them and sta[y] behind-the-beat." What is clear is that Reitz's criticism is constantly invested in opening up a recognition of the wide compendium of historically informed gestures shaped by her musicians, the way that Washington "covers the full spectrum of blues sounds, from the backwoods hallelujah shouts to the urbane flatted fifth." She encourages us to hear the archive in her vocalizing, the extent to which her "country sisters are as alive in her projection as are her slick city brothers of the jazz band," and, in doing so, she forwards the idea of her artists as anything but mere "natural" talents.[68]

Rather, they are students of a tradition that they are steeped in and one that they simultaneously forward and transform. In the case of Dinah, Reitz renders her subject as a gutsy and an intelligent performer who "flamboyantly cut across the historic lines of jazz—from early blues to be-bop; she took what was useful to her and integrated it into her sound, giving her ballast from which she could take off. With such a secure anchor in tradition," she adds, "she could give her pop tunes resonance, amplitude." This sort of strong footing allows her artist a wide berth to improvise at the level of words as well as sounds, experimenting

with "a keen sense of humor" and making use of "sharp" metaphor to deliver lines like "The Queen's hair is about as short as dust on a jug." Washington's "genius," Reitz argues, lay in her "ability to be selective musically . . . to know what the right choice should be and make it almost every time." Her "early church music training gave her the iron below the sometimes closetoned surfaces, supplying her with an unerring density of structure. When she held her notes, it was artistically right and an integral part of her pacing."[69]

At this point in her writing, Reitz was continuing to refine arguments in which she would draw overt and repeated analogies between blues and jazz women musicians and ambitious visual artists. She was putting to work all of the methods she had been honing while living inside other people's criticism. See how Dinah, for instance, emerges in her writing as a deeply nuanced vocalist. She was, in Reitz's mind, an artist who sings like a painter. She "uses pigment: vowels became primary colors," Reitz waxes on, adding that "she sang the color of her dreams, inventing a syntax of sounds." As a critic, she remains devoted to the details that mark the different stages of an artist's career, never settling on monolithicizing their sounds but rather marking the various gradations of their evolution as musicians. Here with Washington she moves her reader through an appreciation of early Dinah's work, "full of freshness, self-discovery and self-invention. She doesn't yet paint the bravura landscapes she would later, but she doesn't imitate herself either. Her basic strong voice is here, as are her special inflections and jazz phrasings."[70] Likening the blues woman to an experimental visual artist is one of her most pivotal and unique aesthetic styles that she innovated as a foremother of sonic studies cultural criticism.

Perhaps Rosetta Reitz's crowning achievement as a historian, as a critic, and as a record label entrepreneur was the 1987 *Jailhouse Blues* collection, which saw her curating and editing contributors' liner notes essays; designing the cover and visual matter for the album, which featured a handpicked Romare Bearden print and archival Farm Security Administration photographs; and overseeing the engineering procedures necessary for converting Alan Lomax and Herbert Halpert's Library of Congress recordings of women prisoners' vocal performances from tape to vinyl.[71] Throughout the two-year gestation process of the project, Reitz remained vigilant about emphasizing historical specificity, context, and analysis in the album's framing essays. In her own notes for the project, she affirmed that "recent research has shown that the majority of women in prisons have experienced physical violence and battering in their lives, prison to prison. There is every reason to assume the women in the Parchman Penitentiary, during the Depression of the 1930s also lived lives of violence." Reitz sought to situate the women prisoners who sang the blues within a larger

history of state and domestic violence that, in turn, informed the nature of the music they performed for the Lomax and Halpert expedition. Bringing together the critical insight of Black studies historian Leon Litwack, veteran activist and vocalist Bernice Johnson Reagon, and folk arts curator Cheri L. Wolfe, she edited a critical throughline between the aforementioned authors' essays that stressed Black women's radical perseverance in the face of chronic Jim Crow subjugation. Here, as is the case in all of her work, Reitz pioneered a critical discourse about Black women's blues that weaves together historical detail with feminist ideology and art criticism.[72]

The first all-women LP compiled from the American Folklife Center's Archive of Folk Culture holdings, *Jailhouse Blues* appears to have taken shape as a result of Reitz's contact with Litwack, one of the preeminent scholars of African American history in the 1970s and 1980s. In a letter to the U.C. Berkeley scholar thanking him for the idea of the project and for agreeing to contribute notes to accompany the album, Reitz goes full on nerd while gushing about the quality of the ten Farm Security Administration photos by Dorothea Lange and Marion Post that she's decided to use for the design ("It will be gorgeous. You'll be proud of it.") and shares her elation over having secured the rights to place "a marvelous collage of two black women" by Bearden on the album cover. Her correspondence with cocollaborators Litwack, Wolfe, and Reagon documents the way that she conceived of her album projects as scholarly endeavors that demanded careful marketing and engineering practices from top to bottom. She, for instance, explained the necessity of her extensive notes to Jackson, Mississippi, State Historical Museum representative Patti Carr Black, arguing that the music was "extremely difficult" to decipher and that it, therefore, "helps listeners to read the words" and "to identify 'where' the songs came from." Reitz believed that the discursive as well as the visual components of the project would ultimately enhance and deepen the historical lens applied to Depression-era African American women prisoners' lives and the singular music they made. To Black she proudly declared that of the photographs, she "loved especially the woman with the bonnet in the cotton field . . . a magnificent abstract composition. . . . Reveal more history than most books because those visual images of the women show the women in a way they have not yet been written about." The photographs were necessary, she insisted in separate notes to Wolfe, since "they show the kind of women who might have been in the penitentiary and the ones who are singing the songs."[73]

For these reasons, she wanted desperately to find ways to get this music to the masses, recognizing that the material she was resuscitating had seemingly limited appeal. "The music was recorded under such poor circumstances and

Jailhouse Women's Blues (front and back covers), Rosetta Records, 1987

with such poor equipment" that she would have to find a way to conjoin the grainy, a cappella recordings that were half a century old with the more recognizable music. Again turning to Bessie, she noted to Black that, when Smith "sang JAILHOUSE BLUES she was standing on a stage and sang it in sympathy and support of the women in prison. That song opens with some of the most beautiful blues lines in existence: . . . Good morning blues / Blues, how do you do / I've come here / To have some words with you. . . . Talk about confrontation?" Reitz plotted her ideas out carefully here. "Strength and survival. I was planning to quote these lines." At all costs, she remained invested in reaching "young people, who are not scholars, but simply listeners . . . so they can hear 'the real thing,' the actual source material." And so she strove to create a product that was legible and as competitive as she could afford to be in the contemporary pop music marketplace of the 1980s, dreaming of Grammy nominations for the project and, as part of her business plan, envisioning "going into the Tower Record[s] stores . . . where I see how the album will be competing." "I want the record to sell," she disclosed to Black, "because unless it does, I've not made any money costs for my work. My fee is the production costs only and until or unless the record is a commercial seller, I'm out of luck."[74] *Jailhouse Blues* was not, as it turned out, a major seller for Reitz's label, and while she nursed hopes of developing other themed compilations (on, among other things, music that she classified as "S&M blues," "women loving women" blues, and self-affirmation blues songs), she told the *Los Angeles Times* in 1992 that four of her albums released in the series Independent Women's Blues, nonetheless, had sold "more than 20,000 copies."[75]

We know from her papers that there was a book—ultimately unfinished yet epic and winding, characteristically ambitious in its reach, voluminous in detail, urgently heartfelt in its prose. She had been working on it for many years, this project that summed up the totality of her career and encapsulated her lifelong arguments about the value of Black women musicians. In one of her manuscript drafts, she stated her intentions as follows:

> I wish to scrutinize them from another angle of vision than the one that has most been applied; from ignoring them to minimizing their importance to totally misjudging them, to reducing them to a single dimension when in fact their lives were full of complexities. If we do not remember them, because so many have been excluded from the history books, then we are doing damage to a significant part of our American past. The women's songs document that past and our collective memory is enriched from that knowl-

Rosetta Reitz with her records

Theater marquee featuring Rosetta Reitz, the public intellectual at work

edge. Their contribution to American culture, sometimes as art and sometimes as pop is not controversial; nor is for example, viewing Billie Holiday as a serious and great artist rather than as a pathetic victim of drug abuse. Or Bessie Smith, as a virtuoso rather than as a crude, low-class drunkard who is too often represented by a "pig foot and a bottle of beer."

In the unfinished book of Reitz, she held forth as she did in all her work, insisting to the end that "women added new territory to the map of American music; [they] both set new standards for singers to come; yet . . . received no honors or prizes for their distinction, and have been maligned by many."[76] In her own relative obscurity, she shared much in common with many of the women she championed. But what the first woman to run her own blues women's record label and author a trove of liner notes essays gave us was a manifestation of the multitudes, just like the music she so adored. She set out to set the record straight, and, one would imagine, she had to have hoped that someone was out there listening closely—to both the sounds of these formidable artists and the grand ideas that she drew out of said sounds. She had to have dreamed of the next feminist music lover who was ready to spin these discs yet again and lovingly converse with them just as she had.

4

THRICE MILITANT MUSIC CRITICISM

ELLEN WILLIS & LORRAINE HANSBERRY'S
WHAT MIGHT BE

Write if you will: but write about the world as it is and as you think it OUGHT
to be and must be—if there is to be a world.

—LORRAINE HANSBERRY, "To Be Young, Gifted and Black"[1]

If, as the song goes, a really excellent deejay has the power to save a woman's life, shouldn't a music critic, a really down-with-you storyteller, an in-the-trenches thinker who feels it all (like Feist), who shares your deepest hopes, desires, fears, and longings (like Aretha), who likes and loves the music alongside you and wants to spell that love out for you (like the critic Rosetta Reitz)—wouldn't and shouldn't a brave and an original writer, one who voices all that you've wanted to hear out loud like an extended banger spinning on the turntable, be able to do the same?[2] Just think about all those unheralded women—blues nerds as well as music novices—who may have stumbled across a Rosetta Records album by happenstance or the ones who made the pilgrimage to the local music shop on a whim, the ones who got curious after reading about that maverick Reitz in *New Women's Times*. Imagine them discovering her pithy, ardent liner notes, her affectionate and scrupulous odes to Ida Cox or Ethel Waters, and consider what could have been set alight, the feelings and pleasures, dreams and frustrations that her meditations on the classic women's blues might have sparked in a reader who felt stirred and awakened by this feminist reclamation of the early hustlers who set pop music all afire during the first half of the "modern" century.

If the timing had been different, one of those readers could have been Ellen Jane Willis, a fellow New Yorker who shared the same fervent second-wave ideals, the same deep-bone passion for music (both had, for instance, important things to say about Bessie Smith), the same approach to writing about culture as a form of feminist power and intent. But the extant archives of these two women critics seem to indicate that they were not engaged with each other, and they most certainly were traveling down divergent paths on their respective, discursive journeys as Jewish feminist music intellectuals. Some of this may have to do with generational differences. They were not close in age. A Depression-era baby, the blues aficionado Reitz would have been on the cusp of setting off for college when Willis was born in Manhattan in 1941. The latter woman's college years in the midst of the 1960s youth culture revolution would lay the critical foundation for her emergence toward the end of that decade as one of the most influential voices in the nascent field of rock music criticism. Reitz gets to work on her blues manifestos some ten years later—and so, if anything, her career as a critic may have been spurred on by the inroads that her junior Willis had made in the world of arts journalism before her. It's safe to assume, then, that it's not Reitz who modeled for Ellen Willis the kind of take-no-prisoners style of feminist critique that would become her trademark. These sorts of mentors, one would have to guess, were scarce for her insofar as there were few senior women writers who were probing the meaning and socially transformative power of mass culture and, in particular, the role of popular music in women's lives when Willis was coming of age.

Tracking the history of these sorts of relations, networks of influence, scenarios between young women readers and aspiring writers like Willis and the critics—arts critics, no less—who made a difference in their lives is clearly a challenge and rarely considered by cultural historians, perhaps because such connections are so intimate, so personal, so qualitative in nature that one would be hard pressed to find "proof," clear-cut documentation of that deeply affective moment when one thinker reached another and expanded her tastes, challenged her opinions, revolutionized her ideas, transformed her views about the world. Yet we know that such influences had to have existed; they instilled in other women the belief in the authority vested in their own voices and the courage to take risks, to "imagine otherwise" in their prose. It's in this context that I find it worth speculating about the extent to which the "fiery loveliness" of one ferociously talented writer, debater, grassroots activist, and feminist public-sphere intellectual may have fleetingly touched a young Ellen Willis and shaped her spirit, enlivened her vision, and perhaps even galvanized the radical passions of this would-be teen critic searching for her own voice in print.[3] Doing so, as

this chapter ultimately suggests, holds the potential to illuminate the shared and yet rarely recognized affinities between Black and white feminist culture writing, as well as the connections between the advent of counterculture music criticism and the Black freedom struggle intellectual politics that created the conditions for the former's flourishing.

Ellen Willis's archive offers the kind of arresting conundrum that draws all of these ideas together. A single image in the late writer's papers serves as the trace of a sole documented encounter with Lorraine Hansberry, a woman who dazzled the literary world during Willis's college years. She comes across, in both the photograph and the accompanying article, as luminous in stature, casually stylish, confident, and charismatic at what would have been age thirty. Surely basking in the glow of burning-bright new fame, she is, nonetheless, earnestly self-conscious about how to manage and carry out the responsibilities of her ascendant position as role model to a new generation of activists and artists. Her startling presence in Ellen Willis's collected papers inevitably provokes an intriguing question: What kind of an impact, if any at all, did this encounter have on Willis's consciousness? What kind of a mark might this meeting have left on her as she was coming of age as a writer? And what if Hansberry—who is all too rarely thought of today as a critic but who, in her own time and Willis's, was most certainly blazing a brief yet unprecedented path forward as a Black feminist public intellectual, a culture pundit, an arts pugilist known for both her "fire" and her grace—what if that arts-world celebrity could have played some part in the waking life of this determined Ivy League undergraduate, this young woman who would one day pioneer cultural criticism that championed female cultural pleasure? What if Willis's poetics of radical feminist analytic discernment in popular music culture can best be understood in relation to the example set for her by Hansberry?

The image itself stands as a poignant and alluring clue as to what kinds of youthful cultural tastes and concerns Ellen Willis possessed, and such a topic may be unfamiliar to many—even in this posthumous era of long overdue praise for and celebration of Willis and the recuperation of her groundbreaking music criticism.[4] Said clipping is nestled in Box 6 of the Ellen Willis Papers at Harvard University's Schlesinger Library, and it features a photo included in a 1960 special issue of *Mademoiselle* magazine: on the right, nineteen-year-old Willis, dressed in a smart, shirtwaist dress and rocking a neat, New Frontier 'do. There she sits, face-to-face with none other than the genius and very famous Hansberry. In the photograph, Willis focuses intently on the characteristically chic playwright, who returns her gaze and looks as though she is in the midst of making a carefully sketched-out point or posing a thoughtful question to her

Lorraine Hansberry and Ellen Willis, side by side, *Mademoiselle*, 1960

teen interlocutor. Two women, two writers, two radicals—one in the prime of her tragically short life, the other just beginning to shape her political sensibilities, articulate her love of rock and roll, and locate a throughline between these two worlds. Willis preserved the article in her files, affixing a handwritten note to the clipping that conveys both her pride and precision when it came to documenting her personal achievements: "Besides conducting and writing the interview with Miss Hansberry above, I composed the final versions of all the interviews in this feature (from the interviewers' notes and rough drafts) and prepared the copy for the printer."[5]

She documented her meeting with Hansberry and filed it away. And perhaps it was a trifle, one of those dazzling opportunities that young women of a certain privileged class are often afforded with the right kind of fancy schooling to get them in the door. Perhaps it was a mere yet mightily impressive building block on her nascent resume. Or perhaps it was a pivotal connection that she stored away yet cherished, returned to only in privacy as a way to right herself, to hold steady, to keep sight of her own ethics, her own moral imagination. For some, like me, one of those readers whose intellectual life and labors have been deeply touched by both women's work, the photograph will always provoke endless speculation, endless romantic ideas of the what-might-be: of Hansberry

in the role of the deejay saving a young Ellen Willis's writerly life. If it was to be, Willis, it seems, left no further trace of Hansberry's impact on her or lack thereof. But the symbolism of their conversation nonetheless sparks all sorts of potentially generative ideas, critical experiments in thinking about the secret intellectual history of popular music culture as it was forged by Black and white women thinkers alike.

Such speculation has utopian aims up its sleeves for sure; no sense in denying it. It is speculation that amounts to critical dreamwork, that which is wholly inspired by the scholarship of the late, great queer-of-color theorist José Muñoz. Muñoz, of course, has famously reanimated and redirected the words and ideas of German Marxist philosopher Ernst Bloch and Bloch's theories of the utopian "then and there," putting them in the service of his queer revolutionary vision. Muñoz's effort in the monumental study *Cruising Utopia* is, in part, to pursue what he calls a queer "potentiality . . . a certain mode of nonbeing that is eminent, a thing that is present but not actually existing in the present tense." Again and again, Muñoz returns in this famous study to what he reads across various cultural works (the queer utopian potentiality in, for instance, Amiri Baraka's *The Toilet*) as a "surplus of both affect and meaning *within* the aesthetic" itself. Radical hope, new worlds, new and unexpected relations, reorderings of intimacies are all lurking in these texts that he identifies. If only we might listen and look out for them. Long ago, Muñoz's work gave me the map forward for this chapter, laying out for me the speculative geography of unmarked places where two drastically different women might cross paths by way of their ideas and intellectual longings.[6]

And so I went looking for the latent possibilities stored up in their sole meeting. I set out to mine the Willis and Hansberry encounter for its surplus, its kernel of critical hope. I went searching for a kind of music criticism that could account for their intellectual affinities. In the end, I have "traveled 70 states," like Solange, and sought to move like that itinerant Toni Morrison heroine Pilate, traversing the enforced boundaries between Black radical thought and rock and roll passion prose in order to not only excavate these two women's shared affinities but also move us closer to a kind of cultural writing that insists that both types of intellectual labor are inextricably linked to one another and should be interested in each other just as Willis and Hansberry were on that one summer day back in 1960. As I suggest later, the Muñozian act of envisioning their "what might be" should ultimately "hel[p] us to see the not-yet-conscious" entanglements between classic rock criticism and Black feminist theory. Theirs is a pairing that, to me, works "in the service of a new futurity," one that alters how we, the nerds who can't stop writing about music, might push ourselves to

keep thinking harder and more deeply about how race, gender, class, and sexuality perpetually shape the very foundations of popular music culture as well as the criticism *about* that culture.[7]

Considering the ways in which Hansberry's work as a cultural intellectual created the conditions for Willis's criticism should remind us of the extent to which the broader history of a modern intellectual tradition of criticism on popular music owes a rarely acknowledged debt to Black feminist thought, queer woman-of-color critique, and second-wave feminism for galvanizing the field, raising the stakes of why the music matters and to what extent it might set us all—and not just some of us—free. Willis's embrace of the popular should matter too to those of us working in Black studies, as she models for us the importance of connecting with crucial and potentially transformative moments in our commercial popular culture, ones in which we might discover transcendent modes of self-making and ways of being in the world that affirm our own sensuous consciousness. This chapter, then, not only sets out to demonstrate the resonances between Hansberry and Willis's respective bodies of revolutionary work but also asks what would happen if their seemingly disparate realms of criticism were given the space to speak to each other more fully, more freely, more extensively. What would that look and sound like, and how might it change our perceptions about the radical potential of popular music and the Black women who make it? In short, what might Black feminist intellectual history mean to rock music criticism and vice versa?

To begin to answer these questions, this chapter first turns back to the details of that meeting that occurred during one of Willis's Barnard summers, and it subsequently considers the reach of Hansberry's stardom, positing the ways that Willis would have, in effect, been drawn to her as she stood in the arts world-meets-pop culture limelight of the Civil Rights era. It then explores Hansberry's passion for mentoring young people like Ellen Willis, nurturing their "wokeness," demanding of them higher principles that they might, in turn, apply to art as well as politics. The second half of the chapter examines the nuances of each writer's achievements and innovations as an arts critic who advanced and radicalized feminist politics in cultural criticism in a variety of ways. In both her public-facing essays, articles, and lectures and her private, improvisatory notes, Lorraine Hansberry clearly valued the importance and exquisite worth of her own critical voice and viewpoints. So, too, did Ellen Willis, who found her calling in not just the music of rock and roll but her ability to document the relevance and complexities of an entire scene through her own feminist vision. The story that I'm telling here considers both her forward-thinking ideas about rock's liberatory potential and the intersectional blind spots that

became infamous stumbling blocks for Willis and her fellow white women second wavers. In the end, as this chapter's conclusion suggests, it would have to be the Black women intellectuals—the scholars as well as the musicians—who might fulfill the what-might-be of Willis and Hansberry's moment together.

"We Hitch Our Wagons": Black Feminist Iconicity and White Girl Fandom

Dear Miss Hansberry,

Thank you for a very enjoyable afternoon! It was a pleasure to hear your views, and I only wish that <u>Mademoiselle</u> would give me more space to express them.

Since I have a special interest in the modern theater, it meant a lot to me to be able to talk with the author of a play I admired. I look forward to the film version of <u>Raisin</u>.

Sincerely,
Ellen Willis[8]

Ellen Willis was principled and clearly comfortable grappling with her convictions from a young age. The daughter of a police lieutenant and a homemaker, she was born and raised in Manhattan, a Bronx and Queens girl whose diary at age thirteen offers a few clues about her emergence as a budding critic. Entries oscillate between familiar girlhood anticipations and joie de vivre—"hoping to go to the Ice Show," "playing in the snow," "seeing Snow White and the Seven Dwarfs," "eating mounds bars," and crafting questioning commentary about television programs that she "couldn't make heads or tails of." It's here that we see her embracing her strong feelings about culture, at one point drawing what is seemingly a self-portrait of herself perched next to a television with "sheer boredom" scrawled in a thought bubble above her head.[9] By the time she reached Barnard University in 1958, we can imagine a young woman who'd turned her opinions about culture into literary pursuits that would eventually open the door to a college internship at a prestigious magazine that afforded her the opportunity to engage with her heroes.

It is August 1960 and the special "college issue" of *Mademoiselle* magazine (a self-proclaimed publication "for smart young women") has just hit the newsstands. Junior Barnard student Willis has won the competition to serve as a

summer guest editor. "Ellen Willis, Barnard College, '62, loves the vitality of her native New York: 'I can't study when it's quiet,' says Willis. She is majoring in English, hopes to do graduate work in modern comparative literature and eventually to write. Other diversions are the theatre, French poetry, and politics: [adds Willis] 'I just don't agree that my generation has no causes.'"[10]

No wonder, then, that she chose as her interview subject the remarkable Hansberry, a woman, a self-proclaimed "radical," an artist with an intersectional cause (long before we had the name for such a thing) rooted deep in her core being. Born in Chicago to a mother who was a teacher and ward leader for the Republican Party and a real estate broker father, she was raised in a middle-class family steeped in uplift leadership politics and integrationist ideals. Her own revolutionary philosophies would take shape in her postwar undergraduate years organizing, debating, volunteering for the Progressive Party's presidential campaign, and joining the Communist Party while at the University of Wisconsin, where she studied for two years before moving to New York City and finding her way into the heart of Black radical activism led by the lionized artist and global elder statesman Paul Robeson.[11]

The Hansberry whom Willis would have encountered in 1960 was sui generis on several fronts. This was a woman who would have still no doubt been basking in the glow of her Broadway triumph *A Raisin in the Sun* from the previous year, a thunderous, historic achievement that resulted in her becoming many things—among them the youngest American playwright and only the fifth woman to win the New York Drama Critics Circle Award. Accolades would abound for Hansberry and her riveting play, a Civil Rights drama that forecast the emergence of a new generation of yearning, dreaming Black protagonists declaring their desire to move—both literally and figuratively—from the margins of American culture. Hansberry was at this moment moving squarely to the center of the arts world as the first Black woman to have a play produced on Broadway. Yet she was also, as post–Civil Rights era Black studies scholars have emphasized, much more than a gifted playwright. Deeply aligned with multiple threads of the global Black freedom struggle—Civil Rights, evolving Black cultural and diasporic nationalisms, and early strains of second-wave Black feminist activism and radical queer politics—she consistently promoted a revolutionary agenda that envisioned art as social agitation and as integral to insurgent reform.[12]

In this photo, Lorraine—the artist/activist/intellectual, the one who was famously called by her dear, dear friend Nina Simone the kind of woman who enjoyed and coaxed out of her the "real girl's talk" of "Marx, Lenin and revolution"—sits side by side with young Ellen, the latter's choice for the feature entitled

"We Hitch Our Wagons: Twenty People Whose Careers Have Special Meaning for Us to Discuss the Pressures and Impulses That Produce the Creative Life."[13] And it should hardly come as a surprise that she was the only Black artist—man or woman—chosen by any of the student guest editors for this particular issue. Willis's brief profile offers a rare snapshot of Hansberry through the eyes of a white teen journalist whose own sociopolitical sensibilities shape the tenor of her profile. "Miss Hansberry," she writes,

> author of *A Raisin in the Sun,* contends that to classify her play as "social drama" is to use an artificial category. [Says Hansberry,] "All art is a bit political. When you deal with human relationships you are dealing with social relationships." Commenting on the contemporary American theatre, Miss Hansberry praised our actors but said that our theatre has become "small" because playwrights treat human problems in a vacuum instead of coming to grips with the world. She also rejects the attitude of despair now prevalent in art. "The artist feels unable to emulate the Michelangos and the Shakespeares," [she argues,] "so he goes to the other extreme and becomes merely complaining." The "apathy" of today's young people is imposed on them, she said, noting that the same college authorities who decry the "silent generation" stifle dissent on their own campuses. She lauded Northern students' recent concern for the plight of the Southern Negro as evidence of "a new vitality in our youth." When I asked what presidential candidate would do the most for civil rights, she smiled, [and] murmured wistfully, "Lincoln."[14]

What a moment. Willis seemingly seeks out and captures here words of wisdom, affirmation, and encouragement for her generation from a young Black woman writer who had taken the literary world by storm that season with her vision of Black longing and desire paired with quotidian agency and brave, burgeoning refusals of the existing social order. We hear, in this interview, an artist both gently pushing back on the sociological fetishization of Black writers and calling attention to the politics informing all cultural production. We hear a playwright expressing her commitment to the aspirational and global potentiality of modern drama, and we hear the sharp observations of a fierce social activist who recognizes the hypocrisy of intellectual institutions and who conversely aligns herself with a new, youth-oriented freedom struggle on the rise in 1960.

This Hansberry is familiar, but to scholars of popular music and sound studies, feminist theory, and cultural histories of progressive activism who are familiar with Willis's formidable body of work, this is an image that, at least a little bit,

complicates what most of us *think* we know about Ellen Willis from the late 1960s forward: the white Jewish second-wave feminist who maintained a dogged commitment to cultural radicalism, radical feminism, what she saw as the as-yet-unfulfilled promise of a more perfect democracy, utopian culture realized, and rock and roll's ability to activate, nurture, and encompass all of these ideologies. The Ellen Willis who wrote "rock lit" (as she called it in one phenomenal, unpublished lecture) during the late 1960s and early 1970s, the one who produced a vibrant body of work on everyone from Bob Dylan to the Stones to Leo Sayer and Creedence Clearwater Revival, seemed to have engaged far less with Black cultural aesthetics and politics, let alone the work of Black feminists (like Lorraine) in particular.[15] Yet she is perhaps far more important a figure than ever before in contemporary popular music and sound studies, in part because of the way that she pioneered a gorgeously robust and razor-sharp analytic style of writing about pop that limned sophisticated explorations of identity politics in sound, as well as pop music culture's relationship to the broader American scene.

That Ellen Willis's work absorbed and reflected the energy and bold intellectual vision of Black radical tradition politics and woman-of-color critique is rarely acknowledged by her colleagues and friends or by those who succeeded her in the world of rock music journalism—in part because Willis herself rarely made these connections but also because we are still a long way from fully affirming and engaging with the significance of Black feminist theory as foundational to our present-day, hot-as-it-will-ever-be field of sonic studies.[16] Placing her in conversation with a figure like Hansberry, though, creates the opportunity to think about the extent to which these two women from very different worlds shared similar and, to a certain degree, complementary personal and political desires that they each mapped out in both formal and informal prose.

Willis's work, like Hansberry's, returns again and again to the same questions of power and the intellectual, sociocultural, corporeal, and affective ways that New Left young folks and women in particular might take pleasure in disassembling power. The articulation of pleasure in relation to popular aesthetics was, to her, a crucial method of waging war against oppressive institutions. The "rebellion of personal style against conventional standards of what you were supposed to look like, the aesthetic rebellion against the hegemony of so-called high art," and the refusal to dismiss "mass culture as inherently inferior," were sixties values that she carried with her and continued to promote late in her life as she would reflect on a time when "there was a rebellion against the stultifying conventions of orthodox newspaper reporting, the validation of new forms of reporting, essay-writing and criticism, and of a vital press."[17]

Ellen Willis, circa 1970

Though her writing may seem worlds away from Black women's sound cultures, this chapter ultimately draws out the important throughlines, and I suggest that it is Willis's work that cultivated ways of imagining how the politics of rock and roll, mass culture, and radical feminisms fundamentally matter in relation to the repertoires of Black women musicians. Think, then, of the photo with Hansberry as holding out to us a kind of possibility, "the not-yet-here (the future) and the no-longer-conscious (the past)," a kind of "queer futurity that . . . is not an end but an opening or horizon," "a future being within the present" image "that is both a utopian kernel and an anticipatory illumination."[18] Think of the photo as beckoning us to consider the "other" Ellen, the one who "hitches her wagon" to Lorraine and who emerges much later in the *margins* of

the archive (in, as we shall see, lesser-known published as well as unpublished writings), in her adult, fully politicized life, as a woman who openly grappled with seeking to address and work through the wounds of racial strife and fragmentation in the second-wave feminist movement brought on by racism and cultural miscommunication.

It is, then, both ironic and poetic to recognize the ways that, in this, the final chapter of *Liner Notes for the Revolution*'s first half, on this final cut on Side A, Ellen Willis's repertoire dances an until-now-unrealized duet of sorts with Lorraine Hansberry's formidable cultural and social criticism as well as the Black feminist critical discourse that came after her and flourished alongside and occasionally in conversation with her own activist work. For these reasons, this chapter traces the parallels and intersections in the work of two exceptionally original and audacious women whose philosophies, politics, and critical belles lettres created the conditions for what we might think of as thrice militant music criticism—writing that values intersectional politics, the collective desires and relevant pleasures of the marginalized, and views all of the aforementioned as precious tools for new world-making. As this chapter makes clear, it is two game-changing sisters, Hortense Spillers and Aretha Franklin, who would bring that world forcefully and most fully into view, producing transformative Black feminist theory, in the case of Spillers, and, in the case of Franklin, manifesting that theory in bursts of electrifying new sound, the likes of which the pop world had not heard until the Queen embarked on her stunning, late sixties ascent.

"Beginning to See the Light": Black Literary Stardom & Public Intellectual Praxis

Snagging an interview with Hansberry would have been a coup for Willis in the summer of 1960. The playwright was at the forefront of the arts press world in the heady, whirlwind first year of *Raisin*'s Broadway debut as the play opened to rapturous reviews on March 11, 1959. The pop frenzy makes it all the more likely that the literary-minded Willis would have been tracking Hansberry's spectacular rise as a much-sought-after public figure. Hansberry was, it seems, everywhere that year as she continued to bask in the glow of red-hot critical adulation. It was the season of new Black celebrity tied to the energy and excitement of Civil Rights movement possibility, and Hansberry, her Hollywood contemporaries (Lena Horne, Harry Belafonte, Dorothy Dandridge, Ossie Davis, Sidney Poitier, Ruby Dee), her fellow midcentury bona fide literary stars

(Gwendolyn Brooks, Ralph Ellison, James Baldwin), and dazzling new music sensations (Nina Simone, John Coltrane, Odetta) were all turning vigorous aesthetic excellence into statements of social defiance and self-determination. Each artist's righteously confident articulations of Black cultural subjectivity were writ large with a kind of stubborn effulgence, what we might now call swagger—understated or in your face depending on each cultural actor's style. Hansberry walked right down the middle of the road on this score. She was glamorous and "often described in the press as a sort of ingénue," as biographer Imani Perry observes in her important new work on Hansberry. Profiles in *Vogue* and the *New Yorker* played to their respective readerships by highlighting her winning persona and on-point sartorial flare (Hansberry, raves *Vogue*, is "easy, brilliant, attractive, downright, and with plenty to say. . . . Her writing clothes at home are still rather campus—white, beat sneakers, thick white socks, chino pants, and a handsome mustardy-checked top") as well as her vivid and assertive theories about the meaning and promise of her own art ("I believe," she tells the *New Yorker*, "that real drama has to do with audience involvement and achieving the emotional transformation of people on the stage. I believe that ideas can be transmitted emotionally.").[19]

Her youthfulness, her race, and her gender, combined with the fact of what she achieved—a first play on the Great White Way at age twenty-eight—meant that she was treated like something of a Black unicorn, feted by major press outlets and congratulated by stage and Hollywood stars with intensity, admiration, and candid affection in ways that underscore the magnitude of what she represented and meant to both white liberal and Black aspirational publics. It's evident in the fan letters she received from figures as varied as actress Anne Bancroft and the ravishing transatlantic cabaret entertainer, dancer, vocalist, actress, and sex symbol Eartha Kitt. "My heart is so big—I can't even talk," proclaims Bancroft. "What a great thing you've done. If nothing else rewards you for your work—know that angels are smiling on you, audiences are sobbing. My love and respect."[20] The handwritten Kitt fan letter was even longer and more detailed in its effusiveness. "Miss Hansberry," she begins,

> I was very pleased to have received your [note?], but even more pleased that I had seen your play. I wanted to write to someone about what I had [experienced?] in my emotions—I wanted to talk to someone about what I felt—I wanted to express what I feel and felt you had achieved in many ways—I wanted to cry—and I wanted to laugh—I wanted to [live?] again and again the values you had given me as a person—the soul that found another spirit of understanding—to create—to find—to [read?] into—an

understanding—a communication that will live and live and live and live—To say I am proud of you is trivial—to say you have made me happy is equally so [?]—but I am all these and more—I would not have missed it for all the world for I knew it all too well as I had read it before its production. I hope we meet someday for now you are a "star" [?] in my mind, and when, I think on you I feel a [?] inside. I will be in N.Y. around June 1st when I shall hope you and I shall meet to rejoice in a gladness of belonging to a world that needs us <u>both</u> as we need it.[21]

Kitt's and Bancroft's letters both attest to the fact that what Hansberry had set out to do in the theater, how she envisioned her work as "transmitting ideas emotionally" to audiences, average theatergoers as well as movie stars who were split open by the candor and urgency of her drama, had paid off in a major way. She was beloved and revered by fans as well as fellow artists who rallied around her both in life and in the wake of her heartbreaking death. Her charisma, like her art, was a beacon to many. But so too was the potency of her voice as a courageous and unwavering Black freedom struggle and feminist activist, a role she had gamely and steadfastly remained committed to assuming once fame came her way.

Having spent the previous decade as a grassroots Black freedom struggle organizer and journalist under the tutelage of Black radical giants like Paul and Eslanda Robeson and W. E. B. and Shirley Graham Du Bois (Perry aptly describes her as the "political daughter" of both men), Hansberry showed no signs of shying away from her social justice politics once her profile rose. Rather, she used the bully pulpit of her stardom to speak openly about the urgent need for mass social reform. She was an "American radical," as Perry reminds, and along with her close friend Baldwin, she largely invented a new category for the culture at midcentury: that of the modern Black public intellectual.[22] Think only of the public speaking events she attended and the appearances she made in that first year after the *Raisin* breakthrough and one gets the sense of the Hansberry that a young Ellen Willis would have likely encountered in newspaper coverage, on the radio, perhaps via the campus lecture circuit grapevine. On April 26, 1959, just a few weeks after winning the New York Drama Critics Circle Award, she appears with *Raisin* director Lloyd Richards on producer David Susskind's *Open End* television show, and the following week she agrees to be a guest on the public affairs program *Look Up and Live*. Within a week of each other in May of that year, she sits for two of her most (in)famous interviews, the first with the obtuse journalist Mike Wallace—though the interview never airs—and the second with the enormously popular and influential broadcaster Studs Terkel

in which she reflects with matter-of-fact ease and conviction that, "Obviously, people who are sophisticated enough to know it say that, obviously, the most oppressed group of any oppressed group will be its women, you know? Obviously. Since women, period, are oppressed in society and if you've got an oppressed group[,] they're twice oppressed. So I should imagine that they react accordingly as oppression makes people more militant . . . and so . . . twice militant because they're twice oppressed. . . ."[23] On May 12 as well, she had delivered a lecture at Chicago's Roosevelt University that focused on, among other things, the state of American drama and included some choice words for the *Porgy and Bess* film director Otto Preminger. The attacks would lead to a subsequent debate with Preminger just two weeks later on local Chicago television.[24]

And so it went. Hansberry would field an onslaught of invitations to speak her mind in public and for the world to hear. By January 1960, she had earned the title of "headstrong" from none other than *Mademoiselle* magazine, which invited her to join an all-male list of outspoken cultural figures to wax philosophical about the new decade on the horizon. In the article entitled "Quo Vadis," Latin for "Where are you going?," she shared space with the Beats W. S. Burroughs and Allen Ginsberg; the English men-of-letters Christopher Logue and John Wain; the future neoconservative Norman Podhoretz; and French film director François Truffaut. *Mademoiselle*'s editors announced that they had asked some people "who have made names for themselves lately by the force of their attacks on things they don't like about the world to say what they *would* like for the 1960s." Hansberry, the global visionary, uses the invitation to thread together urgent demands for macro and micro reform movements, exposing the ways in which war and poverty, racism and health care crises are deeply interconnected catastrophes that politicians and policy makers must address or ignore at their own peril. "Naturally," she offers,

> the first of all longings today is for peace. I hope that governments everywhere will turn war industry to the production of peaceful industrial and consumer goods and rob the armament coffers to pour billions into public welfare. . . . The alternative is a scorched and silent planet. I should also like to see medical care guaranteed to everyone, regardless of income. The various labels hurled at such ideas are irrelevant; what is relevant is that several hundred thousand people die yearly in the United States because of inadequate medical care. This suggests that millions more suffer from improperly attended sickness—surely not permissible in a country that can *afford* to buy the Atlantic Ocean. Popular idiom deals best with racial

prejudice: "Who needs it?" It too is a killer. Negroes, for instance, simply do not live as long as white people in America. I think we must begin to remember facts like that and chatter less about the sensibilities of our bigots. We have been pathetically overgenerous with their malignant whimsy for three centuries. I hope that in the next ten years we will begin to recognize the void that racism has left in the character of the white Americans.[25]

Within less than a year she had risen to the forefront of a cultural arts community that welcomed heady and impassioned interlocutors who translated the newly reinvigorated antiwar effort and the rapidly evolving Black freedom struggle zeitgeist into raw, clear-eyed public address. As queer-of-color theorist Roderick Ferguson has shown in his incisive reading of Hansberry's anticolonial activism and queer archival notes and letters, "[f]or her," sociopolitical "domination deserves an intellectually layered and insurgently ethical response." As such, she assumed her pulpit with fervor and exhausted her energies rising to this call. No other arts figure matched her in the moment on this score save for her dear, intimate ally Baldwin. "Six years his junior," Perry points out, "he treated her as an intellectual peer, a confidant, and at times a friend whom he implored for help." The two of them "in the public eye ... could function like a marvelous tag team, their ideas bouncing back and forth, rapid-fire."[26]

"What Use Are Flowers?": Lorraine Hansberry's Youth Revolution in Letters

I wish others to live for generations and generations and generations and generations.

—LORRAINE HANSBERRY, "The Negro Writer and His Roots"[27]

All of this would have put her within Willis's line of view, that and the fact that she had developed a distinct following among Black and white youths, which was something of an unprecedented phenomenon for a Black woman writer at midcentury. They wrote to her in droves: the ten-year-old sister from Chicago who followed up with her after a Negro history program asking for her help about her singing career, the Berkeley schoolchildren who sent handwritten get-well letters to her. They wrote for advice. They wrote of how they adored and admired her, as well as how much they loved her play. Children were particularly attuned to aspects of her work, perhaps responding to its aspira-

tional vision. Iconic jazz critic Nat Hentoff would even point out, five years after her death, how his "13-year-old daughter" would ask of him, following a performance of *To Be Young, Gifted, and Black: Lorraine Hansberry in her Own Words,* "Is there any way . . . this can get around to a lot of schools?" Young people wrote of wanting to meet her to gain insight and perspective from her. Ernest Green, one of the famed Little Rock Nine, the group of students who integrated Central High School in 1957 while facing daily treachery, sent along a fan letter in which he notes, "I just got through reading your article to the 'Village Voice: An Author's Reflection' which I was overjoyed to read because I have just seen the play." Green adds that he is writing to "congratulate [her] on bringing the Negro actor into a new perspective," to "ask for some time in [her] busy schedule to get [*sic*] chance to meet," and to let her know how much he wished that "all of the students could have seen the play before entering Central in 57." Green muses, "It would have made us prouder to enter Central because we know we were not the only Walter Younger." In *Raisin,* Hansberry had created a protagonist whose smoldering rage, volatility, and dogged determination to break free of Jim Crow social and psychic confinement spoke to this new generation. Notably as well and until illness made it too difficult to do so, it seems that Hansberry remained intent on writing back to her youthful admirers when she could, imploring these young people to stay curious and hungry for knowledge. "I have virtually no influence in the entertainment industry," Hansberry ventures with regret in her letter to elementary school vocalist Faith Taylor, who had sought her assistance with a recording career. Her letter to Taylor closes with a kind admonition in which she encourages her "not to forget your singing—but to become equally and as emphatically" curious about "many, many other things—school and sports and books—not the least among them."[28]

That Hansberry was much concerned with the futurity of not just Black folks but humanity in its broadest sense was apparent in multiple aspects of her career and work—from her thoughtful and detailed correspondence with young fans and students who called on her for this kind of professional and personal wisdom and guidance, to the lectures in which she pronounced her commitment to seeing a way forward for the "generations" ahead of her, to her experimental playwriting in which she explored the conditions of Cold War threats to young people's existential survival. We know from her letters that Hansberry had been drafting *What Use Are Flowers? A Fable in One Act* since 1961 and that she'd described it as "a bit of a fantasy thing about war and peace."[29] The posthumously published version of the play envisions a scenario in which an aging hermit must conquer his own arrogance, impatience, and myopia to teach the young how to resee the world and reimagine their own

human condition in the wake of nuclear decimation. His journey, as well as that of the charges whom he reluctantly takes on, involves revaluing the universe and rediscovering for himself as well the fact that "the uses of flowers were infinite."[30] The pedagogy of the play rests on the hermit's ability to teach a new way of inhabiting the earth to the ones left to start the world all over again.

In many ways, the sense of trying to reach a younger public in order to do just that is very much alive in her letters to young fans, where she assumes the role of mentor, teacher, sounding board, a figure who was ready and willing to be there for the next generation and took them seriously as thinkers. Hansberry's extensive and often philosophical engagement with youthful interlocutors is perhaps most deeply and fully realized in a remarkable exchange that she had with a teenage white male student who sought her out in 1962, and the correspondence is significant inasmuch as it reveals how committed she was to meaningful communication with the people whom she perceived to be next-generation agents of change. The letter from Kenneth Merryman spells out his background and clearly articulates his reasons for seeking Hansberry's counsel. "I'm a white farm boy seventeen years of age," he begins,

> and I live on a rich, fertile farm on the Mason-Dixon Line twenty miles south of York, Pennsylvania. I'm a senior in high school . . . and have been accepted to attend the American University, Washington, D.C. in the fall. . . . I'm doing a research paper in my English class, contrasting and comparing the northern and southern Negroes of today. In it, I hope to compare their problems of today and their hopes for tomorrow. . . . I have a deep interest in the problem of the Negro, the injustices inflicted on him by so-called law-abiding whites, and his ability to love in return. Much material has been made available to me on Martin King's southern fight for justice but material concerning your personal views on our northern Negro is paltry. Your RAISIN IN THE SUN shows that you do have an interest and a keen ability to display it, this has led to my purpose in wanting to know more.[31]

The amount of energy and time that Hansberry puts into responding to Merryman's letter is a testament to how seriously she took young thinkers, and it also reveals how great of a pedagogical role she took on to inform, challenge, and galvanize her fans to seriously wrestle with social and political matters as well as matters pertaining to the arts. As is clear in her lengthy response to Merryman, these sorts of exchanges were strategies of nurturance administered by an elder and meant to serve as a kind of activation for future militancy. "I suppose that at the heart of my views of the 'Negro question' in the United States is the rec-

ognition," she declares, "that it is not a problem of random social discrimination against 'colored individuals' here and there but, in fact, a historical oppression of an entire people." Walking him through the nuances of white supremacy, she maps out for him how "the network of this oppression is intricate, implacable and nearly universal. And has always been so, except, as you may know, for a few brief years which were the Reconstruction, when democracy was almost unleashed in the South." Much of her work in these kinds of epistolary exchanges comes down to cultivating a kind of social intimacy across the color line that might convey both the complexities of Black folks' humanity and the necessity for multifaceted revolutionary tactics to adequately address Black folks' needs. Historically, as she makes clear here, the shape and aspiration of "the Negro's desire for freedom has been complicated and many-faced. It is not different today. This will account for the seemingly diametrically opposite techniques of the various freedom movements and organizations. . . . It is fashionable in our country to treat the reputed 'timidity' of the black man as a mystique which has to do with his ancestral 'docility' and 'submissiveness' and not with the brutality of force and violence which was the fact of his experience in the New World."[32]

There is a tone of readiness in Hansberry's address to Merryman, an attentiveness and watchfulness suggestive of her conviction that full-scale change and sociopolitical transformation are both viable and a long haul, that her sweeping, idealistic beliefs and goals would no doubt constitute the fight of her life as well as the lives of those who come after her. Educating the young about the natural and temporal arc of this battle is thus very much a topic that sits at the forefront of her letter as she points out, "Like most of my generation and, in particular, those behind my generation (I am thirty-two), I have no illusion that" King's valiant nonviolent movement "is enough. We believe that the world is political and that political power, in one form or another, will be the ultimate key to the liberation of American Negroes and, indeed, black folks throughout the world. . . . I think that Dr. King increasingly will have to face a forthcoming generation of Negroes who question even the restraints of his militant and, currently, progressive ideas and concepts."[33] The candor of her political reflections is itself an invitation to dwell in the realm of her maturity and an acknowledgment of how much respect for this form of communication Hansberry had, as well as how much value she placed on it. She held her young interlocutors in high regard and reinforced this point with her parting words. "This has been a conversation not an essay," she declares to him, "and I hope of some meaning to you. If you should care to reply and argue or comment about any of it I would be delighted. If not, may I wish you a happy and regarding

[*sic*] college experience for the next four years. I don't know what field you are going into—but whatever it is, bask in the opportunity for education, won't you? . . . And—neglect not the arts!"[34]

A warm, genuine, and yet sobering voice of wisdom—this is the Hansberry that Willis would have met during the spring of 1960. Having been shepherded along in her activist sensibilities not just by Paul Robeson and W. E. B. Du Bois but by their equally formidable mates, Eslanda Robeson and Shirley Graham Du Bois and having been championed and supported as an artist by the legendary Langston Hughes, Hansberry fully recognized her own responsibility to dynamically mentor.[35] This she learned perhaps most movingly from a figure who loomed large in her early years in New York working as a journalist in 1950s Harlem at the Robeson-helmed, Black radical newspaper *Freedom*. Under the tutelage of editor Louis Burnham and his wife, Dorothy, she came to realize the meaning of making art and doing cultural work in the pursuit of collective fulfillment, that her work was inextricably linked to that miraculous collective. "I had just turned twenty when I met him," she says in a memorial essay about Burnham. The

> thing he had for our people was something marvelous; he gave part of it to me and I shall die with it as he did. He would say simply, "They are beautiful, child," and close his eyes sometimes. I always knew he could see them marching then. It was an open, adoring love that mawkishness never touched. And it was he who insisted that everything under the stars was political, who also came to allow my deepest personal questions to know his counsel. I was taught to hold shadow up to sunlight and try, to the best of my ability and endurance, to discover all its properties; it was a large lesson—of the sort only fine poets teach.[36]

What Louis Burnham saw early on in Hansberry was something that the young ones saw as well: beaming rays of bright light and a wondrous dose of hope. "I sat there today with all my senses open," says Burnham in a letter dated March 1, 1959, and titled "Sunday After the conference."

> I looked and you were beautiful. I listened and your words were music. I thought and felt, and your meaning was essential truth. Perhaps we will not always agree on every point. But at this point in our people's story, who needs it? The search, the quest is the thing. So you must know that you are both a culmination and a beginning: that all that has gone before, for all its

blindness and aimlessness and senselessness, has been necessary; and that all that is to come, for all the anguish that yet portends, will be good.[37]

Burnham had been present at what amounted to Hansberry's major debut as a cultural critic when she delivered "The Negro Writer and His Roots," the keynote address at the American Society of African Culture Negro Writers Conference in New York City just a little over a week before *Raisin*'s opening. One hears in his words a loving awareness of the rare and precious power of Hansberry's genius and passion as well as his strong conviction about what she might do with this power. It is a message delivered by a warrior of the long Civil Rights movement, an African American Communist who forecasts what kind of a conduit Lorraine Hansberry would swiftly become in the weeks after he typed out his lyrical note to her filled with solemnity and grace. When he died suddenly in 1960, he left behind in his pocket yet another letter to her that he'd been intending to mail and that his wife, Dorothy, had passed on to her. In it he reflectively asks of her, "Can the Negro take what's good in America, but steadfastly reject what's sick, putrid and worthless, and form a set of values that may save, not only himself, but the nation as well?"[38] It was a question that Lorraine would set out to answer for the rest of her short life. And while her fan Ellen would go on to pursue strikingly similar queries, it's Hansberry who rehearsed public as well as private ways of theorizing answers to the notes Burnham had left behind.

Fighting the New Paternalists: Hansberry & the Anatomy of Black Feminist Cultural Criticism

Hansberry's well-known obsession with Simone de Beauvoir's *The Second Sex* seemingly marked an awakening in her to not only what was possible in terms of feminism but what it was possible to achieve as a Black feminist *critic*. This, in and of itself, is worth pausing on since her brief and yet meteoric evolution in this role was a modern achievement that made both Willis's work and generations of Black feminist critics' work that followed hers more viable and legible.

De Beauvoir showed her the way. The "reason why I say this de Beauvoir chick is a fine *intellectum*," she explained in a letter to Robert Nemiroff, the freedom struggle ally activist and songwriter whom she married in 1953, "is because she questions everything, including reality."[39] Her engagement with that French "intellectum's" work—and especially her literary phenomenon, *The Second Sex*—was extensive. Perry likens it to her "textbook" and points out the

ways in which she nearly treated it "like a girlfriend." Her immersion in de Beauvoir's groundbreaking feminist theories is most apparent in an unpublished essay from 1957 in which she opines on how *"The Second Sex* may very well be the most important work of this century. . . . Simone de Beauvoir has chosen to do what her subject historically demands: to treat woman with the seriousness and dedication to complexity that any analysis of so astronomical a group as 'half of humanity' would absolutely seem to warrant."[40] Beyond the rigorous ways in which Hansberry wrestles with *The Second Sex*'s ideas about gender oppression and de Beauvoir's views on the path forward and toward women's liberation, the essay is particularly unique in its vision—albeit a romantic one—of a widespread awakening of consciousness spurred by the book and cutting across class lines. "There was the playwright-actress," she begins,

> who kept it open upon her backstage dressing table reading aloud between curtains to the feminine half of the cast and "indoctrinating" them, in the outraged and distressed opinion of the male director. There is the woman reviewer writing in the *Daily Worker* a shamefully brief and limited yet nonetheless exuberant and intelligent review. There is the young, lovely blonde and vaguely literate secretary sitting in her apartment with the weighty thing propped upon her thighs, dictionary but inches away, forcing herself with passionate dedication to endure and, as far as possible, absorb seven hundred pages of what she describes as her "liberation." And then, of course, there is the twenty-three-year-old woman writer closing the book thoughtfully after months of study and placing it in the most available spot on her "reference" shelf, her fingers sensitive with awe, respect on the covers; her mind afire at last with ideas from France once again in history, egalite, fraternite, liberte—pour tout le monde![41]

The essay makes a point to trace the activation and emergence of a range of women who are discerning readers, critics in their own right and in their own varying ways—from the amateur secretary determined to make her way through the tome, to the communist journalist, to the "twenty-three-year-old woman," indubitably some younger version of Hansberry herself. All minds are "afire" here. A spark has been lit to see patriarchy for what it is and what it does to women that will thereby lead to its undoing. This is the way that Hansberry seemingly perceived the noble and ethical responsibility of the philosopher who mounts broad-based social critique. That kind of analytic justice would stay with her even as she made the transition from Harlem grassroots activist-journalist to downtown dramatist. The two roles worked for her, at least, hand in hand.

It made sense, as Perry has argued, for Lorraine Hansberry to "become a critic" because it allowed her to intervene in the racially and gender biased and often obtuse ways in which the arts world failed to read her work with nuance and depth. Though it was "strange for a playwright to write her own criticism," Perry argues, she did so with a stubborn commitment to the value of her own work. She "eviscerated many of those who diminished her characters."[42] Yet being a critic meant doing much more than defending the integrity of her own work. It had to do with a long-standing investment in pushing back against the broader culture industry apparatus as a Black feminist who was both an artist and a consumer and who demanded legibility and respect, the right to be seen and addressed as a lover of art and culture. And it had to do as well with exposing the systemic structures that shape arts criticism itself. Her early beat at *Freedom* gave her the opportunity to wed her political reform values with arts coverage. She produced stories on topics as varied as the dearth of employment for Negro dancers and the history of the Negro national anthem while likewise publishing the occasional book review—for example, of Richard Wright's 1953 novel *The Outsider* and Alice Childress's 1955 play *Trouble in Mind*.[43]

Simultaneously, however, she was developing a real skill for writing pointed and often extensive letters to the editor that took various critics to task for their oversights, small-mindedness, intellectual laziness, or inability to perceive of how various works of art might read to women and people of color, audiences who were most clearly underserved by the critical community. To the film critic at the *Daily Worker*, for instance, she is quick to point out the sexist details of his column on the 1954 Academy Awards, how a reference to Audrey Hepburn's "delightfulness" is, to her mind, an empty and condescending way in which to describe a woman's skills as a thespian. "It occurs to me," writes Hansberry, "that there is a splitting of standards ... when it comes to judging actresses as compared to actors."[44] To the *Village Voice* in 1956 she levels a blistering assessment of the inherent misogyny in August Strindberg's *Comrades* while pushing back as well against the critic's failure "to see the play for what it is": "So!—[Your reviewer] has praises to give to this or that Off-Broadway group which turns to the 'resuscitation of invaluable dramatic material'—! With this he dares to direct us to the Actor's Playhouse production of Comrades. . . . The playwright clearly hated women with a depth and passion which defies reason or a mere expression of the *cute* 'BATTLE OF THE SEXES: MALE POINT OF VIEW.'"[45] The variation in Hansberry's tone across these letters, which ranges from patient and methodical to quick-fuse livid, is evidence of a critical reader and writer whose ardent concern about misinformed or slow-footed analysis could fluctuate depending on the circumstance. Sometimes the oversights were slight

and warranted an easy, educational hand. At other times, the intransigence of sexist and racist double standards could only be met with furious objection. Such is the case in her protest letter—and one of many that were written by a range of activists—in response to Norman Podhoretz's quickly infamous "My Negro Problem—and Ours" article published in his magazine *Commentary* in 1963. Though she and Podhoretz had shared space several years before in the *Mademoiselle* feature, her dissection of his unabashed white displacement narrative is uncompromising.

> Above all was I struck with Mr. Podhoretz's hanging implication that he feels absolved from any crimes that might have been going on around here because after all, his ancestors were somewhere else when the slave ships docked. To long for that particular absolution Mr. Podhoretz and every one else will have to give up that sweeping phrase which he uses without hesitation in the middle of his article, "we white Americans". . . . I charge him with offering up a confessional which will merely be a device of those anxious to see the world stay as it is—"just a little longer". . . . What remains, I should think, is for Commentary to swiftly open its pages to those white thinkers, to some white Baldwin perhaps, who have discerned in Baldwin's appeal to love, sanity and political possibility, that which we can all respond with some fervrent [*sic*] tonality of the future rather than the past.[46]

In this letter, as was often her style, she remains as interested in the psychology—the anxieties, fears, misdirected hopes and dreams—of her interlocutor, how he "feels" about his relationship to history and to what extent his own clouded self-awareness informs the very foundations of his own criticism. This she shared as a technique with Baldwin, and together they would repeatedly take on the white arts establishment as a thing to be, by turns, addressed and dressed down during the first half of the sixties.[47]

Hansberry's signature line of argument was a calibration of two poles—that of the warmly educating and the absolutely intellectually demolishing—and it manifested itself most fully in the aforementioned lectures of note and in a rigorous prose essay published June 1, 1961, in the flagship conduit of white liberal arts journalism, the *Village Voice*. Entitled "Genet, Mailer, and the New Paternalism," it was an essay that she took through many draft stages, working out a voice that initially invokes a collective first-person crisis in consuming racially problematic art. Both revolutionary and revelatory, this was a kind of writing that dared to call attention to the Black woman audience member and her brethren who were "sitting through the too long evening" of Jean Genet's

play "'The Blacks' or wending a careful and respectful way through the printed texts" of Genet's as well, "'Deathwatch' and 'The Maids.'" Her democratic critical prose voices a unified alienation from the art in question. "We are overwhelmed by our sense of his <u>distrust</u> of us; his refusal to honor our longings for communion. Presently," she continues, "we understand that he does not seem to believe that that is what we <u>do</u> long for."[48]

Mounted in part as a response to Norman Mailer's review of *The Blacks* in the *Voice* just a few weeks earlier, "The New Paternalism" was the first of its kind. It showcased a Black feminist critic shrewdly intervening in white liberal male collusion in ill-informed readings of Black culture. "Between the play and Mailer's discernible reaction to it," she wryly observes, "a duet was indeed sung. The rise and fall of his coherence and incoherence alike struck a stunning and, I think, significant kinship with the French writer. It was especially fascinating to discover, in the substance of Mailer's commentary, a lusty acceptance of the romantic racism which needed evocation to allow for the conceptualization of 'The Blacks' in the first place." Multifaceted in its attacks, Hansberry's essay takes on those whom she identifies as "the new paternalists," those for whom "the self-appointed 'top' of society is as utterly rotten as it indeed is" and who thereby presume that "the better side of madness must be the company and the deistic celebration of 'the bottom.' History has, inadvertently, provided them, as far as they are concerned, with a massive set of fraternals, 'The Blacks.'" And echoing the kind of damning observation that came to be Baldwin's trademark, her article forcefully declares that "'The Blacks' is, as Mailer partially observed, more than anything else, a conversation between white men about <u>themselves</u>." But it is "The New Paternalists'" efforts to go after prominent artist-critics such as Nelson Algren and Jonas Mekas for their reductive readings of *Raisin,* the entire New Left subculture (its "little magazines," its "Village Voice," its "living rooms" and "coffee houses") that particularly stand out as sharp and bracing. Hansberry takes her time to rigorously critique this seeming white ally public for its myopia and insularity. Still more, she offers as well a withering view of the "black intellectuals" who remain seduced by "this new paternalism and its revelations," as well as the pawn Negro critics put forth to offer contrary views of Black art. The systemic repression of cultivated engagement with Black aesthetics was a thing to be exposed and destroyed, according to Hansberry. It was the means by which we might get at the root of the fundamental dehumanization of a people. Hence the violence of simplifying Black cultural forms was, at the heart of her criticism, the real enemy in need of defeat. "That is why," she declares, "we created and sang the blues in the first place: it hurt. We are shocked that this was not known; the fact that it was not assumed is, to us, an expression of

the highest contempt. We look back at the current weeping from a stance of astonishment and fury: 'You mean you thought we was being folksy to give you something to believe in? Honey, we was just surviving.'"[49]

There was, however, room for praise and liking fine writing as well. Perhaps tellingly, she would direct her earnest admiration for well-conceived and beautifully wrought cultural criticism toward a work that illuminated what she perceived to be the intimate wholeness of a Black woman genius. In a letter to the *New York Post* published in the wake of Billie Holiday's passing, Hansberry extends touching praise to *Lady Sings the Blues* coauthor William Dufty for his memorial article on the singer.

> I just wanted to tell you that I think that the piece on Billie Holiday is fine and beautiful. I do not save things; I shall save these articles. There is a bold and ungarnished, yet sweet humanity in the writing which is undoubtedly the right, the incredibly right, kind of tribute to what was apparently her true greatness as an artist and human being. I never knew her. William Dufty makes it possible. I am, from his account of her life, much moved. I mention greatness above because of the way it haunts Mr. Dufty's testimony, in the things he selects to remember: her appraisal of Louis; her pronouncement of the world race question; and what the Spanish-speaking people call her on the street. I will say only that the depth of telling in his story makes me grateful that such a woman had such friends as William Dufty and his wife.[50]

Candid writing that could evoke the richness of a Black woman musician's spirit, her assessments of her confidants, her observations about the social scene and how she was met by the world was the kind of work that deeply stirred her and warranted her heartfelt acknowledgment. This was the kind of cultural criticism she was so hungry for, the kind that she needed, the kind that she liked, and it is more than evident that she was fully aware of the fact that she was going to have to keep writing it largely by and for herself during her rise as an artist.

The Pleasure Principle: Private Criticism & Critical Feelings

Hansberry was a media watcher as much as she was a topic of the media's attention, and as such, she maintained her own private archive, her own private experiments in critical thought that subtended and sometimes enriched and deepened her public debates and exegetical prose. She kept a collection of note

fragments and newspaper clippings under the heading "What You So Mad About?" that documented the ongoing atrocities of her day: an ad about preparing for fallout radiation, articles documenting racial hate crimes as well as student sit-ins and protests in Nashville and Charlotte. She kept in this pile stories that, for instance, covered Alabama's weeklong Civil War centennial celebrations and an article on German chancellor Konrad Adenauer that includes the circled line, "The shame the Germans felt at the outbreak of anti-Semitism is still in evidence. But it has been joined now with resentment against what many people feel to be an unjustified effort to assess collective guilt for the actions of a tiny minority." She stored here a *New York Times Magazine* story on South African vocalist and activist Miriam Makeba that closes with a circled line: "Miss Makeba, who knows Afrikaans well, simply smiled. Later she said: 'When they sing in my language, I will sing in theirs.'" Her fury over the threat to global peace, the lack of peace on the domestic front, the repression of historical memory, and ascendant historical revisionism regarding genocide stoked her fires, just as Makeba's defiance in the face of racial apartheid likely offered up an example of eloquent rebellion.[51]

The ugly threads of racism and misogyny coursing through the popular press were worth tallying and archiving: from a *Redbook* story instructing wives on how to "make yourself sexually attractive, not just when you are going out, but also when you are at home with him," to a flagrantly sadistic *Ladies' Home Journal* feature entitled "Can a Marriage Survive Physical Brutality?" Marked up from top to bottom, the latter article, by "Clifford R. Adams, Ph.D.," seemingly held Hansberry's attention as one egregious statement after the other in the clipping is met with deep circles and brackets around claims that "the wife must find ways of relieving pressure *before* it becomes explosive" and suggestions that a wife "gauge" her husband's mood, "avoid arguments," and "indulge his whims." To the question as to whether "sex needs" are "more imperative for husbands than for wives," Adams argues in the affirmative, warning that "unless a wife understands and allows for this difference, it can lead to much tension and disagreement." It is the last line circled in the article, an inscription of notation that accounts for the way that Hansberry lingered on the horrific implications of what the public discourse on gender relations and what American popular culture was communicating about "proper" womanhood, "proper" pleasures, and putatively functional forms of intimacy that were anything but.[52]

But the occasional stentorian feminist tract—delivered by a man no less—was reason to rejoice and seemingly draw inspiration. Max Lerner's treatise "The Ordeal of the American Woman," featured on October 12, 1957, in the *Saturday*

Review, was an article to share, as the handwritten note at the top of the clipping indicates. "Bob," she wrote, "read this <u>show it to your wife too hits home!</u>" Lerner's proclamation that the "most continuous revolutionary is the American woman" is met with a welcome circle. But it is the points at which the underlines emerge that show the extent to which Hansberry's interest in the manipulation and conditioning of women consumers that holds her attention. As Lerner reports, the "head of a trade association of women's retail stores" claims that "'<u>it is our job . . .' to make women unhappy with what they have in the way</u> <u>of apparel and to make them think it is obsolete.</u>'" To reject the oppression of capitalist consumer culture, Lerner's article suggests, is a uniquely gendered dilemma since girls in "low-income families . . . brin[g] consuming rather than earning power" and girls from "middle-class families . . . presen[t] the problem of being married off." Subject to the barrage of ads and products seeking to dictate to women what they ought to want in postwar culture, they fall in peril of never owning their own desires. "The miracle," observes Lerner, "is that with all this world of make-believe she has not succumbed wholly to its tyrannies."[53]

This collecting, this sorting, and this note-taking were steps that Hansberry was taking in the mid- to late 1950s toward accounting for her own desires, her own pleasures, her own likes and dislikes. She was cultivating a critical language for her queer Black feminist sensibilities as a critic and a married woman who loved and longed for a life with women in both very private and occasionally public ways. While her marriage to Nemiroff in 1953 was forged in radical intellectual and political partnership, she kept the fullness of her queer formations alive in her archive of critical notes and in epistolary exchanges with the *Ladder,* the first nationally distributed lesbian publication in the United States, both of which an array of scholars, biographers, journalists, and curators have pored over in recent years as the exultant radicalism of Hansberry's sexual identity politics have received a resurgent groundswell of attention. Cheryl Higashida has argued, for instance, that in some of her most pivotal unpublished drama, Hansberry would "represent lesbianism as an existential choice . . . and critique patriarchal norms," and it was the unfailingly supportive Nemiroff himself, the lifelong advocate of her work and her posthumous legacy, who once observed that Hansberry's lesbianism "was not a peripheral or casual part of her life but contributed significantly on many levels to the sensitivity and complexity of her view of human beings and of the world."[54]

Queerness was, in short, revolutionary relationality for Hansberry, and she openly lamented the dearth of intellectual venues in which her own critical sensibilities about culture and politics as a Black lesbian artist and activist could seek out stimulation. "Women, like other oppressed groups of one kind or

another," she opined in a 1957 letter, "have particularly had to pay a price for the intellectual impoverishment that the second class status imposed on us for centuries created and sustained. Thus, I feel that THE LADDER is a fine, elementary step in a rewarding direction."[55] This was the same year that she was reading Max Lerner in the *Saturday Review* and the same year that she finished her first draft of *A Raisin in the Sun*. It was for her a year of becoming and asserting the value of women's critical and aesthetic agency in the public sphere. "I think it is about time," she declared,

> that equipped women began to take on some of the ethical questions which a male-dominated culture has produced and dissect and analyze them quite to pieces in a serious fashion. It is time that "half the human race" had something to say about the nature of its existence. Otherwise ... the woman intellectual is likely to find herself trying to draw conclusions—moral conclusions—based on acceptance of a social moral superstructure which has never admitted to the equality of women and is therefore immoral itself. As per marriage, as per sexual practices, as per the rearing of children, etc. In this kind of work there may be women to emerge who will be able to formulate a new and possible concept that homosexual persecution and condemnation has at its roots not only social ignorance, but a philosophically active anti-feminist dogma. But that is but a kernel of a speculative embryonic idea improperly introduced here.[56]

In 1957, the time was up for patriarchal intellectual discourse and policy making, according to Hansberry. The importance of the *Ladder* to her was that it held out the promise of encouraging free-thinking queer women to come forward in print to define themselves and alternative philosophies of being that might strike a blow to an inherently biased and oppressive "social moral superstructure." This was writing that, as the great lesbian poet and essayist Adrienne Rich points out, focused "on the economic and psychological pressures that impel many conscious lesbians into marriage: on the connections between anti-homosexuality and anti-feminism, and on the need for a new, *feminist* ethics."[57]

Hansberry's own notes and essays were exercises in just such an ethics, what Higashida characterizes as a "repudiation" of "existentialist solipsism and nihilism" and a move toward the kind of "reciprocal recognition" that might bring about fundamentally new relations. As Ferguson brilliantly contends, it is in her queer writings that one sees her making radical "associative" moves, expressing "discourses of autonomy that not only come out of domestic efforts of gay liberation but out of internationalist discourses of *self-determination, insurgency,*

and *collective belonging,* this time applied not to the circumstances and futures of the nation-state but extended to the parameters of the body and desire [.]"[58] In drawing connections between Hansberry's private, lyrically carnal notes in which she meticulously records her homoerotic desires ("I like / 69 when it really works / The inside of a lovely woman's mouth / The way little JW looks in the movies / Her coquettishness / Her behind—those fresh little muscles") and her active involvement in the global 1950s anticolonial and antiracist struggles, Ferguson makes the case for theorizing what he calls "the serialization" of Hansberry's political affinities. Certain forms of insurgency, he suggests, hold the "potential to serialize and coordinate other questions and problems."[59]

Hansberry would remain forever interested in figuring out ways of translating and transitioning *"self-determination, insurgency,* and *collective belonging"* from one felt context to the next. For Hansberry it meant exploring "the serial relationships between national liberation and gender and sexual autonomy, pointing to the ways in which sexuality was *experienced* through decolonization." For Ellen Willis, who wrote, as she once famously referred to it, toward seeing "the light," it meant pursuing an interrogation of punk rock forms and punk feelings that had, in her mind, the potentiality to undo patriarchal social formations. As we shall see, both women invoked serialization as heuristic praxis in their respective modes of feminist intellectual radicalism.[60] Both women fiercely championed women writing for and about themselves. As Hansberry put it in one of her letters to the *Ladder,* "You are obviously serious people[,] and I feel that women, without wishing to foster any strict separatist notions, homo or hetero, indeed have a need for their own publications and organizations."[61]

But if such spaces weren't readily accessible, the retreat into private writing proved to be a ritual that Hansberry relished over a long period of time. Her private, autobiographical notes reveal a Black feminist intellectual who often made sense of the world and her personal life by producing a series of impressions about culture, people, relationships, politics, her quotidian habits and foibles, her hopes and dreams. An intersectional thinker long before such a term had been invented, she remains in these writings deftly attuned to the ways that class and gender, along with race, were mutually constitutive identity formations that demanded attention in uplift movements, and she likewise seemed to take pleasure in the interplay of longing in multiple registers for many different kinds of objects and intimacies in her personal prose.[62]

Notes that Hansberry apparently wrote only to herself as opposed to the *Ladder* magazine document a young woman who was identifying her pleasures and also wrestling with what it means to recognize one's own lack of fulfillment. In a series of "likes and dislikes" that Hansberry recorded between 1954 and

Lorraine Hansberry in the throes of everyday, Black radical study

the year of her death, she offers "ruminations on her identity, sexuality, writing habits, loneliness, illness, depression, and her role as an activist." Special annual entries were often titled "Myself in Notes" and include intimate confessions and intensely candid, self-probing, and fluid explorations of her desires and disappointments, fantasies and regrets. At twenty-eight in 1959, she was clustering into her "I Like" category music ("Johnnie Mathis, Beethoven, Gershwin, Brubeck"), films and plays ("*Juno and the Paycock*"), literary works of special value ("Books that get to me"), brilliant craft ("the genius of Shakespeare"), the perks of fame ("MAIL, lots of it, which I now get"), her prized friendship ("conversations with

James Baldwin"), everyday delights ("Sunshine, this spring"), the value of her own creativity ("the Novel I am writing, finally") and insatiable drive ("Being hungry"), as well as erotic pursuits both personal and in pop culture (her onetime girlfriend "Renee Kaplan's legs," her crush "EARTHA KITT'S eyes, voice, legs, music"). Here in her personal archive, Hansberry is likewise unfailingly honest as well about what "bores" her ("A Raisin in the Sun, loneliness, most sexual experiences, myself"), what she "hate[s]" ("stupidity, ignorance, loneliness! . . . People who don't appreciate Kitt, FEAR, seeing my picture, Reading my interviews"), and what she "want[s]" ("to work, TO BE IN LOVE!").[63]

The lists constitute an anatomy of the queer Black feminist artist's intimacies, how she experiences new fame and struggles to maintain her aesthetic vision. These lists document the trajectory of her passions and distastes, her ambition and her anxieties, and what critic Jonathan Flatley, in his moving study of the affective gesture of "liking," might refer to as "a readiness to pay attention to something and be affected by it" and "to imagine new, queer forms of affection and relationality." Liking, he argues, "is an opening into the world. . . . It indicates potentiality." Hansberry's liking was a form of radical intimacy, a way to ask of objects and people and rituals about which she cared: "How am I like this? How is this like other things? . . . In what ways are we alike? How do we (mis)fit together?" It was a means through which she might "create an opening where nonmiserable, even joyous plural queer singularity could come into being."[64]

Hansberry's serialization of desire as well as her social and cultural disidentifications ebb and flow in intensity from year to year and amount to their own form of informal cultural criticism. The pursuit of personal pleasure and the rejection of "racism . . . stupidity" and "pain" (as well as, among other things, "what has happened to Sidney Poitier . . . Jean Genet's plays" and "Jean Paul Sartre's writings") are affirmations of her felt experience in life. They are, as Ferguson persuasively points out, building on Umberto Eco's theories of lists, "attempts to move beyond the logocentrism of existing representations as they pertain to race, gender, and sexuality. . . . In the list," he continues, "we can hear the trace of a language of self-determination . . . as it relates . . . to the body and its coexistence with other bodies and other modes of desire." This was her personal declaration of pleasures, of displeasures, of ways of being in the world, of lines of affinity that might ultimately constitute her own self-curated universe of being. It was her own private way in which to "direct" her "attention to those sites of commonality that did exist" beneath the radar of the straight arts white world that she inhabited.[65]

At the same time, these were notes that clearly complemented Hansberry's very public and intensifying ethical sensibilities about the need to resist what

she believed to be modernity's violent and alienating forces that threatened not only Black folks' liberation but humankind. In, for instance, her 1959 manifesto lecture, "The Negro Writer and His Roots: Toward a New Romanticism," the artist who had spent her early New York years under the tutelage of Black radicals such as Du Bois, Robeson, and others at *Freedom* newspaper lamented the effects of a "deluded American culture" shaped by reactionary ideologies about race, class, gender, and sexuality emerging out of a "steady diet of television, motion pictures, the legitimate stage and the novel."[66] In contestation, Hansberry positioned herself as a writer with the responsibility to *feel more* and to catalog that feeling, famously declaring,

> I was born on the South Side of Chicago. I was born black and female. I was born in a depression after one world war, and came into my adolescence during another. While I was still in my teens the first atom bombs were dropped on human beings at Nagasaki and Hiroshima, and by the time I was twenty-three years old my government and that of the Soviet Union had entered actively into the worst conflict of nerves in human history—the Cold War. I have lost friends and relatives through cancer, lynching and war. I have been personally the victim of physical attack which was the offspring of racial and political hysteria. . . . I have, like all of you, on a thousand occasions seen indescribable displays of man's very real inhumanity to man; and I have come to maturity . . . knowing that greed and malice and indifference to human misery, bigotry and corruption, brutality and, perhaps above all else, ignorance . . . abound in this world. I say all of this to say that one cannot live with sighted eyes and feeling heart and not know and react to the miseries which afflict this world.[67]

This Hansberry, the one who delivered bold and trenchant, raw and impassioned public remarks about the Black writer's responsibility to put herself on the line as a conduit of witnessing and as a culture worker who might excavate empathy as a means to righteous reform, is, it would seem, the flipside persona, the public intellectual side to that presented in her notes. But the throughline seemingly tying these two Lorraines together is her steadfast commitment to "combating this alienation of the human sensorium." The act of liking, for Lorraine, was a kind of "nourishing and stimulating of the mimetic faculty," of forging secret solidarities while disliking gave her room to identify the forces that threatened her will to joy.[68]

Disliking was, it would seem, a step toward unlearning and stripping away the oppressive forces getting in the way of the purity of her pleasures, and this is

Lorraine Hansberry, April 1959

readily apparent in her ominous fable *What Use Are Flowers?* That drama, with its antiwar ethos, is well worth returning to when considering Hansberry's theories regarding the value of aesthetics. With its postapocalyptic setting, *Flowers* is a play that, as noted earlier, emphasizes the courageousness and the responsibility that human beings must take upon themselves to remake the world by way of reclaiming its beauty and the preciousness of humanity. "The action of the play," she explains, "hangs upon" a surviving old hermit's "effort to impart" to children "his knowledge of the remnants of civilization" "and how we ought not to go around blowing" up "modern man." A onetime Greenwich Village resident who had soaked up the New Left activism and bohemian energy before moving to a house along the Hudson, Hansberry surely knew well the Pete Seeger no-nukes

classic "Where Have All the Flowers Gone" from 1955 and shows her affinities for the global peace movement in this work. Here she reveals herself to be a dreamer as well as a realist, a humanist Black feminist peace worker who believed in the mortal ability to "triumph over this reckless universe" in the face of catastrophe. As she proclaimed in her "Negro Writer" address, "I think the human race does command its own destiny and that that destiny can eventually embrace the stars." The key to this path would have to come about, as *Flowers* suggests, through an engagement with forms of intensified care for oneself and others. The gorgeousness and preciousness of our own environment might, this play suggests, inspire new relations with each other and with the fragile world that we inhabit. In all of these works, we hear and see Hansberry privately posing (to herself? To the universe?) different versions of the same question: Do you feel me?[69]

Mass Education: Ellen Willis & the Politics of Feminist Rock & Roll Liberation

It was an outrageous song, yet I could not simply dismiss it with outrage. The extremity of its disgust forced me to admit that I was no stranger to such feelings—though unlike Johnny Rotten I recognized that the disgust, not the body, was the enemy.

—ELLEN WILLIS[70]

In her roving, candid writing about rock and roll and her lifelong devotion to it, Ellen Willis was unafraid to let her readers know that she, too, felt it all. The brave and brilliant writer who would succumb to lung cancer at the age of sixty-four in 2006 was a bundle of spirited contradictions: a self-proclaimed radical feminist who loved her some masculinist, racially problematic, Keith-Mick-and-the-boys rock and roll; a critic who was often less interested in music made by women than she was in that made by men. As late 1960s and early 1970s Civil Rights and Black Power activism galvanized soul and funk experimentalism during this period, her engagement with Black popular music culture was, in particular, fleeting during her tenure as the first pop music staff writer for the *New Yorker* magazine, where she served from 1968 to 1975.[71] Yes, see her review of *Aretha in Paris*—an album that she, and perhaps she alone, strangely liked— or see her poignant thoughts about "The Importance of Stevie Wonder," or her alluring, esoteric asides about Gladys Knight's refreshingly "middle class" aesthetics, her candid resistance to the kind of camp that she read the Pointer Sisters as selling, and her stunningly powerful revelation about the sonic insurgency of Bessie Smith as the seventies were coming to a close.[72]

These moments in her body of music writing are memorable, perhaps all the more so because they are so few and far between. Willis was a New Left, feminist subcultural rebel, but she appears to have been less passionate about Black musical aesthetics and practices than she was about championing the concept of "rock" as social reform. While she openly on occasion recognized the ways that rock and roll, as "white exploitation of black music . . . has always had its built-in ironies," she rarely wrote about those ironies or interrogated the ways that they potentially complicated her staunch belief in the music's potential for liberation. From the get-go she maintained a self-consciousness and transparency about her affinities and identifications, confessing that, for instance, she "loved both rock and blues" but was drawn to Mick Jagger, who "touched a part of [her] that black bluesmen and alienated folk singers could never reach . . . because [she] couldn't condescend to him—his 'vulgarity' represented a set of social and aesthetic attitudes as sophisticated as [hers], if not more so." That was 1969. But by 1971 she was throwing down the gauntlet in her feminist manifesto, "But Now I'm Gonna Move," declaring that rock had been "taken over by upper-middle class bohemians" who "tend to feel superior not only to women but to just about everyone." Her acute ability to self-scrutinize and her unflagging candor as a cultural critic would also enable her, at the dawn of the 1980s, to reflect on how "watching men groove on Janis [Joplin]" led her to begin "to appreciate the resentment many black people feel toward whites who are blues freaks. Janis sang out her pain as a woman, and men dug it. Yet it was men who caused the pain, and if they stopped causing it they would not have her to dig. In a way," she concludes, "their adulation was the cruelest insult of all."[73] She was a late-comer when it came to interrogating what was more often than not the phenomenon of simultaneous racial and gender abjection and exploitation in popular music culture, but when she did arrive at this revelation later in her career as a feminist cultural critic, she examined the entanglements between women and Black folks' subjugation in the pop culture industry with her trademark bluntness.

For all its contradictions and perils, mass culture, however, remained the way forward and toward the not-yet for Willis. "Mass art," as she observes, "reflects a complicated interplay of corporate interests, the conscious or intuitive intentions of the artists and technicians who create the product, and the demands of the audience." Yet, she would also insist that mass art can "act as a catalyst that transforms its mass audience into an oppositional community." No surprise, then, that her Stones love was the spark that led her early on in her career in cultural journalism to locating, exploring, writing about and through what she called "the utopian moment in rock and roll, the eternal moment, the moment

of pure pleasure," which she read as having the ability to "transcend history, but not by denying it: rather, this is the moment when history in all its poignancy and contradiction is encapsulated in one perfectly expressive note or phrase, so that the listener is made whole. Rocklit, at its best," she argues, "records what led up to that moment, and holds out the possibility that it can happen again."[74]

Willis evolved into a social and cultural activist who examined and promoted "a commitment to freedom that is also intrinsically intertwined with a commitment to pleasure," as she described it in a lecture from 1993. "Because," as she adds,

> what people want the freedom to do is, at bottom, to enjoy their lives, to really live them and not just get through them, to meet their basic needs for self-expression. Whereas the principle of an authoritarian culture is that you don't live life to enjoy it but for some higher purpose which is needless to say defined by social & moral authorities, not by you. So cultural radicals affirm sexual and sensual and aesthetic pleasure, play, fantasy, imagination, dreams, and challenge the deep anti-pleasure bias of the culture. We value relationships among people that are based on mutual freedom and mutual pleasure rather than authority, domination, and obligation. We put a high value on individuality . . . and the right to be different.[75]

Willis would herself—always candid in her published as well as her unpublished work, never a bullshitter—acknowledge on many occasions that her politics of freedom was rooted in a self-conscious awareness of her liberal middle-class "whiteness" and the conventions associated with these identifications. Of her time in grad school in Berkeley in the early 1960s she writes in "Up from Radicalism: A Feminist Journal" that she has decided "to get involved in the Civil Rights movement." Here she observes that, "I have all the Jewish-leftist tropisms. I've marched for integration and against the bomb, but I've never done anything serious. I put on a SNCC [Student Nonviolent Coordinating Committee] button and go to CORE [Congress of Racial Equality] meetings. But I never feel very welcome, and I never think of anything illuminating to say. Free Speech erupts. I am an enthusiastic partisan, but don't join the sit-in. I'm not a student any more; I won't be a hanger-on."[76]

Maybe not, but there's no denying that her music writing is steeped in notions of cultural radicalism that have everything to do with Hansberry's own philosophies as an "American radical," one who envisioned in her own final works an "imaginative landscape" constituted by "new human relations—

intimate, social, economic, national and international." This, in and of itself, is the Black radical tradition that Stefano Harney and Fred Moten examine with care and beauty and rigor in their work, the kind of radicalism that, as Harney argues, sees "debt as a promise not to continue social relations [as they are] in the future."[77] In Willis's work we can hear the kinds of alternative socialities that Black folks have been innovating for centuries now (as Frederick Douglass, Pauline Hopkins, and the many thousands gone perpetually sing back to us)—"within the circle," in the church pews, out on the street corners, all up in the jook. Because Black folks and indigenous peeps, as we know, have had to be DIY since the violent founding of the nation (original punk rockers, y'all).

Willis's DIY ethos takes culture as a tool of alterity and insurgency dead seriously and imagines the work of culture as specifically and critically of use to the people in the margins. "If white radicals are serious about revolution," she argues in *Ramparts* magazine in 1969, "they are going to have to discard a lot of bullshit ideology created by and for educated white middle-class males. . . . We must stop arguing about whose lifestyle is better (and secretly believing ours is) and tend to the task of collectively fighting our own oppression and the ways in which we oppress others. When we create a political alternative to sexism, racism and capitalism, the consumer problem, if it is a problem, will take care of itself." Paradoxically, it was rock and roll consumerism that she believed could be the "catalyst for the moment of utopian inspiration, that out-of-time moment when you not only imagine but live the self you would be in the world that could be."[78] In other words, she was in no way an orthodox Marxist. She believed that the cultural market could be redeployed toward subversive ends.

Throughout her career, from her time as a rock critic to her full-on commitment to writing radical feminist theory from the mid-1970s forward, Willis imagined the transformative, electrifying power and exquisitely valuable "everyday use" of cultural forms, in this way sharing a kinship with and recontextualizing the theories of Zora Neale Hurston and Alice Walker for the rock and roll public. "But there is another face of capitalism," she reminds, "the corporation, with its authoritarian, hierarchical bureaucracy and its subordination of human values to the discipline of the bottom line. Cultural radicalism, with its celebration of freedom and pleasure and its resistance to compulsive, alienated work, is always a potential threat to the corporate system, however profitable its music, art and favored technological toys may be." Willis was, nevertheless, steadfast in her insistence on recognizing the limitations of rock and roll's reformist reach. Call her a pragmatic idealist, as evidenced in arguments she was making at precisely the moment when she was waxing passionate about the music's promise of insurgency. "What cultural revolutionaries do not seem to

grasp is that," she argued, "far from being a grass-roots art form that has been taken over by businessmen, rock itself comes from the commercial exploitation of blues. It is bourgeois at its core, a mass-produced commodity, dependent on advanced technology and therefore on the money controlled by those in power. Its rebelliousness does not imply specific political content; it can be—and has been—criminal, fascistic, and coolly individualistic as well as revolutionary. Nor is the hip lifestyle inherently radical. It can simply be a more pleasurable way of surviving within the system, which is what the pop sensibility has always been about. . . . The truth is that there can't be a revolutionary culture until there is a revolution."[79]

That revolution was, in Willis's opinion, in the hands of women. On the way to that new day, what she was after was pleasure for women, and in this sense she erred on the side of individual desires while also celebrating the potentiality of the rock and roll crowd as the utopic realization of a new body politic, one that generated and sustained the kind of feelings that could "reorder things." As she would insist in 1969's "Up From Radicalism," "I'm into Marxist theory more than ever before. In the international terms, it offers the only cogent explanation of what's going on. But there's something essential missing: Marxists don't understand the political and human significance of sex. When they consider sexual problems at all it's only to dismiss them as the affliction of a decadent bourgeoisie, to be swept away by the emerging proletariat. But no proletarian revolution has yet been able to sweep them away. What we need is an analysis that can connect the politics of nations with the politics of our own bodies."[80]

Pursuing, speaking about, and protecting a woman's right to feeling and unfettered pleasure are profound values and concerns that Hansberry and Willis shared. And for Willis, the question of pleasure manifested itself most volatilely in late seventies and early eighties feminist circles in relation to porn. Unlike a seemingly ambivalent Rosetta Reitz during this period, Willis took a definitive stance against feminist antiporn activists since, as she argued in a 1979 essay, "if feminists define pornography, per se, as the enemy, the result will be to make a lot of women ashamed of their sexual feelings and afraid to be honest about them. And the last thing women need is more sexual shame, guilt, and hypocrisy—this time served up as feminism."[81] The challenge for Willis was, in part, to try to reimagine and envision forms of cultural production that affirm and articulate the importance of female desire as well as pleasure. She was, as friend and feminist ally Karen Durbin notes, "that wondrous creature, an intellectual who deeply valued sensuality, which is why she wrote with such insight about rock and roll but also with such love. . . . She honored it. She saw how it could

be a path to transcendence and liberation, especially for women, who, when we came out into the world in the early to midsixties, were relentlessly sexualized and just as relentlessly shamed. Rock and roll broke that chain: it was the place where we could be sexual and ecstatic about it. Our lives were saved by that fine, fine music, and that's a fact."[82]

And this is where Willis's ideas dovetail so clearly with her world-making Black feminist contemporaries—women like the legendary Black lesbian poet, essayist, and activist Audre Lorde, whose much-beloved 1978 essay "The Uses of the Erotic" provides a language for the kind of art and liberation that Willis seemed to be pursuing throughout her career. In this essay, Lorde writes that "the erotic is a resource within each of us that lies in a deeply female and spiritual plane, firmly rooted in the power of our unexpressed or unrecognized feeling. . . . We have been taught to suspect this resource, vilified, abused, and devalued within western society." Adds Lorde, "But the erotic offers a well of replenishing and provocative force to the woman who does not fear its revelation, nor succumb to the belief that sensation is enough." The erotic "is a source of power and information," while "pornography emphasizes sensation without feeling." The erotic, she famously declares, "is a measure between the beginning of our sense of self and the chaos of our strongest feelings." It functions as a way to "share deeply any pursuit with another person"; it is "the open and fearless underlining of [one's] capacity for joy," a reminder of one's own "capacity for feeling," and a way of fighting oppression from the inside out. It "gives us the energy to pursue genuine change within our world . . ."[83]

No good scholar of Black studies and American studies would take lightly the fact that Willis was working these theories out in the midst of the explosion of Black feminist literature and cultural criticism in the 1970s—stretching from the era of Toni Cade Bambara's 1970 groundbreaking anthology *The Black Woman,* which famously set out "to find out what liberation for ourselves means, what work it entails, what benefits it will yield," and encompassing the publications of Alice Walker's, Toni Morrison's, and Maya Angelou's early works of searching self-discovery and social critiques of racism, sexism, and classism throughout the decade, as well as the 1978 Combahee River Collective statement, the landmark Black feminist document and declaration that aims to "change" Black women's "lives and inevitably end oppression."[84] Such contiguities should encourage us to find a way to openly contemplate the too often unacknowledged connections between the feminist theories that Willis was developing and the social, political, and cultural theories that Black feminists were pioneering during the same period of time that the former was "beginning to see the light," as she referred to it in one of her most famous articles.

Ellen Willis at work

That watershed essay seemed more relevant than ever in the late 1990s and 2000s world of resurgent, postgrunge and post–riot grrrl, masculinist rock (Limp Bizkit, anyone?) and gangsta and Bad Boy rap, as well as the right now revolution that is the #MeToo movement. Willis, from her vantage point in 1977 New York, was writing about a world in which, she argued, feminist critics—be they women or men and of every stripe and shade—must come to terms with "the heavy overlay of misogyny" in first-wave punk, a music that, as she sharply observes, "equates championing the common man with promoting the oppression of women."[85]

By bravely breaking open dense equations of gender, class, power, and sub-cultural music scenes, what Willis was able to brilliantly do like no one had before her was to identify and hold precious the intellectual and political activism and agency of the fan, the critic, the chick in the bedroom cranking up her stereo who dares to question cock-rock fascism and who likewise feels entitled to enter the world of the stadium, the dive bar, the mosh pit, the battling emcees joint and find a way from the inside to imagine new ways of sounding liberation. To Willis, the enlightened path is one with a music at its center "that boldly and aggressively laid out what the singer wanted, loved, hated—as good rock and roll did," and that "challenged [Willis] to do the same." And "so," she argues, "even when the content was antiwoman, antisexual, in a sense antihuman

the form encouraged [her] struggle for liberation." Fight the real enemy, her work constantly reminded, directing her readers to target punk's English godfathers, the Sex Pistols' misogynistic fear of the female rather than internalize that fear and "disgust." Appropriate the sonic expression of antiwoman rage and turn it back on itself in order to raze and make new the world. At the height of her career as a music critic, then, she held fast to the belief that "rock and roll had unique advantages: it was defiantly crude, yet for those who were tuned into it," she argued, "it was also a musical, verbal and emotional language rich in formal possibilities."[86] Here she resolves to take what's "good" and "reject what's sick," just as Burnham had asked of Hansberry whether this was something that they might do in their own efforts to remake the body politic.

Nevertheless, for all of its audacity, Willis's belief in (re)appropriating the form, in hearing and seeing a gateway to liberation for women in the music of the white male musicians whose work she adored is an inevitably complicated affair. Is it, for instance, myopic of her to read rock as "a socially acceptable, lucrative substitute for anarchy" without rigorously dissecting the racial and sexual power relations that undergird the genre as a corporate entity? Or does her work go the distance and hail feminists to seize the form for themselves so that they might push aside the bad boys and instead assume the role of the "rock-and-roll star" who finds "a way of beating the system, of being free in the midst of unfreedom"?[87] It would seemingly be up to the next generation of feminist music critics to tackle these questions that her work, in part, made possible. From Evelyn McDonnell and Ann Powers's pathbreaking *Rock She Wrote: Women Write about Rock, Pop, and Rap* to the pioneering work of Tricia Rose, Joan Morgan, and Imani Perry writing through the perils of working as Black feminist hip hop heads, we hear the answers to the problems that Willis's work brings into focus. We see her legacy in the way that Kandia Crazy Horse imaginatively reassembles Southern rock from the vantage point of the Black feminist critic, when Jessica Hopper publishes the "first collection of criticism by a living female rock critic," and in the way that Daphne Carr sharply navigates Trent Reznor's industrial maze of white masculine turn-of-the-millennium despair. We see it when Jayna Brown explores the radical possibilities of brown-girl punk, when Laina Dawes documents her experiences as a Black woman metalhead, and when Maureen Mahon digs up and recenters the history of Black women in rock. Inside these unlikely forms, these critics could, like Willis before them, explore and rehearse new modes of resistance, new languages of social and cultural freedom, new ways of being and being elsewhere.[88]

Just as those who came after her have Willis to, in part, thank for modeling a kind of cultural criticism that is ferociously inquisitive and probing, vivid,

cutting, and impassioned in its claims, so too did Willis have Hansberry as an important exemplar who gamely took her place on the front lines of social and cultural debates that she saw as directly pertinent to racial and gender politics in American culture. From this standpoint, we might think of the "searching and voluptuous qualities" of Hansberry's lists as "intimat[ing] a subject who assumes the right to erotic inquiry" alongside Willis's vision of rock as itself a radically erotic form.[89] We can hear her transmitting her connection to the prodigious energy emanating from Bessie Smith's "Send Me to the Electric Chair" as well as the conflicted anarchy of the Sex Pistols' "Bodies," and in the end, it is her writing about rock's visceral, transfigurative powers that is itself joyful, revelatory, pleasure-affirming, feminist. The similarities and ideological connections between Willis's rock criticism and emergent radical feminism in the late 1960s and early 1970s are important to keep in mind because they help us to grasp the ways that, at least in theory and at times in material, quotidian life, Willis's sexual liberationist activism wasn't always all that far removed from conversing with second-wave Black feminism and Black cultural politics more broadly.

Consider, for instance, "Sisters under the Skin," her dense, probing 1982 book review of Angela Davis's *Women, Race and Class,* Gloria Joseph and Jill Lewis's *Common Differences,* and bell hooks's *Ain't I a Woman.* Willis uses the content as well as the form of the review to "move toward 'collaborative struggle'" between white and Black feminists by calling attention to the power dynamics that divide them and the heterogeneity in both Black and white women's communities that might paradoxically unite them. Or consider her occasional meditations on Black political and intellectual thought in print, stretching from at least 1967 when she drafted a review of Stokely Carmichael's *Black Power* and through into the 1990s when she contributed two pieces to the Harvard Black diaspora studies journal *Transition* (filing lengthy reviews of Orlando Patterson's *The Ordeal of Integration* and of Catherine MacKinnon's *Only Words*). At this time too, she participated with Black feminist critical race theorist Kimberlé Crenshaw and others in a special issue of left-progressive Jewish journal *Tikkun*'s roundtable following the hearings of Anita Hill and Clarence Thomas. Throughout this period, she came back to questions of how race, gender, sexuality, and class are forever entangled with one another. She was belated in her conceptualization of intersectionality, but her values and politics leaned toward affinity rather than antagonism and obtuse posturing.[90]

We might think about the place where Willis and Hansberry meet up in their shared pursuit of pleasure, collectivity, and culture as conduits for self-affirming difference. There is, for example, something poignant about the ways that Willis,

with her career-long pursuit of feminist pleasure, and Hansberry, with her devotion to Black freedom struggle politics, would each hold out reparative potential to the other despite the fact that they would never, as far as we know, meet again and even despite the fact that Hansberry would die an untimely death in 1965 at the age of thirty-four. Each of their archives reveals to us the extent to which both women "struggl[ed] against one or another kind of nihilism," as Willis puts it in her gripping 1979 essay in which she looks back on the career of the Velvet Underground. Says Willis, "I believe that body and spirit are not really separate, though it often seems that way. I believe that redemption is never impossible and always equivocal. But I guess that I just don't know." "I regret," declares Hansberry in 1962 at the age of thirty-two, that "love is really as elusive as everybody over 30 knows it to be" and "all the friggin' hurts in this world."[91]

Each of their archives documents the desires of brilliant women who looked to cultural forms, artists, and works of art for a deep reclamation of self and for self-recognition. Both kept material that documents moments when women and girls inserted themselves into such debates in ways both big and small. Willis held on to a *New York Times* clipping in which a teen Pam Ottenberg took critic Richard Goldstein to task for his review of the Beatles' *Sgt. Pepper's Lonely Hearts Club Band* in 1967. Likewise, in Hansberry's voluminous collection of newspaper clippings preserved by Nemiroff, one finds a *New York Times* article from 1957 by Dorothy Barclay entitled "Trousered Mothers and Dishwashing Dads," which observes how, "today, in some circles the tree-climbing, marble-playing, ball-batting boy is just as likely to find a short-haired and betrousered girl beside him as he is another lad. His mother, too, like it or not, wears trousers around the house and yard and is as handy with the screw driver and power mower as dad is."[92]

They were looking for signs of themselves in the culture and writing toward and about such signs. In Willis's reflective 1997 preface to *Rolling Stone's Book of Women in Rock,* she describes how feminism drove her to "lon[g] for a female rock and roller who would be [her] mirror." She writes, "She would make music I loved as much as *Blonde on Blonde* or the Velvet Underground's third album. And she would be a stone feminist, a radical intellectual, a New York Jew with curly hair—yes, I'm joking, but just barely."[93] For Hansberry, her lists became the place where she could document her passion—sometimes sensual, sometimes aesthetic—for musicians as well, including women as varied as Kitt, Mahalia Jackson, Dinah Washington, and Anita Darian, placing them alongside her queer longings for her respective lovers and more: "Renee Kaplan's legs," "the way Dorothy talks . . . older women . . . charming women and/or intelligent women," "the sweet innocence of certain raucous lesbians I know."[94] Their respective

archives reverberate with reciprocating energies and figuratively sustained conversations with each other about women's desires in ways that would continue to resonate in different registers and different contexts for decades to come.

"Somebody Forgot to Tell Somebody Something": Dr. Spillers, Dr. Christian, Dr. Feelgood & the "Knowledge from Below"

Yet still, to paraphrase the marvelous Barbara Christian (who was herself rephrasing Toni Morrison in conversation with Ntozake Shange), "somebody forgot to tell" the brave, roving thinker Ellen Willis something more about Black women and music. Christian uses this Toni Morrison phrase ("somebody forgot to tell somebody something") in 1990 as a point of departure in her examination of Black women's historical novels of the 1980s and these writers' efforts to "remind us that if we want to be whole, we must recall the past, those parts that we want to remember, those parts that we want to forget." To this I would add that if we want to be whole we should, as Hazel Carby beckoned us to do back in 1990 as well in her foundational essay on blues women, listen to the Black women vocalists who help us to remember not only our histories but the value of our own bodies as well.[95]

How thrilling it would have been to the world of rock music letters if Ellen Willis had moved more consistently and forthrightly in this direction in her own work, if she had gifted us with more extraordinary critical examinations of women's work—and especially women of color who rocked the democratic ideals of freedom and pleasure like she heard and saw in Janis Joplin. If only we had Ellen Willis treatises on the outlaw rebel-rebel spirit in Etta James riding up and down the open Interstate 5 like the road warrior journeyman Dylan in her definitive essay on him. If only we had her lyrical meditation on Tina to rival the way she wrote about Mick—and especially given his majesty's kinesthetic indebtedness to the sister from Nutbush. If only she'd covered Aretha live at the Fillmore back in 1971, turning what she had read as the pap and sap of Simon & Garfunkel's version of "Bridge over Troubled Water" into the site of "collective freedom" of which Willis perpetually dreamed. Had this second waver surfed pop music in a way that brought to the fore the innovations of Black women artists, who knows where else her writing might have taken us. But the missed opportunity to mine Black sonic women's mammoth terrain and to, likewise, illuminate the rich connections between those women's sounds and the sociopolitical ideals that she so deeply embraced throughout her career marks a gaping hole in the intellectual history of popular music culture. But where Willis fell

short, a game-changing Black feminist thinker would step in to fulfill the potential of her unfinished project.

It's 1982 and Ellen Willis is back at Barnard again, this time for the university's legendary-turned-infamous *Scholar and the Feminist* Conference IX, entitled "Towards a Politics of Sexuality." It was an event that drew on the organizing vision of an array of feminist luminaries—from the likes of "Mary Ann Doane, Ellen Dubois, Faye Ginsburg, Linda Gordon, Esther Newton, Gayle Rubin, Kaja Silverman," and Willis herself, who lamented in a memo included in her archive that there were so few "women of color" involved. Looking back on the conference, Willis reflected in her notes that it "was a controversial event, because it was up till then the biggest public challenge by feminists to the politics of the anti-pornography movement, and to its claim to having the feminist analysis of sex. I think it was also an important event, because both its existence and the intensity of the controversy surrounding it opened up the feminist debates about sexuality to a much larger public." As Janet Jakobsen points out in her commemorative article on the history of this event, "More has been written about this conference than any other *Scholar and the Feminist* gathering, and in many ways it was the flash point for a revolution in how feminists could approach questions of sexuality." Though she was one of the few women of color speakers on the program, Black feminist critic Hortense Spillers would, on April 24, 1982, deliver an interventionist talk for the ages that would at once address Black women's invisibility in the feminist imaginary and likewise illustrate the ability of culture made by and for Black women to produce radical knowledges. It was a talk that that yoked together the world of women's musicianship and women's sexuality in ways that both resonated with and even more fully realized the feminist radicalism of Willis's bygone rock and roll agenda.[96]

Spillers's "Interstices: A Small Drama of Words" is a classic critical manifesto and one that scholars such as Shane Vogel have beautifully invoked to illuminate the details of Black women vocalists and their revolutionary self-making acts in sound. That this lecture turned essay, a companion piece to her legendary "Mama's Baby, Papa's Maybe" essay, originated at the conference is worth considering since it offered a trenchant corrective to the ideological and sociocultural myopia of second-wave feminist discourse on sexuality (by Shulamith Firestone, among others), work by women with whom Willis was aligned and with whom she fought as well. It also sheds light on the extent to which Spillers, the ascendant Black feminist scholar, was very much a fellow traveler of Willis's, the latter of whom would declare on the final page of the conference diary that "as the sexuality debate goes, so goes feminism. The tendency of some

feminists to regard women purely as sexual victims rather than sexual subjects, and to define the movement's goal as controlling male sexuality rather than demanding women's freedom to lead active sexual lives, reinforces women's oppression and plays into the hands of the new right. It is a dead end, a politics of despair. Feminism is a vision of active freedom, of fulfilled desires, or it is nothing." They were both mapping out expansive visions of women's sexual sovereignty in their work, searching for "counter-power" in sound and the place where the subject not only "is seen" but also "SEES" and "negotiates at every point a space for living" by way of the sensually sonic.[97]

In "Interstices," we hear Spillers going where Willis couldn't quite get to in her own work: grappling with race and difference and examining the musical performances of women (rather than interrogating women primarily as consumers of music) to imagine a new lexicon of pleasure and the poetics of sexuality. The most quoted line of her article reminds us that "black women are the beached whales of the sexual universe, unvoiced, misseen, not doing, awaiting *their* verb. Their sexual experiences are depicted, but not often by them, and if and when by the subject herself, often in the guise of vocal music, often in the self-contained accent and sheer romance of the blues." If, as she makes clear here, American culture suffers from a crisis in words to identify the specificity of Black women as fully complex subjects of their own making, if, as she argues, these "lexical gaps" are "manifest along a range of symbolic behavior in reference to black women," then we need some new verbs so that we might reckon with her at full volume.[98]

This manifesto, a devastating critique leveled at the white feminists in her midst, urges her audience to take seriously the singers. Here she famously invokes the Burkean "grammar of motives and pentad of terms" to locate and innovate by way of sound the missing verbs for and of Black womanhood. Because, as she insists, the "singer is likely closer to the poetry of black female sexual experience than we might think, not so much . . . in the words of her music, but in the sense of dramatic confrontation between ego and world that the vocalist herself embodies. . . . Agent, agency, act, scene, and purpose," all of "the principal elements involved in the human drama," are "compressed" in the singer's "living body . . . and in the dance of motives, in which motor behavior, the changes of countenance, the vocal dynamics, the calibration of gesture and nuance in relationship to a formal object—the song itself—is a precise demonstration of the subject turning in fully conscious knowledge of her own resources toward her object." This critical methodology invested in restoring wholeness where there had been lack steers us toward reading "the singer's *attitude* toward her material, her audience, and, ultimately, her own ego-standing in the world

as it is interpreted through form." It pushes us to contemplate the singer's ability to, as Spillers puts it with her trademark lyrical rigor, travel to the "ontological edge" in her own performances and to translate her own sexual wealth into a range of literal as well as symbolic choices and statements. This, for Spillers, is the fulfillment of "human potential and discursive possibility." It is a way to "encounter agent, agency, act, scene, and purpose in ways that the dominative mode certainly forbids."[99]

And while Willis had been moving on this kind of a methodological trajectory in, for instance, her influential contention that Janis Joplin made songs "her own in a way few singers dared to do. She did not sing them so much as struggle with them, assault them," it's Queen ReRe who clearly makes Spillers's theories come alive and crystal clear. In one of any number of performance examples captured on tape for the archive, she emerges fully as both artist and critic in her 1969, live in Amsterdam, smoldering rendition of "Dr. Feelgood." In this classic and riveting display of musical genius, she is the teacher and the teller, the preacher as well as the choir soloist who calls her audience into service to deliver the secular sermon about a sensuously do-right man before a giddy, swinging sixties, nearly (but not entirely) lily-white crowd.[100]

Accompanying herself with her trusted piano, an instrument that knocks insistently on the door, opens it up, and lets our heroine into the room, Aretha paces deliberately on this rendition of "Dr. Feelgood," pausing to let the opening verses, the opening proclamations of defiance and autonomy, hang in the air and accrue weight and suggestion: "I don't want nobody ... sittin' around me and my man. I tell ya I don't want nobody ... always ... sittin' right there ... just lookin' at me and that man. Be it my mother, my brother, my father or my sister ... would you believe, I get up, put on some clothes, go out and help him find somebody for their self if I can." She establishes the boundaries of privacy and polices it fiercely on what would become one of the classic songs from her repertoire, subtitled "LOVE is a serious business." She plays a wicked, lightning-quick round of signifying, letting her listeners know that while you can't stay up in here delivering judgment about her love life, she will gladly go out and help you find a lover of your own. Dense, rich statements are abundant here, tightly wound and intricately unfurled as Aretha makes manifest a portrait of the artist who is also a theorist of womanly desire who holds court. As Spillers reminds, "Black women have learned as much (probably more) that is positive about their sexuality through the *practicing* singer as they have from the polemicist." Her claims echo those made by another prodigious doctor—Dr. Christian, who tirelessly argued for the need to turn to our writers and artists *as* theorists. As she reminds, they show us the ways to consistently use and practice the art

The Queen of Soul
circa 1968

Aretha Franklin, live at the
Philharmonic Hall

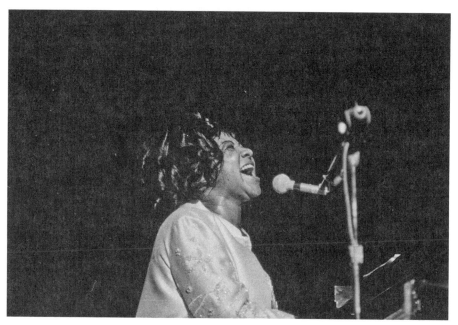

that they make so as to "resis[t] art as artifact . . . ideas as fixed" and to instead "commi[t] to open-endedness, possibility, fluidity and change" in and through ourselves.[101]

Dr. Franklin delivers a sermon and acts as agent of her own scene. Here, as we watch and listen to her house-wrecking tactics, we might take seriously Dr. Spillers's charge to find the "discursive possibility" in our heroine-musician's repertoire since, as she argues, "the black woman must translate the female vocalist's gestures into an apposite structure of terms that will articulate both her kinship to other women and the particular nuances of her own experience."[102] This is Aretha's moment, but it is one that provides us with a compendium of gestures and statements that we might think of as offering a broader public a new vocabulary for pleasure: the melisma that draws out a musical syllable, piling note upon note and driving us toward an excess in words; the sweat that glistens on her brow and frames that fashionably severe, late 1960s go-go makeup, signaling to us the labor and energy emerging out of her body, working for and with her here; the full-on determination to, as Fred Moten reminds, "exhaust the instrument . . . and therefore to become the instrument," to transform herself into "a kind of meditiative medium, a conduit, a means to" reanimating and wholly rewriting Black folks' "long history" of being used *as* an instrument by dominant culture in order to improvise a brand-new thing.[103]

This is what we might think of as the "purpose" of the Black woman vocalist as agent enacting a scene of pleasure and moving through it, to get to that place in sexual ecstasy where transfiguration is possible. Her performance gives us metaphorical and theoretical terms for articulating the specificity of one Black woman's sexual experience in all its wrenching glory and reminds us that, as Michele Russell describes it in discussing the exigencies of Bessie Smith's performances, "where work was often death to us, sex brought us back to life. It was better than food, and sometimes a necessary substitute. With her, Black women in American culture could no longer just be regarded as sexual objects. She made us sexual subjects, the first step in taking control. She transformed our collective shame at being rape victims, treated like dogs, or worse, the meat dogs eat, by emphasizing the value of our allure. In so doing, she humanized sexuality for black women.'"[104] So too goes Aretha.

Coda: "After the Flood"

For centuries I have lived with pain
So now I sing and the centuries sing with me

—LORRAINE HANSBERRY, "Woman" (1951)

I realized with shock that although I'd listened to "Send Me to the 'Lectric Chair" hundreds of times over the years, I had never really heard it before. It was a fierce, frightening song. . . . Bessie had concentrated more intensity in that one song than Janis had achieved in her whole career. I played it over and over.

—ELLEN WILLIS[105]

They both knew that the musicians were the ones who were capable of holding a vigil for all that you can't leave behind. They were the ones who stored the memory, translated the ordeals as well as their own sensuous splendor into undeniable and irresistible treatises concerning their own infinite self-worth. Although Ellen Willis would never write about Aretha the way she did of Janis, her revelations about Bessie in her brooding, postsixties essay "After the Flood" suggest that in 1975 she was closer than she'd ever been before to recognizing the weight, majesty, and the DNA of rock and roll as a rebellious Black feminist operation. This is an article in which Willis, forever the defiant one, still ends her reflections on the meaning of the counterculture revolution with a gut-wrenching review of Lou Reed performing "Heroin." But the suggestion remains that she can now hear more clearly the connections between the woman who sings "with the centuries," as Hansberry put it in one of her early unpublished poems, and the Warholian Factory punk who "forges a pop cliché into an epic about loneliness, sexual craving, endurance, seeing in the dark."[106] The Black woman musician as the lead, the heroine of her own story, a figure of authority and magisterial knowledge, is something else that they could have agreed on—if only they'd had the chance to break bread with each other for a second time, later and with more work and more years under their belts, with illness at bay and stories of war, heartbreak, and survival to share with one another.

What would a second conversation between Ellen Willis and Lorraine Hansberry have sounded like after that summer of 1960? What kinds of solidarities might they have forged as Hansberry continued to evolve as an artist and as Willis continued to mature as a writer? Perhaps the former might have talked of her interest in music, the librettos she was working on, the unpublished odes and protest songs she kept in her hopper, and the experimental scripts that envisioned Black women performers as pivotal storytellers who conveyed the history of a people. "I knew it would have to be Mahalia," one imagines her saying, "who would drown out the voice of the confederate soldier in the resistance piece I wrote for the Martin Luther King, Jr. rally." Or maybe she'd offer that "the early musicians—Elizabeth Taylor Greenfield, Florence Mills—were

key to our history," an excerpt from the "Faces of Black Women" script that she'd been working on when she was Ellen's age in the early 1950s.[107] Perhaps Willis would have picked Hansberry's brain about that Max Lerner article about the "ordeal of women" and carried the discussion with her into her own blistering *Ramparts* article from 1969, which proclaims that "the consumerism line allows Movement men to avoid recognizing that they exploit women by attributing women's oppression solely to capitalism."[108] What if they'd each had more time—with each other and with the world?

The scenarios are endlessly provocative and moving to ponder and dream up: Ellen and Lorraine, advanced in years and gushing about what they each hear in Nina Simone's voice, reflecting on what they each were still learning about the sixties—the revolutionary possibilities and unfinished business of that decade, grappling with the ever-evolving meaning of freedom, what it means to them personally as well as politically and in relation to the social, which books electrify them and which ones enrage them. There they are together sharing deep, existential intimacies: reflecting on their palpable fears about patriarchy, capitalism, and global tyranny, mapping out for each other their convictions about the human condition, what they each believe to be authentic and true. Perhaps, we might imagine Ellen, in the wake of Lorraine's death, settled in next to her radio and listening intently to the star-studded WBAI Hansberry memorial program, by turns melancholic and celebratory, reminding the world of her gone-too-soon genius in January 1967 or attending a performance in 1969 of the Nemiroff-helmed play, *To Be Young, Gifted and Black,* an unprecedented theatrical showcase of a Black feminist's intellectual archive—letters, journal entries, interviews, woven together into stirring narrative and dramatized for the stage. The most fanciful scenario is a motherlode of speculative wonder, one in which Ellen somehow, at some point in her own storied career, impossibly finds her way to Lorraine's legal pad notes, a treasure trove of private philosophies and passions, a "book of strategies," as Jesse McCarthy might call it, encouraging her to pursue her deepest fulfillments and attesting to the fact that revolutionary feminist intellectuals, like herself, placed value in the act of producing, preserving, and protecting their own personal catalogue of ideas. The life of the mind for both Hansberry and Willis would suggest that if, however close or far from the real any of these hypotheticals may have been, all of the above are fundamentally true to each woman's radical spirit.[109]

What we do know for sure is that, in the years that would follow the brief hitching of their wagons, these two brilliant and singular women curated thinking lives for themselves that had more than a few things in common with one another. Hansberry, the Black radical queer feminist intellectual freedom

"I was taught to hold shadow up to sunlight and try, to the best of my ability and endurance, to discover all its properties." (Lorraine Hansberry)

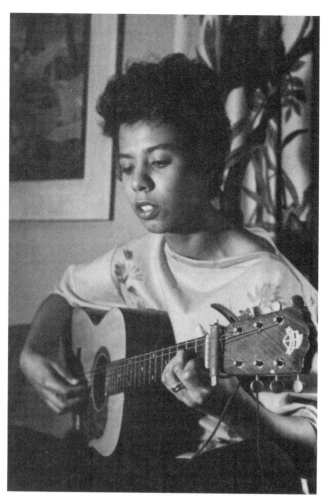

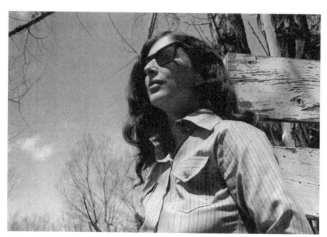

"Even when the content was antiwoman, antisexual, in a sense antihuman the form encouraged my struggle for liberation." (Ellen Willis)

fighter, continued to experiment with ways to incorporate music into her repertoire. And Willis, the bohemian Jewish radical feminist rock critic, in, for instance, her thoughtful review of *For Colored Girls*—in *Rolling Stone* magazine (of all places)—addressed the emancipatory politics of Black feminist drama.[110] Their chiasmic dance through cultural history suggests to us the many untold tales of how sonic culture and critical thought about said culture have been shaped, in part, by the (dis)identifications of creatively dissident and voraciously desiring women, each of whom held close to her heart forceful beliefs about the value of culture and women's pleasure.

Hansberry and her admirer Willis's gift of futurity is one involving both women leaving behind a shared legacy for those of us in third- and fourth-wave generations and beyond to imagine, design, narrate, and document the "erotic," feminist- and life-affirming art that draws all of us closer together at the show and out on the dance floor. Their lifelong labors remain the call that we might answer as we commit ourselves to improvising a new hermeneutics of sonic sustenance and survival. Theirs is a labor that gifts us with the language to newly regard and listen again to the records that give "more life." And just as importantly, the ethical righteousness that Hansberry and Willis each models for us also demands that we labor to find new ways of honoring the sister musicians as well as their ally thinkers who made the sonic and discursive recordings of feminist, queer and minoritarian life that lives on other frequencies.[111] Such endeavors are ones that, as Side B reveals, remain a source of debate and struggle in the contemporary world of blues criticism and record collecting cultures, and there is one case, in particular, that cuts to the very heart of such matters. The grossly overlooked yet recently resuscitated recordings made by a pair of sisters about whom the world had either forgotten or never really heard at all remind us of what's ultimately at stake in the intellectual world of popular music culture. The phenomenon of their lapsed sounds and the disregarded worlds of the girls and young women who passionately "liked" what they were hearing is, as we shall see, a Black feminist history that still awaits us.

Side B

We are engaged in a beautiful struggle to take back that which belongs to us, to get closer to the multitudes that we missed and the dear ones that we miss. Such a battle requires that we think, dream, plot, and prepare ourselves to write from an angular position, to generate critical tales that run askew from the standard script. Such an effort demands that we stretch the limits of our imagination and test the boundaries of the speculative. This is the kind of experimental endeavor that makes it possible to draft avant-garde liner notes in the language of Afrofuturist androids and to compose regional folk odes to the quixotic elsewhere like the kind made by polymath contrarians. Such questing and querying modes of the expressive are the forms we might summon to imperfectly approximate the artistic passions of, say, a solitary postbellum music critic or the wished-for conversations between disparate feminist radicals. We rehearse, we *re-search,* and we narrate the (im)possible. We entertain valid conjectures, compelling theories of the "what if," would-be scenarios, and alternate endings. And, above all else, we turn to the music that warrants our scrupulous Black feminist attention, our inspired notes drafted from a variety of different perspectives and sounded out in as many keys as we might dare to play at once.

So bear with me in this regard as I try to give voice to the feeling of being *in* the archive, searching for traces of Black feminist sound, of forgotten musicians and unloved records. Be with me, here at the table in this place, down in the collection box, with gloves off, holding the withered photograph, the dog-eared

Rhiannon Giddens digging the archive in her "Black Is the Color" music video, 2015

pamphlet, the crumbling letter, the fragile diary. Be with me huddling, squinting, poring over precious materials, back aching, neck spasming, knees stiffening. Our bodies sitting here at the cool, sleek institutional desk carry what others have given up. Together, we labor in the archive, and we ask questions: How did it feel? What did they want? Why did they go, rather than where?—as we yet still respect their right to disappear and recognize the structures of violence that accompanied their disappearance. Their vanishing becomes the occasion to ask, How might we handle the surviving document differently (as we stay wary of the atrocities of "the manual")?[1] How might we move with it, fight with it, care for the people entangled in its web?

We make plans on how and when to break the glass: What are the other ways we might tell this story? What kind of preparation or study do we need to be able to embrace this "anticipatory readiness," to play against the grain?[2]

Maybe it's dance lessons to feel the way your own body curves along the lines of those girls in the hall. Maybe it's notes on a cityscape to absorb the rugged, unpredictable geography of this location where the "forgotten but not gone" reside.[3] . . . Maybe it's a questioning of your own whole experience, the things that make you feel the fullness of life—savoring a decadent meal, swaying on the overcrowded dance floor to a deejay's infinite beat, finding solace in the richness of art—the novels and poetry that give voice to your inner demons and utmost desires—indulging in the sumptuous objects wrought by capital, surren-

dering to the micro-pleasures of making love and how said pleasures lay claim to you, lure you into the space of alterity, push the limits of how you define your own freedom. How can you square that with those who came before? . . .

Perhaps by opening yourself up wide to the event, the opaque figure, the exquisite collective as far as you dare. But be all the time mindful that any quest to know, to touch, to inhabit is not only impossible but perhaps the wrong way to honor the questions that hover around and shroud the lost, the dispossessed, the disavowed. Expect to fail and then write yourself through the failure, write about it and draw truths from the conundrums. Write with the invigorating humility that you are not alone, that you are the conduit, the surrogate, the effigy for those multitudes. You are not sovereign, but neither do you prescribe to the stark white "death of the author."[4]

You are writing of and for and toward "the chorus," but you are also composed of it, instilled with the rhythms and luminous narrative might of a Morrisonian *Jazz* suite; buoyed up by the urgent riddle of what Lynn Nottage's *Intimate Apparel* feels like as it drapes an invisible brown woman's skin; infused with the insurgent possibility of the "too-too girls" who lurk at the edges of photographs and in the fore of police blotters in Farah Griffin's *Harlem Nocturne;* intoxicated by the discovery of Bessie Smith's "lost trunk" that dazzles Jackie Kay's imagination. You look out onto the vistas, across the carnage of history, surveying the scene like Carrie Mae Weems. You see what happened, and you choose to write through and beyond the cries.[5]

You might follow the line of the ensemble, the ones who make it possible to do this kind of labor, the ones to whom I'm singing, the ones with whom I humbly hope to play alongside in the pages ahead. You might, as one grand thinker has done of late, turn speculation into an epistemological maelstrom, into the righteous beauty of the never-accounted-for; just as Tina Campt reattunes us to another kind of grammar of the photograph that eludes the constrictions of the state; just as Rod Ferguson conjures up a queer black bookshop, the place where youthful Black sexual radicals might read about that Other Hansberry; just as Brent Edwards beckons us to tarry in the so-called minutia, the "minor" history of a jazz genius matriarch's quotidian receipts; just as Jacqueline Najuma Stewart takes us into the Micheaux picture show to locate the pleasure and joy of Black movie fans; just as Tavia Nyong'o weaves together the Afrofabulist angularity of Black social life; just as Elizabeth Alexander climbs the scaffolding to stand beside Sarah Baartman so as to pick up her interiority on other frequencies; just as Isabel Wilkerson gets in the car with a Black migrant fugitive and speeds through the landscape of Jim Crow ruin; just as Stephanie Smallwood breaks open the ledgers so as to illuminate the

opacities of the terrible journey; just as Jack Halberstam disturbs the catego-
ries of social legibility that perpetually eclipse the queer rule-breaker, the
speakeasy "deviant"—first to be arrested and first to be forgotten by a history
that has no place for them.[6]

You might wring lyricism out of the conditions of Blackness in all its varia-
tions, modalities, structures of feeling so as to transduce the Motenian philoso-
phies of ontological revolution and object resistance into dense, epic story-
telling of another order.[7]

This is the kind of beautiful struggle of which Saidiya Hartman speaks and
brings to life in her revolutionary study *Wayward Lives, Beautiful Experi-
ments: Intimate Histories of Social Upheaval,* which folds together the voices
of the marginal, the ones in the margins who sing in a minor key of revolution
and sociocultural undoing. This act of critical Judith Butlerian assembly, this
work that asserts that we might follow the ones who saw fit to "cut an errant
path through the city" in early twentieth-century America despite chronic ra-
cial and gender surveillance, is a story about Black radical lateral life and live-
liness forged through networks of intimacy and third ways of being outside
the racial and gender binaries set for them, outside the script of history
handed to them. Hartman's tale is told in panoramic sweep and in intensely
candid, brutally frank, majestically erotic prose. It is a work that manifests an
execution of the ensemblic, a suturing together of archival and speculative
connective tissue. It is a symphony of our collective study, an invitation to
activate our mindfulness of the evidence of things not seen, and an alluring
proposition to search for and locate the insistent romance, the poignant deli-
cacy, the stubborn grace and preciousness of lifeworlds framed by the long
arm of the hold.[8]

Like other pathbreakers' move-the-ground-beneath-you work—like Griffin's
and Wald's respective, numerous, and magisterial explorations of Black sound—
Hartman's monumental study encourages us to aspire to make music out of the
fragments: to revel in the refrain as formalistic and analytic invention, that
which repeats, as Kara Keeling has brilliantly noted, and that which, by virtue
of repetition, resounds as critical difference. This is writing that amounts to his-
torical meditation as well as a form of curation. It makes analytic art out of the
melismatic run, piling image upon image, figure upon figure, placing Harlem
world-character alongside Philly-based antihero W. E. B. Du Bois. In this od-
yssey, *Wayward Lives* highlights anonymity here, and presses on the specificity,
the punctum of a seemingly familiar individual's errant path, there. It swings
cinematically across the Ellisonian masses standing on the train platform in the
grooves of history, swooping down to highlight an intimate struggle, a stolen

pleasure, a prolonged quest. It experiments with choreography that alights from the standard program recital, that takes flight and revels in the whimsy of the unspeakably sensual. It examines the meaning of performing oneself at odds with state narrative and the cruel constrictions of the proper.[9]

Out of all of this historical material(ism) comes a new genre of critical writing as well as new methods that require us to take great care, to ask different questions of the thing that (as Morrison told us at the Nobel podium) we "have in our hands." At every step, this planning, this project, this "old new thing" requires risk and abandon, humility (which we too often lack in academia), fearless imagination, the willingness to be vulnerable, the willingness "to not know" (as Alexandra Vazquez would put it), the willingness to get close and to also respect the impossible, the improbable, as well as the unfathomable distance between our time and that which we took for granted but which still lurks in the crucible of past, present, and future.[10]

To flip from Side A to Side B, as the second section of this book does, is to move from the stories of critics who are artists and artists who are critics and to instead play a different set of songs, so to speak, precious B-side material that asks its readers to take a chance on listening to Black women's sonic histories that often test the boundaries of obscurity and that, likewise, do the kind of bold, sonic curatorial work that thinks through and beyond obscurity. This is the intellectual labor of the historically unaccounted for, and it comes to us by way of Black feminist sound. It should be noted that the music of these B-side artists asks the kinds of questions that have been hovering around our Black radical worlds of study, animating our discussions, stoking our would-be creativity as scholars for some time now. Their work, as Side B sets out to reveal, informs the blueprint for writing for and toward a Black feminist revolution in sound that has long been under way but for which there is no storied hall, no glossy coffee-table books, no primetime specials, no big, busy, and empty awards ceremonies. It is the blueprint that also hands us the language to account for the performers who, like Hartman, are curating the history of a radical Black feminist past and translating that past into present sound.

Without such curatorial work, Side B of this book would not exist. This second section of *Liner Notes for the Revolution* begins, then, by identifying a particular and potent crisis in writing *about* Black women's musicianship, before turning to the Black women artists and musicians who themselves offer counterhistories and countertheories of the historical and the mythic, the mystery and the beauty of the wayward, as it manifests itself in music. Without this wondrous, speculative new critical work, that which has been birthed out of

half a century of Black studies and feminist thought, and out of the revolution that Toni Morrison ignited with her fellow neo-slave narrative Black feminist novelists of the post–Civil Rights era, it would be impossible to explore the so-called problem of "lost" blues women in the white collectors' archive as I do in Side B. It would be impossible to contemplate the impulses and desires, the conditions of the sister who hoards her 78s as a totally disregarded figure in the history of the blues. It would be impossible to write for and about my mother, Juanita Kathryn Watson Brooks, and Dame Morrison's generation of sisters who loved music and found their way into the listening booth at the record shop as a ludic counterframework for their Jim Crow teen years.

Into this new atmosphere of wonder and deep questioning come the unruly musicians as well with their own modes of intellectual labor in the form of cu-ratorial performance: the classically trained folk troubadour who uses a mis-tress's letter as a gateway to the former captive's rage, the one who rejects the hell of the plantation; the hippie Tennessee-by-way-of-Brooklyn folkie blues sister, the one who pens odes to the guitar women known to few; the jazz in-genue prone to dusting off the ribald and forgotten jams, the one who is invested in singing mile-long, profane and profligate prison songs about a sister's queer possibility behind bars.

It's these artists who remind us that the age of otherwise is upon us, and it's their music that captures the feeling as well as the rigorous queries and burning concerns that drive the being and hereness of the dispossessed. Theirs is a form of curatorial performance imbued with a feeling of simultaneity (between past and present) that yields both eulogy and possibility. Their music is a document for the not-here and never-was that lives fundamentally in our vivid freedom dreams. We wonder as we wander with them, as we drift across the archive. Their sounds and performances demand that we think of them as curators, as archivists, as performers who travel an errant path of their own. Their work asks us to imagine a new vocabulary, to assemble a new primer, to innovate a new grammar, a new heuristic for how to read against the framework in which these bluespeople from long ago are "bound to appear." And they, likewise, in-vite us to dream alongside them about those people and feelings and events that remain beyond our view.[11] Like Hartman, we must remain attentive to the com-plexities of this exercise, to get in rhythm with the surplus, with the minor, and to ride that wave into an infinite line of questions, into the swarm, the crowd that sings out to us, "We still here."

Side B takes flight, then, by asking that we first stare into the chasms of the unknown musicians Geeshie Wiley and Elvie/L. V. Thomas—not to shine a light on that which eludes us but to honor the silences and make poetry in the cor-

ners of their histories. Their story reminds us that we need to remain prepared for the arrival of the ones whose names we don't even know yet, whose names we may never know but whose presence informs the very core of our existence and permeates the privilege that we bear to sit in hallowed halls (rock and roll and otherwise) where, to quote Wesley Morris, "we weren't supposed to show up here . . . , and so we show up here . . . every day."[12]

They ask us to dance with them. Time to fall in step.

The sonic curators know the way to move. They come to us as archivists who have documented and made use of Black music's historical past. Ready to look out for and look after "the ones that got away," they engage in some deep listening, putting their ears and their interpretive, curatorial skills in the service of conversing with histories largely overlooked by the heavyweight institutions, the ones with money to burn and little interest in the matter of Black life. This practice of deep listening shapes their own aesthetic intent. And though Achille Mbembe warns that it is the archivist (as well as the historian) who engages in expedient acts "of dispossession," fecklessly "establish[ing] her/his authority" over a "domain of things" obscured from their "authors," the work of the musicians explored in Side B invites ways of reading their sonic performances as both archival and curatorial, as acts of intellectual care that repossess the value of stolen lives and revivify the dynamism of the music made both out of and right at the hot center of the popular music culture industry's public eye.[13]

The story of Black women musicians' archival presence and absence in popular music history is also the rich and complicated story of how critics and scholars write and care about a musician's craft, her ability to generate meaningful cultural knowledge, her attachment to sociopolitical aspirations or supposed lack thereof. It's the story of the critics' and scholars' and archivists' relationship to historical romance with the past and all that it hath wrought in Black folks' lives. All of this matters when it comes to which Black women artists appear in the annals of history and how they do so. So much information shapes and informs the tales of the musician's body of work; tales, for instance, of cherished social encounters and prodigious erotic desire, tales that, in short, give context to their affective experience as it shapes the makings of their own musical event. But the ability of critics and scholars to attune themselves to the deeper, thicker histories coursing through Black women's popular music culture is the thing that the keepers of the standard-bearing popular music historical and critical record often fail to do. This underdeveloped intellectual enterprise has much to do with how and why some artists appear at all in history or get spoken about in very particular ways. Pop music critics and their

scholarly cousins have historically cared less about the thick, multidimensional context (that is, historical, social, and political, but also intimate and varied) of Black women's music, choosing instead to revere the exceptional and the singular techniques or charisma of an Aretha, a Whitney, or a Beyoncé and bestowing regal labels as catchall phrases for their seemingly ineffable talents and magnetism. This leaves us, however, with a dearth of critical conversations about the depth of their art and how it is both born out of and frames sociocultural experience. Such failures, such blindspots delay a reckoning with the historical archive that haunts and informs the constitution of our cultural lives, of the music that envelops our lives, whether we recognize it or not. To face such an archive is to do a kind of work akin to that of which postcolonial historian Antoinette Burton speaks. "An archive," Burton reminds in her study of late colonial women's novels, is the place where "a variety of counterhistories of colonial modernity can be discerned." What would it mean, then, to imagine the sisters, themselves, as taking the reins of the archive itself, marshalling their musicking as storehouses of formidable counterhistories—as sites of busy and industrious alternative world-making?[14]

This is the way we might push up against the aforementioned problems of the archive, of which a whole host of Western poststructuralist and postcolonial critics have enumerated for nearly half a century now, from Foucault's landmark warnings about the archive's crushing and far-reaching institutional power to Ann Stoler's rigorous reading of "archives as condensed sites of epistemological and political anxiety rather than as skewed and biased sources."[15] Derrida's seminal *Archive Fever* from 1995 turned the theoretical tide perhaps most forcefully toward interrogating the archive as an analytic object to be viewed with bottomless skepticism and demystification since, as he insists, "every archive . . . is at once institutive and conservative."[16]

The difference that performance studies and Black feminist studies have each made in navigating these archival minefields is vast and impactful, whether in the form of Joseph Roach's view of embodied performances as sites wherein diasporic networks of cultural memory might evolve and thrive beyond the reach of or in bold tension with institutional control, or in the work of Diana Taylor, whose generative insistence on reading indigenous and vernacular performance repertoires as an intricate and necessary rejoinder to archival hegemony reinvigorated archival debates.[17] Such moves also nod toward the curatorial. This is scholarship that asks us to think about the ways that artists themselves are (re)arranging how we imagine our histories through performances that destabilize and reassemble the historical record altogether.[18]

Black feminist historians and Black queer theorists have been busy planning as well, innovating expansive ways of addressing the violence and domination that frame how we receive or, in many cases, how we never even find the traces and relics of Black lives lived under unfathomable duress and emergency, under brutal forms of antihumanistic power constituted by and dependent on the utter negation and erasure of Black quotidian being. Such crises, their work implies, demand wholesale curatorial reinvention, a reordering of what's available to us in the archive and innovating ethical approaches to handling all that is and isn't there. Think of how, for instance, historians Sarah Haley and Marissa Fuentes are addressing the nature of this catastrophe, "stretch[ing] archival fragments," as Fuentes describes it, "by reading along the bias grain to eke out extinguished and invisible but no less historically important lives." Or think of Keeling's wholly dazzling and visionary, Black feminist queer response to the ubiquity of archival power and the invisibility of Black queer subjects in the cinematic archive. Keeling reminds us that this kind of work entails asking newly formulated, ethical questions about the putatively "missing" subjects themselves and what we perceive to be their remnants.[19] Respecting the boundaries of how to look (out) for them, it turns out, requires some heavy lifting, a willingness to roll one's sleeves up and do a different kind of intellectual labor. As is the case so often, ReRe forecast this turn long ago when she and Annie Lennox sang out to us that "the sisters are doing it for themselves."[20]

This is work forged in alliance and conversation with the Black radical tradition and with the Black feminist thinkers past and present whom I've already summoned in this study. And it is work dedicated to the Black and brown girl listeners, fans, artists, and critics not yet born. Side B invites us to spin this sonic curatorial story of the multitudes. But not without a fight at the turntable first.

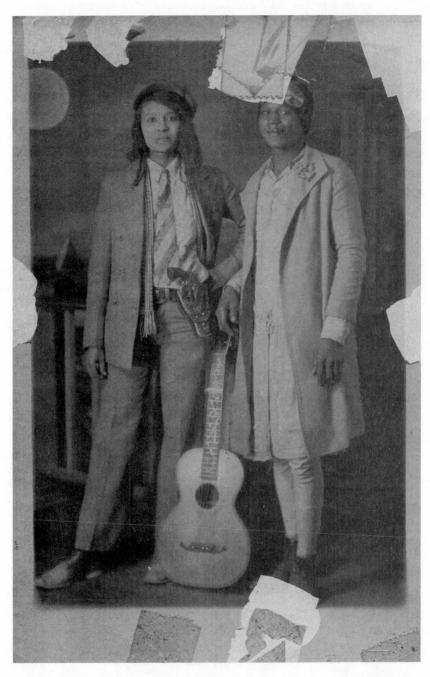

Vintage real photo postcard: two sisters from somewhere, from elsewhere, from the not-yet-and-never-was

5

NOT FADE AWAY

LOOKING AFTER GEESHIE & ELVIE / L. V.

We want the photo to sing to us—ballads of train-hopping, juke joint brawls, and boisterous revelry on the dance floor, of quixotic country blues mischief and in-the-still-of-the-night danger out on the open road. We want the photo to supply us with parables that both match and exceed the "lyin' up a nation" mythical tales of Robert Johnson on a devil's errand, Skip James crooning from one street corner to the next, of Son House, Charley Patton, and that maestra of the keyboards Louise Johnson driving shotgun from Mississippi to Grafton, Wisconsin, to lay down some sides in the once-and-now-again-legendary Paramount Records Studios. Try as some of us may to resist the temptation to swoon over details we cannot yet possibly corroborate, we want the photograph to take us to that place that exists beyond the celebrity queer blues women's histories, beyond the storied fables of afterhours Harlem cabarets and Windy City speakeasies where Ethel declared that she was "no man's Mama," where Gladys rocked her finest tux threads, and Ma and Bessie partied backstage with the chorus girls like it was 1923.

We want this relic of lives not known to us to serve as the "proof," the evidence of butch and femme sisters who played guitar duets in country suppers off the beaten path of the Theatre Owners Booking Association (Chitlin') Circuit while packing heat. We want this image to serve as the trace of what artists and outlaws in transit and transition from Houston to Wisconsin and back to Texas again left behind. We want the photograph to affirm the existence of the queer archive that "no longer exists" while nonetheless holding on to that "most bewitchin[g]" of possibilities, as the editors of *Radical History Review*'s special issue suggest, that this queer archive "never existed" at all, thereby

"mak[ing] explicit how the drama of existence is a central, compelling narrative or mystery inhering in queer archives, a drama borne out by countless scholars' efforts to find lost queer things."[1]

We want the photo to answer our questions, complete the narrative, restore that which has been "lost" to blues history: the blues women who made records *outside* the vaudeville pearls-and-feathers hustle, who made records that maybe only a few folks heard, played, shared with others, and perhaps cherished, and even fewer people bought, and whose work lives on in the form of "fewer than 10 surviving" copies. We want the photograph to be the first and last (kind) word in the Holy Grail of wonkish 78 rpm record collector mysteries: the flesh-and-bone precarious lives of Geeshie Wiley and Elvie Thomas, referred to by critic John Jeremiah Sullivan as the legendary and "vexing ... ghosts" of enigmatic prewar blues Americana, "a couple of women identified on three ultra rare records made in 1930 and '31" who existed "outside the grooves of history," outside the "historical time" of which Ralph Ellison speaks. "There are musicians," says Sullivan in his truly impressive journalistic work on these women, "as obscure as Wiley and Thomas, and musicians as great, but in none does the Venn diagram of greatness and lostness reveal such vast and bewildering co-extent."[2]

Geeshie and Elvie. We long for them. We look for them. We circle that intoxicating diagram, eyeing it for its mysteries and asking so many questions of it that the questions themselves now constitute their own troubling romance and threaten to perpetuate the kinds of confounding myths that tell us much—if not more—about the mythmakers themselves as opposed to the music they made. We know that we "can't always get what we want" from the traces of their sonic being. But there are some, it seems, who nonetheless get what they need.

My own needs suggest to me that we best sit with the photograph a little longer in order to further contemplate its alluring power and ask questions of both it and our own desires, our own attraction to the striking commingling of these artists' genius and obscurity that animates the ideas and imagination of blues music collectors and critics alike. I count myself among them, holding the remains, replaying the records, lingering with the remnants of their history, wrestling with the riddles left behind by two women who, as Hartman tells us, were no doubt part of the "open rebellion" in the early twentieth century, that which was led by Black women, "radical thinkers who tirelessly imagined other ways to live and never failed to consider how the world might be otherwise."

We, the fans of "Geeshie and Elvie"—John Jeremiah Sullivan, Greil Marcus, and I—each came to the image and sat momentarily with it, asking what it might tell us about the "errant path" of these musicians.[3]

Without Sullivan and Marcus, there'd be no photograph from which to think anew about the "ballad of Geeshie and Elvie."[4] Both men are writers and researchers whom I know and respect, and I am grateful to the both of them for sharing this photograph with me. Greil Marcus is a figure who literally opened up my sonic world from my earliest days of riding the bus in Menlo Park, California (his hometown as well, it turns out), down the El Camino Real to the beloved and now departed Tower Records, where I consumed rock rags to make sense of the punk rock and new wave no one else in my family could tolerate. This was where I first encountered his landmark *Mystery Train* opus, and his writing on American popular music culture has since been instructive. Our shared paths through Cal-Berkeley, along with his editorial example, are more reasons why I know that there are always conversations still to be had with him. The same can be said of John Jeremiah Sullivan, a writer whose work has been pivotal in relation to my own. My past discussions with Sullivan about, for instance, the methods, the form, and the content of new millennium blues music criticism have been both generative and provocative. And while such points about influence and collegiality between critics and scholars may seem superfluous to any study of the music, I find them crucial to raise at the outset of Side B, since they point to some of this section's larger and overarching concerns about, among other things, ways of forging dialogue and fellowship among archivists, critics, artists, and teachers tasked with caring for the oft-forgotten and overlooked traces of blues women's work, the very DNA of our modern pop music universe. There is an ethics to what we do, how we (mis)manage the stories of the dispossessed. The photograph became the occasion to think this through.

And to be sure, we were all intrigued by it. The tie that binds us most closely together is that we all wanted to know more, even if each of us was perhaps ultimately searching for different things. It is an object of which I knew only as much as Sullivan and Marcus had kindly passed along to me back in 2015. Beyond the signs of peeling edges, fragments of tape that suggest that someone, somewhere had once affixed it to an album page or a wall—someone, in other words had cared for it, wanted to preserve or display it or both—other than that, though, I knew nothing. It was Sullivan who, in an act of pure generosity as we discussed preparations for doing an event together in the spring of that year, shared with me the photograph that dazzled his imagination anew. "It

just surfaced. I think it was published at one point, in a book about rock 'n roll," Sullivan observes in his note to me. He continues, adding that

> Greil Marcus knows the collector who owns it. He saw it and noticed the parallels. We can't say 100% it's them of course. But so far everything that's coming to light is right. A photo postcard, made btwn 1918 and 1930, in or around St. Louis (through which they passed in 1930, on their way to Wisconsin). A little petite woman like we know LV was, in appearance identical to the way she's described. The faces are similar, when this one is compared w the known photograph (there are differences but those we'd associate with age—her nose got longer, her cheeks hollower). A train hopper, wearing men's clothes, carrying a pistol and guitar. . . . Imagine what they looked like coming onto the stage! Husband and wife almost. It was part of the act. Only not an act. Or something we don't understand. What would the audience at the medicine show have imagined when Geeshie sang, "You need not think because you're little and cute / I'm gonna buy you a box-back suit." Lillie Mae has hands that had picked cotton. LV's a city girl to the bone. The only cotton she ever saw was already on a wagon. "Lillie Mae, you're nothing but a Geeshie. That's right, *Geeshie* Wiley. Get over here." That's how it happened evidently. It's like, it *can't* be them. But it can't not be them. But it *can't* be them. And on and on.[5]

John Jeremiah Sullivan occasionally writes emails pitched as lyrical fever dreams, and I am not gonna lie: I am seduced by the bold force of his narrative animation and invention, his ability to infer from the photograph a queer lifeworld that conjoins sartorial details and dazzling props with fragments of songs left behind, the vision of a possible repertoire that yokes together onstage and offstage intimacies, the audaciousness to extrapolate seeming details about bodies (the possibly "ravaged" versus "delicate" states of the posees' hands) as evidence of lives lived far outside the frame of the photograph. His earnest and oscillating incredulity is a mark of wholesale veneration of the putative singularity of Geeshie Wiley and L. V. Thomas. "It can't be them" because their existence is predicated upon their elusiveness (an undertheorized form of fugitivity, perhaps?). "It can't not be them" because no other queer, cross-dressing blues women who carried a guitar and artillery could possibly have posed for the record?

While I want to gently push back on any kind of romanticization of Wiley and Thomas that renders them exceptional and therefore divorced from both history and broader social networks of cultural production, I would argue that some of what Sullivan is doing here in the course of a two-paragraph email

amounts to a kind of casual historical materialism, less than fully formed, but certainly invested in "a creative process" that "animate[s] history for future significations as well as alternate empathies." In the extended "moment of emergency" in which there is recognition that records of performances laid down once and not again in the small, dark, cramped studios of a midwestern company about to go under have been lost, records with no master copies, no trail of mass market reproducibility, in this moment of peril and mourning, Sullivan here responds to the famous call made by Walter Benjamin "to seize hold of a memory as it flashes up at a moment of danger," to "seize hold of elusive histories" that, as critics David Eng and David Kazanjian add, "have been obscured by the historicist's genuine image." Doing so, they remind, "allow[s] lost pasts to step into the light of a present moment of danger." In many ways, then, Sullivan's engagement with the lives of these women—what we know, what we don't know, what we could never know—is an instructive "intellectual history of loss" that "apprehends itself as an act of provisional writing against the conformism of unwavering historical truths, of histories that claim to blot out the present."[6]

Yet the problem here, of course, is in the fixing and the impulse to "fix" the photograph to a history that threatens to "establish new genuine images or new eternal truths" of, for instance, "cotton picking hands" without a history of labor that instantiates how those hands were used.[7] Moves like these cause me to recall a question that Jack Halberstam once posed to me in a conversation: "What if" Geeshie and Elvie "don't want to be found? What if they want to remain lost?" Halberstam's query shares some affinity with Heather Love's poignant meditation on "a queer ethics of historical practice," the kind of which encourages "a willingness to live with ghosts and to remember the most painful, the most impossible stories" that document those who, rather than revealing themselves in the archive, instead "turn their backs on us." These sorts of questions and concerns have galvanized current lines of thinking in queer theory of late, and they have, likewise, reinvigorated important Black radical tradition debates in recent years as we continue to strategize a politics of care in our archival endeavors. It stands to reason, then, that this too, is the kind of critical thinking that we might heed as well in new blues studies as we continue to take seriously both the possibilities of and limitations in "knowing" more about Geeshie Wiley and Elvie Thomas—from their blues aesthetics to the extent of their "queerness" to their intimate cultures and public lives.[8]

This chapter asks, What is the role of criticism in assessing and addressing these Black women musicians' "lostness" and "greatness," and what kinds of writing and thinking do we have at our disposal to expansively care for these sisters about whom so little is still known? It also suggests to us that we might

ponder this: What if the quest for tactile proof of their existence is a form of re-demption that they never asked for and from which they have nothing materi-ally to gain now? Is there ever a way to write about the work of those Black folks who are lost to the sonic archive that honors this kind of a devastating phenom-enon? Black studies scholarship of the twenty-first century would surely re-spond "yes" to this last question, as it reminds us that the labor of Black art is always already subject to co-optation or in danger of fading away and yet still pushes against its own mass absorption. It does so by sustaining a prodigiously confounding opacity—call it elusiveness, mystery, privacy—at its very core. Put another way, as philosopher Fred Moten famously declares, "The ontological to-tality and its preservation—that, in all its secret openness, is called blackness." By this he means that the arcane, the enigmatic expressiveness of the marginalized, is a necessity of captive cultures, and it is also exigent sustenance, what we might think of us as "righteous obscurity."[9] The "righteous obscurity" of this photo-graph calls on us to do a kind of work that lingers on the matter of Black life as it frames the conditions in which these precious records were made. Most, how-ever, as we shall see, have found such a topic unworthy of attention, choosing instead to follow what some might call the less righteous path, prioritizing their own enjoyment of the music and holding fast to the fetish of the arcane.

Not Fade Away

They are the icons, the heroines, the bandits of blues obscurity. Geeshie and Elvie. Two sisters from somewhere, from elsewhere, from the not-yet-and-never-was who found their way into what was arguably the most influential race records empire ever built, the midwestern recording studio of Paramount Records, in the waning years of its existence. That turn of events has made them the stuff of obsession. Slinging two guitars and delivering unusual blues duets about fate, disaster, and shrewd forms of survival, they were two sisters who have subsequently held the attention and captured the imaginations of a small, rag-tag population of partially elite and erudite, partially eccentric and outsider, and almost entirely male cadre of taste-makers and canon-builders. Theirs is a fan base driven by obsessions. They made music that has subse-quently elicited some of the most passionate, the most intimate, the most vis-ceral responses from critics that, by the measure of their feeling, are perhaps equal to if not exceeding the critical adulation directed toward other iconic Black women artists of the modern century—Bessie, ReRe Franklin, and Queen Bey notwithstanding.

Geeshie and Elvie. Artists whose tiny archive of material—three records, six sides—features two tracks in particular, "Last Kind Word Blues" and "Motherless Child Blues," songs that have been lionized by the blues nerd squad as dual "masterpieces of prewar American music." They are artists who, for over half a century, were heard—as far as we know—by the tiniest group of people, the white male record collectors who traveled hundreds of miles, trolled flea markets and estate sales, knocked on doors on the "black sides" of towns in search of these sounds, shared them in their living rooms with kindred spirits, and wrote about them for each other in old-school newsletters, in zine publications, in magazines like *78 Quarterly*.

For the past two decades the legend of their music as well as their historical ephemerality has grown and reached wider (yet still no less elite and particularly idiosyncratic) publics as a result of R. Crumb (about whom more will be said later), that curmudgeonly Bay Area cartoonist who, in Terry Zwigoff's infamous 1994 bio-documentary, spun his precious copy of Wiley's lament, "Last Kind Word Blues." It was Crumb who effectively ignited a new order of die-hard critical intrigue about this particular enigmatic recording and the whereabouts of the artists who made it. Pioneering rock scribe and indie American studies troubadour Marcus would lead this charge in a 1999 *Oxford American* article, the first in a series of publications and lectures that he's given for some two decades now on a song that came to his attention by way of the Zwigoff documentary. It was an encounter that led him to declare his trademark forceful conviction that "this single recording would have been enough to ensure that once heard, [Geeshie Wiley] would never be forgotten. I was at the record store the next day," he adds ominously, "waiting for it to open."[10]

A fever was setting in on the eve of the new millennium. It stretches across Greil Marcus's various writings on "Last Kind Word Blues" on through to the work of popular music studies scholars, collectors' published testimonials, and the liner notes of record label revivalist entrepreneurs, all of whom have been listening to and hunting for as much as they could possibly find about two elusive Black women who came out of the Jim Crow South with their own indelible sound. There is Sullivan with his game-changing *New York Times Magazine* cover story from 2014 and Marcus again staunchly communing with the musicians and their music in his 2015 *Three Songs, Three Singers, Three Nations*. Here we find Marcus musing about all that static that we hear on "Last Kind Word Blues," how it is, in his opinion, "inseparable, now, from the voice of the song. It drapes an aura of the faraway, the lost, and the abandoned over the performance, and the performance was all of those things from the start." Spiked with references to gothic phantoms and hard-boiled disappearances, much of

the critical language surrounding their music takes intrigue as its topic of inquiry rather than the sisters themselves. Even Sullivan's own predilection for "ghost stories" is apparent in his early work on them, though he cautiously and methodically undoes these sorts of tropes in his *Times Magazine* article on this subject, using *CSI*-like research forensics precision to piece together the little that we now do know about either Thomas or Wiley. Both dogged and savvy, Sullivan's investigative approach in this latter piece sets him apart from many.[11]

Marcus's and Sullivan's respective works on this subject are, to a certain extent, pieces of a whole. Aspects of their criticism are indicative of the varying approaches to exploring this old, arcane music, which tend to fall into three categories. There are those critics who throw their arms around the grip of its aesthetic sublimity, leading with reverence and utter awe in response to the excellence of Wiley and Thomas's musicianship. The innovative sibling archivists and record label owners Scott and Dean Blackwood have promoted the reissues of their recordings from this standpoint. See, for instance, the 2005 liner notes to their *American Primitive* CD anthology in which the latter proclaims with a tinge of starry-eyed incredulity that "hailing from no place, Geeshie and Elvie quickly went back." And there are others, like indie rock journalist Amanda Petrusich, who, as I discuss later, hold fast to, above all else, the perceived aura of the object, the 78 rpm record's exquisite rareness, leaning into the poignancy of the record as an extant trace of humanity, a haunted symbol of something ineffable about the fleeting nature of mortality itself. "Wiley was a specter," she dreamily observes, "fiercely incorporeal, a spirit suggested if not contained by shellac." Still more troubling is a third category, the one that is characteristic of the sort of posturing coming from figures like influential collector and cult minstrel guitarist John Fahey, he of the unapologetically neocolonial rhetoric that bespeaks the arrogance of the collecting class. Fahey's claim that fringe blues musicians "have no history of their own anymore," as he once explained it, "so they insinuate themselves into ours" is the kind of violent dismissiveness that bluntly sums up some of the most malevolent ideas framing the culture of blues collecting and criticism. In all of these instances, the tenor of the conversation about these two artists has been a changing same: each of these critics, at some point in their engagement with the sonic records of Geeshie and Elvie, finds recourse in their disappearance from the historical record. The mystery of this seeming disappearance has, in other words, inspired a kind of writing driven by either freewheeling speculation or a dogged determination to retrace their steps and hunt them down, to uncover the secrets of their evanescent lives. The "error of their resuscitation," as my colleague Katie Lofton succinctly puts it,

lies in their "need to render these women unseen in order to make themselves glorious in their critical finding."[12] It is the sort of "vanishing act" putatively enacted by the artists themselves but one that has been enacted on them as well.

These collectors, as Petrusich notes, are all looking for "songs that somehow captured the tenuousness of even being alive in the first place. Songs that recognized, either explicitly or implicitly, the threat of swift and complete termination that all living creatures are forced to contend with."[13] Here the obvious suggestion is that she and her fellow postmodern fans of "old, weird American" music need our women to be lost in order for them to do a certain kind of work for certain kinds of listeners around questions of loss and perhaps feeling (sometimes quite acutely) lost themselves. In the best-case scenarios, this music that has been for generations "forgotten but not gone" (to cite that familiar Roach refrain yet again) has been drawn to the front pages of major publications, cued up in films, covered by a cluster of contemporary indie artists, and treated with a kind of dominant critical attention and admiration largely denied it in the past. In the very worst cases, the "new" blues critics depend on a second form of disappearance—the erasure of robust sociohistorical and cultural contexts that might guide us to listen to the blues woman's sonic remains in surround sound rather than on a busted-up eight-track.

It would be, I think, too easy to dwell for too long on dissecting the all-too-familiar impulses, desires, and needs of the white critic's melancholic relationship to Black cultural objects of inquiry that, for him or her, archive suffering and alienation, precarious life that suggests an inevitably tragic demise (rather than Judith Butlerian solidarity). The fascination with the marginalized and the disappeared from the blues archive is, as Bryan Wagner sharply points out, "shaped by the pleasure of condescension," but it has also been "governed by a systematic rationale, which correlated economic failure with cultural authenticity."[14] All of those Black voices down at the bottom of the well, presumably—and mistakenly—"untouched" by the workings of modernity, as the oh-so-familiar myth that stretches back to at least the time of F. Scott and his Jazz Age party people goes, are the repository of our purest traumas and unbridled desires.[15] The fact that these kinds of impulses still surface in our current world of blues critical conversations has led my colleague Sonnet Retman to pointedly remark as we've pored over, discussed, and shared these critical works with each other for some time now, "primitivism 2.0," y'all. In spite of such concerns though my ultimate aim here is to steer clear of a study that foregrounds the affective relationship forged between white blues critics of yesteryear as well as today and the records they loved in order to draw out a counterdiscourse of Black folks'—and particularly Black women's—critical

relationship to both the music they made and that which got circulated in Black communities, then as well as now.

And for sure, such an exploration would have to start with some personal reflection. My own relationship to the blues as a Black feminist critic who grew up both drawn to and fighting with the white masculinist "aural gaze" hanging over the history of that music has led me down a very particular path of study and inquiry.[16] Black feminisms tell me to stay in pursuit of deepening and sharpening the ways that we address the loud silences, the "spectacular opacities" in Thomas and Wiley's "wayward lives" and Black women's performance archives more broadly. Black feminisms tell me to bear down on a consideration of craft—how it is shaped by the specificities and exigencies of Black folks' historical and material conditions, how it was cultivated, sustained, and circulated among Black women musicians themselves. This is the kind of study that continues to teach me to look for blues women's "performance remains."[17] This thing called Black feminist study beckons us to continue excavating counterpublics of sociality between Black women musicians and the fans who loved and needed them. It's those "flowin'" migrants who come from far and wide to hear Ma Rainey in Sterling Brown's classic poem who hold my imagination and drive my own investment in what Sullivan has, I think, lovingly coined "the ballad of Geeshie and Elvie." Delineating the places where my passion for these artists' performances versus the complicated and too often devastating history that surrounds them begins and ends is, however, crucial. And in this way, my mad love for and investment in their music both dovetails with and diverges from the interests of others in a number of crucial ways.

This chapter lays out those ways. It focuses squarely on those pesky critics and collectors who both advertently and inadvertently gatekeep these sites of preservation, remembrance, and circulation, and it does so in a bid to call for new methods, new experiments in ways of thinking about and handling these precious cultural documents, in many instances the only records that we have in our hands to account for the lives of Black women, artistic and otherwise, of the Jim Crow era—the first to be forgotten, the last to be remembered, as the genius Toni Morrison told us throughout her magisterial literary career. This chapter is what I hope will mark the beginning of new conversations between blues critics and Black studies scholars.

It is, in short, a call for collaboration because, in my opinion, the archive of blues music, the art of a disenfranchised people, demands our scrupulous collective attention, our communal care. In this regard, then, I pose what I see as urgent questions about the existing scholarship and criticism that focuses on

Wiley's and Thomas's opaque lives and stirring music, and I set out to build on the most promising critical work by asking different questions of their archive, by shifting the context in which we might listen to their recordings, and by hopefully altering our perspective on how we might imagine the circulation of their sound. The time is ripe for a new Black feminist study of the blues that recovers the fundamental spirit of pioneering critical thought laid out by Hazel Carby, Daphne Duval Harrison, Hortense Spillers, Angela Davis, Farah Griffin, and others and moves it back to the forefront of our conversations while also tending to ideas, arguments, and sometimes troubling fantasies posed by those folks who were listening to this music outside the world of Black intellectual life. The list of those latter listeners is long, and it spans several generations. But it is one that demands our attention if we are ever going to challenge the dominant narratives about Black women's sound, recenter Black women's voices in the discussion of that sound, and come up with new ways of telling the story of where it came from, as well as how and why and for whom it matters.[18]

"Romancing the Stone": Toward a Hermeneutics of New Blues Criticism

Let us turn, then, to some of the most troubling collectors and critics and work our way up and over to the other side of old-school record culture. Here we might, for a moment, consider not only a few of the key figures who have left their lasting imprint on how and what we talk about when we talk about 1920s and 1930s 78 rpm blues records but also the figures who best exemplify the collector's ambivalent relationship with Black aesthetic rigor and aspiration. The reasons for doing this seem particularly pressing and necessary if we are going to reckon with a radical counterhistoriography of the blues, one that ultimately tells a different story of not only "lost" blues women but also those who have set out, time and again, to find them. This, it would seem, amounts to a form of "queer archiving" that has been thus far largely absent in critical studies of Geeshie Wiley and Elvie Thomas.[19]

The blues record collecting set's fascination with Blackness and obscurity is a story that has been told and revisited with increasing mindfulness and detail in recent years by cultural critics such as Marybeth Hamilton and Elijah Wald, who each aptly attune their studies to the racialized dimensions of modernist cultures and the primitivist romance mythologies that subtend them. The Mississippi Delta blues collectors of the fifties and sixties were "aware of the ways that music, whether live or recorded, sounded a story about history," as Retman

rightly observes, one "that included industry and technology, the mass and the individual, shifting contours of region and nation, race and democracy." And they were, most certainly, primed for this kind of fetishistic attachment to the race record by way of the prodigiously influential inroads made by the blues ethnographers of the 1930s who set out before them in search of objects that purportedly possessed very particular articulations of race, gender, sexuality, region, and class. Wagner makes this point abundantly clear when he reminds that ethnographers like the Lomaxes and others who traveled south to record the sounds of rural Blackness in the decades before the record-collecting boom "were free to follow their presumption that black culture came from a traditional world where expression was still indexed directly to its producers." In their opinion, "the black tradition was a folk culture where singing and storytelling retained the stamp of its authors, a tradition unlike modern communications that lost their aura as they became standardized, market-based, and mediated by mechanically reproduced image and sound."[20]

These tales of modernity, melancholia, and racial and gender expropriation have, in recent years, turned anew to examining up close the material histories of the 78 rpm blues records themselves, as objects, as well as the people who have fought to possess them. Works by Hamilton and Petrusich explore the social and cultural odysseys of the "earliest iteration of a record as we think of it today," the 78 rpm, a ten-inch shellac disc, usually comprised of two songs, developed around the turn of the century and intended for play on a turntable whose speed can adjust to spinning the disc at seventy-eight revolutions per minute (hence the name). Both Hamilton's and Petrusich's respective studies trace the resonances of these objects in the lives and self-making of their owners in narratives that emphasize the ways that records—in both the early, post–World War II era and the new millennium—have the potential to accrue a particular kind of historical, monetary, and affective value for a subcultural "fraternity of [again, mostly] men" who remain dedicated to finding them.[21] By 1948, with the advent of the 33 1/3 rpm, they began to disappear from the landscape of the recording industry marketplace, shuttled off to the far corners of closets and basements, set out in bins at garage sales and flea market expos, and snapped up beginning largely in the fifties in a hunt led by, among others, queer white collector James McKune. As Hamilton has shown in her influential work on this topic, McKune was one of a tiny yet ardent set of fanboys from different parts of the United States and the United Kingdom who sought these records out, jonesing for sounds they claimed had long since disappeared from modern life, save for in the form of these "time-capsule" commodities, as some have referred to them.[22]

This phenomenon has its genuinely earnest and, I believe, sophisticated thinkers—for instance, Chris King, producer of landmark CD reissues of germinal 78 recordings; the aforementioned Blackwood brothers of Revenant Records in Austin, Texas; and steampunk indie guitar genius, rock icon, and record label entrepreneur Jack White and his Third Man Records label. But the characters who shaped this subculture in the fifties, sixties, and seventies engage in an all-too-familiar game of possess and repress: they pursue and stow away this precious "thing" that they identify in the record, the thing whose name they are, nonetheless, never able to speak for want of knowledge and curiosity, schooling, study, and training. Some of the more egregious offenders openly harbor a full-blown rejection of social empathy. To the vast majority of this particular set of collectors and critics, this thing called "Blackness," this "potentially unregulated or profligate internal difference, an impurity derived from the mixture of modes (major / minor) or of scales (diatonic / chromatic)," is something for which they've lacked the analytic tools at their disposal to even identify, let alone explore with some semblance of imagination and care.[23]

Consider John Fahey, UC Berkeley and UCLA folklore alum who, perhaps most notoriously, went "hunting" in the 1960s for records as well as the musicians who made them (most famously Skip James, whom he located in a Mississippi "charity hospital" in 1964). Known for "stag[ing] barnstorming road trips through the South in search of surviving notables," Fahey kept up a sideshow act for many years, performing as "Blind Joe Death, an aged sharecropper being led by the arm," an alt-ego to rival the twenty-first-century artist Joe Scanlan's blackface avatar Donnell Woolford. As Fahey biographer Steve Lowenthal describes, he was crudely forthright about the moniker's meaning. "The whole point was to use the word 'death,'" he apparently proclaimed, adding, "I was fascinated by death and I wanted to die. I probably could have told you that at the time, but I wasn't being that honest. Blind Joe Death was my death instinct. He was also the Negroes in the slums who were suffering. He was the incarnation, not only of my death wish, but also of all the aggressive instincts in me." Fahey's commingling of "blackness," death, danger, and aggression here is about as casual and transparent as any modern minstrel performer could possibly be about his addiction to the form.[24]

Armed with a self-coined style, "American-primitive," the late Fahey gradually amassed his iconicity as steel guitarist, accruing passionate followers over time and in the wake of his first recordings in 1959, ascending to the level of cult status in the 1970s and on into the 1990s when indie rock adventurists like Beck and Sonic Youth championed his music.[25] His work as a collector is well known to some and follows a familiar-bordering-on-shamanistic type of ritual among

the frenzied of 78 obsessives. After meeting Fahey in 1964 at UCLA, underground radio legend and longtime host of *Dr. Demento* Barry Hansen partnered up with him during his summer trips to the Deep South "looking for old blue singers and collecting old records," as Fahey tells it. Hansen chronicles how the two "would go door-to-door in the black sections of these little towns along the way," in an anecdote that positions him as the apprentice / mentee to a seasoned pro who took to door knocking with the chutzpah of a traveling salesman. Hansen reminisces on Fahey's shtick, how his pitch was always homespun yet direct. "You have any old phonograph records?" he'd apparently say. "We're buying up ooold phonograph records. Give you a quarter a piece for the good ones." Says Hansen, "That was John's spiel, and he kind of trained me how to do it. . . . [John] had been doing it since the early '60s.[26]

Hansen's recollection of their sojourn is laced with an understated appreciation of Fahey's game, his ease and confidence in practices that he'd worked out for himself in cycling through worlds foreign to the both of them. Incredibly, it's these sorts of actions that, to those around him, turned Fahey into something of a ballsy folk hero. Jimmy Crosthwait, a musician on Fahey's own label, Takoma Records, offers a strange assessment of the enigmatic artist's bravery that is predicated on both contextualizing his actions in relation to Civil Rights grassroots activism in the South and disavowing the importance of those radical efforts unfolding in his midst. "There were some other college kids coming into this neck of the woods," Crosthwait marvels. "But," he continues, "they were doing a voter registration drive, and it costs them their lives. And people were not really aware of the courage—or foolhardiness—it took to go into that same neck of the woods being . . . young white guys talking to black people. They could very easily have been either misinterpreted or misidentified."[27] It would seem to take elaborate flip-flops to prioritize Fahey's supposed "guts" in the Deep South 1960s over those of the young people—Black and white—who gave their lives to end racial apartheid in America, of favoring and lingering on the boldness of one man's quest to gather up the music that had a hold on him, the music that he fetishized in ways both grotesque and eccentric.

Fahey is the topic of the thoughtful, complicated, and sometimes very beautiful essay "Unknown Bards" by Sullivan, which probes Fahey's complex persona. Here Fahey's charged legacy is fully on display as the essay likewise documents the ways in which he remains an indispensable resource to blues music collectors and critics.[28] While seeking his aid in deciphering Geeshie and Elvie's "Last Kind Word Blues" lyrics early in his journey with them, Sullivan recognizes some of the spectacular disparities between an individual who, on the one

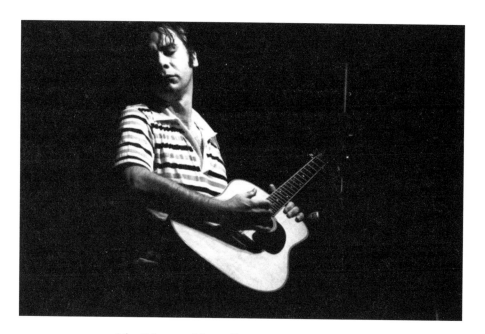

John Fahey, musician, collector, problematic trickster

hand, voraciously consumes Black sounds and, on the other, brutally disparages the artists who made these 78s: "It doesn't really matter anyway [about the lyrics]," says Fahey to Sullivan, "they always just said any old shit." They "didn't care about the words." They were "all illiterate anyways." There is a blunt violence here in these words that shouldn't surprise anyone who knows much about Fahey's personal life, his infamous cruelty and emotional abusiveness toward the women in his orbit, the fact that, as his first wife, Janet, recalls, his "politics were right wing. He had an alcohol problem. He had a drug problem."[29]

Fahey's ugliness, his racial condescension, comes across in works like *Charley Patton,* the book emerging out of his UCLA Folklore Department master's thesis, in which he argues that "Patton was an entertainer, not a social prophet in any sense. He had no profound message. He was probably not very observant of the troubles of his own people. He was *not* a noble savage." His offhand racism and his inability to read the layers of quotidian critique in Patton's blues would not have been uncommon in 1970, the year of his book's publication and in the run of an overwhelmingly white, trans-Atlantic blues revival movement. But his casual disregard for probing Patton's intellectual capacity, his potential to feel for and make art about the conditions of "his own people," is particularly unsettling in its superciliousness—especially given the fact that Fahey spent a portion of his younger years engaging in a kind of strange social intimacy with the

Black folks who were kind enough to welcome him into their homes while he was searching for records. Revenant Records cofounder and Paramount Records archivist Dean Blackwood offers a candid assessment of the roots of Fahey's dizzying treatment of African Americans. "There's the oft-told story of him weeping after hearing Blind Willie Johnson's 'Praise God, I'm Satisfied,'" Blackwood offers before adding, "although initially he was sort of sickened by it. He didn't know what to make of it. . . . It was so alien to him. . . . He grew up in the suburbs. . . . He hadn't had exposure to black artists. He didn't have an instant affinity for this music. This was . . . like a transmission from Mars to him." In his "Unknown Bards" essay, Sullivan (far too generously, in my opinion) observes him as "reflexive[ly] swerving between ecstatic appreciation and an urge to minimize the significance of the country blues." But he, too, collapses into unfortunate and predictable racial romanticism, questioning whether "it's possible [that] he feared giving in to the almost demonic force this music has exerted over many, or [if] he worried he had done so already."[30]

Yet rarely, if ever, has the intersectional specificity of the white (mostly) male collectors' relationship to his records and to the sounds of the cultures of Black womanhood figured into these allusions to blues romanticism. No image, for instance, crystallizes the conflation of race, gender, and commodified racial and gender exploitation in the blues recording industry more vividly than that of the collector's bible 78 Quarterly's special issue devoted to Black Patti Records, the short-lived label that onetime Paramount Records executive Mayo Williams (the company's first and only African American scout) would start in 1927 through the Chicago Record Company, which lasted a mere nine months and produced a total of fifty-five records. Williams and his business partners sought to capitalize on an economy of Black women's artistry, naming their label, like fellow African American record business entrepreneurs of Black Swan Records, after a classical diva sister, in this case, the legendary turn-of-the-century, African American vocalist Sissieretta Jones, "the Black Patti." The invocation of "highbrow" Black women's musical genius did not, however, render the label immune from a market that, into the twenty-first century, has trafficked in the sexual commodification of Black womanhood. Called by the late collector Jake Schneider "the world's sexiest label," the cover of 78 Quarterly's number 11 issue from the year 2000 features "a dark, nearly indiscernible figure with gold eyes emerging from the shadows and holding two Black Patti labels in front of her breasts. The tagline reads: 'The most seductive feature ever!'" Such a championing of the erotics that subtends this world of collecting lays bare a confluence of charged intimacies with nary a coded euphemism: those old blues records are the sensual and alluring objects of (misogy)noire and intrigue, and they

"Black Patti: the most seductive cover ever!" *78 Quarterly,* 2000

are there for the taking, to be used, in short, as a source of one's own enjoyment and satisfaction. Run by collector Pete Whelan, *78 Quarterly* ushered in the '00s with a signature throwback image, one that casually yoked together the reification of female sexuality with the pursuit and acquisition of rare records.[31]

It is ironic and fitting, then, that the aptly named Joe Bussard, "one of the foremost living collectors of prewar 78s," would figure prominently in Black Patti Records collecting lore given his obsessive attachment to the pursuit of other people's discarded possessions. Profiled in that special issue of *78*

Quarterly, in Petrusich's book, and in an admiring 2003 documentary entitled *Desperate Man Blues,* Bussard is based in Frederick, Maryland, and the proud owner of some "twenty-five thousand . . . country blues, Cajun, jazz, and gospel 78s, nearly all from the 1920s and '30s, impeccably and mysteriously filed on floor-to-ceiling shelves in an order" that, as Petrusich observes, "Bussard knew but wasn't sharing." He has long reigned as the king of coal country record collecting. There, in southwest Virginia, as director Edward Gillan details, he targeted an area where Depression-era black as well white folks working in the coal mines and on the railroad had a bit of extra cash to spend on music. It was "a hotbed for 78 activity" that was ripe for the picking and a place that Bussard combed in a legendary crawl beginning in his teens and spanning much of the 1950s and 1960s as he accrued a vast collection of, by his own account, the last "authentic" American music worth anybody's time. The big whale of Bussard's lifework is the topic of an oft-recounted catch tale involving him striking gold in 1966, "uncover[ing] a stack of fifteen near-mint Black Patti 78s in a trailer park in Tazewell, Virginia."[32]

What to make of this man whose transactional relationships with, in particular, Black folks in the Jim Crow South are figured by him as to-the-point hunting expeditions ("Give 'em a couple of bucks, and you're out the door")? The most stirring photographs included in Gillan's documentary and DVD extras show a young Bussard dressed in a mid-quarter-sleeve work shirt and khakis busy at work in the background of a tiny, rural shed surrounded by greenery and woodpiles. Bussard stands in profile to the left of the building, looking over his shoulder from afar and into the camera as he holds a single 78, its black shine catching a glint of light. Stacks and stacks of records are everywhere—visible in the hallway through the door of the shed, to the right of Bussard and laying in somewhat neatly arranged towers in the high grass all around him. And there is this: a failing white picket fence that divides Bussard from more records and the figures in the foreground, four Black children—three boys, one girl. The two boys in the middle are looking down at the stacks and stacks of objects in their midst while the other boy holds a single disc as if to show to the onlooker. The sole girl present stands squarely facing her audience, dressed in a light gingham dress and holding her wrist in a somewhat formal pose. In yet another shot, some of the children are smiling. But it's the girl whose interested stare persists while Bussard, as oblivious as ever, busily inspects his haul. Who's to say whether the children are accustomed to these visits? Accustomed to white folks rifling through their family's belongings, offering what was most often meager compensation to them and gleefully (as Bussard surely was) heading out the door? Like our nameless sisters in the

would-be blues photograph, it's an image that raises more questions than answers about the Black girls and women unaccounted for, disregarded, confined to the margins of the blues music archive.[33]

Much of the collectors' circle's admiration for Bussard, as well his own charming self-aggrandizement, is rooted in an unwavering if narrowly conceived sense of the righteousness of his efforts. These kinds of perspectives hinge on the belief that, were it not for Bussard, who threw all of his time into gathering up these old records, a valuable piece of American history would surely have been lost, that the owners of those old 78s knew not what they had on their hands, were instead interested in modern fancies ("lot of people getting t.v. sets then") and were thus ridding themselves of what they deemed junk. "I would say that about 70–80% of the records I have collected," Bussard speculates, "would have been destroyed if I hadn't got them when I did. You can thank old time record collectors for the music that is left because the record companies didn't give a damn about any of that stuff. . . ." Missing here is a questioning of the larger circumstances that brought us to this place wherein white male collectors see themselves as the last vestiges of hope in the fight to preserve large swaths of music made by and yet fleetingly (if ever fully, from the top of the recording industry on down) *owned* by the dispossessed. Bussard's easy, affable passion for that old-time music produced during "the magical era when records were made live," as he describes it, comes across visibly and palpably in the documentary's scenes when he can barely contain his own sonic enjoyment in spinning record after record. But his euphoria also threatens to overshadow the troubling nature of his nostalgia and steadfast social antiquatedness manifest in speech which is peppered with references on-screen in 2003 to "colored gentlemen" and "fellows" he's met along the way in his travels.[34] We might too recognize the fact that the man who "knock[ed] on doors . . . holding up a 78 to whomever answered, asking if there was anything that looked like that in the attic," is also the Fox News–loving "political conservative" who, Petrusich notes, "dubbed Fahey 'Blind Thomas' and listed his work as 'Negro blues'" in the catalog for his label, Fonotone Records, "despite Fahey being a young, white college student from nearby Takoma Park."[35]

Fahey tells the story of that conspiratorial endeavor as a sort of accidental ruse with him, in a sense, falling prey to Bussard's manipulation of his vices, ultimately for his own pleasure and label profit. The hagiographic film profile of the musician, *In Search of Blind Joe Death*, strangely, and in spite of its title, includes only a passing discussion of Fahey's alt-ego but features audio footage of the artist recounting how he "used to go up to Frederick, Maryland . . . this crazy guy who lives up there . . . used to get me . . . just as smashed as he could

Joe Bussard, 78-rpm record collector, circa 2012

and get me screaming and yelling and playing guitar and trying to make out like I was a drunk Negro blues singer from Mississippi who was . . . 90 years old." Director James Cullingham overlays Fahey's recorded remarks with a cameo of Bussard perched in his archive and listening studio, cranking up a Joe Death record, and tickled by Fahey's drunken, caricatured ramblings ("reminds me of the old black blues guys . . . had a nice style . . . very interesting").[36] It is a "joke" shared between the two collectors that we should take seriously if we are going to turn our attention to the intersections in new blues criticism which are obvious but, I kid you not, almost, never acknowledged, between anti-Blackness and the blues curatorial practices that shape and inform the preservation and dissemination (or lack thereof) of certain "rare" and extant forms of Black cultural labor.

Complicated weirdo cartoonist, musician, blues and folk hot mess archivist, collector, and critic R. Crumb knows what I'm talking about—even if his work perpetually sits on the borders of violent racial fetishism and shrewd racial satire. Crumb's comic strip "Hunting for Old Records: A True Story" was originally published in the *Oxford American* Southern music issue from 1999—just a few years after his creative partner Terry Zwigoff's infamous documentary on the cartoonist, and just a couple of years before cult-classic film *Ghost World*,

Zwigoff's meditation on this same subject, was released in theaters. In the comic, Crumb presents us with an autobiographical tale of blues collecting that takes him as a teen from house to house of the "black section" of Dover, Delaware, in 1960.

A mature African American woman, here rendered in classic Crumbian grotesquery, has her own collection of records, including a rare pressing of Slim Lamar on Victor. She contemplates a deal with Crumb—but only for the right sum. Crumb the hindsight narrator lets us know that his younger self holds change (literally and figuratively) in his pocket. He has the humble funds to veer away from the long arm of racially exploitative practices undergirding the race records industry in his own small, quotidian way. The strip continues, following the elderly sister's reluctance to negotiate and Crumb's ultimate triumph "twenty-five years later" finding "another copy on a dealer's auction list. . . ." The strip closes in ambivalence with our "hunter" back at home swooning over his new, precious possession while the memory of the sister haunts him.

"Strange, though," Crumb muses at the close of his tale, "every time I listen to it, I see that old black lady's angry face." Hers are the last (unkind) words of the strip: "You think I'm just an old ignorant colored woman." The final frame links our sister blues record owner / collector / curator / musician (because who knows what skills she possesses and what interests and passions are housed by her in her home "in the black section of Dover") to the "crazy, eccentric jazz" coming out of Crumb's record player, the music for which he ended up paying much more than a dollar. Her sharp assessment of the record's value and her visible repulsion toward his measly proposition trouble his relationship to the object presumably in infinitude.[37]

In many ways, Crumb's work points us toward a more radical engagement with and critique of 78 collector culture than Petrusich does in her beautifully written, thoroughly researched, and maddeningly frustrating study *Do Not Sell at Any Price: The Wild, Obsessive Hunt for the World's Rarest 78rpm Records*. Much of *Do Not Sell* reads like a reboot of "Hunting for Old Records" as it invokes and translates Crumbian passion and melancholia into crisp and often eloquent expository writing about the eccentricities of an oft-overlooked subcultural network of collectors. We hear the voice of our man Crumb in the narrative that Petrusich constructs about her own seduction into this scene, how she "felt a palpable sense of loss" and comes to know "how hard it was to find" rare 78s, how "invigorating" the hunt and this feeling of "wanting something so badly, even as I was being told . . . I couldn't have it" was, she declares in the midst of her journey, "remembering how precious a song could be."[38] She

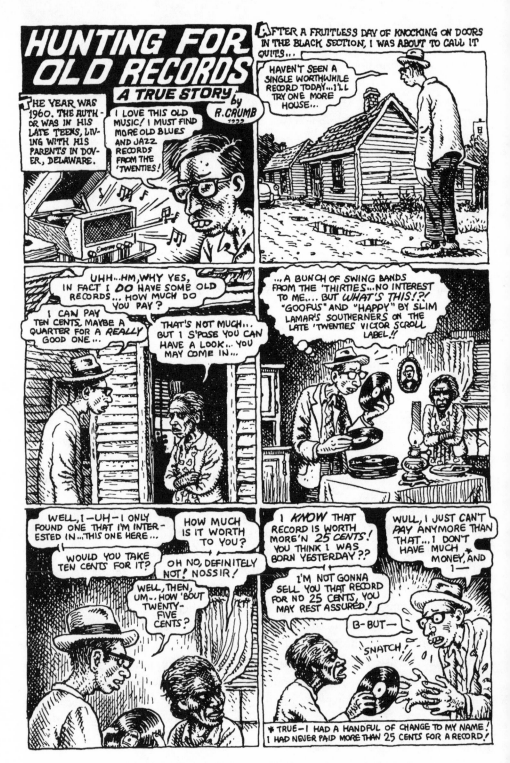

R. Crumb, "Hunting for Old Records: A True Story," *Oxford American*

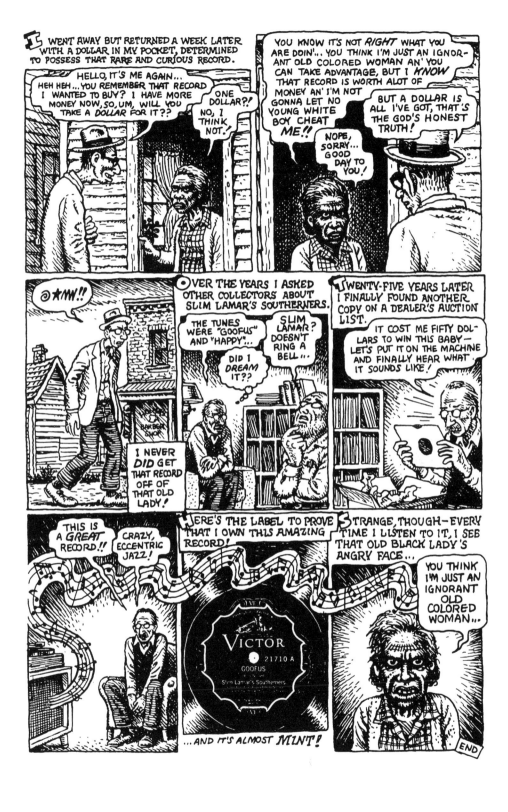

offers readers a familiar kind of quest with little of Crumb's self-loathing irony and nary a recognition of anything that might be "precious" about the blues beyond the music itself. To be clear, examining some of the gross blind spots in Petrusich's writing is something that, I want to stress, I do while still holding her in high regard as a music writer, a colleague, an editorial collaborator, and a fellow feminist rock critic who's surely done her time as the only chick in the room on the indie music journalism beat.[39] Petrusich is an inventive investigative cultural reporter (at one point, scuba diving in the Milwaukee River in search of long-discarded 78s) and an enticing storyteller committed to drawing out big feelings in sad old songs.

But her willful rejection of context in favor of reading the song for song's sake in 78 culture puts her on an obvious continuum with some of the most obtuse members of the old guard. She is, on the one hand, open to documenting the earnest recognition of a collector like Nathan Salsburg that this music "is underheard ... made by people who are either undervisible or invisible ... neglected by culture and society. They deserve—and not out of romanticism—our respect." Yet she is equally drawn to ahistoricizing the anguished complexities of the lifeworlds that gave birth to this music in the first place. "I misunderstand records and lyrics and contexts and genres all the time," Salsburg continues, "because my first approach to them is subjective, as opposed to understanding them in the kind of greater historical or musicological or cultural context that an anthropologist or musicologist would be. But that's where the joy is." Petrusich's response here is not to attempt to know more and to know better, but instead to read Salsburg's acknowledgment of Black sociohistorical literacy as an insurmountable and unsolvable crisis: "I was no longer sure," she confesses, "if there was any honest way to tell any story."[40]

It's an odd line, one that sits comfortably in the crucible between the racial privilege of blissful obliviousness when it comes to reckoning with historical traumas tied to the blues and the outright rejection of the need to engage in an important kind of labor when it comes to handling rare Black art. Petrusich counters with skepticism Chris King's belief that "collectors should embrace research ..." and remains wary of his suggestion that those who refuse to do this kind of work are "dilettantes." But his observations are keen and knowing. "They don't feel like they need to fill in any information ..." he points out to her, "and so it creates this imaginary, artificial mythology. . . ." Still, Petrusich wavers, reflecting on his words and confessing that she "still hadn't quite worked out how [she] felt about most 78 collectors' obsessive desire to contextualize—in the worst instance, to synthesize spotty research into quasi-academic narratives." "I still wanted to believe," she ponders, "that these records were signifi-

cant on their own merits, independently of any applied historical heft." Wiley, she continues in familiar *Pitchfork* war room language, "could destroy anyone, anywhere, regardless of what he or she knew or didn't know." She finds it "undeniable—why it worked on [her]; why, by the time she arrived at the 'What you do to me, baby / It never gets out of me' bit," she tells us, she "was half-breathing and glassy-eyed—but that mystery was a fundamental part of its allure. In 'O Black and Unknown Bards,' the James Weldon Johnson poem that gave Sullivan's piece its title, Johnson wrote of his own bewilderment regarding the composition of certain spirituals, presenting the only useful question one can really ask of Wiley: 'How came your lips to touch the sacred fire?'" But any good student of Black studies knows that much of Johnson's career—as an educator, an anthologist, a literary and cultural critic, a novelist—was invested in answering that question, a question that is rhetorically posed in the poem, a question for which he gives an *answer* in the poem itself as well through the recognition of the material condition of captivity ("What slave poured out such melody / As 'Steal Away to Jesus'?" the poem queries before concluding that "On its strains / His spirit must have floated free" in spite of the fact that "[t]hough still about his hands he felt his chains"). Such a definitive statement is a prerequisite for executing sound and lyric that "runs profligate" from racial abjection.[41]

Petrusich's analysis of prewar blues is consistently and stunningly allergic to any kind of a reading that even considers the possibility that there might be throughlines to be drawn between the sounds of Johnson's "unknown bard" and the guitar duets of two Black women who each, as Sullivan's research seems to suggest, looked the early twentieth-century Southern penal system in the face in the years before and after their Paramount sessions. In both such cases, the artists in question—the lyricist in bonds who, nevertheless, insists on making music, and the sisters who dared to make records in spite of the brutalities of Jim Crow life—slipped off the chains of their subjugation by way of performances that amount to "open rebellion." Wagner has made this kind of a point abundantly clear in his work, which, following that of Hortense Spillers, aims to supply "a solution to" what he argues is "a long-standing problem in interpretation" of Black cultural forms, the problem of refusing "to specify the historical statement against which the black tradition has dramatized its own emergence."[42] Such solutions lie, in part, as I want to suggest, in forging new lines of collaborative criticism that invite in the publics and the peoples who contributed to the rise of this music and lovingly embraced the musicians who made it, the folks who, more often than not, have always been just outside the frame of standard-bearing blues tales.

Digging You Like an Old Blues Record: New Blues Imaginaries

Three thinkers have expanded the universe of our blues imagination in ways that point toward those wider ways of knowing something more or different or perhaps even altogether radically fanciful about the "lost" blues women in the archive. Their approaches to Geeshie and Elvie studies are imbricated and yet also resolutely distinct. All are diligent and exhaustive researchers and two are stunning writers capable of mounting gripping, wide-open tales of both the music and the myths surrounding these women. Without the three of them, we'd have less factual information for the record. We'd also, in some cases, have fewer fictional conceits. But their overlapping and divergent methods of looking after Geeshie and Elvie are crucial to consider inasmuch as they remind us of the charged and sometimes complicated ways in which critics working outside Black studies epistemologies sometimes handle Black things, Black cultural objects, relics of a past steeped in the long history—some four hundred years strong now—of exploitation and unfreedom. While John Jeremiah Sullivan, ethnographer and collector Robert "Mack" McCormick, and Greil Marcus all share a love of these records made by women who fell into the class of "easy prey," women who could seek no recourse in protection from the laws of the land or power via the ballot box, whose lives, like those of their Black brethren, were undoubtedly framed by terror and a culture of state violence and neglect, such concerns are not central to their handling of their music. Their entanglements with one another (in the case of Sullivan and McCormick) and their sophisticated and knowing rehearsal of captivating myth (in the case of Marcus) are, I would argue, big and imposing projects in their own right that, nonetheless, threaten at times to obscure the sisters of obscurity. But it is to their work that I turn most as I think about what it means to collaborate, to engage in a duet of sorts with their efforts, even as I remain committed to making a different set of dust tracks down the road in search of what these women left behind for us.

Over time, it's become clear that Sullivan's work has fully pivoted to making that aforementioned turn toward the richer, robust worlds out of which these artists came. He is, in fact, one of the most intriguing thinkers in this group of new millennial blues interlocutors, probing and thoughtful in the questions that he's been asking about not just the elusive women in our blues past but the people all around them. One sees him moving in this direction in his "Unknown Bards" essay, where he surprisingly and with nuance pushes back on the revisionist scholarship of folks like Hamilton and Elijah Wald who have helpfully pulled to the fore white subjectivity in the making of the race records industry

(from collectors and listening publics to, as Wald reminds, the white entertainers who were able to record and market their own renditions of the music long before Black folks ever did). "White men 'rediscovered' the blues, fine. We're talking about the complications of that at last," Sullivan offers. "Let's not go crazy and say they invented it, or accidentally credit their 'visions' with too much power. That would be counterproductive, a final insult even." He is insistent here about driving his point home, adding the stirring reminder that "Skip James was the first person to hear Skip James. . . . The anonymous African American people described in Wald's book, sitting on the floor of a house in Tennessee and weeping while Robert Johnson sang 'Come On in My Kitchen,'" got to the music and the music got into them long before McKune and the blues mafia arrived on the scene.[43]

Sullivan's gradual turn in his own work has been a source of fascination to me, as he has moved from his early predilection for romancing the "phantoms" of Wiley's and Thomas's legacies to seriously and subtly shifting his focus to finding out as much as he possibly can about the specific Black publics and networks of intimacy that gave rise to these artists in the first place. His meticulous and razor-sharp skill as a researcher, his ardent dedication (in partnership with a dogged and resourceful student assistant, Caitlin Rose Love) to following a single sliver of a biographical detail for months that turned into years on end has resulted in the discovery of more factual information about Geeshie and Elvie than contemporary critics have ever known: that they were born Lillie Mae Scott and L. V. Thomas, respectively, that they met in Texas (where Thomas had been born in 1891 and died in 1979), that they definitely recorded those sides in early 1930 up in Grafton, Wisconsin, that—at the very least, in L. V.'s case, she was almost certainly queer—all that and so much more from following lead after lead and (a bit scandalously) lifting notes from one powerfully influential, obstinate, and perhaps mentally challenged independent blues archivist, critic, and (some might even say) hoarder based in Texas as well.[44]

His work has largely been guided by the principle of finding traces of the Black counterpublics in which Wiley and Thomas were situated, and Sullivan has unshakably committed himself to resituating both musicians as best he can in communal and familial histories that, he has found in the case of Thomas, stretch from a brief carceral past to an even briefer recording history to a long, post-renunciation-of-her-hardcore-blues-adventure-seeking life situated in the bosom of Mount Pleasant Missionary Baptist Church in the Acres Homes section of Houston, where nary a soul knew of her Paramount past. He writes with astonishing clarity, bracing emotional intelligence, and heartbreaking candor about the fragments of these women's respective lives that he's faithfully

retrieved. The census records that he unearths with the help of Love show a teenage Thomas as an inmate in Harris County Jail in 1910. "For a serious crime?" ponders Sullivan. "If you were black in Houston in 1910, it was not hard to get arrested for doing nothing. She was working as a dishwasher, the census says. Any records related to the arrest or any trial that took place are gone." Wiley's potential criminal record is a source of even greater mystery as a result of Sullivan's discovery of her husband Thornton's 1931 death certificate, which states that he had died, according to his brother, at the hands of Lillie Mae ("Geeshie") Scott from a "stab wound in between collarbone and neck."[45]

This is the kind of work that maintains a moving attention to detail—not so much the kind of insurgent performative details that Alexandra Vazquez has shown can lend themselves to sonic counterhistories of diasporic "blackness," but the kinds of historical details that nonetheless suggest networks of sociality that unseat the mythical notions of isolation and ghostliness that have long shrouded these blues women's legacies: ties to other musicians—Alger "Texas" Alexander, whom L. V. apparently played with "down on West Dallas Street"— tales of "out singing Sippie Wallace" at a big party one night, recollections of her casual and yet indelible virtuosity singing with the congregation at Mount Pleasant, memories from great-great family members rediscovered and reunited for a remembrance of L. V. in which her butch sartorial choices, her preponderance for carrying a pistol around the house, and the likelihood of her queerness living on the fringes of the family are generously recounted for a researcher self-conscious enough to sporadically critique and police his own "reptilian journalistic longing" to provoke "tears" (which he doesn't get) from his interviewees.[46]

The seeds for much of the information that Sullivan is able to piece together about Thomas and Wiley come from a single source that he controversially and now infamously obtained from arguably the most enigmatic blues mafia figure of them all: Robert "Mack" McCormick, a Houston-based collector best known for his long and ambivalent dance with obtaining, "hiding," and then questioning the legitimacy of some of the archival remnants of Robert Johnson. McCormick, who passed in 2015, lies at the hot center of Sullivan's *Times Magazine* article as an ethical and practical problem that he both confronts head on and knowingly circumvents. For over half a century McCormick amassed one of the largest private collections of blues, folk, and Black folklore archival materials in North America. His was "one of the postwar period's most storied careers in American cultural fieldwork," culled from his US travels across some "888 counties" according to his recollections, gathering documentation of songs, games, and dances; taking photographs of subjects; and storing troves and troves of

"archives and tapes" in a labyrinth he called "the Monster."[47] He was also noto-riously reluctant to share information with blues seekers like Sullivan, let alone offer Lomaxian theories about the "true" nature of the voices rising up out of his heap of findings. He figures in Sullivan's narrative about the search for Geeshie and Elvie as a kind of classic hoarder, albeit one whom the author sen-sitively renders as someone who's openly battled mental illness for much of the last half century.

Nevertheless, the complicated dimensions of McCormick's mysterious and byzantine project are worth revisiting, especially in light of the fascinating ways that hoarding itself begs for further consideration. For, as Scott Herring has per-suasively shown of late, the idea of hoarding has, in the past several decades, emerged out of a "unique moral panic over material goods, or an *object panic* whereby forms of social deviance attach not only to interpersonal behaviors but also to material ones." From this standpoint, we should perhaps be wary of reading McCormick, owner of notes from the only known interviews with L. V. Thomas, conducted by him in 1961 and stored on four typewritten pages in a slim folder filed away in "the Monster," as a pure pathological loner attached malevolently to his "stuff."[48] Yes, McCormick held on to this material in such a way that, as Sullivan points out, he ultimately did irrevocable damage to mul-tiple cultural publics' abilities to "know more" about these blues women. In turn, Sullivan did much to try to extract information from him (ordering Love, for instance, to photograph the notes in McCormick's house) so as to, from his standpoint, "right the record."[49]

Maybe, just maybe, though, there is something more to be said about a blues ethnographer (should we even call him that?) who rejects the dissemination, theorization, and promotion of his possessions. In this regard, we might ask dif-ferent questions of McCormick's work and the enigma of his collecting. Just as Herring does, we might ask, "Why is 'quality of life' the pivot between a normal and a pathological bond with things, or even a desired condition"? His reminders here are instructive as they urge us to consider the ways that "material devi-ance" does "not only rest upon an imaginary counterpart of cleanliness, sanity, and domestic order." His points suggest to us that we, too, might ask, what is a blues scholar's "normal" versus "pathological bond with things" that he (or she) archives?[50]

What if a disorderly, clandestine attachment to the vitality of Black vernac-ular life is, not an antidote to the white supremacist socioeconomic conditions that gave McCormick the resources to do this work in the first place, but a queerly problematic alternative to the mainstream blues-collecting impulses of others? McCormick's no hero in this tale, by any means, but his practices

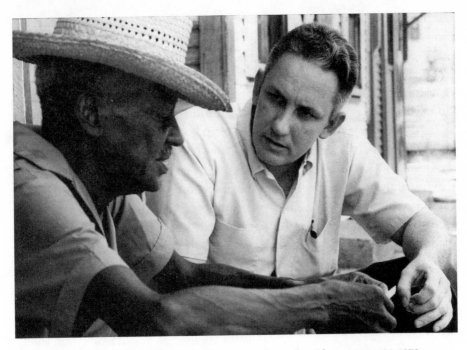

Robert "Mack" McCormick speaks to a Fourth Ward resident, August 24, 1970

challenge me to pursue a different kind of conundrum that I long to answer: What of the sisters who may have had their own little "Monsters" out in the sheds?[51] Crumb knows they are out there . . .

Sullivan, for his part, wants to not make the mistakes of the Faheys, the Bussards, and the Macks who came before him, the "dudes," as one collector in Petrusich's study puts it, "hanging out, relating to each other through objects." In many ways, what he has done is to take the remains of what has been lost of these women—first a record and then the aforementioned purloined material, a four-page transcript of McCormick's interview with Thomas which he never published and which provided Sullivan with the opportunity to "generate," as Eng and Kazanjian might put it from their historical materialist perspective, "a politics of mourning that might be active rather than reactive, prescient rather than nostalgic, abundant rather than lacking, social rather than solipsistic, militant rather than reactionary."[52] It's a shrewd move on his part, one that supplied him with the materials to reshape and reanimate the socio-cultural universe about and around these women and to, in effect, establish a different set of tenets by which to cultivate new methods in blues music criticism.

And there's something both revolutionary and familiar about this kind of work—the gorgeous attention to the material specificity of Thomas's quietly dis-

appeared life as well as the suspenseful unfurling of its heroic excavation. Few other than Sullivan have written with this kind of flourish and urgent style about off-the-radar blues women. The more recognizable elements of his prose, however, cleave close to an aforementioned figure who has cut a foundational example in this field of writing—my friend Greil Marcus. Marcus's focus on Wiley for all these years is hugely admirable in its unfailing commitment to the literal record, a single song, "Last Kind Word Blues," which drives his imagination and his unerring attention to the fact of Wiley's "disappearance" from the archive. It's a song that, for his part, encompasses a free-floating, cross-racial folk tradition, the "property of all" in his opinion, so much so that the facticity of origins tales ultimately aren't the point for him since "Geeshie Wiley," as he writes, "came out of nowhere and took a seat on a Houston train north; then she took a seat on a train back to Houston and disembarked into a nowhere just as deep."[53] The indelible beauty, mystery, and awesomeness of folk legend rings through Marcus as well as Sullivan's approach to tale-telling, and one hears, too, in the former's language a clear indebtedness to the Perry Miller, "myth and symbol" school of American Studies, that which "discourages absolute truth" in favor of "the courage to be free." It is a kind of poetic endeavor that enlivens a sense of American culture as sublimity and romance, and it has shaped Marcus's entire body of hugely impactful and pathbreaking work.

Gently at odds with Sullivan's obsessive and persistent search for facts, Marcus's style rests on a particular kind of not knowing that opens up a world of lyrical possibility for him, one predicated, in part, on that egregiously insouciant observation made by Fahey ("They have no history of their own anymore, so they insinuate themselves into ours"). Tropes of infection, contagion, transgression, compulsion, ostensibly inspired by the song's lyrics, drive the spirit of his project. "What you do to me baby / It just gets into me," sings Wiley in one of the song's most talked about verses among the new blues critics, "I believe I'll see you / After I cross the deep blue sea." For Marcus, "Last Kind Word Blues" is the music that leads him toward the conviction that while "[c]ertain crucial facts have now been established . . . the records still call out to the woman behind them, trying to pull her out from behind the curtain of their static. . . ." Steeped in alluring mysticism, this vision is the reasoning that ultimately moves Marcus to audaciously conclude: "so we are free to tell any story we like."[54]

And that he does, carrying readers on a journey with *his* Geeshie Wiley, who performs in a minstrel show, travels to juke joints, takes up with a quasi-Shaker clan, and travels west to Portland and on to Seattle, where she attends an Elvis concert while seated next to a young Jimi Hendrix. This Wiley surfaces later, surviving in the city as a busker who covers Dylan songs, ones that he, that

transient Minnesotan, picked up all across Old Weird America. No one, it's safe to say, would confuse Greil Marcus's Geeshie Wiley with a heroine steeped in the histories and theories of the Black radical tradition. That is just not the game he's playing here with references to D. H. Lawrence, Poe, the iconic mainstream figures of the rock and roll canon—no Hurston, no Du Bois, no Ellison, no Morrison. Marcus makes a passing reference to Albert Murray (and that writer's resistance to "social science fiction" in his book *Omni-Americans*), using his work as license to innovate a form of criticism that Gerard Ramm incisively calls "fictional historicism." But this kind of writing does not take into account Murray's lifelong championing of Black improvisation as the performer's prerogative for what he refers to as "play in the sense of competition or contest; play in the sense of chance-taking or gambling; play in the sense of make-believe."[55] Yes, we might think of Marcus as a particular kind of master of what Lisa Lowe has beautifully referred to as the "past conditional temporality." His, though, are narratives of the pop music marvelous: neo–punk rock, magical realist rewrites of historical encounters-of-the-never-was-but-might-yet-be that enable Dada artists and Situationists to meet up in the mosh pit with the Sex Pistols as he famously maps out for readers in his 1989 magnum opus *Lipstick Traces*. He is, in other words, not immune to play, especially when it comes to playing iconic Black figures—be they minor or major, like Wiley or like his beloved bluesman Robert Johnson (as he does in *The History of Rock 'n' Roll in Ten Songs*)—through a montage of cultural events and wished-for, eventful meetings that fuel the evolution of pop culture history.[56]

This, it should be noted, is not quite the kind of jazz play that Murray and others seemingly have in mind. As African American Studies scholar Nick Forster has pointed out to me, Murray's form of exigent Black "improvisation" does not seem to fascinate blues mafia critics of yesteryear, nor our friends of today. None of these thinkers of our present-day blues debates and conversations have shown in their work a curiosity about, a hunger to know, what Black study is and how it might work as a method for reading these Black sonic archives of the lost, how Black study challenges us to "be together in homelessness," as Harney and Moten put it, and to recognize "homelessness" as an "interplay of the refusal of what has been refused," an "undercommons appositionality . . . from which emerges neither self-consciousness nor knowledge of the other but an improvisation that proceeds from somewhere on the other side of an unasked question."[57] With regard to the ballads of Geeshie and Elvie, this would mean resisting a kind of "belletristic" writing, as Retman calls it, that emerges in this scholarship when the critic addresses, pursues, "positions [his] blues muse" in a way that "insist[s] . . . on no context, on opacity, on utter and total loss, on rarity

and obscurity" with no politics, no history attached to such claims, quite literally a "motherless child blues"—a song title, by the way, that L.V. Thomas tells McCormick she did not give to her own song. It is a phenomenon akin to that which visual culture scholar Silvia Spitta examines in her exploration of late nineteenth- and early twentieth-century colonial photography in the archive and the *indigenismo* aesthetic movement that "emerge[s]," Spitta points out, "in full force from the 1920s onwards in the search for the *authentic* that could be taken as a synecdoche of nationality." It is "indigenismo," she argues, that "equate[s] Indians with telluric forces, with the land, and in visual terms also with the permanence, grandeur, and inscrutability of lithic monuments." If we "romance the stone," so to speak, the lithic, the "powerful stillness" imposed on Geeshie and L. V., we do more violence to the beauty of their obscurity evidenced in the very photograph that opens this chapter.[58]

"Selling the Shadow": The Blues Photograph Reconsidered

A different kind of archiving is then, it would seem, in order. In his note to me, John Sullivan ponders the likelihood that the woman on our left in that archival photograph that holds our attention is the one he miraculously located in his *Times* article, L. V. Thomas born in Houston, Texas, one year before Ida B. Wells would publish *Southern Horrors*—the L. V. who was also "Elvie" on the Paramount sides, whose recording name, the only trace of her that the general public had for more than half a century, came as a result of a producer's decision to spell out the phoneticization of her name. "'It's just the letters L. V.," says Thomas in that only known interview with her, the one that Sullivan extracted from McCormick and cites in his "Ballad" essay. "'[T]hat's all the name I got but he made it out 'Elvie' someway.' Maybe he wanted to make sure customers knew it was a woman on the song; two women playing guitars (unusual)," he ponders. "As he writes the five letters, he presses a long, invisible blade down between two destinies, hard enough to cut them off from each other for 80 years. There will be Elvie, a singer, who lives nowhere, and L. V., a woman, at her house in Houston."[59]

From the name come tax records, a will, a place of residence, and eventually fellow church congregants and family members (great-great-grand-nieces, a friend's child taken in by her) with stories (of railroad hijinks and a firearm she kept by her side), and with Sullivan's meetings with family members comes one surviving image, a polaroid of Thomas not long before her death. This is the photo that he compares with the other, peering closely into the face of an eighty-eight-year-old woman, steady and still in her nightgown, seated in

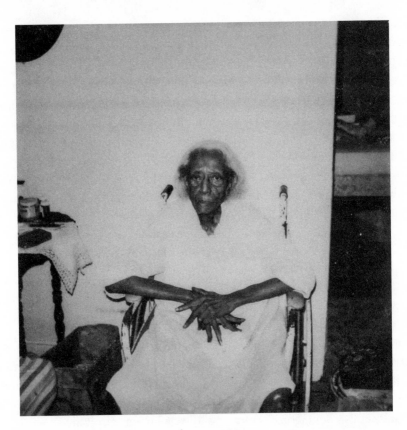

L. V. Thomas, 1974

her wheelchair with hands crossed, long fingers stretching and holding...
something we cannot see... and that of a young woman who rocks a tie, a
pageboy hat, sharp boots, a scarf, and upholstery while standing nonchalantly
with one hand affixed to hip.

If only the shadow here, to quote Sojourner Truth, could "support the
substance." Comparing the sepia-toned image with that of the Polaroid
would, it turns out, prove futile in the end. Marcus ultimately speculates that
the former image is not, in fact, of Thomas and Wiley. "I'm not sure what
you're asking," he quickly offered, again via email, in the fall of 2015. "If you
mean the photo of two people, one with a pistol, which is almost certainly a
cross-dressing couple—there's chest hair visible for the person dressed as a
woman—I initially jumped at the possibility that it might be G and E, but it's
in no way my picture—it came from a recent collection of old music photos."[60]

On to another image instead, one retrieved from a lone box of L. V. Thomas's
keepsakes shared by a family member and included in Marcus's *Three Songs,*

Three Singers, Three Nations. The woman in question is most likely not Lillie Mae, nor is it Sarah Goodman Cephus, the woman Sullivan found in the census living with L. V. in 1920 and then again in 1940, the woman whose death certificate L. V. signed in 1967. This woman, according to the fading inscription on the photo's backside, has a name that Marcus describes as being barely legible. Together he and Sullivan make out the remnants of handwriting: "Miss Ledia Francis my / play mother ain't she sweet."[61]

In the recuperation of this object, a seemingly cherished possession of L. V. Thomas's, Marcus moves, perhaps inadvertently yet admirably, into the world of queer archiving with a motivation akin to the driving ethos of foundational lesbian grassroots organizations like Brooklyn's Lesbian Herstory Archives. Such organizations are known and valued for doing hard, everyday restoration work, "encourage[ing] ordinary lesbians to collect and donate the archival evidence of their everyday lives." And to be sure, the wealth of information and the exquisite objects that both men have been locating and exploring for so long in relation to Geeshie and Elvie are of invaluable use to those of us committed to pursuing work that builds on the spirit of the field-altering example set by Hartman, who aims to tell "a story predicated upon impossibility—listening for the unsaid, translating misconstrued words, and refashioning disfigured lives—and intent on achieving an impossible goal: redressing the violence that produced numbers, ciphers, and fragments of discourse, which is as close as we come to a biography of the captive and the enslaved."[62] But "redressing the violence" that had much to do with the disappearance of these women from the historical record in the first place and "making visible the production of disposable lives" are not concerns that sit at the forefront of (or practically anywhere at all in) either man's work or in any of the work written about Geeshie Wiley and Elvie Thomas.

We can, however, think of their retrieval of these photographs as serendipitously initiating a new thread of queer archival research in blues women's history, in the spirit of the task that Ann Cvetkovich set at the turn of the millennium when she argued for ways of "claim[ing] the fact of history" through a process of "documentation," doing the work of, as Valerie Rohy adds, "'finding names'" in the margins, "making public cultures 'visible' . . . and insisting on "the presence of minute description . . . visual representation . . . narrative accuracy."[63] More recently, Cvetkovich has continued to trace the evolution of archive theory in relation to queer cultures, acknowledging how new debates (and pace Halberstam's comment to me) have been "critiqu[ing] existing archives and the impossibility of creating them. Theoretical critiques"—and particularly Derridean ones—have, she argues, "put the brakes on liberal

enthusiasm for the archive, as do queer approaches to identity and representation, which insist that visibility is not always possible or desirable."[64]

From this standpoint, the photographs are less desirable and less useful to queer projects of longing and possibility if they are misused by critics, if they become tools to foreclose rather than enable the articulation of a "free state," other worlds, other temporalities. As Daniel Marshall, Kevin P. Murphy, and Zeb Tortorici, the editors of *Radical History Review*'s special issue on this topic, remind, following the Foucaultian line of thinking about power and knowledge, "archival practice inherently proceeds on the basis of delimiting the significance of that which is being archived, and practices of necessary delimitation and foreclosure inevitably foreshadow the instability of such knowledge-making techniques. The queer archive is built on acts that repeatedly raise questions about recognition and order through the very effort to instantiate such acts. These acts of cataloging, listing, indexing, describing, narrating provenance, determining acquisition criteria, and administering access to materials demonstrate that, in the archive, it is always 'a naming time.'"[65] It is the place where those without power, without recourse to libraries, museums, and official memorials, are most likely to be captured with no cover, no access to narration, no ways in which to script their own histories and memories, frame their own legacies, affectionately store away their own tokens and mementos that mark their very existence. As institutional archives circumscribe, surveil, and preserve the "named," the silence of those caught in its web is deafening.

Yet Cvetkovich takes pains to suggest that "building a grassroots archive is a somewhat different enterprise than looking for the traces of violence or hidden histories within state or national archives created for purposes of surveillance and epistemic control. The establishment of LGBT archives," she contends, and "especially lesbian ones, by activists interested in creating an archive where none has existed demonstrates a fierce optimism and commitment to survival." This is what is often missing from new blues criticism's fetishization of the relics, the detritus of convivial lives lived on the move: records and photographs, census documents and death certificates, a knowledge of, an investment in, a reckoning with a Black radical tradition politics that shapes the object in question, perhaps with optimism (as well as pessimism), and survival as well as social death, a literacy of a tradition that would yield a "respect" for "black noise—the shrieks, the moans, the nonsense, and the opacity, which are always in excess of legibility and of the law."[66]

Optimism and survival, it should go without saying, cannot be divorced from histories of violence, as the tradition has repeatedly shown us (holla if you hear me, Bryan Wagner), and we are desperately in need of the cultivation of a blues

cultural criticism capacious enough to actualize a kind of queer archive of early Black women musicians that moves and remains "fleet of foot" and one that generates a kind of speculative writing praxis that follows the lead of not only Hartman but Kara Keeling, who, in her phenomenal essay "Looking for M," reminds us in her discussion of Isaac Julien's classic *Looking for Langston* that what that film does that is particularly instructive is posit a Benjaminian emphasis on "using" and "valorizing" Hughes's queerness rather than somehow redeeming it. The film, she persuasively argues, "is unfaithful to any dream of ultimate redemption."[67]

Like Keeling, who executes a "circumvention" rather than a "search" for key figures in her Black queer feminist cinematic archive, I am suggesting that we continue to improvise strategies of archival work that draw out latent or "dormant" performance histories emerging out of "rare" or "obscure" objects without either fixing or obfuscating the subjects who performed but that instead pay close attention to what these performance histories can tell us about obscurity itself and the violence as well as the potential for ludic queer failure (a supposed "failure" to be seen and heard and known and valued by the masses) in relation to some blues women's lives.[68] I am not, I want to stress, even sure that I'm capable of fully doing this myself, but I certainly think it's high time that we had a conversation about this perpetual impulse in popular music criticism of "the arcane." It should be clear by now that we desperately need to bring to the fore the kinds of voices and methods that complicate the (sometimes) well-meaning and sometimes suffocating work of indie critics and counterculture collectors who have dominated the discussions of rare recordings by the sisters you're less likely to have heard of—from Geeshie and L. V. to quirky songbird Lottie Kimbrough and Louise Johnson, that woman who runs things at the piano.[69]

Following Spitta, new blues critics might do well to resist "the drag to the lithic," as she calls it, to resist the urge to capitalize on the "monumental silences" in the archive that seemingly emanate from objects and figures for which "little or nothing is known." For our "inability to come to terms with the radical alterity of," in Spitta's case, "Andean cultures"—in our case the radical alterity of lost blues women's cultures—is "an inability to really come to terms with the archive." She thus asks, "How can we contest the monolithic with the archive's polyphony?"[70] It starts, I would suggest—and I am building here on the moving and brilliant work of Keeling—by "looking after" rather than "for" Geeshie and Elvie. As Keeling argues, "looking after" is a form of radical Black queer praxis that we see in films like *Looking for Langston*, a film that "makes Hughes' purported homosexuality visible in a time when it might be useful,

thereby protecting Hughes' homosexual desire by making it meaningful for and within a collectivity that needs it and therefore 'looks after' it." A "looking for M," one of the elusive protagonists in the documentary film *The Aggressives,* she continues, "asks when she might be" while paying close attention to the ways that our own "interpretative projects" are "circumscribed by the exigencies of the present."[71]

It goes without saying that this is not the predominant vision of any of the critics whom I've been discussing thus far. But as I've said already, I'm not interested in picking a fight with anyone (let's just be friends, as Fred Moten would say).[72] What I *am* interested in, however, is encouraging a Black study revolution in blues music thinking, scholarship, and prose. Calling all Black studies people, all Black studies people (to rephrase a Baraka line), calling all Black studies people wherever you are, we need you to dig these old-school blues archives like an old soul record.[73] We need a Black study of new blues criticism and rare blues records because while the mafia is so concerned with "priceless" lost 78s, they have given no thought to the sociohistorical and political conditions that produced the lost records of Black people in the first place. They have paid no mind to the elderly couple, evicted from their apartment and thrown outdoors in *Invisible Man,* whose archive of objects of that repressed American history—their "free papers"—are strewn out into the street and onto the wind. They have paid no mind to the situation resulting in people who are chronically in danger of falling out of history, who are still trying to find their way into it through the back door, which might also serve as an escape hatch. They have paid no mind to the mutually constitutive relationship between this history and these sounds that haunt them.

Black study people, we need you to, for instance, find inspiration in the knowledge that trickster and indie African American blues musician Jerron Paxton pursues in his performances as Blind Boy Paxton, an artist whom Petrusich interviews in the final pages of her study but one whose focused and uncompromising engagement with 78s she mischaracterizes as being a "story" that is only about the music itself. "Paxton said he collected 78s so that he could be edified by them—could learn songs, discover how to be a better musician. He wasn't," she continues, "particularly swayed by the notion of collecting as a form of historical preservation. 'The hell with my children, I don't care, I want this for me—this is my stuff. . . . I want to become better! I learn from these things.'" Paxton's sly and obstinate responses to Petrusich's queries reject the lithic and excavate the liveness of dialectical exchange between archival objects of Black performances and the artists who turn to them for pedagogical recourse. Ownership is, in this regard, both an aesthetic and an ethical practice, a recognition of

the record's ability to "transform the most recent sound of old feelings into an archaic text of knowledge to come."[74]

Black study people, we need you to turn yourselves anew, like Paxton, to the "archaic" yet persistently present knowledges, the complex and oft-obscured material histories embedded in these texts. Believe it or not, we need you to concede the fact that it is old Crumb, of all people, whose comic strip offers further instruction on these matters. Crumb's image—his mini-narrative of racialized and gendered shame (about his own privilege)—hails us, beckons us to begin to consider all that we do not know about these women who own records that they value, records that affirm a kind of cultural worth and preciousness that often go unrecognized *outside* the objects themselves by the white-dude collector on the hunt for strangeness and beauty on shellac. The Crumb comic strip suggests and then internally critiques the suggestion that there is something disorderly or unuseful about this sister's relationship to objects.

And it's these sorts of sisters' mythically invisible and yet incontrovertible existence in the archive to which I'll turn in Chapter 6 before finally trying to catch up with Geeshie and L. V. Paying attention to the Black women and girls who own sonic objects themselves might, it turns out, do more than provide us with a "multifaceted statement of the self," as Petrusich (riffing on Baudrillard) argues of 78 collectors and their collections. It might also challenge us to ask not of them, "Why do people"—and certain kinds of people in particular— "keep things?," a question that, as Herring reminds, is perpetually asked of hoarders, but to instead pose some of the "better questions" that he suggests: "What counts as an acceptable material life? Who decides? Why is one material life commended while another is reviled" or devalued? "What if," he carefully and critically wonders, "a so-called hoarder takes a liking to her possessions? Accounts of hoarding," he continues, "tend to rely upon the presumption of deep anguish." To this I would add that, when it comes to Black folks (who are scripted as profligate and tasteless), the lingering presumption that remains at the very root of blues recording collecting culture is one in which Black people are fundamentally incapable of defining and narrating the cultural value of their own "stuff."[75] Time, then, for us to imagine new ways of looking after the stuff that we call our own and to strategize ways to memorialize the crises that arise when we lose the things that belong to us. A poet and a visual artist provide some remedies that we might heed.

"IF YOU SHOULD LOSE ME"

OF TRUNKS & RECORD SHOPS & BLACK GIRL EPHEMERA

All those voices set down in the revolving matrix.
Melted down? Mislabeled? Lost?
—SCOTT BLACKWOOD, *The Rise and Fall of Paramount Records*[1]

Right smack in the middle of her 1997 queer meditation on the life and career of Bessie Smith—part bio, part memoir, part dream letter prose—Afro-Scottish poet Jackie Kay makes a decision to reckon with the "lost stuff" of an icon, a superstar, arguably the most famous and influential blues musician who ever lived and one whose life, like Geeshie's and L. V.'s, has fueled the imaginations of many a poet, a playwright, a novelist, critics of all stripes. There, at the turning point in her elegant little book, Kay decides to go into the missing "trunk" of the Empress of the Blues, the one whom jazz critic Rudi Blesh canonized as a "missing object" when he described his efforts to write a biography of Smith in the late 1940s. It was at that time that Blesh conversed with *"Bessie's sisters, Tinnie and Viola—then still alive, living in Philadelphia"* and apparently willing *"to co-operate,"* as Kay retells the story, with Smith's volatile and abusive ex-husband, the notorious Jack Gee, *"in piecing together Bessie's life."* Here I pick up Kay's story of what happened at length, culled from Chris Albertson's germinal biography of the artist: *"The two sisters had a trunk full of rare photographs, letters, sheet music, and other items that had belonged to Bessie. . . . Just as the work was to begin, Jack Gee decided he wanted more*

money. His unrealistic demand made the project impossible, reignited his long-running feud with the two sisters, caused them to withdraw, and led to the complete disappearance of the trunk and its valuable contents."[2] Kay then embarks on a project of writing the impossible, laying forth an absorbing, speculative meditation on the life of Bessie Smith that marks another turning point in the revolution that is Black feminist thought and art about the history of Black women's popular music culture. Watch her as she reframes our memories of the Empress, widening the lens through which we might consider her world. Listen as she spins a narrative that resonates with this larger moment in which Black feminist thinkers and artists are wrestling with lost histories and open questions about the precarity of Black women's lives, the kinds of lives that have been (mis)handled in archives, museums, history books, and films, all of which are just as prone to forgetting as they are capable of remembering anything about the richness of Black women's artistry.

Like Hartman, who sets out to assemble "an archive of the exorbitant, a dreambook for existing otherwise," Kay presents readers with another way of caring for the legendary Smith of our hopes and dreams, that which constitutes the special concern of this chapter and its examination of archives and critical speculation and the profoundly important role that both play in Black feminist sound studies.[3] She imagines the conditions under which sisters Tinnie and Viola might put that trunk on "a ship heading for Scotland" and send it out into the world on a fugitive's errand, out of the reach of Gee's tyrannical and exploitative patriarchy and into the improbable hands of queer Black Atlantic futurity: the time and space in which a lesbian Black diasporic poet in Britain might discover a note, "found sixty years later," and written in Tinnie's "perfect calligraphy and Viola's ... big childish print," along with an exquisite array of items—of which the following constitutes only a partial list:

[A]n old photograph of the shack in Chattanooga where Bessie was born.... An early daguerreotype of Bessie's mother and father ... the electricity between them is still there in the image.

An old poster advertising [mentor Ma Rainey's act with husband Will, musicians who toured as] the two Assassinators of the Blues in the Moses Stokes Show.... [Its edges are] yellow and curled....

Another picture of Bessie herself standing on the corner of Ninth Street singing.

A baby tooth, next to a wisdom tooth, which has its long roots still, also attached, wrapped in newspaper.

A bottle of bootleg liquor and a pint glass with a lipstick imprint of the lips of the Empress. A horsehair wig. . . . A strand of pearls and imitation rubies. A satin dress. Headgear that looks like a lampshade in someone's front room with lots of tassels hanging down. . . .

A notebook in Bessie's handwriting of all her own blues compositions.

. . . . A giant pot of chicken stew still steaming, its lid to the side. . . .

A blues for [her niece] *Ruby,* [confidant, keeper of the queer archival anecdotes and testimonies about her backstage life]. *A blues so raunchy it will become a lesbian classic. . . .*

A conical horn. A diary of the road, written by Bessie. Contains much hot gossip and many lavish curses. Every player gets a mention. . . .

An old streetmap of [her hometown hood] *Goose Hollow* [Tennessee]. *. . .*

A pillow from [her] *bed with her smell still on it. The dress she wore for the recording of "Nobody Knows You When You Are Down and Out" with her odour round the rim of the oxters. A photograph of the Smiths when Bessie was four. . . .*

. . . a pig's foot . . . swimming in water. . . .

Her Bible with the exact date of her birth: 15 April, 1894. A marriage certificate. . . .

Her death certificate: 26 October, 1937. . . .

A piece of Route 61. . . .

A lock of Ruby's thick black hair.[4]

In Kay's hands, the storied Bessie Smith trunk amounts to an archive of the incomplete: a partial catalog of familial, showbiz, and queer relations and corporeal intimacies—documentation of an artist coming of age as a vocalist (singing on that street corner), relics of a young body (a discarded baby tooth) advancing in age and that same body a little older (with "wisdom") and yet clinging to its roots, soul-food delicacies ("gimme a pigfoot") that she celebrated in song, signature costume accoutrements from her legendary stage spectacles, sartorial work wear bearing the traces of her studio labor, the remnants of her song-

writing self (the "singing self" as "signed," as Lindon Barrett might have it) in the form of handwritten compositions, an intimate travelogue with equal amounts of shoutouts and shade, an instrument ("the conical horn") to listen to the world on other frequencies. The governmental instantiation of birth, of death, a piece of the open road on which she seized the power to ramble, a physical remnant of Ruby, the one who believed that this was "a story not to pass on" but to "pass on" to biographer Albertson to get down on paper for the ages. These "archival scraps . . . teeth, a lock of hair," beckon readers to "piece together the bodies that were once there." This array of objects "is not simply a repository" but "also a theory of cultural relevance, a construction of collective memory, and a complex record of queer activity."[5]

Jackie Kay here "looks after" Smith by offering a speculative consideration of the artist's material quotidian life, confronts the "junk in her trunk," if you will, and her aim is as serious as a bawdy Bessie Smith sexual innuendo laying claim to the Black woman's body as "a jellyroll" safehouse for sexual pleasure. With equal care and detail, Kay takes stock of the objects that carry the residue of the departed blues woman's sensorial life. We are invited to consider what a turn-of-the-new-millennium Black feminist poet sees and feels in Smith's possessions and, by extension, to ponder what Smith saw in the photographic remembrance of home and family, how the sumptuous garments (smooth satin) and jewelry (pearls, rubies) felt to the touch of her hands as she dressed herself for the stage, how those hard spirits tasted flowing from the liquor bottle with her lipstick traces.

The fanciful objects that Kay wills into our imagination (and out of hers) invite us to say something more about the situation of not and never knowing, about what we don't and can't know about the departed blues woman and her past and the impulses of self-fashioning and editorial control exacted by women blues musicians that often go unrecognized.[6] These are the objects that constitute the residual traces of a musician's felt life experiences, her roots and routes, the kind of wondrously inventive material details, the stuff of Black folks' everyday matter, that acknowledges the existence of a fully realized Black woman's life but that eludes a totalizing narrative. Kay draws out the latent whimsy in Smith ephemera that "includes traces of lived experience and performances of lived experience." The speculative trunk items "maintai[n] experiential politics and urgencies long after these structures of feeling have been lived."[7] Her work dances in the gaps of how we know and what we know about Smith's world and caresses the conundrums of her privacy as manifested in the imagined personal objects of worth and value to her. If anything, Kay's Bessie Smith calls out to us to look beyond the isolated records for proof of a blues woman's life well lived

and steers our attention instead to the sociality and the anecdotal emanating from blues women's material universes.

This is the "romance," of which Hartman speaks and which she aims to write, that "exceed[s] the fictions of history—the rumors, scandals, lies, invented evidence, fabricated confessions, volatile facts, impossible metaphors, chance events, and fantasies that constitute the archive and determine what can be said about the past."[8] Kay here walks a Janelle Monáe tightrope, tipping nearly into Greil Marcus's "fictional historicism" (projecting, for instance, her queer Black feminist desires onto an uncorroborated account of Smith's possessions), but ultimately aims instead to spin a narrative that "embod[ies] life in words and at the same time respect[s] what we cannot know." It is, in my mind, a narrative of "love" that "reanimate[s] the dead," as Hartman might put it, but one that also rejects the impulse to repair that which is no longer here by way of either mythical recourse or painstaking sleuthing.[9]

The work of Jackie Kay exists in a larger Black feminist moment in which bold and exhilarating, experimental new work—scholarship and literature, visual culture and film—has turned itself inventively toward radical dreaming, rehearsals of the what-might-be, the what-could-have-been, the conditional exploration of elusive histories that remain outside of our direct grasp that may yet still be conjured and examined through creative meditations. We were ready for this moment, as the seeds of it have been handed down to us by our foremothers, the geniuses—Toni and Sherley Anne, Octavia and June—the pioneers who were writing neo-slave narratives and belletristic essays about the interior lives of captive women who longed for and sought to get more for themselves.[10] The tools and techniques that these artists bequeathed to us have shown us the revolutionary beauty of asking different questions of the past, like that which June Jordan asks of America's first (published) Black poet, Phillis Wheatley, and the conditions through which she began to write. "Come to this country a slave and how should you sing?" asks Jordan of our sister bard. "After the flogging the lynch rope the general terror and weariness what should you know of a lyrical life? How could you, belonging to no one, but property to those despising the smiles of your soul, how could you dare to create yourself: a poet?" And before Jordan's gorgeous inquiry, there was Toni Morrison's earth-shattering 1987 epic, *Beloved*, which fundamentally altered the way in which we think about the complexity of captive and formerly enslaved Black women's inner lives, their desires and hauntings, their traumas and their quests for emotional repair and existential clarity. That masterpiece, alongside works like Sherley Anne Williams's intimate plantation drama *Dessa Rose* (1986) and Octavia Butler's Afrofuturist odyssey *Kindred,* communicated to a next generation of Black feminists—be it

the radically disruptive visual artist Kara Walker, the transgressively quirky queer filmmaker Cheryl Dunye, or scholars like Hartman—that "everything is possible," that new questions can and should be asked of our past. But, as I suggested at the close of Chapter 5, such critical questing will require a different approach to navigating the archive. Morrison herself, in discussing her process for writing *Beloved,* would famously describe it as "a kind of literary archaeology: on the basis of some information and a little bit of guesswork you journey to a site to see what remains were left behind and to reconstruct the world that these remains imply." These are the sorts of experimental methods that come alive in Black feminist expressive cultures, especially in that decade following the neo-slave narrative's formalistic breakthrough. Think, for instance, of Dunye's 1996 *Watermelon Woman,* a film that, Cvetkovich argues, allows us to reengage the power of the speculative. Dunye's film illuminates "the need to invent the archive when one doesn't exist," which, in turn, allows for ways of "acknowledg[ing] that the archive is missing (if it is a fetish, it's a queer one), and what survives in its place is not representation as positive image but representation as a complex history of stereotypes and partial and contaminated documents and traces." It is Jackie Kay's ravishing and ambitious "archive of emotion" that aims to "document intimacy, sexuality, love, and activism—all areas of experience that are difficult to chronicle through the materials of a traditional archive."[11]

This chapter takes Kay's work as a point of departure in exploring the revolution that is Black feminist speculative art, which turns the occasion of "partial and contaminated documents and traces" into creative sites on which to grapple with cultural memory and the historical precarity of sonic Black womanhood. It moves from Kay to her visual counterpart, artist Carrie Mae Weems, in order to reveal the kindred spirit of their work and to illuminate the powerful new strategies by which Black women artists are disturbing the historical record in order to reclaim the pasts denied them by critics and institutions that have historically cared little for them. As this chapter aims to further reveal, "rather than seeing [themselves] as the heroic savior of the past," Kay and Weems put themselves "in relation with it, describing [their] own desires for 'partial, affective connection, for community, for even a touch across time.'"[12] Each artist's work, like the conflicting tales of and controversies surrounding Geeshie and Elvie, converses with the crises of archival (and, by extension historical, political, social, and cultural) neglect, invisibility, and disappearance while making forceful aesthetic statements about the ways that counterhistory both speaks back to and is shaped by obscurity, opacity, and the threat of failure (that is, failure to be seen, to be recognized, to be venerated, and to become enfranchised within the dream of an unrealized democracy).

Yet both are likewise wary of the monumental as a means to addressing this kind of crisis, choosing instead to make art that revels in what José Muñoz eloquently describes as "ephemera as evidence," that which "does not rest on epistemological foundations but is instead interested in following traces, glimmers, residues, and specks of things." This is the kind of new turn that scholar Ashley Farmer traces in Black women's history as well, that which believes in the certitude that "black women's voices are there to be found in the casual omissions, the deliberate silences, their traces left in images, court records, bodily scars, and jail cell confessions. Imagine . . . ," says Farmer, "what new histories could emerge from a commitment to doing more with less."[13]

This chapter aims to do just that. Inspired by these kinds of breakthroughs in thinking about and caring for such silences as well as the sounds and sonic objects from the margins of our past, the second half of this chapter rehearses new methods for thinking through, listening out for, and writing about Black women's popular music culture past and specifically cultural histories of blues record culture as it was led and lived by Black girls and young women. In short, then, the place where this chapter is headed is one that we have yet to fully reckon with and might not ever have the tools to fully apprehend in all its casual vibrancy as did the women and girls who loved this site so—that of the Black record shop, where networks of sociality formed in relation to blues women's musicking and where said musicking surprisingly thrived. Such spaces—the Black-owned shops as well as those that were owned by others yet, nevertheless, opened their doors to African American patrons—were, as we shall see, sites of worlding for the young ones who found solace and who forged cultural solidarities in their store aisles and listening booths. Against the backdrop of the 1920s blues women's breakthrough and stretching into and through the long Civil Rights movement era, the sisters were putting their records on. They were cultivating zones of leisure and aesthetic exploration for themselves. They were building fortresses of sound to fight the catastrophe of their invisibility. This, it would seem, is a Black feminist blues archive of the everyday that is both lost and not here yet in our undercommons Black study. It is the location where we, like the sister record shop patrons, themselves, might jubilantly insist on "doing more with less."

"If You Should Lose Me"

The visionary photographer Carrie Mae Weems's work is acutely driven by questions of loss and has, on several occasions, engaged the archival lives and remnants of Black women musicians, how to speak to and with seemingly ar-

cane or obscure artists and traces of artists' lives that seem, at least on the surface of things, to be so fleeting. Like Kay, she uses her "creative powers to perform interventions that keep the archive open to critique and transformation and that produce unpredictable forms of knowledge." Yet she is also perhaps less interested in spinning the fantastic out of archival loss as does Kay when she envisions Tinnie and Viola sending that trunk off to Scotland, having *"liked the look of the country, those big goddam mountains."* In her haunting meditations on women and music, Weems often chooses instead to dwell on the problem of Black sonic disappearances from the public sphere and the ways that her own performance strategies as an artist manage and mediate the evanescence of those figures perched on the edge of vanishing from cultural recognition and legibility, like the voices Scott Blackwood describes as having been "set down in the revolving matrix" of test pressings during those failed Paramount Records recording sessions, like the ones on those discs that employees discarded and hurled into the Milwaukee River void, the "ones that got away"—"melted down? Mislabeled? Lost?"—in the cog wheels of the American culture industry.[14]

Weems's visual art often circles around such conundrums. Since the eighties, as Megan O'Grady points out, she has been "exploring her own sense of herself in relation to a visual culture in which Black women scarcely appeared at all." Her 1989 *Ode to Affirmative Action* includes signature elements of her aesthetic praxis as she places her own body in the image as a site of artifice and critical memory.[15] When it toured in the 1997 traveling exhibition *It's Only Rock and Roll: Rock and Roll Currents in Contemporary Art*, *Ode to Affirmative Action* generated meta-commentary about Weems's own minoritarian and therefore marginal status as the only woman-of-color artist included in the show. But *Ode* both calls attention to and pushes back against the precarity of Black women artists who are embraced, temporarily canonized, institutionalized, and yet perhaps still always on the verge of disappearing from these institutional spaces.

She presses this line of questioning by surrogating the figure of the vocalist, in this case Dee Dee Sharp, the first African American woman to break into the American top forty with her number two hit "Mashed Potato Time" in 1962, and a pop figure indicative of the post–World War II fad culture that signaled "the existential condition of racialized performance." Sharp's "sound of young America" lies at the heart of New Frontier cultural transformations of the modern—even as her fad status forecast her imminent disappearance from modern life. Black fad performances from this era, as Shane Vogel cogently suggests, were often constituted by the performer's recognition that "she is performing her

own obsolescence," and Weems's Sharp holds this history in the photographic moment showcased in *Ode* while simultaneously archiving the obstinate "(a) liveness" of Black women's sounds in the pop imaginary.[16]

Placed side by side with her singing self sits the gold record *Live at the Copa*, both a marker of industry triumph in the form of sales and yet also a suggestion of "the absent narrative," all that which "wasn't recorded or made visible" in the artistic and fiscal process of her visual persona's career. The fictional "Clarksdale Records" imprint signals "the largely African American Mississippi Delta . . . and U.S. policies of racial restitution encapsulated in her 'Ode.'" In this particular work, she comes to us in the form of the vocalist "Dee Dee," who performs on a record cover affixed with an alluring title, "If You Should Lose Me." Here she presumably sings her way into and through the infamous Jim Crow policies of the famed Copacabana club, transgressing white supremacist barriers by way of sound even as the conditional title of her fictionalized single calls attention to the threat of ephemerality.[17] This is a work that, as critic Alexandra Chassanoff observes, uses "the record cover as a means of producing an alternative narrative. Weems makes a formerly absent voice visible. She uses the title . . . 'Live at the Copa' to position [her] new narrative in direct contestation with the old—so that we are not forgetting what came before but also acknowledging what existed *within*."[18]

Weems's *Ode* addresses the impending crisis of loss (rather than that of repair). It is an image that, as art historian Richard Powell suggests, engages "questions of black inclusion, participation, and advantage in a Jim Crow world that "resemble[s] a mob-controlled nightclub."[19] Vocalist, vinyl, and artist mutually constitute each other in the frame of Weems's work, warning each other of what to do in the event that one or the other is "lost." Each is the other's record of existence, temporal here-ness, the trace of the other's sound endeavors. Weems re-records Sharp through a visual performance that places her body and the object of her sonic achievement in arresting relief of one another. It is work that calls to mind postcolonial historian Antoinette Burton's assertion that "loss itself is nothing more or less than *the* subject of history, in whatever form it takes."[20] Weems's meditation on loss, a three-decade-plus artistic expedition into the realm of experimental questioning, visual imaginings of Black women's embodied lives facing down and existing in spite of historical erasure and neglect, and her surprising rehearsals of other ways of being that contest the narrow constraints of racial and gender representation placed on Black women are all moves that are indicative of this larger moment in Black feminist expressive cultures. In the era of radical speculation and the embrace of a lost and

Carrie Mae Weems, *Ode to Affirmative Action*, 1989

forgotten archival past, Weems and her fellow artists use their entire expressive arsenal to prioritize the question of Black life: where and how it might thrive in overlooked and neglected cultural corners of our universe and what unspeakable disaster might look and feel like in the event of its devastating disappearance or annihilation.

To be without sound in particular is, for Weems, the catastrophe that haunts works such as 1998's *Who, What, When Where* series, which places the phonograph at the end of a series of images of objects: a typewriter, the self-actualizing instrument (labeled WHO); a book, the thing brought to life by one's own self-actualizing (the WHAT); a clock, that which centers you in time (the WHEN); and a globe, that which situates you in terms of place (the WHERE). After all of that comes the phonograph, the talking machine that subtends the "who, what, when, and where" of one's experiences but is here a symbol of lost intimacies. Here the phonograph is a thing to be mourned as a present absence, the instrument of convivial, reciprocal self-making that, like our mysterious narrator in the piece, has now ceased to make noise: "I remember long nites and endless

discussions with you," reads the text below the image, "when we were not afraid to speak our minds, and now I only feel the hush, hush, hush of our mutual silence."[21]

These kinds of tropes surface yet again in *Slow Fade to Black,* Carrie Mae Weems's 2010 exhibition that frames and reframes iconic Black women musicians in varying degrees of photographic resolution but uniformly *out of focus.* Their murky images literally and visually disturb the spectacle of hypervisibility and supposed representational transparency (consistently and earnestly "bearing their souls to you," the myth goes) and, instead, call attention to the seldom regarded and yet fraught and often tenuous conditions in which Black women performers exist in the cultural imaginary. These photographs "on the verge of dissolution," as Maurice Berger of the *New York Times* observes, "serve as metaphors of past struggles to remain visible and relevant in a culture" inclined to disappear them. "Diaphanous and cinematic," they "give the illusion of animation as they capture the flourishes of performance—mouths open in song, hands gesturing theatrically, and hips and shoulders swaying to unheard music."[22] One of the signature shows in her repertoire, *Slow Fade to Black* has evolved over time, appearing in various iterations, arrangements, and contexts, on gallery walls as well as giant, outdoor, public installation portraits.[23] In the first version of the exhibit, a striking array of images hang slightly at a remove from one particular print in the show, that of Hattie McDaniel in her *Gone with the Wind* guise perched in the upper right corner of the display wall. The placement is a telling one as social progress seemingly hangs in the balance here. Iconic women of sound, isolated, obscured by the lens, nonetheless, appear in the throes of singing us off the David O. Selznick plantation and transporting us into the majestic temples of their own music. There is the suggestion in Weems's exhibit that Black women artists in these frames—nearly all of them multi-hyphen, musician entertainer phenoms of some sort—are, on the one hand, the ones who might carry out a kind of impassioned labor that bears some form of relief, that executes the break from the straightjacket of racist, misogynist cinematic representations that shadow their own respective careers in the spotlight. McDaniel, the former songwriter, the 1910s and 1920s former minstrel performer, the former Okeh and Paramount Records vocalist and recording artist, here in the guise of her 1939 "Mammy" character looks on skeptically at the women who came after her, as well as the ones who were performing right beside her, as if to question the limits of freedom in a culture industry still destined to forget all of these artists—whether dressed in evening gowns or servant garb.[24] The conversation between these images is, in other words, charged

WHO

I REMEMBER LONG NITES AND ENDLESS DISCUSSIONS WITH YOU, WHEN WE WERE NOT AFRAID TO SPEAK OUR MINDS, AND NOW I ONLY FEEL THE HUSH, HUSH, HUSH OF OUR MUTUAL SILENCE.

Carrie Mae Weems, *Who, What, When, Where*, 1998

Carrie Mae Weems, *Slow Fade to Black,* 2010

and fraught. Weems picks up the alterity of each woman's performed, public-sphere self in celebrity stills and concert publicity photos and presents them out of focus and without audio. The silence is ominous, a portending note, a warning that this is the suggested precursor to vanishing altogether.

Slow Fade to Black grapples with the unbearable, that which Alice Walker once put into words as such: "Consider *if you can imagine it,* what might have been the result if singing," like writing and reading, had also "been forbidden by law. Listen to the voices of Bessie Smith, Billie Holiday, Nina Simone, Roberta Flack, and Aretha Franklin among others, and imagine those voices muzzled for life."[25] Weems remains dedicated to addressing the incalculable in her work which she once described as invested, in part, in provoking nagging, primordial questions forever present on the American scene: "Who is in control? What is our relationship to power and . . . how does one challenge that in the simplest way?"[26] Like their forebears, like Toni Morrison and June Jordan, like Octavia Butler and Sherley Anne Williams, Weems and Kay each make art that asks us to fathom the unthinkable, to listen out for history's silences and curate new scenarios that grapple with the repressed labor of Black women artists in the cultural imaginary. Their work also galvanizes us to pay attention to that which we've ignored: the listening practices and publics of the Black folks and Black women in particular who had "endless conversations" with the records they loved. We want them to be heard again, and so we'll need to listen closely for their lost and forgotten records and rituals, cultural customs and habits, the forms of life that stand as proof that Black girls and young women of the Jim Crow era were busy pursuing their own everyday bliss in music.

"All Things Must Pass": Black Girl Record Shop
Magic in the Blues Age

What if we were to give them another hearing?[27] What if we turned ourselves back toward the ones whom Crumb and his collecting fiends sought out in search of black gold, the ones who loved and listened to their records, stored away their discs or the memories of their favorite sounds and places where they experienced music as quotidian revelry without ever giving it a second thought? How might they offer us a bit more of the counterhistory that we crave, provide us with new pieces of a puzzle that allow us to tell a different and altogether wider tale of blues records that passed from the hands of Northern record label shipping plant employees through the hands of store merchants and into the lives of Black girls and young women who were drawn to and came of age to this music?

Separated by five years in age as well as the Mason-Dixon Line, my mother, Juanita Brooks, and Nobel laureate Toni Morrison each hold exquisite repositories of cultural knowledges, the kinds of which are oft overlooked in standard-bearing blues historiographies. Born Juanita Kathryn Watson to Arthur, a pipe factory worker, and Gertrude, a homemaker, in Texarkana in 1926, my mother experienced a relatively insular Jim Crow South childhood that was not uncommon to Black folks of her generation. While she and her friends and neighbors grew up in the acute shadow of racism and poverty, they nonetheless remained resolute about thriving. An only child who married after college and after teaching on her own in a one-room schoolhouse in rural Texas, she and my father made that familiar trek across the country, riding the western stream of the Black migration phenomenon, making lives for themselves as Bay Area educators in the run of the Civil Rights movement, and starting a family worlds away from their respective Texas and Arkansas roots. The tales my mother tells about her childhood lean largely toward charming and peaceful. She is quick to emphasize how much she greatly benefited from my grandparents' fierce love and protection, and their ability to shield her from the challenges of Depression-era life and to instead provide her with leisure-time activities built around listening to radio broadcasts of baseball games and *The Lone Ranger Show,* riding her bicycle, roller-skating (in the white neighborhoods where families took for granted the privilege and luxury of pavement), and making trips to the local segregated movie theater, where she sat in the balcony with her fellow Black brethren. Up north, the measured tranquility of Chloe Anthony Wofford's midwestern girlhood was resonant with my mother's. Born in February 1931, the woman who would

Left: The author's mother, Juanita Kathryn Watson Brooks, right after college graduation in 1948 *Right:* Young Chloe Wofford (Toni Morrison), circa 1940s

become Toni Morrison, one of the greatest and most influential writers in the English language, was raised in a Lorain, Ohio, household where her father, George, a welder, and her mother, Ramah, a domestic worker, raised her and her three siblings in an integrated neighborhood while nurturing her love of literature, music, and folklore.

My mother and Toni Morrison were two Black girls born in the waning years of the classic blues woman's era, and their distinctly different youth journeys unfolded to the soundtrack of a changing and expanding Black music market sweeping the nation. Each regal woman has shared memories that convey precious details about young Black women's lives from this era as they were shaped at times by music and specifically by records that inspired and fueled their respective social worlds. Morrison's fictional reflections on the culture of jazz are canonically renowned, and my mother's memories of the local Texarkana record store at the center of her childhood are local and personal, testimonies offered in the context of oral history interviews conducted at the time of her ninetieth birthday in 2016. Yet taken together they offer a valuable rejoinder to the riddle of Black girls' and young Black women's sociality from that era which has long gone unanswered: What did this music, what did these records mean to them as they improvised forms of leisure and play and survival in a Jim Crow world

of restrictions, repression, and barriers? If anything, each woman's reflections on such questions offer ways to begin contemplating the nature of social networks and social intimacies emerging out of blues record cultures that eschew exceptionalism, solitude, and loss, and ones that resist genealogies that lead either solely back to a single artist or a single collector or back to a single critic's genre tastes and desires. Through them, we might begin to build a more capacious throughline of connection to Geeshie and L. V. that equally respects the culture of play and sociality and survival out of which this music emerged and one that, as we shall see in Chapter 7, Geeshie and L. V. crucially cultivated with each other and evoked in the music that they made together.

Like film historian Jacqueline Stewart, my interest in tracing the memories of my mother and Professor Morrison—as I always referred to her during my time on faculty as her colleague at Princeton University—is driven by a desire to know more and to know differently with regard to blues histories. Stewart's landmark study of Black spectators in the making of early modern cinema focuses, in part, on shifting discussions of early film culture so as to consider the Black public sphere and Black collective practices that crucially informed the development of the social space of cinema. Her commitment to "reconstruct[ing] the unrecorded, ephemeral, and subtextual aspects of early Black spectatorship and representation" is instructive in the way that it forces scholars and critics to engage with the details and rich, intimate variations in the cultural lives of African American filmgoers. Stewart's project rests, in part, on "illuminat[ing] the wide range of ways in which African Americans negotiated confrontations with cinema as a major feature of modern American life." She forges ways of conveying the cultural sociality of cinema that framed the conditions of Black folks' modern lives and that, likewise, Black folks equally and inventively led the way in shaping.[28]

Blues record culture awaits the kind of analysis that Stewart so brilliantly offers, and this chapter ultimately represents my own effort to follow suit in the realm of sound studies. With Toni Morrison and my mother as dual compasses, my aim here is to take a leap and do a kind of work that runs alongside that of the speculative in its attention to our lost and forgotten histories. It is a kind of work that cares for the music by daring to place it in a different, wider universe than that which has been imagined by most critics and collectors because it aspires to see the ones who bought and loved those records before the Bussards and Faheys ever got their hands on them. Recognizing their worth, their fundamental existence, demands, then, a different way of approaching the music and developing a kind of criticism that can build on the foundational, pioneering blues feminist scholarship that took a bold step toward recuperating the

centrality of the fearless musicians themselves. Their work, which reattuned us to the ones who have been overlooked or misrepresented and mythologized in the history books, is what should enable us now to turn as well to the girls' and women's publics who adored and delighted in their sounds. It is little surprise that the circulation, social value, and cultural uses of blues records in the time in which they were mass manufactured, promoted as "race records," disseminated in African American communities and especially in the era in which they circulated among young Black women and girls have rarely received attention from critics or even the collectors who have dedicated their lives to rifling through their discarded belongings.[29] Yet the autobiographical blog of Detroit native Marsha Battle Philpot, a.k.a. the locally beloved Marsha Music, is testament to the existence and vibrancy of such histories. Music's memories of her record producer father, Joe Von Battle, her mother, Shirley Battle, and the record shop their family owned are, for instance, evidence of the distinct and dynamic communal world of these spaces in which Black girls and young women actively participated and came into cultural consciousness. We might think of how "[f]inding spaces of freedom (even if they were small spaces) and creating respatializations were," as historian LaKisha Simmons argues, "equally important for black girls."[30] Digging for that past, getting closer to its feeling, imagining what those girls and young women valued and adored about the music all around them is, it goes without saying, an urgent enterprise though no easy task given the racial and gender biases that have long shaped and informed popular music culture's archival practices of preservation and remembrance.

But the grand dame of American letters has nonetheless provided us with stirring moments that invite readers to imagine the worth of these records and this music to young African American women coming of age during the interwar years. Think, for instance, of her 1992 Great Migration epic *Jazz*, a novel that aims, in part, to recognize, recapture, and reckon with the affective experience of Black migrancy in the early half of the twentieth century. That novel, which Morrison describes as a work aimed at manifesting "the music's intellect, sensuality, anarchy; its history, its range, and its modernity," traces the emergence of Black twentieth-century sound as it was forged through fire; through white supremacist violence, poverty, and the will to move; through war, displacement, alienation, and dislocation in new and mysterious Northern cities; and through the pursuit of pleasure and succor in the face of the unknown. Inasmuch as Morrison has sustained an interest in what she calls "restoring articularity to sound," her novel reflects the extent to which music is both constitutive and reflective of Black folks' lives. It is a text that manifests Morrison's skills as a theorist of Black sound as well as a craftsman of aesthetic forms shaped by sound.[31]

Having once tried her hand at a bit of songwriting, having written librettos and collaborated on a major opera production as well as numerous live musical events that weave together her narrative mastery with the sonic experimentalism of avant-garde collaborators, Toni Morrison was both a musical force and a sound critic in her own right. Initially she wrote lyrics for a song called "First" about "a young girl who is about to enter prostitution," and she was searching for "the language of a 13 or 14 year old: simple, poignant, but not syrupy. I wanted the listener," she explains, "to share the notion of her doom as well as her juvenile desire." Art songs, "some jazz lyrics, even a spiritual" would follow. Though she'd been raised in a family in which all of the adults could play instruments, including her mother, who had once "played piano in silent-movie theatres," as she tells it, she was anything but an accomplished musician growing up. As she noted in a 2005 keynote address, "I would not enter that field, not only because of lack of talent and interest," but because "it was so completely dominated and occupied by my mother." "She sang," Morrison would add in the 2004 foreword to *Jazz*, "the way other people muse. A constant background drift of beautiful sound I took for granted, like oxygen. 'Ave Maria, gratia plena . . . I woke up this morning with an awful aching head / My new man has left me just a room and a bed . . . Precious Lord, lead me on . . . I'm gonna buy me a pistol, just as long as I am tall. . . . L'amour est un oiseau rebel. . . . When the deep purple falls over hazy garden walls . . . I've got a disposition and a way of my own / When my man starts kicking I let him find a new home. . . . Oh, holy night. . . .' Like the music that came to be known as Jazz, she took from everywhere, knew everything . . . and made it her own." As Morrison tells it here, it is, in part, the casual archival might of her mother, Ramah, the nimble and gifted vocalist, that frames her speculative venture to "restore in writing the beauty and power of the spoken language and the music that already lies within it."[32]

Jazz is the culmination of such efforts. It is a work that manifests Morrison and pioneering musician Sidney Bechet's shared philosophy that "the music had the role of teaching the people what to do with the freedom they now had, that they didn't have before." Along these lines, Toni Morrison has remained adamant about the core ethics of sonic liberation at the heart of her text, arguing that, "when people migrate from Virginia north in *Jazz*, what they hear in the music is this incredible idea of personal choice. The lyrics of jazz and blues are exuberant because for the first time you get to choose whom to love. And that releases all sorts of passion, some of which is fruitful, some of which is not. But it is intense, and it is personal freedom. And it also can activate political freedom."[33] This is the book that Morrison offered her beloved reading public as an invitation to regard the interiority of Black migrants, new people in the

Northern cities who were shaped and inspired by a music predicated on infinite invention, risk, and play. It took as its originating source clusters of archival objects and historical facts—a Harlem Renaissance James Van Der Zee photograph, the well-known tale of a young woman who was doomed to die at the hands of her lover at a rent party, the music of the era, which Morrison researched extensively, poring over Butterbeans and Susie recordings—and it transduces all of that history, all of that material culture into a work of fiction that ultimately evokes something greater than the sum of its parts, a feeling that not only captures a theory of this consummate modern music but crucially ties a Black girl's passion for that music to the narrative's central romance. Indeed, one could argue that this character's first love is the music itself, the thing that kindles her deluge of desires in life.[34]

Morrison's novel maps the arc of liberation by following the movements of one particular teen Black girl who carries her records as if on a mission. It weaves into its early and closing moments a wraparound scene of sorts that follows "a girl with four marcelled waves on each side of her head" and holding an "Okeh record under her arm" as she pays an unexpected visit to Joe and Violet Trace, a broken couple pushed to the limits of grief and despair in the wake of infidelity and murder. That girl, Felice, delivers comfort in the form of messages from and about the dead girl who marked a nearly insurmountable rupture in their lives. She promises to return again with more sounds as the couple gradually reunites, dancing to the neighbors' music coming in through the window. Felice ("happy," "lucky") with the records is the minor character who hits a major note in Morrison's novel, calling our attention to the young women at the opening and close of the narrative who keep the music close to them. She and her girlfriend, the soon-to-be deceased Dorcas, set the rhythm of their youthful adventures to crowded, upstairs parties with soaring, stride piano jams coming off the Victrola, emboldening their flirtations, fueling the thrill of their dance-floor encounters. This music that Aunt Alice, a pious and determined race massacre survivor sister, writes off as "lowdown" sound, as music that "start[s] in the head and fill[s] the heart . . . drop[s] on down to places below the sash and the buckled belts," "lowdown stuff that signaled Imminent Demise," is the music that marks the generational divide between elder guardian and her errant dreamer of a niece. Whereas Aunt Alice reads this "dirty, get-on down" sound as the source of self-destruction for a Negro people trying to get free, she rightly assesses its potency, its "complicated anger," "something hostile" in it "that distinguished itself as flourish and roaring seduction. . . . It made her hold her hand in the pocket of her apron to keep from smashing it through the glass pane to snatch the world in her fist and squeeze the life out of it for

doing what it did and did and did to her and everybody else she knew." Alice, in other words, hears the riot in the music, and so does her niece.[35]

As conceived by Morrison in one of her early character sketches, Dorcas is synonymous with the volatility, the unpredictability, and the fevered intensity of sonic modernity. The "music was not only inside her and for her," her notes explain, "it was about her."[36] Dorcas's passion for hot music, blues and early jazz of the late 1910s and 1920s, the soundtrack to her burgeoning carnal desires, frames the scenes of her sexual awakening while she lies "on a chenille bed-spread" like Hurston's Janie Crawford under the pear tree, "tickled and happy knowing that there was no place to be where somewhere, close by, somebody was not licking his licorice stick, tickling the ivories, beating his skins, blowing off his horn while a knowing woman [sings] ain't nobody going to keep me down you got the right key baby but the wrong keyhole you got to get it bring it and put it right here, or else." A run of canonical blues euphemisms evokes the infectious eroticism of her world, one that she recognizes as the "start of something she looked to complete." A young sister blues lover who is, at times, synonymous with the music itself in the narrative, Dorcas, the East Saint Louis migrant, plays third party in the Traces' fateful love triangle. More still, she is the figure of memorialization in Morrison's lyrical epic. She literally haunts the narrative as its tragic ingenue. But importantly, the novel suggests that her life choices and challenges are shaped as much by the sensuality of this music as they are fueled by the rage and resistance that brought it into being.[37]

Morrison's *Jazz* endeavor is one that involves a kind of digging, drawing out from the music the forgotten tales of the people who produced and were mutually constituted by the music itself. As she famously recounts in her foreword, she was driven in part to write a novel that would manifest the mutually constitutive relationship between the music and a constellation of pivotal historical events and ideas, feelings and phenomena emerging alongside of and in relation to the evolution of jazz, the "moment when an African American art form defined, influenced, reflected a nation's culture in so many ways." With 1926 as her year of focus, the year in which her mother was twenty years old and her father was nineteen, she immersed herself in the archive of that era, reading newspapers, reviewing memorabilia, and listening to "the scratchy 'race' records with labels like Okeh, Black Swan, Chess, Savoy, King, Peacock."[38]

Her own archive reveals extensive research that she conducted on the record listings of early blues and vaudeville artists including Butterbeans and Susie, Tom Delaney, and Charlie Jackson.[39] For Morrison, the music unlocks the memories of her parents, who "played the records, sang the songs, read the press, wore the clothes, spoke the language of the twenties; debating endlessly the

status of The Negro," and it triggers for her as well a scene from her toddler years when she dared to pry open her mother's trunk of treasures (which stored a "crepe dress . . . an evening purse, tiny jeweled with fringe") only to have it slam down on her small fingers. *Jazz* represents an effort to transform that fleeting haptic moment—touching the bejeweled evening garments of her mother—into a literary conjuring, "rais[ing] the atmosphere, choos[ing] the palette, plumb[ing] the sounds of her young life, and convert[ing] it all into language as seductive, as glittery, as an evening purse tucked away in a trunk." Indeed, Morrison spoke often about the ways in which *Jazz* reflected her effort to follow her dedication to her father in *Song of Solomon* by "grab[bing] hold of another parent—my mother. It takes place in 1926 which is the time of my [mother's] . . . girlhood. That is, her memory of that time as told to me is both a veil secreting certain parts and a rend her narrative tore into it."[40]

The love letter that Morrison writes to her mother by way of this novel, it should be noted, is one that honors a tale of Black girl youth rarely considered by the critics. We know, of course, that L. V. Thomas and so many other young Black women in the South as well as the North were especially vulnerable targets of state surveillance and punishment in those early decades of the twentieth century. Historians like Kali Gross, Cheryl Hicks, Cynthia Blair, LaShawn Harris, and Sarah Haley have, in recent years, rigorously documented the extent to which young African American women were disproportionately entangled with the carceral system. Many as well faced socioeconomic catastrophe that led into sex work.[41] The notion of leisure time and the ability to cultivate private or communal forms of cathartic and pleasurable sociality would thus clearly mean something very different for such women compared with that which Chloe Wofford and my mother, Juanita, were fortunate enough to enjoy. But the stories that *Jazz* captures do, nonetheless, encourage us to look and listen to the corners of history so often neglected in stories of blues cultural life. It is a narrative that encourages us to contemplate the ways that, as Simmons observes, Black girls of the Jim Crow era sought "self-satisfaction in places where they did not need to consider others' views of them, worry about their safety, or worry if they belonged." Morrison's novel reminds us of fiction's ability to mobilize a different kind of "evidence" that might serve as "imaginative mediations between . . . the analysis of ethnographic / historical 'facts' and (psychoanalytic) theoretical speculation."[42] Her narrative hails us to unearth a broader, richer history, like that of my mother's, which conveys more about how and in what ways blues records were heard, owned, shared between, and loved by Black girls and young women in the times in which they were made. Such stories suggest to us that which Burton has argued. "Historians," she contends, "must be as concerned

with space as they are with time. And they must account for the 'enlarged space of the domestic' if they are to capture the intricacies and ironies of history."[43]

I went looking for that "enlarged space of the domestic" when I set out to honor my mother on her ninetieth birthday, and I turned to the wisdom of Toni Morrison and the beauty of her *Jazz* as a means to framing and contextualizing her oral history. *Jazz* was the work that spurred my interest in knowing more about my mother's girlhood and pushing beyond creative speculation since I had the privilege of not only asking questions about her past but inviting her to supply her own memories to add to the historical record that has long neglected the Black women of her generation. Only later, after my interviews with her, did I realize that this project took its shape as a kind of response to the profundity of a set of questions that Morrison herself had posed in her 1990 lecture "Black Matter(s)." "Why," she asked, "was the quality of my great-grandmother's life so much better than the circumstances of her life? How was it possible without the feminist movement, without a black arts movement, without any movement, how was it possible that the sheer integrity and quality of her life were so superior to its circumstances?"[44]

In many ways, the story of my mother, Ms. Juanita, growing up in Texas both complements Morrison's approach to this history in her novels and lectures and likewise offers distinctly rich anecdotal details that fill in certain historical gaps. Texas, the place from which L. V. hailed and where, in her conversations with McCormick, she also claims to have heard that Lillie Mae may have at some point been in their post-recording years, is the place where Paramount had scouted for talent. It is, at turns out, also a place where my mother and her dearest friends were listening together to the music. My mother's reflections on her childhood offer a rare glimpse into the world of Southern Black girls who visited record shops and the role that said shops played in their lives. Born in the year that captivated Toni Morrison's *Jazz* imagination, 1926, she would navigate teen years that were far afield from Dorcas's. The music that animated her girlhood in the early forties was not only more than a decade removed from the classic blues women's heyday in which *Jazz* is situated but also, as she tells it, decidedly "chaste" party music compared to the grooves that hypnotized Morrison's teen girl characters. Yet her delight in record culture was real and sincere, as evidenced by the reflections that she shared with me during interviews in the spring of 2016.

Harlem Renaissance New York versus Depression-era Black Texarkana. North versus South. Urban versus burgeoning industrial spot on the map. Vibrant postwar energy versus the onset of a new period of global, world-altering conflict.

No doubt, my mother's youth little resembled that of *Jazz*'s migrant characters. The rhythm of the Black Metropolis that Morrison's novel maps out for readers is that of buoyancy and fluidity, kinetic movement and impassioned spontaneity. On the flip side there was Southern life for my mother as she came of age in an evolving industrial town which had an easier temporality to it, a slow-as-molasses pace to the days, even as World War II announced itself at the onset of her teen years. Big leisure pursuits consisted of chaperone-hosted rec room dances rather than roustabout rent-parties. Yet still, in either case, there were the records, the ones that Harlemite Felice carries under her arm in *Jazz*, on the way to pay the Traces a poignantly climactic visit, and the ones that fascinated my mother and her friends to such an extent that they looked forward to shaping their weekends around them. The records were the keys to dynamic lifeworlds curated by the girls, themselves. They are the objects that yield an array of pressing and important questions about, for instance, the relationships that Black girls and young women forged with their discs of choice in the early twentieth century.

Where did they go to listen to music and to purchase it and what kinds of places were they, that opened their doors to the ones so often unseen in American culture? Were these establishments, these record shops and other sites that sold discs, "safe spaces . . . where new socialities could be forged"?[45] What drew them to these records and drove them to take certain discs home? What were the occasions in which they pulled them out and played them and where? In tiny bedrooms or in tidy parlors with doilies on the armchairs? In crowded kitchens or out on the front porch with a battery-operated contraption? When and how did these girls handle their possessions? Did they store them away under their beds for future hang time? Trade them with one another when they grew tired of them? To even speculate about these seemingly small, informal cultural rituals and routines is to insist on a deeper way of engaging with the casual luxuriance and dynamism of improvisatory life in everyday, blues-era Black girlhood, to take into account their own matter-of-fact gestures and practices that convey their confidence in "shapeshifting," as Black feminist anthropologist Aimee Cox refers to it, this ability wherein "Black girls develop their own rhetorical performances and creative strategies . . ." to navigate worlds created without them in mind. While Cox is interested in tracing how this emerges in Black girls' radical politics of the body and a social choreography that addresses "marginalization, isolation, victimization and absence . . . ," I find inspiration in applying her theory of shapeshifting to the sonic cultures that these Black girls and young women in the Jim Crow era designed for themselves as a way of rejecting the "conceal[ment] of Black girls' centrality in social spaces"

and instead "nurtur[ing] connections, relationships, and community" in said "spaces."[46]

With this in mind, this last section of the chapter follows the subterranean paths of Black girlhood into the record shop so as to consider these moments of young Black women's conviviality with their beloved records and with one another, and it further asks how it is that girls from this era like my mother, though only sporadically able to purchase this music, were nonetheless dancing and grooving to these sounds in spite of the limitations that Jim Crow America inflicted on their lives. Stories like my mother's and Professor Morrison's allow, then, for ways to respect and reckon with the "archival polyphony" of the blues 78 rpm.

Black folks of my mother and Prof. Morrison's generation had a special relationship with their records. This we know is true and this despite the fact that the recording industry was notoriously slow to recognize the desires of Black consumers in the first two decades of the twentieth century. Even as the Great Migration unfolded in step with the birth and rapid expansion of a leisure market that had, by 1919, grown to such an extent that "over 200 disc record companies and over two million records ha[d] been sold," the industry remained resistant to recruiting and cultivating Black blues talent or targeting a wide cross-section of Black listening publics who were interested in popular sounds that ran askew from the opera, the classical music, the instrumentalists, novelty acts, and occasional Black theater fare that made it onto discs during this early period.[47] As Elijah Wald has pointed out, historical footnotes such as Morton Harvey, Al Bernard, and Marion Harris—and a virtual roll call of other forgotten *white* artists—as well as megastars like Sophie Tucker all beat Black folks into the studio to become the first entertainers recruited to record "blues" compositions and amorphously labeled "Negro" material in the liminal period between blackface theater and the talkies film era.[48]

It would take vaudeville vet Mamie Smith, queen of the breakthrough, to belt out songwriter Perry Bradford's "Crazy Blues" in 1920 and launch a recording industry phenomenon. Smith and blues business hustler Bradford were on a mission to counteract the industry's previous decade when Harris and Tucker and the likes were trying to drop it like it was hot with their renditions of the blues while legends-in-the-making like Ma, Ethel, and Bessie were confined to burning up the stages all along the Chitlin Circuit. But Perry Bradford's shrewd determination to get a sister on a 78 rpm led to Smith's robust reading of hot music backed by a freewheeling ensemble of musicians called the Jazz Hounds, an event that incontrovertibly and forever changed the game and how it was played, both literally and figuratively, in American popular music culture. Their

three-alarm heartbreak lament, a recorded-live joint all awash in improvisation, would hail the Black masses, delivering to them the thrill of hearing Black voices and Black instrumentality refracted back to them on record with stunning intricacy, energy, and eloquence. An estimated 75,000 copies of "Crazy Blues" were purchased upon its release in November of that year attesting to the power of Black record fans.[49]

Blues historians have marked this moment though often glossing over the grandeur and complexity of Smith and Bradford's achievement, underselling the fact that their record upended the soundtrack of Black folks' lives as well as American life more broadly. Because of them, as scholars dutifully note, record labels now believed in the (monetary) value of Black mass cultural art, and they provided Black artists with access—though still heavily mediated by white executives—to recording their own music. Pop music was transformed by a people whose musical innovations were the manifestation of a brutal, centuries-long, blood-soaked struggle to be regarded as human in the West.

But of the fans who would make the trips into the record shop, the newsstand, or the furniture store—all valid and viable places where music was sold to African Americans in those early years of "race records" culture as it was called, or the fans who ordered their music by mail and who would, like Felice, keep their discs close—less has been said. Even as the rise of portable phonographs in the 1920s continued to expand the market of who was buying records and how they were listening to them (making it easier for, say, lower-income and younger consumers without fancy phonograph cabinets to play discs), the habits and pleasurable rituals associated with this form of leisure culture for African Americans in the interwar years have gone largely overlooked.[50]

Marxist cynicism teaches us to be wary of a disenfranchised people's romance with "music-producing objects" that "drove a wedge between production and consumption" and encouraged the "sundering of body and voice . . . the substitution of a mechanical algorithm for physical and mental labor," but the recreational activities inspired by and negotiated in relation to these objects beg for greater consideration—especially in the lives of Black girls raised in the crucible between two world wars, the young consumers for whom few full-length studies of any sort have yet to be written. If, as Hamilton assures, "black Americans bought" blues records, and if "they absorbed and identified with what they heard," the quest to recuperate the worlds in which they encountered them, came to own them, and spun them incessantly in social spaces and the privacy of their homes has been overshadowed in recent years by tales of the collectors and their bountiful booty described in Chapter 5. But retracing the itineraries of these beloved possessions, imagining their movement from the hands of

pharmacists, barbers, and funeral directors and into the hands of Black consumers, might open up what Silvia Spitta refers to as the "archival polyphony" of records, how they traveled, where they went before ending up in someone's attic or in the back of someone's closet. The recognition that such merchants, as well as Pullman porters who "carried boxes of discs on their journeys . . . sell[ing] them wherever they found demand, in small towns across the Midwest and the South," played a role in the growth and popularity of Black folks' record cultures is provocative and compelling in that it enables a different kind of peoples' blues history to be told—one that lays claim to the dynamically social, the youthful, and the sometimes uniquely gendered possibilities linked to blues fan cultures.[51]

If you were a Black young woman of a certain age in the 1920s and 1930s and early 1940s who loved blues music, there were places for you to go to experience music—be it in the North or South, in urban or rural areas. The storied "jook" of African American Southern culture, which Hurston would famously celebrate in her 1935 "Characteristics of Negro Expression" essay as "the most important place in America," where "the secular music known as blues," as well as jazz, originated, remains the iconic symbol of grown-folks' social space wherein pleasure and adventurous possibility emerged out of and coalesced around the liveness of Black musical performances. Cabarets in Northern, urban communities offered a complementary and sometimes cosmopolitan iteration of nightlife culture often—yet not always—constructed around vocal and instrumental performances that directly engaged audiences in intimate confines.[52] A third and crucial, interstitial space in blues social culture is that of another kind of juke joint (hence I use "juke" rather than "jook" here to mark the distinction), the tavern which featured jukeboxes, those wondrous automated music machines, the "electrically amplified, multisection phonograph" which appeared in 1927. As Sonnet Retman reveals, these sites "catered primarily to black audiences who wanted to hear the latest Race records but could not afford home phonograph players and could not find the blues . . . on the segregated, 'classed-up' and censored airwaves of early radio." For these folks, the juke joint served as the communal source of recreation where popular songs could be played to the steady flow of libations and jubilant encounters. Jukeboxes "transformed the segregated communal spaces where black listeners gathered to relax, dance, drink, flirt, and socialize. . . . Through a shared listening experience . . . ," she argues, "the jukebox offered a collective sonic reorientation in space and time, a sense of cohesion and possibility, a respite from the hardships of daily labor in Jim Crow."[53]

But what of the sonic spaces for girls? My mother's experiences offer clues. An excellent student who was chosen in the second grade to serve as the first

African American to participate in small-town, Jim Crow Texarkana's annual Christmas parade, my mother lived a life of unabashed respectability politics instilled in her by my grandparents, which placed her on a life path nowhere near jooks or jukes of any sort. This does not mean, however, that blues records did not play a significant role in her childhood and adolescent years. The very fact that records and musicking mattered to her at that age should actually remind us of the wide variety of Black publics who were touched by the blues and who sought a variety of ways to enjoy blues music in their recreational time. For her part, my mother recalls the presence of jukeboxes in her world (the recreation room where a neighbor housed his prized possession turned into a site where she and friends would enjoy afternoon dances with one another), and the record shop, Beasley's Music Store, located on Broad Street in Texarkana, Texas, played an even more prominent role in her weekend activities in the early forties.

Record stores remain the largely forgotten sites of cultural knowledge about African American life in the twentieth century and particularly in the pre–World War II South. They are the sites that generally, as historian Joshua Clark Davis makes clear, have gotten little of the Black press love that Black banks, Black insurance companies, and Black funeral homes—establishments deemed essential to the sustainability of communities—consistently received. Perhaps in some cases, as Davis speculates, it was because of the commodities, themselves. Morrison's Aunt Alice would surely not have approved of what these shops were selling in the way of presumably "risqué" sounds. But these stores, as his research has shown, would become hubs of cultural life for Black peoples, particularly as the long Civil Rights movement era would unfold. They were gathering places wherein the "cost of admission was extremely low . . ." such that youth as well as their elders might find solace in the aisles for hours on end. In this way, African American record store entrepreneurs and consumers who were buoyed by the Black freedom struggles' prioritization of socioeconomic autonomy "partook in a vibrant form of commercial public life, a community-based consumer culture that welcomed shoppers regardless of their color, age or financial means."[54]

But the relevance of the record store in Black folks' lives predates even the period of Black Power movement-driven ownership and "buying black" practices. Davis notes that, for instance, there is evidence that stores such as Louis Armstrong associate Erskine Tate's Chicago-based Vendome Music Shop were circulating preview ("not ready for distribution") "Crazy Blues" ads in November 1920, and other African American–owned record shops in Dallas, Los Angeles, and Kansas City played pivotal roles in the early blues era, as sites of

cultural exchange and lively forms of leisure and as crosscurrents of artist de-velopment. Consumers as well as the musicians, themselves, sought out propri-etors as cultural knowledge resources, in the case of the former, and networking opportunity providers, with regards to the latter. In, for instance, a place like Ashford's record shop located in Dallas, its proprietor, R. T. Ashford, would wear many hats, on the one hand, welcoming patrons to visit "three sound proof rooms," the listening booths and cubicles at the heart of the store where they could play music "on the Victrola before buying the records." He also busied himself with artist development, overseeing a Columbia Records contract for the blues vocalist Lillian Glin and "accompanying Blind Lemon Jefferson to Chi-cago on his first Paramount Recording Session." Record stores were, in other words, their own captivating scene in Black communities, the place where fervid attachments to the music and the people who made it might flourish.[55]

Even those shops controlled in the South in the twenties, thirties, and for-ties by white managers could serve as meeting points where local African Amer-ican musicians might gather or solicit in order to have their names passed on to label scouts coming through town and searching for new talent. This tradi-tion would continue through the postwar rhythm and blues era in places like the Von Battle family's aforementioned Detroit record shop, an establishment whose success ran parallel with Joe Von Battle's historic recordings of the iconic Reverend C. L. Franklin as well as his teen daughter Aretha's gospel efforts, her first releases, and the famed Satellite Record Shop run by siblings Jim Stewart and Estelle Axton, a Memphis retail space that was literally and figuratively at-tached to the inception of soul music giant Stax Records. Like Joe's, Satellite played host to a parade of now-legendary figures in Black popular music cul-ture. Both of these aforementioned spaces had a toehold in their respective communities, serving as what Marsha Music aptly refers to as "culture transfer zones," spaces that fostered creative and professional entertainment collabo-rations as well as all-important fan research and exploration. To those African American collectors who were, for instance, attempting to excavate threads of Black sonic history, such sites served as archives holding ethnographic arti-facts linked to the seeming ephemerality of Black culture. Sterling Brown's 1942 narrative expedition *A Negro Looks to the South* makes this clear, as Retman points out. His travelogue includes a rare description of a Black 1940s jazz fan (Sterling himself) visiting record shops on a "melancholic hunt for the great jazz pioneers of the New Orleans's past, forerunners of a potent form of popular, eminently black music originating in the South."[56]

Everyday Southern Black folk often patronized their local record shops during the interwar years for joyfully less high-minded purposes than Brown.

Joe Von Battle at his record shop, Detroit, MI

Shirley Von Battle at the family's record shop, Detroit, MI

Yet their experiences remain, woefully underacknowledged in the history of the blues. The historical record has largely skipped over the nuances of this cultural world and the intriguing ways that record stores, like book shops, operated as cross-pollinations of intellectual and cultural life, of commerce and business transactions, and as improvisatory sites of aesthetic sociality that held the potential for whimsy and discovery, cultural pleasure and passionate knowledge pursuits.[57] Lerone Martin's examination of the intersections between the African American church and phonographic cultures in the early twentieth century is, in fact, one of the few full-length studies to consider the retail practices of Black race records consumers *as* sociocultural practices in and of themselves. As Martin reveals, "rushing to the store to pick up the latest record was . . . a common scene in urban black communities" during these decades. Though the Black community had been initially overlooked by a recording industry that first largely pitched its product to white middle-class and immigrant communities, "the growth of the black salary and wage-earning classes situated African Americans as a new target market" that eventually became legible to labels and shop owners alike.[58]

This is not to say that white-owned record stores were free of the racist hierarchies and discriminatory practices plaguing all other sectors of American life. Onetime Paramount scout H. C. Speir succeeded Mayo Williams, the first African American record scout in the industry, at that label. And while some recall Speir as "an honest broker" who was revered for having signed blues giants such as Charley Patton, Willie Brown, Son House, and Skip James to Paramount, as well as Robert Johnson to Columbia, it is clear that he was not above succumbing to white supremacist impulses and anxieties as the proprietor of his own shop in Jackson, Mississippi. A shrewd businessman who "calculated that his African American clientele outspent whites 'fifty to one,'" Speir nonetheless followed the tide of reluctance to cater to Black consumers, deeming them "an offense to whites" and opting instead to erect "segregated entrances and listening booths to accommodate his newfound race record business."[59] Conversely, Englishman and fellow Paramount scout and producer Art Satherley took note of Black folks' passion for record-buying. Satherley "marveled that neither Jim Crow nor insufficient funds deterred race record buyers. Prohibited from entering the store, black consumers would form 'a queue all around the stores, borrowing from each other to get the latest Blind Lemon or Ma Rainey or what have you!'" in spite of the daily insult of segregation.[60]

The unsavory and fundamentally racist side of the record business and record shop culture from this period in particular—of which there is no shortage—astonishingly never had a direct impact on my mother's youthful experiences

listening to and loving music and making trips to her local record shop to purchase 78s in her teens. As she tells it, while segregation was the de facto "way of life" for her and her friends, which they were not yet provoked in their young lives to question, Jim Crow did not wrap its tendrils around every aspect of their recreational world. Texarkana's history of being a Southern city with a steady flow of new industrial cash perhaps had something to do with its small-time cosmopolitan feel, even as it played host to the ugly brutalities of racial conflict and suppression.

Founded in the midst of the Reconstruction-era railway boom by the Texas and Pacific Railroad and the Cairo and Fulton Railroad in the winter of 1873–1874, Texarkana sits on the border of the Lone Star State and its neighbor, Arkansas. In many ways conceived of as one of the gateway points of entry to the Southwest, the city served, along with Memphis and Little Rock, as a key route to accessing the Texas interior, and it came to be known as an opportune locale for trade and commerce and the cultivation of small businesses. Neither a bustling Southern metropolis nor a southwestern Wild West town, Texarkana was, by the first half of the twentieth century and particularly in the wake of World War I, a medium-size city whose white business establishment prospered with the tide of railway expansion and services.[61] Its history of race relations in many ways followed the logic of calcified white supremacist inequality and violence while occasionally showing small signs of social progress in fits and starts from the 1910s through the dawn of the Civil Rights era. In, for instance, 1917, which saw one of the nation's bloodiest race riots unfold in East Saint Louis (the catalyst that drives Morrison's Dorcas and Alice to flee to Harlem), a Texarkana business man "formed an interracial council," which, the Texas Observer would report in a 1964 retrospective article, "was not a happy venture, and did not last long. The one meeting ended in a near-riot, and for 47 years," observes journalist James Presley, "Negro-white relations continued catch-as-catch can, sometimes simmering, sometimes exploding."[62]

No doubt, the "explosions" felt by Black folks were as gruesome as anywhere else in the country. The twin city had its own "red record" of lynchings dating back to the late nineteenth century, and my mother recalls the horror of hearing about one such mob execution in her youth.[63] On many an occasion, she has reflected on the gratitude she continues to feel toward my late grandparents, Arthur Watson and Gertrude Graham Watson, for "shielding" her from the worst of Texarkana. With only one child to care for, Arthur and Gertrude were able to stretch a poor working-class budget in the midst of the Depression into the makings of a comfortable and loving home for their daughter. For these reasons, her childhood memories are largely free of the sting and burden of racial trauma

and are more in the vein of Henry Louis Gates Jr.'s famous characterization of the idyllic side of segregated African American life, a "once upon a time when we were colored" youth odyssey in which bicycling and roller-skating with friends were sources of delight for her. [64] Her most vivid memories of Jim Crow are of what were, to her, egregious social nuisances: separate (and unequal) water fountains, separate public bathrooms, balcony rather than front-row movie seating (at a local theater where she would later find summer work and watch films like *The Philadelphia Story* from the Black folks' balcony section). School, travel, and dining establishments remained all-Black for her in a way that she viewed with warm familiarity and casual insouciance.

But merchant culture held out a different promise to her that she and her girlfriends seized on with joyful frequency in the years between 1940 and 1942. At that time, when my mother was fifteen and sixteen and thrilling for the weekends with Mary Works, Ethel Jordan, and occasionally Lawrice Taylor, she made her way into the heart of downtown Texarkana—usually by foot but occasionally by bus—in order to visit Beasley's Music Store at 202 East Broad Street.[65] It was an excursion that she and her dear friends looked forward to on Saturdays, a day of bonding and teen sociality that offset the all-day church obligations that lay ahead come Sunday morning. Like the local department stores that catered to Black as well as white folks under one roof, Beasley's was seemingly the site of slightly looser Jim Crow arrangements, a fact that my mother took for granted. There "was a scattering of white people at the store," she recalls, "but when we were buying records, [the rules of segregation] just never occurred to me." It was a space that she and her friends comfortably inhabited while improvising their own forms of conviviality with one another to the sounds of the records that they actively sought out and came specifically to delight in discovering for themselves in the shop. "When we'd go into the store," my mother recalls, it

> seems [the clerks would] ask, "May I help you?" And we would tell them we were there to listen to some records. And . . . [I] remember it was on the right-hand side, a stack of the records were there. And seems like they just showed us where to go. And after we went so often we walked in and we would know where to go. . . . And we would select the record that we wanted to listen to. So into the booth just the two or the three of us— never more than three—most often there were two of us . . . and then we could play . . . the record. And as I recall, almost every time one of us would buy a record and that was it. One of us would take it to the counter and pay for it.[66]

The bygone listening booths, to which my mother refers here, were staples of record store spaces like Ashford's just up the way in Dallas. Such features of these shops date back to at least the early 1920s. According to anthropologist Philip L. Newman, they "were real hangouts for the kids" during his own "high school years in Eugene, Oregon." They were sites around which young folks would sometimes build their social lives. "You'd talk at lunchtime," says Newman, "about what kinds of things you'd listen to when you went down to the booth." Into the booth they'd go, to the place where they could listen to songs that my mother and her girlfriends had often first heard on the weekly radio show *Manhattan Merry-Go-Round*. Here they could reassess the tracks that had initially intrigued them and piqued their interest. They had a routine with which the Beasley merchants complied, making a beeline to the records, passing them to staff—or walking up to the counter to place their requests. Once the sounds were settled on, they'd make their way to one of the store's private listening rooms. "We didn't dance," says Juanita, "we just listened together and tapped our feet." A quarter could buy a disc that one of them would opt to take back home for another spin. What is remarkable about this experience is how ordinarily pleasurable it was for my mother and her friends and, likewise, how little has been considered about the everyday details and mores and rituals of their world, how the record store with its listening booth served as the site in Jim Crow Texas where teen Black girls could go and casually "travers[e] the racial boundaries" of the state with a "tenor of mundaneness" that nevertheless "challeng[ed] the reification of social relations."[67] By this I mean that one can think of them as having carved out a bit of youthful Black privacy *in* the public sphere on Saturday afternoons on Broad Street, ironically on the same street where the threat of racial violence nonetheless hung in the air, where twenty-five-year-old Willie Vinson would meet his death in 1942 at the hands of a white mob, the story my mother would hear about from her parents.[68] Such a stark juxtaposition between extralegal, white supremacist violence and modern leisure should come as little surprise since, as Jacqueline Goldsby has persuasively shown, the roots of the anti-Black lynching phenomenon in America are deeply entangled with the evolution of modern culture and modern technologies.[69]

To the extent that Beasley's record store and its beloved listening booths were "safe space[s]" for my mother and her friends, they also reflect the ways in which Black girl "intimate publics" sought to "elaborate themselves through a commodity culture" during the blues era and forged the kind of "common emotional world" of "women's culture" that feminist critic Lauren Berlant describes, in which individuals have been "marked by the historical burden of being harshly treated . . . and who have," nonetheless, "more than survived social negativity

by making an aesthetic and spiritual scene that generates relief from the political. . . ." The "'women's culture' concept . . . marks out the nonpolitical situation of most ordinary life as it is lived as a space of continuity and optimism and self-cultivation. If it were political," adds Berlant, "it would be democratic." As my mother remembers it, Beasley's was a hub of casual democracy and cultural continuity, the site where she and Ethel and Mary could further pursue their listening tastes and take pleasure in discovering new music: "Stormy Monday" by "the dreamy" Billy Eckstine (as my mother still refers to him), Lionel Hampton and His Orchestra's hopping version of "Flying Home," Duke Ellington's "Things Ain't What They Used to Be," Sister Rosetta Tharpe's swinging version of "Trouble in Mind" recorded with Lucky Millinder and His Orchestra, the Ink Spots' version of "Don't Get Around Much Anymore," and Saunders King's electric guitar blues hit "S.K. Blues." Beasley's was, for them, a sanctuary of music, one stop in a broad network of sociality that was shaped indelibly by popular music.[70]

Their regular trips to the store were, in fact, the culmination of social rituals driven by a love of blues, jazz, and especially early R&B dance music, the kind that became the soundtrack to their weekends. With radios still a luxury item that most Black families could not afford circa 1940 in Texarkana, Juanita and her friends would travel to one of the "shotgun houses" owned by Mr. Anderson, a Black real estate proprietor who opened up a space on Saturday afternoons for teens to listen to that favorite, *Manhattan Merry-Go-Round*, an "old time radio show" that was "reminiscent of *Your Hit Parade*" and a staple of Texarkana's radio station, KCMC's broadcast lineup. They were listening as much for their names as for the hits, writing in their requests and sending them to the station a week before the show aired. Or they were visiting the house of Mr. Frank, owner of that jukebox that captivated the neighborhood. It was Frank who played host to dance parties for the teens and supplied them with cold drinks while Juanita and friends did the jitterbug with boys like Johnny Pointdexter ("all decked out in a zoot suit!") and Marion Charles ("another great dancer!"). If they weren't at Mr. Anderson's or Mr. Frank's, they may have been en route to the Jamison building on Third Street, a site erected by African American professionals where proms and dances were regularly held.[71] The music enveloped their world, and my mother carried it with her from one social space to the other and sometimes back home, where she was able to play records on a battery-operated phonograph my grandparents had given her one Christmas.

Her stories should challenge us to pay close attention to the remnants of lost histories coursing through all that static, all those scratches and deep grooves on the records in the archive. We might, in fact, reattune ourselves to

Young Black women playing the phonograph, Alabama, 1930s

the material clues left behind in these objects so as to consider the extent to which the "hisses, pops, and clicks, the warped passages where the acetate yield[s] to summer heat" bear the traces of Black girls and young women who may have ardently put these objects of leisure and consumer culture to good use long before the collectors got their hands on them.[72] These are tales that, as Berlant generously suggests to me, are anything but proof of "a smooth historicist genealogy" but rather "a dynamic resonance that allows for partial narratives and alterity within a space of sensed intimacy. It's a feminist project," Berlant continues, "to admire what people could make out of a world not welcoming to them to leave marks for other people to turn up and move with."[73]

In this vein, then, I am doing my damnedest to try and remain attuned to those "marks" the sisters have left behind for us and trying to continue to learn lessons about the beauty of sonic self-curation and worlding from women like my mother or like Miss Maya, an acquaintance of my late father's, a literary icon, and a Bay Area record fiend in her own right. "Music was my refuge," says Maya Angelou in the opening pages of her third memoir, *Singin' and Swingin' and Getting Merry Like Christmas*. When she was piecing together a life in 1940s San Francisco as a single teen mother, it was the need for vinyl—the blues of John Lee Hooker, the "bubbling silver sounds of Charlie Parker"—that drew her to the Melrose Record Shop on Fillmore. Her passion for records drove her to snatch two hours between jobs so she could rove its aisles. It was "where I could wallow," Angelou writes, "rutting in music." Angelou would go on to join the

store's staff, basking in a world of wall-to-wall sounds—Schoenberg, Sarah Vaughan, Dizzy Gillespie—ordering stock and playing records on request. Maya the music wonk. Maya the D.J. Maya the record collector. Her affectionate reminisces of a young adult life of many demands and uncertainties yet enlivened and made livable by these interstitial moments in the day between one line of labor and the next, these moments of sonic immersion, escape, and release, encourage the kinds of alternative epistemologies that we, the archivists and the critics, might continue to seek out in our meditations on the when and the where and the how Black women and girls vappear and matter in histories of popular music culture.[74]

Like Maya's memories, my mother's tales of the record shop, of how she and her girlfriends used the music, how they treated the physical objects—their beloved 78s—with care and yet played them again and again, allow us to imagine ways to resist the record's ruin and to instead recuperate the polyphony of these objects, to come closer to capturing what's in the grooves of their specific material histories, and to consider the many times girls like my mother and her friends and the Dorcases and the Felices of the world spun records and began to hear and invent for themselves a wider universe open to them. These are the moments of recorded intimacies between blues musicians on the move and the girl fans who loved their sounds that we might marvel over and ethically look after so as to perhaps do more than chase their shadows, to in fact learn lessons from them about the practice of ludic Black girl survival. Their stories tell us that they were, indeed, "shapeshifters," the kinds who used sonic modes of being to "map a different world," "to claim more space, take up more room," and "imagine [the] life-affirming possibilities" existing outside and in spite of Jim Crow tyranny.[75] If we turn to them, we come that much closer to affirming the ways that Black girls—and not just women—were vital to the survival of the music.

This is, perhaps, the secret of another photograph, one that is worlds away from the image (discussed in Chapter 5) from long ago that features those mysterious, unnamed women reclaiming their time against the pull of racial segregation's tyranny. Theirs is a universe that is both far off and yet ever so close to the one in which a young Marsha Music appears. It is circa 1960, the thick of the modern Civil Rights era, and she is some eight or nine years old. Standing in front of her father's 12th Street store on the west side of Detroit, its second location, she dons slacks and a short-sleeved, button-down blouse, and strikes a stance with sass and flair; with both hands on her hips, she exudes youthful confidence and ease. Her eyes are closed at the blink of a flash, but she is holding court, posing for the camera, just to the right of the entrance to the shop. A sign

Marsha Music outside of her father Joe Von Battle's record shop

behind her proclaims that "Rev. C. L. Franklin Records" are sold there. Think of her, we might, as the "little woman" at the door, ever watchful, absorbing all of the activity of that Motor City where a pop music revolution in the form of Berry Gordy's Motown "Sound of Young America" would soon be in full swing as the decade unfolded. "I spent weekends and summers of the 60s with my younger brother Darryl," she recounts in her blog, "splicing tapes, reading *Billboard* and ringing up the latest 45s, and mastering the art of discerning a customer's request within a song's first bar."[76] This was the period too, in which, as she would describe to me, she began to be "really immersed in this world. I used to read voraciously . . . ," says Music, "and I read album covers." She was drawn to the allure of images on the sleeves of discs by Bobby Blue Bland, Yusef Lateef, Ahmad Jamal, Elvis (adds Music, "people somehow are shocked all the time that Black people listened to white music. Like what else were they going to listen to? That was all that was on the radio!"). This was her diligent Black study. This was her "avocation . . . ," she points out, noting how "album covers were my windows on the world. . . . An album cover taught you a lot. . . . I would sit behind the counter and read . . . all of the trade papers and magazines, the top 100, read . . . what was going on in the music world." To Music as well,

Joe's Record Shop was anything but a masculinist space. "I remember," she asserts, "there were always women customers always coming in the record shop. And I remember when they would come in . . . they would be knowledgeable about what they wanted. . . . They would say, 'Have you heard that new record on WJLB? I want that record. Baby, give me that record.' So you had a lot of women who were record buyers."[77] All that knowledge. All that play. It courses through the casual and confident stance of a Black girl who would grow up to be a local legend, and it constitutes the undercurrent of that other image of the ones who struck a pose, the ones who came before her, lost to us but cared for by the generations of Black feminists who can't stop dreaming about them.

7

"SEE MY FACE FROM THE OTHER SIDE"

CATCHING UP WITH GEESHIE AND L. V.

If you don't own your masters, your master owns you.

—PRINCE ROGERS NELSON

There is speculation that Geeshie and L. V.'s Paramount odyssey began in a Texas record shop. The scout who made the journey from Wisconsin down to Houston, Arthur Laibly, was accustomed to taking "long trips through the South, visiting the . . . 'houses' that sold race records. In one of those stores," muses John Jeremiah Sullivan in yet another lyrical crack at piecing together the past, "he must have asked, 'Who's good, who's worth recording?' And the guy behind the counter says, 'You need to check out these two girls, Geeshie and L. V.' The guy must have sung their praises. They're the only musicians Laibly recruits during his trip to Houston that we know of. . . . He sets out for Geeshie's house."[1] Thomas' own version of events, in that long-stowed-away interview, fleshes out the tale, supplying details from the perspective of a seasoned musician sussing out a would-be partner, the overtures and orchestrations of a company rep on a mission, and the dizzying events that put her and another sister en route to the north on a musical errand.

The way I came to make records was that I went around a lot with a girl named Lillie Mae Wiley. She was called Geeshie Wiley. Mr. Laibley [sic] of Paramount Records Company came to her house one day and she carried him on over to see me. I don't know how Mr. Laibley heard of her, but I

suppose someone down at the music distributing house told about it. We had a pretty good name as two girls to hire for music. He listened to me play and he listened to her and then he said he'd like for us to go up north and make records. *We knew about his company; I think we both had some Paramount records* and we'd heard of others going up there. I was older; I was about 38 or so then, so I said all right. Lillie Mae and I went up to Milwaukee and stayed four days and made all our records at the time. There was a fellow on the train we met who wanted us to stop off in St. Louis and sing at a night club he said he had there but we were afraid of him. I remember she sang "Skinny Leg Blues" and I sang "Let Him Go God Bless Him" and a bunch of others. We went to the place every afternoon for four days. I guess we made several dozen songs. I didn't hear too much back from them so it's hard to know.[2]

Her own recollection of Laibly's professional "wooing" of the duo adds intimate perspective and detail to the story of these skilled musicians who'd already been making "a pretty good name" for themselves locally when a label scout came calling. They were women who knew some things about Paramount, owned records of their own, and had an idea from others about the path out of Texas and into a faraway recording studio in that place, Milwaukee, which might as well have been Mars. An audition impresses, a deal is made, and two Black women—one pushing forty and the other most likely somewhat younger—prepared to take a trip across the Jim Crow universe into the midwestern bowels of a rapidly evolving recording industry. The perils they faced as "easy prey" on their journey resembled those that Mary Lou and countless other itinerant women musicians would weather under even more brutal circumstances. In Thomas and Wiley's case, they navigated the rough terrain, clocked in, and did their job. They were, in effect, swallowed up by the "masters" who would own their master recordings, by a record company that, over the course of several days, would simply let them slip back into anonymity with the mark of their obscure and beautiful collaborative labor awaiting future publics' care.[3]

They were women who constituted the "important female minority" of country blues artists, and they were stuck in a hard place—overshadowed both by iconic images of Black women vocalists, the hagiographic symbolism of bygone, celebrated Black opera singers whose monikers ("Black Swan," "Black Patti") were affixed to the names of labels, and by the men who slung guitars and sang stripped-down, melancholic anthems of rolling stone alienation and euphemistic desire.[4] They fell neatly into none of these categories, and yet they were out there and constituted an important subculture, as the music of Geeshie

and L. V. reminds us. That duo's precarious positioning in the archive of Paramount Records and on the outskirts of twentieth-century popular music history, though, has led to false presumptions about the enigmatic aura of the two. Championed for their seeming solitude from other sisters and not their shared aesthetic affinities with peers, Geeshie and L. V. are "caught out there" (like Kelis), betrayed by the ones playing games with the music, the music that, as this chapter seeks to explore, is indicative of a broader legacy of the blues than that which has been recognized by most historians and critics of the music, save for the Black feminists determined to turn our ears to it. The music calls for us to get to studying, to follow its trail of evolution as it continues to wend its way around the edges of our current sonic popular culture, a culture built by and once dominated by Black women.

Still, in that early era, we know that Thomas and Wiley were late for the party that Mamie Smith launched in 1920, that Bessie kicked into high gear with her first single in 1923, and that Ma Rainey further popularized that same year, signing to Paramount and laying down tracks that she'd been singing on the road for two decades across the South. The classic blues women's craze that sparked Paramount Records' initial success in the game had begun in 1922 with Alberta Hunter's monster hit "Downhearted Blues," a song she'd cowritten with Lovie Austin, the company's "powerful ensemble player," and one that Bessie Smith would cover as her breakthrough smash for Columbia Records the following year.[5] Though the Empress was an outsize presence in this unprecedented era in which Black women's voices occupied the center of mass cultural life, it was Paramount in the 1920s that, by mid-decade, shrewdly drew on the music of a wide array of blues women to solidify its race records empire. Paramount not only gobbled up the competition by acquiring the first major African American–owned company, Black Swan Records, it manufactured and distributed the music of Rainey and Hunter, as well as Ida Cox, Trixie Smith, Lottie Beaman, and a whole host of lesser-known artists who held the attention of Black audiences.[6] Black Swan's biggest star, Ethel Waters, who had virtually saved the label from going under in its initial year of business, turned similarly healthy profits for Paramount as well before jumping ship to Columbia in 1925.

Taken together, these artists sounded out a blues spectrum wide enough to encompass the assertive, veteran repertoire of Georgia-born Rainey (who was thirty-seven when she signed with Paramount) and the sometimes mannered, sometimes swinging, and always inventive song sets of Pennsylvania-born Waters. All were performing versions of vaudeville blues, a kind of blues that showcased their talents as artists who "neither participated wholly in the illusionistic world" they "inhabited nor one[s] to whom autobiographical intention

was ascribable." Spectacle, camp, double entendres, costumes, and improvisational playfulness were central to their acts. All were accompanied by full bands or other musicians in the studio and in their live performances, and some, such as superstars like Rainey and both Smiths, made use of sometimes lavish sets and donned glorious evening garments for their turns on the stage or when posing for publicity stills and ads.[7]

But this, we know, was not the world of Wiley and Thomas, who made their music far removed from the recording industry's spotlight, with the smallest of bare-bones ad campaigns bereft of images or any other surviving supplemental copy promoting their sole recordings. The press announcements for the Wiley and Thomas sides look, in fact, more like a ledger with the names and catalog numbers of their songs nestled in between announcements for "Race Record" and "New Blues" releases by forgotten talent like Chocolate Brown and Tenderfoot Edwards, Blind Joe Reynolds and Leola Manning. The reasons for this have as much to do with the Great Depression and its gradual, death-blow impact on Paramount as they have to do with major shifts in the race records market that had been under way for at least four years before two Texas women with guitars would try their hand at the recorded blues. Paramount was just a couple of years away from going under and ceasing recording altogether in 1932 when Wiley and Thomas signed to the label in 1930, and one ad for their sides from that year encouraged (presumably) salesmen to stay the course and "master our selling force until we can say that are [*sic*] sales are satisfactory."[8]

Their recordings were, no doubt, also overshadowed by a trend that had put male musicians at the forefront of recorded blues culture. By the time that Arthur Laibly arranged for Wiley and Thomas to take a train headed for Milwaukee in April 1930, the women who had dominated the genre had drifted away from the center of pop culture gravity and were no longer the money-making entities the labels had rapturously made them out to be. The aptly titled "Nobody Knows You When You're Down and Out," what would turn out to be Bessie Smith's last hit single, had charted at number fifteen in 1929, the same year of her only film appearance, in *St. Louis Blues*. Rainey recorded her last sides (including the queer protest and right-to-privacy classic "Prove It on Me Blues") in 1928, and the versatile Ethel Waters was, by the end of the twenties, in the process of making a fluid pivot to furthering her career in theater and making the transition to film musicals as well. Paramount, the company that had once staked its future on the blues women's craze, had by mid-decade turned its sights to the interwar country blues led by artists such as Blind Blake, Charley Patton, Son House, Skip James, and Blind Lemon Jefferson, whose "Long Lonesome Blues" from 1926 launched the subgenre's popularity at the label.[9]

As a result of their emergence as recording artists effectively caught between major junctures in the blues era—women musicians at a time when sisters had less skin in the game, women guitarists when mostly men were becoming all the rage—it is tempting to read their obscurity as a problem of legibility. They were "missed" because there was no conventional place for them on the shifting blues horizon. Obscurity and singularity are often kissing cousins, and a number of critics have thus pondered Geeshie and L. V.'s supposed exceptionalism in the world of the blues, how they sound like "no one else" and "nothing else" that came before and after them, how they "seem to stand in the threshold between older Black secular music and the blues." But perhaps there is a fuller and richer and oft-overlooked context in which to read the riveting performances that they left behind. As Black feminist musicologist Tammy Kernodle reminds, even before Mamie Smith and Perry Bradford dropped "Crazy Blues" on the world in 1920, "there already existed a strong but undocumented history of women blues singers in the Mississippi Delta and Piedmont regions. . . . The sound of these blues," continues Kernodle, "differed greatly from the highly sophisticated classic blues of the 1920s." Artists like "Bessie Tucker, Ida May Mack, Geeshie Wiley, Josie Bush, Bertha Lee, and Memphis Minnie sang the blues before and after the classic blues craze of the 1920s and were significant in spreading rural music traditions throughout the Mississippi Delta region, Texas and beyond." Still more, many of them—musicians like Minnie and Mattie Delaney, along with Wiley and Thomas—"accompanied themselves" and "used the guitar as an extension of their voices and often played intricate melodic lines over the powerful, driving rhythms that define the sound of Mississippi Delta and Texas blues."[10]

Geeshie and L. V. were most certainly not alone, as it turns out. The songs that this mysterious duet put down for the record at Paramount evoke the most familiar elements of the genre—tropes of longing and dissolution, bold flirtation, lust and braggadocio, as well as danger and intimate combat, the full compendium of blues feeling that critic David Wondrich vividly and persuasively describes as "the lowdown ache—a harmonic gloss on Jeremiah's lament. . . . Loneliness, abandonment, disenfranchisement, rejection, exploitation, pointlessness, boredom—all the Prozac emotions, plus horniness." Theirs is music that reflects the country and classic blues traditions out of which these women emerged, and the conditions of their coming into consciousness as artists should be familiar to anyone who studies the history of these sorts of Black women musicians—be it the child prodigy Mary Lou Williams or the blues traveler Esther Mae Scott. "I started playing guitar," Thomas tells McCormick during her 1961 interview with him, "when I was about eleven years old." By seventeen she was

out at those aforementioned "country suppers" jamming, "trying to get her life," as anthropologists Jafari Allen and Aimee Cox might say.[11]

The music that Thomas and Wiley were making, however, was *not* unremarkable. On the contrary. They sang and played guitar together—not solo—and as blues musicians and lyricists they sought to make a living during a moment in their respective, historically evanescent lives when they hovered between falling vulnerable to varying forms of violence at the hands of the state and domestic patriarchs. L. V. Thomas's past as an inmate in the Harris County, Texas, jail, doing time in 1910 for a crime now lost to the archive, and the suggestive history of Lillie Mae "Geeshie" Scott's entanglements with domestic violence, which seemingly unfolded in 1931 in the immediate wake of their recordings, are the kinds of all-too-common stories of brutality meted out on Black women's lives that rarely—if ever—figure into the writing about the tragedy as well as the righteous miracle of the music they made.[12]

But tending to these sparse yet precious biographical details, caring for and about them, helps us to remember just how "backwards"—in Heather Love's queer theorist sense of that word—Wiley and Thomas's archive actually is and, likewise, how much queerness and the blues commingle with each other in constituting the aesthetics of their repertoire. These women's intimacies remain largely opaque in the archive; but in the case of Thomas—and as John Jeremiah Sullivan has shown—she left traces of her queer life behind for the record and with Wiley made strong and unique fugitive music.[13] They made sounds that, in some ways, magnify the imbricated conditions of queerness and Blackness to the extent that both can sometimes articulate "regret, shame, despair, *ressentiment,* passivity, escapism . . . withdrawal, bitterness, defeatism," feelings that, Love argues, are "tied to the experience of social exclusion and to the historical 'impossibility' of same-sex desire." But theirs, I wish to point out, was no wholly (Afro)pessimistic endeavor. As we shall see, while staring peril in the face, they made music that was both somber and slyly ludic. Their recordings offer us the richest trove of untapped, overlooked, and undervalued historical and cultural knowledges about the Black queer blues woman's archive of the everyday—that which is lost, that which we may never fully recuperate, that which begs us to listen differently to and reimagine the scope and range of blues women's aesthetics altogether. It is the music of a duo repertoire that ultimately conveys the complex lifeworlds and imaginaries of both Black women behind bars and those who lived in perpetual proximity to the forces of the Jim Crow carceral world, a world that, as numerous scholars have shown, touched the lives of millions of African Americans from the moment Congress ratified the Thirteenth Amendment.[14] It is music that asks everything of us to the extent

that it reflects and encapsulates and also responds to and revises the conditions of Black women dead set on their own survival and focused on their aesthetic will to power in the Jim Crow era. What are the Black feminist tools that we need to better care for and about these sounds? How might we meet their music on the field of invention? It starts, I suggest, with trying to move in time with their lyrical conundrums and the rhythmic, dialectical pulse of their dueting, to partner with the traces of their archive as best we can as if we were spirit-edly collaborating with them, composing a precious sonic arrangement together. In short, we might think of ourselves as stewards of their music, just as Kara Keeling might urge us to do. Only then might we more fully grasp what this music demands of its listeners, how it whispers to us ways of looking at and lis-tening to Geeshie and L. V. anew, looking after them in their absence, and lov-ingly, mindfully watching over what they left behind.[15]

"Satisfied Having a Family": Revolutions of the Blues Women's Pas de Deux

My first partner was Lillie Mae Wiley. She was about five or six years younger than me and we went around lots together.

—L. V. THOMAS[16]

So let's keep Black queer time with these sisters. Let's entertain the possibility that the Geeshie and L. V. performances that were recorded and pressed into poor-quality 78s, the ones that were stored on metal masters and that may very well have been "sailed" by disgruntled employees "into the Milwaukee River" when the Grafton plant's doors closed for good, were more than exquisite ren-derings of affective turmoil for subjects who were forced to survive at the very bottom of the Jim Crow ladder. Think of these women coming out of the South and up first to Milwaukee and arriving finally in Grafton, a tiny, all-white town about twenty miles north of the city by way of either streetcar or automobile. We might imagine them feeling their way around a studio for the first time and fighting the forces of shell-shocked alienation, disorientation, and perhaps stage fright or instead drinking up the new atmosphere all giddy with anticipation. We might envision these two gifted artists holding musical conversations with each other, composing sounds that might amount to other worlds for them to fleet-ingly inhabit, and recording a history of blues women's subversive interstitial lives forged outside of both the jail cell and the sphere of domestic abuse. Here they lean in to their studio time together and hold at bay the threats

from outside. Together in the scene of performance, in the Paramount recording booth and over the course of no more than a couple of days (and in what some have speculated could very well have been a single afternoon), they collaborated in the production of a particular form of blues women's alterity, a site that we might regard as more than the invention of "a perspective from which people without perspective begin to speak," a place that could hold the performance of a kind of temporality produced by and yet also exceeding the constrictions of their everyday lives as African American women in the interwar South. Their imposingly dense approach to the blues encapsulates the queerness of "nonsequential forms of time." It traffics in tropes of "unconsciousness, haunting, reverie, and the afterlife," and it suggests the power to "fold subjects into structures of belonging and duration that may be invisible to the historicist's eye."[17] Black feminisms provide us with the language to care for their music—that which is informed by that long and overlooked tradition of intellectual labor that spans from Pauline Hopkins and Zora Neale Hurston to Mary Lou Williams and Abbey Lincoln, from Rosetta Reitz, Lorraine Hansberry and Ellen Willis to Phyl Garland and Janelle Monáe. Their work allows us to grasp the quiet and casual genius of Geeshie and L. V.'s blues heroics as a duo, a revolution on the lower frequencies of pop music history.

"Deep and Wide": The Blackness of "Kind Words"

Most critics, for sure, would argue that no song of theirs says more about the ravages of time as well as agonizing regret than the masterful "Last Kind Word Blues," a track so revered now by blues enthusiasts, alt folk and roots Americana musicians, and indie rock artists that nearly a dozen musicians have released covers of the song since Crumb introduced it into the indie cult imaginary back in 1994.[18] Out of its own time now, it is a recording that has reached legendary status in certain circles, and new blues wonks have thrown themselves into poring over this stunning work as an example of Geeshie and L. V.'s enigmatic distinctiveness. Much ink has been spilled about this song alone, a remarkable "pre-blues or not-yet-blues," as Sullivan succinctly and eloquently refers to it, "a doomy, minor-key lament that calls up droning banjo songs from long before the cheap-guitar era, with a strange thumping rhythm on the bass string." There are many who linger on the nature of its riveting power, which stops a critic like Petrusich in her tracks as she finds it "undeniable—why it worked on" her so much that, by the time she arrived at the 'What you do to me, baby / It never gets out of me' bit," she "was half-breathing and glassy-eyed" and concluding that the song's "mystery was a fundamental part of its allure."[19]

Others might find it worthwhile to choose history instead of mystery, to consider the meaningful aesthetic traditions and material conditions that made music like this both possible and necessary. On its surface, it is, for instance, a song that bears much in common with label-mate Blind Lemon Jefferson's "Wartime Blues," recorded in 1926, and a song that we know also resonates with Zora Neale Hurston's folk repertoire as well. His melancholic anthem is rife with floating verses that evoke the socially, politically, and emotionally dystopic universe of the song's protagonist, who weathers unspoken cruelties and injuries so thick and deep that they alter one's sense of time and place and the clarity of distinction between self and other. Both Jefferson in his song and Wiley on "Kind Word" allude to large-scale devastation in the form of war. For Jefferson, it encapsulates the inevitable future ("what you gonna do when / they send your man to war"), and for Wiley it exists in her speaker's past-tense narration, the marker of conditional tragedy forecast by a lover ("If I die, if I die in the German War / I want you to send my money, send it to my mother-in-law"). Just as Wiley's song would do four years later, Jefferson's envisions a bleak and an oblique place; the "wartime" is that of both internal and external turmoil as the song's speaker pledges to "drink muddy water" and "sleep in a hollow log." "Wartime Blues" takes listeners onto the Hurstonian asymmetrical plateau, a key "characteristic" of Black cultural life and one that is filled with "the abrupt and unexpected changes" that capture the feeling of a people exhaustively channeling the traumas of social and material dislocation into modern art and life.[20]

Yet this track, which critics unanimously hail as Wiley and Thomas's signature song, also bears important distinctions from the kind of cataclysmic imagery laid out by Jefferson and fellow blues men. A product of the lament tradition in rural blues women's culture, "Last Kind Word Blues" stands as its own kind of social death dirge, a sister's solemn plaint, her wrenching conversation with the universe as she lingers on the moment of bearing witness to the mortality of lover and mother alike and likewise accrues wisdom about her own mortal limits and limitations as she wanders and waits, "looking for a train" that never comes. The "last kind words I heard my daddy say / Lord, the last kind word I heard my daddy say," begins Wiley in the opening lines, which launch her tale of catastrophic loss. "If I die, if I die in the German War," she continues while shifting into the voice of the now departed,

> I want you to send my body
> Send it to my mother, Lord
> If I get killed, if I get killed,
> Please don't bury my soul

I cry just leave me out, let the buzzards leave me whole
When you see me coming, look 'cross the rich man's
 field.
If I don't bring you flour,
I'll bring you bolted meal.
I went to the depot, I looked up at the sun
Cried 'Some train don't come,
Gon' be some walkin' done'
My momma told me, just before she died,
Lord, precious daughter, don't you be so wild.[21]

Doom and desolation frame the mood of this song, which musicologist AnneMarie Cordeiro calls a "ballad" rendered "in a blues style." Our protagonist's memories of her lover's fatalistic instructions bleed into and overlap with her own distilled visions of tending and being tended to by the apparitional one who is no longer there. The boundaries between this world and the next become porous as Wiley vocally dwells "between pitches and between beats" and troubles the direction of her narrative.[22] It is a performance that stands with its Black woman protagonist on the edge of the universe as she draws wisdom from its abyss.

 Can we stand with her and listen out for something deeper and wider about the song itself? Most "Kind Word" fans are drawn to the song's stirring, existential, penultimate verse:

The Mississippi River, you know it's deep and wide,
I can stand right here,
See my face from the other side . . . [23]

There are those who are floored by, stymied by, wrapped up in these gripping, mournful lines, lines that announce that the singer "is in two places at once. Or . . . nowhere," peering out "from the vantage point of death." To some, these lyrics mark a fundamental rupture in the narrative logic of a song awash already in imagistic and thematic discordances. To some, it simply defies reason that such a metaphysical break between self and other would emerge in the climactic lines of a "lost my lover" blues. Here stand the makings of a bracing and an unusual folk gem that had been lost to history.[24]

 But to those of us who think often and long and hard about the Black radical tradition's aesthetic articulation of Blackness as polyvalence—as constituted, in part, by being at once perpetually here and elsewhere, as always already being

on both sides of that "deep and wide" Mississippi River—Wiley's performance is not exceptional but rather exemplary, foundational Black study 101 itself, which tells us much about the condition of Black alterity. Such verses evoke Du Boisean veils, (Pauline) Hopkinsian Afrodiasporic spiritualism, (Ralph) Ellisonian invisibility. They are verses that evoke the kinds of "black geographies" that Black feminist critic Katherine McKittrick argues "are underwritten by black alienation from the land," "impossible black places . . . and topographies of 'something lost, or barely visible, or seemingly not there" made by "present-past time-space cartographers" who recognize and give voice to the condition of dispossession. More than merely musing that "something spooky" is "happening to the spatial relationships" unfolding in the song, a Black feminist reckoning with the sociohistorical specificities of Wiley and Thomas's world would have to account for the "demonic grounds" on which they stood. It would likewise clarify and deepen our critical readings of the complexity of their blues as well as the spaces they were building together inside that tiny studio.[25]

To see one's face from the other side as does Geeshie Wiley on "Last Kind Word Blues," one has to be willing to acknowledge the "real spatial inequalities" that these two blues women were forced to navigate in their lives, as well as the broader crisis that Black women chronically face in relation to a system of servitude that perpetually renders them "as an inhuman racial-sexual worker, as an objectified body, as a site through which sex, violence, and reproduction can be imagined and enacted . . . as a captive human." From the other side, one might recognize what historian Sarah Haley aptly refers to as "the micropenality of everyday life" for Black women enduring the all-encompassing, daily insult of Jim Crow culture, "the construction of their bodies as monstrous" in American social, cultural, and juridical discourse, which "meant not only that their political and economic power could be limited, but also that they would be subject to disproportionate arrest and imprisonment."[26] In this context, singing *to* oneself, as well as *singing oneself* across that river wide, is the kind of bold and visionary performative act of self-affirmation that holds out the promise of disrupting that which is symbolically and materially crushing. From "the other side," Wiley upsets spatial arrangements that render Black women and girls vulnerable to surveillance and imprisonment. She and her blues partner sing us through to Sylvia Wynter's place, the site that that prodigious thinker influentially dubs the world of "Caliban's 'woman,'" a place that exists in her radically reorienting lexicon of altered knowledges, informed by Black women's historical, social, and material experiences, a place "outside the space-time orientation of the humuncular observer."[27] Geeshie, in effect, stands her ground and sounds out the other worlds that she, they, we might inhabit.

Of Mothers & Daughters: Transgenerational Blues Wisdom

Would that it were, then, that "Geeshie and Elvie" studies might continue to move with these women who were on the move, so as to pay greater attention to other jams on their playlist, other tracks that they recorded in the span of less than a week all those years ago back in 1930, tracks that tell us about the kinds of Black sonic tropes that they mastered and scrambled and rearranged for their own modern moment of Black women musicians' emergence and modern emergency. For it is these tracks, I suggest, that leave us with a record of their collaborative recourse as a duo, as well as their ability to find each other in the performance just when all seems lost. To hear the call of the blues woman who recognizes her own capacity to sonically do more than endure like Dilsey is a thrilling charge that we might accept as we continue to pay greater attention to Geeshie and L. V.

Take, for instance, "Motherless Child Blues," a record "rediscovered" by that old Bussard Joe himself in a Baltimore antique shop in the 1960s. Sullivan yet again offers the most poignant reading of this track to date, noting its "16 bar, four-line stanzas" and observing that, "by repeating the same line four times, AAAA, no variation, just moaning the words, each time with achingly subtle microvariations," L. V. Thomas (who sings lead on this track) delivers "notes blue enough to flirt with tonal chaos. Generations of spirituals," he continues, "pass through 'Motherless Child,' field melodies and work songs drift through it, and above everything, the playing brims with unfalsifiable sophistication. Elvie's notes float. She sends them out like little sailboats onto a pond."[28] Captivating words once more from the incisive critic Sullivan, and I would not for a minute contest their beautiful power to get us to think about a blues woman's innovative ability to narrate and disseminate the transhistorical sounds of Black subjugation and the will to freedom.

I would, however, argue that there is much work left to do with this particular Wiley and Thomas blues. Especially if one considers the distinctions between what the Paramount Records producer who apparently named this song (since Thomas was said to have not even recognized its title when Mack McCormick asked her about it) may have heard in the studio and what we might hear with "bigger ears," as jazz studies critic Sherry Tucker might put it, we are not yet done with looking after it. In the era of Negro spirituals and "neo-spirituals," as Hurston referred to them, Black religious songs classically (re)arranged and packaged as uplift performance, it is all too probable that this particular song threatens, on the surface, to say more about the Paramount team's business-minded expedience and less about the tradition of Black religious sound.[29]

The difference between the complex, familial intimacies in this lyrical narrative and that of the song's title is pronounced, perhaps exposing a producer's whimsy to fold (or force) Thomas's tale of a daughter's conversation with a dying parent into line with the Negro spiritual tradition's most recognizable song ("sometimes I feel like a motherless child") about abandonment and dislocation. Or perhaps it might suggest his commercially shrewd inclination to turn Thomas's tune into a kind of answer-song blues (a foreshadowing of what was to come much later in the century when, for instance, the Roxanne Shante versus UTFO gender-fueled rap wars emerged in 1980s pop culture) for the race records market since the title itself is a duplication of what had then been a recent hit, 1927's "Motherless Child Blues" by Robert "Bob" Barbecue Hicks. Hicks's song, its rolling stone, ne'er do well, misogynistic contempt lines unfold thus: "If I mistreat you gal, I sure don't mean you no harm / I'm a motherless child and I don't know right from wrong."[30]

Whichever cultural reference on which he was seeking to capitalize, such a title negates the extraordinary and profoundly unique sonic testimony that Thomas is offering us here, one in which a Black woman protagonist not only comes into consciousness about the transgenerational vulnerability of women in patriarchal culture but one that attests to the blues itself as a source of repair and catharsis for women. "My mother told me just before she died," sings Thomas as she echoes Wiley's "kind words" themes of maternal wisdom, instruction, as well as the sorrow of maternal mortality. A Black feminist listener may be especially privy to hearing the aching nuances in Thomas's repeated reading of "mother" across the opening four lines as she pushes that word up in register three times as if to accompany her elder, her maternal protector, her teacher as she makes her way out of this world. A Black feminist listener may further tune in to Thomas as she follows a similar arc of vocalizing the word "daughter," sounding out a parental plea to do right and avoid the peril that awaits her on the other side of a mother's imminent disappearance from this earth. In two stanzas alone, Thomas stages for us a micro-domestic drama in which Black maternal foresight about and counsel with regards to a daughter's coming-of-age choices and confrontation with desire are foregrounded in the opening scenes of the song. Our maternal figure agonizes over her child's potential fate, "Oh daughter, daughter please don't be like me." And while it's clear that she has failed to heed her mother's word, the survivor's despair and the belated recollection of her mother's sage advice become a catalyst for her to declare in spite of her grief that she "didn't have no blues." Best, her song suggests, to quit "tarryin' aroun'" and make this music instead.

Together, Geeshie and L. V. were fighting the forces of white supremacist, interwar culture that veteran blues scholar Paul Oliver recognizes as contextually relevant to their repertoire. Against the backdrop of an environment in which Black folks were countenancing the corrosive effects of grossly unequal education, disenfranchisement, being "subject[ed] to segregation, intimidated by police and state, subject to the pressures brought about by economic and natural forces beyond their control," he observes, they played on, recording a guitar rag, "Pick Poor Robin Clean," that Oliver reads as being rife with "eloquent symbolism." These musicians, who were "unusual in that they were two women guitarists" who "possessed a strong rhythmic sense and rural accents," sang in unison a signifying folk blues about power and dispossession.[31] Gently braiding their voices together, two blues women become one in lyric as they deliver a tale of fate and (queer) failure.

> I picked poor Robin clean, picked poor Robin clean
> I picked his head, picked his feet,
> I would've picked his body but it wasn't fit to eat
> Picked poor Robin clean, picked poor Robin clean,
> And I'll be satisfied having a family.
> Oh didn't that jaybird laugh, when I picked poor Robin clean,
> Then I'll be satisfied having a family.[32]

Here in this curious folk ditty, the little women gloat over their own brash tricksterism. Both Oliver and Cordeiro hear the jaybird loudly in "Pick Poor Robin," mocking "the subjugation" of "the black labor force." Yet still, this is a Wiley and Thomas track often trivialized by critics as a showbiz trifle, as the afterlife of blackface stage antics, Chitlin' Circuit vaudeville mischief detritus. Most have read the song narrowly in the "coon song" tradition that glorifies the skills of the embattled survivor, zeroing in on lyrics that follow a gambler who gets one over on his foe, throwing the n-bomb around as his story unfolds. The song's picaresque hero warns onlookers to "get off my money, and don't get funny / For I'm a nigger, don't cut no figure . . . I'm a hustling coon / that's just what I am." Marcus and Sullivan are among those who refer to the song as rooted in this tradition. Take note of how, as he plays the record for Thomas's relatives, Sullivan, for instance, alludes to the song's "curious opening, eight seconds of minstrel-show banter, possibly part of a stage act Geeshie and L. V. had perfected," he speculates as the voices of the artists rise up and greet a

family who'd known nothing about L. V.'s Paramount past: "Well hello there, Geetchie!" "Hello there, Slack," "What are you doing down here?" "I'm just down here trying to play these boys a little hot robin." "Let me hear it then."[33]

There is mischief in this music, that which lives far outside the minstrel arena. To read Geeshie and L. V.'s "Pick Poor Robin" as a blackface tune, then, risks eliding the relevance of the song's historical, social, and cultural genealogy, its invocation of signal elements of Black aesthetic legacies. Still more, it risks overemphasizing a focus on subjugation and overlooking what wisdom Black feminist sonic study might offer about the massive problem of Jim Crow carceral life for Black women as well as how to survive it. While it's true that proof of the song's genealogical links to this genre remain scant, what we do know is that Lynchburg, Virginia, blues musician Luke Jordan recorded a version of "Pick Poor Robin Clean" in 1927 for Victor in Charlotte, North Carolina.[34] Music historians have called Jordan "a unique and forceful guitarist," and he is best known for songs like "Cocaine Blues" and "Church Bell Blues." Some have speculated that Jordan may have plucked "Robin" from the "gambling song" folk tradition, which Hurston did much to mine and preserve, laying down tracks like "Georgia Skin" and "Let the Deal Go Down" during her Florida recording expeditions in the 1930s. But Jordan's "high-pitched, fast" vocal delivery sounds nothing like the rhythmically percussive songs from that genre that Hurston performed. Still more, it bears little resemblance to the songs sung by Ernest Hogan, Bob Cole, and J. Rosamond Johnson or Bert Williams and George Walker in the era of African American blackface stage culture (to say nothing of the sometimes violent, sometimes melancholic, always nostalgic plantation tunes handed down to us from Stephen Foster and the rest).[35]

There is much risk in this misreading of "Robin" as pure blackface hokum, as it threatens to obscure, among other things, an important legacy of Black vernacular exchange, improvisation, and internal critique in the very performance itself. A blackface reading of "Robin" risks missing, for instance, the intimate ways that "Slack" and "Geetchie" address each other in performative, dialectical play. These are nicknames, "labile" names, as Nadia Ellis has reminded me, names that slide between Geeshie and Geetchie and between L. V. and Slack in Sullivan's own historical research that has partially brought these women's lives into the light. Theirs is an internal dialogue between two genius artists playing out the "folk knowledge" that Ralph Ellison's 1952 *Invisible Man* protagonist slowly, painfully recollects in a moment of danger: "And I heard myself humming the same tune that the man ahead was whistling, and the words came back: *O well they picked poor Robin clean/ O well they picked poor Robin clean/ Well they tied poor Robin to a stump/ Lawd, they picked all the*

feathers round / from Robin's rump / Well they picked poor Robin clean. . . . What was the who-what-when-why-where of poor old Robin? What had he done and who had tied him and why had they plucked him and why had we sung of his fate?"[36] Ellison offered an answer himself in an influential essay entitled "On Bird, Bird Watching & Jazz," which he wrote in homage to jazz legend Charlie Parker:

> "They Picked Poor Robin." It was a jazz-community joke, musically an ex-tended "signifying riff" or melodic naming of a recurring human situation, and was played to satirize some betrayal of faith or loss of love observed from the bandstand. . . . Poor robin was picked again and again, and his pluckers were even unnamed and mysterious. Yet the tune was inevitably productive of laughter even when we, ourselves, were its object. For each of us recognized that his fate was somehow our own. Our defeats and fail-ures, even our final defeat by death, were loaded upon his back and given ironic significance and thus made more bearable.[37]

Geeshie and L. V.'s duet versioning and inversion of Ellison's Black radical tra-dition gem offer a "theorization of the necessity of collectivity in the face of car-ceral terror and the recognition of black women's vulnerability to state vio-lence." In this other time and place that is the site of their duet and the sound of their collectivity, it is the women who do the "plucking" while "down here trying to play these boys," while trying to create a "family," a counterpublic in the face of defeat and potential devastation leveled by the state. This is their moment, their time to reject the doomed and sacrificial role of the obtuse bird who suffers at the hands of exploitative figures (failed and malfeasant patriarchs in *Invisible Man*'s odyssey), the women with their guitars choose other paths for themselves. "Ah, won't be long now," sings Wiley as she and Thomas shift into a swift-picking instrumental passage. Here Wiley unleashes a jubilant line of scatting before both women meet up vocally in a final round of the chorus. This is the song of and for all those jaybirds, a "blues of black feminist sabo-tage," as Sarah Haley would put it, one that "encompass[es] . . . an epistemology of collective rebuke of structures of authority" and one that "disavow[s] a poli-tics of ascendance even as it proliferates the allure of rebellion."[38]

Flying far from the blackface stage, the lyrics to "Robin" champion heroines rather than clowns. They star in a tale of their own making here, turning the tables on an unsuspecting dupe, one who is robbed "clean" while the "jaybird" laughs and points us toward the carceral world lurking at the edges of Geeshie's and L. V.'s respective lives. Freighted with symbolism, "jaybird," or "j-bird" in

1920s and 1930s slang, also stands for "jailbird." Thus, she who laughs does so while looking out from behind bars at the ones who got away with mischief. Geeshie and L. V.'s performance revels in the kind of "blues women's sabotage" that Haley describes as that which is "not about success or triumph against systematic violence and dispossession" but which is instead "about the practice of life, living, disruption, rupture, and imagined futures." Their music offers a queer articulation of "hope" that is "inseparable from despair," a blues woman's blueprint for the queer art of failure, which demands more than critics' frequent and yet cursory characterizations of "Poor Robin" as racial caricature parody. This song in particular demands now, with what we do know about both women, a more nuanced hearing, one that chooses *not* to forget how each of them most likely stared the Southern penal system in the face at different points in their lives and who, like other Black women who found themselves entangled with criminality in the early twentieth century, may have "used some form of violence to defend themselves and to seize the things they wanted."[39]

Their incarcerated lives matter in ways that have gone almost entirely unrecognized in the writing produced about Geeshie and Elvie by new blues critics for nearly two decades now. What would it mean to take seriously this recuperated past of theirs? The condition of their embattled lives as Black women searching for "more life" in the face of Jim Crow entrapments, domestic patriarchal strife, and all of the perils that would await marginalized women in the time of segregation is, in fact, the foremost thing that we might keep in mind when settling in with their 78s. Looking after them necessitates nothing short of that, grappling with that past as an inescapable point of departure when arriving at their repertoire and this one song in particular. For "Robin" tells us much about the exigencies of improvisation as a tactical response to the chronic carcerality inflicted on Black folks' lives. Their music should, at the very least, force us to continue to come to terms with the ways that the "state institutionalized gendered racial terror as a technology of white supremacist control" in the Jim Crow era of their recordings, and especially the ways that "this state violence compounded intraracial intimate abuse" that Black women "faced in their homes." As Haley makes clear, "State violence alongside gendered forms of labor exploitation made the New South possible, not as a departure from the Old, but as a reworking and extension of previous structures of captivity and abjection through gendered capitalism." From this standpoint, Geeshie and Elvie's music stands as an important entry in the undertheorized genre of incarcerated women's blues. Theirs is the sound of both post- (in the case of Thomas) and potentially pre-incarceration women's blues (in the case of Scott), the sound

of women who were all too aware of Jim Crow–era Black womanhood's per-petual proximity to and entanglements with carceral life "through policing, legislation, and judicial enforcement," through a state-ordained system that made "black women inverts: perverse, primitive, and pathological, and there-fore unentitled to protection or freedom."[40]

Think, then, of Geeshie and Elvie's "Robin" as a sonic heuristic for responding to crisis. Theirs is the practice of freedom, a blues woman's tale to tell and one that offers wisdom and strategy in the long moment of danger for Black folks that is then as well as now. Their practice of freedom is a blues woman's pre-rogative, and the beauty, nuance, and invention of how they meditate on that practice is rendered compellingly in the form of the duet, the kind of perfor-mance in which collaboration and dissent, partnership and competition, and discordant harmonies as well as antiphonal conspiracies can run profligate from the song itself, as our friend Fred has taught us time and again. Geeshie and L. V.'s art of the blues women's duet in "Poor Robin" reminds us of what, Dani-elle Goldman points out, is improvisation's "keenest political power," which lies in its ability to operate "as a vital technology of the self," as "an ongoing, crit-ical, physical, and anticipatory readiness that, while grounded in the individual, is necessary for a vibrant sociality and vital civil society."[41] In those rare instances when blues women like Geeshie and Elvie set out together on some great shared task in performance, we hear their readiness. We hear in "Poor Robin" the so-cial and political efficacies of the vibrant, the pulsating, the striking, that which is full of what Lindsay Reckson might recognize as purposefully sly and exul-tant enthusiasm of another order.[42]

Through "Poor Robin," the jaybird sees her face on the other side, and she can hear "a dreamscape produced outside or perhaps parallel to the known world, nebulous and distinct from but nevertheless related to the material reality of imprisonment." Here, in what Haley refers to in a nod to Wynter and McKit-trick as the "demonic sonic imaginary" of incarcerated women's blues, "the still indiscernible rather than the knowable constitutes the terrain of futurities of freedom and a rejection of the ideologies of modernity that conscripted spe-cific racialized and gendered bodies for the pulling of hoes—a rejection of the human categories upon which convict labor is premised. Between pulling hoes and enjoying reunion is the dream, the vehicle that changes history toward the direction of seemingly impossible justice."[43] Listening to the "dream" embedded in this Geeshie and L. V. song would most likely mean also listening beyond the epithets that have overdetermined the ways that blues historians have catego-rized their version of "Poor Robin" in the past. Reading and thinking this song back into the oft-overlooked tradition of jailhouse women's blues might in fact

open up ways to consider the sociopolitical scope and range of these two artists' seemingly enigmatic repertoire. It might allow us to hear the "productive laughter" of these women on a different frequency as they share the yokes and the jokes with each other holed up in that Wisconsin studio, a place, that, as Gerard Ramm sharply observes, receives more attention in the work of new blues critics than the possible sites of incarceration where Thomas and likely Wiley too did time. These were sites that, to be sure, were real locations in their quotidian lifescapes.[44]

Coda: "Criminal Dreams"

How might we duet with them? Perhaps by keeping in mind the fact that there were sisters behind bars who were singing while they were up in Grafton just as there surely had been when L. V. was incarcerated as a teen and when Geeshie allegedly put a knife in her husband's neck one year after their trip to Grafton and took to the wind. The sounds of Black women's imprisonment are the unspoken context of their Paramount blues. And while it is true that the music of incarcerated Black women in Mississippi's infamously brutal Parchman Penitentiary bears little resemblance to the duets of Wiley and Thomas, two skillful instrumentalists with polished performance chops, we might nonetheless keep in mind the ways that the blues of Parchman women generates a structure of feeling that resonates from Mississippi to Wisconsin.[45]

The music made by the women of Parchman was, as Rosetta Reitz describes it, a kind of "living female blues, the kind that a woman might sing at her chores like washing dishes or clothes, or cooking, or rocking a baby." Reitz would lead the effort in 1987 to anthologize and reissue these recordings of the women prisoners of Parchman first collected as fieldwork by Herbert Halpert and John A. Lomax in 1936 and 1939 and stored in the Library of Congress. As Reitz contends in her liner notes essay for the *Jailhouse Blues* album, this music is "'everyday,' not originally intended for performance. These were untrained voices. . . . No matter the tempo, they lilt along with their own tone." But it is also the music that bears witness to the ways that women prisoners negotiated the conditions of their subjugation through sound.[46]

Recognizing and paying close attention to the heterogeneity of this genre's aesthetics—the play, the banter, the "recorded improvisation" that unfolds at the intro and outro of, for instance, "Poor Robin"—allows us to draw a throughline between Wiley and Thomas's performance and the sounds of "survival" and collaborative "pleasure" forged in solidarity on some of the Parchman re-

"—*Pick* Poor Robin Clean"

"I PICKED his head, I picked his feet, I would have picked his body, but it wasn't fit to eat." . . . Everybody knows some snappy version of this roving song of the gambler.

"Now, *if you have it*, gentlemine, I'm gonna *have* your mon'." . . . Luke Jordan sings the rollicking words with that careless abandon that the song needs. A deep-voiced guitar rolls along in accompaniment.

The other side of the record carries "The Traveling Coon," another popular number. The very first time you hear this Victor Record, you'll just naturally have to buy it to play at home. Get your nearest Victor dealer to play these new releases for you — *today!*

Pick Poor Robin Clean *With Guitar*
Traveling Coon *With Guitar* LUKE JORDAN
 No. 20957, 10-inch. List price 75c

Moten Stomp
 BENNIE MOTEN'S KANSAS CITY ORCHESTRA
Blue Guitar Stomp
 CLIFFORD HAYES' LOUISVILLE STOMPERS
 No. 20955, 10-inch. List price 75c

I'm Coming Virginia *With Piano*
Miss Annabelle Lee *With Piano*
 CARROLL C. TATE
 No. 21003, 10-inch. List price 75c

National Blues
Southern Shout DIXIELAND JUG BLOWERS
 No. 20954, 10-inch. List price 75c

We Pray to the Peace of Jerusalem
Michael, Hand Me Down My Robes
 IMPERIAL QUINTET
 No. 20956, 10-inch. List price 75c

What Kind of Love Is That?
Dead Drunk Blues MARGARET JOHNSON
 No. 20982, 10-inch. List price 75c

Abraham Have Mercy On Me
He Shall Speak for Himself
 REV. WILLIAM RANSOM
 No. 35855, 12-inch. List price $1.25

New Orthophonic
Victor Records

1927 *Chicago Defender* advertisement, "Pick Poor Robin"

cordings. As Haley makes clear, the "closeness and deep knowledge of the songs can be heard through the moments of laughter, verbal exchanges about the correct lyrics, and the unison that marks these recordings." Eerily akin—but in no way identical—to the power dynamics shaping the conditions between Black women musicians transplanted to the icy Midwest and working at the behest and whims of white male record label executives, the Parchman recordings must likewise, she argues, "be understood as firmly bounded by relations of coercion and pleasure that delineated white male freedom and black female

captivity and rendered performances of both joy and sorrow pleasurable for field interviews, field recorders, and the audiences" who came to love and listen to the Rosetta reissue some fifty years after Halpert and Lomax archived this music.[47]

On the other side and all the way inside the studio room we go. It is a "cold and damp space," we are told by Paramount Records historian Alex van der Tuuk, a space "draped with burlap and blankets" to reduce the reverberation. "Thick carpets on the floors. A dark, furred box. A horrible place to record," says Sullivan. There, Geeshie and Elvie sit before that big horn. In this place that some say featured walls as well as covered windows "to conceal the artist from the local people," in this place where Black folks were hidden like contraband and milked for the economic value of their talent, here two women share a "signifying riff" about fate and sacrifice, about playing slow-witted foes for their foolishness, about Black social life and, above all else, the work of the ensemble, the work of Black women's blues collaborations and conspiracies, and their ability to slip the bonds of white record producers as well as white archivists, the ones intently listening in on them as they rag the jailhouse women's blues and attest to the fact that "the black feminist criminal dreams represented therein both reflect and exceed those relations of power."[48]

Poor Robin's song reminds us of the ways in which blues women then as well as now improvise "an anticarceral conception of social life" through their sonic repertoires. It's a song that suggests that, if you should lose me, don't come and find me because the band, my duet partner, my rugged and fearless fellow musician who "basses" alongside me will buoy me up, will see me through as she surely recognizes that my fate is her own.[49] It's a song that reminds us that if Geeshie and Elvie are, in fact, "nowhere at all," it's we, the critics, who haven't caught up with them yet.

8

"SLOW FADE TO BLACK"

BLACK WOMEN ARCHIVISTS REMIX THE SOUNDS

> I started thinking about this idea . . . sort of like a kind of slow fade to
> black . . . the way in which things disappear, the way in which things
> dissipate . . . so something . . . is fading, but something is also blossoming,
> something is growing at the same time . . . into—not OUT of but INTO a new
> space of . . . production, of cultural awareness, of political awareness, of
> cultural possibility. . . . So I'm doing this project with . . . these fabulous
> sisters who are currently on the scene.
>
> —CARRIE MAE WEEMS[1]

We lose things, and the crisis yields sound. In the long recognition of our own disappearance, we turn to our own lyrical noise as the eloquent statement of our "blossoming," our infinite "cultural possibility," our driving "cultural awareness." We see and know and recognize the fade. We are intimately familiar with it, have felt the sorrow of its silences, negations, neglect, and brutal mishandling. We know the meaning of our seeming valuelessness, of being "forgotten but not gone," and yet our masterful rejoinder has always been to build our own monuments by using "wave[s] of sound," the kind that are "wide enough to sound deep water and knock the pods off chestnut trees."[2] This is the very old and yet forever "new space" of which visual artist Carrie Mae Weems speaks, the one that she and the late, great jazz pianist Geri Allen were curating together in 2012 live and in the round with a range of dynamic and inventive fellow artists who shared the stage with them on a summer night that

year in Brooklyn's Prospect Park. The "slow fade to black" to which Weems refers is one that she had already sought to make visible in her haunting 2010 exhibit of the same name, one that archives and memorializes the onset of Black sonic women's vanishing, the point at which they begin to slip out of view and into the void of cultural memory. Here she and Allen and a mighty ensemble—bassist and singer Esperanza Spalding, drummer Terri Lyne Carrington, additional vocalist Lizz Wright, multi-instrumentalist Patrice Rushen, tap dancer Maurice Chestnut, and the Howard University vocal group Afro Blue—return to the scene of the crime and draw visuals and spoken-word material into dialectical play. Conversations will be had, dreamscapes will be conjured. We fade into Blackness here and reach the territory where the preciousness of our own memories might be acknowledged and cared for in song.

Projections spill across three large, overhead screens: profiles of women strutting or cogitating, inhabiting the fullness of their own lives. They are glorious sisters with billowing Afros—dancing sometimes alone and other times with each other or occasionally for a lover. They are the spectacular embodiment of Black women's life and vitality. At the heart of this montage are Weems's blurred images of Black women musicians weaving in and out of view, barely legible yet persistently there, hovering like stirring apparitions approximating a ghostly duet with our live artists, who hold it down at the center of the stage. Always on the brink of either slipping away or coming (back) into focus, the figures of the "slow fade" morph into spectacles of movement. They beckon the order of dueting, crying out for a score to capture and convey the conditions of their own ephemerality, and Weems, Allen, and company answer the call by composing an alternate future for the "ones that got away." They make music that forcefully responds to the threat of precarity and answers the riddle of the gripping photographs of iconic yet evanescent artists who are forever "receding from cultural prominence." This sisterhood of performers transforms the concept of "fad[ing] to black" into the vision of Black sonic womanhood reclaimed and manifesting itself in the work of "a new generation of emerging black female artists." They produce a new soundtrack for the photos frozen in time and communicate the revolutionary potential of the contemporary Black feminist curatorial performer, the kind of artist, this chapter asserts, who boldly alters our relationship to the sonic past, ferociously jolts dominant perceptions of history, and consistently awakens listeners to the meaning and value of Black women's lives and livelihood that undergirds that history.[3]

Weems and Allen's joint concert extravaganza is a public exegesis on these very matters. It is a show that amounts to nothing less than a Black feminist emancipation project, a communal meditation on the crisis of "the fade." Like

the public forums that visual culture critic Silvia Spitta has organized to discuss the photographs of the indigenous dispossessed, this performance draws out the latent complexities lurking beneath the images of legendary Black women musicians, presenting them to the public "in other ways that will render" them "polyphonic," resonant on other historical frequencies.[4] The sounds they make disrupt the solitude of the women vocalists who appear alone in these images, singing, posing, staring off into the distance or straight into the camera. To "knock the pods" off trees, the performance begins with the vocal group Afro Blue's rendition of "Oh Freedom," the uncompromising, give-me-liberty-or-give-me-death Negro spiritual. This will be a grand ritual, a deep historical recontextualization of the original *Slow Fade* stills. Led by Howard University associate professor of music Connaitre Miller, Afro Blue reframes the photos with centuries of longing in song and offers with the ensemble a meditation on the question of how it feels to be Black and free. We are invited to consider the ways that each of the subjects in these familiar images—in, for instance, record label and film studio stills, promotional objects for a culture industry that repeatedly showed them no Mary J. "real love"—is here quietly, privately, in spite of performing in the glare of the public eye, perhaps working out her own answers to the riddle of Black women's liberation: Marian, Mahalia, Dinah, Ella all with eyes closed, Mary Lou in contemplation, Abbey midverse, Nina leaning into a well-placed chord, Eartha returning the gaze that ogles her, Billie staring into the universe, Dorothy and Lena and Ethel settling into high posing mode. The representational afterlives of these women hang in the balance as the voices of an acapella vocal group of Howard students offer the hushed audience sonic testimonies that exceed what the lens can capture. "And before I'd be a slave," one sole sister sings with clarion assuredness, "I'll be buried in my grave / And go home to my Lord and be free."

The evening unfolds and new millennium jazz vocalist Lizz Wright picks up the baton, deftly covering eclectic songs that commune with the elders, paying homage to their sacrifices, wisdom, and martyrdom. It is a performance that yet again acknowledges the urgent responsibility to care for their legacies. Wright and band move through classics like Bill Withers's 1971 poignant tribute to matriarchal protection and care, "Grandma's Hands," and a kind of quietly ironic cover of godfather of grunge Neil Young's 1972 generations-colliding classic "Old Man" ("old man, look at my life / I'm a lot like you were"). She marks the distance between our time and theirs while yet still keeping these iconic women close, these geniuses who were often alone, caught out there on the pop front with nary a sister to break the glass ceiling with them. She moves toward them in song, tackling the pioneering Black feminist vocal

group Sweet Honey in the Rock's masterpiece "I Remember, I Believe," a 1995 tune written by group cofounder Bernice Johnson Reagon in somber recognition of "the dreams, the struggle, the hope, the determination of all of those who came before." "I Remember, I Believe" is also, as Reagon tells it, a summoning of "the strength of all those behind us" to "propel ourselves forward with the mission that we have" to give "to the generations beyond us to use our hope, our struggle, our beliefs, our dreams and everything that we have to lay down a foundation for their futures."[5]

Perched between past sorrows and the taste of futurity, Wright, in conversation with Allen's stripped-down piano arrangement, moves through the music of Sweet Honey and stages a requiem for the unrecorded past, the burdens carried by generations whose agonies are impossible to capture in words, the magnitude of their revolutionary endurance and will to survive: "I don't know," sings Wright, "how my mother walked her trouble down / I don't know how my father stood his ground." With the original tempo of the song slowed down so as to savor every verse, she ventures steadily into lyrics that signal a way forward, "I don't know how my people survived slavery / I do remember and that's why I believe."[6]

The song's intricate genealogy unites past freedom fighters with the as-yet-to-be-born and yet still makes space to memorialize forgotten, elided, and invisible struggles that linger. Our contemporary *Slow Fade* sisters in sound hold these two worlds together and act as the conduit to "raise" the voices of the fallen "in justice." They build a performance path that Weems describes as "an evening of music, centered on this idea of a woman's journey, the span of a life," "explorations of the nature of love, desire and female identity, examining women's relationships to men, children and, most important, to themselves."[7] Visual artist and musician duet with each other in this production, scoring, revisioning, and repurposing the philosophy of what it means to live a free life, that which has been passed down to them as idea and possibility by the ancestors. They make art of and for the here and now, art for the next world(s), art informed by the past and built to run a thousand miles (or more) toward the freedom of the future. They make art that follows the compass that is the archive. Sitting for an interview with the *New York Times*, Weems and Allen make this much clear. *Times* critic Felicia Lee describes how, in the midst of rehearsals for the *Fade* production and "at Ms. Allen's suggestion," Weems shares "some Harriet Tubman quotations" in preparation for the evening:

"I had no one to welcome me to this world of freedom," Ms. Weems read[s] in her husky, melodious voice.

Carrie Mae Weems, *Slow Fade to Black*

Ms. Weems then [tells] a story about how Tubman left her husband behind in one of her Underground Railroad excursions. Returning to find him with another woman . . . Tubman simply ask[s] the other woman to join her in escaping bondage.

Ms. Allen and Ms. Weems exchang[e] a knowing high five.[8]

What they "know" is a truth that the women in and of the historical archive—everyone from the Paulines to the Zoras, from the Mary Lous to the Rosettas, from the Abbeys to the Janelles—have long held close to them: that the potential for women to save themselves and each other is a key and crucial aspect of the history of Black liberation. Allen and Weems extend the legacies of those aforementioned sisters by turning to sound as the realization of those conspiracies and freedom dreams. Like the ones who came before them, they go digging in the archive, delighted by the evidence of righteously conceived escape plots hatched by that woman, called the "Moses of Her People," the one who will serve as the symbolic gateway into the evening they've collaboratively curated. They are making a way, pushing us forward into the underground. Others are following and also forging their own path. This chapter looks to them, the twenty-first-century Black feminist musicians keeping the revolution in intellectual labor alive and transforming it for new generations.

The Curatorial Turn

Those women who answered the call of Tubman, Weems, Allen, and company are perhaps more present than ever in this our current pop culture moment of the curatorial turn. For the most part, it is a beneath-the-radar phenomenon, this scene in which Black women musicians make history and memory their principal sources of concern, aesthetic inspiration, and avant-garde experiment. And it is one that largely lives outside the Twittersphere, one less likely to capture Arts section headlines or generate a thousand culture pundit think pieces. But make no mistake, theirs is nothing less than a sonic revolution led by polymath performers who see and know no boundaries between deeply imaginative archival and curatorial work—the work that one most commonly associates with ivory tower scholars—and radical music making. This Black feminist excavation labor at the site of music is a demanding and beautiful endeavor, undoubtedly tied to an ethical reclamation of the people and sounds and things that these artists insist through their recordings and performances that we cannot leave behind.

They are out there—artists like the longtime jazz icon, vocalist, guitarist, and pianist Cassandra Wilson. A smoky-voiced master of post–soul era jazz vocalizing, Wilson has been in the game longer than most in this set of sonic curators, having long focused her attention on a vast array of blues, rock, country, show tunes, and folk classics as well as jazz standards that encapsulate key points in half a century's worth of popular music history. Writing for the formidable jazz pianist Jason Moran's journal *Loop,* Wilson describes her "first encounter with the music of Billie Holiday," reflecting on the memory as one that is "bittersweet," a reminder of her relationship to a complicated photograph in her father's possession, one that she feels compelled to look after. It was "taken at a party held in [Holiday's] honor after a performance in Chicago," Wilson recalls. Her father, she continues, "never played her music for me in our home, I think because the stories surrounding her life were too salacious and sad to share with a teenager," she continues. "Everyone loves Billie Holiday now. But would they have loved her as much while she sang 'Strange Fruit' at Café Society in 1939? . . . Tall tales still cast shadows over the legacy of Lady Day. You rarely see balanced and informed criticism of her music and the music of many of her successors. Many journalists either don't take the time to educate themselves or they simply spout specious critiques for the sake of notoriety and compensation. Either way, we are all shortchanged by this kind of reckless" criticism.[9] Here, Wilson, the experimental jazz chanteuse, sounds a lot like Mary Lou Williams does in her letters that meticulously

keep score of the narrow-minded jazz critics in her own midst. And Wilson's own 2015 reading of Lady Day's songbook, the album *Coming Forth by Day*, pushes back against these very sorts of critical conversations. Here Wilson's comments also reinforce the enormous importance of Farah Griffin's break-all-the-rules Black feminist reimagining of Holiday cultural criticism, 2001's *If You Can't Be Free, Be a Mystery: In Search of Billie Holiday*. Above all else, Wilson sounds like a member of the Allen and Weems chorus when she lets her readers know that "For the record, I will express my intentions here and now: I follow this path to pay respect to my elders, homage to the ancestors, and . . . present uniquely inspired performances for my audiences. This is not," she assures, "the workplace for a diva; it is a sacred space for the rituals of an adept."[10]

They are out there, busy at work, laboring alongside Wilson, making new records of history. Classical avant-gardist vocalist Julia Bullock shares, for instance, an intensity in interpretative register with her. Like her, Bullock possesses a deep and abiding fascination with immersing herself in cultural history and mining the sometimes ominous complexities of a challenging, iconic artist's repertoire. She translates their sonic lifeworlds into sprawling works that often feel like dizzying journeys, odysseys that start in one emotional location and end somewhere else dramatically new and startling. Bullock is an archivist and a curatorial force in the most recognizable sense of the word in that her much-lauded 2018–2019 residency at New York City's Metropolitan Museum of Art set out to, in part, tackle what the artist referred to as "history's persistent voice." This was the title of both an essay by Bullock on the topic and her opening Met program that year, which showcased the artist's stirring readings of songs from slavery alongside the words of artists such as Alabama's brilliant Black women quilters from Gee's Bend, which were, in turn, set to music by a group of all-women composers, including the powerhouse New Orleans musician Courtney Bryan.[11]

The arresting manifestation of Bullock's ambitions is fully on display in *Perle Noire: Meditations for Josephine*, a dense, "darkly captivating," epic event staged in the Met's Great Hall in 2019 in which Bullock collaborated with experimental percussionist-composer Tyshawn Sorey and interpreted the words of the formidable poet Claudia Rankine. A concert piece that adventurously explores the speculative interiority of Parisian music hall sensation Josephine Baker, *Perle Noire* is at turns cataclysmic, thunderous, haunting, and defiant, as well as achingly tender. It also aggressively deromanticizes nearly a century's worth of primitivist public-sphere sentimentality and rapacious mythology about Baker, the grande dame of transatlantic music hall and cinematic spectacle in the 1920s and 1930s and an inventive physical comedian whose abundance of

kinesthetic talents hung in the balance with her sex appeal. Bullock's rich and unexpected reading of Baker, a heart-wrenching love letter from one St. Louis sister to another, literally gives voice to a legend known in France especially for her singing as well as her dancing brilliance and, during World War II, her valor and loyalty to the French resistance effort. Her surprisingly stentorian soprano vocals, her strategic choreography—a combination of frenetic movement, sensuous grace, and recalcitrant stillness—and her fearless, middle-fingers-in-the-air denouement reveal of a sheer top to her evening gown attire amount to the bold embodiment of Rankine's searing text, in which her Baker declares at one point, "All of me was already owned." *Perle Noire* is a ritual of archival and curatorial reclamation waged at the level of sound, movement, and visual statement.[12]

They are out there, showing up in some of the most unlikely places. Think, for instance, of how Bullock's work runs alongside that of an on-the-verge hip hop, R&B, and spoken-word artist like Jamila Woods. Woods's exuberant work pays close attention to ancestry and uses a wealth of aesthetics to press the question of historical speculation and the related, exquisite details of a Black woman artist's prerogative, creative choices, social refusals, and sly and sometimes whimsical ways of being. Armed with degrees in Africana and theater and performance studies from Brown University, Woods has infused a wide and dynamic range of her work with Black feminist theory—from her chapbooks and published poetry, to her efforts as the artistic director of Young Chicago Authors overseeing the beloved and influential Louder Than a Bomb slam poetry festival, to her energies collaborating with fellow Chicagoan and hip hop superstar Chance the Rapper. The relationship between the world of hip hop and Black grassroots activists and arts circles is a mutually constitutive line of creation and possibility in Woods's world, and her second album, 2019's *Legacy! Legacy!,* moves squarely to the center of a Black feminist sonic recuperative movement that mounts a series of poignant imaginings—of, for instance, sexually free funk rebel Betty Davis, who lays out the terms of her notorious difference on the track "BETTY" ("Oh I'm different, I'm a cup of mild sauce. . . . Let me be, I'm trying to fly, you insist on clipping my wings"), and of the Afrocosmopolitan cabaret trickster Eartha Kitt, who, in Woods's hands, stays the course as a stubborn outsider, impatient and misunderstood, on the track "EARTHA" ("I don't want to compromise . . . I'm trying to see eye to eye but you walk right over me").

Like Bullock, Woods is interested in the undocumented, forgotten, or overlooked interiority of Black sonic heroines, making music out of the details of their intimate selfhood hanging in the grooves of their recordings. With a mel-

lifluous timbre reminiscent of 1990s neo-soul flow and eccentricity (think Erykah Badu crossed with Jill Scott's rhythmic bounce and sway), Woods lays down slow-burning, highly curatorial jams that cut like a knife. Her masterpiece, "ZORA," achieves this kind of imagining as a "beautiful experiment in living free," as Saidiya Hartman might put it.[13] As is the case with "BETTY" and "EARTHA," Woods's ode to the Floridian polymath takes the form of a second-person address, an audacious confrontation with those skeptics who misread, underestimate, or altogether fail to see her in all her bodacious fullness and genius. "Must be disconcerting how I discombob' your mold," she sings with the kind of swagger and vernacular play that constitutes the characteristics of Zora Neale Hurston's expression, "I've always been the only, every classroom, every home. . . . My weaponry is my energy." Woods's Zora issues the opaque taunt that is, itself, archival pedagogy and a lesson in ethics—that is, that the beloved figures who animate our dreams and fuel our inquisitive desires do, nonetheless, hold the right to claim their own obscure remains. "You will never know everything, everything," her chorus insists, "I will never know everything, everything / And you don't know me so you up the creek." Eviscerating the forms of knowledge intent on circling and surveilling her, her "ZORA" mocks foes and moves, as she declares, onto "a new plane."[14]

They are out there. And this chapter leans into the ferocious and prolific energy of this artistic movement, this curatorial turn, and it turns now to three remarkable artists in particular who are building repertoires that run with the vivacity and vision of their fellow, aforementioned musicians. They travel the path set for them by Wilson, they imagine Black women's lost histories and unspoken lifeworlds like Bullock and Woods and, likewise, invent their own specific and indelible journeys in sound and memory. Rhiannon Giddens, Valerie June, and Cécile McLorin Salvant each uniquely revisit the traumas of racial histories in sound while standing in the eye of the current pop culture storm, performing for contemporary folk, indie, and jazz audiences, respectively, who possess varying degrees of "wokeness." By turning the songs of the past into a historical scene of contemporary contemplation, drama, and social critique, each of these women troubles the limited lanes to which Black women musicians have been consigned for over a century. Ahead, then, this chapter explores the work of these three distinct and distinctly curatorial musicians who repeatedly jump lanes and drive like Mary Lou out onto new frontiers, crisscrossing temporal and cultural milieus while holding fast to histories that demand our attention. All draw knowledges and creative vision from the pioneering sisters' repertoires, and each insists on keeping close the spirit of sonic foremothers in what amounts to singular, historically rich, genre-bending

bodies of work. In the tradition of the ones who came before them, these women each innovate a whole range of cultural ideas and artistic gestures that convey the ways in which blues and folk music remain deeply capacious sonic forms, broader and deeper modes of performative experimentation than one might expect of sounds so closely associated with seemingly long-gone socialities, with antiquated race record crazes and Old and New Left movements of the early to mid-twentieth century, with earnestness rather than avant-garde adventure.

But the music of Giddens, June, and Salvant reminds us of just how radical these old-school sounds were, are, and can be—these sounds that Hurston tells us came out of the jook. It is the music of self-making and Black feminist cultural memory, the music of storytelling and epic, historiographic ambition. Giddens, June, and Salvant find kinship with the legacies of these forms and, in particular, with regard to the blues, the surprising heterogeneity of its early roots, its melding of spiritual longing with secular desires and aspirations, the rawness of testimonial authenticity coupled with thespian flare, drama, and spectacle. They study the blueprints laid out for them by the early twentieth-century *Black* blues women, paying homage to them, digesting their aesthetic knowledge and translating it for new publics. It is worth remembering too that these iconic artists—the Smiths (Mamie and Bessie), Ma Rainey, the "Mother" of them all, and the dozens upon dozens of other women who were the first to make the blues a full-on sensation in the early 1920s—were themselves archivists in their own right. Collectors of sounds, translators and mediators of culture, these women gathered up the Southern, rural experiences and feelings of a people and yoked them together with the migratory conditions of Blackness. They were the ones who first broke through, the ones who seized hold of the blues form, wresting it from the white artists who aspired to sing this intoxicating music as well and who were granted entry into the recording studio long before the Black women who were inventing the music out on the rural tent show circuit. But history tells us that, when those sisters got in the recording booth, the sounds that they sent out into the world insisted that "everything was possible."

"There Is a Light That Never Goes Out": Mamie Smith Sounds Modernity

The music that constitutes the archives of Giddens, June, and Salvant is rooted in a long Black radical history of sound, and knowing something about each of these artists' archives means having to know more and think more expansively

about the Black women blues legends who paved the way for their aesthetic revolution. Their path toward curatorial genius was established in part by the fact that these old-school sisters had to arm themselves with a special set of (performance) skills, the kind that would allow them to engage a panoply of voicings, a supple approach to strategies of characterization, a capacious sense of the past and a recognition of present exigences as well as future possibilities for a people living under the heel of Jim Crow horrors and inhumanities. This was the O.G. blues woman's arsenal of powers that Harrison, Carby, Davis, and others have theorized and enumerated in their landmark readings of this work.[15] New millennium blues criticism might follow their example and use a broader lens to catch up with not only that vaster array of sisters who were doing this work but also, just as well, the volatile prehistory of the recorded blues that shaped and informed the kinds of aesthetic choices and strategies that African American women musicians would ultimately make in the era of their popular mass market emergence. The turbulent anti-Black conflicts and power struggles particular to the prehistory of the "race records" era, as it came to be known—the era when popular recordings began to be made by and for Blacks folks—is an essential phenomenon to keep in mind when considering what these pioneering women artists of the 1920s were facing as well as how they artistically responded to said conflicts and struggles.

As I've argued elsewhere, the specter of blackface minstrelsy frames the conditions of emergence for the blues music tradition inasmuch as the form was yet another site of intellectual property struggle between white folks with means and Black folks with no ability to copyright and mass disseminate their sounds. To the African American entertainers who made a way in that period before the blues breakthrough in the postbellum era, the ones who "blacked up" in order to keep up with the entertainment industry's blackface hustle, what was clear was that archiving and subtly subverting the gestures and performance practices of white minstrel troupes was going to be a necessity in order to survive.[16] Entertainer George Walker made this clear in a 1906 *Theater* magazine article on this subject. A skilled comedian and singer, an entrepreneur, and the performing partner of vaudeville legend Bert Williams during a highly successful stretch of years at the turn of the century, Walker was a stone-cold pioneer when it came to imagining how Black performers might actively out-bamboozle their lovin' and hatin' white competitors by entering into the business of blackface minstrelsy themselves. In his blunt and candid *Theatre* remarks, Walker notes how "Bert and I watched the white 'coons,' and were often much amused at seeing white men with black cork on their faces trying to imitate black folk." Walker "watches the white 'coons'" with a mixture

of amusement and condescension. These "fools," he suggests, "ain't got nothin' on us."[17]

We might think of George Walker's reflections as something of a prelude to the rarely discussed interracial women's encounters, quotidian collaborations, and cultural appropriations that shaped the evolution of early blues and the repertoires of the radical women who were our first Black performance archivists and curators of the recording era. They were the ones who were gathering it all up for the record, storing the sonic and cultural memory of the Black masses, and reassembling it in their intricate repertoires. They were out there, in spite of the fact that history has obscured them, favoring instead the folkloric grandeur of a lone brother bluesman roaming the crossroads and wrangling with the devil. This heavy romance has long distorted the recording history of the blues as an event that was shaped, in part, by women who were "watching" and listening to each other and who were vocally interpreting the musical texts of Black male composers like W. C. Handy and Perry Bradford.

Mamie Smith was at the very forefront of this craze, though she is often overlooked as a pioneer of the form. Mamie Smith. *That* Smith. You might get her confused with Bessie or Clara, perhaps even Ma Rainey—the sisters who would easily and rapidly outshine her in the 1920s—but it is Mamie who holds the distinction of being the first Black woman vocalist to record the blues. Her "Crazy Blues," a tune written by composer and performer Perry Bradford, set off a cultural sensation in 1920, creating a demand within the New York City African American community alone that resulted in a reported seventy-five thousand copies of the record being distributed to Harlem record shops within four weeks of its release.[18] It was an event that had been forecast by the silent parades and Black girls' longing for and love of the music that Morrison's *Jazz* plays out for us. In the midst of that "long, hot summer of 1919" when "black America thought, after the war, it deserved a new deal [and] white America disagreed, violently," Perry Bradford, the African American vaudeville veteran turned songwriter and record producer, went to work on scouting for a sister who could break the blues color line that placed white folks on record singing the blues and barred Black folks from doing the same. Bradford came up with Smith, a singer who, as David Wondrich puts it, "was tearing up the boards in a show called Maid of Harlem uptown at the Lincoln Theater."[19] Together, Smith and Bradford drew on Mamie's multifaceted skill as a vocalist who was "equally comfortable with raggy pop and Synco-Pep" and made a record that changed the course of modern popular music culture by bringing Black recording artists as well as their fans into the white mainstream frame of legibility. As Bradford, himself, promised in the self-described "jive" he kicked to Fred Hagar,

the Okeh Records label exec to make their case, this "colored girl . . . sings jazz songs with more soulful feeling than other girls, for it is only natural with us." This was the conversation that led to Smith's first track with the company, a sloping vaudeville number, "That Thing Called Love" recorded on February 14, 1920 with white musicians.[20]

Bradford's hard sell for what presumably came "naturally" to Smith, however, obscured her consummate professionalism as an artist. Indeed, Smith's artistic versatility led her to becoming what we might think of as a curatorial bridge figure of sorts whose "Crazy Blues" connected Black musical theater to evolving blues culture, Northern theater aesthetics to the faint yet felt traces of Southern jook sound, and the aesthetics of the "coon shouter"—that repugnant label for late nineteenth and early twentieth century white minstrel popsters—folding it all into Black women's popular music vocalities. These were Smith's roots and she flaunts them with ease and assurance on this game-changing joint of hers and Bradford's. Her history-making record not only altered American popular music culture's racial politics it also established a template for Black women artists to take artistic risks on record, to cross-pollinate genres, and to claim the kind of aesthetic entitlement of which Walker spoke so boldly—to, in short, "consent not to be a single being" with venom and verve in the sonic world of interracial love and theft. It was music for the people, and they snapped it up in droves.[21] Mamie's smash calls out to us to rethink our standard narratives of the blues as well as the gutsy complexity of Black women's musicianship more broadly.

In the summer of 1920, Smith, the Cincinnati-born-turned-New York performer, walked into a studio with Bradford, a shrewd blues business hustler. They were on a mission to counteract the industry's previous decade, when white blues artists like Marion Harris and Sophie Tucker, the daughter of Jewish Ukrainian immigrant parents, were breaking out with their own recorded renditions of Black music while African American entertainers—legends like Ma Rainey, Ethel Waters and Bessie Smith—were confined to burning up the stages all along the "Chitlin Circuit," the Theatre Owners Booking Association's array of venues designated for Black performers. Bradford and Smith's strategy was simple yet novel: allow an African American woman blues vocalist to appeal to Black listeners, proving they had a taste for popular sounds while spotlighting the artistry and the seriousness of the singer and her accompanying band. In short, they would showcase Black pop music excellence as achievable and commodifiable and win over manufacturers who, as the *Chicago Defender* noted on July 31, 1920, "may not believe that the Race will buy records sung by its own singers."[22]

Recorded on August 10, 1920, for Okeh Records and released in November of that year, Smith's gripping and rambunctious "Crazy Blues" hit all of those benchmarks and more. In its nearly three-and-a half-minutes, Smith sings in a robust vibrato atop horns and woodwinds, lamenting a love affair that brings her a boatload of pain. This is heartbreak that demands a multitude of emotions, so it's no surprise that she would lean into her pronounced theater-world talents. Smith's tale of woeful heartache and inconsolable grief eschews the gritty vocal chops that would rapidly become synonymous with the blues as the 1920s wore on. Our girl was a "vaudeville chanteuse" (appearing, for instance, in 1908 in Salem Tutt Whitney and Homer Tutt's stock company), and her style was unmistakable in that vein in that her voice resonated with the qualities of racial musical caricature translations and mutations found in turn-of-the-century stage shows.[23] Mamie Smith's skills as a vocalist reflect an accumulation of shifts over time in the Black vaudeville universe in which she was situated, shifts away from imagined folk vernacular and toward nascent jazz stylings, away from ersatz Southern regional aesthetics foisted upon Black folks by the ofays—who had their own ideas about "Black" expression—and toward the migration's pull into the colorful and varied sounds of the city.

For these reasons, it's crucial to think of Smith as situated alongside her Black women stage contemporaries, women like choreographer, singer, and actress Aida Overton Walker, who famously assumed her husband's George's musical roles in drag after his untimely passing. These were the sisters who were comfortable assuming many roles, wearing many stylistic "hats," as it were, and especially actively rewriting blackface forms and carving out a space for themselves in a line of work—that of popular performance culture which, it bears repeating, was first dominated by white men donning burnt-cork makeup in the nineteenth century, appropriated by Black male theater entrepreneurs such as Williams and Walker who saw a point of entry to disrupt and disassemble caricature from the inside out, and yet still again picked up by white men as well as women in the age of phonographs and film who were trying to make a living for themselves. "Crazy Blues" holds this history in its grooves.

Smith's "Crazy"-ness brought together all of these sounds and tropes, all of these feelings and history by way of a blues sister *on* record for the first time. It was pop radicalism that drew on her stage fabulosity in order to create a wicked amalgam of voices and gestures in song, a compressed 78 rpm edition of oft-overlooked Black women's love and theft, as well as a bold-faced lament of white repression, and a battle cry for Black revolt. Vocally, Smith's voice did, indeed, resonate with the swaggering lilt of coon-shouter Tucker's saucy singing, itself a reflection of pioneering sister vocalist Alberta Hunter's no-

table, early blues stylings. Backed by the Jazz Hounds, a band of Black musicians led by trumpeter Johnny Dunn, she wailed out a lament that would thematically typify the existential struggles of a musical genre on the verge of mass-market popularity: "I can't sleep at night / I can't eat a bite / 'Cause the man I love / he don't treat me right." Smith's threnody is a song hardwired in big, enveloping loss as wide as "the deep blue sea." It is a song that registers the plaintive wail of the standard blues heroine whose sense of abandonment leads her to the depths of suicidal despair.

Sonically it also bears the traces of Bert Williams's turn-of-the-century Black vaudeville musical poetry in songs such as the classic "Nobody," which finds Williams expressing his sense of social nonpersonhood. Like Williams's signature song, Smith's "Crazy Blues" features vocals that weave back and forth around wailing brass. The wind instruments in fact would make her number far more akin to early jazz rather than the acoustic juke joint blues born out of Southern culture, but Bradford had seemingly planned all along to spoon-feed this "new" music to the masses. She gets to work with the Jazz Hounds, "put[ting] a little rhythm into the proceedings" while "keep[ing] it light" and still "driving" and "swerving" a twelve-bar blues that left "plenty of room in the vocal line for Mamie to work the Senegambian bends." Says Bradford, "[a]s we hit the introduction, just as we had put it together in rehearsal, and Mamie started singing. . . . We were playing just as we felt, with those home-made 'hum and head' arrangements. . . ." It was, declares Wondrich in his excellent reading of Smith's release, "black folks' opera," the "first record to present American music as a fully realized art, capable of moving emotions as well as hormones, hearts as well as feet. Like European opera, it integrates the full range of human musical expression, instrumental and vocal, rhythmic, melodic, and harmonic. Like opera, it has love, death, beauty, and pain. And yet it's *not* opera. There's no score."[24] Traces of African American minstrelsy and vaudeville, white coon shouter contrivances, and early jazz instrumentation thread through "Crazy Blues." In its own time it was the quintessential generic and cultural mash-up track of its age. It was a masterful work of curation.

"Crazy Blues" was also one hot mess of a record—from its pathologized, hysterical, lovelorn heroine to its provocative fantasy of armed resistance to state surveillance, to its jarring racial caricature lyric, "I'm gonna do like a Chinaman, go and get myself some hop." On one end of "Crazy Blues," our heroine is all tied up in knots about the man she loves doing her wrong; by its close, her despair has morphed into a militant rage. Somehow we've gone from "Crazy in Love" to "Fuck tha Police" in the course of one song. The crudeness of the epithet and the awkward gesture toward mimicking the mythologized,

outlaw habits of the comarginalized, are, for sure, troubling and, unfortunately, *not* uncommon tropes for Black musical theater of the period. Where one might, on the one hand, hear an unsophisticated, cross-racial identification with the fellow dispossessed folks of color struggling in an America shaped in the early twentieth century by anti-immigrant policy and the expansion of US empire, others might rightly hear a lazy play on deviance. This was a song, then, that in its own time both waged and staged conflicts that were historical, social, personal. Blues woman Smith held court over it all and steered a volatile ship through stormy waters just as Bessie would do at the other end of the decade.[25]

No doubt, there will always be those who say that Mamie had little to do with breaking this portentous ground, that she was merely ventriloquizing what critics presume to be Bradford's Black male militancy sounded out in those haunting, hardcore, and troubling final verses. The explosiveness of Bradford's parting lyrics, its casual ethnic slur, its references to drugs and vigilantism, are perhaps some of the reasons why "Crazy Blues" was such an earthshaking cultural event in 1920. Something taboo was being uttered on record for the first time in the form of popular song by a Black woman entertainer interpreting the lyrics of a blues journeyman. As cultural historian Adam Gussow argues, such a line showcases Bradford's radical articulation of the "black bad man / outlaw" figure willing to seize on "black violence as a way of resisting white violence and unsettling a repressive social order" in the recording studio North as well as the Jim Crow South.[26]

But an overdetermined reading of Black masculinist desire here falls in danger of dismissing the fact that Black women had, for instance, voiced their own visions of radical, armed resistance and self-defense in postbellum works like Pauline Hopkins's 1879 musical *Peculiar Sam*, which features a gun-toting heroine in a supporting role, and in the insurgent antilynching journalism of Ida B. Wells, who forcefully called for the right to bear arms. That context, combined with the fact that blues women artists were active, improvising innovators in their own right, complicates this sort of a reading. "The blues took shape," as Ann Powers reminds, through "hidden exchanges—women comparing techniques, as they did in every aspect of their lives, and taking words or ideas shaped by men and correcting them to better reflect their own experiences. Female singers and their male accompanists," she concludes, "performed a sonic tango."[27] And this is the "Crazy" that we hear. Smith's recording wed Stagolee /"bad man" tropes with the Tin Pan Alley mannerisms of white women bluesers and siphoned all that energy into a Black woman's gripping sonic testimony about lost romance but perhaps also something devastating on

an even greater scale. It perhaps voiced a fresh sorrow that hung in the air in 1920, in the year that followed widespread racial massacres all across the nation, a reminder that the mad fever of white supremacy perpetually threatened Black life. Blues woman Smith recorded the feeling and sent out an invitation for others to follow.[28]

Her moment in the blues spotlight was, however, a relatively brief one. Mamie Smith had an impressive run as a mega-wattage celebrity who capitalized on the success of "Crazy Blues" into the mid-1920s with lavish wardrobes and sold-out shows. This is "one of the first cases in history," Elijah Wald asserts, "where a record makes a difference in somebody's career."[29] She was drawing white as well as Black audiences in droves. But blues veterans (like that other Smith) were nipping at her heels and would soon eclipse her in fame. Her stardom is key to keep in mind though because it forces us to reconsider the ways that classic blues women have been scripted—if and when they're referred to at all in the pop music canon—as the earthy, authentic "mamas" capable of charged double entendres but rarely as artists who pulled from multiple sonic genres, from vaudeville and folk, and who crafted vocal phrasings that could weave in and out of Black vernacular languages. Smith and her hard-working peers cultivated complex personas and, along the way, documented sonic America, keeping score of its panoramic pop music archive and issuing insurgent critiques of the American scene.

"Crazy Blues" is, then, the *curatorial* performance that sets everything down for the record and sends it into play. It is the encapsulation of modern sounds that indicates and inaugurates the arrival of a new turn in modern culture led by Black women. Like an archive, it holds together the histories of intertwined gender and racial appropriation narratives (between, as Jayna Brown reminds, white women entertainers like Fanny Brice, Mae West, and especially Jewish singer Tucker, "the last of the red hot mamas," and the Black women artists like Alberta Hunter and Ida Forsyne in their midst), traveling Black big-tent performances (that Rainey had been heading since the 1900s), and the turmoil of always imminent racial violence that Black folks have forever had to navigate.[30] Mamie Smith is the blues summation of all of this charged history and feeling. She is paradigmatic of blues music's oft-forgotten cultural fluency, multilingualism, cross-racial imaginings, insults, and injuries. Such a performance, the first of its kind to work its way to the center of the culture industry and thus fundamentally transform it, inverts dominant perceptions of mythically static ur-Blackness in pop, that which Hortense Spillers famously tells us is born out of an "American grammar" in which "ethnicity . . . freezes in meaning, takes on a constancy, assumes the look and the affects of the Eternal."[31] Into

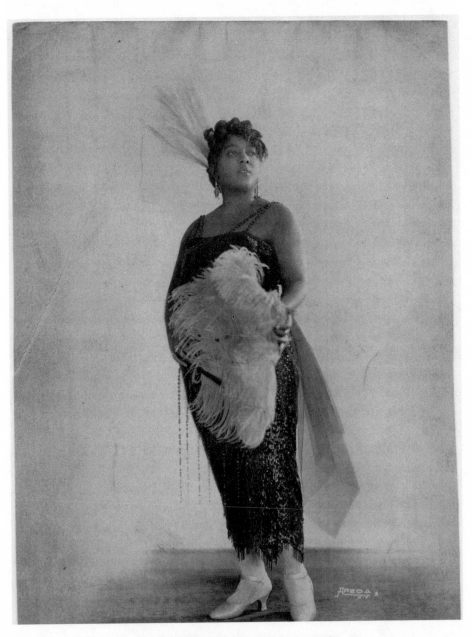

Vocalist and vaudeville star Mamie Smith,
the first African American woman to record the blues

this context, "Crazy Blues" introduces on record the figure of the African American woman vocalist as a conduit for complicated, colorline-busting Black sonic womanhood as she had (literally) never been heard before by the masses.

Smith's recording conveys the interpretative depth, the archival savviness, the dramatic will to translate history into sound, and it is an oft-forgotten and an underheralded recording that nevertheless undergirds a long line of Black women performers and the practices that they keep innovating and making anew. It is a record that is nothing less than revolution in and of itself. The sound of revolution erupts from the work of an artist who claimed everything behind the microphone in spite of Jim Crow culture that did its best to restrict her human desires and social ambitions and expected little from her. She sings out to the brilliant musicians who are digging in the archive to come and find her.

Her "madwoman" declarations live on in the howling incantations of twenty-first century millennium women musicians who have pushed the limits of social defiance and multiformalistic possibility, from still "crazy in love" after all these years Queen Bey to Bronx tale "money moving" Cardi B to "Protect Black women" Megan Thee Stallion, and her archival invention, her boldness as a sonic curator, lives on in the work of the three artists in particular examined later in this chapter. The heirs to Mamie are the reminder that this revolution in Black women's radical sonic repertoires shaped by curatorial vision and experimentation is long and strong. But it's crucial to first remember that it's Mamie, the breakthrough sonic curator, who lit the fuse.

A particular set of sister archivists have taken up her charge, adventurously committing themselves to doing this old-school women's work. And they each most certainly need Mamie's aforementioned skills not only to sing their own particular version of the new millennium blues but to use those skills in the service of speculative dreaming and remembering. It's Mamie's multifaceted craftsmanship and heterogeneity that allow each of them to open up history like a Bessie Smith trunk, to, in short, demand that audiences experience history on different frequencies, to conjure the interior lives of Black folks in the archive, and to insistently and inventively not let this history fade away.

The Fieldwork

Out in the field she is digging up the roots of America's sonic past. The revivalist, folk instrumentalist, and classically trained vocalist Rhiannon Giddens is on an expedition. A critically beloved pop anomaly, Giddens is the kind of curator and archivist who propelled herself from an Oberlin Conservatory world

Rhiannon Giddens

of classical vocal training to playing instruments steeped in the history of global migrations and cultural cross-pollinations. She has broken the sound barrier in contemporary folk and roots music culture by insisting with a kind of pointed conviction that the "moral imagination" of these genres, as Valerie Smith might put it, demands that musicians like herself flex their interpretative muscles so as to record and (re)cover songs that render *the past in sonic form*."[32] Giddens's discipline as a musician, the depth of her multi-instrumentality and versatility as cofounder of the beloved, "old-time" Afro string band the Carolina Chocolate Drops, and most intriguingly, her passion for very old songs from the deep grooves of racial, gender, class, and regional histories of the repressed, the neglected, and the forgotten past make for a formidable repertoire, one that honors that pioneer class of Black entertainers who were, as she insists, "transcending the blackface" in spite of the times that demanded caricature by the cartloads.[33]

No popular music artist of her generation has so publicly invested her career in making this kind of archaeological "dig" into the vaults of Black Americana

so principal in a repertoire. One would have to look back to the likes of Odetta or Nina to find a major-label musician as omnivorous about consuming and reinhabiting songs that cycled through this country's antebellum and post-bellum horrors, as well as one who has committed herself to gathering up trace materials of slavery's "unspeakable things spoken" and shaping them into musical reckonings for a new day. Like Zora, like Odetta, like Nina Simone before her, Giddens is unabashed in defining her musician's work as something akin to the work of the *historian,* and she wears this hat while bearing a kind of ethical responsibility to the music itself and looking after the instruments tied to sounds and peoples from far away and long ago whose resonances are still with us. This is fieldwork conducted by an artist who often expounds on what it means to "give old songs new life" and make the past "a living thing." The humility that she brings to said projects is evident in how she manages the ac-colades. Upon becoming the first African American as well as the first woman to win the Steve Martin Prize for Excellence in Banjo and Bluegrass in 2016, for instance, she deferred to the Black diasporic instrument itself as the object most worthy of our focus and care ("I don't want it to bring attention to me—I want it to bring attention to my banjo. I exist to tell the story of that thing."[34])

Black Feminist Roots Music

Giddens the historian, the curator. Giddens, the one doing work way out in the field, is on a mission. She breathes new life into forgotten stories, sounds, and instruments to reach an audience who is, more often than not, far removed from her mixed-race Black North Carolina upbringing and whose affective in-vestment in the afterlives of slavery is a question mark rather than a given. To make white listeners, roots music aficionados, Newport Folk Festival regulars, *New Yorker* intellectuals feel something more about the human condition of Black captivity and its aftermath is a recurring trope and strategy that courses through her work. To alter her listeners' relationship to Black folks' history, Giddens leans into her deft instrumentality and rigorous classical training as a tool for exigent and intense storytelling precision. These are the sorts of chops she puts to work in the service of, at times, speculative narration, imagined scenarios, and invented lifeworlds she draws out of her own archival research on slavery. This is pragmatic sonic curation with an eye toward recuperating the humanity of the enslaved as Giddens invites audiences to imagine culti-vating deeper relationships with the ones who are rendered nameless and kin-less as a result of bondage.

To tell a free story of the people and things (and the people who endured cen-turies of being deemed "things") that constitute her multiracial, "Affrilachian"—

as one critic refers to it—feminist being and, more broadly, to tell a free story of the bedrock of America's densely charged racial and gender history in music, Giddens has turned the topic of her own indebtedness to musical ancestors into the driving conceptual vision that has shaped her emergence as a solo artist beginning with her 2015 debut album, *Tomorrow Is My Turn,* produced by roots music icon T Bone Burnett. It is an album that constitutes a break from the intoxicating string band music she'd been making for a decade already with the Carolina Chocolate Drops. Whereas her tenure with the Drops showcased her rich command of country blues, early twentieth-century "hot" music, classic blues, and early jazz idioms, *Tomorrow Is My Turn* brings to the fore Giddens's passion for feminist artistic intervention.[35]

The tale of the title is itself a statement of pointed reclamation and the execution of her "I'm-just-a-vessel" philosophy. Giddens makes clear her intent on the liner notes to the album, describing how she was "enthralled" with Nina Simone's ravishing 1968 London performance of French vocalist Charles Aznavour's "comme ci, comme ça" anthem, as Ann Powers might refer to it. "This imagery," Giddens continues, "was never too far from me for the recording of this album." While some critics have misread this choice as, for instance, "Giddens' gentle approximation of 'My Way,'" others, like Powers, have noted the ways that both title and song are, for her, articulations of her solidarity with the archive, her investment in drawing out and honoring a legacy of resistance that's bigger than either woman. From Simone's reimagining of Aznavour's song as "an expression of both determination and rage" to Giddens's cover on the album, which reads as "more elegant European pop than jazz," the latter ultimately "preserves Simone's fierceness but also mellows it, making it a stealth declaration of resilience." Says Giddens, "You can interpret it as me saying, 'Tomorrow is my turn,' like I finally get to have a solo record, but it actually has nothing to do with that. . . . I was watching [Simone] and just thinking this was the soundtrack for her."[36]

To curate a soundtrack for the marginalized and the forgotten, the overlooked and the undertheorized, Giddens went crate-digging, assembling a collection of songs inspired by a conversation she'd once had with choreographer Twyla Tharp about a dance of hers inspired by the Chocolate Drops' version of bluegrass standard "Ruby, Are You Mad at Me?" by white banjoist and country singer Cousin Emmy. "I realized Ruby represents these women like Emmy who have done so much amazing music before me," says Giddens. "So when T Bone asked me, 'What is the record of your dreams?' I said, 'Finding Ruby.' That's what I want to do." *Tomorrow Is My Turn* is an invitation to go searching with Giddens for women musicians, "songwriters and performers, claiming

with them that it is their time" and seizing on her interest "in the feminism of women in American music," how they were going out on the road "way before the opportunities and advantages that I have—it was absolutely rough out there. The fact that they were still able to get their art out there and do what they're doing is really impressive to me."[37]

She follows the trail of the lauded as well as "the lost" on this record, reaching out to the elusive women, the ones who have fallen off of or who maybe slipped for themselves outside the cultural radar altogether. This is the occasion for pointed covers of, for instance, Geeshie Wiley and L. V. Thomas's underground classic, "Last Kind Word Blues," becoming the first Black woman artist to deliver a recording of that song. As she explains it in her notes, Wiley and Thomas's song "calls to [her] in a way that [she] can't really explain, but when" Burnett "suggested it for the record, [she] knew instantly it was the way to begin." Geeshie and L. V.'s ballad goes electric as Giddens and her band's guitar-driven cover keeps pace with the ticking counterpoint of a mandolin. With "the ghosts of the unknowable and mysterious blues musician[s]" by her side, she walks the line of musical lineage that threads through the album from beginning to end. A cluster of covers, signature songs made popular by Odetta ("Waterboy"), Sister Rosetta Tharpe ("Up above My Head"), Nina Simone ("Black Is the Color"), Patsy Cline ("She's Got You"), and Dolly Parton ("Don't Let It Trouble Your Mind"), constitute the fierce moral backbone of Giddens' *Tomorrow*. It is a record that performs a history of popular music culture with women at the center rather than at the margins, "a mosaic of women's perspectives on love, war, work and faith."[38]

This is a point that Giddens amplifies with the aid of her liner notes, the site of her intellectual labor in relation to her own music. These are notes that amount to alternative historical ground, a platform for her to highlight the untold metanarratives of these artists' careers as sources of inspiration. She shows her love for Parton's business acumen as well as her being "a damn fine songwriter"; Patsy's skill in taking "care of her family and friends" while also taking "control" of her career, "inspir[ing] respect in an industry run by men"; Tharpe's role as a "pioneer of rock-n-roll guitar"; folk and blues heroine Elizabeth Cotten's time spent "keeping house for the Seeger family" in the period of her discovery. She floats alongside these women as she looks after their songs, offering up a sweetly ironic dedication tune of sorts as the denouement for the album. Initially written at the close of working on 2014's hagiographic Dylan project, *Lost on the River: The New Basement Tapes,* with a cluster of iconic roots and indie rock dudes, "Angel City" is an original song by Giddens, her way of paying tribute to what she describes as "an intense, difficult, and

incredibly rewarding experience." But as she was "considering it" for inclusion on her album, "it struck [her] that the lyric also represented how [she] felt about" the women covered on her record. As musician Susan Davis poignantly observes, Giddens clearly "includes the song here acknowledging the rich lineage of women who paved a way in stories, songs and suffering."[39]

> Time and time at hand
> You helped me over the sand
> Gently rising to be
> You walked a mile with me.[40]

"Angel City" is a significant track in Giddens's career inasmuch as it references her shared intellectual and creative affinities with Bob Dylan as opposed to her unabashed worship of that giant. An admitted *non*–"Dylan head," she accepted Burnett's invitation to participate as the only woman in a supergroup featuring Elvis Costello, Jim James, Marcus Mumford, and Taylor Goldsmith. "I knew I was going in as the traditionalist. . . . I was listening to the stuff that he listened to. So I kept it that way. I didn't bone up on Dylan, I didn't listen to the original Basement Tapes, I just went straight for a traditional sound." Recontextualizing ye old bard as a student of past sounds and worlds, Giddens reframes the Dylan archive as an assemblage of aspirations not unlike her own: to collect songs and use them as portals to translate and transduce the tenuous divide between that which has come before and that which constitutes our present conditions. Both have shown no fear in burrowing deep into history and transforming songs as a means to reveal "the political power of the single voice," as Powers puts it, "not to dictate or even necessarily cajole, but to state truths from a different perspective that shows earlier tellings to be shockingly incomplete. The song opens up and receives this new information; listeners hear it and realize something fresh about their own lives. They may even be compelled to act."[41]

Such is the case with her reading and video treatment of "Black Is the Color," a traditional ballad made popular in contemporary culture by Simone and Joan Baez. Giddens's sonic and visual reimagining of this classic, however, reverberates with "new information," new speculations about Black music's past, and it invites her listeners to go with her to the site of jubilant discovery. Turning the song, itself, inside out, she transforms the reverential tenor of that brooding ode into a modern beatbox-driven, Zydeco-inflected tale of a woman's exultant awe savoring the beauty of her lover. The accompanying video, however, goes one step further, turning a love story into an historical revelation about the

fullness of everyday, archival Black musicians' lives. Shot on location at Nashville's landmark historically Black college Fisk University, the "Black Is the Color" video literally positions Giddens *as* the archivist, suited up in a sharp blazer and carefully turning the pages of J. B. T. Marsh's 1875 classic, *The Story of the Jubilee Singers with Their Songs*, the tale of the "young, gifted and Black" powerhouse choir emerging out of Fisk in the era of Reconstruction. Brave students committed to their craft, the Jubilee Singers flexed their commanding skills as vocalists and stormed the trans-Atlantic world for the uplift cause. Immersed in this history, the Giddens of the video combs through rare photographs, portraits of young Black folks bearing strong and steady gazes, old letters, material mementos and trinkets, the traces of intimate life presumably left behind by lovers, a mystery for her to piece together. One Giddens studies while another roams the corridors barefoot and contemplative, drinking up the aura of that historic place, while yet another dances in the archways with the band, decked out in an elegant cocktail dress, waving a tambourine, delighted by this rapturous discovery of love in the archive. She shares the news with her band and off they go, heading in the direction set for them by Tubman.[42]

"Playing the Deep Layer"

She is in pursuit of all of it, the kind of history best conveyed through the affective details that only song can supply, the kind of history that comes bursting through her earnest and fiery performances, her original compositions, and her interpretations of very old and long-forgotten music. This is, at the end of the day, a self-consciously radical and ethical affair, one that recuperates long-repressed tales of racial entanglements all bound up in the archival instruments so precious to her. This is deep, visceral work for Giddens, as she candidly explained to me and to my colleague Brian Kane during a public conversation in November 2018. "Look," she offered. "I am so happy with my life, but I am also aware that this stuff eats me up from the inside out. I cannot do anything but what I'm doing. It's an obsession."[43] Two major questions seem to stir this passion: What can I do to honor the ones no longer here, the ones whose stories have yet to be told? And how might the music and the instruments of our American past disturb all of our presumptions about racial alienation, othering, and estrangement? What might one Black woman roots musician, a self-described "super nerd," do to ignite a revolution to reform this country's faulty and fallacious racial memory and seize its chance for a different kind of (re)union with itself? Big ambitions for one niche artist most loved by the NPR set. All she can do is "her piece," as she indicated in her interview with us. But what's clear is how ironically important the legacies of that profane and most durable art

form, blackface minstrelsy—the sounds of which Mamie was remixing in the studio but also those that reach even further back, a century earlier, to the scene of antebellum pop mania—are to Rhiannon Giddens's moral musical project in the archive.

"I had to go to this white dude Briggs," she explains. It's this 1855 banjo tutor by Thomas F. Briggs, the first published pamphlet of instructions on how to "hold, tune, strike and finger the banjo," and a "primary source of the five-string banjo tradition," that Giddens takes up as source material for her work with that instrument. This is her point of departure, a chance to study the specific minstrel banjo and to dig for the kind of complexity in sound that might for her open up deeper, subterranean historical truths that need to be told.[44] The fact that it is Briggs, the white guy transcribing and notating Black sounds, who remains the mediating figure in her movement toward and through minstrel music is, it turns out, crucial to the tale that she's committed to telling. "I accept that this is a white man who wrote this down," she muses,

> This is through his lens.... Every piece of music we have from enslaved people in the Americas up to a certain point is through the white European lens. So I accept that. So I can either say "alright, I'm just not going to do this." Or, I'm gonna say, "how can I find what I'm looking for in this music?" ... Especially the early stuff ... 1855 ... to me, is nothing but African American [music].... And so I have ... really gotten deep into the minstrel banjo and through that into minstrelsy and realized that this is a legacy that we ... haven't even begun to grapple with. And as a black woman ... I feel like I have an opportunity to talk about it in a way ... that goes forward.... I feel like it's part of *my* journey, I have a duty to do that because of what that banjo has done for me in terms of unlocking some voices ... being an instrument. Part of my reclamation of that instrument is writing slave narrative songs *on* it.... And it wasn't something [where] I said, "I'm going to sit down and write some slave narrative songs on this banjo." It just *happened*.[45]

This particular instrument, charged with the residue of white male working-class immigrant strife and longing, angst, and ribald fun at the site of Black insult and subjugation, is yet still the thing to be taken up by the Black feminist sonic archivist who remains ready to unlock the other musicians submerged in the contours of its gut strings, in the grain of its wood. Having devoted her early career in part to moments of arresting memorialization in relation to old school African American string music with, for instance, the Chocolate Drops' luminous rendering of "Snowden's Jig," Giddens's own odyssey with the min-

strel banjo has kindled a fire in her to keep widening the story of how intrinsically valuable and necessary Black sonic life is and has always been to American culture as well as how deeply entangled Black and white sounds are with one another in the making of that culture.[46] She orchestrates a dense network of historical callings and conversations through this African instrument transplanted to the US South and emergent on the scene in the early nineteenth century.[47] Break the fear of looking blackface in the eye, Giddens insists, and one reclaims the truth of Black innovation driving American aesthetics. "We have to . . . really look at it," she argues,

> because it is in *every* piece of every American cultural [life] there is. . . . It's just that embedded. . . . I'm going to do my little one piece by looking at it through the music. . . . We need to look at how terrible this was and what it means for our culture, but we also have to look at it as some of the first black-white cultural exchange that we have . . . [as well as the notion] that there were a lot of working class whites who were playing this music because that's what they could do. . . . I just think that there's more sophistication that needs to [inform the conversation] . . . and as a musician, my job is to lead with the music. Let's demystify this term, "minstrel," and let's . . . say—it happened. . . . The images are hard. I *live* in this stuff. I see the images, I read the lyrics. They're *awful* . . . but yeah. This is our history. We gotta look at it. . . . [It] has to do with our national identity and stuff that's happening now.[48]

Lead with the music and use the instrument as your fact finder, your object that picks up the traces of taboo and repressed encounters, cycles of theft and mimicry resulting in Black innovative sound repeatedly being removed from the hands of its first architects and transformed into America's principal definition of its (cultural) self. Imagine her slinging that banjo like freedom-fighting Woody with his infamous antifascist "machine." But the analogy only goes so far, as Giddens pointed out to us during our public conversation. The metaphor of her own instrumentality is insurgency without the violence. Rather, as she asserts, "it's a response to violence," this music that she writes on the banjo. "Because," she adds,

> of where it comes from, what it comes out of. What it means. The fact that the banjo was the first American cultural export. The first one. Banjo music is the first indigenous—if you're not counting the numbers of indigenous musics that existed before the colonists got here—the first

["American music"]....*And it was considered that*....And because of that it has a weight and [an] importance to our culture that other instruments don't have. It was the original dance instrument....One hundred years before rock and roll and the guitar it was minstrelsy and the banjo.[49]

This is the mission, then, the work that continues out in the thick of the field: to restore Black life to the banjo itself in public and communal settings with white folks witnessing scenes of Black musicianship steeped in a history that they may not even fully comprehend but with which they are nonetheless invited to engage. This is how it went down at the 2016 Mark Twain Prize awards ceremony honoring comedian Bill Murray, an affair in which Giddens performed two songs, including one derived from the minstrel-loving Twain's 1865 short story "The Celebrated Jumping Frog of Calaveras County." Giddens called it, "a reclamation...because I had my friend Roland...the most amazing bones player in existence....We are up [there] doing pieces...inspired by music that *we* created many years ago....It's like full circle....I'm not up there in a blackface outfit. I'm up there in my gown." What's staged is intimate, private, and yet right out in public, a taking up of a thing shot through with generations of pain and violence masked in folksy, local-color soft-shoe humor. "The people in the audience didn't get the joke," she adds. "They didn't know it was blackface tunes. They didn't know it was minstrelsy. They just see a black woman with a banjo and a black man with bones playing this tune that sounds cool. Everything has multiple layers....I'm playing the deep layer knowing that the other layers are hopefully getting out there."[50]

Sound Insurrections in the Archive

Rarely has a contemporary pop musician been so explicit about her insistence on inhabiting the role of what she describes to Gayle Wald in a 2016 interview as an "historical musician." Her investment in using song as the plateau on which to sort through her archival excavations, to use performance as its own form of further expedition into the historical past, of conjuring slavery's afterlives in music of our moment, is even more fully realized on her 2017 album, *Freedom Highway,* which includes original compositions such as "Julie" and "At the Purchaser's Option." Both songs bespeak brutal tales of slavery's calamitous wounds. The former is a high-voltage rumination on the complex forms of intimate power, domination, exploitation, and forced domestic entanglements in Southern plantation culture. Inspired by an historical anecdote included in Andrew Ward's 2008 book, *The Slaves' War: The Civil War in the Words of Slaves,* Giddens's "Julie" channels a speculative dialogue between the captive

heroine of the song's title and her incredulous white mistress as they each contemplate their shifting fortunes in a plantocracy that's pitching toward ruin. The "archive of emotion" that Giddens bodies forth in her performance is keen and strong, the pivotal epistemic tool in her repertoire that enables listeners to question what they think they know about the depths of Black folks' rage and resistance in slavery. All of that comes to the fore in a fiery climax, one in which captive-no-more declares to her mistress, "In leavin' here, I'm leavin' hell." Giddens "offers herself," as Wald sees it, "as the vessel for surfacing the traumas of slavery."[51] She has built these songs like "Julie," as well as "At the Purchaser's Option" and "Come Love Come," out of the archival remnants of anonymous Black folks' lives, out of the traces of people who are buried in the detritus of the peculiar institution's industry as it manifests itself in the ads posted by masters and slavecatchers hunting for lost human "property" (in the case of "Purchaser's Option") and stories detailing the agonies of separated families and the quest for love in the face of bondage. The important and necessary work of "Julie," as she insists, is that it gives "voice" to the fury and "grief of an enslaved black woman—exactly the sort of black interiority the minstrel tradition erased, or hid behind the masks of comedy or parody."[52]

This is Rhiannon Giddens staging a quiet yet forceful sonic insurrection in the archive. As comfortable with Celtic song and art song arias as she is with field hollers and the blues, she brings righteous conviction as well as nuance and color to her portrait of a people in sound. "I feel like it's what I'm here to do," she ponders, adding, "As soon as I found those books and I started writing these songs it was like even beyond the Chocolate Drops. 'Julie' is named and the mistress is not for a reason. And 'Julie' just announced herself to me.... There are these songs ... I feel ... uncomfortable even claiming them."[53] Summoning the many voices—Appalachian, early jazz, operatic—that live in "different places" in her body, she tells rich and varied tales that constitute her own being. "The more I learn about those old songs," she declares, "the more I learn about my grandparents which means I learn about my parents which means I learn about me." Poring over primary documents from the disaster of the peculiar institution, Giddens returns time and again to the scene of the historical crime that has yet to end. She stays in the field, digging and demanding an emotional reckoning with the archival materials—letters, photographs, bills of sale—that account for the fact that, as Toni Morrison reminds, "slavery was one person at a time."[54]

What can it mean, though, to wrestle with these horrors for a fan base largely removed from the legacies of subjugation born out of captivity? As John Jeremiah Sullivan observes, "She is an artist of color who plays and records

what she describes as 'black non-black music' for mainly white audiences." His 2019 *New Yorker* profile of Giddens lingers on the emotional relevance of this point by offering a poignant, contrasting scene in which the artist tearfully recounts "the first time she'd played to a majority-black crowd. 'It was so many beautiful brown faces all together, listening to my music, and responding to it in a cultural way I don't get to experience—talk-back, movement," she recalled. "They called me Rhi-Rhi.'"[55] The choice that Giddens has made at this juncture of her career, though, pivots on a kind of outsiderness that she is determined to upend, turn inside out.

Her "quest, . . . is, in part, to remind people that the music she plays *is* black music," as Sullivan observes.[56] It is also music that she describes with aspirational sincerity as right out on "the edge," as capable of conjuring and radically recapitulating quotidian racial intimacies of bygone days, nestled in the margins of the past, neglected and forgotten, the sounds that are, for her, the key to a different kind of national futurity. Cut, then, to Wilmington, North Carolina, the fall of 2018, where Giddens stands in a theater built in 1858, the same year of the make of her replica banjo. She is on hand to mark and hold a requiem for the victims of the 1898 racial massacre in that city, to perform music that memorializes the slain. "And I played the banjo in that house with no amplification," she recalls weeks after the event.

> *People freaked out over this music.* . . . That's the moment where I was like, "o.k. what I'm doing is useful." . . . That moment of being in that theatre with that banjo. . . . If we can understand that, we can understand . . . the music that is coming out of two . . . cultures. . . . It's at the edge . . . right where the edge rubs. That's where the magic happens . . . all of the really tough stuff that happened in history. You have all of this "edge work" going on between people who are just living their lives. They're not generals. They're not presidents. They're not plantation owners. They're just people living their lives. And maybe trading licks with that guy or getting a tune from over here. And those edges is [sic] where America is. It's where all of the unique stuff about America is born.

"So," she adds, "anything that we can do to highlight" that—even when it's "born out of a lot of misery and a lot of sorrow"—is seemingly worth the risk of occupying the culturally in-between as an artist.[57]

That ambiguous realm is the place where she has resigned herself to thrive. In spite of her seeming illegibility among a large swath of contemporary African American listeners removed from and likely uninterested in banjo-based,

historically resonant sounds, she is conversely every bit the rock star in the world of American songbook–loving, folk festival–attending white boomers like the crowd I observed out in force to hear her on May 13, 2017, at New York City's Alice Tully Hall during a stop on the *Freedom Highway* tour that year. The former issue clearly weighs on her. As she notes to Sullivan, a collaboration like the marvelous and unprecedented-in-this-modern-moment Our Native Daughters project, which features Giddens, Amythyst Kiah, Leyla McCalla, and Allison Russell—women-of-color banjoists "depict[ing] black women's resilience from numerous angles"—is likely to receive scant attention in African American communities. "It won't get covered by any black press," says Giddens of the album, which prompts her to ask, "Am I truly that out of the black cultural Zeitgeist, or are the gatekeepers just that narrow-minded?" Contrast that wistfulness with her stubborn attention to staying the course of Blackness while engaging her devoted fan base, given what's at stake for her as a folk artist doing the fieldwork of sonic racial reform.[58]

At Tully Hall that May night, performing her blunt, Black Lives Matter protest lamentation, "Better Get It Right the First Time," Giddens cultivated a mixture of plain-spoken ache and rage about the fate of Black young manhood under perpetual surveillance, the crisis of forever being a moving target in the crosshairs of state terror, and the moral risk hanging over a failed justice system. With nephew Justin Harrington, a.k.a. the rapper Demeanor, joining her onstage and supplying his own intimate verse, Giddens did torn-from-the-headlines, woke-training, racial bridge work for a crowd that she held rapt with attention, willing and ready to witness, albeit from a comfortable distance, the resurgent sorrows of African American communities under assault. We might think of this as another version of her in-your-face agitation, her way of not letting her audience look past the perils faced by Black folks of the past as well as the very real and urgent present. It's persistent protest work like that of Mamie, who lets us know that there's a riot goin' on just as her "Crazy Blues" is coming to a close. This folk operation of Giddens's, like Smith's sly blues radicalism, is one that will not let the catastrophes of Black life run mute in her music.

The Séance

Three thousand miles away from the Ireland-based Giddens, the Tennessee-born, Brooklyn-based guitarist and singer-songwriter Valerie June is on a mission as well, sharing tales about "roll[ing] and tumbl[ing]" and "toss[ing] and

gambl[ing]" on "lonely roads" and "astral planes" across her own Southern cosmic repertoire that floats somewhere in between ethereal outer-space Afro-folk and dreamy, Black country tavern soundscapes. June's is a repertoire of the folk and blues marvelous, a scene of perpetual archival enchantment. Like Giddens's, her music makes much of the archaic and the spirit-minded. It strives to account for those who have been mourned as well as those who have been wholly overlooked. Hers are sounds that have the power to both soothe and disrupt, stirring up the bygone, felt lives of genius Black women artists and song makers who performed and recorded music that affirmed the vast complexity as well as the tremendous delicacy and details of their humanity. She is an artist who combines mischief, whimsy, risk, and an ominous inquiry of the universe with the plaintive crooning of roots music balladeers and the aching vibratos of lonesome yodelers. The twenty-first-century jook joint is June's rapturous domain, and it's there that she unleashes her curatorial eye, mixing up genres—folk, country, blues, R&B, and indie rock—that attest to the thick and textured hybridity of American sonic culture. June, the conjurer in the archive, recenters Black women's artistry at the center of that heterogeneous culture in the spirit of Mamie and the multitudes. Instruments—that of the voice, the banjo, the guitar, the ukulele—are, in particular, her curatorial tools of wonder to explore the mysteries of the cosmos, to trip the (Afro) light fantastic, so to speak, and to draw her listeners onto other planes of being and knowing. And key to June's allure is that voice of hers, her conduit for inquisitive thinking and contemplation about the beauty, the magnitude, and the particularity of Black life. Alongside other instruments in her repertoire, June's voice is the sublime pathway to hidden and lost histories, lingering spirits, and stories that, to her, beg to be heard.

Voicing the Marvelous in the Archive

Like Giddens, June is all about her instruments, beloved, well-worn objects tied to a forgotten and neglected Black past that she might use, play, and commune with as a way to will contemporary publics into states of historical reckoning and existential wonder. This, too, is a passion project for her and one in which June handles her voice and other instruments rather than extensive archival citations (as does Giddens) as centerpieces in her work, as conceptual relics to create sonic scenes that bespeak temporal change, that convey the bonds of kinship, the scope of personal and regional journeys. These instruments are the sites of curation for Valerie June. They are the tools through which she works her imagination and, likewise, opens herself up to the historical imaginary. She builds a marvelous archive, one populated with musical

equipment for fanciful living that, for her, operates as a wondrous portal of enchantment.

June's vocal timbre is an aesthetic superpower in its own right, beautifully strange and defamiliarizing, almost Brechtian in its alienating off-kilter lilt, fanciful, at once Afrofuturistic and antiquated, the bridge between past, present, and someday Black ways of being in the world. She interpolates her quirky, endearing, distinctive vocality into the archive. Much of the drama and romance of Valerie June's sound comes by way of the gorgeous peculiarity of this voice, a pure and exquisite oddity in a pop world driven now by Auto-Tune standards and big, post-Whitney diva delivery. June's voice, in contrast, inspires striking metaphors, oddball descriptives, and oppositional analogies: "hypnotically gnomish," "a keening soprano that shows off its twang yet sounds totally contemporary," "a Billie Holiday-inflected voice," "tinny but also yowly and scratchy, like Dolly Parton meets Nina Simone meets some kind of singing cat."[59] It is a voice that is both endearing and uncanny, soothing and yet jarring, and it fully commands your attention. It is a multifaceted instrument that she curates and one that enables her to do speculative dreamwork through the riveting sounds that she invokes and evokes. Its strangeness is an invitation to listen from the standpoint of the otherwise, to be open to other frames of knowing and being *in* the world. Valerie June uses the dazzling instrument that is her voice to great effect and as a means to cultivating a kind of otherworldliness, an altered spatiality and temporality that is an archive of cultural memory in and of itself. It is a source of time-traveling, the medium by which she stirringly moves listeners in, across, and through panoramic vistas and historical realms with the turn of a phrase. With a "sense of time that's fluid and multi-dimensional," which critic Ken Tucker likens to a sci-fi "time slip," her sounds seamlessly loop together the bygone and the earthly right now.[60]

It is a voice that, in its luminous variations, sounds out the idiosyncrasies of the chorus, the lessons that Mamie and the blues sisters in all their vaudeville selfhoods taught us long ago. Such lessons involving the power of ontological multiplicity lie at the very core of blues feminist ideology. Yet the canon of long-standing blues criticism, crafted with an eye toward the romance of masculinity, has tied this music to the narrowest line of expressiveness, to one-trick-pony sexual self-making and the dangerous outlaw odyssey. No one would deny that such themes have been popular and necessary and have their roots in the jook and the material conditions of African American life lived on the edges of a Jim Crow culture perpetually policing and punishing Black folk. But June's séance with the spirits, like Giddens's historical fieldwork, tells us that the multitudes have so many more stories that they were trying and dying to

tell us. Her panoply of voicings is a throwback to Mamie remixed for twenty-first-century indie music culture. It is a thread that ties her to the elders: the line that she follows as she sifts through blues history searching for forgotten people and the instruments they played, ultimately aiming to look after them.

The dreaminess of a chosen migratory life, the wonder of temporal phases and seasons, longing for, finding, and losing love—these are all recurring themes that loom large across her body of recordings, which include two full-length albums, 2013's *Pushin' against a Stone* and 2017's *The Order of Time*. Voice is compass, ballast, magnifying glass in June's repertoire, intensifying the mood of the lyrical narratives she conveys like an Abbey Lincoln conjure woman. One hears a track like "Love You Once Made" and the condition of ephemerality is palpable as she alludes to "a memory faded to dust," a time when "suppers were on the table / And electric's paid and rent was stable." The very quality of her voice evokes that which is beyond the literal eulogy for a lost love that hangs front and center in the song. When June sings of "time's hand turn[ing] / to point straight away," that voice, "a marvel of seeming guilelessness" that "lightly but firmly shap[es] the melody" with its "scratches, cracks and quavers," is the insistent reminder of our ontological precarity, of our preciously fleeting relationship to the things and beings that are no more. It is "organic moonshine roots music," as June has herself described it, that stages a rolling (stone) séance.[61]

Born Valerie June Hockett in Jackson, Tennessee, and raised in a household filled with gospel, R&B, and soul, June relocated to Memphis in the early 2000s, becoming a beloved fixture on the local scene in that city of storied Black sound. It was there that she continued to develop her incandescent vocalizing, a signature style that yokes together the blues and gospel that she'd been raised on along with a healthy dash of Appalachian folk. Having resettled in Brooklyn's Williamsburg neighborhood, where she connected with an enclave of indie rock musicians, Valerie June has been cultivating an aesthetic that combines those said influences with folk and country, resulting in a repertoire that evokes something akin to neo-soul meets *In Search of Our Mothers' Gardens* bohemian, post-Erykah Badu tranquility all wrapped up in confident Black girl quirk. With Black Keys front man Dan Auerbach as her champion and key collaborator on *Pushin' against a Stone*, June came out of the gate on the national scene sporting the energy of revivalist electric blues, the aura of atmospheric, lo-fi Lomax field recordings, and the earnestness and fervor of the spirituals she grew up hearing in the church. The bluegrass gospel song "Trials, Troubles, Tribulations" on that album signals her enthrallment with the field recordings canon as she and Auerbach perform a delicately rendered

vocal duet of white folk and gospel singer Estil C. Ball's end-times, book of Revelations classic, one that forecast the coming of "the beast with horns." Here she fades the sounds of "white" rural music—yodeling, high-pitched harmonies set to acoustic guitar—into the Blackness of sensual blues and moody gospel incantations (on songs like "Wanna Be on Your Mind" and the album's title track), skillfully crafting a voice with "reedy, piercing intonation that cuts straight to the quick" and simultaneously demolishing pop's racial demarcations along the way. June, the curator of long-gone sounds, is "meld[ing] a nasal voice that is at once young and old—sometimes," Marissa Moss argues, "trying to sing like a grandfather, other times, a child, thinning the lines between both."[62]

This is singing that, June points out, evolved out of her upbringing in first a Black and then a white church, the result of her parents' decision to move the family "to the country." What could have turned into a familiar post–Civil Rights tale of social trauma and racial dislocation was, for June, a scene of serendipitous discovery. "That's where I learned to sing," she points out, "was sitting beside a different person every Sunday, and listening and listening. . . . Five hundred teachers, so a thousand total times in two churches." "Somewhere in the middle," June recalls, "I kind of messed up my voice." Critic Jewly Hight persuasively reads this moment as pivotal in June's journey toward becoming as an artist. This was the key point at which "a small-town Tennessee kid . . . made a study of varied voices in the Church of Christ congregations her family attended, planting herself in the pew next to singers male and female, young and old, black and white—those who pushed the notes of the old a capella hymns from their nasal cavities, from the backs of their throats or from deep in their chests. By now," Hight observes, "June [has] developed an inviting, inscrutable drawl that seems to encapsulate all of those possibilities, youth and agedness and everything between."[63]

That singular sound of "Williamsburg Appalachian country blues pop," as the *New York Times* refers to it, is music that converses with a bygone, agrarian folk era while still, like Giddens's work, pulling the past into our felt, present moment so as to challenge audiences to query the unfamiliar or the far-off and forgotten, to "have it be a question mark when you walk into the world" she creates.[64] There is a wistfulness to June's music on songs like "Twined and Twisted" and the acoustic version of her "Somebody to Love" (which appears as a hidden track at the end of *Pushin' against a Stone*) that tugs the listener onto a solitary plateau with her as she performs odes that sound out cosmic despair and human longing. Those feelings are especially pronounced in measured doses on *The Order of Time*, the album that followed the passing of her

father, concert promoter and construction company owner Emerson Hockett, in November 2016. All of that spirit work is especially poignant as June, the product of a tight-knit family, serenades loved ones on both sides of the great divide in her work.[65]

Equipment for Living: Secrets of the Sound "Babies"

Multiple instruments accompany her in this endeavor and take on new life through her curatorial eye. June keeps her guitars as well as her ukuleles and banjos close and lovingly flags her influences, by turns calling on the portentous gravity of the Leadbelly she had come to know through Nirvana's unplugged cover of "In the Pines"; the beams of celestial light emanating from Rosetta Tharpe's steel guitar; the simple sagacity of the Carter Family's storytelling. Peace and Civil Rights activists, Black feminist icons, painters, and literary luminaries—from Oprah and Michelle Obama to Gandhi, John Lennon, and Martin Luther King Jr., from David Bowie, Basquiat, and Frida Kahlo to Zora Neale Hurston, Josephine Baker, and Stevie Nicks—drive her imagination. June too, like Giddens, makes digging the archive a topic integral to her craft.[66] In conversation, she is, for instance, quick to pay homage to the practice of studying her forebears, absorbing the pedagogy of the figures who have created the conditions for her sonic being. She finds the photographs—the ones with sisters playing guitars—arresting, a point she shared with me during a 2017 public conversation. Tharpe and blues legends Elizabeth Cotten and Memphis Minnie are obvious influences who piqued her interest early as she began to write and play music, but she is just as drawn to the sounds and stories of the lesser-knowns like Jessie Mae Hemphill, a North Mississippi hill country blues guitarist who made her first field recordings in 1967 with blues researcher George Mitchell and ethnomusicologist David Evans. Enchanted by a photo of Hemphill decked out in her signature cowboy hat while playing guitar, a relic of the musician that she stumbled across in a local library, June sought out Evans's oral history of Hemphill to flesh out the life beyond the photo and the testimonies of a fellow Black woman guitarist situated in the Deep South. While working at a Memphis café, as she tells it, she "opened up the paper one day" and saw

> this beautiful Black woman with an electric guitar. And underneath it, it said, "We're raising money for her funeral" ... and so I was like, *Who is this woman, this Black cowgirl?* I was just like, *And she played electric.* ... How could I know her? How could I not know her? It was 2006! And so, I started to dig. I was just like, *I gotta know who she is.* And I found out, you know, so much about her as far as Hill country blues is concerned. And

then I started to go down to the Arkansas Blues and Heritage Festival, and meet so many musicians. . . . I fell in love with Jessie Mae. I was like *This is the best, most inspirational, and the best thing ever and how can she be dying broke, you know? What's up with this world.* . . . [67]

"Once I found out about Jessie Mae," she declares, imbuing each word with awe and reverence, "[I thought,] *How many other Black women have been playing electric guitar that I don't know about?* . . . And so I just kept digging and digging and I hit Sister [Rosetta Tharpe] and I was just like, *Okay. You just blew my mind, like.*[68] June the archivist resurrects Hemphill, holds her recording close to her in a collection of her own curation. Her recording is a thing of wonder, an object to be looked after, a document to be studied time and again. And she recognizes that she had to "deserve it," as Alexandra Vazquez might put it, this pedagogy manifest in Hemphill's life and career.[69] She had to commit herself to asking the kinds of big questions that might get at both the music that she'd never known and the fundamental reasons why renegade Black cowgirl music had eluded her. More still, June presses the question of root inequality framing the conditions of Hemphill's poverty and disappearance from the historical record. The taped interview that she holds dear to her is one that June keeps in her own archives. It is a precious document detailing a beautifully spirited life lived, like Geeshie's and L. V.'s, in the margins of pop music culture. Hemphill recounts the origins of her largely self-taught multi-instrumentality at a young age with a kind of determination and pragmatism that dazzles and inspires.

EVANS: When do you . . . start playing the guitar? . . .

HEMPHILL: When I was nine. . . . My granddaddy, he would tune it for me. . . . [Her aunt, blues musician] Rosa Lee [Hill] . . . when she learnt me some, she teach me . . . she's about twenty-three. . . . They quit tried to learn me after I got about nine . . . and I had to take the guitar and learn it by myself . . . so when I got the guitar I go out way out from the house by myself, and when I get out there all I do is ask my granddaddy is to tune it for me. See I couldn't catch on how to tune it, but I could pick it. So my granddaddy tuned it for me, and I took the guitar and went on out from the house and I sit out there and I picked—I picked, I sang. . . . I wouldn't pick nothing if I wouldn't sing it. And everything I picked, I tried to make the strings say what *I* say. . . . And then I learn how to blow the harp. . . . When I start beating drums . . . that was . . . oh I was . . .'bout 9 and

10— . . . I was learning it all at the same time—drums, guitar . . . I would just go in the room and just try *all* of them. . . . So . . . I learn how to beat the drums and I would take the drums when [the family] would go off, when they would leave home . . . hook up on the porch. . . . I wasn't tall enough to reach [the drums] . . . I'd get up in that chair, and I'd take that stick and I would beat that drum 'til the time went long . . . and there'd be so many cars out there in that road . . . parking side the road [asking] "where your granddaddy at?" "I'd say granddaddy not here. Ain't nobody here but me!" [They'd say,] "you the one beating those dreams?" I'd say, "yes, sir!" . . . They'd be all of them—white and colored. . . . Learn how to play piano . . . church songs, boogie. . . . How to play the tambourine . . . [70]

June has turned this interview with Hemphill over and over on many occasions, returning to it, as she tells me, as a source of wonder and as a model for how to stay close to the instruments of her own—the exquisite vintage banjos that she seeks out as utilitarian vestiges of the Black diasporic past—"that have something to say to" her, that "speak to her" in ways reminiscent of how characters have come to Alice Walker in visions. Like the apparitions of Walker's fiction, June's beloved instruments whisper long-dormant histories to her, and as in Hemphill's affectionate relationship with the guitar and drums that endlessly intrigue her, they are the extension of her own voice—the resolute and head-turning sounds of a "rambling yet precise" sister, one who is "regal yet down home, earthy yet mystical," and whose "musical imagination," one that is shaped by the archive, "is a world to get lost in."[71] Instruments are June's characters, objects that, as she describes it, share her universe and demand of her to be used, just as she strives to stay vigilant and aware of how the universe sees fit to use her. This is a kind of performative curation that centers the instrument—be it voice or sonic object—as the key to historical memory and narration, as the ultimate source of historical knowledge and storytelling. It is sonic séance work. Like Giddens, June finds that banjos hold special sway in her world, yet her penchant for the ethereal is such that these objects are, for her, even more of a thing of Black wonder and mysticism. Dazzled by clips of Elizabeth Cotten's, Pete Seeger's, and Roscoe Holcomb's picking, she found herself nonetheless nonplussed by receiving one as a birthday gift one year. It "collected dust," as she puts it. "And then it started calling me, and the call, it was like, 'Okay, I want to sing a song' and when it started to sing, it was so sad from all of this time being alone while I was going around with all of my other instruments. And it had to experience this loneliness, so it sings that song about being lonely." The "baby," as June refers to it, the banjo that sat in the

Jessie Mae Hemphill, June 1987

corner "for two or three years" until she "started to hear songs on it," is its own being, a roommate with some stories to tell, an intimate to be cared for. On the Southern Black gothic spirit terrain of Charles Chesnutt's postbellum fiction and Zora Neale Hurston's busy and animated folkloric landscape, she weaves tales of conversation and communion with ostensibly mundane objects, finding the (Black) life in said things. Her romance with the banjo, this instrument steeped in tangled racial histories, cleaves to the spiritual ethics of her artistry.[72] More medium than pedagogue, she plays guardian and conjurer in relation to this tool of sound, intent on liberating it from its legacies of racial division, appropriation, caricature, and segregatory cultural divisions. "I'm just sorry for that instrument," says June with characteristic sincerity, "because all it wants to do is everything, like every other instrument. Like songs, instruments have feelings." "I said, 'Thank you,'" June tells one critic, "because the banjo needs freedom. It doesn't have to be bluegrass; it wants to be free to go wherever it wants to get to. . . . These instruments want to be set free, just like I want to be set free."[73]

This sense of freedom that extends beyond the confines of material, of-this-world categories and boundaries permeates June's fundamental sensibilities as an artist, her raison d'être as a musician. When asked by American studies scholar Alexia Williams about her thoughts as to why it remains "difficult" for

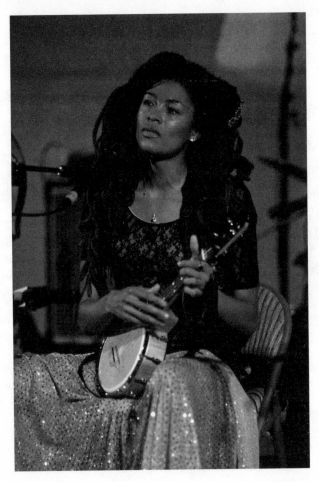

Valerie June

the masses to "see black people performing folk music and country music and bluegrass," she gave an answer that reflects a distinctly transcendent approach to the kinds of obstacles faced by her fellow archivists. For June, those formative years coming up in Black and then white church spaces, singing alongside "500 teachers," as she calls these congregants, was seemingly a way of becoming fundamentally cognizant of the nature of intimate humanity as it was sounded out voice by idiosyncratic voice, phrase by regionally and culturally inflected phrase, and ringing in her ears. June recounts this story sequentially in relation to her experiences as a recording industry artist. It comes before her acknowledgment that there are times when she "look[s] out at [her] crowd, and there's starting to be more black people at [her] shows." It comes before

her reference to the ancestors, the Sister Rosetta Tharpes and Hendrixes who were systemically "not accepted in our own country. . . . That keeps you from making it to that level where you're able to do what you need to do." But those experiences sitting in the pews of her grandmother's church as a girl, listening to "black country people" who "sounded like the Carter Family," forever shook up her reading of racial hierarchies and divisions that hover over her own performance spaces. "You have to constantly say, well what is it really?" June muses. "It's the spirit," she continues,

> and the spirit transcends that and it had to transcend that for these songs to me. You know, the same songs. And so we, in these physical bodies, we're trying to make all these divisions and, you know, "No, this is white. This is black." That doesn't work for me. I've never been able to live that way. My family doesn't live that way. . . . And I find that I go to play these blues things and there's more white people there, I see one black person there. And it's the same with the country gigs, you know? I see one black person there, so where are the black people? I'm like, okay, this is our music. This is our heritage. And I'm not mad at anybody about it, because I know it's all gonna come full circle. The understanding of it not being a physical thing, and the body being not as important . . . it's all gonna settle. . . . I don't spend much time being a prisoner of the history. . . . A prisoner of the blues or anything.[74]

June's musical center, her curatorial compass, is philosophically imbued with the pursuit of higher forms of being, other "genres of being human," as Sylvia Wynter might put it, that allow for ways to "climb out of our present order of consciousness."[75]

June notes, "That's probably where the futuristic side of my music comes from. Because I can't be a prisoner to it." June's reasoning about her aesthetics is steeped in a resistance to that which says that she should ever have to choose sides, "know her place" and stay there. In this regard, then, hers is an Afrofuturist form of archiving that faces forward, that leans toward new conditions of Black possibility. "I could read certain books about slavery and certain books about our history, but I learn most of it through the songs. And then I try to say, okay, well how can we move beyond that? How can we grow?" For her, the answers to that question have to do with rejecting the critical narratives about the music she makes, narratives that "package music" as "race records over here" and "hillbilly music over there, white people buy this, black people buy that," and rewriting the whole story through her sound, remapping the universe

through her roaming. The "lines can be drawn," she argues, "and that happens when people like, write articles in fancy newspapers and things like that. . . . Again and again and again and again. But we are the listeners, and we have to just be like, no, take it out of the body. Take it out. I wanna honor it, but I also don't want it to be a prison. So when it becomes a prison, take it out of the body, you know? That's just what I have to do."[76] June's séance, her communion that she curates by way of her sound "babies," is a manifestation of her own "moral imagination," her own investment in music as the thing that will free us from the wretchedness of racial scripts that police and limit our modes of expression.

Out of the body and on the galactic roots-music frontier, Valerie June is making and curating sounds that are unabashedly mystical, what she herself calls "cosmic ethereal heart music . . . otherworldly . . . spirit music," what others have referred to as "luminous" and "ancient," fueled by a "tranquility that seems elusive" and "aspirational," strewn with "ambient flourishes that had previously only existed in June's head," "a marvel of mindfulness." She is a "psychedelic wander[er]" with a penchant for "song-catching," a self-proclaimed "servant of the song."[77] The ethics of June's work have everything to do with "receiv[ing] a song" and following it to the site of its origins. Songs are anthropomorphic entities for her, they are "funny" things, "very alive . . . they [are] like clothes." They ask, "Does this fit on me? Does that fit on me?" They are also, quite crucially for her, much vaster than the bodies that carry them. "They're not," says June, "that person's song. They're bigger and they live in this place. I don't know where it is, but they have different colors and moods and attitudes." This, she assures, "is spiritual information." These songs "choose" people, according to June, to deliver their message. They "live somewhere," she insists, "where people can catch them. You can catch songs, really!" She follows the voices that come to her "in layers, like a chorus," the ones that sing to her. The ones that she, in turn, "sing[s] to [us]," sharing with us "what [she] hears." She builds the ultimate alterity out of the voices that have the power to take her to other galaxies entirely, places of unadulterated sublimity, as was the case when she "caught" "Astral Plane." Of that original composition, June recalls, "I do feel like I escaped and I was in this very iridescent space that was illuminated and starry. . . . The voice came and it took me to wherever it was."[78]

The Heist

A struggle is under way, high, high up in the house that Wynton built, where the towering glass windows are the portals through which the audience—

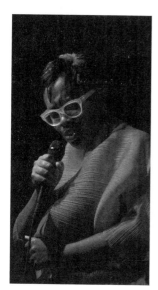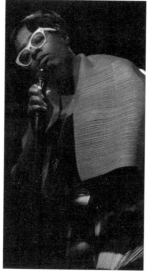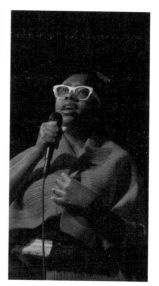

Cécile McLorin Salvant

Upper West Side regulars, senior jazz enthusiasts, and moneyed professionals—might all look out at the urban bustle of streetlights and headlights and swirls of people either dashing to the afterhours next best thing or lingering on the sidewalk, tarrying alone or with one another. Evening has settled so resolutely into night while one ferocious sister, called by critic Nate Chinen and so many others the "finest jazz singer to emerge in the last decade," leans in to begin her set accompanied by the Aaron Diehl Trio. Beaming, she peers out into the crowd—a sea of white faces, as far as I can tell—save for me and a smattering of boomer–to–Gen X Black folks who yell a little bit louder, a little bit longer, with the hopes that our I-got-mad-love-for-you exclamations might linger in the air, might surround her like a Toni Morrison circle in the clearing as we stand ready to bear witness to this thievery that's about to go down. That long, silent surveying of the room with an inscrutable Ellingtonian grin on her face unsettles a few fans who laugh nervously, alarmed by the uncertainty of twenty-first-century jazz gig formalities, sociality, and niceties being broken here. Her inspection of the crowd steers everyone's attention back to her and nowhere else. The outside distractions of Columbus Circle after dark all fall away.

For those of us who know the plan that's afoot, the situation is fraught. You may have heard the hints that she dropped on Facebook earlier that day or, like me, you may have stumbled into one of those preshow "Jazz at Lincoln Center conversations" with earnest and well-meaning seniors who wax on adoringly about her marvelous NPR *Fresh Air* interview but who are, it turns out,

rendered speechless by the preview of what she'll be singing that night. If you fall into that category of folks who have a clue about her repertoire for the second set of the evening, perhaps you were consumed, as I certainly was, by all the feels—rising tension, rolling anxiety peppered with delicious anticipation, and a nagging impulse to protect and shield a fellow sister, one who was about to "step out," as Chinen has put it about our girl Cécile McLorin Salvant's performance chutzpah, "into moving traffic." We see her on that ledge alongside Yoncé and wait for her too to cross her arms and drop out into the great unknown. Pray we catch her.

Salvant, the riotous and brilliantly artful "drama queen," is the kind of musician whose penchant for risk, whose passion for taking left turns in her methods of interpretation, has set her apart from her peers. In the short time that she's been rising to the top of the new millennium jazz scene, she has made a name for herself as an exuberant, a fastidious, and an audacious vocalist. Critics have noted her ability to craft a kind of art that "lies in [the] spontaneous emergence and beautiful accumulation of small gestures, informed by empathetic collaboration, careful study and forethought, and masterful execution." Composer and bandleader Darcy James Argue elaborates on the "exceptionalism" of her "commitment to narrative" even more fully, observing that "it is all about communication, and doing something as a vocalist that instrumentalists can't do at all," "which is working with text, with motivation, with dramatic irony, with the literary possibilities that are part of songcraft. Those things are pretty thin on the ground in the history of jazz singing, and so it is wonderful to see someone of this generation who's so attuned to that, and is also a phenomenal musician."[79]

Known and celebrated for her limitless curiosity and inventiveness as a musician, her "intelligent control over her material and her audience," she burrows deep into the grooves of jazz and blues history, tarrying in its margins, listening closely to charged and alluring obscurities and dusting them off for new truths. The catalog of songs that she continues to compile and the vault (so to speak) that she keeps at her disposal during her riveting and enchanting live sets and across five full-length albums attest to her keenly sophisticated gifts as a sonic excavator, as the kind of musician who takes seriously what it means to turn an ear to the past and put it in conversation with our present moment by way of bold, majestic, deliciously unpredictable vocal abilities cultivated first by way of an early classical training and subsequently shaped by jazz, blues, vaudeville, musical theater, and folk influences—to say the least. She is a musician unafraid to wield daring thespian chops and bottomless interpretative skills in order to electrify and make anew classic songbook stan-

dards as well as those obscure tunes known to few. With a big and wide archive of songs at her disposal, Salvant revels in rewriting each one of them—the ones we thought we knew so well and those that we'd barely discovered—making each of her interpretations breathlessly, startlingly new, urgent, intoxicating.

Call this a "command" of the Black radical tradition, or better yet, call it a "communion," as does Margo Jefferson, akin to Rhiannon Giddens's fieldwork and Valerie June's Black feminist séances in orphic sound. Or call it the sound of Black study, the sound of Mamie's legacy, the sound of the archive as well as the archivist joyously at work—exploring, interrogating, invoking, (re)mixing, and insistently or lovingly or playfully rearranging Billie and Bert, Judy and Ida, Sarah and Valaida, Langston and Josephine, Cole and Dinah, Sondheim and Bernstein, Noel Coward and Rodgers and Hart, as well as the many folk and blues songwriters whose names we'll never know. "I love these people," Salvant tells the *New York Times*. "I don't believe in ghosts, but I'm in communication with them. I carry them with me." Surrogation for her is a question of "'portals' . . . a notion that the past and present can be in dialogue, not on some kind of linear continuum but all at the same time." She curates a world of sonic possibility where histories of the dispossessed, that which has been scored by the forgotten as well as the nameless geniuses and innovators who maintain their right to elude us, burst forth in thrilling new arrangements of her own design.[80]

On her own plane of sonic drama, she hangs close to Bessie, the Empress of the Blues, sifting through her versions of "St. Louis Gal," "You've Got to Give Me Some," and "Sam Jones Blues" with a stubborn insouciance that resuscitates the stank autonomy of the classic sisters' tradition. She immerses herself in the limitless "colors and textures" of her early, foundational model of "absolute virtuosity," Sassy Sarah. She lingers on the innuendo-laden "Growlin' Dan" by Blanche Calloway, sister to Cab, extrapolating that forgotten "bandleader" and "belter's" sound of "charisma," what Sonnet Retman incisively reads as "that quality of magnetism, persuasion, and seduction, relational, sometimes transactional," to create big character. She makes use of Nancy Wilson's "suave" "hyper clarity" like a scalpel and draws out the fragility and quirkiness of cabaret legend Blossom Dearie's songbook ("I'm Hip," "The Ballad of the Shape of Things"), mining it for its emotive delicacy and precision. She turns to Abbey with her "political consciousness and dissonant note-bending" of "the saloon-song tradition," her "edge" that guides her to "think about repertoire in a different way."[81]

She reminds us of the heavy, serious, and profoundly undertheorized work of the jazz vocalist as both a sophisticated archivist and an actor, the kind who

holds history in her hands, in her head, in the visceral passions of her heart as a musician, and in the singular instrument that is her voice. And it is her voice that is her greatest weapon and compass as she does battle with the song that no one can quite believe she's committed herself to singing at Lincoln Center's Appel Room that night: Jelly Roll Morton's "The Murder Ballad," a song that Morton recorded for Alan Lomax at the Library of Congress in 1938, three years before Morton died in 1941. As Lomax himself describes this session, "All Jelly couldn't say—the whole complex and orchidaceous story he had in his mind—came pouring out in the recordings he made" there.[82]

Comprising over fifty graphically sexual, graphically violent, profanity-laden verses and roughly 100 total lines of lyrics that tell a familiar tale of a blues love triangle gone wrong, "Murder Ballad" takes audacious and stunningly nuanced plot turns that unfold across the epic arc of the song, and in Salvant's *performance* of the song. Morton's marathon "Ballad" clocks in at a whopping thirty minutes and travels a lifetime, and in many respects it was, at that point in Salvant's career, perhaps the pinnacle of her daring as well as her grandest statement about the meaning of time in all of her work. One could argue that it is a subject that has remained a prominent recursive marker in her repertoire since her breakout 2013 album *WomanChild*, when she tinkered with the Broadway standard "I Didn't Know What Time It Was." Ethnomusicologist Mark Lomanno calls this "one of the album's binding concepts and most important motives" in the way that she "performs the song's meaning, de-constructing its steady tempo by slowing down her vocal phrases with rubato and shifting them across barlines—out of sync with the measured accompaniment and more canonical renditions of the song." It's this "clockwork setting" that contextualizes Salvant's penchant for stories that offer meditations on the trials and demands of the durational, especially as countenanced by the marginalized—from the labor exploitation parable that is "John Henry" to Morton's prison ordeal turned tale of Black women's transformation and triumph.[83]

And so it begins. We who are there on that night in May 2017 look on and listen to our maestra as she takes us on the temporal journey of a blues heroine who vigorously admonishes her lover for cheating on her, confronts her romantic rival, threatens her, and viciously murders her. We travel with her through the time of arrest, through standing trial, through conviction and imprisonment as she endures the extreme human cruelties of Jim Crow incarceration. She finds her own rehabilitation and salvation by way of queer love behind bars before asking for penance for her crime and succumbing to death. We who are there in that glass temple of jazz hovering over Central Park watch and listen carefully to Salvant, the storyteller, to ourselves, and to the room—

"And suddenly I find myself wanting more . . ." —Cécile McLorin Salvant, "More"

reacting in phases to the shock value of Morton's quixotic blue tale. We listen to the reverberations in the room as the f-bomb, the b-bomb, and the n-bomb fly fast and furious, as detailed descriptions of maiming and throat cutting and crotch shooting, of lesbian sex, and of potently forthright sex talk, sexual desire, and questions posed from one woman to another on how best to pleasure each other linger in the air as Salvant and band soldier on through the strophic insistence of the song in something akin to a "bardic trance" jam.[84]

There is jittery laughter, of course, for the first five minutes or so—the sound of bewilderment with smatterings of gasps, expressions of incredulity and horror, audible discomfort from our white liberal friends who seem to be struggling to find a way to voice their simultaneous disapproval of the racial epithets and their support of our masterful musician, an artist so promising and self-possessed that she won the Thelonious Monk International Jazz Vocal Competition in 2010. An artist so beloved by critics and peers alike that she's now won a Grammy twice for Best Jazz Vocal Album and (like Giddens as well) a MacArthur "Genius" Grant. A "master curator," as *Rolling Stone*'s Will

Hermes puts it, and one who "deconstruct[s] American artifacts like a bomb squad technician."[85]

"We are with you, dear Cécile—even if this thing you are dropping on us is freaking us the fuck out, is trying us and forcing us to think differently about our relationship to jazz performance—what's asked us of us, what it demands that we reckon with as we sit in our velvet-covered Appel Room seats accustomed to listening with way too much ease to a music born out of and constantly revolting against captivity and subjugation, anti-Blackness and white patriarchal control. We are with you, Cécile—we *think*—but you are scaring the shit out of us right now."

This is a show tune, as dear Nina would say, but the show has not been written yet.[86]

"You Bring Out the Savage in Me": Cécile McLorin Salvant's Black Feminist Sonic Drama School

Some of the riddles that bedevil critics about Cécile McLorin Salvant involve having to figure out how to square her interest in charged and unsettling (if not downright unpleasant) material in her song sets culled from "the deeper, darker ore in the bedrock of American song" with new millennium sensibilities and cultural proprieties that—even in the Trump era—still tend to code rather than blatantly broadcast racist crudities so foundational to early American pop music. Salvant has talked often about her penchant for dissecting this sort of volatile material, how deep cuts and deeply cutting numbers like trumpeter Valaida Snow's "You Bring Out the Savage in Me" are, to her, "so racist and perfect and hilarious," how Josephine Baker's "Si j'étais blanche" ("If I Were White") is "so bold," how intrigued she is by the thought of Black folks "making fun of black people for a living, and at the same time" finding the ability to "be a genius and be an incredible entertainer," while yet still being "extremely conflicted and feel[ing] terrible for doing that, essentially which is what Bert Williams felt."[87]

These sorts of dizzying absurdities and outrageous ambivalences have long fascinated her. The fact that these artists "turned this racist fad on its head," Lomanno argues, "confronting audiences with the stereotypes' absurdity and moral decrepitude through ironic and critical performance of the music," is an object of inquiry for Salvant. It is the pedagogy by which she is ultimately able to engage in radical curatorial performances, "combin[ing] the rigorous sensitivities of an artist with the wary calculation of a critic. Her whole bearing as a performer—judicious, confiding, theatrical, skeptical," Chinen notes, "suggests a watchful distance from the persona she so persuasively embodies." This al-

lows her to, as David Hadju observes, "accomplis[h] two seemingly incompatible feats simultaneously: taking on a standard with a palpable respect for the intention of the material and bringing forth the essence of the song, while at the same time communicating a second meaning, an analytical or ironic commentary. It's almost as if she has two selves," he muses, "the first one singing for all she's worth and the other standing alongside, offering her own thoughts." This is performative boldness writ large, a kind of vocal abandon born out of what we might think of as a Black feminist sonic drama school that Salvant curated for herself across a circum-Atlantic arc of music training, influences, and study.[88]

The daughter of a Haitian father and French Guadeloupean mother, Salvant was raised in the global South's cosmopolitan capital of Miami and trained in Aix-en-Provence, France, at the Conservatoire Darius Milhaud under the tutelage of clarinetist Jean-François Bonnel, who introduced her to a wide array of blues and jazz vocalists that stretched well beyond convention. All of these experiences wove multilingualism into the fabric of her aesthetic being and created the conditions for her to approach song styling, songbook interpretation, and the craft of vocal performance as big theater that she herself might direct. The logic of how we get to Salvant is born out, then, in tracing the line that extends from the time of Mamie, the early twentieth-century minstrel and vaudeville blues era, extends through the advent of jazz and classic pop vocalizing, which bore the work of arch, modernist songsters like Dinah as well as the saucy cabaret chansons of Eartha, and takes us all the way to Columbus Circle, New York City, on a cool spring night in the twenty-first century.

She demands that we spend time with her and with the sisters who were and are doing time.[89] Like Ellison's *Invisible Man*, she sees "those out of time, who would soon be gone and forgotten," and builds massive sonic performances for and about the sisters, the ones "who knew but that they were the saviors, the true leaders, the bearers of something precious." The "stewards of something uncomfortable, burdensome . . . ," the ones who "were outside the grooves of history." She takes up the job to "get them in, all of them." Like Ellison's nameless narrator, she "look[s] into the design of their faces," "forgotten names" that sing out "like forgotten scenes in dreams."[90] She is the sonic bridge of restitution and repair, the architect of music that attests to the conditions, experiences and desires of those who appear as absences—both forced as well as self-willed—in the archive. She holds a space for them in long, drawn out songs that operate as visions of all we cannot see but might yet still hear.

Such visions are not uncommon in her repertoire. Her epic concept album *Dreams and Daggers* lives in this realm. A double-album opus, it oscillates

between live performances of standards at the Village Vanguard and in-studio renditions of mostly original compositions featuring her trio and a string group, the Catalyst Quartet. The juxtaposition of these two worlds—live and recorded, bare-bones jazz ensemble and classical outfit—sparks a dialectical charge that Salvant thought through carefully in her approach to making the album. "Little by little," she explains, "I thought, 'This could be a really good opportunity to use these string pieces as my subconscious analysis of these standards and these themes.'" The result is a work that sustains a conversation between two realms, what she describes as the "very visceral live experience" and "the very dreamlike, floating, surreal environment." It's an album that, as Hermes contends, "reimagin[es] classics hiding in plain sight," resulting in a "merging of, and dialogue between, the classic and the contemporary." The emergent songwriter takes the trace of the archival song and transforms it, elasticizes it, distends and transmogrifies that trace into countermyth.[91]

This is vocal dramatization that she continues to craft, that which capitalizes on the classic blues aesthetics and strategies laid out by sweet Mamie and her fellow blues rule breakers. Like them, Salvant flexes her astonishing versatility as a vocalist, that which she invokes on her albums and in lauded live sets wherein she puts into play Sarah's rolling contralto, Billie's striking phrasing, Judy's exuberance, and the quirky sonic hyperboles and discordant sounds of postbellum Black musical theater hero Bert Williams.[92] The exacting matter of Holiday's phrasing offered her early instruction on how to deliver intense and vivid linguistic turns. In the tradition of Garland, she flexes her acting chops, a spirited ingenue turning the songs into multi-faceted theater, into full-scale dramas where depth of character reigns supreme. "This impulse to dramatize a song, treating it less as a monologue than as a play," has become something of her trademark, which she has addressed on more than one occasion. "To me, performance is acting as a character on the stage," she has told the *New Yorker,* adding, "Trying to get inside a world for other people and getting them to join in—that's thrilling."[93] At the root of her approach to sonic storytelling is the capaciousness of her emotive register ranging from the darker edges of affective lifeworlds—pathos and heartbreak—to screwball humor and sharp-edged wit. These latter postures and perspectives have earned her the soubriquet "the counter-diva" by Jefferson, whose brilliant take on Salvant is as lush and intoxicating as the work of the artist herself. On Salvant's version of Garland's 1944 *Meet Me in St. Louis* "Trolley Song," Jefferson finds her playing the role of "the counter-diva: the heroine as ebullient comedian" who invokes the screen icon alongside Sarah Vaughan and Betty Carter, "pay[ing] homage to all three with touches of loving parody—Garland's girlishness, Vaughan's love for her

own silky vibrato, Carter's near-manic tempo changes—finding her own interpretation. The train rhythms stop, start and stutter; so does Salvant's voice. Our heroine is thinking and feeling her way, note by note, word by word, into exuberant infatuation, fashioning a romantic-comedy monologue in which the woman surprises herself with each turn of phrase and tempo."[94]

Such a virtuosic vocalist has also got to be a master interpreter of complex, dramatic, shapeshifting personas, a curator of her own sonic drama. Counter-divas, for instance, know their comedy as well as their capacity to develop personas that run in the opposite direction from the assuredly regal, the affectively grand and often imperious gestures associated with blues, jazz, and contemporary pop divas. They revel in the art of subversive surprise and are not above sometimes revealing their delight in said triumphs. One might think of them as rightful heirs to the early twentieth-century sister vaudevillians— everyone from our "Crazy Blues" superstar to the all but forgotten pioneers, women like Rosa Scott, Bessie Gillam, Carrie Hall, and celebrated comedienne Muriel Ringgold. As Jayna Brown reveals, a number of these Gilded Age Black woman show business troubadours drew ironic inspiration by way of deforming the iconic blackface role of *Uncle Tom's Cabin* character Topsy. Using the outlaw "pickaninny" caricature of Topsy as a template for performative insurgency, these artists would experiment with the whimsical, the occasionally ribald and boisterous so as to manipulate the kinesthetic poetics of time. These were entertainers who choreographed counterhegemonic constructions of spectacular Black womanhood, and those who sang most surely followed suit in sound as well. Considering the autonomous performative resources of these women and the "entireness" of their routines—as one anonymous critic described Muriel Ringgold's act—fundamentally expands the lexicon by which we can hear and read Salvant's approach to developing complicated vocals that do many things at once, that convey an "emotional range" that "inhabit[s] different personas in the course of a song, sometimes even a phrase—delivering the lyrics in a faithful spirit while also commenting on them, mining them for unexpected drama and wit."[95]

The nature of their repertoires suggests that Salvant and our archival women have shared affinities. But without recordings of these entertainers' early 1900s repertoires, the details of their sonic aesthetics remain elusive. And yet still the song titles in, for instance, vocalist Carrie Hall's revue attest to the fact that Black women performers were willing to tackle the "coon song" hit parade (for example, Williams and Walker's "The Game of Goo-Goo Eyes," Ernest Hogan's "The Phrenologist Coon," and Cole and Johnson's "My Castle on the Nile") while touring with the big, Northern-based African American road shows from this era. Like their male counterparts, Williams, Walker, and

Hogan, Black women entertainers from this period approached the problem of anti-Blackness in popular song in a way that required and cultivated dense forms of ironic phrasing and nimble narrative scrutiny. In the case of Hall, for instance, her rendering of a song like "The Phrenologist Coon" would no doubt have to take into consideration the masterful and emerging superstar Williams's drawling, revisionist intonations of white supremacist caricature in order to produce her own (Black women's) version of "a mimicry of racial mimicry." Add to this the fact that performers such as Muriel Ringgold made names for themselves by crafting a range of lauded impressions, from the anthropomorphic (playing the role of "the sea" in a number entitled "Bobbing Up and Down") to pre–drag king posturing (singing in "decidedly male" fashion the song "By Myself Alone, Nobody but Me") and one might recognize that the sheer vocal versatility of these performers, who thrived in their entertainment subculture, is strikingly apparent.[96]

These are skills and strategies mapped out by the ones on whom she trains her attention, the ones to whom she listens carefully. One of those figures, blackface virtuoso Bert Williams, supplies what would become a pivotal track in her career. His most famous song, 1906's "Nobody," a breathtaking lamentation about racial injury, social invisibility, and the quiet insurgency of the dispossessed, is clearly instructive and gains new life in her hands, as she embarks on a painstakingly pointed and mindful conversation with Williams's signature tune associated with his turn as the modern era's greatest musical theater performer.[97] With a ragtime accompaniment that loiters and dawdles and slips in and out of moody, contemporary jazz contemplation, her reading of "Nobody" travels the map of Black postbellum sorrow and matter-of-fact cynicism, and the WomanChild ensemble, with Aaron Diehl on piano, Rodney Whitaker on double bass, Herlin Riley on drums, and James Chirillo on guitar and banjo, slow roll and tumble with her on the journey. Salvant stretches her supple vocals across chorus and verse, swinging between the highs ("when summertime comes cool and clear / and my friends see me drawing near") and the lows ("who says, c'mon let's have a beer . . . Nooooobody") of a protagonist's melancholic isolation. She plumbs the depths of Williams's tune ("when I was in that railroad wreck / And thought I'd cashed in my last check / Who took the engine off my neck? Nobody"), chasing the chromaticism of her pianist before climbing back up tempo and strutting out of the song. We hear how she's drawn to the affective doubleness of the song, it's "funniness," its "heartbreaking" elements. "You don't know if you want to laugh or cry," she notes, reflecting on Williams's composition and adding, "It took me some time to have the courage to actually sing it." The miracle of her performance, as veteran jazz

critic Ted Gioia argues, is that while "Nobody" "can be presented comically or as heart-on-your-sleeve-confession," she "manages to bring out both the qualities in the same performance."[98]

Murder, She Wrote

Imagine, then, if you will, a set in which for thirty minutes plus, this fearless artist drew on her arsenal of skills to invoke a compendium of feelings that Jelly Roll Morton's rendition of the aforementioned "Murder Ballad" flattens out (for any number of reasons we might imagine—from thwarting folklorist Alan Lomax's overbearing, quasi-colonial listening tactics to Morton's own distance and possible disinterest in examining the complexities of Black women's marginalization or queer Black women's desire). In her epic rendering of Morton's long-form tale, Cécile McLorin Salvant builds a pathway for us back to the jailhouse women's blues, that oft-overlooked genre that receives far less attention than the work of the brother bluesmen in folk Americana mythology, the Johnsons and the Jeffersons and the other outlaws lauded by our blues revivalists of the past who both carefully and carelessly overlooked the conditions resulting in these men having to turn themselves into outlaws in the first place.

Her performance counters such presumptions with an underlying cri de coeur: Who will sing for, care for, listen out for the voices of the women who are locked down? Certainly, as discussed in Chapter 3, even before Salvant was born in 1989, Rosetta Reitz and Bernice Johnson Reagon were doing their damnedest to try. Recall how Reitz, by way of her Rosetta Records 1987 *Jailhouse Blues* anthology, made it a point to emphasize that the music made by the women of Parchman was, as she describes it, a kind of "living female blues, the kind that a woman might sing at her chores like washing dishes or clothes, or cooking, or rocking a baby." Reagon adds further that such songs by Black women prisoners "are a small artificial window" into their lives. "Maybe they heard about Leadbelly singing himself to freedom," she poignantly suggests. "Maybe they responded with enthusiasm to anyone who felt they had something of value to offer. They sing prison work songs, blues, ring play songs, inside songs about sexual play, and sexual exploitation, songs sung by the male prisoners, songs they learned, picked up or songs they wrote."[99] In her speculative gambit, Reagon demands that we acknowledge the vitality as well as the dense, the rending and yet still ravishing range of prodigious desires that music crafted by women prisoners might contain, and she urges us to contemplate how they may have put it to use—to lay down emancipatory plans, to document their own labor, their intimacies and traumas. They were songs that

were capacious enough to refract infinite experiences and relations. They were songs built out of networks of survival, of love, lust, longing, and loss.

Do we doubt that Morton heard this music? Knew this music? Knew women (as well as men) who were touched in every sense of the word by the carceral state that spread and continues to wreak havoc on Black folks' lives? "Murder Ballad" is the recording of Morton's ventriloquized performance of "the micropenality of everyday life" for Black women who were enduring the broad daily insult of Jim Crow culture in which circumstances were chronically "grave," as Haley reminds. Black women, she reveals, "were subject to arrest for any infraction of political etiquette or for simply being in public."[100]

And yet, obviously, Morton's no angel when it comes to looking out for these sisters. This we know for sure. Like his fellow blues and jazz men, he had his share of numbers where women most certainly do not come out on top, so to speak. Morton's version is a study in measured feelings, mannered ache, and tempered storytelling that belies the affective extremes of the lyrical content: "If you don't leave my fucking man alone/if you don't leave my fucking man alone/you won't know what way you will go home."[101] His restraint conveys Black women's picaresque blues with a kind of cyclical romantic certitude, as if to suggest that no matter what, we'll make our way back to the tonic time and again.

And so imagine the triangular wrestling match as it unfolded that night when the most original and gifted jazz vocalist of our present age attempted to stage a heist and steal this song about Black women's criminality and Black women's erotic woman-to-woman self-actualization out of the hands of our iconic New Orleans jazz and blues man while the audience attempted to hold on and stay the course. What Salvant has at her disposal to draw on citationally in building her "Murder Ballad" narrative that Morton does not, however, is the passage of historical and aesthetic time in jazz and blues and pop songbook histories. She, of course, has post–post–Civil Rights new millennium privilege and a different kind of performative agency not afforded to her forebear. More still, she has that potent epistemic point of view called Black feminist wisdom, culled, in part, from her mastery of songs long forgotten or overlooked for their salience with regard to race, gender, class, and power. What is there to learn from a song like Burt Bacharach's 1963 sexist-meets-saccharine pop confection "Wives and Lovers," which warns that "wives should always be lovers too/run to his arms the moment he runs home to you"?[102]

By inhabiting such songs, Salvant gets up close and personal with patriarchy, dissecting its anatomy syllable by syllable and using the irony of her own iconoclastic, gender-revisionist jazz persona, what Jefferson astutely refers to as "gamine glam" ("close-cropped hair," "big, blocky white glasses—a droll trademark

like Fats Waller's derby; a red fascinator with feathers that look like insect feelers"), as its own external pushback on the song's corrosive, lyrical content. From this position, she moves in and out of a song like "Wives and Lovers"'s oppressive character voicings ("Hey! Little girl/Comb your hair, fix your makeup"), exploding its disciplinary intent. These kinds of readings have the power to jolt standard-bearing jazz fans unaccustomed to having their feminist consciousness raised, calling on them to, for instance, take seriously the structural pressures of patriarchal biases such as those identified in *Funny Girl*'s stinging lament, "If a Girl Isn't Pretty" ("She must shine in every detail/Like a ring, you're buying retail/Be a standard size that/Fits a standard dress"). This is work that examines the unnerving oddities about how intersectional power formations menacingly endure in our quotidian cultural lives in the form of pop obscurities and afterthoughts, in tunes that passed in and out of public consciousness, quietly leaving their marks, their impressions, their wounds.[103]

How to craft vocal protagonists who might convey the obverse, the untold, the misremembered? Salvant's curatorial blueprint, which undergirds her "Ballad" performance, involves preparation informed by her absorption of the archival, the understudied Black diasporic women who have their own tales of sensuality, longing, and mischief to tell. Be it throwing herself into a 1924 anthem like Ida Cox's "Wild Women Don't Have the Blues" or turning her attention to "one of Haiti's first feminist and queer" writers, Ida Faubert, she has blazed a trail embracing the position of the restless, emotionally complex protagonist in song whose big, unregulated desires, whose "wildness" drives her ambitions, as a suggestion of, as Jack Halberstam has argued, "what lies beyond current logics of rule." For Halberstam and pace José Muñoz and Tavia Nyong'o, wildness is "this 'spirit of the unknown and the disorderly,'" and star characters in Salvant's repertoire radiate this energy, strutting their stuff, "get[ting] full of good liquor, walk[ing] the streets all night," as Cox's women do, warning, as Snow's "savage" queen does, "You'll find out how wild I can be." Even Faubert's mournful heartbreaker, "Le front caché sur tes genoux" ("The Face Hidden on Your Knees"), which Salvant sets to music, includes a woman's nostalgia for the unbridled, "Je revivais l'heure lointaine/Où je faisais des rêves fous/Le front caché sur tes genoux," which Haitian literature scholar Shanna-Delores Jean-Baptiste translates as "[For] I was reliving the distant hour/When I had wild dreams/My face [forehead] hidden on your lap." Building on Black feminist Caribbeanist critic Omise'eke Natasha Tinsley's groundbreaking recuperation of Faubert and her lush, erotic poems to women, Jean-Baptiste locates the queerness and femininity in this work of hers as well, citing "the absence of gender pronouns" in this scene of gentle, private intimacy.[104]

This dense, varied, unusual, and surprising material serves as scaffolding for Salvant's meeting with Morton. To handle it with audacity and acuity, she leans into her powers as a thespian. Cécile McLorin Salvant's enormous skill as an actress comes to bear on the ways in which she is consistently able to magnify narrative and the dramatic stakes of each song in her repertoire. This is no accident. She herself has talked of a childhood in which she "wanted to be an actress" as well as "an opera singer" or a "history or literature professor," the latter being a sign of her penchant for analytic exploration of her songs. It's a gift that many have noted, this ability to transform "each song into a little play," this "impulse to dramatize a song, treating it less as a monologue than as a play." Something of the operatic, that classical training from long ago, perhaps informs the conceptual frames in which she builds her approach to storytelling and grandly-conceived narration.[105]

So it goes, then, as she roves through the blue lines of "Murder Ballad" that assert, "I'll cut your throat and drink your fucking blood like wine," and "She said open your legs, you dirty bitch, I'm going to shoot you between your thighs," and "She had a thing just like mine . . . we rub together / my but it was fine." What Nate Chinen has referred to as "the precision" with which she takes apart these words, mining them for their meaning, allows us to hear the humor and heartbreak, the mourning and melancholia, the sensuality as well as the rage, longing as well as remorse—the deep humanity of the blues heroine whose story has been told and stored away by two men (and no doubt more).[106] That we, the audience members at Lincoln Center that night, were with her in it (whether we asked for this journey or not) speaks to the ways that this extraordinary performance of blues feminist archiving is an exercise in the art of duration, beckoning us into the realm of rapturous attention.

"Murder Ballad" is an outsize, extended narrative that travels a lifetime and encompasses many moods. Its blues temporality is spectacularly surplus in relation to that of conventional blues song structures, exploding the 12-bar blues form with its sprawling narrative length, so long, in fact, that the recording is "broken into [seven] parts" since, as New Orleans artist and novelist Louis Maistros points out, "the discs could only hold around 4 minutes apiece."[107] From this standpoint, we might think of it as a work of something akin to temporal scatting, if we read it in the vein of what Brent Edwards has influentially described as "scat aesthetics" in his virtuosic study of Louis Armstrong. Edwards refers to Armstrong (by way of a Gary Giddens line) as a "transfiguring agent," a "self-assured modernist who negotiates the trumpet parts" in his performance in the film *Rhapsody in Black and Blue* with "brilliant technique." The genius Armstrong, Edwards adds, "inject[s] self-reflexive commentary into his vocal performance as

well." It is an effect that "forces the viewer to confront a swinging incommensurability—an untamable, prancing set of contradictory indices that seem to be saying all too much at once."[108]

Salvant's will to engage in what we might think of as temporal scatting differs from the classic "Heebie Jeebies," "Flying Home" aesthetics of our greatest, revolutionary jazz heavyweights. Although she is fully capable of finding her way around a scat, that is principally and notoriously not her game. "I believe," she has said, "scatting has to come from a place of complete freedom. There's almost an element of embracing the absurd in scatting. When it becomes an obligation, or a tool to prove something, it loses that element." Think of Salvant's scat, then, as "freedom" of a different order, as strategic disorderliness, as experimental wildness, as an adventurous confrontation with time. We hear it in the way that she plays within and through the excesses of the temporality of the song, stretching out and "distend[ing] an expressive medium through the proliferation of an index." "Scat aesthetics," Edwards reminds, "involve an augmentation of expressive potential rather than an evacuation or a reduction of signification. Words drop away from music so that 'unheard sounds [come] through.'"[109] Her "Ballad" holds on to the words but also revels in the "overgrowth" of words as she lays claim to Black fugitive practice fundamentals—repetition with a critical difference, circling back to scenarios, images, familiar tropes and language again and again and in a multiplicity of registers, Barthesian grains (the guttural as well as the ethereal), and narrative vantage points so that Black women's historical "unheard sounds" come through.[110] In this altered place, the tyranny of their stolen time is laid to waste.

Coda: Wild at Heart

The recording of this "Murder Ballad" performance is not available to the public. The Church of Wynton Marsalis's Jazz at Lincoln Center is just not giving up the goods. Without the footage, we might yet still imagine what "Murder Ballad" sounded like transduced by Salvant. We might yet still imagine how her heterogeneous singing style in other landmark performances would come to bear on a song like the one that Morton recorded. She maps out her strategy for us. "I like the idea of dreams," says Salvant,

> because a dream can be at the same time dreams from your sleep, or things that are unexplainable. There is also the idea of dreams as hope—as this big idea we have for the future, like dreams for things to get better. . . . The

dagger to me is an instrument of attack and also [defense]. . . . Some of the songs are dreams and some of the songs are daggers. . . . Dreams can also be expressed forcefully. If you have a dream or hope for the future it can be accompanied with some kind of force. I don't mean violence but any resistance or progress needs to be accompanied by some kind of force.[111]

Her countercritical self who wields the dagger and dreams with cataclysmic force is the one who spins wildness into colossal other worlds and onto darkly fantastic, speculative frontiers. Unafraid of the durational, the transmogrifying, the freakish, and the preposterous, she mines the monstrous for new grammars in the Black feminist tradition of Hortense Spillers and Christina Sharpe. Behold *Ogresse,* her seventy-five-minute song cycle with lyrics by Salvant and orchestrations by Darcy James Argue. It is a work that spills over with riveting sonic experiments. Genres swoop and collide with one another, morphing into altogether unexpected realms. Salvant "cuts an errant path" through music history, moving across a banjo line that carries blues cadences and rolls gently into and through picaresque folk, hints of country, flashes of classical baroque, and French fanciful interludes and in and out of the sweep of a thousand jazz women's melodies turned on their heads and buoyed up by a stirring and adventurous ensemble willing to go anywhere with her. Anchor, curator, conductor of her own sound, Salvant links up the language of the golden age of Ella's American songbook aesthetics with Abbey's unbound screams, with Nancy's sophisticated melancholy with Diahann Carroll's Broadway verve with young Sarah's ingenue ambition.[112]

At the edge of the universe, Salvant's *Ogresse* weaves together all of these modes of music-making into the unruly, mystic noise of dark romance, a Black feminist moral tale of dispossession and longing. This mammoth work of gothic tragedy and wonder debuted at New York's Metropolitan Museum of Art in October 2018, and it features a fourteen-piece set of players traveling with her through a tale that wends its way through the woods following the vicissitudes of a protagonist never before seen in jazz. Salvant, the songwriter, the aesthetic curator with a clear-cut vision, makes use of Abbey Lincoln's example in this regard, what she sees as "the simplicity of [Lincoln's] writing, and the impact of it. . . . The text is clear. It's not hermetic." This she uses to orchestrate new myths in order to address old truths about the nature of intersectional oppression. It "all started," she offers, "because I was thinking about female monsters—the idea of being a monstrosity and liking it."[113] *Ogresse* folds together recurring themes in her repertoire—of the struggle for women's aspiration and its thwarting; of hunger and the desperate pursuit for love, pleasure,

and satisfaction; of isolation, abandonment, and the costs of betrayal; and, above all else, the wretched experience of feeling unpretty in the eyes of the world. *Ogresse* is one of those all-too-rare occasions in which women jazz artists are given room to create whole fictive landscapes in which to roam, and it marks the emergence of a protagonist in the genre whose evolution and development reaches back to idyllic origins ("I was born in a redwood / house in the clouds") and stretches all the way to her violent demise, consumed by passion and poisoned by the consumption of love itself. The tragedy is Shakespearean in its basic plot turn as the title character and the lover whom she believes to have deceived her ultimately perish and "travel together / to that undiscovered country / from which no one ever returns."[114]

Salvant's take on this narrative convention, however, is exhaustive in its sonic originality, a wholly Black feminist reinterpretation of age-old folkloric myths that traffic in "beauties" and "beasts," in the aspirations of supposed "prince charmings" and the dreams of "lily-white" damsels in distress. Like the whole of Toni Morrison's body of work, *Ogresse* is a tale of root-and-branch betrayal that starts in the home where the waltzing sumptuousness of a mother's love (a figure who holds our protagonist "to the sky . . . and sang songs of [her] beauty") is swiftly displaced by the rule of an abusive stepfather who "tried to put" our girl "into his mouth." What unfolds is an origins tale, the birth of her fantastic "monstrosity," that which also becomes a source of her survival ("I bit his head off / and then I fled off into the woods . . ."). It is a spectacle that runs akin to visual artist Wangechi Mutu and Afropunk Dora Milaje warrior musician Santigold's shifting and rapacious, postapocalyptic figure in their 2013 video short, *The End of Eating Everything*. Like Mutu's "Medusa-like being," Salvant's Ogresse is imposing and insatiable as she pronounces that she is "vaster than the sea / she opens her mouth / it's the size of a planet / if you get too close / then she'll fit you right in it."[115]

What's particularly astonishing is the dramaturgical might that she brings to this story of existential crisis, how Salvant bobs and weaves between the *Ogresse*'s first person narration, that of her wolf-in-sheep's clothing suitor's, and that of a third-person framing that conveys the details of a tale of expulsion and othering that rests on spectacles of difference. Everything you need to know about the sheer depth and fearless invention of Cecile McLorin Salvant's musicianship can, in fact, be found in a cutting refrain that threads through the middle-section of her performance. "I do not believe you," are the lyrics she first delivers thiry-six minutes into the song cycle. It is an initial response to a man on a fool's errand, one whose pursuit of a bounty to slay the supposed "black beast" of the woods, leads him to dispassionately woo her with the jaunt and confidence of a

suave, supper-club serenade. "I do not believe you," sings Salvant's heroine in response to the declaration of her beauty, "why should I believe you?" Four times she turns over this pronouncement of incredulity, wringing each version of the phrase for subtle, explosive shifts in her character's emotional ontology—from halting disbelief, to softening inquisition, to faltering submission finally that is laced with fear, "*what* if I believe you?" What will happen if I give up the terms of my self-possession? Might I, instead, "refuse the thing that's been refused to me"?[116] Salvant's Ogresse contemplates the terms of her own sovereignty as well as the credibility of her oppressor.

She also imparts questions that, for any Black feminist listener, exceed the boundaries of that character's cataclysmic seduction, and in its hypnotic repetition at two crucial junctures in the performance, it whispers to us the key to our own liberation: reject the racial and gender shibboleths that banish a girl from her own household, that insist to her, as Ogresse comes to believe, that "Blackness" is a thing to be expunged from the face of the earth, that "whiteness" in the form of the wandering-in-the-woods girl "Lily," is precious and prized. Reject the patriarchal ruses that "set things up" this way and, instead, fundamentally question the epistemological tyranny of a world in which Blackness and womanhood are easily and brutally disregarded, that seemingly must be discarded for the presumptive sanctity of systemically structured life.[117]

Ogresse is a "wild" work, one that both courses through and yet lives outside of any one genre. Its orphic preface conjures the mood of a sonic fable; its cyclical interludes follow the folk rhythms of a picaresque banjo traveling through the tensions in its storybook town; the Rat Pack cocktail culture misogyny of a song like "She's Big" ("she's bigger than a tree / she's vast / she's vaster than the sea / she opens her mouth / it's the size of a planet") finds its swinging counterpoint in the rebellious "I'm Breezy" ("I'm happy, mostly / I do what I want / whenever I want / when Folks come laughing / and leering and pointing at me / I eat them for breakfast / with tea"). It delights in cabaret chansons that traffic in the racist caricature of colonial culture ("C'est tres simple a faire / 700g de chair / fraiche de paysan . . . 1009 de beurre) while yet still undoing such tropes by conveying the complex interiority of a Black heroine who is, at turns, another one of Salvant's screwball "counterdiva" personas.[118]

Unruly and unregulated, her *Ogresse* is as big and boundless as its doomed heroine. But in its vision of a pariah who strives and fails to attempt to live outside of the constrictions of the dominant and the proper, it dares to envision, as does Toni Morrison's ninth novel *A Mercy*, a kind of womanhood perched in the "wide and untrammeled space" of the forest frontier, away, for a spell, from the mob intent on annihilating her.[119] There she might pursue her curiosity, outlive

Wangechi Mutu, *The End of Eating Everything*, 2013

Cécile McLorin Salvant, illustration for *Ogresse,* Rose Theatre,
Jazz at Lincoln Center, New York, September 27–28, 2019

her restlessness, find the form that she might shape into her own exquisite expressive language. Salvant gives us glimpses of this bold and other way of being, this wildness that Halberstam names, the kind that unseats colonialism's hold on that word and, instead, troubles the "normativity that holds the deviant and the monstrous decisively at bay. . . ." There is another world, this song cycle calls out to us, one beyond "the great hill covered in flowers . . . covered in snakes," where she sings the martyred bones of Ogresse to rest.[120]

And this end is, to be sure, yet another one of Salvant's new beginnings. Like Giddens, like June, she writes her own ripostes and invents her own speculative questions and open-ended answers about dense histories of subjugation and survival, precarity and fugitive dreaming. She sings alongside the women like Mamie who left behind conundrums for her to mine, turn over, and reshape into new tales of possibility. She gathers up the traces of the wild, just as Hortense Spillers urged us to do all those years ago, and "*claim*[s] the monstrosity . . . which her culture imposes in blindness," composes new endings, alternative futures, striking suggestions, forbidden scenarios, and "rewrite[s] . . . a radically different text for female empowerment."[121] She takes the durational

and the transformative promise of the song cycle form and invents a new sonic grammar steeped in the history of Black women's musicking across the ages.

There on the "great hill," for this burial, she invites us to do some "loud dreaming" with her as she brings to a close her extended Black feminist sonic monologue, this archive of the shrieks and sighs, the coos and wails, the sounds mellifluous and discordant, vernacular and liturgical, dangerous and soothing, regal and whimsical, cantankerous and solemn. Here with heavy melisma, a run of vocal trills, and nearly three minutes of ardent lyrical, nearly shamanistic repetition, she holds vigil and sounds out the scale of this tragedy. It is the "sound that [breaks] the back of words . . . ," and it does not shy away from pointing its finger at the long dead and still here who fail to listen to all of this history of the dispossessed.[122] It is a reclamation of all of what we might yet still hold precious in the immense musical lexicon handed down to us by our mothers. This space that is wild Salvant's, the Salvant of *Ogresse*, is the source of "vibrancy that limns all attempts to demarcate subject from object." It is the space that troubles the "normativity that holds the deviant and the monstrous decisively at bay." Here she "speak[s] not in the language of order and explanation but in beautiful, countermythologizing grammars of madness."[123] She is out on the edge, in the forest, beckoning us to join her in this alterity, and the call from that WomanChild—"You'll find out how wild I can be"—echoes forward. Do we dare to follow her?

EPILOGUE

In the Basement with the Boys in the Band

There are those who say that the lore of the modern rock and roll archive starts here, deep in the rustic outer country of upstate New York, in a house affectionately nicknamed Big Pink because of its gaudy, pastel siding. Here in West Saugerties, New York in 1967, Bob Dylan and the Toronto outfit once known as the Hawks and now simply as "the Band" are down in the basement singing songs about Bessie Smith and ye "old, weird America," as Greil Marcus famously puts it. Here in this place and in the same year that *Rolling Stone* magazine would be born and set into play a kind of self-congratulatory music criticism that haunts our present-day taste-making institutions and Bradley Cooper's *A Star Is Born* dreams, here in the same year that King would deliver his "Beyond Vietnam" speech condemning American empire and exposing its inextricable ties to racial and class terror, the same year that over 150 communities of the working poor, the urban and distressed, from Newark to Detroit and beyond would light up in rebellion—in the run of that roiling epoch, a band of brothers (one with indigenous roots, another with a notoriously fabulist past) laid down tracks that stoked the mythologies associated with rock history and the fetishistic, deep wonk ways that certain kinds of cultural histories get rendered as "precious," get dubbed as worthy of "preservation," while other forms are left to seemingly fade away.

The "Basement Tapes," as they came to be known, were recorded that year in relative isolation and under the cover of Dylan's storied convalescence in the wake of a nasty motorcycle accident in 1966. They were mischief-making jam sessions featuring one-offs, breakdowns, wistful ballads, whiskey-soaked supplications, and roughshod odes to the open road. They were tavern blues and campfire tales, "casual recordings ... more than one hundred performances of commonplace or original songs."[1] They were documents of young white men (or "white-seeming" men in the case of guitarist Robbie Robertson) who were armed with, among other things, Dylan's trademark esoteric lyrics (albeit a bit leaner here), his always-elsewhere, punctum vocals, which he shared with Robertson and Rick Danko (who takes lead on the song "Bessie Smith"), and the insistent warmth and elegiac tenor of Garth Hudson's Hammond organ and accordion work.

Fourteen songs pressed into permanence on an acetate disc and passed around—first to fellow musicians and then bootlegged all across the rock and roll universe by 1970. Their major-label release in 1975 was cause for celebration among the critics and fans who longed for the chance to further archive the rehearsals and experimentations of that sacred rock bard, forever shrouded in mystique, forever the iconic ideal, forever the romantic embodiment of all that is putatively authentic and organic in popular music culture—in spite of the fact that he himself reveled in the talents of his own endless mythmaking.

What The Basement Tapes held out to Dylanites, however, was the assurance of pure and unadulterated art, resistant to commerce, pounded out on the ground floor of a house rental in upstate New York. This was a music-making "laboratory," as Marcus refers to it, "where, for a few months, certain bedrock strains of American cultural language," he argues, "were retrieved and reinvented."[2] Yes, there were those naysayers who called out the slacker tendencies of a collective that appeared to pay little (or not enough) mind to their own— "This Wheel's on Fire"—American present ("these were deserters' songs," cries one critic in 1990s hindsight), but to those haters Marcus would famously offer an extended treatise on the prodigious value of the tapes and the ways that they document "an unimaginable speech, an undocumented country," an "invisible republic," "music made to kill time that end up dissolving it."[3] As is the case with all of his signature work, he is transfixed by a song's ability to encapsulate a constellation of rhizomatic historical moments, to condense the most romantic elements of American history—"the Puritan's dares" and folkloric outlaws' death wishes—and transduce them into present-day articulations of longing and suffering, adventuresome pleasure and playfulness. If these tunes sound familiar, uncanny, maybe even a bit clichéd with their country twang and frontier saloon

sadness, they do so purposefully, according to him, in order to convey larger truths about the human condition. They are songs that stage scenes of "Comedy and Tragedy sitting down for a long bout of arm-wrestling with a drunken mob cheering them on," as he puts it.[4]

As this book has aimed to show, Black feminists—musicians, critics, and fans—are repeatedly on the sidelines of the sidelines watching all of this go down. There's no shade that I'm throwing here, only the simple and yet thoroughly underacknowledged fact that in the big, hallowed intellectual histories of popular music culture and the practices of collecting, memorializing, and assigning value to sonic art, Black women are rarely in control of their own archives, rarely seen as skilled critics or archivists, all too rarely beheld as makers of rare sounds deemed deserving of excavation and long study. In the world of the *Tapes,* even Bessie Smith, the blues empress whose legend has spawned generations of poetry, theater, dance, visual art, and book-length explorations and tributes, makes a cameo in the service of the Band and Dylan's typically solipsistic pilgrimage toward the talismanic powers of a long-lost "friend" who, as the lyrics go, shared with them "the good times and the bad." Back in those days, we're told, our protagonists "didn't worry about a thing." They wonder whether it was "her sweet love or the way she could sing."[5] *Tapes* collectors and critics tend to spend little time with this song other than to squabble over sound quality and the question of whether this track—with its noticeable studio polish—even belongs in the "Big Pink" sessions.[6] As Yoncé Knowles might say (channeling Karen O and calling out to Bessie), "They don't love you like I love you."

It is for me, therefore, a perhaps quixotic exercise, a compelling riddle in the legend of the *Tapes,* to imagine otherwise, to envision a world in which sisters not only make glorious, pathbreaking sounds but also listen to, love, collect, think about, write about, and find ways of preserving and passing forward said sounds. This is the kind of labor that might capture the attention of our cultural imaginaries such that we might more fully grasp the vastness of the "invisible republics" that they've built for us, that constitute our modern sonic lives. Along these lines, then, this study has been an exercise in calling attention to this phenomenon of Black feminist sonic archiving and taking seriously the critical practices of musicians and critics whose work as such was often chiasmic. It has been a call to spend more time with these artists who are spending time with the archive.

We hear them all in the basement, and here again we might heed Marcus's words: "Where the past is, in the basement recordings, in the mood of any given performance, is the question to ask the music and the question the music

asks. This question raises the frame of reference that each performance passes through as if it were a door. In the chronology remade in the Catskills in 1967, the basement was an omphalos and the days spent within it a point around which the American past and future slowly turned."[7] The omphalos, the hub, the focal point of Black feminist sound, these sites of Black feminist archiving demand more legible and cared-for cartographies so that we might better hear and grasp the magnitude of this dazzling and gripping work about Black women's pleasure and joy, suffering as well as survival as it flows forth from their own laboratories where cultural memory and future possibility intersect and yield new meaning.

Can You Dig It with Beyoncé?

Way down low. That's where we're ultimately heading before coming up for air. The implication is such because of the spiraling architecture, the slow-rolling, vertiginous crawl of the camera that hugs walls and creeps around corners. Just a hint of the string-tinged, echoing trace of our reigning pop empress's self-defense Ole Opry anthem lingers in this cavernous space. Fading vocals whisper to us that threats abound, that trouble lurks here.

Blink and you'll miss it, but the transition—from wide-open, out-on-the-range horse-riding and Afrocowboy socials to the stark, cold enclosures of a cement fortress parking structure—is one of *the* most pivotal moments in Yoncé Knowles's 2016 Black feminist magnum opus, *Lemonade,* her New Orleans reclamation manifesto, a work that, as the vast majority of pop fans good and well now know, has been tilled many times over with passion and mostly with great care by everyone from that obsessive fan "hive" to critics and scholars across the globe. (I would place my money on a hunch that it is arguably now the most "reviewed" album of all time if we count the hundreds of blog posts and think pieces that flourished on social media alongside formal press outlet analyses in the weeks and months following *Lemonade*'s premiere on HBO on April 23, 2016—and I most certainly would do just that. [8])

The majority of pundits have zeroed in on how much place matters in this epic work and the extent to which the Crescent City emerges as a key character—from the quotidian grandeur of marching bands strutting down the streets of the Algiers neighborhood to the shots of Lake Pontchartrain's lush splendor, the sun-kissed sands of Fontainebleau State Park, and the ludic energy of Bourbon Street.

But the heart of *Lemonade*'s cartography, as a number of critics make clear in readings of Beyoncé's second visual album (her sixth solo effort in a career now spanning two decades), resides at the scene of the plantation—Destrehan, Madewood, and Fort Macomb—sites that remind us of that most famous of Hartman mantras that haunts and shapes our thinking, our feeling, and our scholarship about "the conditions of the present": "If slavery persists as an issue in the political life of black America, it is not because of an antiquarian obsession with bygone days or the burden of a too-long memory, but because black lives are still imperiled and devalued by a racial calculus and a political arithmetic that were entrenched centuries ago. This is the afterlife of slavery—skewed life chances, limited access to health and education, premature death, incarceration, and impoverishment."[9] These critics remind us of the ways Knowles tarries, as historian LaKisha Simmons puts it, at the site of "monumental history" in this project and how she and her Black radical study ensemble of creatives on *Lemonade*—among them, Black feminist director Melina Matsoukas and experimental video filmmaker Kahlil Joseph—draw inspiration from the ways that visual artist Carrie Mae Weems "places her body on the ruins" of Louisiana sugar plantations "to become a witness to this past" in her work. Yoncé too, Simmons argues, "merge[s] past landscapes with the present to centre black women within narratives of the U.S. nation." Beyoncé's sweeping and alluring pop masterpiece, which is dense with historical and cultural citations molded into being by the artist and her team of collaborators, encourages us "to see the monument of the sugar plantation anew."[10]

This insistence on reckoning with the location, location, location that matters in *Lemonade* is for sure built out of the grist of woman-of-color critical thought and study emerging over the past decade and a half—most notably in the work of scholars like Katherine McKittrick and Mary Pat Brady, both of whom illuminate the ways that aesthetics are the tools by which the historically marginalized might reoccupy, redesign, and reframe sites of wounding and catastrophe, gross neglect, and forgotten and undervalued loopholes of retreat. McKittrick has, for instance, influentially shown us how Edouard Glissant's "poetics of landscape allow black women to critique the boundaries of transatlantic slavery, rewrite national narratives, respatialize feminism, and develop new pathways across traditional geographic arrangements; they also offer," she adds, "several reconceptualizations of space and place, positioning black women as geographic subjects who provide spatial clues as to how more humanly workable geographies might be imagined."[11] And before her it was Chicana feminist scholar Brady, who made the contention that we should take seriously how "the imbrication of the temporal within the spatial ... illustrates" that, in spite of the long colonial-neoliberal project's "seemingly successful abstraction of space," in spite of a long systemic game to convert people's land into "geometric homogeneities" and a "quantitative" set of ideas from that of vibrant human dwelling, in spite of the tenacity of capitalist expansion and state surveillance, there are nonetheless "alternative conceptions" of the spatial that challenge "oppressive" alignments of power and instead privilege revolutionary socialities.[12]

This is the undergirding philosophy of *Lemonade,* that Black women activists—Mothers of the Movement and culture workers, musicians and dancers, athletes and actors, legendary chefs and Mardi Gras masqueraders—might reinhabit the ruins of our spurned history, might reclaim the earth and overrun the wilderness with our wildly sensual and sumptuous, celebratory selves and ultimately birth a new time and restorative, new collectivities. The journey to get to there, though, requires roaming fields, bursting through floods, levitating on slick, firewall roads, walking through flames, and plunging to new depths, to the bottom of oceans of despair, beneath shipwrecks that left bodies in the wake.[13]

Even before we hit rock bottom in the parking lot with her, Our Lady Knowles is on a subterranean expedition in *Lemonade,* one that is loaded with counterhistorical meaning, taking us to the place where buried New World truths lie. Her plunge reminds us of Glissant's wisdom yet again, how he calls out to us to heed the bottom of the sea, the sedimentary layers of traumas submerged. Early on we see her falling into a deep-blue netherworld, her house that is not a home now capsized.

Her resurrection yields waves of operatic wrath in multiple pop registers, giving context and meaning to the forgotten sisters, the phantoms made flesh once more and here to walk and sit among us until we might reckon with their beings, incorporate their pasts into our ontological present. She is our sonic archivist, the one who banana dances to the beat of Josephine; the one who does it "Proud Mary"-style like electric Tina; the one who drops the stank funk like Betty in a spy movie send-up; the one who gives good glam as Supreme Lady D; the one who is our ride-or-die chic Etta at Chess Records. She is someone who's long been interested in staging scenarios (pace Diana Taylor) and engineering the mechanics of Joe Roachian surrogation to yoke her own ambitions and aesthetic lifeworlds with those of her predecessors.

This *Lemonade* joint, though, takes the scale of her vision to vaster territories— up, out, and beyond her own performed effigy—to focus instead on a beloved city,

an entire territory, a region as the locus of our Black diasporic dreams as well as our chronic New World sorrows, the capital of our twinned economy of grief and obstinate reinvention. Beyoncé's lyrical fable offers to us a *Lemonade* subterranean that is the repository of all that has been discarded yet remains with us at the very core of our everyday lives. It is the site of the basement tapes of a Blackness born out of the fact of history's racial and gender and class brutalities. It is a work that releases the pent-up energy of Black folks' misbegotten value—that which is stored up in the sediment of our culture—and sends it back into the atmosphere.

Of the work's many gripping Black feminist statements that broke unprecedented ground in the pop music imaginary (statements about the specificities of

Black women's historical injury, the intersections of mourning; of melancholia; of racial trauma as it manifests itself at the level of hetero-intimacies; the quality and potentiality of reparative futures), the symbolism that intrigues me the most is that in which Yoncé appears underneath it all and in the dankest and the most mundane of settings compared with all of those bucolic vistas she walks, rides, and glides through across the span of the video.

Here in a desolate parking lot, three tracks into her visual album, she rises from the back of an inoperable ride draped in fur armor and rocking a crown of cornrows, hot with fury about micro and macro crimes—thefts, betrayals, desertions, and violations. In hindsight now, we know that this rage is about much more than domestic spats. Along with miles of razor-sharp cultural criticism, X, of course, tells us so when he declares in the sound bite that "the most disrespected person in America is the black woman. The most unprotected person in America is the black woman. The most neglected person in America is the black woman."[14] Allegory is awash all over this text as it aims to convey the exponential magnitude of generations of dispossession and simultaneously choreograph scorched-earth refusals of multifaceted subjugations. From this place that is both symbolic and material, from this place that is the Ellisonian underground rewritten as Black feminist maelstrom, as "undercommons appositionality," as Nina Simone-style revolution (where "the only way we can stand in fact / Is when you get your foot off our back"), she battles catastrophe on two fronts.

On sonic grounds she wages a *Game of Thrones* war here with rock and roll racial and gender hierarchies. Tagging blues archivist guitar hero Jack White as her accomplice, she digs into the powder-keg energy of a minimalist groove

and seizes the purloined goods in Led Zeppelin's vaults. Folding together drummer John Bonham's loping rhythm signature from the band's 1971 cover of "When the Levee Breaks" with bursts of fireball vocal distortion, "Don't Hurt Yourself" is an exercise in Black rock reappropriation as much as it is a "final warning" for Jigga to get his shit in order. If Led Zep guitarist Jimmy I-have-issues-with-Black-folks Page has often downplayed the significance of Kansas Joe McCoy and Memphis Minnie's 1929 original version of this record, Knowles, White, fellow coproducer Derek Dixie, and fellow songwriter Wynter Gordon recenter the lapsed and long-obscured origins of a song that chronicles mass Black displacement and destruction following the Great Mississippi Flood of 1927. Yoncé sings across the centuries, reconnecting Minnie and McCoy to the sorrows of new millennium racialized eco distress, putting Bonham's percussive drive to work in the service of something other than Robert Plant's phallus.[15]

This is cultural arm wrestling, the staging of an historical intervention with the ways in which rock and roll timelines notoriously obscure the labors of Black folks, makers of the form. This is Yoncé the warrior archivist using an enclosed parking lot early in her epic as her omphalos, her laboratory to dissect, confront, and lay waste to patriarchal abuses in the home as well as pop music culture writ large. To get to the bottom of her basement theater truths, though, to hear the tapes that she is making in full, subwoofer stereo, we have to stay with her, travel with her to the halfway point in *Lemonade*, to that moment to which I alluded earlier, where we hit the bends circling downward.

This is the final descent. Soon enough, in the glorious denouement, we'll gather together aboveground, having reached the end of the search for our mother's verdant gardens, finally ready to harvest new fruit and sing redemption songs out in the woods together. But before all that, we'll have to return to the territory, to the place where governmental neglect conspired with legacies of disenfranchisement to yield false forms of shelter and institutional as well as intimate forms of violence during the height of the Katrina disaster.

The Superdome. As my Tulane colleague, historian and public humanist Andy Horowitz, makes clear in answer to my question about the "chaos" of that place, "Depends entirely what you mean by chaos. If you mean the 'people raping babies' variety, then that didn't happen, despite the New Orleans police chief saying so on *Oprah* at the time. Nobody was murdered inside the Superdome. (According to the Louisiana National Guard, six people died: four of 'nature causes,' one OD'ed, and one person committed suicide, and four bodies were recovered outside the Superdome, but none of these were classified as murders either.) If by chaos you mean well over 10,000 people there with no electricity, no flush toilets, and no means of getting out of town, then yes, there was abject chaos."[16]

Hurricane Katrina aftermath, the Superdome, New Orleans,
Louisiana, September 2, 2005

Lemonade invites us to go not just into the Superdome but, significantly (in my mind), *beneath it*. Yes, research tells us that these scenes in the garage were likely shot three minutes away (at Royal Parking Garage in the 800 block of Carondelet, to put a finer point on it), but the suggestion by virtue of editing and clip montage is that the rage from below that courses throughout this saga emanates from under the field, under the stadium, where some local lore holds that a cemetery once sat (a hotly contested myth).[17] Beyoncé's epic suggests to us that if we're going to reorient our bodies and spirits toward futures rooted in Nina's *Silk & Soul* freedom dreams, we have to return to this place to confront and, if not expel, at least know better the nature of our anguish. She lays herself across the fifty-yard line while those Black feminist angels of history watch over her and look over the scene. Her stillness, her sadness, is a wake for that which we must never forget, that which Horowitz makes plain in his brilliant new book on Katrina. I quote him here at length as a way to archive the endless sorrow of that which we must not leave behind:

> Licensed to kill, and believing that savage gangs had besieged the city,
> New Orleans police officers shot at least nine people during the week

after the storm. On September 1, a police officer shot Keenon McCann as he helped to distribute water to flood victims from a Kentwood Springs bottled water truck on the Claiborne Avenue overpass. Police say McCann brandished a pistol; no pistol was recovered from the scene. On September 2, a police officer shot and killed Henry Glover, a 31 year-old father of four, then another officer set fire to Glover's body and dumped it over a levee. On September 3, a police officer shot Danny Brumfield in the back, outside of the Convention Center, where the 45 year-old man had taken refuge with his family after their home in the Ninth Ward flooded. The officer who shot him said Brumfield was attempting to stab him with a pair of scissors; members of Brumfield's family, who witnessed the shooting, said he was trying to flag down the officer for help. No scissors were recovered from the scene. On September 4, police responded to reports of an officer shot near the Danziger Bridge over the Industrial Canal. When they arrived, the police officers shot six unarmed people, and two of them died: James Brissette, a 17 year-old boy, and Ronald Madison, a 40 year-old man who was mentally disabled. Madison was shot five times in the back. No weapons were recovered from the scene. All of these people were African American. When some people nearby got in a scuffle, [Angela] Perkins said a police officer at the Convention Center forced her to her knees and pointed a gun at her, too. "Made us look like animals," she said. "Like we deserved whatever was happening to us."[18]

And so we are with her here, beneath this place that is the ground zero of this carnage. The hints are everywhere in the video: fleeting images of a brick stairwell up then down. Recall those sister dancers in flowing garments and iridescent in black light, moving together in Ailey–esque *Revelations* rituals, swaying and undulating and exorcising something together in the parking lot. Think too of those other warriors striking battle-ready moves in the locker room, in bathroom stalls and hallways.

Beyoncé's epic hinges on passing through this crucible, reinhabiting this space and transforming it into a different iteration of the "basement theater" that Marcus designs for his boys, where "nothing was exactly clear and nothing was obviously wide open." Like the Band, she shows us how there "were doors all around the room . . . all you had to do was find the key. Each time a new key opened a door," Marcus continues, "America opened up into both the future and the past. . . . There is no nostalgia in the basement recordings. . . . The mechanics of time in the music are not comforting. In the basement, the past is

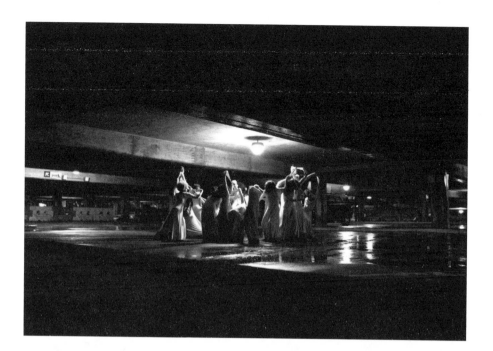

alive to the degree that the future is open, when one can believe that the country remains unfinished, even unmade."[19]

Watch her, then, as she rides this revolution out of the basement, out of that shadowy New Orleans garage, and into the center of our consciousness. Her *Lemonade* kicks down the door between Black past and Black futures, pulling us toward the light and willing us to come up for air. Take a deep breath.

NOTES

Introduction

1. Christopher Small's work is germinal to popular music and sound studies. It has opened up the field of critical interrogations of musical practices emerging out of socialities that extend beyond the realm of formal composition and instrumental performances and into the realm of cultural reception—listening and dancing—but also into the sphere of cultural work that complements and subtends such performances. Christopher Small, *Musicking: The Meanings of Performing and Listening* (Middletown, CT: Wesleyan University Press, 1998). Small characterizes these practices as "musicking."

2. The phrase "more life" is the defiant rally cry spoken by the moral tornado of a character, Prior Walter, as he physically and spiritually battles AIDS in Tony Kushner's queer masterpiece, *Angels in America*. Tony Kushner, *Angels in America: A Gay Fantasia on National Themes* (New York: Theater Communications Group, 2013). Zora Neale Hurston's "You Don't Know Us Negroes" is an unpublished manuscript that was originally intended for the pages of *American Mercury* magazine. A handwritten note at the top of the manuscript in the magazine editor Lawrence Spivak's papers reads "Kill." Zora Neale Hurston, "You Don't Know Us Negroes" (1934), MSS40964, Container 37, Lawrence Spivak Papers, Library of Congress.

3. Toni Morrison, *Jazz* (New York: Vintage, 1992), 220.

4. Cedric Robinson, *Black Marxism: The Making of the Black Radical Tradition*, 2nd ed. (Chapel Hill: University of North Carolina Press, 2000), 199. The revolution that I'm exploring here draws some inspiration from the spirit of *Tough Enough*, Deborah Nelson's brilliant study of "unsentimental" women writers, intellectuals, and artists. Though we differ greatly in our respective explorations of affect in the work of women thinkers and creatives, Nelson's interest in identifying threads of ethical, political, and aesthetic commonality in a cluster of pivotal women intellectuals' bodies of work serves as an important model for this study. Deborah Nelson, *Tough Enough: Arbus, Arendt, Didion, McCarthy, Sontag, Weil* (Chicago: University of Chicago Press, 2017).

5. David Wondrich, *Stomp and Swerve: American Music Gets Hot, 1843–1924* (Chicago: Chicago Review Press, 2003), 208. As the masterful archivists Lynn Abbott and Doug Seroff point out, though "Mamie Smith is routinely credited as the first black blues singer on record . . . Bert Williams recorded a blues title in 1919. . . ." Lynn Abbott and Doug Seroff, *The Original Blues: The Emergence of the Blues in African American Vaudeville* (Jackson, MS: University of Mississippi Press, 2017), 371, footnote 119. This makes Smith the first African American woman to record a blues record.

6. Telegraph operator Victor H. Emerson was the first of several white entrepreneurs who sought to profit on the wonders of new "talking machine" technologies in the 1890s by capitalizing on the recorded vocal musicianship of African American street entertainer George W. Johnson, believed to be the first African American to "make records for commercial sale." See Tim Brooks, *Lost Sounds: Black and the Birth of the Recording Industry, 1890–1919* (Urbana: University of Illinois Press, 2005), 26. Brooks adds that the "phonograph was a white middle-class toy" (5). On early white blues performers, see Elijah Wald, *The Blues: A Very Short Introduction* (New York: Oxford University Press, 2010), 23–24. Frederick Douglass, *Narrative of the Life of Frederick Douglass, an American Slave* (New York: Penguin Classics, 1982), 57–58; and Angela Davis, *Blues Legacies and Black Feminism* (New York: Vintage, 1999).

7. Gloria Naylor, "A Conversation: Gloria Naylor and Toni Morrison," in *Conversations with Toni Morrison,* ed. Danielle Taylor-Guthrie (Jackson: University Press of Mississippi, 1994), 214.

8. Brent Edwards, *Epistrophies: Jazz and the Literary Imagination* (Cambridge, MA: Harvard University Press, 2017), 171. Sedgwick's famous invocation of the concept is Deleuzian in origin. As she reminds us, "*Beside* comprises a wide range of desiring, identifying, representing, repelling, paralleling, differentiating, rivaling, leaning, twisting, mimicking, withdrawing, attracting, aggressing, warping, and other relations." Eve Kosofsky Sedgwick, *Touching Feeling: Affect, Pedagogy, Performativity* (Durham, NC: Duke University Press, 2003), 8, emphasis in the original.

9. Mia Bay, Farah J. Griffin, Martha S. Jones, and Barbara D. Savage, "Introduction: Toward an Intellectual History of Black Women," in *Toward an Intellectual History of Black Women,* ed. Mia Bay, Farah J. Griffin, Martha S. Jones, and Barbara D. Savage (Chapel Hill: University of North Carolina Press, 2015), 3; Gayle Wald, conversation with the author, June 17, 2019.

10. Toni Morrison, *Beloved* (New York: Vintage Classics, 1987), 315.

11. Lester Bangs, "The White Noise Supremacists," *Village Voice,* April 30, 1979.

12. Houston Baker, *Blues, Ideology, and Afro-American Literature: A Vernacular Theory* (Chicago: University of Chicago Press, 1987); Farah Jasmine Griffin, "When Malindy Sings: A Meditation on Black Women's Vocality," in *Uptown Conversation: The New Jazz Studies,* ed. Robert G. O'Meally, Brent Hayes Edwards, and Farah Jasmine Griffin (New York: Columbia University Press, 2004), 102–125. See also Emily Lordi, *Black Resonance: Iconic Women Singers and African American Literature* (New Brunswick, NJ: Rutgers University Press, 2013), which builds extensively on Griffin's concepts.

13. Sterling Brown, "Ma Rainey," in *The Collected Poems of Sterling A. Brown,* ed. Michael Harper (Evanston, IL: Triquarterly Books, 1996), 62–63; James Baldwin, "Sonny's Blues," in *Going to Meet the Man* (New York: Vintage, 1995).

14. Alex Ross, *The Rest Is Noise: Listening to the Twentieth Century* (New York: Picador, 2008), xviii.

15. Saidiya Hartman, *Wayward Lives, Beautiful Experiments: Intimate Histories of Social Upheaval* (New York: Norton, 2019).

16. As Deleuze and Guattari define it, a "rhizome" is a "subterranean stem" that is "absolutely different from roots and radicles." The "rhizome is an acentered, nonhierarchical, nonsignifying system without a General and without an organizing memory or central automaton, defined solely by a circulation of states." To be rhizomatic is to eschew linearity, hierarchy, fixity, the sedentary. It manifests "nomadology" and "lines of flight." So much of what Deleuze and Guattari call for in their manifesto *A Thousand Plateaus* resonates with the spirit of what I'm after in my work—an attention to routes and not just roots, maps and not tracings, heterogeneous rather than singular ways of experiencing the world. As they declare, "Music has always sent out lines of flight, like so many 'transformational multiplicities,' even overturning the very codes that structure or arborify it; that is why musical form, right down to its ruptures and proliferations, is comparable to a rhizome." Gilles Deleuze and Félix Guattari, *A Thousand Plateaus: Capitalism and Schizophrenia*, trans. Brian Massumi (Minneapolis: University of Minnesota Press, 1987), 6, 21, 11. But the analogy is not a clean one and many distinctions exist between Deleuzian theories of the rhizome (as, for instance, "an antigeneaology" as "a short-term memory or antimemory") and my own readings of black women's sound relations with the world. Kara Keeling's majestic *The Witch's Flight* remains the most exemplary Black feminist reimagining of Deleuze and Guattari's theories. Kara Keeling, *The Witch's Flight: The Cinematic, the Black Femme, and the Image of Common Sense* (Durham, NC: Duke University Press, 2007).

17. Giuliana Bruno, *Streetwalking on a Ruined Map: Cultural Theory and the City Films of Elvira Notari* (Princeton, NJ: Princeton University Press, 1992), 6.

18. Christian observes that in "exploring ourselves as subjects, not only do we reflect on what *we* know, but we also know a great deal about those who are perceived as being 'something' rather than 'nothing at all.'" Barbara Christian, "What Celie Knows That You Should Know," in *Barbara Christian: New Black Feminist Criticism, 1985–2000*, ed. Gloria Bowles, M. Giulia Fabi, and Arlene R. Keizer (Urbana: University of Illinois Press, 2007), 6, 21, 11, emphasis in the original.

19. On queer blues feminist cultures, see, for instance, Davis, *Blues Legacies and Black Feminism*. See also Hartman, *Wayward Lives, Beautiful Experiments;* Sandra R. Lieb, *Mother of the Blues: A Study of Ma Rainey* (Amherst: University of Massachusetts Press, 1983); and Jack Halberstam, "Queer Voices and Musical Genders," in *Oh Boy! Masculinities and Popular Music*, ed. Freya Jarman-Ivens (New York: Routledge, 2007), 183–196.

20. For obvious reasons, the scope of this work—sprawling as it is—could simply not accommodate extensive examinations of remarkable diasporic artists like Miriam Makeba, Graciela Perez, Rita Marley, Cesoria Evora, Angelique Kidjo, Zap Mama, and countless others. Nevertheless, the alliances and collaborative endeavors among key twentieth-century Black women musicians shed light on the ways that Blackness is a transnational and diasporic experience and the ways that conditions emerging out of said experience matter in the sonic lives of African American women.

21. Alexandra Vazquez, *Listening in Detail: Performances of Cuban Music* (Durham, NC: Duke University Press, 2013); Bruno, *Streetwalking on a Ruined Map*. My thanks to Kara Keeling and Jacqueline Stewart for bringing Bruno's work to my attention and for encouraging me to consider the structural and methodological resonances between her tremendous work and my own. Bruno argues that her "analysis has been designed as a palimpsest. Moving

on the edge, through the archeological site of textual absences and voids, [her] inquiry traces overlapping textual journeys in a series of 'inferential walks' through novels, paintings, photographs, and architectural sites. The filmic palimpsest is drawn across a broad cultural field at the intersection of art history, medical discourse, architecture, photography, and literature. In a space where fiction is not only the object of inquiry but also shapes the scene of writing, in a logic that does not separate object and form of writing, the structure of [her] study is itself a palimpsest" (3–4).

22. Peter Szendy, *Listen: A History of Our Ears* (New York: Fordham University Press, 2008), 6, 36, 52. John Szwed stages something of a listening-to-a-listening in "The Prehistory of a Singer," a chapter from his study on Billie Holiday. Here Szwed carefully walks through a historically and socially contextualized network of early twentieth-century vocalists, what he calls "a set of common resources from the past" from which not only Holiday but Bessie Smith, Ella Fitzgerald, Sarah Vaughan, and Betty Carter would have likely drawn "to craft their own approaches." John Szwed, *Billie Holiday: The Musician and the Myth* (New York: Viking, 2015), 77–96.

23. Halona Norton Westbrook, "The Pendulum Swing: Curatorial Theory Past and Present," in *The International Handbooks of Museum Studies*, vol. 2, *Museum Practice*, pt. 3, *Processes* (Chichester, UK: John Wiley and Sons, 2015), 341, 349; Kara Keeling, *Queer Times, Black Futures* (New York: New York University Press, 2019). Westbrook, "The Pendulum Swing," 349.

24. Meta Jones discusses a practice akin to this—especially with regard to poets engaging known and often beloved literary works and "renovating" them through avant-garde poetic invocations of sound and visual aesthetics. Meta Jones, "Soul to Soul through Soul on Soul: An Open Letter to the Diaspora's 'Homegirls'" (paper presented at Duke on Gender Colloquium, Duke University, October 21, 2019).

25. Beyoncé, "'Take My Hand, Precious Lord': The Voices," YouTube video, 8:07, posted February 9, 2015, https://www.youtube.com/watch?v=nVtT4jZM9GA.

26. Jennifer Stoever, *The Sonic Color Line: Race and the Cultural Politics of Listening* (New York: New York University Press, 2016), 17; Mary Lou Williams, "Rhythm Section," in *Talking Jazz*, ed. Max Jones (New York: Norton, 1988), 179.

27. Interview with Esther Mae Scott, August 11, 1976, and November 3, 1977, Black Women Oral History Project Interviews, ed. Ruth Edmonds Hill, 8:310–357, Radcliffe Institute.

28. Daphne Duval Harrison, *Black Pearls: Blues Queens of the 1920s* (New Brunswick, NJ: Rutgers University Press, 1988); Hazel Carby, "It Just Be's Dat Way Sometime: The Sexual Politics of Women's Blues," in *Unequal Sister: A Multicultural Reader in U.S. Women's History*, ed. Ellen Carol DuBois and Vicki Ruiz (New York: Routledge, 1990), 238–249; Davis, *Blues Legacies and Black Feminism*. See also Hettie Jones, *Big Star, Fallin' Mama: Five Women in Black Music* (New York: Puffin Books, 1997); and Linda Dahl, *Stormy Weather: The Music and Lives of a Century of Jazz Women* (New York: Limelight Editions, 1989).

29. Peter Szendy writes of the "making of the modern ear" in his meditation on "listening as arrangement. . . ." Szendy, *Listen*, 99. One of my early inspirations for probing the aesthetic intricacies and dynamism of marginalized Black women musicians in the archive came in the form of Linda Dahl's pioneering study, *Stormy Weather*. Dahl reminds that early artists like brothel performer Mama Lou of 1880s New Orleans and voodoo queen Marie Laveau were also "songwriters and, along with a slew of turn-of-the-century black women musicians in early minstrel, ragtime, and vaudeville bands," they contributed in pivotal ways to the evolution of the genre. Dahl, *Stormy Weather*, 3–12.

30. Greil Marcus, *Lipstick Traces: A Secret History of the Twentieth Century* (Cambridge, MA: Harvard University Press, 1990), 129. The body of scholarship on the perils of the culture industry is voluminous. For an example of the kinds of claims that are especially pertinent and provocative in relation to this study, see, for instance, Theodor W. Adorno, "On Jazz," in *Essays on Music,* ed. Richard Leppert (Berkeley: University of California Press, 2002), 470–495.

31. On the politics of Black women's embodied performances and the modern, see Jayna Brown, *Babylon Girls: Black Women Performers and the Shaping of the Modern* (Durham, NC: Duke University Press, 2008). Emily Thompson identifies "the shocks and displacements" emerging out of the modern. Emily Thompson, *The Soundscape of Modernity: Architectural Acoustics and the Culture of Listening in America, 1900–1933* (Cambridge, MA: MIT Press, 2004), 11; Jean-Luc Nancy, *Listening* (New York: Fordham University Press, 2007); Sterne, *Audible Past,* 119.

32. Parliament, "One Nation under a Groove," *One Nation under a Groove,* Warner Bros. Records, 1978.

33. Stuart Hall, introduction to *Modernity: An Introduction to Modern Societies,* ed. Stuart Hall, David Held, Don Hubert, and Kenneth Thompson (London: Wiley-Blackwell, 1996), 17; Robin D. G. Kelley, foreword to Robinson, *Black Marxism,* xviii; Robinson, *Black Marxism,* 240.

34. Hortense Spillers, "Interstices: A Small Drama of Words," in *Black, White, and in Color: Essays on American Literature and Culture* (Chicago: University of Chicago Press, 2003), 155, emphasis added. Spillers's landmark work has fundamentally shaped Black studies, and her classic essay, "Mama's Baby, Papa's Maybe: An American Grammar Book," expands on these ideas at length. Both essays also famously trouble the category of gender altogether in the context of Atlantic World slavery, lingering on the concept of the "ungendering" of Black bodies in the terrible oceanic journey commencing "New World" bondage. Hortense Spillers, "Mama's Baby, Papa's Maybe: An American Grammar Book," In *Black, White, and in Color,* 203–229. A recent DNA study of the transatlantic slave trade has brought Spillers's arguments and that of Black feminist scholars of slavery into even sharper relief, "uncover[ing] startling difference in the experience of men and women between regions in the Americas." The scientists calculated that enslaved women in the United States contributed 1.5 times more to the modern-day gene pool of people of African descent than enslaved men. In the Latin Caribbean, they contributed 13 times more. In Northern South America, they contributed 17 times more. What's more," *New York Times* journalist Christine Kenneally adds, "in the United States, European men contributed three times more to the modern-day gene pool of people of African descent than European women did. In the British Caribbean, they contributed 25 times more." Christine Kenneally, "Large DNA Study Traces Violent History of American Slavery," *The New York Times* July 24, 2020. For more on the history of African American women in captivity, see, for instance, Jennifer Morgan, *Laboring Women: Reproduction and Gender in New World Slavery* (Philadelphia: University of Pennsylvania Press, 2004).

35. Paul Gilroy, *The Black Atlantic: Modernity and Double Consciousness* (Cambridge, MA: Harvard University Press, 1993), 37, 38.

36. Spillers, "Interstices," 165.

37. Lindon Barrett, *Blackness and Value: Seeing Double* (New York: Cambridge University Press, 1998), 60, 76, 80. Barrett contends that "the valuelessness of African Americans is always proclaimed *unreasonably* in the *name* of value" (93). As he puts it, the "propensity is to underscore the acoustic and affective materiality of all linguistic signs" (79, 84).

38. Barrett, 80.

39. Alexander Weheliye, *Phonographies: Grooves in Sonic Afro-Modernity* (Durham, NC: Duke University Press, 2005), 8, 3, 6, 11. Weheliye observes that "black music is not merely a byproduct of an already existing modernity, ancillary to and / or belated in its workings, but a chain of singular formations integrally linked to this sphere, particularly as it collides with information technologies" (23).

40. David Scott, *Conscripts of Modernity: The Tragedy of Colonial Enlightenment* (Durham, NC: Duke University Press, 2004), 19. Following the lead of C. L. R. James in *The Black Jacobins,* Scott insists that "New World plantation slavery was a constitutive part of the making of the modern world" and that the "transplanted black slaves, consequently, were integrally modern subjects" (107, 112).

41. Weheliye, *Phonographies,* 8; June Jordan, "A Poem about My Rights," in *Directed by Desire: The Collected Poems of June Jordan* (Port Townsend, WA: Copper Canyon, 2012).

42. The late, great Richard Iton warns us, for instance, to be wary of "the apparent absence of a thickly transformative dialectic within modernity's matrix (e.g. the Hegelian blueprint); its seeming inability to shake itself free of its embedded sexism and racism; its primal tendency to read issues that make race salient as pointing toward either the premodern or antimodern; and the ways it makes, excluded, and yet exploits and contains black bodies, raise doubts about the feasibility of any simplistic reconciliation of the modern and the black (however constructed), and the more superficial depictions of the Afro-modernity and Afro-modernism project." Richard Iton, *In Search of the Black Fantastic: Politics and Popular Culture in the Post–Civil Rights Era* (New York: Oxford University Press, 2010), 13. Iton concedes that "blackness is a constitutively modern albeit unstable formation," but cautions against any easy conflation of black folks with the modern since, as he reminds, pace Toni Morrison, "modern life begins with slavery" (14–15). His project, to "rais[e] the possibility that the norms, assumptions, and constructions of the modern need to be superseded," does not, as he insists, "overloo[k] the fact that blacks can rightly claim co-ownership as stockholders in the projects of modernity (and copyright holders with regard to the definition of many of these endeavors)," nor does it "conten[d] that modern developments are uniformly problematic and that there is some easy alternative" (15). Rather, his study of post–Civil Rights Black popular culture illuminates the multiplicity of ways that "blacks, and other nonwhites, have been crucial participants in the framing, making, and negotiation of this thing called modernity" (14–15, 300n44).

In his posthumous work—the masterpiece he was unable to complete before his untimely death—Lindon Barrett would prove even more anxious about and yet simultaneously intrigued by Black folks' relationship to modernity, pushing even harder to draw out the violence that is constitutive of the enterprise itself. He reminds that "the materialities of African diasporic peoples are crucial to the interwoven economic, epistemological, and political constructions inaugurating the modern West. Put most simply, the material catalogue of the body as a conceptual point coincides with the material catalogue of the body as an emphatically consequential racial point." As Barrett insists, the "matter is not economic simply but, rather, involves, as specifically, the turns of the imagination that demand the impossibility—violently secured—of racial blackness being a feature of openly recognized human being." Lindon Barrett, *Racial Blackness and the Discontinuity of Western Modernity,* ed. Justin A. Joyce, Dwight A. McBride, and John Carlos Rowe (Urbana: University of Illinois Press, 2013), 3, 31. Adds Barrett, "Differently put, at its most basic, Western modernity amounts to the novel

quotidian world established by the ready availability of commodities far beyond their sites of production, most important initially the largely tropical items cocoa, coffee, cotton, sugar, and tobacco, all products that stress the equally novel demand for the commodification of mass, coerced, African-derived laborers. The establishment of these modern commodity chains constitutes 'racialization' as a signal proposition for their viability" (15).

43. Sylvia Wynter, "Beyond Miranda's Meanings: Un/silencing the 'Demonic Ground' of Caliban's 'Woman,'" in *The Routledge Reader in Caribbean Literature,* ed. Alison Donnell and Sarah Lawson Welsh (New York: Routledge, 1996); Morrison, *Beloved;* Hortense Spillers, *Black, White, and in Color: Essays on American Literature and Culture* (Chicago: University of Chicago Press, 2003); Saidiya Hartman, *Scenes of Subjection: Terror, Slavery and Self-Making in Nineteenth-Century America* (New York: Oxford University Press, 1997).

44. Fred Moten, *In the Break: The Aesthetics of the Black Radical Tradition* (Minneapolis: University of Minnesota Press, 2003), 18; Fred Moten, "Black Op," *PMLA* 123, no. 5 (2008): 1743–1747. He argues that "black studies' pleasurable series of immanent upheavals and bad, more than subjunctive moods are the critique of Western civilization" (1743). See also Fred Moten, *Stolen Life,* Consent Not to Be a Single Being (Durham, NC: Duke University Press, 2018); Moten, *Black and Blur,* Consent Not to Be a Single Being (Durham, NC: Duke University Press, 2018); and Moten, *The Universal Machine,* Consent Not to Be a Single Being (Durham, NC: Duke University Press, 2018).

45. Fred Moten, "The Case of Blackness," *Criticism* 50, no. 2 (2008): 179. Famously, he declares, "What I am after is something obscured by the fall from prospective subject to object that Fanon recites—namely, a transition from thing(s) (*choses*) to object (*objet*) that turns out to version a slippage or movement that could be said to animate the history of philosophy" (181). See also Moten, "Chromatic Saturation," *The Universal Machine,* especially 140–157.

46. Moten, 179, 182, 186–187. Moten theorizes a kind of "exhaustion" that is the "condition that expresses, once again by repudiation, the necessity of both preservation and abolition . . . to exhaust the instrument and therefore to become the instrument, as a kind of meditiative medium, a conduit a means to the long history of being an instrument, of being a means, of exhaustion's still extant capacity to catapult us into the new: that whole extended combination of exhausted feet/rested soul that moves within the zone of the relegated, the maternal space that is for [Orlando] Patterson the 'merely informal.'" Moten, "On Escape Velocity: The Informal and the Exhausted (With Conditional Branching)," unpublished manuscript, 9.

47. Hortense Spillers, "Mama's Baby, Papa's Maybe: An American Grammar Book," in *Black, White, and in Color,* 206.

48. Moten, *In the Break,* 22; Szendy, *Listen,* 6; Stefano Harney and Fred Moten, *The Undercommons: Fugitive Planning and Black Study* (New York: Autonomedia, 2013); Shane Vogel, *The Scene of Harlem Cabaret: Race, Sexuality, Performance* (Chicago: University of Chicago Press, 2009), 34.

49. Spillers, "Interstices," 153.

50. Vogel, *Scene of Harlem Cabaret,* 34.

51. Joseph Roach, *Cities of the Dead: Circum-Atlantic Performance* (New York: Columbia University Press, 1996). In his discussion of Angela Davis's decision to join the Communist Party, Jonathan Flatley describes the extent to which she was compelled by reading Lenin's 1902 pamphlet *What Is to Be Done?,* in which he expounds on the meaning and purpose of

becoming a political movement "we" in the Black radical imaginary. See Jonathan Flatley, "Black Leninism" (unpublished manuscript, 2019).

52. Denver Post, "Black National Anthem Replaces Star-Spangled Banner," YouTube video, 2:36, posted July 2, 2008, https://www.youtube.com/watch?v=rTpQpRHYKpw. Shana Redmond offers an illuminating extended reading of Marie's performance. Shana Redmond, "Indivisible: The Nation and Its Anthem in Black Musical Performance," *Black Music Research Journal* 35, no. 1 (Spring 2015): 102, 103, 108. See also Imani Perry, *May We Forever Stand: A History of the Black National Anthem* (Chapel Hill: University of North Carolina Press, 2018).

53. James Weldon Johnson and J. Rosamond Johnson, "Lift Ev'ry Voice and Sing," 1900. See also Moten, "Case of Blackness," 177.

54. Szendy, *Listen*, 66–67; Meta Jones, "Soul to Soul through Soul on Soul."

55. For more on sound as recourse in the face of Empire, see Vazquez, *Listening in Detail*.

56. Szendy, *Listen*, 68.

57. Moten, *In the Break*, 22; Moten and Harney, *Undercommons*, 93, 95–96. Adds Katherine McKittrick in reference to Sylvia Wynter's meditation on this subject (discussed later), "The question-problem-place of blackness is crucial, positioned not outside and entering into modernity but rather the empirical-experiential-symbolic site through which modernity and all of its unmet promises are enabled and made plain." Katherine McKittrick, "Yours in the Intellectual Struggle: Sylvia Wynter and the Realization of the Living," in *Sylvia Wynter: On Being Human as Praxis,* ed. Katherine McKittrick (Minneapolis: University of Minnesota Press, 2014), 2.

58. Jayna Brown, *Babylon Girls*, 17.

59. Iton contends that the Black performances in his study "displace modernity as a master signifier within black and global discourse, along with its norms and modal infrastructures." Iton, *In Search of the Black Fantastic*, 28.

60. Simone White, "Dear Angel of Death," in *Dear Angel of Death* (New York: Ugly Duckling, 2018), 131, 122, 99, 104. A celebrated poet as well as a theorist, White offers ferociously trenchant, at times irreverent, and at other times furiously critical and probing points in an essay that is especially concerned with Black poetics' emphasis on "the complex knit of song and people, today," which, she argues, "confesses a contraction in the imagination of freedom from the status of property, plunging headlong into the terrifying convergence of blackness with capital the likes of which we have never seen and have not begun to understand" (136). "I just want to know," White declares, "what else might be available. What metaphor, if not the Music, will hold the pressure of being forced into 'bone-deep listening,' uncanny attunement to the surround?" (104). Her claims about "the masculine order of black writing," which she regards as "an order that values being seen together" (79), are complicated and deserve more space that I can devote here. What's perhaps important to note is that White is calling attention to the overwhelming domination of Black music studies in relation to poetics by a cluster of iconic and powerful male theorist-artists (many of whom I've already discussed in this chapter). But critics like Moten and Mackey have, it should be pointed out, devoted pivotal aspects of their work to Black women artists—from Zora Neale Hurston to Billie Holiday and Abbey Lincoln. See Nathaniel Mackey, "Other: From Noun to Verb," *Representations* 39 (1992): 51–70; and Moten, *In the Break*. Landmark Black feminist poet-scholars such as the pioneering Sherley Anne Williams and the experimental poet and scholar Harryette Mullen provide alternative examples of a Black feminist poetics that tend

to the importance of sound. See, for instance, Sherley Anne Williams, *The Peacock Poems* (Middletown, CT: Wesleyan University Press, 1975); and Harryette Mullen, *Muse Drudge* (San Diego: Singing Horse, 1995). Finally, White, too, is seemingly very self-consciously and pointedly situating herself within the ambivalent position of a theorist of popular music culture. Her essay, for instance, opens with a racially charged epigraph from legendary grunge rock producer Steve Albini, closes with an extended exegesis on rap music (and other forms of popular music), and is bookended by critical lists of R&B, hip hop, and (black) alt-rock tracks.

61. Hartman, *Wayward Lives,* 34, 59.

62. Hartman, 347.

63. Scott, *Conscripts of Modernity,* 129.

64. Hartman, *Wayward Lives,* 347.

65. Hartman, 93.

66. Sylvia Wynter and Katherine McKittrick, "Unparalleled Catastrophe for Our Species? Or, to Give Humanness a Different Future: Conversations," in McKittrick, *Sylvia Wynter,* 45; Walter Mignolo, "Sylvia Wynter: What Does It Mean to Be Human?," in McKittrick, *Sylvia Wynter,* 117; Katherine McKittrick, "Axis, Bold as Love: On Sylvia Wynter, Jimi Hendrix, and the Promise of Science," in McKittrick, *Sylvia Wynter,* 154.

67. Jonathan Sterne observes that "the technology enabling the reproduction of sound . . . is supposed to be a 'vanishing' mediator—rendering the relation as transparent, as if it were not there." Sterne, *Audible Past,* 218. Also see Walter Benjamin, *The Work of Art in the Age of Mechanical Reproduction* (New York: Penguin, 1994). Sterne's discussion of Benjamin is especially instructive in that, as he contends, although Benjamin's classic and deeply influential essay suggests that the "copy is that which is similar to the original but has failed to be the same, 'the pretender who possesses in a secondary way.' . . . To stop here would be to miss the point of the entire essay. . . . The very concept of aura is, by and large, retroactive, something that is an artifact of reproducibility, rather than a side effect or an inherent quality of self-presence." Sterne, *Audible Past,* 220.

68. Sterne, 223, 13, 213, 285.

69. McKittrick, "Axis, Bold as Love," 156; Wynter and McKittrick, "Unparalleled Catastrophe for Our Species?," 24. See also Mackey, "Other."

70. David Scott is interested in telling "a story about the transformed conditions (indeed the specifically *modern* conditions) in which the slaves were obliged to fight for freedom. . . . conditions . . . that gave distinctive shape to the political projects they undertook in making the futures they made." Scott, *Conscripts of Modernity,* 131. But following Wynter and McKittrick, I would argue that these conditions do not yield the end game for how Black subjects define themselves and their worlds. Rather than rejecting the modern altogether and rather than merely submitting to recognizing the dynamic materiality of modern power that constitutes the grounds on which Black women articulate selfhood, I am suggesting that modern conditions are but the scaffolding for these artists to create, examine, and redefine modern life as we know it.

71. Jonathan Sterne, "Sonic Imaginations," in *The Sound Studies Reader,* ed. Jonathan Sterne (New York: Routledge, 2012), 6.

72. Michael Denning, *The Cultural Front: The Laboring of American Culture in the Twentieth Century* (New York: Verso, 2011), xix. I am by no means suggesting that Black women musicians are inextricably linked to the proletariat causes of the 1930s that produced the

cultural front. Beyoncé is no Rosie the Riveter. Indeed, her biography is one of the most intriguingly elite in contemporary Black women's pop history. What I am arguing, however, and what I hope to show in this book is that the "labor of cultural production," Michael Denning's "third definition" of the laboring of American culture—a formulation he centrally mobilizes in his study—is a concept that informs much of the popular music made by Black women across the twentieth and twenty-first centuries.

73. Hartman, *Wayward Lives,* 307.

74. Sylvia Wynter and Katherine McKittrick, "Unparalleled Catastrophe for Our Species? Or, to Give Humanness a Different Future: Conversations," in McKittrick, *Sylvia Wynter,* 11, 24, 11, 25.

75. Peter Szendy observes that "from a legal point of view, everything happens as if there were no more room for a musical criticism *in music:* any work that includes musical quotations is either a *new* musical work, or an *adaptation;* thus music criticism, relegated to the 'extramusical,' becomes the exclusive business of words, and language." Szendy, *Listen,* 97.

76. Ralph Ellison, "The Little Man at Chehaw Station," in *The Collected Essays of Ralph Ellison,* ed. John F. Callahan (New York: Modern Library, 1994), 490, emphasis in original.

77. Ellison, 496.

78. Nicholas Boggs, "A Grammar of Little Manhood: Ralph Ellison and the Queer Little Man at Chehaw Station," *Callaloo* 35, no. 1 (2012): 245–266. Ellison's terms of endearment with regard to women music mentors extend beyond his Little Man mediations. In "Going to the Territory," he refers to his grade school instructor Mrs. Breaux, "a musician and a teacher," as "an agent of music, which soon became the main focus of my attempts to achieve my own identity." Ellison, "Going to the Territory," in *Collected Essays of Ralph Ellison,* 604.

79. Ellison, "Little Man at Chehaw Station," 499, emphasis in the original.

80. Greg Tate, "Introduction: Lust, of All Things (Black)," in *Flyboy 2: The Greg Tate Reader* (Durham, NC: Duke University Press, 2016), 1. See also Mark Anthony Neal, *What the Music Said: Black Popular Music and Black Public Culture* (New York: Routledge, 1998).

81. Farah Griffin, *If You Can't Be Free, Be a Mystery: In Search of Billie Holiday* (New York: Free Press, 2001). Tricia Rose's historic study of hip hop, *Black Noise,* opened up new lines of critical Black feminist study in popular music scholarship; see *Black Noise: Rap Music and Black Culture in Contemporary America* (Middletown, CT: Wesleyan University Press, 1994). Among the most pivotal feminist studies of Black women's musicianship, see Gayle Wald, *Shout, Sister, Shout: The Untold Story of Rock-and-Roll Trailblazer Sister Rosetta Tharpe* (Boston: Beacon, 2008); and Tammy Kernodle, *Soul on Soul: The Life and Music of Mary Lou Williams* (Boston: Northeastern University Press, 2004). See also Salamishah Tillet, *All the Rage: Nina Simone's Mississippi Goddam, Four Women and the Fight for Freedom* (New York: Ecco, 2021); and Maureen Mahon, *Black Diamond Queens: African-American Women and Rock and Roll* (Durham, NC: Duke University Press, 2020). Finally, Danyel Smith's *Shine Bright* is one of the most wide-ranging and ambitious of these new studies exploring Black women in pop, and my own study happily sits alongside Smith's in an effort to expand the universe of cultural criticism on Black women musicians. See Danyel Smith, *Shine Bright: The Soulful and Sequined Story of How Black Women Took over American Pop and Changed Culture Forever* (New York: One World, 2021).

82. Edwards, *Epistrophies,* 9–10, emphasis in the original.

83. The sole woman artist whom Brent Edwards explores at length in *Epistrophies* is Mary Lou Williams. Edwards's dazzling study foregrounds the complex relationship between

music and writing as crucial forms of mutually constitutive knowledge production, and he compellingly argues that "what is at stake in the need to imagine the first great jazz musician [Buddy Bolden] to be not only the first jazz writer but also the first jazz archivist" "is not just that the music seems to contain articulate reflection and even critical analysis, but also that it can serve as a reservoir for a range of historical experience preserved in no other form" (14).

84. Edwards, 12.

85. Alexandra T. Vazquez, "Toward an Ethics of Not Knowing," in *Pop When the World Falls Apart: Music in the Shadow of Doubt,* ed. Eric Weisbard (Durham, NC: Duke University Press, 2012). Deborah Vargas's theories of what she calls *"archisme"* are helpful to me here as well, as she maps out ways of thinking about an *"'archivo de chisme'* (archive of gossip) or ... *archisme* to function as a feminist project for historicizing nonnormative Chicano/a genders and sexual desires." Vargas contends that the *"archisme* remains a dynamic knowledge-in-making for the *sinverguenzas* (those without shame) and indecentes (the indecent) in the borderlands." Deborah Vargas, *Dissonant Divas in Chicana Music: The Limits of La Onda* (Minneapolis: University of Minnesota Press, 2012), 77–78, emphasis in the original.

86. Lindon Barrett, *Blackness and Value,* 91. See also Theodor W. Adorno, "On the Fetish Character in Music and the Regression in Listening," in *The Culture Industry: Selected Essays on Mass Culture,* ed. J. M. Bernstein (New York: Routledge, 2001), 29–60; Adorno, "On Jazz"; Max Horkheimer and Theodor W. Adorno, *Dialectic of Enlightenment* (Palo Alto, CA: Stanford University Press, 2007); and Theodor W. Adorno, *Minima Moralia: Reflections on a Damaged Life* (New York: Verso, 2006).

87. In a lovely meditation on the lasting legacy of "The Little Man at Chehaw Station," intellectual historian Pete Kuryla posits a crucial contrast between Adorno's critique of "commodity fetishism" and Ellison's contrasting belief in both culture's democratizing forces and its simultaneous manifestation of democracy's diversity and plurality. Upon rereading Ellison's essay, Kuryla describes how he "thought about Theodor Adorno's merciless take-down of jazz record collectors, where obsessiveness among those warped personalities stacked up to the worst sort of commodity fetishism. What Adorno saw as symptomatic of the culture industry, Ellison saw as a potential virtue of democracy. Adorno's pitiful record collector might have shown up somewhere, sometime as Ellison's sparkling little man behind the stove." Pete Kuryla, "A Few Thoughts on Ellison's 'Little Man at Chehaw Station,' with Special Thanks to an Outlaw Philosopher," *US Intellectual History Blog,* May 23, 2018, https://s-usih.org/2018/05/a-few-thoughts-on-ellisons-little-man-at-chehaw-station-with -special-thanks-to-an-outlaw-philosopher/.

88. Greil Marcus, *Lipstick Traces,* 184, 441, 23, 18, 185. Marcus notes that Henri Lefebvre's words are worth recalling: "To the degree that modernity has a meaning, it is this: it carries within itself, from the beginning, a radical negation—Dada, this event which took place in a Zurich café" (184).

89. Living Colour, "Type," *Time's Up,* Epic Records, 1990.

90. Moten, "Black Op." The B side of *Lipstick Traces* that I always longed for was the one featuring Guy Debord and the Situationists, Rotten and Malcolm McLaren as well as Douglass, Du Bois, Grace Jones, and Fannie Lou Hamer, Montgomery-meets–*Battle of Algiers* revolutionaries Bayard Rustin and Ella Baker, "all, fixed on the wrong faces, pass[ing] each other by" because "this is the drift of secret history, a history that remains secret even to those who make it, especially to those who make it." Marcus, *Lipstick Traces,* 185.

91. Sleater-Kinney, "A New Wave," *No Cities to Love,* Sub Pop, 2015. In addition to discussing Walter Benjamin's philosophy on an episode of *The Late Show with Stephen Colbert,* Carrie Brownstein has made forays into scholarly publishing. See her "More Rock, Less Talk: Live Music Turns Off the Voices in Our Heads," in *This Is Pop: In Search of the Elusive at Experience Music Project,* ed. Eric Weisbard (Cambridge, MA: Harvard University Press, 2004), 318–324. Moten builds on Hartman's crucial theories of obscurity. See Fred Moten, "'Words Don't Go There': An Interview with Fred Moten," by Charles Henry Rowell, *Callaloo* 27, no. 4 (2004): 960. See also Lindon Barrett, who argues that the singing voice emerges as alternative, "secret" language for those in the margins of American culture. It "invariably revises the *signing voice,* it marks a point of exorbitant originality for African American cultures and expressivities" Barrett, *Blackness and Value,* 83.

92. Moten, "Black Op," 1744, 1745; Nathaniel Mackey, "Cante Moro," in *Paracritical Hinge: Essays, Talks, Notes, Interviews* (Madison: University of Wisconsin Press, 2005), 193.

93. Moten, *In the Break,* 17, 18.

94. Patricia Ybarra, "'The Whole Thing Is Over by Nine O'Clock': The Rude Mechs' Adaptation of Greil Marcus's *Lipstick Traces," Journal of Dramatic Theory and Criticism* 19, no. 2 (Spring 2005): 15; Moten, *In the Break,* 18.

95. Ralph Ellison, *Invisible Man* (New York: Vintage, 1995).

96. Alexander Weheliye, *Phonographies,* 8. Dylan himself would cite the likes of gospel guitar phenom Sister Rosetta Tharpe and folk luminary Odetta as central inspirations in his own work. Daphne A. Brooks and Gayle Wald, "Women Do Dylan: The Aesthetics and Politics of Bob Dylan Covers," in *Highway 61 Revisited: Bob Dylan from Minnesota to the World,* ed. Colleen Sheehy and Thom Swiss (Minneapolis: University of Minnesota Press, 2009). Dylan was also romantically involved with soul legend Mavis Staples for a good period of time in the 1960s. For more on Dylan's relationship with Staples and other African American women creatives, see David Yaffe, "Tangled Up in Keys: Why Does Bob Dylan Namecheck Alicia Keys in His New Song?," *Slate,* August 11, 2006, http://www.slate.com/articles/arts /music_box/2006/08/tangled_up_in_keys.html. See also Jessica Edwards's 2015 documentary, *Mavis!,* in which Dylan and Staples both discuss their past relationship and long-standing friendship. Jessica Edwards, dir., *Mavis!* (New York: Film First, 2015). For more on Odetta, see Matthew Frye Jacobson, *Odetta's "One Grain of Sand"* (New York: Bloomsbury, 2019).

97. Ellison, *Invisible Man,* 6, 9.

98. Mackey, "Cante Moro," 182, 187, 191.

99. Mackey, 187; Ellison, *Invisible Man,* 8.

100. Griffin, "When Malindy Sings," 117, 111, 104.

101. Edouard Glissant, *Caribbean Discourse: Selected Essays* (Charleston: University of Virginia Press, 1999), 67, emphasis in the original; Iton, *In Search of the Black Fantastic,* 3–4; May Joseph, *Nomadic Identities: The Performance of Citizenship* (Minneapolis: University of Minnesota Press, 1999), 133; Glissant, *Caribbean Discourse,* 66.

102. Iton, *In Search of the Black Fantastic,* 4; Stephanie Webber, "Nicki Minaj Talks VMA Rant: Black Women Aren't Credited for Their Contributions," *USWeekly,* July 23, 2015, http://www.usmagazine.com/celebrity-news/news/nicki-minaj-talks-vma-rant-black -women-arent-credited-for-their-work-2015237.

103. Moten and Harney, *Undercommons,* 12; Jack Halberstam, "The Wild Beyond: With and For the Undercommons," in Moten and Harney, *Undercommons,* 9. Danyel Smith, "The Unstoppable Genius and Glory of Black Women in Music," *Zora,* June 15, 2020,

https://zora.medium.com/the-unstoppable-genius-and-glory-of-black-women-in-music-b8294ac4399. One of my Black feminist intellectual heroes of pop music criticism, Smith is also concerned with the culture industry's long, slow turn towards acknowledging Black women's musicianship, pointing out that in "this era, when in some months, Black women dominate the covers of mainstream magazines, it's easy to forget that until the 2000s, mainstream magazines rarely featured Black female recording artists (or film stars) on their covers. . . ." Smith adds that, the line of grandeur that she's seeking to recuperate is a line that includes "Ella Mai and Jhené Aiko and Nicki Minaj and Megan Thee Stallion. . . . I want canons that explode like real cannons. . . ." Smith, "The Unstoppable Genius and Glory of Black Women in Music."

104. John Clarke, Stuart Hall, Tony Jefferson and Brian Roberts, "Subcultures, Cultures and Class," in Stuart Hall and Tony Jefferson, eds., *Resistance through Rituals: Youth Subcultures in Post-war Britain* (New York: Routledge, 2006), 14; Dick Hebdige, *Subculture: The Meaning of Style* (New York: Routledge, 1979), 128–133.

105. Carby, "It Just Be's Dat Way Sometime"; Mackey, "Other," 530, 514, 513; Marcus, *Lipstick Traces,* 70–72. Patricia Ybarra argues that, "like Marcus, Adorno depends on performance, particularly musical performance, as a utopian mode through which aesthetic experience can avoid being recuperated by dominant social structures despite the ubiquity of crass commercialization called the culture industry. And it is only through re-imagining Adorno's 'performance theory' that Marcus can find the punk in pop." Ybarra, "'The Whole Thing Is Over by Nine O'Clock',"13.

106. Hebdige, *Subculture,* 128–133; Michael Warner, *Publics and Counterpublics* (Cambridge, MA: Zone Books, 2005), 113; George Lipsitz, *Footsteps in the Dark: The Hidden Histories of Popular Music* (Minneapolis: University of Minnesota Press, 2007), ix–x, xxiv. In both *Mystery Train* and *Lipstick Traces,* his two seminal studies of rock and roll culture, Greil Marcus makes a similar case for considering ways of understanding rock and roll as a central force in American self-making narratives and, more broadly, in Western historical and cultural imaginaries, and subaltern social and political movements. In the former, Marcus demonstrates how the secret history of American iconoclasm and the grand and seductive mythologies of American exceptionalism manifest themselves most potently in the life and music of figures such as blues guitarist Robert Johnson and Elvis Presley. Likewise, in *Lipstick Traces,* Marcus locates, at opposite ends of the twentieth-century spectrum, the shared ideological linkages between Dadaism and punk legends the Sex Pistols. Greil Marcus, *Mystery Train: Images of America in Rock 'n' Roll Music,* 5th ed. (New York: Plume, 2008); Marcus, *Lipstick Traces.* For other ways of considering the radical history of popular music culture, see, for instance, Josh Kun, *Audiotopia: Music, Race, and America* (Berkeley: University of California Press, 2005); and George Lewis, *A Power Stronger Than Itself: The AACM and American Experimental Music* (Chicago: University of Chicago Press, 2008).

107. Robin Kelley, *Freedom Dreams: The Black Radical Imagination* (Boston: Beacon, 2002), 16.

108. Robert O'Meally, *Romare Bearden: A Black Odyssey* (New York: DC Moore Gallery, 2008), 14, 17.

109. Paige McGinley, *Staging the Blues: From Tent Shows to Tourism* (Durham, NC: Duke University Press, 2014), 58, emphasis in the original.

110. Albert Murray, "Improvisation and the Creative Process," in O'Meally, *Jazz Cadence of American Culture,* 111–112. See also Albert Murray, *The Hero and the Blues* (New York: Vintage,

1996); and Robert O'Meally, "Romare Bearden's *A Black Odyssey:* A Search for Home," in *Romare Bearden.* For different takes on the politics and poetics of improvisation in the context of the Black radical tradition, see George Lewis, ed., *The Oxford Book of Improvisation Studies,* vol. 1 (New York: Oxford University Press, 2016); Danielle Goldman, *I Want to Be Ready: Improvised Dance as a Practice of Freedom* (Ann Arbor: University of Michigan Press, 2010); and Vijay Iyer, "Beneath Improvisation," in *The Oxford Handbook of Critical Concepts in Music Theory,* ed. Alexander Rehding and Steven Rings (New York: Oxford University Press, 2019). See also Fred Moten's vast body of work, including *In the Break, The Universal Machine, Black and Blur,* and *Stolen Life.* Thank you to Hunter Hargraves and Brandi Monk-Payton for pushing me on this question of the heroic in this study. Thank you to Ralph Lemon for urging me to continue thinking about the politics and poetics of risk in the repertoires of these artists. For more on risk in relation to queer temporality, see Keeling, *Queer Times, Black Futures.*

111. Sydney Pollack, dir., *Amazing Grace,* starring Aretha Franklin, Reverend James Cleveland, Southern California Community Choir (40 Acres and a Mule Filmworks, 2018). In her memoir, Nina Simone recounts her early days performing at the Midtown Bar and Grill in Atlantic City. "The deal was I performed from 9 p.m. to 4 a.m.," explains Simone. "I knew hundreds of popular songs and dozens of classical pieces, so what I did was combine them. I arrived prepared with classical pieces, hymns and gospel songs and improvised on those, occasionally slipping in a part from a popular tune. Each song—which isn't the right way to describe what I was playing—lasted anywhere between thirty and ninety minutes." Nina Simone, *I Put a Spell on You: The Autobiography of Nina Simone* (New York: Da Capo, 2003), 50.

112. manzi mcoast, "Lauryn Hill in Houston, Texas Oct 31 2012," YouTube video, 7:45, posted November 1, 2012, https://www.youtube.com/watch?v=0o_fpRttaV4. My thanks to Imani Perry for bringing this clip to my attention in 2012. See also a studio version of the track that she dedicated to "the people fighting for racial equality" in Ferguson, Missouri, in the wake of Michael Brown's death at the hands of a police officer in that city. Ms. Lauryn Hill, "Black Rage (Sketch)," SoundCloud recording, 3:46, posted August 20, 2014, https://soundcloud.com/mslaurynhill/black-rage-sketch; Kory Grow, "Lauryn Hill Dedicates 'Black Rage' Song to Ferguson," *Rolling Stone,* August 21, 2014. For more on Lauryn Hill's career and influence, see Joan Morgan, *She Begat This: 20 Years of the Miseducation of Lauryn Hill* (New York: Atria Books, 2018). See also Daphne A. Brooks, "'Bring the Pain': Post-soul Memory, Neo-soul Affect, and Lauryn Hill in the Black Public Sphere," in *Taking It to the Bridge: Music as Performance,* ed. Nicholas Cook and Robert Pettingell (Ann Arbor: University of Michigan Press, 2013), 180–203; Daphne A. Brooks, "Open Channels: Some Thoughts on Blackness, the Body, and Sound(ing) Women in the (Summer) Time of Trayvon," *Performance Research: A Journal of the Performing Arts* 19, no. 3 (2014): 62–68; and LaMarr Bruce, "'The People Inside My Head, Too': Madness, Black Womanhood, and the Radical Performance of Lauryn Hill," *African American Review* 45, no. 3 (Fall 2012): 371–389.

113. "Lauryn Hill in Houston," https://www.youtube.com/watch?v=0o_fpRttaV4

114. John Coltrane, "My Favorite Things," *My Favorite Things,* Atlantic Records, 1961; Robert Wise, dir., *The Sound of Music* (Los Angeles: 20th Century Fox, 1965). The musical, starring Mary Martin, opened on Broadway on November 16, 1959.

115. Salim Washington, email correspondence with the author, 2013.

116. manzi mcoast, "Lauryn Hill in Houston." In the performance, the emphasis is Hill's.

Side A

1. For more on the origins of *Rolling Stone* magazine, see Robert Draper, *Rolling Stone Magazine: The Uncensored History* (New York: Doubleday, 1990). Cofounder Gleason was a pioneering critic who straddled the midcentury jazz and early rock and roll eras. See Ralph J. Gleason, *Music in the Air: The Selected Writings of Ralph J. Gleason,* ed. Toby Gleason (New Haven, CT: Yale University Press, 2016).

2. The Cleveland Growth Association launched an aggressive campaign to build the Rock Hall in their city, citing DJ Alan Freed's alleged coinage of the term "rock and roll" and Elvis's visit to Cleveland, the site of his first northern concert. James Barron, "Honoring Old Cities, Great Men," *New York Times,* January 20, 1986. See also Robert Palmer, "Rock Music Will Have Its Own Hall of Fame," *New York Times,* August 5, 1985.

3. In addition to its display holdings, the Rock and Roll Hall of Fame houses a library archive of rare books and print media associated with the history of rock and roll. Mbembe's focus is on the violence of the state and the role that archives play in preserving, promoting, and extending the reach of state power. My intention here is not to conflate these forms of power with that of rock and roll's pop culture hegemony during the second half of the twentieth century but rather to underscore how these Wenner-driven endeavors have insidiously shaped the kinds of stories told about cultural origins and culture makers, resulting in the continuing unequal distribution of social and cultural power. Still however, the parallels between Mbembe's claims regarding the state's use of archives and the Rock Hall's focus and impact remain compelling to consider. Think, for instance, of Mbembe's observation that the "commodification of memory obliterates the distinction between the victim and the executioner, and consequently enables the state to realise what it has always dreamed of: the abolition of debt and the possibility of starting afresh." With its annual induction ceremonies, its working museum, and various local civic events, the Hall markets a form of rock memory that unsurprisingly elides the socioeconomic history of racially informed cultural appropriation that gave birth to the music. See Achille Mbembe, "The Power of Archive and Its Limits," in *Refiguring the Archive,* ed. Carolyn Hamilton, Verne Harris, Jane Taylor, Michèle Pickover, Graeme Reid, and Razia Saleh (Dordrecht: Kluwer Academic, 2002), 20–22, 25.

4. Ann Powers, *Good Booty: Love and Sex, Black and White, Body and Soul in American Music* (New York: Dey St., 2017), 111–154. See also Daphne A. Brooks, "100 Years Ago, 'Crazy Blues' Sparked a Revolution for Black Women Fans," *The New York Times,* August 10, 2020. As we shall see, the divisions between the visceral and cerebral in pop music culture are a false dichotomy if ever there was one.

5. Robert Christgau, "A History of Rock Criticism," in *Reporting the Arts II: News Coverage of Arts and Culture in America,* ed. András Szántó, Daniel S. Levy, and Andrew Tyndall (New York: National Arts Journalism Program at Columbia University, 2004), 140.

6. See W. E. B. Du Bois, "The Sorrow Songs," in *The Souls of Black Folk* (New York: Penguin, 1996), 204–217, 244–247; Langston Hughes, "The Negro Artist and the Racial Mountain," *Nation,* June 23, 1926; Ralph Ellison, "Living with Music" and "The Music Demanded Action," in *Living with Music,* ed. Robert G. O'Meally (New York: Random House, 2001), 3–14, 139–147; and LeRoi Jones, *Blues People* (New York: Morrow Quill, 1963). See also LeRoi Jones, "Jazz and the White Critic," in *Black Music* (New York: Da Capo, 1998), 11–20. For a study of early Black music criticism, see Phillip McGuire, "Black Music Critics and the Classic Blues Singers," *Black Perspective in Music* 14, no. 2 (Spring 1986): 103–125. For an extended discussion of this topic, see Daphne A. Brooks, "The Write to Rock: Racial Mythologies, Feminist

Theory, and the Pleasures of Rock Music Criticism," *Women and Music* 12 (2008): 54–62. Daphne A. Brooks, "Once More with Feeling: Popular Music Studies in the New Millennium," *Journal of Popular Music Studies* 22 (1): 98–106.

7. Founded in 1969, *Creem* magazine distinguished itself from *Rolling Stone* as the wild child of rock and roll publications. It also held the distinction of having a woman co-founder, journalist Jaan Uhelszki, and "provid[ing] opportunities for women writers like Roberta Cruger, Cynthia Dagnal, Lisa Robinson and Penny Valentine at a time when," as the *New York Times*' Mike Rubin points out, "the music industry was intensely misogynist." None of this, however, meant that *Creem* was above the sexism and racism coursing through rock music journalism of the sixties and seventies. Mike Rubin, "The Wild Story of Creem, Once 'America's Only Rock 'n' Roll Magazine,'" *The New York Times,* August 3, 2020. See also. Scott Crawford, dir., *Boy Howdy: The Story of* Creem *Magazine* (2020).

8. Christgau, "History of Rock Criticism," 142.

9. Kelefa Sanneh, "The Rap against Rockism," *New York Times,* October 31, 2004.

10. Jody Rosen, "The Perils of Poptimism," *Slate,* May 9, 2006, https://slate.com/culture /2006/05/does-hating-rock-make-you-a-music-critic.html. For a more recent journalistic take on race and pop canons, see Wesley Morris, "Who Gets to Decide What Gets to Belong in the Canon?," *New York Times Magazine,* May 30, 2018.

11. Douglas Wolk, "Thinking about Rockism," *Seattle Weekly,* May 4, 2005.

12. See Brooks, "Write to Rock."

13. Daphne Duval-Harrison, *Black Pearls: Blues Queens of the 1920s* (New Brunswick: Rutgers University Press, 1988). Lynn Abbott and Doug Seroff note that the "women who constituted the first wave of African American blues recording artists were all based in New York City," and they list close to three dozen women by name who were recording in the city "in 1921 and 1922, a full year or more before Ma Rainey, Bessie Smith, Clara Smith, Virginia Liston, or Laura Smith ever set foot in a recording studio. . . ." Lynn Abbott and Doug Seroff, *The Original Blues: The Emergence of the Blues in African American Vaudeville, 1899–1926* (Jackson, MS: University Press of Mississippi, 2017), 254. They point out that male impersonator Jeannette Taylor was the artist whom Perry Bradford sought out to get in the studio before turning to Mamie Smith whom he steered towards becoming the first Black woman vocalist to make a record (267–268).

14. Jonathan Lethem and Kevin Dettmar, introduction to *Shake It Up: Great American Writing on Rock and Pop from Elvis to Jay Z,* ed. Jonathan Lethem and Kevin Dettmar (New York: Library of America, 2017), xiv. Of the fifty authors included in this volume, twelve are women and (as far as I can tell) one is a woman of color, veteran Black feminist music journalist Danyel Smith. Importantly, many of the works by women critics included in the collection cover men's musicianship.

15. Evelyn McDonnell and Ann Powers, eds., *Rock She Wrote: Women Write about Rock, Pop and Rap* (New York: Delta, 1995). Jessica Hopper's *First Collection of Criticism by a Living Female Rock Critic* throws shade at the long-standing gender problems in the field in its very title. Jessica Hopper, *The First Collection of Criticism by a Living Female Rock Critic* (Chicago: Featherproof Books, 2015). For a first-person account of being the only woman writer at *Rolling Stone* in the early 1970s, see Robin Green, *The Only Girl: My Life and Times on the Masthead of "Rolling Stone"* (New York: Little, Brown, 2018).

16. Sandra Shevey, *Ladies of Pop/Rock* (New York: Scholastic Book Services, 1971), 9–10. While her critiques of patriarchy are withering throughout her study ("The Fifth Dimension

music glorifies male dominance, female passivity"), Shevey's analyses, like Lillian Roxon's, discussed later, occasionally cleave to problematic racial romanticism even as her work aims to highlight increasing diversity in pop music culture. She argues, for instance, that singer-songwriter Buffy Sainte-Marie "adds to contemporary harmonics Indian hoots and howls, as Tina [Turner] grinds out primitive African rhythms" (10–11). The latter line echoes Roxon's language about Turner.

17. Lethem and Dettmar, introduction, 114.

18. Lillian Roxon, *Lillian Roxon's Rock Encyclopedia* (New York: Grosset and Dunlap, 1969), 193, 494.

19. Roxon, 193. Morrison uses the formulation "easy prey" across several of her novels as a reference to the ways in which Black women have historically been deemed sexually available and chronically subjected to sexual violation. See her *Jazz* and *Paradise*, and for the long history of this crisis, see her masterpiece *Beloved*.

20. Roxon, *Lillian Roxon's Rock Encyclopedia*, 494, 47–48, 428. Roxon's take on the Supremes is hardly a romanticized one—which makes it all the more refreshing and rigorous. She argues that when the trio moves, "it's in the beautiful but predictable steps they have choreographed inside their minds. And yet it's that timing and planning that makes them exciting, like a woman who has planned every detail of what she'll wear, and she knows you know, but you are flattered that she has gone to that trouble for you" (428–429). My thanks to Sonnet Retman for taking me back to Lillian Roxon's singular work and for introducing me to Sandra Shevey's.

21. Lillian Roxon, "Author's Note," in *Lillian Roxon's Rock Encyclopedia*.

1. Toward a Black Feminist Intellectual Tradition in Sound

1. Pauline Hopkins, *Of One Blood: Or, The Hidden Self* (New York: Oxford University Press, 1988), 67. The "forgotten but not gone" reference is Joseph Roach's which he shared with me in a pivotal exchange in 1999. His landmark claims and breakthroughs in performance studies remain central to this study. Joseph Roach, *Cities of the Dead: Circum-Atlantic Performance* (New York: Columbia University Press, 1996). Ronald Radano, *Lying Up a Nation: Race and Black Music* (Chicago: University of Chicago Press, 2003), 97, 100. As Jennifer Stoever argues, "Earlier black writers and musicians experimented with aural imagery to radically challenge the mobilization of sound by white power structures, and they did it with *style.*" Jennifer Stoever, *The Sonic Color Line: Race and the Cultural Politics of Listening* (New York: New York University Press, 2016), 17, emphasis hers.

2. The family of Ella Sheppard, who was born into slavery in Nashville in 1851, guided her to freedom in Ohio, where she emerged as precocious musical talent. A multitasking phenom, she went on to enroll at Fisk University, becoming an original Jubilee Singer, a disciplined pedagogue, and the fundamental artistic backbone of the ensemble. An organist as well as a guitarist, a soprano, a pianist, a composer, and an arranger of Negro spirituals, a teacher and eventually an orator who partnered with her husband, the Reverend George Moore in American Missionary Association efforts, Sheppard gave the first ensemble of Fisk Jubilee Singers a blueprint for its signature vocal performances and built the framework for its elegant, enchanting, and meticulously crafted vocal style. Sheppard's 1877–1878 diary entries and her epistolary and Christian missionary writing intimately document her travels

with the group, the creative challenges she faced, and opportunities she seized upon while collaborating with her fellow artists. See Ella Sheppard Moore, "The Diary of Ella Sheppard of the Fisk Jubilee Singers, October 19, 1877 to July 15, 1878," transcribed by Andrew Ward, Special Collections and Archives, Fisk University, Nashville, TN; and Ella Sheppard Moore, "Before Emancipation," Special Collections and Archives, Fisk University, Nashville, TN. See also Jennifer Stoever's excellent exploration of Sheppard and the Fisk Jubilee Singers in *The Sonic Color Line,* 132–149. See as well Gabriel Milner's expansive reading of Ella Sheppard's "Before Emancipation." Gabriel Milner, "The Tenor of Belonging: The Fisk Jubilee Singers and the Popular Cultures of Postbellum Citizenship," *The Journal of the Gilded Age and Progressive Era* 15, no. 4 (2016): https://www.cambridge.org/core/journals/journal-of-the -gilded-age-and-progressive-era/article/tenor-of-belonging-the-fisk-jubilee-singers-and -the-popular-cultures-of-postbellum-citizenship/CFF90D7F71BDADE650CB058012EFB B76/core-reader.

Born in 1874, classical pianist Maud Cuney Hare studied at the New England Conservatory, taught music at a variety of institutions in the South at the turn of the century, and rose to prominence as both a lecturer as well as a musician who accompanied Canadian baritone William Howard Richardson on concert tours. Hare founded the Allied Arts Center in Boston, where she mentored young Black composers, performers, and playwrights. She edited a music column for the *Crisis* under the editorial leadership of Du Bois, and in 1936 she published *Negro Musicians and Their Music,* a work that explores Black sound in Africa and America but largely steers clear of an extensive study of blues and jazz. Maud Cuney Hare, *Negro Musicians and Their Music* (New York: Da Capo, 1971).

As Juanita Karpf reveals, Azalia Hackley was a social activist, vocalist, and music teacher (who counted a young Marian Anderson as one of her pupils) who published work focused on varied subjects ranging from social etiquette to spiritualism. Juanita Karpf, "The Early Years of African American Music Periodicals, 1886–1922," *International Review of the Aesthetics and Sociology of Music* 28, no. 2 (1997): 143–168; Juanita Karpf, "Get the Pageant Habit: E. Azalia Hackley's Festivals and Pageants during the First World War Years, 1914–1918," *Popular Music and Society* 34, no. 5 (2011): 517–556.

Composer, vocalist, and music critic Nora Holt was born in Kansas City in 1884 and contributed music criticism to the *Chicago Defender* between 1917 and 1921. She spent a dozen years touring Europe and Asia as a vocalist and composing over two hundred works, largely orchestral and chamber music pieces. Holt taught music at the University of Southern California in the 1930s and in the 1950s and 1960s hosted a radio concert series, Nora Holt's Concert Showcase. See Lucy Caplan, "Strange Cosmopolites: Classical Music, the Black Press, and Nora Douglas Holt's Black Feminist Audiotopia," *Journal of the Society of American Music* 14, no. 3 (2020): 308–336. See also Guthrie Ramsey's forthcoming work on Hare and Holt.

Hired by Harvard University in 1974, musicologist Eileen Southern became the first Black woman appointed to a tenured full professorship at the university. Her germinal work, *The Music of Black Americans,* transformed the field of musicology by, among other things, expanding the study of Black music well beyond jazz. Eileen Southern, *The Music of Black Americans* (New York: Norton, 1971).

3. Frederick Douglass, *Narrative of the Life of Frederick Douglass, an American Slave* (New York: Penguin Classics, 1982), 57–58; W. E. B. Du Bois, *The Souls of Black Folk* (New York: Penguin, 1996); Ralph Ellison, *Invisible Man* (New York: Vintage, 1995); James Baldwin, "Sonny's Blues," in *Going to Meet the Man* (New York: Vintage, 1995), 103–140.

4. Black women, Hortense Spillers reminds, were "the primary receptacle of a highly profitable generative act." They "became . . . the principle point of passage between the human and the non-human world. . . ." Hortense Spillers, "Interstices: A Small Drama of Words," in *Black, White, and in Color* (Chicago: University of Chicago Press, 2003), 155.

5. It was my colleague Nina Eidsheim who once generously suggested to me that this project involved applying "a different needle" to the sonic pop record so as to pick up the voices of Black women artists and thinkers. The pun here contrasts with Eidsheim's pathbreaking arguments regarding the "fiction of fidelity" in relation to putatively racialized sounds. In her study, Eidsheim carefully dissects "the ways in which sociophysical conditioning (rather than skin color or some other measurement) structures the naming of race." Nina Eidsheim, *The Race of Sound: Listening, Timbre and Vocality in African American Music* (Durham, NC: Duke University Press, 2019), 7.

6. Godfather rock critic Lester Bangs famously assessed the racist conditions of the punk rock scene in a searing 1979 *Village Voice* article on the subject, referring to his peers as the "white noise supremacists" and candidly addressing his own complicity with the scene. Lester Bangs, "The White Noise Supremacists," *Village Voice*, April 30, 1979.

7. Wesley Morris, *Still Processing,* podcast, see Side B, note 12. During a memorial roundtable honoring the work of the late R&B critic Rashod Ollison, veteran pop music critics Ann Powers, Carl Wilson, Jack Hamilton, Karen Tongson, and Emily Lordi discussed the importance of the local music critic and her/his/their contributions to their immediate communities, providing info and documentation about shows and music gatherings directly linked to local culture. They emphasized the local critic's importance to the cultural lifeblood of their communities. "Still Hear: A Roundtable for Rashod Ollison," 2019 MoPop conference, Museum of Popular Culture, Seattle, WA, April 2019.

8. Cynthia Dagnal-Myron, *The Keka Collection: Soul Food for Lone Wolves and Wild Women from Keka's Blog on Open Salon* (self-pub, BookBaby, 2010), 102. Adds Dagnal-Myron, reflecting on her early success at the *Sun Times* interviewing the likes of Steven Tyler, Roger Daltry, and KISS, "Now I had been warned that the party couldn't last by some very, very smart men. Lester Bangs . . . was one" (104). Conceptual artist and cultural critic Lorraine O'Grady is often identified as being the first Black woman critic to publish work in *Rolling Stone.*

9. O'Grady's pathbreaking art places performance and her own body politic at the center of works that, among other things, question the power and possibility of Black art while simultaneously critiquing constrictive representations of Black womanhood. See Uri McMillan, *Embodied Avatars: Genealogies of Black Feminist Art and Performance* (New York: New York University Press, 2015), 1–3.

10. See Lorraine O'Grady, "Bruce Springsteen and the Wailers: Max's Kansas City, July 18, 1973," http://lorraineogrady.com/wp-content/uploads/2015/11/Lorraine-OGrady_Bruce-Springsteen-and-the-Wailers_Maxs-Kansas-City-Art-Glamour-Rock-and-Roll.pdf. O'Grady's full-circle career has taken her from a job as a federal intelligence analyst to arts writing to becoming one of the most influential Black feminist performance artists and conceptual artists working in contemporary culture. Her iconicity landed her on a roll-call list of noteworthy avant-garde rule breakers name-checked by post–riot grrl band Le Tigre in their 1993 song "Hot Topic." Le Tigre, "Hot Topic," *Le Tigre,* Mr. Lady, 1999. See also Kaitlyn Greenidge, "Lorraine O'Grady: From Bureaucrat to Rock Critic to World-Renowned Artist," Lenny, July 28, 2017, https://www.lennyletter.com/story/lorraine-ogrady-interview.

11. While writing and editing for *Ebony*, Phyl Garland moved up the chain of command in the Johnson Publishing empire, serving from 1969 to 1972 as the New York editor and director of editorial operations for the Johnson Publishing Company in New York. Later in her career she served as a music critic for *Stereo Review*. She also published a book on Michael Jackson immediately in the wake of his *Thriller* phenomenon. See Phyl Garland, *Michael: In Concert, with Friends, at Play* (New York: Beekman House, 1984). In 2005, pioneering cultural critic Margo Jefferson would publish the second full-length meditation on Michael Jackson. Margo Jefferson, *On Michael Jackson* (New York: Pantheon, 2005).

12. Phyl Garland, "Martin Luther King, Jr.: I've Been to the Mountain Top," *Ebony*, May 1968; Garland, "Black Women: New Builders of a New South," *Ebony*, August 1966.

13. Phyl Garland, "Leontyne Price: Moving Out at the Top," *Ebony*, June 1985; Garland, "Jessye Norman: Diva," *Ebony*, March 1988; Garland, "The Legacy of Louis Armstrong," *Ebony*, September 1971; Garland, "Requiem for Trane," *Ebony*, 1967; Garland, "Wynton Marsalis: Musical Genius Reaches the Top at 21," *Ebony*, March 1983; Garland, "Duke Ellington: He Took the A Train to the White House," *Ebony*, July 1969; Garland, "Nina Simone: High Priestess of Soul," *Ebony*, August 1969; Garland, "Aretha Franklin: Sister Soul," *Ebony*, September 1967.

14. Phyl Garland, "A Coast to Coast Comeback: Esther Phillips Beats Drugs to Win New Fame," *Ebony*, October 1972.

15. Griffin demonstrates the ways in which *Ebony*, which positioned itself as "*Life* for black Americans," was consistently invested in covering Black female celebrities in domestic settings. The July 1949 cover story on Billie Holiday, for instance, "utilizes the terms of respectability to present a version of her to the black middle class." Farah Griffin, *If You Can't Be Free, Be a Mystery: In Search of Billie Holiday* (New York: Free Press, 2001), 73–77.

16. Garland, "Coast to Coast Comeback." Manuscript drafts of this article housed in the Phyl Garland Collection reveal that Garland worked on multiple drafts of this essay and seemingly experimented with including less conventional biographical information in her article. For instance, in her handwritten notes alongside the photo of Phillips with her boyfriend and promoter, Stephen Adams, she writes that Phillips "has never been married . . . with her companion of many years." See Esther Phillips Comeback folder, SC 111, Series 1: Ebony Columns, 1972–188, Phyl Garland Collection, Archives of African American Music and Culture, Special Collections, Indiana University, Bloomington. For more on Haizlip's festival as well as his influential work as the host of the historic late 1960s and early 1970s television program *Soul!*, see Gayle Wald, *It's Been Beautiful: "Soul!" and Black Power Television* (Durham, NC: Duke University Press, 2015). See also her "Soul Vibrations: Black Music and Black Freedom in Sound and Space," *American Quarterly* 63, no. 3 (2011): 673–696. See also Melissa Haizlip and Samuel D. Pollard, dir., *Mr. Soul! The Movie* (Shoes in the Bed Productions, 2020).

17. Addison Gayle, *The Black Aesthetic* (New York: Doubleday, 1972). See also Stephen Henderson, *Understanding the New Black Poetry: Black Speech and Black Music as Poetic References* (New York: William Morrow, 1973).

18. Garland, "Coast to Coast Comeback."

19. Garland, emphasis Phillips's as quoted by Garland. Sadly, the great Esther Phillips died a little over a decade later in 1984 at the age of forty-eight from liver and kidney failure, the result of long-term effects of addiction.

20. Phyl Garland, *The Sound of Soul* (Chicago: Henry Regnery, 1969), i–iv. In 1981, Garland "became the first African American and first woman to earn tenure at the Columbia University Graduate School of Journalism." She also worked at the *Pittsburgh Courier* from

1958 to 1965, following in the steps of her mother. See Ervin Dyer, "Obituary: Phyllis Garland/Journalism Professor at Columbia University," *Pittsburgh Post-Gazette,* November 9, 2006. Indiana University houses the Phyl Garland Collection, which features an array of the writer's personal papers and correspondences, published articles, unpublished manuscripts, and recorded interviews with a diverse range of artists, including Josephine Baker, Nina Simone, Mary Lou Williams, Don Shirley, Leonard Feather, Roberta Flack, B. B. King, Hall and Oates, Melba Moore, and many others. The Garland Collection also includes a number of press kits that attest to her wide level of engagement with the pop world. The archive holds publicity material covering everything from new releases by R&B legend Ruth Brown to a teen Destiny's Child, from the Jimi Hendrix estate to indie music songsmith Aimee Mann's breakthrough New Wave band 'Til Tuesday. "Phyl Garland Collection, Approximately 1952–2005, Bulk 1972–1990," Archives Online at Indiana University, accessed July 8, 2020, http://webapp1.dlib.indiana.edu/findingaids/view?brand=general&docId=VAC2130&chunk.id=d1e105&startDoc=1.

21. Garland, *Sound of Soul,* 44, iii, 6.

22. Garland, 5, 6, 1, 2, 20, 27, 11. Garland argues that Baldwin's famous assertion in *The Fire Next Time* that "'to be sensual . . . is to respect and rejoice in the force of life, of life itself, and to be present in all that one does, from the effort of loving to the breaking of bread. . . .' . . . is, perhaps, the most eloquent and concise definition of soul and all it entails ever to be set down on paper" (27).

23. Phyl Garland, "Black Music: A Key to Continuing Cultural Exchange within the Pluriverse or 'the Square Root of Blackness,'" n.d., p. 1, Box 3, Series 1: Stereo Review, Contin., Misc. Articles, Correspondence, Phyl Garland Collection. Although the date of the lecture is not included on this document, we can identify the year in which she wrote her talk. In her lecture, Garland describes heading to Ghana "in March of this year" to cover the Soul to Soul music festival. The festival was held on March 6, 1971, in Accra, Ghana. Garland, "Black Music," 3. See also Denis Sanders, dir., *Soul to Soul* (1971).

24. Garland, "Black Music," 1–2. It should be noted that Garland was well versed in jazz music criticism, and it's clear that she was comfortable engaging with that field's luminaries in her own work. In her article on Esther Phillips, for instance, she invokes the work of Leonard Feather. And Feather likewise reached out to her, inviting her to contribute a chapter on soul to an anthology he was developing. See Garland, "Coast to Coast Comeback"; and Leonard Feather to Phyl Garland, November 14, 1973, Box 3, Correspondence from Leonard Feather folder, Phyl Garland Collection. Garland's most indispensable reference work of this kind remains her entry on Black women and the genre of rhythm and blues, which she contributed to historian Darlene Clark Hine's monumental *Black Women in America* encyclopedia. See Phyl Garland, "Rhythm and Blues," in *Black Women in America Encyclopedia,* vol. 2, *M–Z,* ed. Darlene Clark Hine (New York: Carlson, 1993), 974–977.

25. For examples of the turn away from essentialism and toward poststructuralist thought in Black Studies scholarship, see Henry Louis Gates Jr., *Figures in Black: Words, Signs, and the "Racial" Self* (New York: Oxford, 1989); and Houston Baker, *Blues, Ideology and Afro-American Literature: A Vernacular Theory* (Chicago: University of Chicago Press, 1984).

26. Garland, "Black Music," 2–3.

27. Garland, 9. The reference to "wounded kinship" comes from Nathaniel Mackey. Garland notes in this lecture that she is one of only three writers assigned to cover the Soul to Soul festival, the "first international soul music festival featuring African and Afro-American artists on one marathon of a 15-hour concert in Black Star Square" in Accra, Ghana. While

socially, politically, and culturally moved—indeed, transformed—by this experience in a number of ways, Garland is nevertheless critical of the concert's corporate ties, its diasporic blind spots in terms of inclusion, and especially the resulting concert film "released to the American public . . . and making a great deal of money for the whites who contrived the whole thing." Garland, 3–5.

28. Garland, 9. Garland moves from her general allusions to the diasporic presence of Black sound in "Ghana" and "South America" to the popular soul of Charles and Franklin. She also makes a dense, "deep cut" reference here to *Freedom in the Air,* the germinal album recording featuring highlights from the 1961 Albany, Georgia, desegregation campaign led by a voters' rights coalition that included Martin Luther King Jr. and the Southern Christian Leadership Conference, the Student Nonviolent Coordinating Committee, and the NAACP. Folk protest singer and activist Guy Carawan coproduced the album released by the Student Nonviolent Coordinating Committee and distributed it as means to promoting early grass-roots efforts in the modern Civil Rights movement. *Freedom in the Air: A Documentary on Albany, Georgia, 1961–1962* (Atlanta: Student Nonviolent Coordinating Committee, 1962). See also Candie Carawan, *Sing for Freedom: The Story of the Civil Rights Movement through Its Songs* (Montgomery, AL: New South Books, 2007). Garland added a handwritten gospel track to the bottom of her manuscript page, "Edwin Hawkins Singers, 'I'm Going Through.'" Garland, "Black Music," 9.

29. Roach, *Cities of the Dead.*

30. Garland, "Black Music," 3, emphasis in the original; Langston Hughes, "The Negro Speaks of Rivers," *The Weary Blues* (New York: Knopf, 2015), 33–34; Funkadelic, *One Nation Under a Groove* (Warner Bros., 1978).

31. A. O. Scott, *Better Living through Criticism: How to Think about Art, Pleasure, Beauty, and Truth* (New York: Penguin, 2016), 12, 21–22. Scott, a *New York Times* critic-at-large and a critic who conducted doctoral work in English at Johns Hopkins University, takes the decidedly high canon (Matthew Arnold meets Harold Bloom) road as he explores aesthetics and cultural influence and as he makes the case for recognizing the role of the arts journalism critic in today's pop culture universe.

32. Elizabeth Mendez Berry and Chi-Hui Yang, "The Dominance of the White Male Critic," *New York Times,* July 7, 2019; Margo Jefferson as quoted in Berry and Yang. "Old school white critics," they continue, "ought to step aside and make room for the emerging and the fully emerged writers of color who have been holding court in small publications and online for years, who are fluent in the Metropolitan Opera and the rapper Megan Thee Stallion." Toni Morrison, "Black Matter(s)," in *The Source of Self-Regard: Selected Essays, Speeches, and Meditations* (New York: Knopf, 2019), 197. In 2017, Berry and Yang launched an initiative entitled Critically Minded to "amplify the work of critics of color and knock down the barriers that they face." Their effort prioritizes "racial justice in criticism." Berry and Yang, "Dominance of the White Male Critic."

33. Josh Kun, *Audiotopia: Music, Race, and America* (Berkeley: University of California Press, 2005); Jonathan Lethem and Kevin Dettmar, introduction to *Shake It Up: Great American Writing on Rock and Pop from Elvis to Jay Z,* ed. Jonathan Lethem and Kevin Dettmar (New York: Library of America, 2017), xii.

34. Janelle Monáe, "Cold War," *The Arch Android,* Bad Boy Records, 2010.

35. Scholars such as Henry T. Sampson, Anna Everett, and Lucy Caplan, as well as journalist John Jeremiah Sullivan, have done much in recent years to excavate the impact and

significance of pioneers in Black press arts writing, recuperating the work of folks like Sylvester Russell, Lester Walton, and Nora Holt. Sampson's *The Ghost Walks* is an indispensable history of early African American theater that exhaustively catalogs the arts reviews of African American critics in the early Black press. Henry T. Sampson, *The Ghost Walks: A Chronological History of Blacks in Show Business, 1865–1910* (Metuchen, NJ: Scarecrow, 1988). Featured in Simpson's history are two of the most influential African American theater critics of all time, postbellum Progressive Era journalist Sylvester Russell and Harlem Renaissance critic Lester Walton. Russell served primarily as theater critic for the *Chicago Defender*. Walton wrote extensively for a variety of publications, including the *New York World* (1922–1931) and the *New York Age,* where he served as associate editor beginning in 1932. Anna Everett's definitive study of early Black arts writing explores the work of both Russell and Walton. Anna Everett, *Returning the Gaze: A Genealogy of Black Film Criticism, 1909–1949* (Durham, NC: Duke University Press, 2001). Nora Holt was a vocalist as well as a composer who turned her energies to writing about classical music for the *Chicago Defender* in the 1910s and founded her own monthly magazine, *Music and Poetry,* in 1921. Critics such as Phillip McGuire and Lucy Caplan have examined the significance of Holt's work. Phillip McGuire, "Black Music Critics and the Classic Blues Singers," *Black Perspective in Music* 14, no. 2 (Spring 1986): 103–125; Caplan, "Strange Cosmopolites." Sullivan and I have commiserated on the importance of this neglected history of Black arts writing.

36. Saidiya Hartman, *Wayward Lives, Beautiful Experiments: Intimate Histories of Social Upheaval* (New York: Norton, 2019), xv.

37. In the early 1880s, Pauline Hopkins performed with her family's theatrical troupe, the Hopkins Colored Troubadours (also known as the Pauline E. Hopkins Colored Troubadours). Vocalist Hopkins appeared as "Virginia, the plantation nightingale," in the musical she also authored, *Escape from Slavery; or, The Underground Railroad* (later titled *Peculiar Sam,* the earliest extant Black musical on record). Notices included in archival programs document Hopkins's favorable press as a performer. The *Cape Ann Weekly Adviser* notes, for instance, that "the sweet voice of Miss Pauline E. Hopkins, soprano, showed wonderful expression and control, and painstaking culture. . . . In addition to her rare gifts as a vocalist, Miss Hopkins is the author of several successful musical comedies." *Cape Ann Weekly Advertiser,* August 13, 1880; program for the Pauline E. Hopkins Colored Troubadours performance, Pauline Hopkins Papers, Special Collections and Archives, Fisk University, Nashville, TN.

38. Lois Brown, *Pauline Elizabeth Hopkins: Black Daughter of the Revolution* (Chapel Hill: University of North Carolina Press, 2008), 526–536.

39. See Siobhan Somerville, *Queering the Color Line: Race and the Invention of Homosexuality in American Culture* (Durham, NC: Duke University Press, 2000), for an exploration of queer tropes in Hopkins's fiction. See also Hopkins's lengthy letter of professional appeal to African American editor William Monroe Trotter in which she obliquely alludes to the question of gender relations in her life. She writes, "I am not a woman who attracts the attention of the opposite sex in any way." Such an admission should in no way be equated with an articulation of queerness, but it does shed some light on Hopkins's complicated relationship to heteronormative intimacies. See Pauline Hopkins to W. M. Trotter, April 16, 2005, Pauline Hopkins Papers.

40. The likelihood that she owned a phonograph player would have increased exponentially during the 1920s, the decade that saw the emergence of blues women's cultural iconicity and the dawn of the race records industry, as well as one for which scholars know the

least about Hopkins's activities, as she slipped out of the public eye. Would it were that she had produced more speculative fiction and arts journalism that mined the complexities of this history-altering moment in Black women's sonic cultures.

41. Hartman, *Wayward Lives, Beautiful Experiments,* 48–49.

42. Pauline E. Hopkins to W. M. Trotter, April 16, 1905; John C. Freund to Miss Pauline E. Hopkins, March 17, 1904; John C. Freund to Miss Pauline E. Hopkins, March 24, 1904; John C. Freund to Miss Pauline E. Hopkins, January 27, 1904; Pauline E. Hopkins to Mr. W. M. Trotter, April 16, 1905, all in Pauline Hopkins Papers. The epistolary exchanges between editor and benefactor John C. Freund, Hopkins, and William H. Dupree, the African American co-owner of the *Colored American* magazine before the Washington takeover are truly stunning and document the turbulent battle on Hopkins and Dupree's part to withstand the pressures of Freund (who was, as Hopkins notes, sardonically referred to by the staff as "Papa Freund") to adhere to the Booker T. Washington accommodationist doctrine.

43. Hartman, *Wayward Lives, Beautiful Experiments,* xiv.

44. Hazel Carby influentially contends that "through her reconstruction of the 'spirit' of abolitionism, Hopkins hoped that her fiction would encourage among her readership a resurgence of the forms of political agitation and resistance of the antislavery movement." Hazel Carby, *Reconstructing Womanhood: The Emergence of the Afro-American Woman Novelist* (New York: Oxford University Press, 1987), 129.

45. Pauline E. Hopkins, "Famous Women of the Negro Race: Phenomenal Vocalists," *Colored American,* November 1901, 45–53. Hopkins biographer Lois Brown observes that the "professionalism and artistic resilience that [Hopkins] displayed so early on in her career" as a playwright, vocalist, and actress in the 1870s and 1880s "was undoubtedly linked to the inspirational and romantic history of Annie Pauline Pindell, her cherished aunt and a celebrated American prima donna of color." Brown, *Pauline Elizabeth Hopkins,* 76. Brown's epic study provides the most extensive examination of Hopkins's life and career in the world of the arts some two decades before her transition into journalism, public history, and fiction writing. The work of a cosmopolitan Black feminist intellectual, Anna Julia Cooper broke new ground in scholarship on the social, political, and cultural dimensions of postbellum Black womanhood. Cooper's 1892 text *A Voice from the South* (which invokes vocal imagery in its examination of race, gender, sexuality, and enfranchisement in the post-Reconstruction era) is an important forebear to Hopkins's work.

46. Lois Brown, *Pauline Elizabeth Hopkins,* 77; Hopkins, "Famous Women," 46.

47. Hopkins, "Famous Women," 50, 46.

48. Nathaniel Mackey, *Bedouin Hornbook* (Los Angeles: Sun and Moon, 2000), 22.

49. Farah Jasmine Griffin, "When Malindy Sings: A Meditation on Black Women's Vocality," in *Uptown Conversation: The New Jazz Studies,* ed. Robert G. O'Meally, Brent Hayes Edwards, and Farah Jasmine Griffin (New York: Columbia University Press, 2004), 113.

50. Sterling Brown, "Ma Rainey," in *The Collected Poems of Sterling A. Brown,* ed. Michael Harper (Evanston, IL: Triquarterly Books, 1996); In a 1999 interview, August Wilson stated that his work was influenced by "my four Bs": poet Luis Borges, playwright Amiri Baraka, painter Romare Bearden, and the blues. "August Wilson, The Art of Theater No. 14," Interviewed by Bonnie Lyons and George Plimpton, *The Paris Review* 153 (1999): https://www.theparisreview.org/interviews/839/the-art-of-theater-no-14-august-wilson. NPR Morning Edition, "Intersections: August Wilson Writing to the Blues: In Bessie Smith,

Playwright Heard Language of Black Experience," https://www.npr.org/templates/story /story.php?storyId=1700922. See Griffin, "When Malindy Sings," for a longer list of these kinds of influential associations. See also Emily Lordi, *Black Resonance: Iconic Women Singers and African American Literature* (New Brunswick, NJ: Rutgers University Press, 2013), which owes much to Griffin's arguments and theories. For Shakespeare's "so musical a discord, such sweet thunder," see *A Midsummer Night's Dream,* act 4, scene 1; and Duke Ellington, *Such Sweet Thunder,* Columbia Records, 1957.

51. Griffin, "When Malindy Sings," 102, 103–104; Hopkins, *Of One Blood,* 67; Fred Moten, *In the Break: The Aesthetics of the Black Radical Tradition* (Minneapolis: University of Minnesota Press, 2003), 12.

52. Moten, *In the Break,* 10–11; Paul Laurence Dunbar, "When Malindy Sings," in *The Collected Poetry of Paul Laurence Dunbar,* ed. Joanne M. Braxton (Charlottesville: University of Virginia Press, 1993), 82–83; James Weldon Johnson, *The Autobiography of an Ex-Coloured Man* (New York: Vintage, 1989), 8, 27.

53. Hopkins, *Of One Blood,* 453; Griffin, "When Malinday Sings," 111. My meditation here on *Of One Blood* builds on my previous reflections on Hopkins's work. Daphne A. Brooks, *Bodies in Dissent: Spectacular Performances of Race and Freedom, 1850–1910* (Durham, NC: Duke University Press, 2006), 281–342.

54. Lindon Barrett, *Blackness and Value: Seeing Double* (New York: Cambridge University Press, 2002), 92; Charles Merewether, *The Archive* (Cambridge, MA: MIT Press, 2006), 10. On the politics of "partials" in the Black sound archive, see Radano, *Lying Up a Nation.*

55. Farah Jasmine Griffin, *Harlem Nocturne: Women Artists and Progressive Politics during World War II* (New York: Nation Books, 2013), 152.

56. Griffin, *Harlem Nocturne,* xii.

57. Griffin, 140, 143. See also Linda Dahl, *Morning Glory: A Biography of Mary Lou Williams* (New York: Pantheon, 2000); Tammy L. Kernodle, *Soul on Soul: The Life and Music of Mary Lou Williams* (Boston: Northeastern University Press, 2004); and Brent Edwards, *Epistrophies: Jazz and the Literary Imagination* (Cambridge, MA: Harvard University Press, 2017), 154–180. On Williams's "Tree of Jazz," see Kernodle, *Soul on Soul,* 257. Kernodle notes that Williams's idea about "the 'Americanness' of jazz" is "a perspective that mirrored that of emerging black scholars, activists, and writers" such as Amiri Baraka / LeRoi Jones, especially in the *Blues People* phase of his career. Baraka, "like Mary," she argues, "believed that jazz was a derivative of the African's transmutation into the American. But Baraka's assertions did not seem to breed the type of venom that Mary attracted when she said the same thing" (257). Mary Lou Williams, "Music and Progress," *Jazz Record,* November 1947. For more on this essay, see Griffin, *Harlem Nocturne,* 179–181.

58. Edwards, *Epistrophes,* 155. See Mary Lou Williams, *A Keyboard History,* an album in which the artist, as Edwards puts it, "figures herself as a living repository of black music" (155). Mary Lou Williams, *A Keyboard History,* Poll Winners Records, 2012, first recording 1955. See also Williams's liner notes for her *Embraced* concert album with Cecil Taylor, which extends this idea and which Edwards explores at length. Mary Lou Williams and Cecil Taylor, *Embraced: A Concert of New Music for Two Pianos Exploring the History of Jazz with Love,* Pablo Records, 1995, first recording 1978; Edwards, *Epistrophes,* 170–174. See also Dahl, *Morning Glory;* and Kernodle, *Soul on Soul,* on this subject.

59. On the significance of the spirituals, see Mary Lou Williams, "Has the Black American Musician Lost His Creativeness and Heritage in Jazz," unpublished essay, n.d., MC 60,

Series 5, Box 2, Folder 7, Mary Lou Williams Collection, Institute of Jazz Studies, Rutgers University, Newark, NJ (hereafter referred to as the MLW Collection). In the Smithsonian's sprawling 1973 interview with Williams, she argues, "I think it's best for a musician to learn to feel everything and teach himself." John S. Wilson, interview with Mary Lou Williams, June 26, 1973, p. 5, Smithsonian Institution Interviews with Jazz Musicians, Jazz Oral History Project, interview housed in the MLW Collection. "I am not against a musician going to school." Williams argues, "I am against anything that destroys natural ability." Mary Lou Williams, "Musicians since the Beginning," unpublished manuscript, n.d., MC 60, Series 5, Box 2, MLW Collection. In "Jazz Is Our Heritage," she proclaims her singularity as an artist who "changed and developed" in concert with the music across time." Mary Lou Williams, "Jazz Is Our Heritage," MC 60, Series 5, Box 2, Folder 8, MLW Collection. Williams contemplates "the definition of genius" in Mary Lou Williams, "Musicians since the Beginning," unpublished essay, MC 60, Series 5, Box 2. MLW Collection. On the "manly privilege of experiment," see Mary Lou Williams, "Don't Destroy the Roots," unpublished essay, p. 6, MC 60, Series 5, Box 2, Folder 3, MLW Collection. See also Williams, "Has the Black American Musician."

60. In her letter to Garland, Williams continues, "Phyl, what is wrong with our blacks?" The letters from Williams document what may have been a complicated—or, at the very least, an intense—professional relationship. At times, Williams presses Garland to find out when and if the *Ebony* feature would run. Mary Lou Williams to Phyl Garland, March 23, 1977, Box 3, Correspondence 1977–1979, Phyl Garland Collection. In another letter, she alludes to the Pittsburgh connection between the two, telling Garland that her mother, the veteran *Pittsburgh Courier* journalist Hazel Garland, "has been a princess since the first day she met me. There was a bad period in Pittsburgh when a dark skin didn't have a chance . . . your mother went to bat for me all the way." Mary Lou Williams to Phyl Garland, December 3, 1978, Box 3, Correspondence 1977–1979, Phyl Garland Collection. The Garland Collection also includes an exclusive invitation to the *Embraced* concert. Box 3, Correspondence 1977–1979, Phyl Garland Collection, Special Collections. See also Phyl Garland, "Mary Lou Williams: The Lady Lives Jazz," *Ebony*, October 1979.

61. Mary Lou Williams, "How This Concert Came About," liner notes for Mary Lou Williams and Cecil Taylor, *Embraced*, Pablo Records, 1978. Here she refers again to "James Brown and Aretha Franklin" as singing "a form of rock related to Jazz—we used to call it Rhythm and Blues." For more on this album, see Edwards's extensive reading of this legendary and complicated collaboration, Edwards, *Epistrophies*. Williams, "Musicians since the Beginning"; Mary Lou Williams to Leonard Feather (copy), June 20, 1973, MC 60, Series 3: Personal Correspondence, Box 13, MLW Collection. Williams and Feather's correspondence documents a relationship that oscillated between warmth and strained tensions, particularly in the wake of his published profile on the pianist, with which she apparently took umbrage. See various Williams and Feather letters, MC 60, Series 3: Personal Correspondence, Box 13, MLW Collection.

62. Williams, unpublished note, n.d., in "Incomplete Handwritten for Various Projects," MC 60, Series 5, Box 2, MLW Collection. "I have news for you," Williams continues, apparently addressing the critics stoking her ire, the "spirituals came first . . . blues, jazz & swing & bop."

63. Edwards, *Epistrophies*, 154, emphasis in the original. For more on "zoning," see Edwards, 160. His brilliant meditation on Williams reads her, in some respects, as the aestheti-

cally conservative foil to revolutionary avant-gardist Cecil Taylor. "One reconstitutes the protocols of the past with positivistic exactitude, toward its 'peak perfection,'" Edwards muses, adding that "'progress' for Williams means that 'when it has reached this so-called 'peak,' it is really only the beginning, for then we build the new ideas on top old.' The past . . . is at the disposal of the future, the 'new'" (168).

64. *Shorter Oxford English Dictionary on Historical Principles,* 5th ed., vol. 2, N–Z (New York: Oxford University Press, 2002), 3236.

65. In 2014, jazz pianist Geri Allen led the charge to pay tribute to Williams, organizing various events to celebrate the artist's legacy. The cyberevent featured Farah Jasmine Griffin, Jason Moran, Vijay Iyer, and others. See Sharon S. Blake, "A Cyber Tribute to Jazz Legend Mary Lou Williams," *Pitt Chronicle,* April 14, 2014, https://www.chronicle.pitt.edu /story/cyber-tribute-jazz-legend-mary-lou-williams. The three-day event in Harlem looked to next-generation artists carrying forward Williams's legacy. Nate Chinen, "A Mentor Recalled by Talking Pianos," *New York Times,* March 6, 2014.

66. Barbara Christian, "The Race for Theory," *Feminist Studies* 14, no. 1 (Spring 1988): 68.

67. Christian, 67; Lorde as quoted in Christian, 79.

68. Wilson, interview with Mary Lou Williams, 17, 24; Kernodle, *Soul on Soul,* 46–47.

69. Wilson, interview with Mary Lou Williams, 17; Kernodle, *Soul on Soul,* 46–47. Williams recounts tales of the dangers involved in performing at roadhouse establishments in the late 1920s. As Kernodle indicates, the kidnapping episode involved "a 'fan' who came night after night" to her gigs in Memphis and listened "attentively to the petite, almond-eyed pianist. One evening, the cook tipped her off that the man was interested in more than just her piano playing." Williams escaped out the washroom window of the venue and skipped her pay. For more on these incidents, see Wilson, interview with Mary Lou Williams, 40–41; and Kernodle, *Soul on Soul,* 47. Williams's "Roll 'Em" was a composition she wrote at the behest of Benny Goodman.

70. Filmmaker Carol Bash recounts the story of Williams's rape and survival in her documentary about the musician. Carol Bash, dir., *Mary Lou Williams: The Lady Who Swings the Band* (New York: Paradox Films, 2015).

71. Mary Lou Williams, "Rhythm Section," in *Talking Jazz,* ed. Max Jones (New York: Norton, 1988), 186. See also Dahl's discussion of the "great danger" that she faced as a "target of predators" at "clubs and dancehalls" as well as in her own personal life. Dahl, *Morning Glory,* 36.

72. Paul Gilroy, *Darker Than Blue: On the Moral Economies of Black Atlantic Culture* (Cambridge, MA: Harvard University Press, 2010), 35; W. T. Llahmon Jr., *Deliberate Speed: The Origins of a Cultural Style in the American 1950s* (Washington, DC: Smithsonian Institute Press, 1990), 78; Gilroy, "Driving While Black," ed. *Car Cultures,* ed. Daniel Miller (Oxford: Berg, 2001), 94. Chess Records released Jackie Brenston and His Delta Cats' "Rocket 88" in 1951. The recording was actually the work of Ike Turner and the Kings of Rhythm in spite of its listing otherwise. On the trope of masculinist speed in rock and roll, see Simon Reynolds and Joy Press, *The Sex Revolts: Gender, Rebellion and Rock 'n' Roll* (Cambridge, MA: Harvard University Press, 1995), 43–65.

73. Her familiarity with cars, anomalous as it was for a girl or woman of any age during this period, came as a result of a pivotal mentorship as she was cared for in her Pittsburgh youth by yet another father figure who saw fit to bequeath her with skills that transgressed gender norms. The "sporting man" Roland Mayfield is a prominent figure in Williams's

childhood, having taken her under his wing and having taught her how to both fix cars and race them through the streets of Pittsburgh in her preteen years. See Wilson, interview with Mary Lou Williams, 43, 109. For more on Mayfield, see Dahl, *Morning Glory,* 35–6. See also Kernodle, *Soul on Soul,* 26. Mary Lou Williams, *A Keyboard History,* Jazztone, 1955.

74. It should be noted when discussing Williams's penchant for risk that she also struggled with an addiction to gambling later in her career. While I remain wary of conflating personal and psychic challenges with artistic impulses, the connections between her aesthetic energies and her addictive impulses (and the contiguities between the two) are apparent. See Griffin, *Harlem Nocturne,* 171–173.

75. Cotten Seiler, *Republic of Drivers: A Cultural History of Automobility in America* (Chicago: University of Chicago Press, 2008), 56–57.

76. Paul Gilroy, "Bold as Love? Jimi's Afrocyberdelia and the Challenge of the Not-Yet," in *Rip It Up: The Black Experience in Rock 'N' Roll,* ed. Kandia Crazy Horse (New York: Palgrave, 2004), 27.

77. Kernodle, *Soul on Soul,* 48, 42, 53.

78. Kernodle, 61.

79. Seiler, *Republic of Drivers,* 14, 41. In his reading of the abundant archival traces of Williams's quotidian "zoning," her, for instance, seemingly "compulsive" stockpiling of various receipts and notes collected over the course of her life, Edwards argues that "one might even speak of [this process] in terms of an aesthetics of accounting, in that it sounds a scattered deposit of styles." Edwards, *Epistrophies,* 178.

80. Warren Belasco as quoted in Seiler, *Republic of Drivers,* 113. Seiler, 113

81. Abbey Lincoln, "The Negro Woman in American Literature," *Freedomways* 6, no. 1 (Winter 1966): 13; Zora Neale Hurston, "Spirituals and Neo-spirituals," in *Negro: An Anthology,* ed. Nancy Cunard (New York: Continuum, 1934), 224; Griffin, *If You Can't Be Free,* 161–192; Eric Porter, *What Is This Thing Called Jazz? African American Musicians as Artists, Critics, and Activists* (Berkeley: University of California Press, 2002), 149–190.

82. Sarah E. Wright, "The Negro Woman in American Literature," *Freedomways* 6, no. 1 (Winter 1966): 9. Porter, *What Is This Thing Called Jazz?,* 170–171. See Thelonious Monk, "Blue Monk," *Thelonious Monk Trio,* Prestige, 1954. Abbey Lincoln, "Blue Monk (Monkery's the Blues)," *Straight Ahead,* Candid, 1961. Nat Hentoff as cited in Robin Kelley, *Thelonious Monk: The Life and Times of an American Original* (New York: Free Press, 2009). For more on Lincoln and Monk, see Kelley, 299–300. On music as criticism of itself, see Edwards, *Epistrophies.*

83. Abbey Lincoln, "The Man the African the European Man," unpublished essay, n.d., Box 24, Folder 3, Abbey Lincoln Papers, Institute of Jazz Studies, Rutgers University, Newark, NJ; Abbey Lincoln, "To Whom Will She Cry Rape?," emphasis in the original, Box 27, Folder 11, Abbey Lincoln Papers. A drastically revised version of "To Whom Will She Cry Rape?" appeared in *Negro Digest* in 1966 with a new title, "Who Will Revere the Black Woman?" Lincoln appears on the cover of the magazine. She had delivered a version of this material a year earlier at the Black Arts Repertory Theater / School. A version of the essay appears in Cade Bambara's 1970 anthology. See Abbey Lincoln, "Who Will Revere the Black Woman?," *Negro Digest,* September 1966, 16–20; and Abbey Lincoln, "Who Will Revere the Black Woman?," in *The Black Woman: An Anthology,* ed. Toni Cade Bambara (New York: Signet, 1970), 80–84. In her fine intellectual history of Black Arts women dramatists, La Donna L. Forsgren reveals in her interview with Sanchez that the poet was so moved by Lincoln's lecture that she took up playwriting "to further validate Lincoln's critique of misogyny,

and stereotypes of black womanhood." La Donna L. Forsgren, *In Search of Our Warrior Mothers: Women Dramatists of the Black Arts Movement* (Evanston, IL: Northwestern University Press, 2018), 74. The collection of Abbey Lincoln's unpublished writings is vast and varied—from informal journal entries to prepared lectures. Finished and unfinished essay and poetry manuscript titles in this collection include "A Book of Random Notes on Egypt," "Where Are the African Gods," "Art of Being Human," and "In a Circle Everything Is Up." A fragment of a draft of a lecture titled "Lecture—Kalamazoo" and a program for her May 8, 1999, Dillard University "Abbey Speaks" lecture are also included in her papers. See Abbey Lincoln Papers.

84. Abbey Lincoln, handwritten notebook entry, n.d. Box 22, Folder 9, Abbey Lincoln Papers; Abbey Lincoln, "Unknown Composers," n.d. Box 23, Folder 3, Abbey Lincoln Papers; Abbey Lincoln, "There Are No Temples Here," Dillard University lecture manuscript, May 8, 1999, Abbey Lincoln Papers.

85. Griffin, *If You Can't Be Free*, 175. See also Porter, *What Is This Thing Called Jazz?*; and Sarah E. Wright, "The Negro Woman in American Literature," *Freedomways* 6, no. 1 (Winter 1966): 9–10.

86. Lincoln, "The Negro Woman in American Literature," 11–13.

87. Zora Neale Hurston, "First Version of Folklore," n.d. 2–3, Box 12, Zora Neale Hurston Papers, George A. Smathers Library, University of Florida, Gainesville; Hurston, "Spirituals and Neo-spirituals," 224.

88. Jonathan Flatley, *Affective Mapping: Melancholia and the Politics of Modernism* (Cambridge, MA: Harvard University Press, 2008), 19–20. See also Martin Heidegger, *Being and Time* (New York: Harper Perennial Modern Classics, 2008).

89. Lincoln, "The Negro Woman in American Literature," 11; Flatley, *Affective Mapping*, 21.

90. Lincoln, "The Negro Woman in American Literature," 11; Alexander Weheliye, *Phonographies: Grooves in Sonic Afro-Modernity* (Durham, NC: Duke University Press, 2005), 30.

91. Lincoln, "The Negro Woman in American Literature," 13.

92. Porter, *What Is This Thing Called Jazz?*, 163, 185.

93. Griffin, *If You Can't Be Free*, 174; Porter, *What Is This Thing Called Jazz?*, 187.

94. Ralph Ellison, "As the Spirit Moves Mahalia," in *Living with Music: Ralph Ellison's Jazz Writings*, ed. Robert O'Meally (New York: Modern Library, 2002), 92–93, 91. For more on Ellison's relationship to Mahalia's music, see Emily Lordi, *Black Resonance: Iconic Women Singers and African American Literature* (New Brunswick, NJ: Rutgers University Press, 2013), 66–98.

95. Ralph Ellison, "As the Spirit Moves Mahalia," 93, 90.

96. The sonic aesthetics of her remove rhymes with the "impersona" of Lena Horne of which Shane Vogel writes so persuasively. However, we might think of Lincoln as invoking distance as criticism while the latter uses it as armor in Jim Crow nightclubs. Shane Vogel, "Lena Horne's Impersona," in *The Scene of Harlem Cabaret: Race, Sexuality, Performance* (Chicago: University of Chicago Press, 2009).

97. Flatley, *Affective Mapping*, 24.

98. Janelle Monáe, *The Electric Lady* Bad Boy Records, 2013.

99. Monáe co-starred in the 2016 Oscar-winning film, *Moonlight* as well as the Oscar-nominated *Hidden Figures* the same year. In 2018 she released *Dirty Computer* which was nominated for the Grammy album of the year award.

100. Janelle Monáe, Dirty Computer [Emotion Picture]: "a narrative film and accompanying music album." https://www.youtube.com/watch?v=jdH2Sy-BlNE.

101. See Janelle Monáe, *Metropolis: Suite I (The Chase)*, Bad Boy Records, 2007.

102. Francesca Royster, *Sounding Like a No-No: Queer Sounds and Eccentric Acts in the Post-soul Era* (Ann Arbor: University of Michigan Press, 2012). See Monáe's official website for details about various ongoing projects. The release of her *Dirty Computer* video album coincided with the artist's first public discussion of her queer identity politics. See Janelle Monáe Official Website, accessed July 8, 2020, http://www.jmonae.com. See also Brittany Spanos, "Janelle Monáe Frees Herself," *Rolling Stone*, April 26, 2018.

103. Shana Redmond, "This Safer Space: Janelle Monáe's 'Cold War,'" *Journal of Popular Music Studies* 23, no. 4 (2011): 393–411. Richard Iton as quoted in Redmond, 406. Redmond, 406. See also Daylanne K. English and Alvin Kim, "Now We Want Our Funk Cut: Janelle Monáe's Neo-Afrofuturism," *American Studies* 52, no. 4 (2013): 217–230; and Marquita Smith, "Visions of Wondaland: On Janelle Monáe's Afrofuturist Vision," in *Popular Music and the Politics of Hope: Queer and Feminist Interventions,* ed. Susan Fast and Craig Jennex (New York: Routledge, 2019), 31–38.

104. T. W. Adorno and Max Horkheimer, *Dialectic of Enlightenment* (Palo Alto, CA: Stanford University Press, 2007), 56; Rita Felski, *The Gender of Modernity* (Cambridge, MA: Harvard University Press, 1995), 5–6.

105. Felski, *Gender of Modernity,* 6.

106. Janelle Monáe, "Look into My Eyes," *The Electric Lady,* Bad Boy Records, 2013.

107. Barbara Engh, "Adorno and the Sirens: Tele-phono-graphic bodies," in *Embodied Voices: Representing Female Vocality in Western Culture,* ed. Leslie C. Dunn and Nancy A. Jones (New York: Cambridge University Press, 1994), 134; Adorno and Horkheimer, *Dialectic of Enlightenment,* 73.

108. Donna Haraway, *Simians, Cyborgs, and Women: The Reinvention of Nature* (New York: Routlege, 1990), 151.

109. For more on twenty-first century pop spectacle and the politics of gender, see Jack Halberstam, *Gaga Feminism: Sex, Gender, and the End of Normal* (New York: Beacon Press, 2013).

110. The character of Starchild first appears on Parliament's first album, 1975's *Mothership Connection* (Casablanca Records, 1975). David Bowie first unveiled his astronaut folk hero Major Tom on 1969's "Space Oddity" on his album from that year, *David Bowie* (later retitled *Space Oddity*). *David Bowie,* Philips / Mercury, 1969. Grace Jones and Labelle are clear and important antecedents to Monáe as well. For more on Labelle, see Maureen Mahon, *Black Diamond Queens: African American Women and Rock and Roll* (Durham, NC: Duke University Press, 2020). See also Gayle Wald, *It's Been Beautiful* (Durham, NC: Duke University Press, 2015). Jones is perhaps the best source on her own cultural impact. See her riveting, page-turner of a memoir. Grace Jones, *I'll Never Write My Memoirs* (New York: Galley Books, 2016). See also *Kara Keeling, Queer Times, Black Futures* (New York: New York University Press, 2019), 145–176. Uri McMillan, "Introduction: skin, surface, sensorium," *Women & Performance: a journal of feminist theory* 28 (2018): 1–15. Daphne A. Brooks, "Betty Davis, Grace Jones, and the Art of Anti-Confessional Cinema," *Los Angeles Review of Books,* July 29, 2018, https://lareviewofbooks.org/article/betty-davis-grace-jones-and-the-art-of-anti-confessional-cinema/.

111. Janelle Monáe, liner notes for *The Arch Android,* Bad Boy Records, 2010.

112. Merewether, *Archive,* 10.

113. Tom Piazza, *Setting the Tempo: Fifty Years of Great Jazz Liner Notes* (New York: Anchor Books, 1996), 3–4. For more on jazz liner notes, see John Gennari's fine study of jazz music criticism, *Blowin' Hot and Cool: Jazz and Its Critics* (Chicago: University of Chicago Press, 2006).

114. Dean Biron calls Dylan's "sleeve writing" for *Bringing It All Back Home* the "most notable" from this period. Dean L. Biron, "Writing *and* Music: Album Liner Notes," *Journal of Multidisciplinary International Studies* 8, no. 1 (2011): 5–6.

115. Piazza, *Setting the Tempo,* 1.

116. Recent liner notes by scholars of Black feminist studies point toward an expansion of the field in terms of form and content. See Farah Griffin, liner notes for Geri Allen, *Flying toward the Sound: A Solo Piano Excursion Inspired by Cecil Taylor, McCoy Tyner and Herbie Hancock* (2010); Farah Griffin, liner notes for Nnenna Freelon, *Blueprint of a Lady: The Once and Future Life of Billie Holiday,* Concord Records, 2005; Farah Griffin, liner notes for Lena Horne, *Stormy Weather,* RCA Victor, 1957, Bluebird reissue, 2002; Gayle Wald, liner notes for *Shout, Sister, Shout,* Enhanced Records, 2003; Salamishah Tillet, liner notes for John Legend and the Roots, *Wake Up!,* SBME Special MKTS, 2013. See also Daphne A. Brooks, liner notes for Aretha Franklin, *Take a Look: Complete on Columbia,* Sony Music, 2011; Tammi Terrell, *Come On and See Me: The Complete Solo Collection,* Hip-O Select, 2010; and Daphne A. Brooks, liner notes for *Prince, Sign O' The Times: Super Deluxe Edition,* Warner Brothers, 2020. Ron Moy reads Monáe's "collaborative authorship" as it manifests itself in her liner notes and beyond as an excellent example of her commitment to "open[ing] up avenues of creativity denied the sole author." Ron Moy, *Authorship Roles in Popular Music: Issues and Debates* (New York: Routledge, 2015), 35. Matthew Frye Jacobson points out that Odetta actively wrote her own liner notes for some of her key recordings. See Matthew Frye Jacobson, *Odetta's "One Grain of Sand"* (New York: Bloomsbury, 2019).

117. Biron, "Writing *and* Music," 9. For more on Fahey's deeply complicated relationship to Black music, see Chapter 5.

118. P. A. Skantze, "Shake That Thing: Liner Notes, Shakespeare and the Dark Lady of the Sonic," unpublished lecture, University of Roehampton, December 2018, 2.

119. Janelle Monáe, liner notes for *The Arch Android.*

120. Weheliye, *Phonographies,* 38, 36. For Weheliye, "the novel cleft between sound and source initiated by the technology of the phonograph in twentieth-century black culture supplies the grooves of sonic Afro-modernity," as he calls it. "By drastically re / constructing the flow between sounds and identifiable human source, the technology of the phonograph worried the complex intersection of orality, music and writing," thus creating a gateway for "black cultural producers and consumers" to "productively engag[e]" this split, to "create a variety of musics, literary texts, and films" that disturb conventional notions of "temporality, spatiality and community" in such a way as to allow for "black subjects to structure and sound their positionalities within and against Western modernity." In sum, "no western modernity without (sonic) blackness," he concludes, and "no blackness in the absence of modernity" (7–8, 45).

121. Christopher Small, *Musicking: The Meanings of Performing and Listening* (Middletown, CT: Wesleyan University Press, 1998); Sylvia Wynter and Katherine McKittrick, "Unparalleled Catastrophe for Our Species? Or, to Give Humanness a Different Future: Conversations," in *Sylvia Wynter: On Being Human as Praxis,* ed. Katherine McKittrick (Minneapolis: University of Minnesota Press, 2014), 31. Summing up one of the fundamental claims of her work, Wynter observes that we "do *not* know about something called *ontological*

sovereignty. And I'm being so bold as to say that in order to *speak* the conception of ontological sovereignty, we would have to move completely outside our present conception of what it is to be human, and therefore outside the ground of the orthodox body of knowledge which institutes and reproduces such a conception." Sylvia Wynter, "The Re-enchantment of Humanism: An Interview with Sylvia Wynter," by David Scott, *Small Axe* 8 (2000): 136, emphasis in the original. See also Alexander Weheliye, *Habeas Viscus: Racializing Assemblages, Biopolitics, and Black Feminist Theories of the Human* (Durham, NC: Duke University Press, 2014). Walter Mignolo discusses the "emancipatory cognitive leap" that Wynter's work enacts. Walter Mignolo, "Sylvia Wynter: What Does It Mean to Be Human?," in McKittrick, *Sylvia Wynter,* 106. Wynter and McKittrick, "Unparalleled Catastrophe for Our Species?"

122. Janelle Monáe, liner notes for *The Electric Lady,* Bad Boy Records, 2013; Janelle Monáe, liner notes for *Dirty Computer,* Bad Boy Records, 2018.

123. Colin Symes, "Off the Record: Some Notes on the Sleeve," *Setting the Record Straight: A Material History of Classical Recording* (Middletown, CT: Wesleyan University Press, 2004), 124–125; Kevin Young, *The Grey Album: On the Blackness of Blackness* (New York: Graywolf, 2012). My hearty thanks to Shane Vogel for inspiring this particular thread of my thinking here and in relation to the liner notes discussion ahead in this chapter.

124. Young, *Grey Album,* 11–20. See also Shane Vogel, "The Sensuous Harlem Renaissance: Sexuality and Queer Culture," in *A Companion to the Harlem Renaissance,* ed. Cherene Sherrard-Johnson (New York: Wiley-Blackwell, 2015), 267–284.

125. Skantze, "Shake That Thing," 1. See also Ashon Crawley, *Black Pentacostal Breath: The Aesthetics of Possibility* (New York: Fordham University Press, 2016).

126. Merewether, *Archive,* 10.

127. Diana Taylor, *The Archive and the Repertoire: Performing Cultural Memory in the Americas* (Durham, NC: Duke University Press, 2003), 21–22.

128. Rebecca Schneider, *Performing Remains: Art and War in Times of Theatrical Reenactment* (New York: Routledge, 2011), 101.

129. Theodor W. Adorno, "The Curves of the Needle," in *Essays on Music,* ed. Richard Leppert (Berkeley: University of California Press, 2002), 274.

130. Adorno, 275; Engh, "Adorno and the Sirens," 129.

131. Theodor W. Adorno, "The Form of the Phonograph Record," in *Essays on Music,* 280.

132. Small would influentially argue that music "is not a thing at all but an activity, something that people do." Small, *Musicking,* 2. His remarks follow Hurston's interest in the value and prioritization of action in African American cultures in her 1934 "Characteristics of Negro Expression" essay discussed in chapter 2. See also Nathaniel Mackey, "Other: From Noun to Verb," in *The Jazz Cadence of American Culture,* ed. Robert O'Meally (New York: Columbia University Press, 1998), in which he builds on both Hurston's essay and LeRoi Jones's arguments regarding the importance of Blackness and action.

133. Griffin, "When Malindy Sings," 111; Anthony Giddens, *Modernity and Self-Identity: Self and Society in the Late Modern Age* (Palo Alto, CA: Stanford University Press, 1991). My thanks to Rod Ferguson for drawing connections between Giddens's work and my thinking here.

134. Jonathan Sterne, *The Audible Past: Cultural Origins of Sound Production* (Durham, NC: Duke University Press, 2003), 182; Kun, *Audiotopia,* 122–123, 125.

135. Roland Barthes, "The Grain of the Voice," in *Image. Music. Text* (New York: Hill and Wang, 1978); Alexandra Vazquez, *Listening in Detail: Performances of Cuban Music* (Durham, NC: Duke University Press, 2013); Sterne, *Audible Past,* 210, 213.

2. "Sister, Can You Line It Out?"

1. Zora Neale Hurston, "She Rock," *Pittsburgh Courier,* August 5, 1933, A3. Reprinted for the first time in "African American Literary Studies: New Texts, New Approaches, New Challenges," ed. Werner Sollors and Glenda Carpio, special issue, *Amerikastudien/American Studies* 55, no. 4 (2010): 592–597.

2. Zora Neale Hurston, *Folklore, Memoirs, and Other Writings,* ed. Cheryl Wall (New York: Library of America, 1995), 738. Randall Cherry, "Ethel Waters: The Voice of an Era," *Temples for Tomorrow: Looking Back at the Harlem Renaissance,* ed. Genevieve Fabre and Michael Feith (Bloomington, Indiana UP, 2001), 99–124. In his reading of her classic performances of "Stormy Weather," Shane Vogel argues that Waters's "voice . . . became a modern technology, replacing effects with affects and redeploying the popular song in the service of an African American modernist critique." Shane Vogel, "Performing 'Stormy Weather': Ethel Waters, Lena Horne, and Katherine Dunham," *South Central Review* 25, no. 1 (Spring 2008): 100.

3. Ethel Waters as quoted in Rosetta Reitz, liner notes for *Ethel Waters, 1938–1939: The Complete Bluebird Sessions* (Rosetta Records and Tapes, 1986); Reitz, Liner Notes for *Ethel Waters, 1938–1939.* Foremothers Volume 6, RR1314, Rosetta Records, 1986.

4. Ann Powers, *Good Booty: Love and Sex, Black and White, Body and Soul in American Music* (New York: Dey St., 2017), 74; Hurston, "She Rock" (1933). Mills dazzled audiences in the legendary Broadway production of *Shuffle Along* in 1921 but died tragically in 1927 following a long struggle with tuberculosis. Her massive Harlem funeral is a thing of legend in the world of Black theater. Drawing over ten thousand mourners to the streets of New York City, the event was covered widely in the press. See "Scores Collapse at Mills Funeral," *New York Times,* November 7, 1927. Powers argues that Mills "was a blueswoman . . . though she's not remembered" as such. "She brought to life," she continues, "that new sense of music as a personal provocative force" (74). In her oral history interview, Mary Lou Williams recounts meeting Mills at the age of fourteen. She was, says Williams, "the most beautiful little delicate-looking person and very sweet. I was wondering why there isn't more said or done about her because she was a great star." John S. Wilson, interview with Mary Lou Williams, June 26, 1973, p. 91, Smithsonian Institution Interviews with Jazz Musicians, Jazz Oral History Project, Mary Lou Williams Collection, Institute of Jazz Studies, Rutgers University, Newark, NJ.

5. Hurston, *Folklore, Memoirs,* 739.

6. Ethel Waters and Her Ebony Four, "Shake That Thing," Columbia Records, 1926.

7. Saidiya Hartman, *Wayward Lives, Beautiful Experiments: Intimate Histories of Social Upheaval* (New York: Norton, 2019), 183.

8. Diana Taylor, *The Archive and the Repertoire: Performing Cultural Memory in the Americas* (Durham, NC: Duke University Press, 2003), 19. In her essay "Spirituals and Neo-spirituals," Hurston calls for a rigorous examination of the intricacies of "real Negro" singing and critiques the popularity of concert hall spirituals. Zora Neale Hurston, "Spiritual and Neo-spirituals," in *Negro: An Anthology,* ed. Nancy Cunard (New York: Continuum, 1934), 223–225.

9. My thanks to Nate Jung for his insightful points here regarding Hurston's engagement with the modern.

10. As Sonnet Retman reminds, "even in her earliest collecting," Hurston "harbored an abiding interest in recording in the field and elsewhere. While working for historian Carter G.

Woodson in 1927, she wanted to buy 'a recording machine so that she could record what really had happened in black history.' She hoped to use the machine to collect material for her theatrical folk revues." Sonnet Retman, "Voice on the Record: The New Negro Movement's Recording Imaginary," in African American Literature in Transition, 1750–2015, series edited by Joycelyn Moody (New York: Cambridge University Press, forthcoming).

11. Hurston collected material all across the South and the Caribbean that she performed and recorded on this expedition. See, for instance, the Bahamian "Fire Dance" in *Go Gator and Muddy the Water: Writings by Zora Neale Hurston from the Federal Writers Project*, ed. Pamela Bordelon (New York: Norton, 1999), 176–177. For more on Hurston's Black diasporic sonic performances, see Sonya Posmentier, *Cultivation and Catastrophe: The Lyric Ecology of Modern Black Literature* (Baltimore: Johns Hopkins University Press, 2017). See also Alexandra Vazquez, "The Florida Room" (Durham, NC: Duke UP, unpublished manuscript). Hurston apparently "acted as an advance agent locating [Cuban] folk singers in Tampa for Folklore Recording Expedition." Hurston, "Cuban Music," manuscript note, n.d., Box 12, Zora Neale Hurston Papers, George A. Smathers Library, University of Florida, Gainesville.

12. Hurston, *Folklore, Memoirs*, 804.

13. Valerie Boyd, *Wrapped in Rainbows: The Life of Zora Neale Hurston* (New York: Scribner, 2004), 227.

14. Ann duCille, "The Mark of Zora: Reading between the Lines of Legend and Legacy," in "Jumpin' at the Sun: Reassessing the Life and Work of Zora Neale Hurston," special issue, *The Scholar and Feminist Online* 3, no. 2 (2005): 1–7, http://sfonline.barnard.edu/hurston/ducille_01.htm; Farah Jasmine Griffin, "When Malindy Sings: A Meditation on Black Women's Vocality," in *Uptown Conversation: The New Jazz Studies*, ed. Robert G. O'Meally, Brent Hayes Edwards, and Farah Jasmine Griffin (New York: Columbia University Press, 2004), 104.

15. Marti Slaten, email message to the author, January 31, 2011.

16. Sonnet Retman, *Real Folks: Race and Genre in the Great Depression* (Durham, NC: Duke University Press, 2011), 262–263.

17. The tendency to distance Hurston from blues culture often stems from an infamous and oft-repeated quote from her Florida expedition summary report, which she drafted under the supervision of Franz Boas. In this document, Hurston disdainfully remarks that "the bulk of the popular now spends its leisure in the motion picture theaters or with the phonograph and its blues." Hurston as quoted in Robert Hemenway, *Zora Neale Hurston: A Literary Biography* (Urbana: University of Illinois Press, 1980), 92. But by focusing solely on this line from her scholarship, we fail to consider the countercommercial ways in which she put the blues to use in her research—not just as a marker of Black folk material's evolution in modern culture but as a hermeneutic tool. Retman's new research explores Hurston's undertheorized engagement with blues songwriting, her "ambivalent" relationship to the race records industry, and Hurston's relationship to what Retman refers to as "the New Negro recording imaginary." Retman, "Voice on the Record." Her connection to the blues is pronounced at moments in her archive. See, for instance, her rendition of "Ever Been Down," which she refers to on her recording of the song as a "blues" that she "got" in "Palm Beach from a man named Johnny Barton." The lyrics include the genre's stock carnal blues imagery: "Oh roll me with your stomach / feed me with your tongue / Do it a long time, baby / 'til you make me come." Zora Neale Hurston, "Ever Been Down," Herbert Halpert 1939 Southern States recording expedition, AFS 3138 B1 recording, recorded in Jacksonville, Florida,

June 18, 1939, American Folklife Center, Library of Congress, Washington, DC. See also Zora Neale Hurston, "Po Gal," Herbert Halpert 1939 Southern States recording expedition, AFS 3139 A2 recording, recorded in Jacksonville, Florida, June 18, 1939, American Folklife Center, Library of Congress, Washington, DC.

18. Cheryl Wall, *Women of the Harlem Renaissance* (Bloomington: Indiana University Press, 1995), 166; Zora Neale Hurston, "Characteristics of Negro Expression," in *The Jazz Cadence of American Culture*, ed. Robert O'Meally (New York: Columbia University Press, 1998), 306. Wall continues, observing that, "free of the constraints of ladyhood, the bonds of traditional marriage, and the authority of the church, women improvise new identities for themselves" (166) in the jook.

19. Zora Neale Hurston, "First Version of Folklore," n.d., 2–3, Box 12, Zora Neale Hurston Papers. See also Zora Neale Hurston, "Go Gator and Muddy the Water," in Bordelon, *Go Gator and Muddy the Water*, 71.

20. Blues man iconicity is everywhere in pop culture, from the 1960s blues revival led by critics who rediscovered Robert Johnson's groundbreaking recordings to the twenty-first-century rock and roll parody of indie rock tricksters Tenacious D. See Marybeth Hamilton, *In Search of the Blues* (New York: Basic Books, 2009); Elijah Wald, *Escaping the Delta: Robert Johnson and the Invention of the Blues* (New York: Amistad, 2004); and Liam Lynch, dir., *Tenacious D in the Pick of Destiny* (Burbank, CA: New Line Cinema, 2006). The poststructuralist turn in African American literary and cultural studies scholarship has found recourse in this figure as a sign of fundamental Black vernacular life and culture. See Houston Baker, *Blues, Ideology, and Afro-American Literature: A Vernacular Theory* (Chicago: University of Chicago Press, 1984). See also Albert Murray, *The Hero and the Blues* (New York: Vintage, 1996). For a critique of this wave of criticism, see Jeffrey Ferguson, "A Blue Note on Black American Literary Criticism and the Blues," in "African American Literary Studies: New Texts, New Approaches, New Challenges," ed. Werner Sollors and Glenda Carpio, special issue, *Amerikastudien / American Studies* 55, no. 4 (2010): 699–714.

21. Zora Neale Hurston, "Halimuhfack," Herbert Halpert 1939 Southern State Recording Expedition, AFC 1939 / 005: AFS 03138 B02, recorded in Jacksonville, Florida, June 18, 1939, American Folklife Center, Library of Congress, Washington, DC, https://www.loc.gov /item/flwpa000014/.

22. On contemporary Zora hagiography, see duCille, "Mark of Zora."

23. For the definitive biographical study of Hurston's life, see Boyd, *Wrapped in Rainbows*. See also Robert Hemenway's landmark work on the author, *Zora Neale Hurston: A Literary Biography*. Her former field collaborator Alan Lomax would forecast a reverential obituary published soon after her death in the beloved folk quarterly *Sing Out!* Alan Lomax, "Zora Neale Hurston—a Life of Negro Folklore," *Sing Out!* 10, no. 3 (October–November 1960), 12.

24. The details of Hurston's tragic and solitary financial ruin, illness, and death are well known, as is the tale of Walker's massively influential recuperation of her legacy. See clippings from the Zora Neale Hurston Papers: Howard Sharp, "Seek $ for Zora's Funeral," *Fort Pierce News Tribune*, February 4, 1960; "Zora Neale Hurston, 57, Writer Is Dead," *New York Times*, February 1960; "Author Dies in Obscurity at Ft Pierce," unmarked clipping, Zora Neale Hurston Papers. See also Hemenway, *Zora Neale Hurston*; Boyd, *Wrapped in Rainbows*; and Alice Walker, "Looking for Zora," in *In Search of Our Mother's Gardens: Womanist Prose* (New York: Harcourt Brace Jovanovich, 1983), 93–116. Alan Lomax's *Sing Out!* tribute to

Hurston upon her passing in 1960 sums up both the tragedy of her death and the magnitude of her importance in American culture. "This was the week," begins Lomax, "that three Kingston trio records were among the top twenty albums in the country. This was the umpteenth week of Belafonte's smash run at the Palace on Broadway. This was a peak week in the great American folk song revival. This was also the week that the most skillful and talented field collector and writer that America has thus far produced died in a third-rate hotel in Florida without a penny in her purse or a friend in the world. There is no one to replace Zora Hurston, but her contribution to American life and literature will long outlive the noisy and easily won success of the market-place." Lomax, "Zora Neale Hurston."

25. By far the most well-known and oft-cited Hurston conflict involved novelist Richard Wright. See "Zora Neale Hurston, Richard Wright," in *Call and Response: Key Debates in African American Studies,* ed. Henry Louis Gates Jr. and Jennifer Burton (New York: W. W. Norton, 2005). As discussed later, Hurston's blunt convictions led her to both collaborate with and also aggressively critique fellow folklorists like Alan Lomax at different points in her career. As is often noted, she also benefited from and capitalized on the support of white benefactors, most notably socialite Charlotte Osgood Mason, a well-known Harlem Renaissance booster. See Boyd, *Wrapped in Rainbows.*

26. For more on Hurston's early years and particularly her time with the Gilbert and Sullivan Repertoire Company, see Boyd, *Wrapped in Rainbows,* 69–72.

27. Both highly competitive and prestigious grants were a boon to her in funding her academic research and artistic endeavors. For an example of Hurston's research proposal writing style, see Zora Neale Hurston, "Proposed Recording Expedition into the Floridas," in Bordelon, *Go Gator,* 61–67. For more on the art, intellectual brilliance, and shrewd professional intricacies of Hurston's grant-writing practices, see Vazquez, "Florida Room."

28. New feminist and sound studies scholarship on Hurston's sonic performances and recordings is rapidly emerging. See the rich and provocative work of Vazquez on Zora's Florida roots/routes and experimentation; Roshanak Kheshti, whose forthcoming book examines Hurston's extensive work in sound and film; Sonnet Retman, whose forthcoming book chapter resituates Hurston in the broader context of Harlem Renaissance technological modernities; Myron M. Beasley whose probing and inventive study of "digital Zora" considers the ways in which the "digitized sounds of her voice haunt us, creating more performative spaces of possibility" and "the chance to reimagine her. . . ." (50). See also Adrienne Brown's nuanced reexamination of Hurston's encounters with white women. Vazquez, "Florida Room"; Roshanak Kheshti, "'We See with the Skin': Zora Neale Hurston's Synesthetic Hermeneutics" (unpublished manuscript); Retman, "Voice on the Record." Myron M. Beasley, "Performing Zora: Critical Ethnography, Digital Sound, and Not Forgetting," in *Digital Sound Studies,* ed. Mary Caton Lingold, Darren Mueller, and Whitney Trettien (Durham, NC: Duke University Press, 2018), 49–63. Adrienne Brown, "Hard Romping: Zora Neale Hurston, White Women, and the Right to Play," *Twentieth-Century Literature* 64, no. 3 (2018): 295–316. See also Ellie Armon Azoulay, "Reclaiming the Lore: Critical Readings of Archives and Practices of Collectors of African American Folk Music in the US South, 1900–1950," dissertation in American Studies, University of Kent, 2020, which includes a brilliant chapter on Hurston's practices of collecting and the politics of both "rage" and "care" informing said practices.

29. Zora Neale Hurston to President Thomas E. Jones, October 12, 1934, Folder 225, Box 10, James Weldon Johnson Papers, Beinecke Rare Book and Manuscript Library, Yale University.

30. Zora Neale Hurston, Letter to Professor E. O. Grover, June 8, 1932, Folder 69, Box 2, Zora Neale Hurston Papers.

31. Anthea Kraut, *Choreographing the Folk: The Dance Stagings of Zora Neale Hurston* (Minneapolis: University of Minnesota Press, 2008), 124.

32. At varying points in her career, Hurston oscillated between professing her respect for and gratitude toward Howard University professor and Harlem Renaissance figurehead Locke and directing unbridled vitriol his way. Locke served as the key mediator between Hurston and their shared patron Mrs. Mason, and in the "Concert" section of her autobiography, which was restored in the collection of Hurston's writings edited by Wall, Hurston describes her regret for having not publicly thanked Locke for his support of *The Great Day*. She states, "Right here, let me set something straight. Godmother [Mason] had meant for me to call Dr. Locke to the stage to make any explanations, but she had not told me. . . . It may be too late, but I ask him please to pardon me. He had been helpful and I meant him good." Hurston, *Folklore, Memoirs*, 807; Zora Neale Hurston, *Dust Tracks on a Road* (New York: Amistad, 2006), 283. Yet in a scathing written response to Locke's disparaging review of *Their Eyes Were Watching God*, Hurston declares, "Dr. Locke knows that he knows nothing about Negroes, and he should know, after THE NEW NEGRO, that he knows nothing about either criticism or editing. . . . [He] is abstifically [*sic*] a fraud, both as a leader and a critic. . . . He is a public turn coat." Zora Neale Hurston, "The Chick with One Hen," n.d., James Weldon Johnson Papers, JWJ MSS9, Box 1, Folder 8a, Beinecke Rare Book and Manuscript Library, Yale University. Her professional relationship with celebrated African American composer and arranger Hall Johnson was equally turbulent. Initially Hurston sought out Johnson in a bid to collaborate with him on music for her folk concerts, but the relationship soured when several of Johnson's African American singers clashed with Hurston's Bahamian dancers. See Kraut, *Choreographing the Folk*, 95–98; John Szwed, *Alan Lomax: The Man Who Recorded the World* (New York: Penguin, 2011).

33. Hurston's emphasis as quoted in Boyd, *Wrapped in Rainbows*, 251. During this period, Hurston joined the faculty of North Carolina College in Durham and briefly taught drama at Bethune-Cookman College in Daytona Beach, Florida. She wrote for the poorly reviewed musical revue *Fast and Furious* (in which she also made a cameo appearance as a cheerleader alongside comedienne Jackie "Moms" Mabley). *Fast and Furious* had a brief run in New York City in 1931. That following year, Hurston achieved critical success on the stage with *The Great Day*, and she would continue to organize and present versions of this folk material in concert form and under such titles as *From Sun to Sun* (1933) and *Singing Steel* (1934) in Chicago and Florida. The *From Sun to Sun* program includes a number of songs that she would end up performing on her recording expeditions later in the decade. The program also includes song annotations extrapolated from Hurston's research notes. See *From Sun to Sun* program, February 11, 1933, Folders 2–4, Box 13, Zora Neale Hurston Papers.

34. Zora Neale Hurston, *A Life in Letters*, ed. Carla Kaplan (New York: Doubleday, 2002), 171; Wall, *Women of the Harlem Renaissance*, 178; Zora Neale Hurston, "Bluebird," recorded in Petionville, Haiti, December 21, 1936, AFC 1937/010: AFS 1879A1, Alan Lomax Haiti Collection, American Folklife Center, Library of Congress, Washington, D.C.; Hurston, "Bella Mina," recorded in Chosen, Florida, June 1935, AFC 1935/001: AFS 377B1; Alan Lomax, Zora Neale Hurston, and Mary Elizabeth Barnicle Expedition Collection, American Folklife Center; Zora Neale Hurston, "Bama, Bama," AFC 1937/010: AFS 1879A2, Alan Lomax Haiti Collection. Fellow WPA colleague Stetson Kennedy documents the locations

the group covered in his unpublished notes. Stetson Kennedy, "Alan Lomax / Zora Neal Hurston Field Trip of 1935 . . . As Described by Alan [Lomax] to Stetson Kennedy," Zora Neale Hurston Box 1, Stetson Kennedy Papers, uncataloged, n.d., George A. Smathers Library, University of Florida, Gainesville. The professional and personal connections and tensions between Hurston and the Lomaxes (both Alan and his father, John) are worthy of a study in and of itself (perhaps even a film treatment? Taraji P. Henson and Noah Centenio / Mark Ruffalo, anyone?) and deserve far more attention than I am able to give here. It is worth noting, however, that Hurston's performative ethnography is in some ways akin to John Lomax's penchant for singing the archive of cowboy songs, prison songs, and work songs that he amassed while conducting fieldwork with his son in the early 1930s. As Paige McGinley observes, "John Lomax's theatrical collecting practices and public performances staged a drama of circulation, a drama of singing-as-vehicle which championed mobility and travel through 'the magic of song.'" Paige McGinley, "'The Magic of Song!': John Lomax, Huddie Ledbetter and the Staging of Circulation," in *Performance in the Borderlands,* ed. Ramon H. Rivera-Servera and Harvey Young, (New York: Palgrave, 2010), 129. See also McGinley, *Staging the Blues: From Tent Shows to Tourism* (Durham, NC: Duke University Press, 2014), 81–128. But, as we shall see later, Hurston's theoretical and material emphasis on and cultural identifications with the theatrical dimensions of Black culture would have placed her at odds with the elder, racially condescending Lomax, whose "own performing body," as McGinley contends, "became the site, sight, and sound of spatial—and racial—*difference,* privileged as one that could move with ease between both worlds—the men of letters and the men of the land." McGinley, "'Magic of Song!,'" 137, emphasis added. The Hurston letter to Lomax discovered by Carla Cappetti reveals the extent to which Hurston's unbridled contempt for father Lomax and even more so for son Alan was deep-seated and palpable. Here she fiercely "reads" the latter, brutally dissecting his character and dressing him down for having, in her opinion, spread rumors about the two of them, for exploiting her fieldwork labor, and reneging on promises to share research materials that she had requested. Hurston rails, "You knew no more about folk-lore than a hog knows about a holiday, you were content to have me do it for you, but contrive to have it appear I didn't deserve credit." She also notoriously butted heads with Barnicle, whom she refers to here as "looking like a mammy walrus with a sunburned nose." See Carla Cappetti, "Defending Hurston against Her Legend: Two Unpublished Letters," in "African American Literary Studies: New Texts, New Approaches, New Challenges," ed. Werner Sollors and Glenda Carpio, special issue, *Amerikastudien/American Studies* 55, no. 4 (2010): 602–614. In a recorded interview from 1977, a frail Barnicle claims that Hurston "thought that she was the queen of the world." Mary Elizabeth Barnicle and Tillman Cadle, interview by Gene Moore, January 1977, recorded interview AFS 19536 (LWO 12983; reel 1), American Folklife Center, Library of Congress, Washington, DC. My thanks to Werner Sollors and Glenda Carpio for inviting me to think with them about Zora's sound archive.

35. Alan Lomax as quoted in Stetson Kennedy, unpublished manuscript, n.d., 63, Zora Neale Hurston Box 1, Stetson Kennedy Papers, uncataloged. Kennedy also maintains here that Lomax "swears that he darkened his face and hands at Zora's direction to avoid attracting attention in the segregated environs" (63).

36. Theodor W. Adorno, "The Form of the Phonograph Record," in *Essays on Music,* ed. Richard Leppert (Berkeley: University of California Press, 2002), 280.

37. As already suggested, the closest comparison to Hurston's methods would be that of the senior Lomax. John Lomax hired Huddie William Ledbetter (Leadbelly) upon his release from prison to serve as his chauffeur, eventually arranging for Ledbetter to assist him

with folk song collecting as well as the performance of this material. As McGinley reveals, the work relationship was rife with abusive Jim Crow power dynamics. McGinley, *Staging the Blues*, 81–128; Szwed, *Alan Lomax*. See too Retman's exploration of Hurston's use of "one technology of recording—writing—to put another—mass-produced music—into order." She argues that Hurston and other folklorists also used writing "to seize control over popular music's messy implications by offering racial categorizations of the genuine and the artificial, the folk and the commercial, an alignment of racialized bodies with racialized sounds and regions." Retman, "Voice on Record," 14.

38. See Langston Hughes, Charles Mingus, and Leonard Feather, *The Weary Blues with Langston Hughes, Charles Mingus, and Leonard Feather* (MGM, 1958). See also Hughes' narrative history of Black music which includes documentary recordings of diasporic sounds. Langston Hughes, *The Story of Jazz*, Folkway Records, 1954.For more on Hughes's poetry performances, see Meta Jones, *The Muse Is Music: Jazz Poetry from the Harlem Renaissance to Spoken Word* (Urbana: University of Illinois Press, 2013), 33–84. See also Josh Kun, *Audiotopia: Music, Race, and America* (Berkeley: University of California Press, 2005), 143–183.

39. Hurston was determined to convey these sounds to audiences who were open to their beauty and wonder. One, for instance, hears her immersive orchestrations as a conductor and not just a collector of this music in a May 1938 appearance at the National Folklore Festival in Washington, DC, at which Hurston led a college choir through six songs that would later end up on her field recordings. See various recordings from the National Folk Festival in Washington, DC, May 6, 1938. The choir was sponsored by the Rollins College Folklore Group of Winter Park, Florida. AFS 9845 A1: "Can't You Line It," AFS 9845 A2: "Mule on the Mount," AFS 9845 A3: "Dat Old Black Gal," AFS 9845 A4: "Oh Lula, Oh Gal," AFS 9845 A5: "Somebody's Knockin' at My Door," AFS 9845 A6: unidentified song, National Folk Festival recordings, American Folklife Center, Library of Congress, Washington, DC.

40. Hemenway, *Zora Neale Hurston*, 105.

41. Hurston, "Spirituals and Neo-spirituals," 224.

42. Hurston, 224.

43. Zora Neale Hurston, "Evalina," Herbert Halpert 1939 Southern States Recording Expedition, AFC 1939/005: AFS 03144 B04, American Folklife Center, Library of Congress, Washington, DC, https://www.loc.gov/item/flwpa000044/.

44. William T. Dargan, *Lining Out the Word: Dr. Watts Hymn Singing in the Music of Black Americans* (Berkeley: University of California Press, 2006), 11, 15, emphasis in the original.

45. Azalia Hackley, Maud Cuney Hare, and Nora Holt would precede Hurston in the field of Black music scholarship. See Juanita Karpf, "The Early Years of African American Music Periodicals, 1886–1922," *International Review of the Aesthetics and Sociology of Music* 28, no. 2 (1997): 143–168; Karpf, "Get the Pageant Habit: E. Azalia Hackley's Festivals and Pageants during the First World War Years, 1914–1918," *Popular Music and Society* 34, no. 5 (2011): 517–556; and Lucy Caplan, "Strange Cosmopolite: Classical Music, the Black Press, and Nora Douglas Holt's Black Feminist Audiotopia," *Journal of the Society of American Music* 14, no. 3 (August 2020): 308–336.

46. Alexandra T. Vazquez, *Listening in Detail: Performances of Cuban Music* (Durham, NC: Duke University Press, 2013); Hurston, "Characteristics of Negro Expression," 299, 301.

47. Hurston, "Characteristics of Negro Expression," 298; Zora Neale Hurston letter to E. O. Grover, June 15, 1932, Folder 68, Box 2, Zora Neale Hurston Papers.

48. Hurston, "Characteristics of Negro Expression," 302.

49. Hurston, 306.

50. Dean L. Biron, "Writing *and* Music: Album Liner Notes," *Journal of Multidisciplinary International Studies* 8, no. 1 (2011): 4–5. Colin Symes argues that "cover notes help to frame and focus the conduct of the listener, both while handling and playing records and when listening to them." Colin Symes, *Setting the Record Straight: A Material History of Classical Recording* (Middletown, CT: Wesleyan University Press, 2004), 150.

51. Szwed, *Alan Lomax,* 78.

52. Szwed, 78.

53. Szwed, 80; Boyd, *Wrapped in Rainbows,* 69. Alan Lomax to Oliver Strunk, August 3, 1935, AFC 1935 / 001 File Alan Lomax, Zora Neale Hurston and Mary Elizabeth Barnicle— Folder 2: Correspondence, American Folklife Center, Library of Congress, Washington, DC. Boyd describes how, "sometime between 1914 or 1915 she endures an ordeal in a mysterious 'shotgun house' which she eventually fled" to join the troupe. After "about a year and a half with the company," she moved to Baltimore and returned to school, eventually graduating from Morgan State, after which she decided to pursue undergraduate study at Howard University. She graduated from Barnard in 1927 and began doctoral work at Columbia in 1934. Boyd, *Wrapped in Rainbows,* 70–75.

54. Robert Christgau, "Writing about Music Is Writing First," *Popular Music* 24, no. 3 (October 2005): 421. And "if we get lucky," adds Christgau, "maybe even give them a shot of abracadabra" (421).

55. Christgau, 417.

56. Hurston, "Spirituals and Neo-spirituals," 224. Hurston, *Dust Tracks on a Road,* 148. Hurston's essentializing romanticization of Black sound politics is no joke and no secret either. In addition to her essays, she toed the line on this topic in private correspondence throughout her life. Two years before she died, Hurston noted in a 1958 letter to Mitchell Ferguson that she "find[s] Negroes predominantly aural-minded. I conceived the notion that based on that, some means could be devised for teaching Negro children faster." Zora Neale Hurston letter to Mitchell Ferguson, March 7, 1958, Box 1, Folder 15, Zora Neale Hurston Papers.

57. Hurston, *Dust Tracks on a Road,* 143, 148. See Zora Neale Hurston, *Sweat,* ed. Cheryl Wall (New Brunswick, NJ: Rutgers University Press, 1997).

58. Brent Edwards, "The Seemingly Eclipsed Window of Form: James Weldon Johnson's Prefaces," in O'Meally, *Jazz Cadence of American Culture,* 593.

59. Edwards, "Seemingly Eclipsed Window," 595–596; Hurston, "Spirituals and Neo-spirituals," 224.

60. Hurston, *Dust Tracks on a Road,* 149. Independent Black studies scholar Azizi Powell observes that "rhythm was necessary both to synchronize the manual labor, and to maintain the morale of workers" Azizi Powell, "Early Versions of 'Can't You Line 'Em' ('Linin Track')," *Pancocojams* (blog), October 22, 2012, http://pancocojams.blogspot.com/2012/10/early-versions-of-cant-you-line-em.html.

61. Kevin Young, *The Grey Album: On the Blackness of Blackness* (New York: Graywolf, 2012), 11–20. See also Shane Vogel, "The Sensuous Harlem Renaissance: Sexuality and Queer Culture," in *A Companion to the Harlem Renaissance,* ed. Cherene Sherrard-Johnson (New York: Wiley-Blackwell, 2015), 267–284.

62. Tom Piazza, *Setting the Tempo: Fifty Years of Great Jazz Liner Notes* (New York: Anchor Books, 1996), 2. Pamela Bordelon argues that Hurston's recording expedition proposal, produced "without the strict confines of guidebook writing," additionally showcases her in-

terest in "draw[ing] more subjectively on her background as an anthropologist and folklorist and her creativity as a writer." Pamela Bordelon, "Zora Neale Hurston: A Biographical Essay," in Bordelon, *Go Gator,* 30.

63. Boyd, *Wrapped in Rainbows,* 324.

64. Library of Congress to Zora Neale Hurston and Hurston response, August 9, 1945, Zora Neale Hurston Correspondence Folder, American Folklife Center, Library of Congress, Washington, DC.

65. Boyd, *Wrapped in Rainbows,* 313; Kennedy as quoted in Boyd, 318. Says Kennedy, "She had already published her first two books by that time, but she wanted a job and was given the same job title that I had when I started out. I was junior interviewer. Imagine Zora Hurston, junior interviewer. She had already had her degrees from Boaz (*sic*) and Columbia and Barnard and so on." "The Sounds of 1930s Florida Folklife," *All Things Considered,* February 28, 2002, NPR Hearing Voices, http://hearingvoices.com/transcript.php?fID=23. In his unpublished manuscript on Hurston's career and his time working with her on what became known as the "Negro Unit" of the FWP, Kennedy notes that Hurston was given the title of "Junior Interviewer" and paid "$67.20 per month" for her work with the WPA. "Ironically," Kennedy adds, "the typist at the Negro Unit" in Jacksonville "was paid $5.00 per month more than Zora, by virtue of a higher urban wage scale." Stetson Kennedy, unpublished manuscript, 62, Zora Neale Hurston Box 1, Stetson Kennedy Papers, uncataloged at the time of archival research. However, Stetson remains a tricky figure when it comes to his own treatment of Hurston's legacy. He was a fierce champion of her legendary status, a jealous protector of his own archival materials related to their shared work for the WPA, and also a spectacularly harsh critic of Hurston's contradictory persona. See, for instance, his searing list of "SAD-BUT-TRUE ASPECTS of Zora" which includes a range of inflammatory monikers including "THE SELF-STYLED 'PET DARKEY' . . . NO RACE CHAMPION . . . THE LICKER OF THE WHIP HAND, THE 'HOUSE NIGGER' . . . THE RACISTS' DARLING," "THE ARCH REACTIONARY," and "THE 24-KARAT BITCH." The latter insult Kennedy attributes to Alan Lomax, quoting him as having said that in "the field, Zora was absolutely magnificent—but of course you know she was a 24-karat bitch. . . ." Kennedy, "SAD-BUT-TRUE ASPECTS OF ZORA," September 5, 2000, Zora Neale Hurston Box 1, Stetson Kennedy Papers, uncataloged at the time of archival research. Kennedy wrote obsessively about Hurston in a range of published material and unpublished material that recycled and occasionally reworked versions of the aforementioned list of traits he logged. See, for instance, Kennedy, "ALMOST ALL I KNOW ABOUT ZORA," unpublished manuscript, September 5, 2000, Zora Neale Hurston Box 1, Stetson Kennedy Papers, uncataloged at the time of archival research. Kennedy, untitled ("I am the one who wrote, in my Tribute to Zora . . ."), unpublished manuscript, September 8, 2000, Zora Neale Hurston Box 1, Stetson Kennedy Papers, uncataloged at the time of archival research.

66. Boyd, *Wrapped in Rainbows,* 322; Stetson Kennedy, unpublished manuscript, 6, Zora Neale Hurston Box 1, Stetson Kennedy Papers, uncataloged at the time of archival research.

67. Zora Neale Hurston to Carita Dogget Corse, December 3, 1938, in *Life in Letters* (New York: Anchor, 2003), 417–418.

68. "Sounds of 1930s Florida Folklife." Kennedy traces the recorder back to "the Hurston / Lomax / Barnicle team," pointing out that the team "borrowed the recorder of the Library of Congress" because of Lomax's father's ties to that institution. "In those pre-tape days," he muses, recorders "consisted of a heavy monstrosity. . . ." After joining the FWP, "Zora was able to again wangle it on loan from the Library of Congress" Stetson Kennedy,

unpublished manuscript, 62–63, Zora Neale Hurston Box 1, Stetson Kennedy Papers, uncataloged at the time of archival research. Bordelon further points out that Halpert would arrive in Jacksonville "with the equipment carefully stored in a converted World War I ambulance outfitted by workers from the Federal Theater Project. . . . He was one of the few folklorists with field recording experience. He knew how to transport, repair, and set up the cumbersome equipment as well as how to conduct the first-person interviews, an integral part of the recording sessions." Bordelon, "Zora Neale Hurston," 45; Boyd, *Wrapped in Rainbows,* 324.

69. Boyd, *Wrapped in Rainbows,* 325; Bordelon, "Mule on the Mount" transcription, 163–164; Herbert Halpert, "Tentative Record Check List: SOUTHERN RECORDING EXPEDITION," March 12– June 30, 1939, Herbert Halpert 1939 Southern States Recording Expedition (AFC 1939/005), Archive of Folk Culture, American Folklife Center, Library of Congress, Washington, DC. Kennedy maintains that it was his "bright idea" to "sav[e] travel money," "summo[n]" Hurston to Jacksonville, "si[t] her down in a chair, and recor[d] all the folkstuff she carried around in her head," and he looked to Halpert, who was "using the machine at the time," to "collaborate in interviewing" her. Stetson Kennedy, unpublished manuscript, 64, Zora Neale Hurston Box 1, Stetson Kennedy Papers, uncataloged at the time of archival research.

70. Kennedy's version of this recording expedition occasionally frames Hurston as the object of ethnographic inquiry rather than as a fellow collaborator ("I had gotten into the habit of asking my informants if they knew any 'dirty songs.' As it turned out, they knew plenty. . . . I asked Zora if she knew a song called 'Uncle Bud.'"). Stetson Kennedy, unpublished manuscript, 64, Zora Neale Hurston Box 1, Stetson Kennedy Papers, uncataloged at the time of archival research. The Library of Congress website lists both Halpert and Kennedy as "speakers" along with Hurston on various recordings from these sessions. Elsewhere Kennedy elaborates on the team's working conditions, describing how, "in recent years when asked to speak on the subject 'Working with Zora' . . . I have been tempted to suggest that the title 'Trying to Get Zora to Work' would be more appropriate. Like many of us who were on our own out in the field (again myself included), production was sporadic." Stetson Kennedy, "Zora's Contributions," n.d., unpublished manuscript, n.p., Zora Neale Hurston Box 1, Stetson Kennedy Papers, uncataloged. Kennedy was one of Hurston's greatest defenders and also one of the most consistent critics of her well-known ambivalences when it came to racial uplift politics, her "accomodationist-if-not apologist" leanings, as he puts it. But repeatedly in his manuscript, he argues that "we and generations yet to come should focus upon how Zora Neale Hurston wrote, not how she voted." Stetson Kennedy, unpublished manuscript, 68, Zora Neale Hurston Box 1, Stetson Kennedy Papers, uncataloged. See also Kennedy, "SAD-BUT-TRUE ASPECTS OF ZORA," unpublished manuscript, September 5, 2000, Zora Neale Hurston Box 1, Stetson Kennedy Papers, uncataloged at the time of archival research. For more on Hurston's political leanings, see Boyd, *Wrapped in Rainbows.*

71. Zora Neale Hurston, "Mule on the Mount," Herbert Halpert 1939 Southern States Recording Expedition, AFC 1939/005: AFS 03136 B01, American Folklife Center, Library of Congress, Washington, DC, https://www.loc.gov/item/flwpa000008/.

72. Bordelon transcription of "Mule on the Mount," Bordelon, *Go Gator,* 163–164; Hurston, "Mule on the Mount."

73. Blind Lemon Jefferson's 1926 "Wartime Blues" makes use of the blues form's "floating verses," oft-repeated verses in Black radical tradition lore, and ones that reference familiar images, for instance, "trains" and "rivers" and tropes evocative of African American rural and migratory life. Such visions and figures and themes "float" from one song to another and can sometimes take shape as jarring abstractions, as thematic non-

sequitar. But in every case, they are manifestations of both a dispersed and disrupted culture and the innovative contemplation of and rejoinder to quotidian and ubiquitous crisis. Blind Lemon Jefferson, "Wartime Blues," Release # 12425A, Matrix # 3070, Take #1, *The Rise & Fall of Paramount Records, Vol. 1 (1917–1932)* (Third Man Records-Revenant Records, 2013). For more on blues aesthetic traditions, see also Scott Blackwood's monumental work on the archive of Paramount recordings. Scott Blackwood, *The Red Book* liner notes for *The Rise & Fall of Paramount Records, Vol. 1 (1917–1932)*; and Chapter 7.

74. Hurston, "Mule on the Mount."

75. Hurston, "Characteristics of Negro Expression," 307; Hurston, *Dust Tracks on a Road,* 67.

76. Retman, *Real Folks,* 152–190.

77. Katherine McKittrick, *Demonic Grounds: Black Women and the Cartographies of Struggle* (Minneapolis: University of Minnesota Press, 2006), xii. McKittrick is talking here about the slave ship, clearly a very different kind of "moving technology" from that of the car. But I reference her trenchant observations in this context as they are helpful in destabilizing and complicating the "'where' of Black geographies and Black subjectivity" (xi).

78. David Taylor, *Soul of a People: The WPA Writers' Project Uncovers Depression America* (Hoboken, NJ: John Wiley and Sons, 2009), 16–17. Pamela Bordelon notes that Hurston's tales appeared anonymously in the FWP's automotive guide to Florida. Pamela Bordelon, foreword to Bordelon, *Go Gator,* xii. She notes that for the automotive guide, Hurston "dipped into her files and drew material from her concentrated collecting expeditions throughout the South during the 1927–31 period. Her folklore vignettes targeted Florida topics such as the all-night roar of alligators and how the land turtle got its name. Some of this material derived from her childhood." Bordelon, "Zora Neale Hurston," 26.

79. Space here does not allow for me to linger on some of the parallels to be drawn between white rock and roll's obsession with the "Not Fade Away" trope first popularized by Buddy Holly (in his much-covered 1957 B-side of the same name) and the anxiety regarding Black folk precarity which fueled the work of some Harlem Renaissance thinkers such as Hurston as well as novelist Jean Toomer. But they are worth pointing out here. Toomer's 1923 classic *Cane* famously opens with a freak out-fade out moment of sorts with luminous verse announcing that "Her skin is like dusk on the eastern horizon, O cant you see it. O can't you see it. . . ." Jean Toomer, *Cane, A Norton Critical Edition,* ed. Rudolph P. Byrd and Henry Louis Gates, Jr. (New York: Norton, 2011, 5). Toomer famously set out in this text to forecast what he saw to be the beginning of the end of Black southern vernacular life. For more on Toomer, see Byrd and Gates, "'Song of the Son': The Emergence and Passing of Jean Toomer," *Cane, A Norton Critical Edition,* xix–lxv.

80. Zora Neale Hurston, "Bluebird" (1936), "Bella Mina" (1935), "Bama, Bama" (1936) AFS 1879 A1, A2, A3, American Folklife Center, Library of Congress, Washington, DC. For more on the conflicts between Hurston, Lomax, and Barnicle, see Cappetti, "Defending Hurston"; Mary Elizabeth Barnicle and Tillman Cadle, interview by Gene Moore, January 1977, recorded interview AFS 19536 (LWO 12983; reel 1), American Folklife Center, Library of Congress, Washington, DC; Retman, *Real Folks,* 154, 155.

81. Jonathan Sterne, *The Audible Past: Cultural Origins of Sound Reproduction* (Durham, NC: Duke University Press, 2003), 27.

82. Retman, *Real Folks,* 173, 174–175; Nora Neale Hurston, *Mules and Men* (New York: Harper and Row Perennial Library, 1990), 17; Retman, *Real Folks,* 179.

83. Adrienne Brown, "Drive Slow: Rehearing Hip Hop Automotivity," *Journal of Popular Music Studies* 24, no. 3 (2012): 267. Brown calls for ways to reread "the value of the hip hop

car" in total as not all about "chromes and rims" and more about "its ability to galvanize types of looking, seeing, and being related to collective forms of ownership." Brown, 267.

84. Hurston, *Dust Tracks on a Road* (New York: Harper Perennial, 1996, 146; Carla Kaplan, "'De Talkin Game': The Twenties (and Before)," in *Zora Neale Hurston: A Life in Letters* New York: Anchor Books, 2002), 51–52. With regards to the opacity of *Dust Tracks*, Maya Angelou's 1995 foreword to the book is instructive. Angelou famously observes of *Dust Tracks* that "the author stands between the content and the reader. It is difficult, if not impossible, to find and touch the real Zora Neale Hurston" (xii).

85. Hurston, *Dust Tracks on a Road*, 67. See also Boyd, *Wrapped in Rainbows*, 57. Fellow FWP recording expedition team member Kennedy recalls Hurston's time in the field with him "record[ing] more of the songs of migratory black workers in the Everglades mucklands." Stetson Kennedy, unpublished manuscript, 63, Zora Neale Hurston Box 1, Stetson Kennedy Papers, uncataloged at the time of archival research.

86. Marti Slaten, Email message to the author, Jan. 13, 2011. Josh Kun would most certainly identify the "audiotopian" sites of cultural memory, communal questing, and questioning in Hurston's sounds. Kun, *Audiotopia*. Concerning this noted Blackness and suffering trend, redolent in the work of some of her most prominent 1930s contemporaries like George Gershwin and Richard Wright, she lamented in a 1936 letter that "some writers are playing to the gallery. That is, certain notions have gotten in circulation about conditions in the south and so writers take this formula and workout so-called true stories." Zora Neale Hurston to Stanley Hoole, March 7, 1936, Folder 60, Box 2, Zora Neale Hurston Papers.

87. Zora Neale Hurston, "Halimuhfack," Herbert Halpert 1939 Southern State Recording Expedition, AFC 1939/005: AFS 03138 B02, recorded in Jacksonville, Florida, June 18, 1939, American Folklife Center, Library of Congress, Washington, DC, https://www.loc.gov /item/flwpa000014/.

88. Hurston, "Characteristics of Negro Expression," 306–309.

89. McKittrick, *Demonic Grounds*, xiii. McKittrick calls these kinds of "clandestine geographic-knowledge practices" the "spaces of black liberation" that were "invisibly mapped across the United States and Canada and that this invisibility is, in fact, a real and meaningful geography. . . . the unmapped knowledges" (18). These "black geographies," she argues, "are deep spaces and poetic landscapes, which not only gesture to the difficulties of existing geographies and analyses, but also reveal the kinds of tools that are frequently useful to black social critics" (21–22).

90. Zora Neale Hurston, "First Version of Folklore," n.d., manuscript, Box 12, Zora Neale Hurston Papers. Pamela Bordelon includes "the third and final draft of the folklore and music chapter for The Florida Negro" in her collection of Hurston's transcribed FWP writings, but she spells the title as "Halimufask." The song title in Hurston's "first version" is "Halimuhfack." See Zora Neale Hurston, "Go Gator and Muddy the Water," in Bordelon, *Go Gator*, 72. The Stetson Kennedy Papers include a Zora Neale Hurston "set list" of sorts with "Halimuhfack" listed as "Halimuhfact," as well as the handwritten additional lyric, "My slow drag will bring you back!" Black theater scholar Eric Glover notes that "Halimuhfack" appears in Hurston's script for *Polk County* as well. See Eric Glover, "By and About: An Antiracist History of the Musicals and Anti-musicals of Langston Hughes and Zora Neale Hurston" (PhD diss., Princeton University, 2017).

91. Bordelon points out that one of the "Negro mythical places" included in her automotive guide excerpt, "'Diddy-Wah-Diddy' . . . [is] a magical destination where neither man

nor beast had to worry about work or food. Both were magically supplied. They often laughed and dreamed of far-off 'Heaven,' pinning human qualities on its celestial inhabitants." Bordelon, "Zora Neale Hurston," 26. See also Christopher D. Felker, "'Adaptation of Source': Ethnocentricity and 'The Florida Negro,'" in *Zora in Florida,* ed. Steve Glassman and Kathryn Lee Seidel (Orlando: University of Central Florida Press, 1991), 149.

92. Bordelon, "Zora Neale Hurston," 17.

93. McKittrick, *Demonic Grounds,* xxvi–xxvii.

94. McKittrick, 5.

95. Stetson Kennedy, "Z Is for Zora," n.d., unpublished manuscript, n.p., Zora Neale Hurston Box 1, Stetson Kennedy Papers.

96. Zora Neale Hurston, "Shove It Over," Herbert Halpert 1939 Southern State Recording Expedition, AFC 1939/005: AFS 03136 A01, American Folklife Center, Library of Congress, Washington, DC, https://www.loc.gov/item/flwpa000006/. See also Bordelon, transcription of "Shove It Over," in Bordelon, *Go Gator,* 161–162. Bordelon notes that the song was sung "by workers as they double-tracked Henry Flagler's Florida East Coast Railway." Pamela Bordelon, "The Jacksonville Recordings," in Bordelon, *Go Gator,* 157. The interlocutor is fellow WPA researcher Herbert Halpert.

97. Dargan, *Lining Out the Word,* 1. Dargan explains that "'Dr. Watts' connotes the particular call-and-response form and style wherein a hymn text is read or chanted by a worship leader and then sung by the conversation" (26). The name refers to "Dissenting English theologian Isaac Watts and others, including Charles Wesley, brother of the founder of Methodism" (1).

98. Hurston, "Shove It Over"; Zora Neale Hurston, "Let's Shake It," Herbert Halpert 1939 Southern State Recording Expedition, AFC 1939/005: AFS 03135 B01, American Folklife Center, Library of Congress, Washington, DC, https://www.loc.gov/item/flwpa000004/. See also the children's educational resource, "Zora Neale Hurston and the Railroad Track Lining Chants," Florida Memory Division of Library and Information Services, accessed July 15, 2020, https://www.floridamemory.com/learn/classroom/learning-units/railroads /lessonplans/4thgrade/hurston/.

99. Powell, "Early Versions." See also Barry Dornfeld and Maggie Holtzberg-Call, dirs., *Gandy Dancers* (Cinema Guild, 1994), http://www.folkstreams.net/film,101. Adds Archie Green, "The building of any roadbed section involved myriad skills: timber falling, brushing, blasting, grading, tie and steel unloading, track laying and lining, spike driving, tie tamping. Each detailed function called for a characteristic rhythm that drew to itself hundreds of floating lyrics." Archie Green, preface to *Railroad Songs and Ballads: From the Archive of Folk Song,* ed. Archie Green (Washington, DC: Library of Congress, 1968), 4. For Hurston's detailed description of lining rhythms, see Zora Neale Hurston, "Description of Lining Track," recorded in Jacksonville, Florida, June 18, 1939, https://www.loc.gov/item /flwpa000004/. See also Zora Neale Hurston, "Can't You Line It," AFC 1950/017: AFS 9845A1, sung by a choir led by Hurston, recorded May 6, 1938, American Folklife Center, Library of Congress. Hurston performs the spiking rhythm "Dat Old Black Gal" with additional percussive sound during the June 18 session as well. See Zora Neale Hurston, "Dat Old Black Gal," recorded in Jacksonville, Florida, June 18, 1939, https://www.loc.gov/item /flwpa000005/. For an example of a classic lining rhythm, see the TCI Section Crew, "Track Linin," *The Rise and Fall of Paramount Records,* Third Man Records and Revenant Records, 2013.

100. Hurston, "Let's Shake It." Bordelon lists this song as "Ah, Mobile." Several of the songs that Hurston recorded—including "Let's Shake It" and "Evalina"—would make their way into her 1942 memoir, *Dust Tracks on a Road*. Hurston, *Dust Tracks on a Road,* 148; Bordelon, transcription of "Ah Mobile," 160–161.

101. Zora Neale Hurston, "Uncle Bud," Herbert Halpert 1939 Southern State Recording Expedition, AFC 1939/005: AFS 03138 A01, American Folklife Center, Library of Congress, Washington, DC, https://www.loc.gov/item/flwpa000012/. The lyrics for "Uncle Bud" warn that if he "can't get a woman goin'," he's "goin' use his fists." Much of the song resembles the vernacular toasts genre, which often catalogs the adventures of an epic figure. Hurston sings of how Uncle Bud's got "nuts hang down like a jersey bull" and "girls . . . long and tall." She calls "Uncle Bud" "not a work song" but "a social song." Bordelon, transcription of "Uncle Bud," 167–168. Hurston, "Uncle Bud."

102. Green, preface, 1; Bordelon, "The Jacksonville Recordings," 158.

103. Toni Morrison, *Beloved* (New York: Vintage, 2004), 128. Other lines move the song more squarely onto folkloric terrain by referencing anthropomorphic animals, including a "rooster [who] chew tobacco" and a "hare [who] dip snuff." Hurston, "Shove It Over."

104. Shane White and Graham White, *The Sounds of Slavery: Discovering African American History through Songs, Sermons, and Speech* (Boston: Beacon, 2005). See also Sam Floyd, *The Power of Black Music: Interpreting Its History from Africa to the United States* (New York: Oxford University Press, 1996); Robert Farris Thompson, *Flash of the Spirit: African and Afro-American Art and Philosophy* (New York: Vintage, 1984); Lindon Barrett, *Blackness and Value: Seeing Double* (New York: Cambridge University Press, 1998); and Fred Moten, *In the Break: The Aesthetics of the Black Radical Tradition* (Minneapolis: University of Minnesota Press, 2003).

105. Boyd, *Wrapped in Rainbows,* 326. Bordelon notes that by 1939, conservatives "had finally voted down federal sponsorship of the projects and cut back on the WPA relief rolls by implementing the 'eighteen-month rule,' which terminated any WPA worker who had been on relief for more than eighteen months, as Zora Neale Hurston was about to be." Bordelon, "Zora Neale Hurston," 46. Peter Szendy, *Listen: A History of Our Ears* (New York: Fordham University Press, 2007), 6; Sterne, *Audible Past,* 221. What Sterne is addressing here is the narrow readings of Walter Benjamin's landmark essay, "The Work of Art in the Age of Mechanical Reproduction," that don't allow for a more nuanced interpretation of his theory of "aura" so as to reckon with the ways that aura is "the object of nostalgia that accompanies reproduction." He adds that, "[i]n fact, reproduction does not really separate copies from originals but instead results in the creation of a distinct form of originality" (220). On the politics and poetics and intricacies of black instrumentality, see Fred Moten, "On Escape Velocity: The Informal and the Exhausted (with Conditional Branching)," n.d. (unpublished paper).

106. Alexander G. Weheliye, *Phonographies: Grooves in Sonic Afro-Modernity* (Durham, NC: Duke University Press, 2005), 38. Weheliye considers the ways that past critics have often "abandon[ed] the *phone* or the *graph* in *phonograph*" rather than "taking into account how sound suffuses New World black writing" (39). I am suggesting that we explore the ways that Hurston's use of sound in relation to her discursive ethnography demands that we theorize other forms of phonography, ones in which, for instance, embodied sonic performances directly engage with and complicate written texts. Likewise, we might think more about the ways that Zora's angular vocal techniques interrupts the phonographic projects of the literary "race men" (Du Bois and Ellison) who sit at the forefront of Weheliye's cogent

study. See also Weheliye's continuing generative conversation about gender in Alexander We-heliye, "Engendering Phonographies: Sonic Technologies of Blackness," *Small Axe* 18, no. 2 (44) (July 2014): 180–190.

107. Matthew Frye Jacobson, "Take This Hammer: Odetta, Coffeehouse Publics, and the Tributaries of the Left, 1953–1962" 2010 (unpublished paper). See also Matthew Frye Ja-cobson, *Odetta's "One Grain of Sand"* (New York: Bloomsbury, 2019). I'm grateful to Matt Jacobson for his endless conversations about musicians as archivists and Odetta's work as what he refers to as "a public historian."

108. Cheryl A. Wall, *Women of the Harlem Renaissance* (Indianapolis: Indiana University Press, 1995), 166.

109. Though the last of these songs, "Uncle Bud," traffics in masculinist profanity, Hur-ston also confesses in laughter during her recording of the song that "I learned it from women." Hurston, "Uncle Bud."

110. Wall, *Women of the Harlem Renaissance,* 166. For more of Hurston's sound archive, see Zora Neale Hurston Recordings, Manuscripts, Photographs, and Ephemera, The American Folklife Center, The Library of Congress, https://www.loc.gov/folklife/guides/Hurston .html.

3. Blues Feminist Lingua Franca

1. The *New York Times* notes that *Menopause* is "considered one of the first books to look at menopause from the viewpoint of women and not doctors." Among the many odd jobs that Reitz held, she worked as "a classified-advertising manager" at the *Village Voice* and owned a "greeting card business." She "negotiated a loan to buy her own bookstore, the 4 Seasons in Greenwich Village." Other profiles list her as having "worked as a Wall Street stockbroker" and a "secretary." Reitz published her *Voice* article in 1971 entitled "The Liberation of the Yiddishe Mama." She was a member of the New York Radical Feminists and Older Women's Liberation group. Her first book, *Mushroom Cookery,* was published in 1965. Douglas Martin, "Rosetta Reitz, Champion of Jazz Women, Dies at 84," *New York Times,* November 14, 2008. See also clipping, Box 6, Record Reviews Folder, Rosetta Reitz Papers, David M. Rubenstein Rare Book and Manuscript Library, Duke University (hereafter referred to as RRP). Reitz notes that Saul Bellow and Richard Wright were regulars at the Four Seasons Bookshop. She also threw a party at the store for Ellison's *Invisible Man.* See Rosetta Reitz, Untitled auto-biographical profile, n.d., "(Auto)biography" Folder 1, RRP; Rosie Reitz, *Menopause: A Posi-tive Approach* (New York: Penguin, 1979); and Rosie Reitz, *Mushroom Cookery* (New York: Gramercy, 1945).

2. Jill Nelson, "*Mean Mothers:* Unearthing Our Musical Heritage," *New Women's Times,* May 9–22, 1980, Box 6, Record Reviews Folder, RRP; John S. Wilson, "'Blues Is a Woman' Tonight Explores Other Side of the Blues," *New York Times,* July 1, 1980.

3. Cheryl Keyes, "Sound Recordings Reviews: Women's Heritage Series: Rosetta Records," *Journal of American Folklore* 105, no. 415 (Winter 1992): 73. The correspondence with Gee's attorney apparently stemmed from Reitz's having sold postcards of Bessie Smith via the record label without the permission of Gee, the heir to his father's estate and by default the heir to the Bessie Smith estate. Reitz's lengthy letter to Gee's lawyer Martin Bressler is a study in brilliant diplomacy and shrewd business acumen as she moves carefully to protect

herself from a lawsuit and to, likewise, advance the legacy of Smith. See Rosetta Reitz to Martin Bressler, February 27, 1986, Record Reviews Folder, Box 6, RRP.

4. See *Mean Mothers*, Independent Women's Blues, Vol. 1, Rosetta Records, 1980; *Sorry, But I Can't Take You: Women's Railroad Blues*, Rosetta Records, 1980; and *Jailhouse Blues*, Rosetta Records, 1987. For this latter anthology, Reitz worked for over two years with Cheri Wolfe, director of the Folk Arts Program of the Mississippi Arts Commission, to compile the collection, and she enlisted University of California, Berkeley, historian Leon Litwack and SNCC Freedom Singers and Sweet Honey in the Rock cofounder Bernice Johnson Reagon to contribute liner notes essays to accompany Wolfe's and her own respective pieces in the volume. See *Jailhouse Blues* Folder, Box 5, RRP.

5. Rosetta Reitz to Martin Bressler, February 27, 1986, Record Reviews Folder, Box 6, RRP.

6. Wilson, "'Blues Is a Woman.'"

7. Rosetta Reitz, "Wild Women Don't Have the Blues," Kool Jazz Festival Book, 1981, "Wild Women Don't Have the Blues" Folder, Box 8, RRP, Special Collections, Duke University. Rosetta Reitz to John, April 24, 1980, Blues Is a Woman Folder, Box 8, RRP. Reitz's "Blues Is a Woman" concert came about as a result of a letter that she sent to legendary show producer George Wein. In an autobiographical profile for Mario Valdez of WGBH, she explains that she told Wein that she thought "the Newport Jazz Festival should honor women, they had been ignored too long." Rosetta Reitz, "Who Is Rosetta," Autobiographical Notes for Mario Valdez, WGBH, March 9, 1990, "(Auto)biography" Folder, RRP. "Blues Is a Woman" was held in 1980 at Avery Fisher Hall as part of the Newport Jazz Festival. The "Wild Women Don't Have the Blues" concert was held in 1981 as part of the Kool Jazz Festival. By way of these events, she became the first person to "produce women's blues/jazz concerts for the Newport Jazz Festival at Avery Fisher Hall . . . Carnegie Hall . . . and the Hollywood Bowl." Reitz, "Biography," August 30, 2004, "(Auto)biography" Folder, RRP.

8. As is the case with all of her projects, Reitz was involved with even the most minute production details related to both of these events. Her personal notes reveal a creative mind perpetually at work brainstorming ideas for the show. They also document the extent to which she worked closely with the artists who performed in the show, selecting versions of songs for them to perform (to Nell Carter, she writes, "I will send you a tape of Ma Rainey doing Trust No Man and will send you the 1924 version of Ida Cox doing Wild Women when she was younger") and authoring a full-length script for Carmen McRae to follow as the event host and narrator of the show. ("It is URGENT," Reitz declares in a letter, "that Carmen McRae get it in her hands, along with the program, so she'll know what it's all about. It is CRUCIAL that she become totally familiar with it.") Rosetta Reitz to Nell Carter, March 5, 1980, Box 8, "Blues Is a Woman" Folder, RRP; Rosetta Reitz to John, April 24, 1980, "Blues Is a Woman" Folder, Box 8, RRP, emphasis in the original.

9. She sought out lesser-known yet still living musicians like blues and jazz pianist Dorothy Donegan, lobbying her for permission to commemorate her career in a Rosetta Records album compilation. Correspondence with Donegan, n.d., *Dorothy Romps* Folder, Box 5, RRP. She fretted over correctly representing and doing justice to artists like the legendary all-women's swing orchestra the International Sweethearts of Rhythm, whom she revered, in part, for having "lived 'the history.'" Rosetta Reitz to Anne Le Baron, January 27, 1986, Record Reviews Folder, Box 6, RRP. With Sippie Wallace in particular, she maintained a deep and abiding friendship that emerged out of having worked together when Reitz inter-

viewed the singer for a Smithsonian oral history project. In the run-up to the "Blues Is a Woman" show, Reitz consulted Wallace to confirm that, "when we talked last Easter for the Smithsonian Oral History tapes, it was the section on Sunday, after we came back from your church, you told me you were not always credited for some of the songs that you wrote." Rosetta Reitz to Sippie Wallace, March 5, 1980, "Blues Is a Woman" Folder, Box 8, RRP. The "swell old songs . . . need retrieval," argues Reitz, because "in spite of being old—they represent the female sensibility of the '80s." Rosetta Reitz, program essay, "Wild Women Don't Have the Blues" concert, "Wild Women Don't Have the Blues," Kool Jazz Festival Book 1981, "Wild Women Don't Have the Blues" Folder, Box 8, RRP. She once scribbled on a yellow sticky note, "I see myself as the messenger. . . . Images of them are extremely important & moving images, as in film, tell us more than any written material can." Rosetta Reitz, handwritten note, n.d. Research Notes Folder, Box 14, RRP.

10. Ruth Rosen, *The World Split Open: How the Modern Women's Movement Changed America* (New York: Tantor Media, 2006), loc. 1265, Kindle. In one of the many autobiographical profiles that she wrote—seemingly for herself and at the behest of the press and fellow feminist researchers—Reitz alludes to the death of each of her parents during her childhood, resulting in her oldest brother serving as her guardian. "(Auto)biography" Folder, RRP.

11. Hazel Carby, "It Just Be's Dat Way Sometime: The Sexual Politics of Women's Blues," in *Unequal Sister: A Multicultural Reader in U.S. Women's History,* ed. Ellen Carol Dubois and Vicki Ruiz (New York: Routledge, 1990), 238–249; Angela Davis, *Blues Legacies and Black Feminism: Gertrude "Ma" Rainey, Bessie Smith, and Billie Holiday* (New York: Vintage, 1999), 4. Many thanks to Hazel Carby for first bringing the Rosetta Records collection to my attention.

12. Rosetta Reitz, handwritten notes, n.d., Research Notes Folder, Box 14, RRP; Rosetta Reitz, handwritten note, Billie Holiday Folder, Box 36, RRP.

13. Sidney Mintz and Richard Price, *The Birth of African-American Culture: An Anthropological Perspective* (1972; New York: Beacon, 1992); Melville J. Herskovits, *The Myth of the Negro Past* (1941; New York: Beacon, 1990).

14. Rosetta Reitz, notes, n.d., *Dorothy Romps* Folder, Box 5, RRP; Rosetta Reitz, "Empress of the Blues: Bessie Smith (1894–1937)," *Mississippi Rag,* December 1991, Bessie Smith Folder, Box 12, RRP. On Donegan, Reitz adds that "when she plays the rhythm and melody as though they were the same we hear Mother Africa shouting!" Reitz, notes, *Dorothy Romps* Folder, Box 5, RRP.

15. Rosetta Reitz, personal notes, "Sweet Petunias: Independent Women's Blues, Volume 4," Folder, Box 4, RRP. This portion of the notes had been scribbled out. In his influential study from that era, Houston Baker famously likens the blues to Hegelian "force," to a "matrix" from which Black modern life springs. Houston A. Baker, *Blues, Ideology, and Afro-American Literature: A Vernacular Theory* (Chicago: University of Chicago Press, 1984), 1–14. More recently, Jeffrey Ferguson questions Baker's impulse to theorize an origination narrative for African American literature rooted in vernacular forms or elsewhere. See Jeffrey B. Ferguson, "A Blue Note on Black American Literary Criticism and the Blues," in "African American Literary Studies: New Texts, New Approaches, New Challenges," ed. Werner Sollors and Glenda Carpio, special issue, *Amerikastudien/American Studies* 55, no. 4 (2010): 699–714. Ferguson observes that "instead of actual blues songs, or their varied histories, blues aesthetic critics typically cite the general qualities of the music—its general formal features,

its emphasis on non-linearity, improvisation, loss, chance, turns of fate, and stories without sure conclusions—when characterizing how black American literary texts employ it as foundation of expression" (700). Importantly, he pushes back against this sort of reading with careful, extended readings of lyrics by, among others, Bessie Smith and Lucille Bogan that disturb the generalizations made by Baker, Baraka, and other critics about the form. Reitz remained steadfast in her commitment to stressing the specificity of blues expression in her work.

16. New Age sentiments emerge at certain moments in Reitz's archive. For instance, in the notes she kept while compiling *Dorothy Romps,* she lists Donegan's zodiac sign of Aries and draws a connection between the artist's astrological profile and how "she plays piano with . . . fire." Rosetta Reitz, typewritten draft liner notes manuscript for *Dorothy Romps* album project, September 26, 1990, *Dorothy Romps* Folder, Box 5, RRP. Likewise, in one of her many book proposal drafts, Reitz muses, "As for the origin of the blues, my Placenta Theory may sound quirky but it's as valid as most of the existing ones." Rosetta Reitz, "EV-ERYWOMAN'S BLUES, Singers and Their Songs, 1920s to 1950s," unpublished manuscript, June 2000, "Everywoman's Blues Book Proposal" Folder, Box 11, RRP. As for stumbles, see, for instance, her unpublished references to Ella Fitzgerald ("born a poor pickaninny") and Josephine Baker (a "ragged pickaninny who . . . could hardly speak intelligible English. . . . She was the female savage tamed who could perform on cue") which depend on startling racist tropes. She also was not above engaging in a rare and surprising oversimplification of identity politics (again, with regard to Fitzgerald, she describes her voice as having "no particular race or color, class or ethnicity"). Rosetta Reitz, "Ella Fitzgerald" typewritten unpublished manuscript, April 16, 2002, Ella Fitzgerald Folder, Box 12, RRP; Rosetta Reitz, typewritten notes, n.d., Josephine Baker Folder, Box 35, RRP.

17. Amanda Petrusich, *Do Not Sell at Any Price: The Wild, Obsessive Hunt for the World's Rarest 78rpm Records* (New York: Simon and Schuster, 2014), 223. "Obviously," she adds, "these kinds of theories are reductive if not absurd" (223).

18. For more on gender, record collecting, and fandom, see Will Straw, "Sizing Up Record Collections: Gender and Connoisseurship in Rock Music Culture," in *The Gender and Media Reader,* ed. Mary Celeste Kearney (New York: Routledge, 2011), 632–640.

19. Jill Nelson, "Mean Mothers." John S. Wilson, "'Blues Is a Woman' Tonight Explores Other Side of the Blues," *New York Times,* July 2, 1980. Marybeth Hamilton, *In Search of the Blues* (New York: Basic Books, 2009); Petrusich, *Do Not Sell;* Nelson, "*Mean Mothers.*" Adds Petrusich, the profile of the solitary and obsessive collector was "certainly true in America in the 1940s and '50s, when the first wave of collectors—men like James McKune and Harry Smith—were establishing the rules of the trade and the seeds of world-class collections" (223). Further, she observes that there "is a stereotype in place, and it is unflattering: picture . . . a middle-aged, balding, socially awkward, slightly plump or disconcertingly skinny basement-dwelling dude who breathes through his mouth and wears stained shorts" (4). Although Petrusich concedes that "most collectors have challenging full-time jobs, sustained romantic partners, pleasant social lives, and functional wardrobes," her book confirms the fact that the majority of 78 rpm record collectors are white men invested in preserving and sustaining "a countercultural identity" (21) predicated on the pursuit of rarity, fragility, and singularity in cultural objects and a rejection of contemporary mainstream cultural tastes. For more on race, gender, and record collecting, see Side B.

20. Rosetta Reitz, "Charters-Bio," March 15, 2005, "(Auto)biography" Folder, RRP.

21. Petrusich, *Do Not Sell*, 24. There are, of course, exceptions to the rule. See, for instance, Petrusich's profile of Christopher King, 78s record collector as well as a major architect of various important and influential reissue albums culled from his preservation efforts. Petrusich, 31–44.

22. Samuel Charters, "Rosetta and the Parchman Women's Blues," *Living Blues*, January/February 2006, 70.

23. Susan Kaufman, "Womanews: Menopause Gave Her the Blues," *Chicago Tribune*, February 22, 1987; Charters, 71.

24. Susan Kaufman, "Menopause Gave Her the Blues," *Chicago Tribune*, February 22, 1987. See also "(Auto)biography" Folder, RRP.

25. Rosetta Reitz, notes, *Wild Women Don't Have the Blues* Folder, Box 8, RRP.

26. Rosetta Reitz, notes, *Wild Women Don't Have the Blues* Folder, Box 8, RRP. One could argue that Alice Walker's recuperation of the queer blues woman's redemptive spirit in *The Color Purple* was a major turning point in revisionist representations of these artists. Alice Walker, *The Color Purple* (1982; New York: Mariner Books, 2003). Reitz was thrilled to discover that Walker used the first Rosetta Records compilation, *Mean Mothers*, as a resource while writing the novel. Said Walker, "The women on the 'Mean Mothers' album. I loved the way they dealt with sexuality, with the relationships of men. They showed you had a whole self and you were not to succumb to being somebody else's." Reitz preserved a flyer with a pasted copy of the Walker quote from the *New York Times*, October 14, 1984. The flyer also includes the handwritten swoon: "Alice Walker loves MEAN MOTHERS!", Flyer for *Mean Mothers, Independent Women's Blues, Volume 1*, Record Reviews Folder, Box 6, RRP. Walker also noted in *The Same River Twice* her desire to use *Mean Mothers* tracks in *The Color Purple* film adaptation. Alice Walker, *The Same River Twice: Honoring the Difficult* (New York: Scribner, 1996), 55. Along with poet Sherley Anne Williams and fellow novelist Gayl Jones, Walker revitalized an interest in blues women's music in the 1970s and 1980s. Pioneering Black feminist critics published landmark works in the 1980s, 1990s, and early 2000s that followed suit. Daphne Duval Harrison, *Black Pearls: Blues Queens of the 1920s* (New Brunswick, NJ: Rutgers University Press, 1988); Hazel Carby, "It Just Be's Dat Way Sometime," in *Unequal Sisters: A Multicultural Reader in U.S. Women's History*, ed. Ellen Carol DuBois and Vicki Ruiz (New York: Routledge, 1990); Davis, *Blues Legacies and Black Feminism*.

27. Rosetta Reitz, Memo to Joyce Lotterhos, April 26, 1984, National Women's Hall of Fame (Bessie Smith Induction) Folder, Box 10, RRP. The culmination of Reitz's copious notes on Bessie Smith comes in the form of her 1991 article on the singer for the *Mississippi Rag* publication. See Reitz, "Empress of the Blues."

28. Reitz, unpublished note, Box 12, Sarah Vaughan Folder, RRP. Her comments here anticipate the groundbreaking work of Farah Jasmine Griffin, the first Black woman scholar to publish a full-length study of Billie Holiday's career and her cultural iconicity. Farah Griffin, *If You Can't Be Free, Be a Mystery: In Search of Billie Holiday* (New York: New York: Free Press, 2001).

29. Reitz, "Weekend of a Secretary" liner notes draft manuscript for June Richmond project, June Richmond Folder, RRP. Reitz, notes on "Dorothy Everett's Fat Mouth Blues," Record Ideas "S&M Blues," Folder, RRP. Reitz was said to have chosen Ida Cox as the first in her Foremothers series for Rosetta Records "because she was exceptional and little is known about her." Keyes, "Sound Recordings Reviews," 75. Valaida Snow would emerge as one of Reitz's most significant "rediscoveries" since, at the time that she launched the label, her

material, which included approximately fifty songs in Europe, had all but "vanished" in the United States as result of having been issued on small, independent labels. Keyes, 75. Performance studies scholar Jayna Brown draws heavily on Reitz's Snow reissues in her influential study of the trumpeter. See Jayna Brown, *Babylon Girls: Black Women Performers and the Shaping of the Modern* (Durham, NC: Duke University Press, 2008). Reitz never completed the June Richmond album project but conducted extensive research on her career and the work of some of her fellow underappreciated peers. See Record Ideas Folder #1, Box 5, RRP. See also Rosetta Reitz, notes, Record Ideas Folder #2, Box 5, RRP; and Juanita Hall Folder, Box 12, RRP.

30. Rosetta Reitz, unpublished handwritten notes, n.d., Record Ideas Folder, Box 5, RRP.

31. Don Snowden, "Rosetta Tracks the Women of the Blues," *Los Angeles Times*, July 20, 1986; Rosetta Reitz, notes, n.d., "Women's Railroad Blues" Folder, Box 4, RRP; Rosetta Reitz, Memo to Dorothy, "Ideas for Three Records," September 22, 1991, *Dorothy Romps* Folder, Box 5, RRP. Reitz's reverence toward early Black women entertainers was clearly enormous, and her knowledge of their careers was extensive. As she points out in her 1986 letter to Jack Gee Jr. attorney Martin Bressler, "no one almost, has heard of the first woman pictured" on a Rosetta Records album cover, "Ada Overton Walker, who at the turn of the century was leading lady with Bert Williams and George Walker, and the first big success of this line of performing black women. I choose her because I think she is important, not because I will make money." Rosetta Reitz to Martin Bressler, February 27, 1986, Record Reviews Folder, Box 6, RRP.

32. Rosetta Reitz, Dinah Washington notes, n.d., Dinah Washington Folder, Box 37, RRP; Keyes, "Sound Recordings Reviews," 76. On Reitz's foremothers, see clipping story on Reitz, Scrapbook Clippings Folder, Box 2, RRP. Rosetta Reitz, notes on Bogle, Scrapbook Clippings Folder, Box 2, RRP. Donald Bogle, *Brown Sugar: Over One Hundred Years of Black Female Superstars* (New York: Harmony Books, 1980).

33. Rosetta Reitz, handwritten note, n.d., Sarah Vaughan Folder, Box 12, RRP. Reitz makes notes on "Lil's all girl band: Dolly Jones, trumpet, Mae Brady, violin, Leora Meoux (sp?) trumpet . . . featured Hazel Scott's mother (who also led an all girl band). Dolly Jones— daughter of pianist Dyer Jones. 'Someone tells Louis there's a woman who plays just like him— he and Lil talk about it. They go hear her. Later she played with Lil.'" Rosetta Reitz, handwritten notes, n.d., "Piano Singers" Folder, Box 4, RRP. Reitz titled her pianists compilation *Piano Singer's Blues: Women Accompany Themselves: Lil Armstrong/Sippie Wallace/Victoria Spivey*. Rosetta Reitz, handwritten notes, n.d., "Piano Singers" Folder, Box 4, RRP. Reitz was particularly enamored with Lil Armstrong's musicianship and influence on jazz—particularly in relation to her onetime husband and fellow musician Louis Armstrong.

34. Dirk Sutro, "Ladies Sing the Blues: Rosetta Reitz Single-Handedly Runs the Only Label Devoted to Keeping Alive Rare Jazz and Blues Recordings by Female Artists," *Los Angeles Times*, April 12, 1992. See also Rosetta Reitz, handwritten notes, n.d., *Piano Singers* Folder, Box 4, RRP. See also her extensive research on an album commemorating the career of the International Sweethearts of Rhythm, which paved the way for feminist jazz studies of instrumentalists by Sherrie Tucker and others. Rosetta Reitz, *International Sweethearts of Rhythm* Folder, Box 4, RRP; Sherrie Tucker, *Swing Time: All-Girl Bands of the 1940s* (Durham, NC: Duke University Press, 2001). See also Nichole T. Rustin and Sherrie Tucker, *Big Ears: Listening for Gender in Jazz Studies* (Durham, NC: Duke University Press, 2008).

35. Rosetta Reitz, handwritten note, n.d., Sarah Vaughan Folder, Box 12, RRP.

36. Albert Murray, *The Hero and the Blues* (1973; New York: Vintage, 2012), chap. 2, loc. 548, Kindle; Rosetta Reitz, handwritten notes, n.d., "Sweet Petunias: Independent Women's Blues," Volume 4 Folder, Box 4, RRP; Rosetta Reitz, handwritten notes, n.d., *Big Mamas*, Independent Women's Blues, Volume 2 Folder, Box 4, RRP. On Dinah Washington, see Rosetta Reitz, handwritten notes, n.d., "Mean Mothers" Folder, Box 4, RRP. Her notes suggest that she was rehearsing arguments about Bogan's controversial brand of blues, carefully examining the lyrics "for accuracy" and thinking through the ways to categorize and identify aesthetic value in her work. Rosetta Reitz, handwritten note, n.d., Research Notes Folder, Box 14, RRP.

37. Rosetta Reitz, memo to Joyce Lotterhos, April 26, 1984, Re: BESSIE SMITH, CORRECTIONS & ADDITIONAL INFORMATION . . . Notable American Women, National Women's Hall of Fame (Bessie Smith Induction) 1984 Folder, Box 10, RRP; Rosetta Reitz, handwritten notes, n.d., Bessie Smith Folder, Box 12, RRP; Rosetta Reitz, handwritten notes, n.d., Ella Fitzgerald Folder, Box 12, RRP; Rosetta Reitz, "Wild Women Don't Have the Blues" 1981 Kool Jazz Festival program essay, "Wild Women Don't Have the Blues" Folder, Box 8, RRP; Rosetta Reitz, handwritten notes, n.d., Billie Holiday Folder, Box 36, RRP; Rosetta Reitz, handwritten notes on Holiday, Dinah, Bessie, and Matisse, n.d., Sarah Vaughan Folder, Box 12, RRP; Rosetta Reitz, handwritten note on Holiday, n.d., Research Notes Folder, Box 14, RRP; Rosetta Reitz, handwritten note on "an art of profundity," n.d., Sarah Vaughan Folder, Box 12, RRP.

38. Clipping, n.d., Scrapbook and Clippings Folder, Box 2, RRP.

39. Albert Murray, "Improvisation and the Creative Process," in O'Meally, *Jazz Cadence of American Culture*, 113.

40. Rosetta Reitz, *Dorothy Romps* liner notes manuscript, *Dorothy Romps* Folder, Box 5, RRP, emphasis in the original.

41. Murray, "Improvisation and the Creative Process," 112–113. She compared Sarah Vaughan to Sonny Rollins in the way that she "work[ed] with a structure and improvis[ed]" with the bop experimentalists. She "was not thrown or shaken & improvised with them, complemented them which not only brought admiration, it was more like awe." Rosetta Reitz, handwritten notes, n.d., Sarah Vaughan Folder, Box 12, RRP.

42. The intimacy that Reitz hits upon here is akin to that of Toni Cade Bambara's narrative style in her lush, funny, and bittersweet short story "Medley," in which the protagonist Sweet Pea and her jazz musician lover, Larry Landers, choreograph breakup sex that plays out in the denouement like a magnificent duet. "I dipped way down and reached for snatches of Jelly Roll Morton's 'Deep Creek Blues,'" says Sweet Pea, "and Larry, so painful, so stinging on the bass, could make you cry. . . . Then I'm racing through Bessie and all the other Smith singers." Toni Cade Bambara, "Medley," in *The Jazz Fiction Anthology*, ed. Sascha Feinstein and David Rife (Bloomington: Indiana University Press, 2009), 65. Adds Farah Griffin, "there is no speech, no quotation marks, and no verbal exchange" between these two characters. "Instead, he provides the rhythm and chord changes, and she sings the sometimes wordless melody." Farah Jasmine Griffin, "It Takes Two People to Confirm the Truth: The Jazz Fiction of Sherley Anne Williams and Toni Cade Bambara," in *Big Ears: Listening for Gender in Jazz Studies*, ed. Nichole Rustin and Sherrie Tucker (Durham, NC: Duke University Press, 2008). The intimacy of Reitz's Donegan reading is warm and palpable, and it operates as a spirited accompaniment to the performance.

43. Rosetta Reitz, notes, "Dorothy Romps" Folder, Box 5, RRP; Rosetta Reitz, handwritten notes, n.d., Sarah Vaughan Folder, Box 12, RRP.

44. Thomas Carson Mark, "On Works of Virtuosity," *Journal of Philosophy* 77, no. 1 (January 1980): 29, 36, 35.

45. Rosetta Reitz, handwritten notes, n.d., "Mean Mothers" Folder, Box 4, RRP; Edward Said, "The Virtuoso as Intellectual," in *On Late Style: Music and Literature against the Grain* (New York: Pantheon, 2006), 117.

46. Rosetta Reitz, Ella Fitzgerald unpublished manuscript, April 16, 2002, Ella Fitzgerald Folder, Box 12, RRP; Rosetta Reitz, handwritten notes, n.d., *Sweet Petunias* Folder, Box 4, RRP.

47. Rosetta Reitz, Bessie Smith notes, n.d., Sarah Vaughan Folder, Box 12, RRP.

48. Rosetta Reitz, "Ella Fitzgerald," April 16, 2002, Ella Fitzgerald Folder, Box 12, RRP.

49. Whitney Balliett as quoted in Gary Shivers, "A Woman's Place," *American Arts,* clipping, Scrapbook and Clippings Folder, Box 2, RRP; Clipping, *Record Research Issue* no. 38, October 1961, Scrapbook & Clipping Folder, "Piano Singers" Folder, Box 4, RRP; Rosetta Reitz, notes on Bogle, Scrapbook Clippings Folder, Box 2, RRP; Rosetta Reitz, handwritten notes, n.d., Bessie Smith Folder, Box 37, RRP. She published a review of Albertson's book in which she argued that "Bessie Smith was a superwoman a wonder woman a mean woman. In 'uptown' parlance to be called a mean woman is not bad, it means this human being won't take shit from anyone. This is the kind of woman Bessie Smith had to be, no question about it if you listen to her records but if you read the new biography by Chris Albertson you won't be too sure." Reitz, "Empress of the Blues."

50. On Giddens's work, see "Sweet Petunias: Independent Women's Blues, Vol. 4" Folder, Box 4, RRP. On Hentoff's work, see Sarah Vaughan Folder, Box 12, RRP. On Palmer's work, see "Sweet Petunias: Independent Women's Blues, Vol. 4" Folder, Box 4, RRP. On Pareles's work, see "Sweet Petunias: Independent Women's Blues, Vol. 4" Folder, Box 4, RRP. On Rockwell's work, see Sarah Vaughan Folder, Box 12, RRP. On Watrous's work, "Dorothy Romps" Folder, Box 5, RRP.

51. Rosetta Reitz, Letter to Stanley [Dance], March 11, 1981, Valaida Snow Folder, Box 4, RRP, emphasis in the original. Dance reported back to Reitz with Hines's answers to her query: "Dear Rosetta, I sent the world albums by Valaida up to Earl & he said she was deliberately trying to play like Louis much of the time on them, but that she did not play that way when she was with him. He said also that he used to criticize her vocal vibrato, & that as a singer she had to be seen. What he felt should be emphasized was her great stage personality, & that (without denigrating her musical talent) the playing and singing were attributes added to the act, or complementary to it. . . . Best, Stanley." Stanley Dance, Letter to Rosetta Reitz, 1981, Valaida Snow Folder, Box 4, RRP, emphasis in the original.

52. Carol Muske, "Lingua Materna: The Speech of Female History," *New York Times,* January 20, 1985 clipping, "Sweet Petunias: Independent Women's Blues, Vol. 4," Folder, Box 4, RRP, bracketed text, strike-throughs, and emphasis in the original clipping as marked by Reitz.

53. John Wilson, "Jazz: Tony Tamburello," *New York Times* clipping, n.d., "Sweet Petunias: Independent Women's Blues, Vol. 4" Folder, Box 4, RRP, bracketed text in the original clipping as marked by Reitz; Michael Walsh, "A Symbol Takes the Stage: Soviet Pianist Vladimir Feltsman Makes His U.S. Debut," *Time,* November 23, 1987, clipping, *Dorothy Romps* Folder, Box 5, RRP. In her notes on Pareles's article "3 Pianists and Their Debt to Thelonious Monk," Reitz adds the handwritten note, "She uses the piano as conductors use an orchestra." Rosetta Reitz, handwritten notes atop Pareles clipping, "Dorothy Romps" Folder, Box 5, RRP. In her notes on a *Time* magazine review of James R. Gaines's book about Bach, Reitz includes a handwritten note that reads, "How casually and gracefully Dorothy incor-

porates the baroque mysticism of Bach with the ragtime bluesy orchestral piano style of Jelly Roll Morton from the early part of the century." Rosetta Reitz, notes on Christopher Porterfield, "Duel at the Tipping Point," review of *Evening in the Palace of Reason: Bach Meets Frederick the Great in the Age of Enlightenment,* by James R. Gaines, *Time,* March 14, 2005, clipping, "Dorothy Romps" Folder, Box 5, RRP.

54. Robert Hughes, "Singing within the Bloody Word," *Time,* July 1, 1985, clipping, *Sweet Petunias: Independent Women's Blues, Vol. 4* Folder, Box 4, RRP, bracketed text, strike-throughs, and emphasis in the original clipping as marked by Reitz. Reitz turned to Hughes for inspiration on more than one occasion. On a clipping of his review of painter Frank Stella's work, Reitz muses in the margins on how "Dorothy wrings more musical feeling then [*sic*] anyone alive that the possibilities of playing standards are all played out." Robert Hughes, "The Grand Maximalist," *Time,* November 2, 1987, Reitz handwriting atop original clipping, "Dorothy Romps" Folder, Box 5, RRP.

55. Jennifer Brody, *Punctuation: Art, Politics and Play* (Durham, NC: Duke University Press, 2008), locs. 189, 283, 221, Kindle. Brody observes that punctuation marks "allow us to enter a disorienting circuit among voice, thought, body, writing and graphicity" (loc. 211).

56. Murray, "Improvisation and the Creative Process," 112; Rosetta Reitz, handwritten notes, n.d., "Sweet Petunias: Independent Women's Blues, Vol. 4" Folder, Box 4, RRP. Rosetta Reitz, handwritten notes, "Dorothy Romps" Folder, Box 5, RRP; Rosetta Reitz, handwritten notes, n.d., "Record Ideas, S&M Project" Folder, Box 5, RRP; Rosetta Reitz, handwritten notes, "Dorothy Romps" Folder, Box 5, RRP.

57. Douglas Martin, "Rosetta Reitz, Champion of Jazz Women, Dies at 84," *New York Times,* November 14, 2008.

58. Keyes, "Sound Recordings Reviews," 78, 74, 79. All nineteen titles released by Rosetta Records were reissued in 1992 as the *Women's Heritage Series.* The records were available in album, CD, or tape cassette format. For more on the history of the Rosetta Records label, see the Rosetta Tribute Site at https://rosettatribute.weebly.com, which is run by Rebecca Reitz, a crucial and generous champion of her mother's legacy.

59. Rosetta Reitz, liner notes for *Lil Green: Wails the Blues / Chicago 1941–1947,* Foremothers Vol. 5, RR 1310, Rosetta Records, 1985.

60. Rosetta Reitz, liner notes for *Georgia White Sings and Plays the Blues,* Foremothers Vol. 3, RR 1307, Rosetta Records, 1982.

61. Rosetta Reitz, liner notes for *Ethel Waters, 1938–1939: The Complete Bluebird Sessions,* Foremothers Vol. 6, RR 1314, Rosetta Records, 1986; Rosetta Reitz, liner notes for *Sorry but I Can't Take You: Women's Railroad Blues,* RR 1301, Rosetta Records, 1980; Rosetta Reitz, liner notes for *Sister Rosetta Tharpe: Gospel, Blues, Jazz,* Foremothers Vol. 8, RR 1317, Rosetta Records, 1988.

62. Reitz, liner notes for *Ethel Waters;* Reitz, liner notes for *Sister Rosetta Tharpe.*

63. Reitz, liner notes for *Ethel Waters;* Reitz, liner notes for *Sister Rosetta Tharpe.*

64. Reitz, liner notes for *Sorry but I Can't Take You;* Rosetta Reitz, liner notes for *Red White & Blues: Women Sing of America,* RR 1302, Rosetta Records, 1980.

65. Reitz, liner notes for *Ethel Waters;* Gayle Wald, *Shout, Sister, Shout: The Untold Story of Rock-and-Roll Trailblazer Sister Rosetta Tharpe* (Boston: Beacon, 2008). Reitz observes how "many artists have tried to communicate those feelings, Franz Kafka evoked them in his novels, *The Castle* and *The Trial,* and so did the painter Paul Klee in his drawings of leafless trees in somber landscapes." Rosetta Reitz, liner notes for *Sincerely, Sister Rosetta* RR 1992, Rosetta Records, 1988; Rosetta Reitz, liner notes for *Wild Women Don't Have the Blues:*

Ida Cox, Foremothers Vol. 1, RR 1304, Rosetta Records, 1981; Reitz, liner notes for *Red White & Blues;* Reitz, liner notes for *Georgia White;* Rosetta Reitz, liner notes for *Sweet Petunias,* Independent Women's Blues Vol. 4, RR 1311, Rosetta Records, 1986. Rosetta Reitz, liner notes for *Super Sisters: Independent Women's Blues,* Vol. 3, RR 1308, Rosetta Records, 1982.

66. Rosetta Reitz, liner notes for *Dinah Washington: Wise Woman Blues*, Foremothers, Vol. 4, RR 1313, Rosetta Records, 1984.

67. Rosetta Reitz, liner notes for *Dinah Washington.* The performance of Black women artists at all-white, mid-twentieth-century debutante balls is an underexamined phenomenon. Alexis Clark explores, for instance, the Supremes' performance at the Country Club of Detroit in all-white Grosse Pointe, miles and light years away from their Brewster Project roots. See Alexis Clark, "For One Night in 1965, the Supremes Brought the Two Detroits Together," *New York Times* February 13, 2019.

68. Reitz, liner notes for *Dinah Washington.*

69. Reitz.

70. Reitz.

71. As is the case with all of her projects, Reitz meticulously documented the entire process of compiling, arranging, producing, and packaging the album *Jailhouse Blues.* See *Jailhouse Blues* Folder, Box 5, RRP.

72. Leon Litwack's liner notes essay (which Reitz gently edited to convert "he" pronouns to "they") emphasized the ways that "the history of black people in the United States is not simply a history of extralegal violence." Leon Litwack, "Jailhouse Blues" liner notes essay manuscript, n.d., "Jailhouse Blues" Folder, Box 5, RRP. Reagon's essay considers, among other things, the power dynamics involved in the production of these recordings ("THE HALPERT WORK REVEAL[S] AN ANXIOUSNESS TO PLEASE AND PARTICIPATE . . . MAYBE THEY RESPONDED WITH ENTHUSIASM TO ANYONE WHO FELT THEY HAD SOMETHING OF VALUE TO OFFER") as well as the vast range of songs sung by these women ("THEY SING PRISON WORK SONGS, BLUES, RING PLAY SONGS, INSIDE SONGS ABOUT SEXUAL PLAY, SONGS SUNG BY THE MALE PRISONERS, SONGS DONE BY BOTH, SONGS THEY LEARNED, PICKED UP. SONGS THEY WROTE, SONGS ABOUT SEXUAL EXPLOITATION, AND THE LOMAX SESSION HAS THE MOST WONDERFUL RANGE OF CONGREGATIONAL CHURCH, GOSPEL AND SPIRITUAL SONGS WITH RICH, FULL PRACTICED HARMONIES"). Bernice Johnson Reagon, *Jailhouse Blues* liner notes essay manuscript, n.d., "Jailhouse Blues" Folder, Box 5, RRP, capitalization in the original. Wolfe's short essay affirms how "these recordings enable us to feel something of what it meant to be a black woman, in the South, before the Civil Rights Movement. Her music simultaneously related social injustices and reflected her fortitude." Cheri L. Wolfe, *Jailhouse Blues* liner notes essay, n.d., *Jailhouse Blues* Folder, Box 5, RRP.

73. Gerald E. Parsons, Reference Librarian, American Folklife Center, Library of Congress, Letter to Rosetta Reitz confirming status of the album, July 17, 1987, "Jailhouse Blues" Folder, Box 5, RRP; Rosetta Reitz to Leon Litwack, June 1, 1987, "Jailhouse Blues" Folder, Box 5, RRP; Rosetta Reitz to Patti Carr Black, August 4, 1987, "Jailhouse Blues" Folder, Box 5, RRP; Rosetta Reitz, notes to Cheri Wolfe, "Jailhouse Blues" Folder, Box 5, RRP.

74. Rosetta Reitz to Patti Carr Black, August 4, 1987, "Jailhouse Blues" Folder, Box 5, RRP; Rosetta Reitz to Cheri Wolfe, August 25, 1987, "Jailhouse Blues" Folder, Box 5, RRP; Rosetta Reitz to Patti Carr Black, August 4, 1987, "Jailhouse Blues" Folder, Box 5, RRP.

75. Dirk Sutro, "Lady Sings the Blues," *Los Angeles Times,* April 12, 1992. Reitz's research for her unfinished "S&M blues" compilation documents the ways that she seriously grap-

pled with 1980s feminist debates about pornography in relation to violent tropes in classic blues women's repertoires. She collected "AGAINST SADOMASOCHISM" feminist porn flyers denouncing the "degradation" of women, and particularly Black women, in porn. Yet she seemed to equally consider ways of affirming the dignity and wholeness of sadomasochists. In a copy of a *Time* magazine review of Janet Malcolm's 1981 book *Psychoanalysis: The Impossible Profession,* an underlined excerpt describes "understan[ding] . . . the overwhelming fullness" of a patient being treated for sadomasochism, "his individuality and idiosyncrasy . . . ambiguity and complexity." In this same folder of clippings and notes on "S&M blues," Reitz included a track list of songs ("Billie, Everything I Have Is Yours," Lil Armstrong's "Just for a Thrill") and notes about other recordings that fell under this topic (Trixie Smith's "You've Got to Beat Me to Keep Me"), left a reminder to herself to retrieve the lyrics to "T'ain't Nobody's Bizness but My Own," and kept an OKEH Records ad featuring the quote, "I have killed my man." She kept a copy of a review of Andrea Dworkin's "Right Wing Woman," underlining in red the quote, "unpredictable male violence. In a country where a woman is raped every three minutes . . ." See S&M Blues Folder, Box 5, RRP. She also asked in her notes, "How can the suffering of a woman be inscribed in my memory as something almost lovely? When I look at the words . . . of the song . . . I am appalled . . . I still find the music beautiful." Rosetta Reitz, notes, Record Ideas Folder, Box 5, RRP. On the "women loving women" project and "celebration blues," see Record Ideas Folder, Box 5, RRP.

76. Rosetta Reitz, "Bessie to Billie: The Poetry of Women's Blues, 1920 to 1950s" (unpublished manuscript, November 1997), From Bessie to Billie Folder, Box 11, RRP. Reitz changed the title of her unfinished book project several times through the years. In 2000 the project was called "Everywoman's Blues: Singers and Their Songs 1920 to 1950s," and in 2005–2006, she refers to the manuscript as "Women's Blues and Jazz: Their Magic 1920 to 1950s." Reitz's legend lives on. In a May 2020 email, daughter Rebecca Reitz reported that residents in Leiden, Netherlands, had successfully mobilized to change the name of "Reitzstraat" (Reitz Street) in that city. The street had been named after "a leader in the Boer War, Francis W. Reitz." Local activists, says Rebecca Reitz, "researched for a woman named Reitz and discovered Rosetta and were so impressed with her accomplishments (from my Tribute site) and just went ahead and made a new sign. They will go through the official Council channels also. We just love that they took immediate grassroots action themselves. I am glowing from this action. Rosetta would have LOVED it." Rebecca Reitz, email message to the author, May 20, 2020. See also, Bob Weinberg, "Setting the Record Straight: Rosetta Reitz fought for Women's Place in Jazz History," Jazziz, August 20, 2020, https://www.jazziz.com/setting-the-record-straight-rosetta-reitz-fought-for-womens-place-in-jazz-history/.

4. Thrice Militant Music Criticism

1. Lorraine Hansberry, "To Be Young, Gifted and Black," May 1, 1964, Remarks to Prize Winners of the United Negro College Fund, *Readers Digest* Creative Writing Contest, Box 59, Folder 3, Lorraine Hansberry Papers, Schomburg Center for Research in Black Culture, New York Public Library, capitalization in the original, hereafter cited as LHP.

2. Indeep, "Last Night a DJ Saved My Life," *Last Night a DJ Saved My Life!,* Sound of New York / Becket Records, 1982; Feist, "I Feel It All," *The Reminder,* Cherrytree / Interscope Records, 2007; Aretha Franklin, *I Never Loved a Man the Way I Love You,* Atlantic Records, 1967.

3. *New York Post* columnist James Wechsler describes Lorraine Hansberry as speaking with "a fiery loveliness" during a historic forum at New York City's town hall on June 15, 1964, entitled "The Black Revolution and the White Backlash" in which Wechsler, along with Paule Marshall, John O. Killens, LeRoi Jones, Ossie Davis, and Ruby Dee, also appeared. More on this gathering later. Says Wechsler, "it was she who tried hardest to speak to all of us, more in injury than in wrath, and with a fiery loveliness. . . ." "The Black Revolution and the White Backlash," *New York Post*, clipping, n.d., Box 56, Folder 1, LHP.

4. Ellen Willis, *Out of the Vinyl Deeps: Ellen Willis on Rock Music*, ed. Nona Willis Aronowitz (Minneapolis: University of Minnesota Press, 2011).

5. Ellen Willis, "We Hitch Our Wagons: Twenty People Whose Careers Have Special Meaning for Us to Discuss the Pressures and Impulses That Produce the Creative Life," *Mademoiselle*, August 1960, clipping includes handwritten note, Clippings Folder, Box 6, Ellen Willis Papers, Schlesinger Library, Harvard University (hereafter cited as EWP). The clipping is also included in Hansberry's papers. See Box 63, Folder 13, LHP.

6. José Esteban Muñoz, *Cruising Utopia: The Then and There of Queer Futurity* (New York: New York University Press, 2009), 9, 3, emphasis added. Portions of this chapter were first presented during a panel session at the American Studies Association annual convention in Washington, DC, in November 2013 in which Muñoz and others also presented their work. This chapter is dedicated to him.

7. Solange, "Cranes in the Sky," *A Seat at the Table*, Saint / Columbia, 2016; Munoz, *Cruising Utopia*, 3. Pilate, the journeywoman in Toni Morrison's epic *Song of Solomon*, traverses wide swaths of territory both as a result of her outsider status (as a woman with "no navel") and as a woman of her own self-making. See Toni Morrison, *Song of Solomon* (New York: Vintage, 1977), 141–151.

8. Ellen Willis to Lorraine Hansberry, June 3, 1960, Box 3, Folder 9, LHP.

9. Ellen Willis, "Diary 1952," Series I. Biographical and Personal, 1941–2002, EWP.

10. Willis, "We Hitch Our Wagons."

11. Imani Perry, *Looking for Lorraine: The Radiant and Radical Life of Lorraine Hansberry* (Boston: Beacon, 2018).

12. Cheryl Higashida, "To Be(come) Young, Gay, and Black: Lorraine Hansberry's Existential Routes to Anticolonialism," *American Quarterly* 60, no. 4 (2008): 899–924; Michael Anderson, "Lorraine Hansberry's Freedom Family," *American Communist History* 7, no. 2 (2008): 259–269; Joy Abell, "African / American: Lorraine Hansberry's *Les Blancs* and the American Civil Rights Movement," *African American Review* 35, no. 3 (2001): 459–470; Margaret B. Wilkerson, "The Dark Vision of Lorraine Hansberry: Excerpts from a Literary Biography," *Massachusetts Review* 28, no. 4 (1987): 642–650; Steven Carter, "Commitment amid Complexity: Lorraine Hansberry's Life in Action," *MELUS* 7, no. 3 (1980): 39–53. See also Ruth Feldstein, "I Don't Trust You Anymore," which, in part, considers the friendship forged along radical political and intellectual lines between Hansberry and Nina Simone. Ruth Feldstein, "I Don't Trust You Anymore: Nina Simone, Culture, and Black Activism in the 1960s," *Journal of American History* 91, no. 4 (2005): 1349–1379. In 2013–2014, the Brooklyn Museum mounted "Twice Militant: Lorraine Hansberry's Letters to *The Ladder*," an exhibition that showcased the playwright's letters to the *Ladder*, "the first subscription-based lesbian magazine in the United States, published from 1956 to 1972." On Hansberry's radical queerness, see also Roderick Ferguson, "The Serialization of Sexuality: Lorraine Hansberry, the 1950s, and Anticolonialism" (February 2015, unpublished manuscript).

13. Nina Simone, *I Put a Spell on You: The Autobiography of Nina Simone,* 2nd ed. (New York: Da Capo, 2003), 87.

14. Willis, "We Hitch Our Wagons."

15. Willis's 1990s lecture marks a moment when she publicly reflected on the genre she referred to as "rock lit" and the evolution of the field. Ellen Willis, "The Paradox of Rocklit," manuscript of lecture for Symposium on Rockutopia, Vienna, Austria, April 28, 1995, Box 10, Folder 15, EWP. Ellen Willis, "Dylan" (from *Cheetah,* 1967), "Dylan's Anti-surprise" (April 1969), "New Morning: Dylan Revisited" (December 1970), "The Rolling Stones Now" (December 1973), "Dylan and Fans: Looking Back and Going Forward" (February 1974), "Sympathy for the Stones" (July 1975), "After the Flood" (April 1975), "Mott the Hoople: Playing the Loser's Game" (May 1974) (on Leo Sayer), "Creedence as Therapy" (1972), in *Out of the Vinyl Deeps.*

16. Gustavus Stadler, "On Whiteness and Sound Studies," *Sounding Out!,* July 6, 2015, https://soundstudiesblog.com/2015/07/06/on-whiteness-and-sound-studies/.

17. Ellen Willis, "Lessons of the New Left," manuscript of lecture given at the City University of New York, February 22, 1990, Teaching, Speeches and Lectures, 1980–2006, Box 9, EWP.

18. Muñoz, *Cruising Utopia,* 83, 91.

19. Perry, *Looking for Lorraine,* 102; "Lorraine Hansberry," *Vogue,* June 1959; Lillian Ross, "Playwright," *New Yorker,* May 9, 1959, 34.

20. Anne Bancroft to Lorraine Hansberry, March 12, 1959, Folder 11, Box 63, Lorraine Hansberry Papers. Bancroft and her brilliant comedian husband, Mel Brooks, would become ardent and steadfast supporters of Hansberry's up until her death. The two led the high-profile charge to raise funds to keep her play *The Sign in Sidney Brustein's Window* open during the fall of 1964 as Hansberry's health worsened and as the production faced critical and financial setbacks. See Nemiroff's reflections on this moment in the introduction to *Sign at Sidney Brustein's Window.* Robert Nemiroff, "The 101 'Final' Performances of Sidney Brustein," *Lorraine Hansberry, A Raisin in the Sun / The Sign in Sidney Brustein's Window* (New York: Vintage, 1995), 159–203. Bancroft and Brooks offered their care and support for a grieving Nemiroff in the immediate wake of Hansberry's passing. See Mel Brooks and Anne Bancroft, Western Union Telegram to Bob Nemiroff, January 15, 1965, Folder 5, Box 68, LHP. A range of actors as varied as *Raisin* cast member Ruby Dee, Shelley Winters, Nichelle Nichols, Godfrey Cambridge, and Roxie Roker, as well as Civil Rights leaders such as Martin Luther King, Jr. and John Lewis on behalf of SNCC, were among those who sent get-well cards to Hansberry or condolences to Nemiroff at the time of her passing. Her dear friend Nina Simone sent her loving cards and letters of encouragement, hope, and humor during her illness. Dee and Winters each spoke at her funeral. See "Tributes," Box 68, Folder 5, LHP.

21. Eartha Kitt to Lorraine Hansberry, May 9, 1959, Folder 11, Box 63, Lorraine Hansberry Papers, emphasis in the original. As discussed later, Kitt would loom large in Hansberry's sensual imagination, as evidenced by her notes from 1960, but it's not clear when her smoldering interest in the entertainer began or what the "note" to which Kitt refers here is.

22. Perry argues that Hansberry had "shown herself to be . . . a diligent student, a worker, a laborer for the cause of freedom, and also an artist like Robeson. She was, in a sense, his and his friend DuBois's political daughter." Perry, *Looking for Lorraine,* 56. Here I stress the word "modern" to mark the distinction between Hansberry and her generation of high-profile agitators versus that of her mentors—Robeson and Du Bois—not to mention the abolitionist

and postbellum figures who used earlier forms of media as uplift tools. Hansberry and Baldwin, in line with the mass media's spotlight on Civil Rights movement action, represented a new form of erudite and agitating Blackness, camera-ready, confrontational, and comfortable in front of the microphone in ways that broke from the style of older Black celebrities like the urbane and yet publicly apolitical Nat King Cole and the politically ambiguous Sammy Davis, Jr. For more on the media and Civil Rights celebrity activism, see Emilie Raymond, *Stars for Freedom: Hollywood, Black Celebrities, and the Civil Rights Movement* (Seattle: University of Washington Press, 2015). Matthew Frye Jacobson, "Dancing Down the Barricades: Sammy Davis, Jr. and the Long Civil Rights Era" (unpublished manuscript).

23. Lorraine Hansberry, interview by Studs Terkel, broadcast on WFMT Radio, Chicago, May 12, 1959, transcript and interview recording, Studs Terkel Radio Archive, https:// studsterkel.wfmt.com/programs/lorraine-hansberry-discusses-her-play-raisin-sun?t=743 .277%2C777.496&a=ObviPeopWho%2COfLeadHist. See also Roderick A. Ferguson, "The Bookshop of Black Queer Diaspora: Hansberry and the Multiplications of Insurgency," unpublished public lecture manuscript, Yale University, February 14, 2019. For more on Hansberry's political radicalism, see Anderson, "Lorraine Hansberry's Freedom Family"; Carter, "Commitment among Complexity"; Fanon Che Wilkins, "Beyond Bandung: The Critical Nationalism of Lorraine Hansberry, 1950–1965," *Radical History Review* 95 (Spring 2006): 191– 210; and Cheryl Higashida, *Black Internationalist Feminism: Women Writers of the Black Left, 1945–1995* (Urbana: University of Illinois Press, 2011). See also Perry, *Looking for Lorraine.*

24. For a timeline of these events, see "Timeline," *Sighted Eyes/Feeling Heart,* accessed July 17, 2020, https://www.sightedeyesfeelingheart.com/timeline/. In a letter to Nemiroff, Hansberry describes her encounter with Studs Terkel, who is on hand for her Roosevelt University talk. Lorraine Hansberry to Robert Nemiroff, May 12, 1959, Folder 1, Box 1, Lorraine Hansberry Papers. The May 8, 1959, interview with then–CBS correspondent Mike Wallace never aired. See *Lorraine Hansberry Audio Collection,* Caedmon, 2009. The May 12, 1959, interview with Studs Terkel has been anthologized and reprinted on numerous occasions. See "Make New Sounds: Studs Terkel Interviews Lorraine Hansberry," *American Theater* 1, no. 7 (November 1984), 5–41. The Preminger tête-à-tête became a thing of legend in certain press circles. See Era Bell, "Why Negroes Don't Like *Porgy and Bess,*" *Ebony,* October 1959. The *Chicago Sun Times* would note some two years later about this period of Hansberry's public appearances that her Roosevelt University lecture "was a strong speech and those who heard her tangle with Otto Preminger on 'At Random' (she called his 'Porgy and Bess' 'bad art' and 'stereotyped') know she's no mouse." Glenna Syse, "Early Bird Hansberry Flies High," *Chicago Sun Times,* February 26, 1961.

25. Lorraine Hansberry, "Quo Vadis?," *Mademoiselle,* January 1960.

26. Ferguson, "Serialization of Sexuality," 5. Perry, *Looking for Lorraine,* 119–120, 122.

27. Lorraine Hansberry, "The Negro Writer and His Roots: Toward a New Romanticism," *The Black Scholar* 12, no. 2 (March/April 1981): 1. Hansberry first delivered these remarks on March 1, 1959 at the American Society of African Culture conference.

28. Faith Taylor, Letter to Lorraine Hansberry, March 9, 1959, Box 7, Folder 7/8, LHP; Nat Hentoff, "They Fought—They Fought!," *New York Times,* May 25, 1964; Ernest Green, Letter to Lorraine Hansberry, August 13, 1959, Box 7, Folder 7/8, LHP; Lorraine Hansberry, Letter to Faith Taylor, March 20, 1959, Box 7, Folder 7/8, LHP. The fourth-grade class at the Franklin School in Berkeley, California, sent numerous letters to Hansberry in the fall of 1964 when her illness was made public. See Folder 4, Box 4, LHP.

29. Lorraine Hansberry, "The Negro Writer and His Roots: Toward a New Romanticism," 11. Hansberry as quoted in Robert Nemiroff, "A Critical Background," in Hansberry, *Les Blancs,* 223.

30. Lorraine Hansberry, *What Use Are Flowers? A Fable in One Act,* in *Les Blancs: The Collected Last Plays,* ed. Robert Nemiroff (New York: Vintage, 1972), 261.

31. Kenneth N. Merryman, Letter to Lorraine Hansberry, April 4, 1962, Box 57, Folder 20, Lorraine Hansberry Papers, capitalization in the original.

32. Lorraine Hansberry, "Letter to Kenneth Merryman, a White H.S. Student," on the Mason-Dixon Line, April 27, 1962, Box 57, Folder 20, LHP. In the wake of Hansberry's passing, Nemiroff tried unsuccessfully to place the letter in a major publication. See 1967 note of rejection from the *New York Review of Books,* Box 57, Folder 20, LHP.

33. Hansberry, "Letter to Kenneth Merryman."

34. Hansberry.

35. For vivid examples of but one of Hansberry's warm mentor-mentee relationships with luminaries in the world of Black letters, see for instance Langston Hughes' laudatory letter to her upon the publication of her "New Paternalists" essay in which he opens his letter gushing, "<u>Wonderful</u> piece of yours on 'The New Paternalism' in the 'Voice.' I could read you all night long—and stay awake!" Langston Hughes, Letter to Lorraine Hansberry, May 5, 1961, emphasis in original, Box 63, Folder 13, LHP.

36. Lorraine Hansberry, untitled reflections on Louis Burnham, n.d., Box 2, Folder 13, LHP. See also the publication of this material in Lorraine Hansberry, *To Be Young, Gifted, and Black* (New York: Signet Classics, 2011), 99–100.

37. Louis Burnham, note to Lorraine Hansberry, March 1, 1959, Box 2, Folder 13, LHP.

38. Louis Burnham to Lorraine Hansberry, n.d., Box 2, Folder 13, LHP. Burnham continues by adding, "I raise these questions not because 'I know I can't be President'—and no other Negro can either. I don't want to be president, really. I just want to be free."

39. Lorraine Hansberry to Robert Nemiroff, n.d., emphasis in the original. Box 2, Folder 19, LHP. Here she is specifically referring to de Beauvoir's 1954 novel *The Mandarins.* Hansberry biographer Margaret Wilkerson notes that she read the book either in 1953 or 1954, "shortly after the English translation was released in the States." Margaret Wilkerson, "Lorraine Hansberry," in *Words of Fire: An Anthology of African American Feminist Thought,* ed. Beverly Guy-Shefthall (New York: New Press, 1995), 126.

40. Perry, *Looking for Lorraine,* 77–78; Lorraine Hansberry, "Simone de Beauvoir and the Second Sex: An American Commentary: An Unfinished Essay-in-Progress," in Shefthall, *Words of Fire: An Anthology of African-American Feminist Thought,* ed. Beverly Guy (New York: The New Press, 1995), 129.

41. Hansberry, "Simone de Beauvoir," 130.

42. Perry, *Looking for Lorraine,* 107.

43. Paula Jones, "Negro Dancers Are Superb . . . But They Don't Get Jobs . . . ," *Freedom,* clipping, n.d., Box 66, Folder 1, LHP; L. H., "*The Outsider* by Richard Wright," n.d., *Freedom,* clipping, Box 66, Folder 1, LHP;; Lorraine Hansberry, "Alice Childress' Acting Brightens a Fine Off-Broadway Theatre Piece," *Freedom,* clipping, n.d., Box 66, Folder 1, LHP. Early in her career, Hansberry occasionally wrote under the pseudonym Paula Jones while at *Freedom.*

44. Lorraine Hansberry, "Letter to the Editor on Academy Awards Actresses," 1954, *Daily Worker,* Box 61, Folder 17, LHP.

45. Lorraine Hansberry, "On Strindberg and Sexism," in *Women in Theatre: Compassion and Hope,* ed. Karen Malpede (New York: Drama Book, 1983), 171, emphasis and capitalization in the original. Originally published in the *Village Voice,* 1956. Original letter manuscript found in Box 58, Folder 18, Lorraine Hansberry Papers.

46. Lorraine Hansberry, letter to *Commentary,* March 5, 1963.

47. For more on Baldwin's style of addressing the racial psyche of his white interlocutors, see any one of his classic essay collections but especially James Baldwin, *Notes of a Native Son* (Boston: Beacon, 2012); and James Baldwin, *The Fire Next Time* (New York: Vintage, 1992).

48. This first draft of the manuscript is entitled "Thoughts On: Genet, Mailer, Algren, Mekas and the New Paternalism," original first draft of "The New Paternalists," n.d., Box 58, Folder 9, LHP. See also Lorraine Hansberry, "Genet, Mailer and the New Paternalism," *Village Voice,* June 1961, 10.

49. Hansberry, "Thoughts On."

50. Lorraine Hansberry, letter to the editor, *New York Post,* July 27, 1959, 23.

51. See Milton Bracker, "Xhosa Songstress," *New York Times* Magazine, February 28, 1960, clipping, Box 62, Folder 2, LHP.

52. John Lord Lagemann, "The Male Sex," *Redbook,* December 1955, clipping, Box 62, Folder 2, LHP; Clifford R. Adams, "Can a Marriage Survive Physical Brutality?," *Ladies' Home Journal,* March 1959, clipping, Box 62, Folder 2, LHP.

53. Max Lerner, "The Ordeal of the American Woman," *Saturday Review,* October 12, 1957, clipping, Box 62, Folder 2, LHP.

54. Higashida, *Black Internationalist Feminism,* 65; Nemiroff as quoted in Steven Carter, *Hansberry's Drama,* 6.

55. Letter signed "L. H. N." [Lorraine Hansberry Nemiroff], *Ladder* 1, no. 8 (May 1957): 26, 28.

56. Letter signed "L. N." [Lorraine Nemiroff], *Ladder* 1, no. 11 (August 1957), 31.

57. Adrienne Rich, "The Problem with Lorraine Hansberry," *Freedomways* 19, no. 4 (1979): 252, emphasis in the original.

58. Higashida, *Black Internationalist Feminism,* 65–66; Ferguson, "Serializaiton of Sexuality," 14, emphasis in the original.

59. Lorraine Hansberry, "Myself in Notes, November 26, 1961," in *Twice Militant* exhibit; Ferguson, "Serialization of Sexuality," 10.

60. Ferguson, 14. Ferguson draws on early Deleuze's meditations on "variation" and "metamorphosis" in his cogent analysis of Hansberry's notes. Ellen Willis, "Beginning to See the Light" (1977), in *Out of the Vinyl Deeps.*

61. L. H., letter to the *Ladder.* See also Ferguson, "Bookshop of Black Queer Diaspora." In the historic 2013 Brooklyn Museum exhibit *Twice Militant: Lorraine Hansberry's Letters to "The Ladder,"* the archival traces of a privately queer artist who consistently found solace in sending letters to a lesbian "little magazine" are on full display. As John Schwartz of the *New York Times* observes of the archive, the "letters reveal a woman joyous about being able to discuss sexual identity, same-sex attraction, feminism and more." John Schwartz, "A Concealed Voice Rings Loud and Clear," *New York Times,* October 25, 2013.

62. Ferguson, "Bookshop of Black Queer Diaspora." I'm grateful to Matthew Frye Jacobson for his pointed remark after seeing the *Twice Militant* exhibit that Hansberry was doing intersectional theory long before the milestone 1980s woman-of-color feminist an-

thology *This Bridge Called My Back* or the 1990s coinage and usage of the term by Black feminist scholars such as Kimberle Crenshaw and Valerie Smith. Gloria Anzaldúa and Cherríe Moraga, eds., *This Bridge Called My Back,* 4th ed. (New York: State University of New York Press, 2016); Kimberle Crenshaw, "Mapping the Margins: Intersectionality, Identity Politics and Violence against Women of Color," *Stanford Law Review* 43, no. 6 (1991): 1241–1299; Valerie Smith, *Not Just Race, Not Just Gender: Black Feminist Readings* (New York: Routledge, 1998). In her letters to the *Ladder* magazine, Hansberry holds forth on a range of subjects, including the challenges of "heterosexually married lesbians," of which she points out, "I am . . . one of those incidentally." Here she considers, for instance, the class challenges facing queer and closeted 1950s women and their limited options. The "estate of woman being what it is, how could we ever begin to guess the numbers of women who are not prepared to risk a life alien to what they have been taught all their lives to believe was their 'natural' destiny— AND—their only expectation for ECONOMIC security. It seems to me that this is why the question [of why the "prefer[rence for] emotional-physical relationships with other women" is higher for men than women] has an immensity that it does not have for male homosexuals." Hansberry as quoted in *Twice Militant: Lorraine Hansberry's Letters to "The Ladder,"* exhibit, Brooklyn Museum, November 22, 2013–March 16, 2014.

63. Hansberry, "Myself in Notes, April 11, 1959," LHP, included in *Twice Militant* exhibit. For more on the exhibit, see Victoria Brownworth, "Twice Militant: Lorraine Hansberry," *Lambda Literary,* February 25, 2014, http://www.lambdaliterary.org/features/02/25/twice -militant-lorraine-hansberry/; and Tracy Clayton, "This List of Random Things Lorraine Hansberry Liked and Hated Is Fascinating," Buzzfeed, March 19, 2014, http://www.buzzfeed .com/tracyclayton/list-of-random-things-lorraine-hansberry-liked-and-hated#.pibjE4zbP.

64. Jonathan Flatley, *Like Andy Warhol* (Chicago: University of Chicago Press, 2017), 4. Flatley contends that Warhol's work is "an archive of his liking" and that it constitutes "a praxis, a de-instrumentalized affective labor" (4, 7, 37, 43, 47). Importantly, Hansberry's lists of *dislikes* clearly also set her at odds with Warhol's "promiscuous liking."

65. Lorraine Hansberry, "Myself in Notes, April 1, 1960," *Twice Militant* exhibit; Ferguson, "Bookshop of Black Queer Diaspora," 12, 13. Hansberry's penchant for acute articulations of inner conflicts is on display in "Myself in Notes" as well. A year later, on April 1, 1960, she lists "my homosexuality" as both a "Like" and a "Hate," "Being alone" as a "Like" and "My loneliness" as a "Hate," "My husband most of the time" under "Like" and "sneaky love affairs" under "Hate." Under "want," she has added to her list one of her longtime lovers, "Dorothy Seceles (at the moment)." Under "Bored to Death With . . ." she includes "A RAISIN IN THE SUN! . . . Eartha Kitt, Being a Les, 'Lesbians' (the capital L variety) . . . Being a 'celebrity.'" Hansberry, "Myself in Notes, April 1, 1960," *Twice Militant* exhibit. Flatley convincingly theorizes the ways in which "the world 'like' itself makes the chiastic double assertion that to be pleased by something is to feel like it, and that feeling similar to something is itself pleasing. . . . When you want to be like something," he argues, "it means you really love it." Flatley, *Like Andy Warhol,* 9, 10, 15.

66. Hansberry, "Negro Writer," 3, 4.

67. Hansberry, 4, 11–12.

68. Flatley, *Like Andy Warhol,* 21.

69. Hansberry as quoted in Robert Nemiroff, "A Critical Background," in Hansberry, *Les Blancs,* 223; Hansberry, *What Use Are Flowers?,* 259; Hansberry, "Negro Writer," 12.

70. Willis, "Beginning to See the Light," 156.

71. Notes Sasha Frere-Jones, "Willis was writing for a larger audience than almost any other critic—475,000, while *Rolling Stone* reached only 75,000. At the dawn of pop criticism, when the field was barely a field and certainly not a well-paying gig, a woman wrote seven years' worth of serious, politically engaged pieces about pop for a national magazine." Sasha Frere-Jones, "Foreword: Opening the Vault," in Willis, *Out of the Vinyl Deeps*, x.

72. Ellen Willis, "Two Soul Albums" (November 1968) (on *Aretha in Paris*), "The Importance of Being Stevie Wonder" (December 1974), "The Best of 1974" (January 1975), "Roseland Nation" (October 1973) (on the Pointer Sisters), "Beginning to See the Light" (1977) (on Bessie Smith), in *Out of the Vinyl Deeps*.

73. Ellen Willis, "The Big Ones" (February 1969), in *Out of the Vinyl Deeps*, 78; Ellen Willis, "But Now I'm Gonna Move" (October 1971), in *Out of the Vinyl Deeps*, 136. Her timeline in this piece is a bit idealized and simplistic since she argues here that "most people seem to have missed a crucial point: that there is an alarming difference between the naïve sexism that disfigured rock before, say, 1967 and the much more calculated, almost ideological sexism that has flourished since. . . . What had been a music of oppression became in many respects a music of pseudoliberation." Willis, "But Now I'm Gonna Move," 135. Again, racial histories of subjugation dating back to the origins of the genre would clearly complicate such a contention. Ellen Willis, "The Velvet Underground" (1979), in *Out of the Vinyl Deeps*, 56; Ellen Willis, "Janis Joplin" (1980), in *Out of the Vinyl Deeps*, 128. Even still, her reading of Joplin fails to fully reckon with the dimensions of the singer's white privilege as a blues singer. Willis argues that Joplin "used blues conventions to reject blues sensibility. To sing the blues is a way of transcending pain by confronting it with dignity, but Janis wanted nothing less than to scream it out of existence." Willis, "Janis Joplin," 128. Her inability to consistently recognize racial politics informing such choices is indicative of her limitations when it comes to theorizing whiteness.

74. Ellen Willis, introduction to *Beginning to See the Light: Sex, Hope and Rock 'n' Roll* (Minneapolis: University of Minnesota Press, 2012), xvii. Ellen Willis, "The Paradox of Rocklit" (1995); Ellen Willis, "Cultural Legacy of the '60s," Wisconsin State Historical Society lecture manuscript, April 1993, Box 10, Folder 7, EWP.

75. Willis, introduction to *Beginning to See the Light*, 221–222; Willis, "The Paradox of Rocklit"; Willis, "Cultural Legacy of the '60s." In a talk on the 1996 "Living a Radical Life" panel, she muses, "Ironically leftists who attack identity politics often invoke a populism or a version of pro-working class that's itself a form of identity politics. Populism glorifies the standpoint of 'ordinary people' against minorities, dissidents, intellectuals, 'cultural elitists' etc; vulgar class politics glorifies the standpoint of the 'worker'—usually a long surpassed fifties model of a white male industrial worker—as opposed to 'middle class' or 'upper middle class.' Both converge in [an] attempt to dismiss cultural issues as anti-people or anti-worker or a distraction from the 'real issues' of class—regardless of the fact that feminism, changes in sexual and cultural values, etc. and opposition to those values now cut across class." Ellen Willis, lecture, "Living a Radical Life" panel paper manuscript, *Dissent*, New York University, October 23, 1996, Box 10, Folder 22, EWP. For Willis, cultural radicalism was always a distinct category from that of socialism. As she argues, "The enemy is not capitalism per se, but the authoritarian structure of all our institutions, including those—the family, especially—that regulate our so-called private lives." Willis, introduction to *Beginning to See the Light*, 219–220. See also Daphne Carr and Evie Nagy, "Afterword: Raise Your Hand," in Willis, *Out of the Vinyl Deeps*, 226. For more on Willis's New Left ethnic feminism, see Mat-

thew Frye Jacobson, *Roots Too: White Ethnic Revival in Post–Civil Rights America* (Cambridge, MA: Harvard University Press, 2006), 268–275.

76. Ellen Willis, "Up from Radicalism: A Feminist Journal," 1969 Box 6, Folder 12, EWP. She did not entirely divorce herself from considering Black liberation politics in the sixties though. In her draft notes for an unpublished book review of Stokely Carmichael and Charles V. Hamilton's 1967 book, *Black Power,* she rehearsed and turned over a series of revolutionary ideas, including the belief that "black must not assimilate into middle class—which is anti-human, materialistic, values permit racism. . . . Black people should organize as consumers against businessmen, form independent political parties. . . . Money & jobs not final answer." Ellen Willis, Review of *Black Power* drafts, Box 4, Folder 5, EWP. Many of Ellen Willis's key, published political writings, including "Up from Radicalism," are now accessible via the anthology, compiled by her daughter, the author Nona Willis Aronowitz. *The Essential Ellen Willis,* ed. Nona Willis Aronowitz (Minneapolis: University of Minnesota, 2014). My archival research on Willis preceded the release of this volume. Except when indicated, my references to works also included in *The Essential Ellen Willis* are to the versions held in the EWP.

77. Perry, *Looking for Lorraine,* 182; Stefano Harney and Fred Moten, "On Debt" (paper presented at the American Studies Association Annual Meeting, Washington, D.C. November 2013).

78. Ellen Willis, "Consumerism and Women," *Ramparts,* 1969, Papers Folder, Box 7, EWP; Ellen Willis, "Preface to Barbara O'Dair's *Trouble Girls: The Rolling Stone Book of Women in Rock*" (1997), in *Out of the Vinyl Deeps,* 161.

79. For more on Hurston's quotidian cultural politics, see Chapter 2. Alice Walker, "Everyday Use," in *In Love and Trouble* (New York: Mariner Books, 2003); Ellen Willis, "On the Barricades," *New York Times Book Review,* November 8, 1998. "In the meantime," she argues, "we should at least insist that the capitalists who produce rock concerts charge reasonable prices for reasonable service." Ellen Willis, "The Cultural Revolution Saved from Drowning," in *Out of the Vinyl Deeps,* 185–186.

80. Willis, "Up from Radicalism."

81. Ellen Willis, "Feminism, Moralism, Pornography," ed. Aronowitz, *The Essential Ellen Willis,* 95.

82. Durbin as quoted in Frere-Jones, "Foreword," xiv.

83. Audre Lorde, "The Uses of the Erotic," in *Sister Outsider: Essays and Speeches* (Berkeley: Crossing, 2007) 53, 54, 56, 57, 59. The *Diary of a Conference* reading list for the 1982 *Scholar and the Feminist* conference includes Lorde's essay, along with other selections, such as Hattie Gossett, "Intro and 10 Takes," *Heresies,* Sex Issue, no. 12 (1981): 15–18; and EW, "Lust Horizons: Is the Women's Movement Pro-Sex?," *VV,* June 17, 1981.

84. Toni Cade Bambara, ed., *The Black Woman* (New York: Washington Square, 2005); Alice Walker, *The Third Life of Grange Copeland* (New York: Mariner Books, 2003); Toni Morrison, *The Bluest Eye* (New York: Vintage, 2007); Maya Angelou, *I Know Why the Caged Bird Sings* (New York: Ballantine Books, 2009). These first novels by Walker and Morrison were first published in 1970. Angelou's autobiography was first published in 1969. Combahee River Collective, "The Combahee River Collective Statement," April 1977, http://circuitous.org/scraps/combahee.html.

85. Willis, "Beginning to See the Light," 148–157.

86. Willis, 156; Willis, "Velvet Underground," 54. For more on racial and gender biases in canonical rock music criticism, see Daphne A. Brooks, "The Write to Rock: Racial

Mythologies, Feminist Theory, and the Pleasures of Rock Music Criticism," *Women and Music* 12 (2008): 54–62.

87. Willis, "Big Ones," 80.

88. Evelyn McDonnell and Ann Powers, eds., *Rock She Wrote: Women Write about Rock, Pop and Rap* (New York: Delta, 1995); Tricia Rose, *Black Noise: Rap Music and Black Culture in Contemporary America* (Middletown, CT: Wesleyan University Press, 1994); Joan Morgan, *When Chickenheads Come Home to Roost: A Hip Hop Feminist Breaks It Down* (New York: Simon and Schuster, 2000); Imani Perry, *Prophets from the Hood: Politics and Poetics in Hip Hop* (Durham, NC: Duke University Press, 2004); Kandia Crazy Horse, ed., *Rip It Up: The Black Experience in Rock 'n' Roll* (New York: Palgrave Macmillan, 2004); Jessica Hopper, *The First Collection of Criticism by a Living Female Rock Critic* (Chicago: Featherproof Books, 2015); Daphne Carr, *Nine Inch Nails: Pretty Hate Machine* (New York: Continuum, 2011); Jayna Brown, "'Brown Girl in the Ring': Poly Styrene, Annabella Lwin, and the Politics of Anger," *Journal of Popular Music Studies* 23, no. 4 (December 2011): 455–478; Laina Dawes, *What Are You Doing Here? A Black Woman's Life and Liberation in Heavy Metal* (New York: Bazillion Points, 2013). Maureen Mahon, *Black Diamond Queens: African-American Women and Rock and Roll* (Durham, NC: Duke University Press, 2020).

89. Ferguson, "Bookshop of Black Queer Diaspora," 14.

90. Ellen Willis, "Sisters under the Skin: Confronting Race and Sex," The *Village Voice*, Literary Supplement, Number 8, June 1982; Ellen Willis, Review of *Black Power* drafts, EWP; Ellen Willis, published articles, *Transition*, 1994–1998, Box 8, Folder 1, EWP. See also Willis's various published essays from the mid-to-late 1990s and early aughts which address, with varying degrees of intersectional consciousness, several high-profile racial crises and political debates—from the publication of racist geneticist Charles Murray's *The Bell Curve* (co-authored by Richard Herrnstein) to the O.J. Simpson murder trial to the 1995 Louis Farrakhan-led "Million Man March." See Ellen Willis, "What We Don't Talk about When We Talk about *The Bell Curve*," in Aronowitz, *The Essential Ellen Willis*, 327–333. Ellen Willis, "Rodney King's Revenge," in Aronowitz, *The Essential Ellen Willis*, 334–338. Ellen Willis, "Million Man Mirage," in Aronowitz, *The Essential Ellen Willis*, 339–342.

91. Willis, "Velvet Underground," 65; Lorraine Hansberry, "Myself in Notes at 32 (July 1962)," *Twice Militant* exhibit. As Frere-Jones points out, "One of [Willis's] gifts, and not something many editors could handle now, was an acceptance of ambiguous conclusions, no matter how much she craved intellectual resolution." Frere-Jones, "Foreword," xi.

92. Pam Ottenberg, letter to the editor, *New York Times*, June 18, 1967, clipping, Box 3, EWP; Dorothy Barclay, "Trousered Mothers and Dishwashing Dads," *New York Times Magazine*, April 28, 1957, clipping, Box 62, Folder 2, LHP. The Barclay clipping includes handwritten marginalia: "VERY GOOD" and "O, Pioneers!"

93. Willis, "Preface to Barbara O'Dair's *Trouble Girls*," 161. However, she also sagely observes, "Maybe it's just that the longer I live, the less I need some other larger-than-life woman to reveal me to myself. . . . It's been a long time since I asked, of each new rock-and-roll woman to come to my attention, is she the one?" (162).

94. She likes "Mahalia Jackson's music," "Dinah Washington as much as ever," and "Anita Darian's voice as much as ever." Hansberry, "Myself in Notes, April 1, 1960" and "Myself in Notes, November 26, 1961," *Twice Militant* exhibit. The "Dorothy" referred to here is thought to be Dorothy Secules, the woman with whom, as Perry points out, Hansberry had "her longest relationship." Renee Kaplan was another of Hansberry's lovers who became a dear

friend. See Perry, *Looking for Lorraine,* 83. For more on Hansberry's queer relationships, see Perry, 91–93. Both Secules and Kaplan were honorary pallbearers at Hansberry's funeral, which was held on January 16, 1965, in New York City. A number of luminaries—among them Paul Robeson, Ruby Dee, SNCC activist and childhood friend James Foreman, and actress Shelley Winters—shared remarks. Nina Simone performed. In addition to Secules and Kaplan, other honorary pallbearers included Dick Gregory, Rita Moreno, and Diana Sands. Lorraine Hansberry funeral program, January 16, 1965, *Raisin in the Sun* Production Files, Box 5, Philip Rose Papers, YCAL MSS 438, Beinecke Rare Book and Manuscript Library, Yale University.

95. Barbara Christian, "'Somebody Forgot to Tell Somebody Something': African-American Women's Historical Novels" (1990), in *Barbara Christian: New Black Feminist Criticism, 1985–2000,* ed. Gloria Bowles, M. Guilia Fabi, and Arlene R. Keizer (Urbana: University of Illinois Press, 2007), 98; Hazel Carby, "It Just Be's Dat Way Sometime: The Sexual Politics of Women's Blues," in *Unequal Sisters: A Multicultural Reader in U.S. Women's History,* ed. Ellen Carol DuBois and Vicki Ruiz (New York: Routledge, 1990).

96. Ellen Willis, *The Scholar and the Feminist* 1982 conference planning committee papers and notes, Box 1, Folder 2, EWP; Ellen Willis, handwritten notes, n.d., Box 8, EWP. In a letter to Toni Morrison, Spillers recounts her initial wariness and reluctance to participate in the conference. "When I was invited to participate in the conference that yielded these papers," she writes, "I thought to myself . . . the old grief—yes, put a dime in the phone, and, as Gloria Hull said, I think, dial a nigger who, in turn, gives the Gospel on 'Black experience' from Genesis to the Revelations. So I told the lady that I honestly could not speak for the global 'sexuality' of black women, across oceans, in and out of closets . . . but then I wanted to talk about the word itself—like 'civilization' and 'aesthetics,' for example, a word that makes the blood run cold, not for itself, but for all the hidden ways you think people unconsciously use and mean [it?]. Then I looked at all the books on my shelves—on feminist theory, in general, and 'sexuality,' in particular and got mad as hell." Hortense Spillers to Toni Morrison, November 29, 1984, Box 94, Folder 17, Toni Morrison Papers, Special Collections, Princeton University.

97. Hortense Spillers, "Interstices: A Small Drama of Words," in *Black, White, and in Color: Essays on American Literature and Culture* (Chicago: University of Chicago Press, 2003), 152–175. See also Spillers, "Mama's Baby, Papa's Maybe: An American Grammar Book," in *Black, White, and in Color,* 203–229; Shane Vogel, *The Scene of Harlem Cabaret: Race, Sexuality, Performance* (Chicago: University of Chicago Press, 2009); and Willis, *The Scholar and the Feminist* 1982 conference planning committee papers and notes, Box 1, EWP.

98. Spillers, "Interstices," 153, emphasis Spillers's, 156.

99. Spillers, 165–166, emphasis Spillers's.

100. Willis, "Janis Joplin," 128; Aretha Franklin, "'Dr. Feelgood' Live in Amsterdam 1968," YouTube video, 4:31, posted August 21, 2018, https://www.youtube.com/watch?v=QdBK5PLf1UI.

101. Spillers, "Interstices," 167; Barbara Christian, "But What Do We Think We're Doing Anyway: The State of Black Feminist Criticism(s) or My Version of a Little Bit of History" (1989) in Barbara Christian, *New Black Feminist Criticism, 1985–2000,* ed. Gloria Bowles, M. Guila Fabi, and Arlene R. Keizer (Urbana, IL: University of Illinois Press, 2007), 14.

102. Spillers, "Interstices," 167.

103. Fred Moten, "On Escape Velocity: The Informal and the Exhausted (with Conditional Branching)," 2013, 10.

104. Michele Russell as quoted in Spillers, "Interstices," 166.

105. Lorraine Hansberry, "Woman," 1951, Box 61, Folder 17, Lorraine Hansberry Papers; Willis, "After the Flood," 150.

106. Willis, "After the Flood," 159.

107. Among the numerous unfinished projects that Hansberry left behind at the time of her death were drafts of the libretto for an opera on Haitian Revolution hero Toussaint-Louverture and the script for a musical adaptation of Oliver La Farge's 1929 novel *Laughing Boy*, which focuses on Native American cultural history. See Lorraine Hansberry, "Toussaint," bulk of material 1958, Box 42, LHP; and Lorraine Hansberry, "Laughing Boy," editorial drafts, 1961–1963, Box 46, LHP. In 1954, Hansberry also wrote to Nemiroff about having an idea for "a libretto. John Henry—'an original American folk opera.'" Hansberry to R. N., September 1954, Box 1, Folder 1, Lorraine Hansberry Papers. Hansberry wrote the script for what amounted to a musical resistance piece performed at the In Defense of Martin Luther King rally in May 1960. Historian Judith Smith describes the event, billed as "a spectacular night of stars," as "a freedom rally" held "in New York at the 369th Armory in Harlem." Judith Smith, *Becoming Belafonte: Black Artist, Public Radical* (Austin: University of Texas Press, 2016), 169. Hansberry's manuscript for the program called for Diahann Carroll as well as Jackson to play pivotal roles alongside Ruby Dee, Harry Belafonte, Sidney Poitier, and others. Lorraine Hansberry, "In Defense of Martin Luther King" presentation script, (1961?), Box 51, Folder 3, LHP. The "Faces of Black Women" was a documentary project on the history of African American women that evolved alongside Hansberry's involvement with the Sojourners for Truth delegation of 132 women who traveled to Washington, DC, seeking to "fight against triple oppression facing working class black women and anti-apartheid activism." Fellow Sojourners included Shirley Graham DuBois and Eslanda Robeson. Lorraine Hansberry, "The Faces of Black Women," 1950–1952, Box 50, Folder 8, LHP.

108. Willis, "Consumerism and Women."

109. The two-part, six-hour radio show, featuring readings of Hansberry's wide body of work—a kind of precursor to *To Be Young, Gifted and Black*—aired in January and February 1967 on WBAI. Sixty leading actors of stage and screen participated in the program, including Diana Sands, Anne Bancroft, Lauren Bacall, Godfrey Cambridge, Bette Davis, Louis Gossett, Paul Newman, Laurence Olivier, Geraldine Page, Sidney Poitier, Maureen Stapleton, Rod Steiger, Rip Torn, and Joanne Woodward. See Jerry Tallmer, "Across the Footlights: Lorraine: Beneatha: Diana," *New York Post*, January 21, 1967. *To Be Young, Gifted and Black*, a biographical play about Hansberry featuring excerpts from her published and unpublished writings, opened off Broadway at the Cherry Lane Theater on January 2, 1969. Jesse McCarthy once brilliantly observed in a seminar entitled "A Sound Theory of Blackness" that we might think of Ralph Ellison's *Invisible Man* as "a book of strategies." The formulation has stuck with me ever since. Author's seminar conversation with Jesse McCarthy, Spring 2013, Princeton University.

110. Ellen Willis, "Alternating Currents," *Rolling Stone*, September 23, 1976, clipping, Papers Folder, Box 7, EWP. She was well aware of *Rolling Stone*'s old-boys network. In her review of Robert Draper's *Rolling Stone Magazine: The Uncensored History*, Willis points out that "women remained marginal at *Rolling Stone*. Its hip-macho tone did not appreciably change, nor did its audience: as the only regular writer on feminist issues, I was struck by the amount of misogynist mail I received. As Draper acknowledges, *Rolling Stone* was even whiter—in terms of its music coverage, general content, and sensibility, as well as the skin color of its contributors—

than it was male. And gay liberation simply didn't exist." Ellen Willis, "Getting a Lock on Rock," review of *Rolling Stone Magazine: The Uncensored History,* by Robert Draper, *Columbia Journalism Review* 29, no. 4 (November 1990): 60. Willis's archive reveals her increasing engagement with intersectional feminist theory in the 1990s. In 1993 and writing from her post as an associate professor of journalism at New York University, Willis argued that in "this post-Thomas / Hill era, it should hardly be news that the politics of race and gender are deeply intertwined" and that in this climate there ought to be room to recognize Alice Walker's "analysis of repressed eroticism and the violent pursuit of 'manhood' in the Black Panther Party." In this letter, Willis carefully and self-consciously walks a tightrope in supporting Walker's claims in the face of Elaine Brown's critiques of her stance. Her response is charged, defensive, still complicated. She, for instance, makes reference to "Brown's white-feminist baiting." Yet there is a cautious mindfulness on her part as well. She declares here that "I in no way mean to disparage the importance of black feminist criticisms of the women's movement's racial politics." Willis continues, adding that it "should be possible, however, to subject black nationalism to a comparable sexual-political critique without being vilified as an enemy of black men. Nearly 15 years after Michele Wallace's groundbreaking Black Macho and the Myth of the Superwoman, this remains a controversial proposition. I appreciate Alice Walker's refusal to be deterred." Ellen Willis, letter to the editor, 1993, Box 3, Folder 8, EWP. See also Ellen Willis, "Sexuality after Thomas / Hill," Tikkun Folder, Box 7, Folder 23,EWP; and Willis, review of Orlando Patterson's *The Ordeal of Integration.* Ellen Willis, "The Up and Up: On the Limits of Optimism," *Transition* 74 (1997): 44–61, Box 8, Folder 1, EWP.

111. The list of woman of color and queer of color thinkers who created the conditions for thrice-militant music criticism is a long one that includes giants who emerged in the decades following Hansberry and Willis's intimate summit and who have now tragically passed on: Barbara and June and Audre, Sherley Anne and Gloria, Claudia and Nellie, Veve, Paula and Paule, Rosemary and José, Toni and Toni, Cheryl and so many more.

Side B

1. Saidiya Hartman, *Wayward Lives, Beautiful Experiments: Intimate Histories of Social Upheaval* (New York: Norton, 2019), 77–79.

2. Danielle Goldman, *I Want to Be Ready: Improvised Dance as a Practice of Freedom* (Ann Arbor: University of Michigan Press, 2010).

3. The "forgotten but not gone" reference is Joseph Roach's which he shared with me in a pivotal exchange in 1999.

4. Joseph Roach, *Cities of the Dead: Circum-Atlantic Performance* (New York: Columbia University Press, 1996); Roland Barthes, "The Death of the Author," in *Image, Music, Text* (New York: Hill and Wang, 1978).

5. Hartman, *Wayward Lives, Beautiful Experiment;* Toni Morrison, *Jazz* (New York: Vintage, 1992); Lynn Nottage, *Intimate Apparel; Fabulation* (New York: Theatre Communications Group, 2006); Farah Jasmine Griffin, *Harlem Nocturne: Women Artists and Progressive Politics during World War II* (New York: Nation Books, 2013); Jackie Kay, *Bessie Smith* (Bath: Absolute, 1997); Carrie Mae Weems, *From Here I Saw What Happened and I Cried,* 1995–1996, http://carriemaeweems.net/galleries/from-here.html.

6. Tina Campt, *Listening to Images* (Durham, NC: Duke University Press, 2017); Roderick A. Ferguson, "The Bookshop of the Black Queer Diaspora: Hansberry and the

Multiplications of Insurgency" (unpublished Yale University lecture manuscript), February 14, 2019; Brent Edwards, *Epistrophies: Jazz and the Literary Imagination* (Cambridge, MA: Harvard University Press, 2017); Jacqueline Najuma Stewart, *Migrating to the Movies: Cinema and Black Urban Modernity* (Berkeley: University of California Press, 2005); Tavia Nyong'o, *Afro-fabulations: The Queer Drama of Black Life* (New York: New York University Press, 2018); Elizabeth Alexander, *The Venus Hottentot: Poems* (Saint Paul, MN: Graywolf, 2004); Isabel Wilkerson, *The Warmth of Other Suns: The Epic Story of America's Great Migration* (New York: Vintage, 2011); Stephanie Smallwood, *Saltwater Slavery: A Middle Passage from Africa to American Diaspora* (Cambridge, MA: Harvard University Press, 2008); Jack Halberstam, *In a Queer Time and Place: Transgender Bodies, Subcultural Lives* (New York: New York University Press, 2005); Halberstam, *The Queer Art of Failure* (Durham, NC: Duke University Press, 2011).

7. Fred Moten, *In the Break: The Aesthetics of the Black Radical Tradition* (Minneapolis: University of Minnesota Press, 2003); Fred Moten, *Stolen Life,* Consent Not to Be a Single Being (Durham, NC: Duke University Press, 2018); Fred Moten, *Black and Blur,* Consent Not to Be a Single Being (Durham, NC: Duke University Press, 2018); Fred Moten, *The Universal Machine,* Consent Not to Be a Single Being (Durham, NC: Duke University Press, 2018).

8. Judith Butler, *Notes toward a Performative Theory of Assembly* (Cambridge, MA: Harvard University Press, 2018). "Hold" refers to the hold of the slave ship as elaborated on by Hartman in *Lose Your Mother* and Christina Sharpe in *In the Wake,* among other critics. Saidiya Hartman, *Lose Your Mother: A Journey along the Atlantic Slave Route* (New York: Farrar, Straus and Giroux, 2008); Christina Sharpe, *In the Wake: On Blackness and Being* (Durham, NC: Duke University Press, 2016).

9. Farah Griffin, *If You Can't Be Free, Be a Mystery: In Search of Billie Holiday* (New York: Free Press, 2001); Gayle Wald, *Shout, Sister, Shout: The Untold Story of Rock-and-Roll Trailblazer Sister Rosetta Tharpe* (Boston: Beacon, 2008); Kara Keeling, *Queer Times, Black Futures* (New York: New York University Press, 2019); Ralph Ellison, *Invisible Man* (New York: Vintage, 1995).

10. Toni Morrison, *The Nobel Lecture in Literature, 1993* (New York: Knopf, 2009); Alexandra T. Vazquez, "Toward an Ethics of Knowing Nothing," in *Pop When the World Falls Apart: Music in the Shadow of Doubt,* ed. Eric Weisbard (Durham, NC: Duke University Press, 2012). Before *Wayward* in its fullest incarnation, Saidiya Hartman, it should be noted, had been creating the conditions for a different kind of thinking, writing, performing, and being from within as well as beyond the confines of the academy—from the wretched "scenes" that she limned for new and necessary truths to the requiem for the ones "in the wake," the ones for whom there is "no mercy here" on the chain gang. Because of what she's already put out into the world, we have (Christina) Sharpe ways of thinking about the long event of mournfulness for which there is no language. And we have Sarah Haley's account of sisters doing time and improvising ways to undo the tyranny of their temporality. See Sharpe, *In the Wake;* and Sarah Haley, *No Mercy Here: Gender, Punishment, and the Making of Jim Crow Modernity* (Chapel Hill: University of North Carolina Press, 2016).

11. Huey Copeland, *Bound to Appear: Art, Slavery, and the Site of Blackness in Multicultural America* (Chicago: University of Chicago Press, 2013).

12. *New York Times* critic-at-large Wesley Morris first spoke a version of these words ("I wasn't supposed to show up here . . . and so I show up here everyday.") on the critically-acclaimed podcast *Still Processing* which he co-hosts with fellow *Times* cultural critic, Jenna

Wortham. We discussed the comment in an email exchange. Email to Wesley Morris, September 4, 2020.

13. Achille Mbembe, "The Power of Archive and Its Limits," in *Refiguring the Archive,* ed. Carolyn Hamilton, Verne Harris, Jane Taylor, Michèle Pickover, Graeme Reid, and Razia Saleh (Dordrecht: Kluwer Academic, 2002), 25–26. The most famous dust-up in recent years with regards to pop cultural institutions' dismissal of Black musical achievement remains the Grammys' failure to recognize the widely acclaimed *Lemonade* by Beyoncé Knowles in the 2016 "Album of the Year" category. The award that year went to British vocalist Adele. As of this writing, no woman of color artist has won the prize for best long-playing record since Lauryn Hill, who took home the Best Album Grammy for her 1998 debut album. Only three others have won since 1959, the first year that the award was presented: Natalie Cole, Whitney Houston, and Norah Jones. In 2018, Kendrick Lamar became the first African American pop musician (and first musician outside the classical and jazz categories) to win the Pulitzer Prize for music. For more on the 2016 Grammys, see Daphne A. Brooks, "Displacing Whiteness," in *Popular Music and the Politics of Hope,* ed. Susan Fast and Craig Jennex (New York: Routledge, 2019).

14. Antoinette Burton, *Dwelling in the Archive: Women Writing House, Home, and History in Late Colonial India* (New York: Oxford University Press, 2003), 5. Thanks to Brent Edwards for bringing Burton's work to my attention.

15. Michel Foucault, *The Archaeology of Knowledge* (New York: Pantheon, 1972); Ann Laura Stoler, *Along the Archival Grain: Epistemic Anxieties and Colonial Common Sense* (Princeton, NJ: Princeton University Press, 2009), 20.

16. Jacques Derrida, *Archive Fever: A Freudian Impression,* trans. Eric Prenowitz (Chicago: University of Chicago Press, 1995), 7. Stoler adds that this "move from archive-as-source to archive-as-subject gained currency across the richly undisciplined space of critical history and its range of fields energized by that reformulation." Stoler, *Along the Archival Grain,* 44. See also Foucault's extensive work on this subject in, for instance, *The Archaeology of Knowledge* and "Nietzsche, Genealogy, History." Foucault, *Archaeology of Knowledge;* Foucault, "Nietzsche, Genealogy, History," in *Nietzsche,* ed. John Richardson and Brian Leiter (New York: Oxford University Press, 1978), 139–164. See also Stephen Best, *None Like Us: Blackness, Belonging, Aesthetic Life* (Durham, NC: Duke University Press), 29–62.

17. Roach, *Cities of the Dead;* Diana Taylor, *The Archive and the Repertoire: Performing Cultural Memory in the Americas* (Durham, NC: Duke University Press, 2003). Diana Taylor, *The Archive and the Repertoire: Performing Cultural Memory in the Americas* (Durham, NC: Duke University Press, 2003).

18. Both performance studies and Black feminist studies have benefited enormously from the ways that Hartman and Moten have respectively broken unprecedented ground in illuminating the role played by white supremacist patriarchy and the regime of slavery in exposing what Hartman has famously characterized as the need for Black studies researchers and thinkers to maintain a "struggle within and against the constraints and silences imposed by the nature of the archive—the system that governs the appearance of statements and generates social meaning." That struggle, as Moten's work reveals and on which this book elaborates, is waged most palpably in sound and by way of the strategies of women who decided to make and become their own records, their own documentation of existence and vitality. Saidiya Hartman, *Scenes of Subjection: Terror, Slavery, and Self-Making in Nineteenth-Century America* (New York: Oxford University Press, 1997), 11; Moten, *In the Break.* See

also Avery Gordon's germinal *Ghostly Matters* for her classic, daringly experimental take on addressing the archival opacities of the marginalized and the crisis of racial historical memory. Avery F. Gordon, *Ghostly Matters: Haunting and the Sociological Imagination* (Minneapolis: University of Minnesota Press, 2008).

19. Haley, *No Mercy Here;* Marissa Fuentes, *Dispossessed Lives: Enslaved Women, Violence, and the Archive* (Philadelphia: University of Pennsylvania Press, 2016), 7; Kara Keeling, "Looking for M: Queer Temporality, Black Political Possibility, and Poetry from the Future," *GLQ* 15, no. 4 (2009): 565–582. See also Keeling, *Queer Times, Black Futures,* 87–106. For a touchstone with regard to the question of archival precarity, see also Michel Foucault, "The Life of Infamous Men," in *Power, Truth, Strategy,* ed. Meaghan Morris and Paul Patton (Sydney: Feral, 1979), 76–91. Keeling's and Haley's respective works come to bear on a number of the questions explored in the chapters ahead.

20. Eurythmics and Aretha Franklin, "Sisters are Doin' It For Themselves," Aretha Franklin, *Who's Zoomin' Who?* (Arista Records, 1985)

5. Not Fade Away

1. Daniel Marshall, Kevin P. Murphy, and Zeb Tortorici, "Editors' Introduction: Queering Archives: Historical Unravelings," in special issue, *Radical History Review* 120 (Fall 2014): 1.

2. John Jeremiah Sullivan, "The Ballad of Geeshie and Elvie," *New York Times Magazine,* April 13, 2014.

3. Saidiya Hartman, *Wayward Lives, Beautiful Experiments: Intimate Histories of Social Upheaval* (New York: Norton, 2019), xiv, xv.

4. Many thanks to John Sullivan, who first shared the photograph with me that appears at the beginning of this chapter, and my hearty thanks to Greil Marcus for passing along further info about the book in which it is included. Collector, archivist, and former librarian Jim Linderman's *The Birth of Rock and Roll* is a complicated and jolting visual "storyboard of sorts," as critic Joe Bonomo refers to it in his afterword interview with the author. Comprised of a wide range of images that Linderman refers to as "vernacular photography," it is a work designed to call attention to the spectacular racial, gendered, regional, and social porousness of rock and roll's volatile roots and the raucousness and taboo rebellion erupting in the spontaneous margins of culture, which ultimately informed the evolution of the music. Caricatures and archetypes abound in photographs detached from historical context, critical commentary, or narrative. It is a work that demands its own attention well beyond the scope and range of this chapter's central focus. Linderman's love of "vintage anonymous photographs of musicians," of "outsiders and eccentrics," served as the seeds of a project in which he seeks to convey "the beauty of anonymous, vernacular photographs," which "leave so much to the viewer's imagination. . . . The true history of our culture," he continues, "is told in anonymous photographs." According to Linderman, the aforementioned photo that held our attention "is a Real Photo postcard . . . common until around 1940 or so," and possibly "an arcade photo of some sort." Jim Linderman, *The Birth of Rock and Roll: Photographs from the Collection of Jim Linderman Plus a Conversation with Joe Bonomo* (Atlanta: Dust to Digital, 2014), n.p.; Jim Linderman, email to the author, February 13, 2020.

5. John Jeremiah Sullivan, email to the author, May 3, 2015. Sullivan folds in Wiley and Thomas lyrics here with references to their songs, "Skinny Leg Blues" and "(Come on) Over to My House." For a full list of transcribed lyrics for Wiley and Thomas's six songs, see "Geeshie

Wiley and Elvie Thomas Lyrics," WeenieCampbell.com, April 21, 2006, http://weeniecampbell .com/yabbse/index.php?topic=2269.0. See also AnneMarie Cordeiro, "Geechie Wiley: An Exploration of Enigmatic Virtuosity" (MA thesis, Arizona State University, 2011).

6. David Eng and David Kazanjian, "Introduction: Mourning Remains," in *Loss: The Politics of Mourning,* ed. David Eng and David Kazanjian (Berkeley: University of California Press, 2002), 1. Walter Benjamin, "Theses on the Philosophy of History," in *Illuminations* by Walter Benjamin, ed. Hannah Arendt and trans. Harry Zohn (New York: Harcourt Brace Jovanovich, 1968), 255. Eng and Kazangian, 6.

7. Eng and Kazanjian, 6.

8. Conversation with Jack Halberstam, spring 2015; Heather Love, *Feeling Backward: Loss and the Politics of Queer History* (Cambridge, MA: Harvard University Press, 2009), 43. The point Halberstam is making here aligns with historian Ashley Farmer's recent and illuminating overview of new scholarship aimed at addressing "the paradox of simultaneously finding copious archival records on some black women, while also accounting for the deafening archival silence on others." Says Farmer, "It is a question of how historians account for where and how these women wanted to be seen in the archive." Ashley D. Farmer, "Into the Stacks: In Search of the Black Women's History Archive," *Modern American History* 1, no. 2 (2018): 289, 292. Love's examination of literary and cultural intellectuals who engage in a "repertoire of queer modernist melancholia" focuses in part on "queer historical figures who may be turning their backs on us," and she wrestles with a lingering conundrum, one in which "these lost figures do not want to be found?" Of this puzzle, she asks, "What then?" Love, *Feeling Backward,* 5, 25, 37.

9. Fred Moten, "'Words Don't Go There': An Interview with Fred Moten," by Charles Henry Rowell, *Callaloo* 27, no. 4 (2004): 960; Moten, "Black Op," *PMLA* 123, no. 5 (2008): 1745. Moten here is building his points on Saidiya Hartman's theories of obscurity in her *Scenes of Subjection: Terror, Slavery, and Self-Making in Nineteenth-Century America* (New York: Oxford University Press, 1997).

10. Greil Marcus, "Who Was Geechie Wiley? The First and Last Kind Words from a Ghost of the Blues," *Oxford American,* Summer 1999.

11. Greil Marcus, *Three Songs, Three Singers, Three Nations* (Cambridge, MA: Harvard University Press, 2015), 62, 89; Sullivan, "Ballad of Geeshie and Elvie." For his early study of Wiley and Thomas's music, see John Jeremiah Sullivan, "Unknown Bards," in *Pulphead: Essays* (New York: Farrar, Straus and Giroux, 2011), 253–278. Scholars Alan B. Govenar and Kip Lornell indicate in their new study drawn from Robert "Mack" McCormick's and Paul Oliver's intersecting archives and correspondence on Texas blues culture that, when they "stumbled across this information" about Thomas in McCormick's personal archive "in spring 2013 while editing" their book, "both of [them] were as stunned by this information as Sullivan. This was a year or so before Sullivan visited McCormick at his northwest Houston home, and it underscores not only the gems of information hiding in this archive but also the popular interest in blues, even very obscure—though utterly haunting—artists like Thomas and Wiley." Alan Govenar and Kip Lornell, "Recording the Blues and the Folk Revival: A Prelude," in *The Blues Come to Texas: Paul Oliver and Mack McCormick's Unfinished Book,* by Paul Oliver and Mack McCormick, ed. Alan B. Govenar (College Station: Texas A&M University Press, 2019), 19.

12. Dean Blackwood, "The Revenant," liner notes for *American Primitive Vol. II: Pre-war Revenants (1897–1939),* Revenant Records, 2005, 14; Amanda Petrusich, *Do Not Sell at Any Price: The Wild, Obsessive Hunt for the World's Rarest 78rpm Records* (New York: Simon and Schuster, 2014), 36; John Fahey as quoted in Scott Blackwood, "Out of Their Anonymous

Dark," liner notes for *American Primitive Vol. II*, 3; conversation with Katie Lofton, February 2018. Toni Morrison reminds that "what is important . . . is that the critic not be engaged in laying claim on behalf of the text to his or her own dominance and power. Nor to imagine his or her professional anxieties for the imagined turbulence of the text. As has been said before, 'the text should become a problem of passion, not a pretext for it.'" Toni Morrison, "Black Matter(s)," in *The Source of Self-Regard: Selected Essays, Speeches, and Meditations* (New York: Knopf, 2019), 172.

13. Petrusich, *Do Not Sell*, 35.

14. Bryan Wagner, *Disturbing the Peace: Black Culture and the Police Power after Slavery* (Cambridge, MA: Harvard University Press, 2009), 35.

15. With regards to primitivism and literary modernisms, Michael North's influential study still remains instructive. Michael North, *The Dialect of Modernism: Race, Language, and Twentieth-Century Literature* (New York: Oxford University Press, 1994). See also Karl Hagstrom Miller, *Segregating Sound: Inventing Folk and Pop Music in the Age of Jim Crow* (Durham, NC: Duke University Press, 2010).

16. See Jennifer Stoever's theories of "the listening ear as the ideological filter shaped in relation to the sonic color line," "an aural complement to and interlocutor of the gaze . . . regulating cultural ideas about sound." Jennifer Stoever, *The Sonic Color Line: Race and the Cultural Politics of Listening* (New York: New York University Press, 2016), 13.

17. Rebecca Schneider, *Performing Remains: Art and War in Times of Theatrical Reenactment* (New York: Routledge, 2011).

18. The pioneers of Black feminist blues criticism have made my work possible. Hazel Carby, "It Just Be's Dat Way Sometime," in *Unequal Sisters: A Multicultural Reader in U.S. Women's History*, ed. Ellen Carol DuBois and Vicki Ruiz (New York: Routledge, 1990); Daphne Duval Harrison, *Black Pearls: Blues Queens of the 1920s* (New Brunswick, NJ: Rutgers University Press, 1988); Hortense Spillers, "Interstices: A Small Drama of Words," in *Black, White, and in Color: Essays on American Literature and Culture* (Chicago: University of Chicago Press, 2003), 152–175; Angela Davis, *Blues Legacies and Black Feminism* (New York: Vintage, 1999); Farah Jasmine Griffin, *If You Can't Be Free, Be a Mystery: In Search of Billie Holiday* (New York: Free Press, 2001).

19. On queer archiving and the politics of historiography, see Howard Chiang, "Archiving Peripheral Taiwan: The Prodigy of the Human and Historical Narration," *Radical History Review* 2014, no. 120 (2014): 204–225.

20. Marybeth Hamilton, *In Search of the Blues* (New York: Basic Books, 2009); Elijah Wald, *Escaping the Delta: Robert Johnson and the Invention of the Blues* (New York: Amistad, 2004); Sonnet Retman, "Memphis Minnie's 'Scientific Sound': Afro-Sonic Modernity and the Jukebox Era of the Blues," *American Quarterly* 72, no. 1 (March 2020): 75–102; Wagner, *Disturbing the Peace*, 35. Adds Wagner, "The black tradition was identified by its collectors among the last remnants from a disappearing world where artistic expression maintained its individuality" (35).

21. Hamilton, *In Search of the Blues*; Petrusich, *Do Not Sell*, 3–4.

22. Hamilton, *In Search of the Blues*. Both Hamilton and Petrusich trace the long arc of McKune's journey in collecting from his initial interest in jazz 78s in the 1930 to his violent demise in a New York City YMCA in 1971. Hamilton, especially 219–224. See also Petrusich, *Do Not Sell*, 121–127.

23. Fred Moten, "Chromatic Saturation," *The Universal Machine*, Consent Not to Be a Single Being (Durham, NC: Duke University Press, 2018), 156. See also Moten, "Black Opti-

mism/Black Operation," unpublished paper, 2012. Moten, "Black Op," *Stolen Life,* Consent Not to Be a Single Being (Durham, NC: Duke University Press, 2018).

24. Sullivan, "Unknown Bards," 253–254. Artist Joe Scanlan has hired various African American women to portray a Black character of his own invention, Donnell Woolford, and to assume that role in the public sphere. Controversy erupted in 2014 in response to Scanlan's work. See Carolina A. Miranda, "Art and Race at the Whitney: Rethinking the Donnell Woolford Debate," *Los Angeles Times,* June 17, 2014; and Steve Lowenthal, *Dance of Death: The Life of John Fahey* (Chicago: Chicago Review Press, 2014), 28. Lowenthal argues that "part of the appeal of an alias was being able to hide behind the significance of blues culture. With this cloak, he could obscure the fact that the music was made by a white surbanite" (27). On Fahey's career and legacy, see also David Fricke, "John Fahey, 1939–2001: A Folk Blues Innovator of the 1960s Who Became a Post Punk Hero in the 1990s," *Rolling Stone,* April 12, 2001, as reprinted at JohnFahey.com, https://www.johnfahey.com/Rolling%20 Stone%20Fricke.htm. On "Blind Joe Death" as well as Fahey's cult status, see James Cullingham, dir., *In Search of Blind Joe Death: The Saga of John Fahey* (Tamarek Productions, 2013). See also Sean O'Hagan, "John Fahey: The Guitarist Who Was Too Mysterious for This World," *Guardian,* November 26, 2013.

25. Petrusich describes "American-primitive" as "generally instrumental, and performed by a solo, steel-string guitarist working in an open tuning. The feel is introspective, if not plainly melancholic—like gazing out over flat water." Amanda Petrusich, "John Fahey and a Celebration of American-Primitive Guitar," *New Yorker,* April 12, 2018. She points out that "Eugene Denson, an owner and manager at Takoma Records, the label that Fahey founded, in 1959, suspects that he might have been the first to use the term, then a reference to the self-taught painters of the eighteenth through the twentieth centuries, and their gnarled, cockeyed canvasses," but she largely sidesteps the long history of the term in relation to racial modernisms. See also Lowenthal, *Dance of Death,* 13. For an extended discussion of Fahey's guitar style and innovations, see Cullingham, *In Search of Blind Joe Death.*

26. Barry Hansen in Cullingham, *In Search of Blind Joe Death.*

27. Jimmy Crossthwait in Cullingham.

28. Sullivan calls Fahey "a channeler of some kind, certainly; a 'pioneer' (as he once described his great hero, Charley Patton) 'in the externalization through music of strange, weird, even ghastly emotional states.'" Sullivan, "Unknown Bards," 253.

29. Sullivan, 258; Jessica Hopper, "Living with John Fahey aka A Room Full of Flowers," May 23, 2019, in *Lost Notes,* KCRW podcast, 38:13, https://www.kcrw.com/culture/shows/lost -notes/living-with-john-fahey-aka-a-room-full-of-flowers. Janet Fahey notes that she did not share any of Fahey's views, which, in part, contributed to the dissolution of their marriage. This episode of Jessica Hopper's podcast *Lost Notes* explores Fahey's problematic relationship with women. KCRW reporter Carla Green interviews Janet Fahey and his second wife, Melody, as well as various female fans and musicians who encountered Fahey, knew him intimately, and often idolized him as an iconic "master of the steel guitar" who was, nonetheless, prone to "cruel bully[ing]." Observes Green, "Throughout his life, Fahey undeniably suffered . . . and sometimes he inflicted that suffering on others." Hopper, "Living with John Fahey." See also Cullingham, *In Search of Blind Joe Death* which includes a brief allusion to Fahey's abusive relationship with one of his female accompanists and romantic partners.

30. John Fahey, *Charley Patton* (London: Studio Vista, 1970), 29; Dean Blackwood as quoted in Edward Gillan, dir., *Desperate Man Blues: Discovering the Roots of American Music* (Atlanta: Dust-to-Digital, 2006), DVD; Sullivan, "Unknown Bards," 261.

31. *78 Quarterly,* no. 11 (2000), https://s3.amazonaws.com/DinosaurDiscs/78+Quarterly +No+11.pdf. Pete Whelan, *78 Quarterly*'s founder and collector, published letters, images of memorabilia, and photographs from readers that amount to straight pinup magazine material. "Pete—I've sent you my favorite postcard," reads one correspondence with an accompanying illustration of a white woman genuflecting in heels with her rear to the viewer, "so 'you know by that,' how much I enjoyed the succulent photos in the new 78Q. Yumm . . . Great cover: great colors, great thighs. I think I'll flop it over my girlfriend's face next time I—nevermind . . . Tony." Letter to the editor, *78 Quarterly,* no. 11 (2000): 8. Williams seemingly named his label in the spirit of Harry Pace's historic Black Swan Records, which paid homage to mid-nineteenth-century African American opera phenom Elizabeth Taylor Greenfield by invoking her nickname for its own label. But the respectability politics of the two labels were clearly at odds, as Pace sought with his "race men" business partners such as W. E. B. Du Bois to promote African American class and cultural mobility through the representational politics of the label. In contrast, Williams extended his dealings in black and "blue" recordings. As historians have noted, Black Swan would quickly come to depend on the popular race records market as well to keep itself afloat. For more on Black Swan Records, see David Suisman, *Selling Sounds: The Commercial Revolution in American Music* (Cambridge, MA: Harvard University Press, 2012), 204– 239. *78 Quarterly*'s special issue on Black Patti Records juxtaposes *Chicago Defender* ads that trumpeted the brand legacy of Sissieretta Jones, the "biggest and brightest star in the firmament of song" with ads that promoted sides like the "Gang of Brown Skin Women," the kind of music that "you can't keep your feet from misbehaving" to when listening to these sides. Rolf von Arx, "A Glimpse at the Golden Years of Ida Cox," *78 Quarterly,* no. 11 (2000), 109–122. See also Petrusich, *Do Not Sell,* 206–207.

32. Petrusich, *Do Not Sell,* 199, 209, 201, 206; Gillan, *Desperate Man Blues.* Bussard has told his 1966 expedition tale on more than one occasion. He is also the longtime host of a weekly radio program on Georgia Tech's WREK Atlanta that focuses on American roots music, and from 1956 to 1970 he ran the independent label Fonotone Records. See Tom Tsotsi and Pete Whelan, with Joe Bussard, Matt Mintzell and Rolf von Arx, "Black Patti," *78 Quarterly,* no. 11 (2000), 11–92. Profiles of Bussard are numerous in the world of record collecting. See, for instance, Eddie Dean, "Desperate Man Blues," *Washington City Paper,* February 12, 1999, https://www.washingtoncitypaper.com/news/article/13017091/desperate-man-blues. Marshall Wyatt, "A Visit with Joseph E. Bussard, Jr.," *The Old Time Herald,* vol. 6, No. 7, http://www.oldtimeherald.org/archive/back_issues/volume-6/6-7/visit-bussard.html. Marc Minsker, "Joe Bussard: King of 78s," in *Dust and Grooves: Adventures in Record Collecting,* ed. Eilon Paz (New York: Ten Speed, 2015), 322–333.

33. Gillan, *Desperate Man Blues.* Bussard's reflections in the documentary include descriptions of his travels in which he describes having "met an old colored gentleman. He sold Paramount Records out of his house. . . . I was in heaven." The film also features Bussard comfortably interacting with two African American men who invite him to review their collection items for sale. Bussard also recounts his early childhood memories of first being drawn to music played by Black street musicians in his hometown in Maryland, stating, "When I was 8 or 9 years old I used to go down to the East part of town where the blacks lived . . . hear 'em playing mandolins and guitars right there on the street. . . . It was beautiful. There was one old guy who used to play a bottleneck guitar . . . used to sit and watch him." The familiar tropes of racial and cultural fascination, amusement, desire, "love and theft" course through his story. For the additional images of Bussard on his record-collecting expeditions, see the DVD extra chapter, "Joe Road Trip," in Gillan, *Desperate Man Blues.*

34. Bussard as quoted in Gillan, *Desperate Man Blues,* and in Bruce Elder, "Desperate Man Blues," liner notes for Gillan. Adds journalist Eddie Dean, who appears as a talking head in the film, "He's an independent . . . compared to the other collectors. . . . He doesn't believe in the Library of Congress. . . . He's done it on his own, and it's his. He figures if it's more accessible there . . . than if it were boxed up in some library. . . . It's like a public library when you go down." Gillan.

35. Petrusich, *Do Not Sell,* 201, 199.

36. Cullingham, *In Search of Blind Joe Death.* Adds Fahey in the film, "When I made my first record . . . I thought it'd be a good joke to have me on one side . . . and this guy Blind Joe Death on the other. . . . A lot of the people I learned from on 78rpm records . . . were blind. . . . Their names were 'Blind.' . . . Most of them were black." On hate in folk music culture, see the recent *New York Times* coverage of the newly released companion to Harry Smith's legendary *Anthology of American Folk Music* which reveals the collection's racist B-sides material. Grayson Haver Currin, "How to Handle the Hate in America's Musical Heritage," *The New York Times,* October 14, 2020.

37. R. Crumb, "Hunting for Old Records: A True Story," *Oxford American,* Summer 1999. The events depicted in the R. Crumb cartoon bear some similarity to an incident that Joe Bussard recounts in the *Desperate Man Blues* DVD extra—with one crucial exception being the ending to Bussard's tale versus that of Crumb's. "I went to this place one time," Bussard begins, "probably in the '60s. This woman had the most beautiful records I had ever seen in my life. And she was kind of hesitating, you know . . . this and that. And I said [to myself], 'oh my God, is she going to sell these records?' . . . I picked out what I wanted. I had a $50 bill. And I says," raising his voice, "'Thank you so much! I'll see you, 'bye'! And out the door I went. I didn't even give her any time to say 'yes' or 'no'! I was out. . . . Before—I think she was still spinning around. I wasn't gonna give her time to think." "Joe Road Trip," DVD extra, in Gillan, *Desperate Man Blues.* Even as R. Crumb is clearly capable of blunt commentary about his own white masculinist privilege in the world of collecting, one should never lose sight of the well-documented and openly avowed misogyny in the cartoonist's body of work, which the *Crumb* documentary explores at length. The album cover for Yazoo Records' "old time hokum blues" compilation entitled *Please Warm My Weiner,* which Crumb designed, is a blatant example of the racist and sexist dimensions of the artist's politics and aesthetics, as it features two minstrel blackface male bluesmen ogling a well-endowed, scantily dressed Black female figure passing them by on the street. *Please Warm My Weiner,* Yazoo Records, 1974. Oxford, Mississippi, collector Scott Barretta reads the cover as "cheeky, politically incorrect art." He continues, "With its bawdy title and minstrel-like images, this record could be seen as a thumb in the face of the overly serious social and political analysis of the blues typically found on other reissues." Scott Barretta as quoted in Paz, *Dust and Grooves,* 109.

38. Petrusich, *Do Not Sell,* 116.

39. Amanda Petrusich is a *Pitchfork* and a *New Yorker* staff writer, as well as an independent pop music scholar. From 2016 to 2018, she and I served with Gayle Wald and Kevin Dettmar as coeditors of the 33 1/3 Books about Music series for Bloomsbury Press. Her writing is always gripping and compelling, and I consider her an important interlocutor in spite of our distinct approaches to blues music criticism.

40. Petrusich, *Do Not Sell,* 176.

41. Petrusich, 42–43, 37; James Weldon Johnson, "O Black and Unknown Bards," in *The Book of American Negro Poetry* (Chicago: Book Jungle, 2008).

42. Wagner, *Disturbing the Peace,* 21.

43. Sullivan, "Unknown Bards," 276. See also Hamilton, *In Search of the Blues*; and Wald, *Escaping the Delta*. Petrusich adds that "McKune's discovery of Patton set off an avalanche of cultural events, a revolution that's still in progress: blues records became coveted by collectors, who then fought to preserve and disseminate them. . . . [He] was the first collector to realize how powerful these artists could be outside of their original contexts." Petrusich, *Do Not Sell*, 127.

44. Sullivan, "Ballad of Geeshie and Elvie." The brilliance and commitment of Sullivan's research assistant, then–college student Love, cannot be overstated. See her *New York Times* blog post in which she details her diligence in attempting to locate Scott's gravesite. Here Love also details her and Sullivan's researched theory that "if Wiley was really Lillie Mae Scott, and Scott was a second married name and not a maiden name, as we assumed, then, according to a dense collection of census records, Wiley's maiden name was Lillie Mae Boone, and Lillie Mae (Wiley / Scott) Boone died of head trauma in 1950 and was buried with her mother, Cathrine Nixson in Brushy Cemetery in Burleson County, Tex., a quiet plot of land on private property in the country about two hours outside Houston." Caitlin Love, "On Geeshie Wiley's Trail," *The 6th Floor* (blog), *New York Times,* April 18, 2014, https://6thfloor .blogs.nytimes.com/2014/04/18/on-geeshie-wileys-trail/.

45. Sullivan, "Ballad of Geeshie and Elvie." For an excellent study of archival Black women's lives entangled with racism, sexism, criminality, and the juridical system, see Kali Nicole Gross, *Hannah Mary Tabbs and the Disembodied Torso: A Tale of Race, Sex, and Violence in America* (New York: Oxford University Press, 2016).

46. Sullivan, "Ballad of Geeshie and Elvie." The details of L. V.'s solitary life in Mount Pleasant, Texas, as recounted by family members in Sullivan's article suggest a kind of queerness that Halberstam argues emerges "as an outcome of strange temporalities, imaginative life schedules, and eccentric economic practices." Her queer time "leaves the temporal frames of bourgeois reproduction and family," as well as—in her disappearance from the blues archive—"longevity, risk / safety, and inheritance." Jack Halberstam, *In a Queer Time and Place: Transgender Bodies, Subcultural Lives* (New York: New York University Press, 2005), 1, 6. For more on queer blues women's cultures, see the work of Cookie Woolner. Cookie Woolner, "'Ethel Must Not Marry': Black Swan Records and the Queer Classic Blues Women," IASPM-US Conference, March 8, 2012, https://iaspm-us.net/iaspm-us-conference -preview-cookie-woolner/.

47. Sullivan, "The Ballad of Geeshie and Elvie"

48. In his epic tale of investigative diligence and knotty relations with McCormick, Sullivan reveals his discovery, crucially aided by Love, of an extant interview with Thomas in McCormick's possession. Sullivan, "The Ballad of Geeshie and Elvie." Scott Herring, *The Hoarders: Material Deviance in Modern American Culture* (Chicago: University of Chicago Press, 2014), 7.

49. Ominously, he builds towards the denouement of his story by recounting how "scans were coming through of old yellowed pages. Typescript, ring-binder holes in the left margin. 'L.V. Thomas. . . . Interviewed June 20, 1961.' . . . She told him she was born in August 1891, in Houston. 'I was born right down here at 3116 Washington Avenue,' she said. She continues: 'I started playing guitar when I was about 11 years old. There were blues even back then. It wasn't so big a part of music as later but there were blues. I can't hardly name them—I don't know that those songs had a name. One song was, 'Oh, My Babe Take Me Back,' and another was 'Jack O' Diamonds.' There was a lot of set pieces, stuff that'd be called for dancing, that everybody learned. . . . 'But in 1937 I joined the church so I gave up all I ever did know about

music. I joined the Master and followed after him and gave up all my music since 1937 and I hate for you to ask me about my sinful days. I'm a member of the Mount Pleasant Baptist Church out here in Acres Homes and that's the only place I do any singing anymore. . . .' The two interviews went on for four single-spaced pages. . . ." Sullivan, "The Ballad of Geeshie and Elvie."

50. Herring, *The Hoarders,* 16.

51. Eilon Paz's *Dust and Grooves* is a monumental, ambitious (and excellent) coffee-table documentation of contemporary, global record collector subcultures, and it is one of the few studies to profile female record collectors. Some of the women included are deejays, others are music critics, and still others devote themselves entirely to hunting for and archiving rare vinyl from specific popular music subgenres. Among those included in Paz's volume are Margaret Barton Fumo, Jess Rotter, Sheila Burgel, Valerie Calano, Natasha Diggs, Julia Rodionova, Alexandra Henry, Colleen Murphy, Debra Dynamite, Edan, Miriam Linna, and Rebecca Birmingham. The vast majority of these collectors are white and based in Brooklyn, New York. Latina Arlene "Soulera 5150" Sepulveda of Los Angeles and African American Melissa "Soul Sister" Weber of New Orleans are two women of color in *Dust and Grooves* who live and work outside the New York City area. See Paz, *Dust and Grooves.* Girl group records collector Burgel sat for an informative interview on gender politics and record collecting. See Sheila Burgel, "Melody, Hooks, and Magic: Sheila Burgel," interview by Eilon Paz, in Paz, *Dust and Grooves,* 334–345. See also Eilon Paz, "Margaret Barton Fumo—Brooklyn, NY: The Prog Lady in Her Natural Habitat," Dust and Grooves, June 9, 2011, http://www .dustandgrooves.com/margaret-barton-fumo-brooklyn-ny-2/. For more on Melissa "Soul Sister" Weber, see her website at http://www.djsoulsister.com. For more on Arlene "Soulera 5150" Sepulveda, see Oliver Wang, "Arlene Sepulveda and Ruben Molina: The Southern Soul Spinners: Revolving around the Eastside Sound," Dust and Grooves, January 24, 2014, http://www.dustandgrooves.com/south_spinners/. See also the exciting work of self-described "DJ scholar" Lynnée Denise, who figures herself as a Black feminist DJ archivist. http://www.djlynneedenise.com

52. Petrusich, *Do Not Sell,* 185; Eng and Kazanjian, "Introduction," 2. The story behind Sullivan's engagement with McCormick's archive and especially his decision to cite the Thomas letter in McCormick's possession has been an ongoing source of controversy. See Matthew Kassel in "Robert McCormick's Daughter 'Appalled' by *NY Times Magazine* Cover Story," *Observer,* April 29, 2014, https://observer.com/2014/04/robert-mccormicks -daughter-responds-to-nyt-magazine-cover-story/. Kassel references McCormick's daughter's email in which she accuses Sullivan of "thievery." See also Sullivan's eloquent and principled response, worth citing here for what it conveys about his own sense of seeming ethical commitment to the story. "I would submit," he argues, "that by hiding L. V. Thomas's voice, by refusing for over half a century to credit or even so much as name the two singers who created those recordings while they or their contemporaries were alive, Mack McCormick committed a theft—through negligence or writer's block or whatever reasons of his own—far graver than my citation of interviews L. V. granted him decades ago. I don't think he could help it. I tried to write that too." Matthew Kassel, "John Jeremiah Sullivan Responds to *NYT* Controversy regarding Robert McCormick," *Observer,* May 1, 2014, https://observer .com/2014/05/john-jeremiah-sullivan-responds-to-nyt-controversy-regarding-robert -mccormick/.

53. Marcus, *Three Songs,* 68.

54. Marcus, 89, 91.

55. Albert Murray, "Improvisation and the Creative Process," in *The Jazz Cadence of American Culture*, ed. Robert G. O'Meally (New York: Columbia University Press, 1998), 111. Marcus, *Three Songs, Three Singers, Three Nations*, 111; Gerard Ramm, oral presentation at the University of California, Berkeley, fall 2015.

56. Lisa Lowe argues that the *"past conditional temporality* of the 'what could have been' symbolizes aptly the space of a different kind of thinking, a space of productive attention to the scene of loss, a thinking with a twofold attention that seeks to encompass at once the positive objects and methods of history and social science, and also the matters absent, entangled, and unavailable by its methods." Lisa Lowe, *The Intimacies of Four Continents* (Durham, NC: Duke University Press, 2015), 40. Marcus uses much the same style of historically speculative writing in the Johnson passage in *The History of Rock 'n' Roll*. Here he offers "other ways to tell the story" of artists who "disappeared from public life" or "who lived on in obscurity for decades after they wrote their names in invisible ink on the American map, unseen and unheard." Marcus's Johnson is a kind of revenant figure from his earliest appearance in 1975's *Mystery Train* who moves across space and time, all the way from Memphis to New York City in 1938 (just in time to attend the legendary From Spirituals to Swing concert he famously missed on account of death), all the way to working with N.W.A. and Clive Davis (who gets him his lost royalties), sitting for interviews on *Fresh Air* and reading Dylan's *Chronicles*. Greil Marcus, *The History of Rock 'n' Roll in Ten Songs* (New Haven, CT: Yale University Press, 2014), 154–164. Marcus's Wiley makes an appearance here as well when Johnson suggests to fellow literary salon attendee, a young Ralph Ellison, that he use "Pick Poor Robin Clean" for the prologue of his novel-in-progress, *Invisible Man*. Marcus, *History*, 158–159. For more on "Pick Poor Robin Clean," see Chapter 7.

57. Stefano Harney and Fred Moten, *The Undercommons: Fugitive Planning and Black Study* (New York: Autonomedia, 2013), 11.

58. Sonnet Retman, conversation with the author, October 2013; Silvia Spitta, "On the Monumental Silence of the Archive," in "On the Subject of Archives," ed. Marianne Hirsch and Diana Taylor, special issue, *emisférica* 9, nos. 1–2 (Summer 2012), http://www.hemisphericinstitute.org/hemi/en/e-misferica-91/spitta. Hortense Spillers famously refers to the "powerful stillness" of "ethnicity" as it "freezes in meaning, takes on constancy, assumes the look and affect of the Eternal" in 1965's devastatingly obtuse Moynihan Report, "The Negro Family: The Case for National Action." Hortense Spillers, "Mama's Baby, Papa's Maybe: An American Grammar Book," *Black, White and In Color: Essays on American Culture* (Chicago: University of Chicago Press, 2003), 205.

59. Sullivan, "Ballad of Geeshie and Elvie."

60. Greil Marcus, email to the author, September 15, 2015. For more on Sojourner Truth and photographs, see Darcy Grimaldo Grigsby, *Enduring Truths: Sojourner's Shadows and Substance* (Chicago: University of Chicago Press, 2015). See also Nell Painter, *Sojourner Truth: A Life, a Symbol* (New York: Norton, 1997).

61. Marcus, *Three Songs*, 67. And the hunt continues. The French edition of Marcus's book includes a photo from the 1930s of two stylishly dressed Black women, decked out in flowing culottes and matching sleeveless blouses, posing on a porch. The photo was supplied by Texas archivists Jon Hoigan and Maria Moss of Marfa, Texas, and found in an Oklahoma flea market by Lynne Rostochil, photo archivist in Dallas. The group invited Sullivan to corroborate whether Wiley and Thomas are the pair in the image. Marcus's note in this edition of *Three Songs* states, "On ne pourra probablement jamais identifier les deux femmes

avec certitude, mais des details de la photo restent plus qu'evocateurs" (The two women will probably never be able to be identified with certainty, but details of the photo remain more than evocative). Greil Marcus, *Three Songs, Three Singers, Three Nations,* French ed. (Paris: Editions Allia, 2018), 99. My thanks to Greil Marcus for sharing this volume with me and for his long-standing generosity on the Geeshie and Elvie journey.

62. Ann Cvetkovich, *An Archive of Feelings: Trauma, Sexuality, and Lesbian Public Cultures* (Durham, NC: Duke University Press, 2003), 243; Saidiya Hartman, "Venus in Two Acts," *small axe* 26 (June 2008): 2–3. See also Hartman, *Wayward Lives, Beautiful Experiments.*

63. Kara Keeling, Jacqueline Stewart, and Daphne A. Brooks, "'If You Should Lose Me': Looking for Labor in Black Women's Performance Archives" (co-lecture, Program in American Studies and Ethnicity lecture series, University of Southern California, Los Angeles, May 2015); Cvetkovich, *Archive of Feelings,* 228; Valerie Rohy, "In the Queer Archive, *Fun Home,*" *GLQ* 16, no. 3 (2010): 354, 342, .

64. Ann Cvetkovich, "Queer Archival Futures: Case Study Los Angeles," in "On the Subject of Archives," ed. Marianne Hirsch and Diana Taylor, special issue, *emisférica* 9, nos. 1–2 (Summer 2012), http://www.hemisphericinstitute.org/hemi/en/e-misferica-91/cvetkovich. Hartman, "Venus in Two Acts"; Hartman, *Wayward Lives, Beautiful Experiments.*

65. Marshall, Murphy, and Tortorici, "Editors' Introduction," 4.

66. Cvetkovich, "Queer Archival Futures;" Hartman, "Venus in Two Acts," 12.

67. Kara Keeling, "Looking for M: Queer Temporality, Black Political Possibility, and Poetry from the Future," *GLQ* 15, no. 4 (2009): 572. See Moten, "Black Optimism / Black Operation." See also Fred Moten, *Black and Blur,* Consent Not to Be a Single Being (Durham, NC: Duke University Press, 2018); Wagner, *Disturbing the Peace;* and Kara Keeling, *Queer Times, Black Futures* (New York: New York University Press, 2019), 81–105. Here Keeling also discusses Cheryl Dunye's landmark 1996 Black feminist queer speculative film *Watermelon Woman.*

68. On the violence of obscurity as a figure of knowledge in the queer archive, see Love, *Feeling Backward,* 47–51. On queer failure, see Judith (Jack) Halberstam, *The Queer Art of Failure* (Durham, NC: Duke University Press, 2011).

69. One awaits, for instance, an ode to Lottie Beaman's (a.k.a. Lottie / Lena Kimbrough's) works. A Kansas City vocalist, Lottie Kimbrough married William Beaman and began her recording career with Paramount in 1924. Known for her arresting, keening vocals that ring with an almost cosmic lilt, Beaman's recordings anticipate the iridescent beauty of twenty-first century folk and blues experimentalist Valerie June. See for instance, Lottie Kimbrough and Winston Holmes, "Wayward Girl Blues," *Lottie Kimbrough and Winston Holmes* (1928–1929) (Wolf Records). See also "Lottie Beaman," *The Rise and Fall of Paramount Records, Field Manual FM 21-100, Paramount Records, Volume 1 (1917–1927)* (Port Washington, WI: New York Recording Laboratories Inc.; re-released by Revenant Records / Third Man Records, 2013), 24. "Lottie Kimbrough," Wikipedia, https://en.wikipedia.org/wiki/Lottie _Kimbrough. Similarly, there is work to be done to devise a kind of study that can play alongside Louise Johnson, the vocalist and pianist for whom little is known beyond the fact that the Mississippi musician ended up performing four songs with Charley Patton, Son House, and Willie Brown during a storied recording session for Paramount up in Grafton, Wisconsin in May of 1930. Volume 2 of the Paramount *Field Manual* notes that "'Son' House remembered her as a young woman about twenty-three or twenty-four years old and being Charley

Patton's mistress. 'She didn't do but drink and play music; she worked for nobody,'" said Son House. She may have also "ru[n] a juke business on the side" while farming. Johnson's zealously "blue" style of blues, her piano duets with another sister in the 1930s, her alleged romance with both Patton and Son House, and the vernacular lore about her solo gigging in to the fifties are all reasons to absorb her as a source of Black feminist radical tradition blues studies. See "Louise Johnson," *The Rise and Fall of Paramount Records, Field Manual, Paramount Records, Volume 2 (1928–1932)* (Port Washington, WI: New York Recording Laboratories Inc.; re-released by Revenant Records / Third Man Records, 2014), 177. See also "Louise Johnson" (blues), Wikipedia, https://en.wikipedia.org/wiki/Louise_Johnson_(blues).

70. Spitta, "On the Monumental Silence."

71. Keeling, "Looking for M," 572, 577.

72. Fred Moten, "Blackness and Nothingness," *South Atlantic Quarterly* 112, no. 4 (2013): 737–780.

73. Amiri Baraka, "S.O.S.," in *S.O.S.: Poems, 1961–2013* (New York: Grove, 2016). Consider as well Toni Morrison's call for "the development of a theory of literature that truly accommodates Afro-American literature," and imagine replacing the word "literature" with "music." Here Morrison urges for a theory "based on its culture, its history, and the artistic strategies the works employ to negotiate the world it inhabits." Morrison, "Black Matter(s)," 172.

74. Petrusich, *Do Not Sell*, 237–238; Theodor Adorno, "The Form of the Phonograph Record," in *Essays on Music*, ed. Richard Leppert (Berkeley: University of California Press, 2002), 280.

75. Petrusich, *Do Not Sell*, 5; Herring, *Hoarders*, 17.

6. "If You Should Lose Me"

1. Scott Blackwood, "How to Make a Race Record," *The Rise and Fall of Paramount Records, Volume One (1917–1927)* (Revenant Records / Third Man Records, 2013), 59.

2. Jackie Kay, *Bessie Smith* (Bath: Absolute, 1997), 56, emphasis in the original. For Albertson's account of this incident, see Chris Albertson, *Bessie* (New Haven, CT: Yale University Press, 2003), xi–xiii.

3. Saidiya Hartman, *Wayward Lives, Beautiful Experiments: Intimate Histories of Social Upheaval* (New York: Norton, 2019), xv.

4. Kay, *Bessie Smith*, 57–60, all emphasis in the original. Kay's work is one of several Black feminist speculative explorations of iconic musicians by poets. See, for instance, the landmark work of Rita Dove, whose daring, probing, interventionist verse on Billie Holiday influenced the likes of Farah Griffin's revisionist study of Lady Day. Rita Dove, "Canary," 1989, Poetry Foundation, https://www.poetryfoundation.org/poems/43359/canary. See too Yona Harvey's luminous poems in which she considers the life and work of Mary Lou Williams. Yona Harvey, "Communion with Mary Lou Williams," in *Hemming the Water* (New York: Four Way Books, 2013), 42–46.

5. Marianne Hirsch and Diana Taylor, "Editorial Remarks," in "On the Subject of Archives," ed. Marianne Hirsch and Diana Taylor, special issue, *emisférica* 9, nos. 1–2 (Summer 2012), http://www.hemisphericinstitute.org/hemi/en/e-misferica-91/hirschtaylor; Lindon Barrett, *Blackness and Value: Seeing Double* (NY: Cambridge University Press, 1999); Jack

Halberstam, *In a Queer Time and Place: Transgender Bodies, Subcultural Lives* (New York: New York University Press, 2005), 169–170.

6. See Scott Blackwood, "Introduction: Out of the Anonymous Dark," *Rise and Fall, Volume 1*, 11. We might think of her work as the narrative accompaniment to the curious archival ephemera left behind in the blues archive like the photograph of Jimmy O'Bryant's (Famous Original) Washboard Band in 1925, which features band members Papa Charlie Jackson, the legendary "hokum" blues musician, on banjo; Jasper Taylor on washboard; Arnold Wiley on keys; and O'Bryant on reed, all flanking vocalist Irene Wiley, who stands at the center of the band but whose image has apparently been destroyed by the singer herself. According to Paramount Records historians, it was this Wiley (not Geeshie) who "tore out her own image . . . preferring the photo of herself" peering confidently into the camera, holding a large feather fan to her chest, sitting with one hand on hip, and sharing the piano bench with husband Arnold. The hole in the photograph is testimony to the provocative ways in which blues women self-consciously managed their own modes of self-representation.

7. José Esteban Muñoz, "Ephemera as Evidence: Introductory Notes to Queer Acts," *Women and Performance* 8, no. 2 (1996): 10–11.

8. Hartman, *Wayward Lives,* 9.

9. Saidiya Hartman, "Venus in Two Acts," *Small Axe* 26 (vol. 12, no. 2) (2008): 3.

10. Toni Morrison, *Beloved* (New York: Vintage, 1987); Sherley Anne Williams, *Dessa Rose* (New York: Harper Perennial, 2018); Octavia Butler, *Kindred* (Boston: Beacon, 2003); June Jordan, "The Difficult Miracle of Black Poetry in America: Something like a Sonnet for Phillis Wheatley," in *Some of Us Did Not Die: New and Selected Essays* (New York: Basic / Civitas Books, 2003), 174–186.

11. Jordan, "Difficult Miracle"; Ann Cvetkovich, "Queer Archival Futures: Case Study of Los Angeles," in "On the Subject of Archives," ed. Marianne Hirsch and Diana Taylor, special issue, *emisférica* 9, nos. 1–2 (Summer 2012), http://www.hemisphericinstitute.org/hemi/en /e-misferica-91/cvetkovich; Toni Morrison, "The Site of Memory," in *The Source of Self-Regard: Selected Essays, Speeches, and Meditations* (New York: Knopf, 2019), 238; Ann Cvetkovich, *An Archive of Feelings: Trauma, Sexuality, and Lesbian Public Cultures* (Durham, NC: Duke University Press, 2003), 241. For more on Dunye's film, see Kara Keeling, *Queer Times, Black Futures* (New York: New York University Press, 2019), 81–105. See also Dunye and photographer Zoe Leonard's ancillary *Watermelon Woman* book of images, which extends the fabulist mythology of the film. Zoe Leonard and Cheryl Dunye, *The Fae Richards Photo Archive* (San Francisco: Artspace Books, 1996). For more on "Afro-fabulation," see Tavia Nyong'o's coinage of the term and study of the same name. Tavia Nyong'o, *Afro-fabulations: The Queer Drama of Black Life* (New York: New York University Press, 2018).

12. Carolyn Dinshaw as quoted in Heather Love, *Feeling Backward: Loss and the Politics of Queer History* (Cambridge, MA: Harvard University Press, 2009), 37. See also Carolyn Dinshaw, *Getting Medieval: Sexualities and Communities, Pre- and Postmodern* (Durham, NC: Duke University Press, 1999).

13. Muñoz, "Ephemera as Evidence," 13; Ashley D. Farmer, "Into the Stacks: In Search of the Black Women's Historical Archive," *Modern American History* 1, no. 2 (2018): 293. See also Dinshaw, *Getting Medieval.* For more on queerness, temporality, and historical memory, see José Esteban Muñoz, *Cruising Utopia: The Then and There of Queer Futurity* (New York: New York University Press, 2009); and Elizabeth Freeman, *Time Binds: Queer Temporalities, Queer Histories* (Durham, NC: Duke University Press, 2010).

14. Cvetkovich, "Queer Archival Futures"; Kay, *Bessie Smith,* 57; Blackwood, "How to Make a Race Record," 59. See also Linda Dahl, "The Ones That Got Away," in *Stormy Weather: The Music and Lives of a Century of Jazz Women* (New York: Limelight Editions, 1989). A onetime graduate student in folklore at the University of California, Berkeley, Weems has often referenced "Zora Neale Hurston's writings" as a source of inspiration for her work. See, for instance, Megan O'Grady, "How Carrie Mae Weems Rewrote the Rules of Image-Making," *New York Times Magazine,* October 15, 2018.

15. Carrie Mae Weems, *Ode to Affirmative Action,* 1989, held at the Nasher Museum of Art at Duke University; O'Grady, "How Carrie Mae Weems Rewrote the Rules of Image-Making."

16. Shane Vogel, *Stolen Time: Black Fad Performance and the Calypso Craze* (Chicago: University of Chicago Press, 2018), 33.

17. Carrie Mae Weems, *Ode to Affirmative Action,* 1989, held at the Nasher Museum of Art at Duke University; Richard Powell as quoted in Franklin Sirmans, "A World of Her Own: Carrie Mae Weems and Performance," in *Carrie Mae Weems: Three Decades of Photography and Video,* ed. Kathryn Delmez (New Haven, CT: Yale University Press, 2012), 46.

18. Alexandra Chassanoff, "Life Has Surface Noise: (Further) Ruminations on the Record," Hastac, January 23, 2012, emphasis in the original, https://www.hastac.org/blogs/achass /2012/01/23/life-has-surface-noise-further-ruminations-record.

19. Powell as quoted in Sirmans, "World of Her Own," 46–47; Chassanoff, "Life Has Surface Noise."

20. Antoinette Burton, *Dwelling in the Archive: Women Writing House, Home, and History in Late Colonial India* (New York: Oxford University Press, 2003), 144, emphasis in the original. Burton contends that "if the history of the archive is the story of loss, this need not mean the end of History, though it begins to explain why some historians are so eager to place archives under 'protective custody'" (144).

21. Carrie Mae Weems, *Who, What, When Where 1998;* see http://carriemaeweems.net /galleries/who-what.html. Kathryn E. Delmez reads *Who, What, When, Where* as a work that conveys "unveiled calls for social equality and political reform" as it imagines the methods for actuating Black revolution. Kathryn E. Delmez (ed.), *Carrie Mae Weems: Three Decades of Photography and Video* (New Haven, CT: Frist Center for Visual Arts in association with Yale University Press, 2012). This online version of the piece differs from the version included in the aforementioned anthology. In the Delmez-edited collection, *Who, What, When, Where, 1998* features the image of a rolling pin set against the same red backdrop in which the other objects in this piece are situated. The Malcolm X mantra, "By Any Means Necessary" appears at the bottom of the frame.

22. Maurice Berger, "Black Performers, Fading from Frame, and Memory," *New York Times,* January 22, 2014. See also Weems's 2017 conversation and photo shoot with Mary J. Blige in *W* magazine in which she references her *Slow Fade to Black.* Here Weems warmly tells the musician Blige "about this beautiful image I have of . . . Dinah Washington, who, too, is crowned. The act of crowning is about giving it up, it's the act of recognition. For this project, I knew I had to participate in crowning you as a gift and an homage." Carrie Mae Weems, "Crowning Glory," in "The Art Issue," *W,* December 2017, 84–89.

23. Two different versions of *Slow Fade to Black* exist: The 2010–2011 *Slow Fade to Black* exhibit. The first ran from April 22–May 22, 2010 at the Jack Shainman Gallery in New York City and includes a Hattie McDaniel photograph. See https://jackshainman.com /exhibitions/slow_fade_to_black. *Slow Fade to Black II,* 2010, printed 2012 was purchased by

the National Art Gallery in Washington, D.C. in 2014. https://www.nga.gov/collection/art-object-page.165237.html Almost all of the fourteen images are approximately 9″ × 12″, with the exception in this first version of the exhibit of the inkjet print of Eartha Kitt, which is twice as large. My thanks to Carrie Mae Weems for her assistance with this information. In 2019, the Scotiabank Photography Festival in Toronto featured a massive outdoor public installation version of *Slow Fade* with "13 larger than life portraits" of Black women artists "bridging several generations . . ." and "presented at a crossroads in Toronto's Entertainment District. . . ." See "Carrie Mae Weems Slow Fade to Black," https://scotiabankcontactphoto.com/archived/slow-fade-to-black/. Of the artists who appear in photographs in the first iteration of the exhibit—Billie Holiday, Josephine Baker, Sarah Vaughan, Hattie McDaniel, Dorothy Dandridge, Ethel Waters, Katherine Dunham, Pearl Bailey, and Lena Horne—all had careers which included musicianship. Even McDaniel cut her teeth as a songwriter, a minstrel perfomer, and a recording artist for Okeh and Paramount, and Dunham, the prodigious choreographer, was a composer and songwriter as well. Though known for being a "screen siren," Dandridge made recordings with her sisters in the late 1930s and 1940s before embarking on a solo recording career that stretched into the early 1960s. Other versions of the exhibit include images of Abbey Lincoln, Marian Anderson, Ella Fitzgerald, Nina Simone, Dinah Washington, and Mahalia Jackson. See Delmez, *Carrie Mae Weems*, 242.

24. For more on Hattie McDaniel's long and diverse career as a street performer, a blues musician, a comedienne and stage entertainer, and a film star, see Jill Watts, *Hattie McDaniel: Black Ambition, White Hollywood* (New York: Amistad, 2005).

25. Alice Walker, "In Search of Our Mothers' Gardens," in *In Search of Our Mothers' Gardens: Womanist Prose* (New York: Harcourt, 1983), 234.

26. Portland Art Museum, "Carrie Mae Weems: An Artist Reflects," YouTube video, 1:29:03, posted February 6, 2013, https://www.youtube.com/watch?v=hiPL1GPhpgU.

27. See Colin Hanks's love letter documentary to the once-beloved and now-defunct Tower Records, Colin Hanks, dir., *All Things Must Pass: The Rise and Fall of Tower Records* (New York: FilmRise, 2015).

28. Jacqueline Najuma Stewart, *Migrating to the Movies: Cinema and Black Urban Modernity* (Berkeley: University of California Press, 2005), 8.

29. Historians like Tera Hunter have offered illuminating and nuanced studies of Southern Black women's social lives in the wake of the Civil War, and various other scholars have focused on the sociality and cultural lives of Black women and especially Black women artists from later periods such as the Harlem Renaissance and the 1940s. But little to no work exists on either Black girlhood or young Black womanhood specifically in relation to the social world of blues records. See Tera Hunter, *To 'Joy My Freedom: Black Women's Lives and Labors after the Civil War* (Cambridge, MA: Harvard University Press, 1998); Cheryl Wall, "On Being Young—a Woman—and Colored: When Harlem Was in Vogue," in *Women of the Harlem Renaissance* (Bloomington: Indiana University Press, 1995), 1–32. See also LaKisha Michelle Simmons, *Crescent City Girls: The Lives of Young Black Women in Segregated New Orleans* (Chapel Hill, NC: University of North Carolina Press, 2015), esp. 174–205; and Marcia Chatelain, *South Side Girls: Growing Up in the Great Migration* (Durham, NC: Duke University Press, 2015). Griffin calls some of the city-based young women of the World War II era the "too too girls," in allusion to the rebellious excess and vernacular plenitude of their Harlem lives. See Farah Jasmine Griffin, *Harlem Nocturne: Women Artists and Progressive Politics during World War II* (New York: Nation Books, 2013). See also Hartman, *Wayward Lives,*

for not only an epic meditation on the radical sociality of early twentieth-century Black girlhood but an expansive exploration of Black queer and nonconforming youth sociality during this era as well. For more on precarity and Black girlhood, see Aimee Cox, *Shapeshifters: Black Girls and the Choreography of Citizenship* (Durham, NC: Duke University Press, 2015).

30. Marsha Music, "Joe Von Battle: Requiem for a Record Shop Man," Marsha Music: A Grown Woman's Tales from Detroit, accessed July 23, 2020, https://marshamusic.wordpress .com/page-joe-von-battle-requiem-for-a-record-shop-man/; Simmons, *Crescent City Girls,* 178. Marsha Music has written extensively about her memories of her father Joe Von Battle's record shop and studio, which opened on Hastings Street in 1945. The shop and studio were both destroyed, as she notes on her website, "in Detroit's '67 Rebellion." Music, "Joe Von Battle." In my interview with Ms. Music, she provided a rich and vivid history of her father's shop, his origins in the record sales business, his partnership making records with John Lee Hooker, Reverend C.L. Franklin, a young Aretha, and others, and the devastating damages Joe's Record Shop weathered as a result of the Detroit 1967 racial uprising. Marsha Music notes that her father showed a willingness to provide operational space to an ambitious woman named "Idessa," a Black woman record company / label owner who is believed to have owned the Staff Record company from 1949 to 1952. Author's phone interview with Marsha Music, July 31, 2020; Marsha Music, email to author, July 31, 2020.

31. Toni Morrison, foreword to *Jazz* (New York: Vintage: 2004), xvi; Toni Morrison, "Borderlife," George Mason University lecture, October 31, 1995; Box 297, Folder 19, Toni Morrison Papers, Special Collections, Princeton University.

32. Toni Morrison, "Opera America" Keynote Address, May 5, 2005, Box 300, Folder 33, Toni Morrison Papers; Betty Fussell, "All That Jazz," *Lear's,* October 1992, 71; Morrison, "Opera America" Keynote Address, May 5, 2005; Morrison, foreword to *Jazz,* xix; and Toni Morrison, "Opera Club of America Speech," April 19, 2006, lecture manuscript draft, Box 301, Folder 11, Toni Morrison Papers. Morrison's numerous collaborations with musicians include writing lyrics for a 1995 Kathleen Battle song cycle, *Honey and Rue,* with music by Andre Previn, Sylvia McNair, and Jessye Norman. She wrote the book and lyrics for an unproduced musical, *New Orleans,* which focuses on the Storyville district circa 1917. She performed live with Max Roach and Bill T. Jones and wrote the libretto for Richard Danielpour's 2005 opera *Margaret Garner,* about the historical figure whose ordeal inspired *Beloved.* Her collaboration with director Peter Sellars and musician Rokia Traoré resulted in the 2011 play *Desdemona.*

33. Alan Rice, "Take It from the Top," *Times Higher Education Supplement,* June 9, 1992, 16; Toni Morrison, "Love and Pleasure as Political Liberation," lecture manuscript, November 8, 2002, Box 300, Folder 11, Toni Morrison Papers. For more on Morrison as a philosopher of sound, see Daphne A. Brooks, "Toni Morrison and the Music of Black Life," *Pitchfork,* August 15, 2019, https://pitchfork.com/thepitch/toni-morrison-and-the-music-of -black-life/.

34. Box 20, Folder 1: "1989–1990 Research Assistant Notes—Jazz," Folder 21: "Miscellaneous Undated," Toni Morrison Papers.

35. Morrison, *Jazz,* 6, 205, 58–60.

36. Toni Morison, unpublished notes, "Dorcas, circa 1989–1992," n.d., emphasis in the original, Box 23, Folder 2; Toni Morrison Papers.

37. Morrison, *Jazz,* 60.

38. Morrison, foreword to *Jazz*, xviii, xvii.

39. The research for *Jazz* that Toni Morrison conducted with the help of assistants was diverse and far-reaching, and it included inquiries made to New York City mayor Ed Koch's office about the city's 1920s geography and urban development plans, an exploration of popular films from the era, and record listings of popular artists from the period. For record listings, see Box 20, Folder 21: "Miscellaneous Undated," Toni Morrison Papers. For further research material, see Box 20, Folder 1: "1989–1990 Research Assistant Notes—Jazz," Toni Morrison Papers.

40. Toni Morrison, *Jazz;* Morrison, foreword to *Song of Solomon* (New York: Vintage, 2007), xvii–xix; Toni Morrison, unpublished notes, Box 295, Folder 7, Toni Morrison Papers.

41. Kali Gross, *Colored Amazons: Crime, Violence, and Black Women in the City of Brotherly Love, 1880–1910* (Durham, NC: Duke University Press, 2006); Cheryl Hicks, *Talk with You like a Woman: African American Women, Justice, and Reform, 1890–1935* (Chapel Hill: University of North Carolina Press, 2010); Cynthia Blair, *I've Got to Make My Living: Black Women's Sex Work in Turn-of-the-Century Chicago* (Chicago: University of Chicago Press, 2010); LaShawn Harris, *Sex Workers, Psychics and Number Runners: Black Women in New York City's Underground Economy* (Urbana: University of Illinois Press, 2016); Sarah Haley, *No Mercy Here: Gender, Punishment, and the Making of Jim Crow Modernity* (Chapel Hill: University of North Carolina Press, 2016).

42. Simmons, *Crescent City Girls*, 178; Stewart, *Migrating to the Movies*, 96. Stewart turns to Morrison's fiction as an alternate terrain on which to contemplate early Black cinema patrons' relationship to screen images and theatergoing practices. Her work is an inspiration for my own.

43. Burton, *Dwelling in the Archive*, 143.

44. Toni Morrison, "Black Matter(s)," in *Source of Self-Regard,* 223.

45. Cvetkovich, "Queer Archival Futures." In addition to record shops, as historian Joshua Clark Davis reminds, Black folks were getting their music from places and people often outside of "brick-and-mortar record store" establishments in the earliest years of the race records boom. Records are, he points out, being sold in furniture stores ("next to phonographs"), at "newsstands," at "variety stores" and through other "informal networks." Author interview with Joshua Clark Davis, July 29, 2020. See also Joshua Clark Davis, "For the Records: How African American Consumers and Music Retailers Created Commercial Public Space in the 1960s and 1970s South," *Southern Cultures* (Winter 2011): 71–90.

46. Aimee Cox, *Shapeshifters: Black Girls and the Choreography of Citizenship* (Durham, NC: Duke University Press, 2015), 27, 30.

47. Tim Brooks' definitive study on early African American recording artists, *Lost Sounds,* documents the work of the Black pioneers who emerged in the earliest years of the recording industry. Street musicians like George W. Johnson (one of the very first African American recording artists known to historians), theater legends like Bert Williams and George Walker, breakthrough opera artists Roland Hayes as well as Florence Cole-Talbert, Fisk University's storied Jubilee Singers, boxing icon Jack Johnson, superstar poet Paul Laurence Dunbar, and masterful composer-instrumentalists like Will Marion Cook, James Reese Europe, and "Father of the Blues" W. C. Handy all populate Brooks's study which reveals the innovations of those Black folks who were audio pathbreakers. Tim Brooks, *Lost Sounds: Blacks and the Birth of the Recording Industry, 1890–1919* (Urbana and Chicago: University of Illinois, 2005). My thanks to Lucy Caplan and Elijah Wald for their insight on this

topic as well. Although the aforementioned Williams would cut what is believed the first blues record by an African American in 1919, it's Mamie Smith's joint with Bradford that ended up capturing the zeitgeist. See Lynn Abbott and Doug Seroff, *The Original Blues: The Emergence of the Blues in African American Vaudeville* (Jackson: University of Mississippi Press, 2019), footnote 119, p. 371. Daphne A. Brooks, "100 Years Ago, 'Crazy Blues' Sparked a Revolution for Blues Women Fans," *New York Times,* August 10, 2020.

48. Elijah Wald, *Escaping the Delta: Robert Johnson and the Invention of the Blues* (New York: Amistad, 2004), 17–19; Wald, *The Blues: A Very Short Introduction* (New York: Oxford University Press, 2010), 23–24. For more on Sophie Tucker, see Lori Harrison-Kahan, *The White Negress: Literature, Minstrelsy and the Black-Jewish Imaginary* (New Brunswick, NJ: Rutgers University Press, 2011), 16–57; and Lauren Rebecca Sklaroff, *Red Hot Mama: The Life of Sophie Tucker* (Austin: University of Texas Press, 2018).

49. For more on the birth of the recording industry, see William Howland Kenney, *Recorded Music in American Life: The Phonograph and Popular Memory, 1890–1945* (New York: Oxford University Press, 1999). See also David Suisman, *Selling Sounds: The Commercial Revolution in American Music* (Cambridge, MA: Harvard University Press, 2012). On early African American recordings, see Tim Brooks, *Lost Sounds* and Bryan Wagner, *Disturbing the Peace: Black Culture and the Police Power after Slavery* (Cambridge, MA: Harvard University Press, 2009). For more on Mamie Smith, see Chapter 8. For an excellent reading of Smith and the Jazz Hounds, see David Wondrich, *Stomp and Swerve: American Music Gets Hot, 1843–1924* (Chicago: Chicago Review Press, 2003), 207–214. Historian Lerone Martin attributes the race record explosion to a shrewd and necessary market shift, arguing that, as a result of the inability of many Black folks to afford radios, the media technology fast overtaking the phonograph in sales in the 1920s, the "advent of radio primarily in white America made the phonograph industry's policy of racial exclusion no longer cost effective. Thus beginning in 1920 labels finally expanded their attention and production activities toward black audiences." Lerone Martin, *Preaching on Wax: The Phonograph and the Shaping of Modern African American Religion* (New York: New York University Press, 2014), 31.

50. An exception is Martin's *Preaching on Wax.*

51. Suisman, *Selling Sounds,* 113. See Simmons's *Crescent City Girls* for an excellent study of young Black women in segregated New Orleans, one of the few full-length studies exploring the social and cultural lifeworlds of interwar Black girls. See also Chatelain, *South Side Girls.* Marybeth Hamilton, *In Search of the Blues* (New York: Basic Books, 2008), 131, 9. For more on Pullman porters' participation in the record sales business, see Suisman, *Selling Sounds,* 204–239.

52. Zora Neale Hurston, "Characteristics of Negro Expression," in *The Jazz Cadence of American Culture,* ed. Robert O'Meally (New York: Columbia University Press, 1998), 306. For more on 1920s African American cabaret culture, see Shane Vogel, *The Scene of Harlem Cabaret: Race, Sexuality, Performance* (Chicago: University of Chicago Press, 2009). For more on black women and dance hall culture in the 1910s, see Tera Hunter, "'Sexual Pantomimes,' the Blues Aesthetic, and Black Women in the New South," in *Music and the Racial Imagination,* ed. Ronald Radano and Philip V. Bohlman (Chicago: University of Chicago Press, 2000). See also Hunter, *To 'Joy My Freedom;* and Vogel, *Scene of Harlem Cabaret.*

53. Sonnet Retman, "Memphis Minnie's 'Scientific Sound': Afro-Sonic Modernity and the Jukebox Era of the Blues," *American Quarterly,* 72, no.1 (March 2020): 75–102.

54. Joshua Clark Davis, "How African American Consumers and Music Retailers Created Commercial Public Space in the 1960s and 1970s South," *Southern Cultures* 17, no. 4 (2011): 73. Davis documents the valuable role that Black-owned record stores have played in postwar African American communities. The legendary Aikei Pro's Records Shop in Holly Springs, Mississippi, run by local Civil Rights activist David Caldwell, opened in 1960 and is located along the Mississippi Blues Trail, which Caldwell played an instrumental role in helping to form. He boasts a collection of some ninety thousand records and tapes in his tiny store, called by blogger Phillip Knecht "a hoarder's paradise." See Phillip Knecht "Holly Springs: Aikei Pro's Record Shop (1960)," Hill Country History, July 3, 2015, https://hillcountryhistory.org/2015/07/03/holly-springs-aikei-pros-record-shop-1960/. See also Eilon Paz, ed., *Dust and Grooves: Adventures in Record Collecting* (New York: Ten Speed, 2015), 273–275, 428–437.

55. Abbott and Seroff, *The Original Blues*, 282; author's July 29, 2020 phone interview with Joshua Clark Davis on sites where Black record fans purchased music during this early era.

56. Rob Bowman, *Soulsville U.S.A.: The Story of Stax Records* (New York: Schirmer Trade Books, 2003), 20; Sonnet Retman, "'Return of the Native': Sterling Brown's *A Negro Looks at the South* and the Work of Signifying Ethnography," *American Literature* 86, no. 1 (2014): 106. Gary Calamar and Phil Gallo reveal how "many a jazz label got its start in record stores in the 1940s." Gary Calamar and Phil Gallo, *Record Store Days: From Vinyl to Digital and Back Again* (New York: Sterling, 2009). While Paramount Records launched as an endeavor to support the sales of the Wisconsin Chair Company's entry into the phonograph cabinet sales market, their label scouts (which for a time included Mayo Williams, the first Black executive for a white-owned record label) cultivated relationships with Southern record shop owners in the 1920s and 1930s in a bid to recruit new talent. Sullivan describes how Paramount scout Arthur Laibly "would regularly pack up his car with fresh" Paramount records "and go on long trips through the South, visiting the record 'houses' that sold race records." John Jeremiah Sullivan, "The Ballad of Geeshie and Elvie," *New York Times Magazine,* April 13, 2014. For an exploration of, in part, the emergence of family-run Black businesses in various aspects of the recording industry, see Clara Wilson-Hawken, "'Am I That Easy to Forget?': The Sounds and Forms of Black Women's Labor in the Music Industry 1945–1985" (PhD diss., Yale University, in progress).

57. For more on Black bookstores, see Joshua Clark Davis, *From Headshops to Whole Foods: The Rise and Fall of Activist Entrepreneurs* (New York: Columbia University Press, 2020).

58. Martin, *Preaching on Wax,* 39.

59. Martin, 39. Scott Blackwood refers to Speir as "an honest broker" in Scott Blackwood, liner notes for *The Rise and Fall of Paramount Records, Volume 2* (Revenant Records / Third Man Records, 2014), 45. Martin, 39. See also Stephen Calt and Gayle Dean Wardlow, "The Buying and Selling of Paramount—Part 3," *78 Quarterly* 1, no. 5 (1990): 7–24. Calt and Wardlow argue that "the record industry's early antipathy towards black music was a fear that it would create a surge of Black shoppers in white-owned stores." For Speir, however, the dollar spoke loudest to him and apparently drove him to run a profitable Jim Crow business as he stood to make as much as $500 worth of race records sales on Saturdays. Calt and Wardlow, 18. Blues scholar David Evans notes in his 1972 interview with the elderly Speir that he must "regretfully mention that Speir expressed a number of stereotyped views of Negroes and of musicians in particular. . . . It is perhaps ironic," Evans muses, "that a man like

Speir could hold stereotyped views about Negroes yet also have a deep appreciation for and a considerable understanding of black music." David Evans, "Interview with H. C. Speir," *John Edwards Memorial Foundation Quarterly* 8, pt. 3, no. 27 (1972): 117–118. It should also be noted that Paramount's first African American scout, J. Mayo Williams, though a pioneer in many ways, was likely no angel with regard to his business tactics. Blackwood notes that while he came to be "known as 'Ink' for his remarkable capacity for securing contracts with the biggest Black music stars, Williams would turn out to be quite a complex figure, and something short of wholly benevolent to either the label or its artists. See Scott Blackwood, "Holy Fools of the Record Business," *The Rise and Fall of Paramount Records, Volume 1,* 23. Petrusich, *Do Not Sell,* 69.

60. Martin, *Preaching on Wax,* 39. Satherley and Mayo Williams were two of the key architects of the Paramount ad campaign directly targeting Black consumers in the *Chicago Defender* and other African American press outlets. Satherley also sold records for the company on the road "from Nova Scotia to the Florida Keys." In the label's early years when store dealers remained loyal to Columbia and Victor and wary of the race records business, Satherley oversaw the sale of records "at house parties . . . in urban ghettoes like Philadelphia and Washington, as well as throughout the South." Norm Cohen, "'I'm a Record Man': Uncle Art Satherley Reminisces," interview transcription by Lisa Feldman, *John Edwards Memorial Foundation Quarterly* 8, pt. 1, no. 25 (1972): 18–19.

61. For more on the history of Texarkana, see "Lindsey Railroad Museum, Mainstreet Texarkana," https://www.mainstreettexarkana.org/lindsey-railroad-museum.html. See also Opinion Editorial, "Happy Birthday, Texarkana: Our hometown is 145 years old today," *Texarkana Gazette,* December 7, 2018. /

62. James Presley, "After the Riot," *Texas Observer,* August 21, 1964. Presley's article, which was written in the wake of President Johnson's signing of the Civil Rights Act, assesses the state of race relations in the city of Texarkana in the month following passage of the historic legislative bill and covers the efforts of local citizens to form a new interracial council aimed at addressing a new surge of white supremacist violence directed at Black Texarkanans.

63. My mother's memories of hearing about the lynching of a Black man in her girlhood remain vivid. "We were told," she tells me, that "they dragged his body to the Sunset District, a Black community." Author's phone interview with Juanita Kathryn Watson Brooks, October 2019.

64. Henry Louis Gates Jr., *Colored People: A Memoir* (New York: Vintage, 1995).

65. H. V. Beasley opened his piano store in Texarkana in 1899, and he and his family would go on to sell instruments, sheet music, and eventually 78s and 33 1/3 discs out of various Broad Street locations for more than fifty years. *Piano Trade Magazine* as quoted in "Texarkana Pioneer Family Histories," Texas Genealogy Trails, accessed July 23, 2020, http://genealogytrails.com/tex/pineywoods/bowie/pioneers.html.

66. Author's phone interview with Juanita Kathryn Watson Brooks, July 4, 2016.

67. Philip Newman as quoted in Calamar and Gallo, *Record Store Days,* 52; Juanita Kathryn Watson Brooks, interview by the author via phone, July 4, 2016; Vogel, *Scene of Harlem Cabaret,* 18. Legendary record stores in the North and the West functioned as social meeting grounds for fans in the thirties, forties, and fifties. In the late 1930s and 1940s, Milt Gabler's Commodore Music Shop in New York City "attract[ed] customers by playing the radio" and became "a meeting ground for fans and musicians" like Louis Armstrong. Calamar and Gallo, *Record Store Days,* 46, 48. Wallich's Music City, a sprawling record emporium in Los Angeles,

played host to celebrities while showcasing its listening booths beginning in 1940 (49–50). Manhattan's Jazz Record Center was a particularly storied and a decidedly wonkish and masculinist site where the blues mafia collectors came together in what was "the default clubhouse for a cabal of distinctive gentlemen." Petrusich, *Do Not Sell,* 117.

68. Historians consider the mob murder of William Vinson to be one of the last East Texas lynchings from the first half of the twentieth century. Vinson, a twenty-five-year-old local dishwasher, was accused of raping a white woman, seized by a mob, dragged by car through Broad Street in Texarkana and hung "on a cotton gin winch" on July 13, 1942. "Negro Is Lynched after Attempted Attack on Woman: Texas Mob Drags Victim behind Auto, Hangs Him," *Evening Independent* (Saint Petersburg, FL), July 13, 1942, https://news.google .com/newspapers?nid=950&dat=19420713&id=0vdPAAAAIBAJ&sjid=MVUDAAAAIBAJ &pg=4911,1858889&hl=en. Bob Bowman and Doris Bowman, "Death by Rope," Texas Escapes, accessed July 23, 2020, http://www.texasescapes.com/BobBowman/Death-by-Rope.htm; Presley, "After the Riot"; "Article 12," *New York Times,* July 13, 1942, http://timesmachine .nytimes.com/timesmachine/1942/07/13/85565959.html?pageNumber=17; Megan K. Stack, "A Hanging Haunts East Texas," *Los Angeles Times,* May 9, 2001.

The long history of lynching in Texarkana, Texas, and Texarkana, Arkansas, has been documented by a number of journalists and scholars. Ida B. Wells exposed the brutal details of the 1892 lynching of Edward Coy in Texarkana, a thirty-year-old African American man who was accused of assaulting a white woman and burned at the stake before a crowd of approximately one thousand people. Ida B. Wells, "Lynch Law in All Its Phases," *Our Day,* May 1893, 333–337. As of this writing, the murder of James Byrd Jr., an African American man who was dragged to his death by white supremacists in 1998 in Jasper, Texas, is considered one of the last-known lynchings in the state. Carol Marie Cropper, "Black Man Fatally Dragged in Possible Racial Killing," *New York Times,* June 10, 1998. Yet Black deaths—either at the hands of or as a result of being touched by the state, such as Sandra Bland's in 2015—are another matter. At the time of her death in jail, arrested for a highly dubious traffic violation, Bland was set to begin a new job at my mother's alma mater, Prairie View A&M University, in Prairie View, Texas.

69. Jacqueline Goldsby, *A Spectacular Secret: Lynching in American Life and Literature* (Chicago: University of Chicago Press, 2006). Goldsby reveals the extent to which both modern photography and the early phonograph were key instruments of propaganda and participation in turn-of-the-century mob violence. She observes that "the convergence of violence and cultural advances does not repudiate our notions of 'modern' progress; their intersections appear to confirm and specify them." Goldsby, *Spectacular Secret,* 23.

70. Lauren Berlant, *The Female Complaint: The Unfinished Business of Sentimentality in American Culture* (Durham, NC: Duke University Press, 2008). With the exception of Tharpe's "Trouble in Mind," which was recorded in 1941, all of these tracks were released in 1942, the year that my mother and her friends began frequenting Beasley's. Eckstine performed at my mother's 1946 college prom during her junior year at Prairie View A&M University in Texas.

71. Author's phone interview with Juanita Kathryn Watson Brooks, July 4, 2016; "Manhattan Merry-Go-Round," Old Time Radio Catalog, accessed July 23, 2020, https://www .otrcat.com/p/manhattan-merry-go-round.

72. Wagner, *Disturbing the Peace,* 219. Wagner makes an important but also a very different point about how these sorts of material "distractions" on the records themselves "augment the music's authenticity" for blues ethnographers and collectors, in that they "recal[l] the live encounter in the field. They are essential to its raw sound," he argues, "facilitating a fantasy of immediate access that puts the listener in the collector's place. The irony here is that cultural

fidelity becomes inversely proportional to acoustic fidelity" (219). Collector DJ Andujar's words are instructive. "I have learned so much about people, culture, politics, and geography," says Massachusetts-based Andujar (a.k.a. Brendon Rule), "just from the records and their grooves. The world opens to me from there." DJ Andujar as quoted in Paz, *Dust and Grooves*, 171.

73. Lauren Berlant, email to the author, February 24, 2018. Many thanks to Lauren Berlant for her marvelous perspectives on this work. Berlant's extensive meditations on the ethics and strategies of "reading with things" as an extended form of intimate collaboration in her conversations with Lee Edelman are helpful to me as well in this regard. See Lauren Berlant as told to Andy Campbell, "Lauren Berlant discusses 'reading with' and her recent work," *Artforum*, January 30, 2014. https://www.artforum.com/interviews/lauren-berlant-discusses-reading-with-and-her-recent-work-45109.

74. Maya Angelou, *Singin' and Swingin' and Gettin' Merry Like Christmas* (New York: Random House, 2009), 3–13. My thanks to Melanie Masterson Sherazi for kindly pointing me back toward Angelou's memoir. The 2020 Hulu reboot of *High Fidelity* starring Zoë Kravitz, Da'Vine Joy Randolph, and David H. Holmes imagines this "when and where," taking the original narrative's white masculinist ideas about contemporary popular music culture, the semi-self-conscious "rock snobbery" sentiments of Nick Hornsby's novel on which it was based and its slightly more expansive film (that Lisa Bonet casting had to mean something) from 2000 which starred John Cusack and Jack Black in his breakout role as Barry Judd, a full-on manifestation of record store denizen hyperbole and music wonk excess. As the gender-flipped leads, Kravitz and Randolph quietly made history, holding down a now-defunct show that took seriously the tastes and passions of their two Black woman characters. *High Fidelity*, Hulu, 2020. For other fascinating contemporary representations of Black women in popular music culture, see Taraji P. Henson's iconic hood heroine, Cookie on Fox's *Empire* and Tracee Ellis Ross's revisionist diva character in *The High Note*. *Empire* (Fox, 2015–present). *The High Note* (Focus Features, 2020).

75. Cox, *Shapeshifters*, 233–235.

76. Joe's Music Shop moved from its initial location on Hastings Street in Detroit, where it was located from 1945–1960, to its 12th Street location, the spot where Music, born in 1954, spent much of her childhood. Author's interview with Marsha Music. Music, "Joe Von Battle." In her blog, Music writes about a number of moving and extraordinary memories of growing up in the run of a blues and R&B phenomenon, with which her father had much to do in local Detroit. She writes, "I remember many a Saturday afternoon in the later days of the shop, affixing labels to records, unloading them from boxes, and always, playing all the music we wanted and doing the Shing-a-ling and Boo-ga-loo in the middle of the floor. . . . I remember when I went 'up North' with Daddy to the record pressing plant in Owasso, Michigan, or to Chicago to see the Chess Brothers, Phil and Leonard, where I listened to Bo Diddly masters—with Bo Diddly. Years before me, my elder half-brother Joe had sat in the Chess studios talking with Muddy Waters and the Chicago 'Blues Boys.'" Music, "Joe Von Battle."

77. Author's interview with Marsha Music. Black women's widespread interest in records, we know too, was not restricted to the North. Elijah Wald points out to me that "in rural areas, pretty much everything I've seen" in his research "suggests that record consumers were almost entirely women. . . ." Wald theorizes that the reasons have to do with economics and gendered labor practices. He points out that men "didn't have cash money whereas women were," for instance, "doing laundry for white folks and getting paid [in] cash so that when" peddlers "came around" selling records and other household items, the women consumers were ready for them. "[O]ne of my general rules," adds Wald, dispelling long-held

sexist beliefs in popular music studies scholarship, is that "pop consumers are women. . . ." Author's interview with Elijah Wald, July 31, 2020.

7. "See My Face from the Other Side"

1. "People think I'm a crazy fool for writing 'slave' on my face," Prince told *Rolling Stone* in 1996. "But if I can't do what I want to do, what am I? When you stop a man from dreaming, he becomes a slave. That's where I was. I don't own Prince's music. If you don't own your masters, your master owns you." Anthony DeCurtis, "Free at Last," *Rolling Stone,* November 28, 1996, 61–63. John Jeremiah Sullivan, "The Ballad of Geeshie and Elvie," *New York Times Magazine,* April 13, 2014.

2. L. V. Thomas, interview by Robert Mack McCormick, Houston, Texas, June 20 and November 2, 1961, as quoted in *The Blues Come to Texas: Paul Oliver and Mack McCormick's Unfinished Book,* by Paul Oliver and Robert Mack McCormick, ed. Alan B. Govenar (College Station: Texas A&M University Press, 2019), 363, emphasis added.

3. Sullivan's article places Thomas at thirty-nine and speculates that Wiley was somewhat younger than her partner. Thomas says the same in the interview, pointing out that Lillie Mae Wiley "was about five or six years younger than me." L. V. Thomas, interview by Robert Mack McCormick, Houston, Texas, June 20 and November 2, 1961, as quoted in Oliver and McCormick, *Blues Come to Texas,* 75. For more on the threats and violence Mary Lou Williams faced as a single woman musician on the road, see Chapter 1. The work of blues historian Paul Oliver and archivist/researcher Robert "Mac" McCormick renders the dissatisfaction of women artists working for Paramount vivid and in their own words. One Texas musician, Bernice Edwards, was said to have gotten word from Thomas herself. "'In about 1930,' says Edwards, "Mr. Laibley . . . stopped at my house in Houston and wanted me to make records. I told him I'd write him. A woman that lived here in Houston that made records from Paramount told me they were making records in Wisconsin now and that it was a raw deal and there wasn't no money. So I never did go back.' The woman," add Oliver and McCormick, "was L.V. Thomas, whom Laibley [*sic*] found on the same trip" (363).

4. Sullivan, "Ballad of Geeshie and Elvie." In a bid to brand his company as a symbol of aspirational class and cultural mobilization, Pace named Black Swan Records after Elizabeth Taylor Greenfield, dubbed the "Black Swan" during her rise to fame in mid-nineteenth-century opera. David Suisman, *Selling Sounds: The Commercial Revolution in American Music* (Cambridge, MA: Harvard University Press, 2012), 213–217. Though his own company trafficked in straight-ahead blues from the get-go, Mayo Williams nonetheless followed Harry Pace's lead by naming his short-lived label Black Patti in reference to the late nineteenth- and early twentieth-century classical vocalist Matilda Sissieretta Jones, called "the Black Patti" as a result of being compared to Italian vocalist Adelina Patti. On the Black Patti label, see Amanda Petrusich, *Do Not Sell at Any Price: The Wild, Obsessive Hunt for the World's Rarest 78rpm Records* (New York: Simon and Schuster, 2014), 206–207. On Taylor, see Julia J. Chybowski, "Becoming the 'Black Swan' in Mid-Nineteenth-Century America: Elizabeth Taylor Greenfield's Early Life and Debut Concert Tour," *Journal of the American Musicological Society* 67, no. 1 (Spring 2014): 125–165. On Jones, see John Graziano, "The Early Life and Career of the 'Black Patti': The Odyssey of an African American Singer in the Late Nineteenth Century," *Journal of the American Musicological Society* 53: 543–596.

5. Scott Blackwood, "Rise of the Blues Women," liner notes for *The Rise and Fall of Paramount Records, Volume One* (Third Man Records/Revenant Records, 2013), 72.

6. A Black uplift endeavor founded in 1921 and led by W. E. B. Du Bois mentee Harry H. Pace, Black Swan Records was, as Suisman argues, an experiment that "sought explicitly to reconnect issues of production and consumption, thus in a sense defetishizing the music and fashioning it instead into an instrument of social and economic justice." Suisman, *Selling Sounds,* 206. For examples of Black Swan's antiracist blues records ad campaigns, see Suisman, 224–226. The list of blues women signed to Paramount as a result of the merger with Black Swan includes Edna Hicks, Edmonia Henderson, Maude De Forrest, and Faye Barnes. See Blackwood, "Rise of the Blues Women." Amazingly, Paramount also employed what is believed to be the only Black female race records label management staff member from this era, Aletha Dickerson. Dickerson had served as Mayo Williams's secretary and took on many of his in-house responsibilities when he departed in late 1927 to launch his own label. Blackwood observes that she was "among the first female recording managers in the record business, a job she never wanted, partly because she felt uncomfortable around many of the artists—though her conversations with Blind Arthur Blake remained a fond memory." Scott Blackwood, "The Discoverers," liner notes for *Rise and Fall of Paramount Records, Volume 2* (Third Man Records/Revenant Records, 2014), 49. Ironically, he adds that Dickerson had a hand in launching "hokum" music, "the sexually suggestive genre first pioneered on records by the great Papa Charlie Jackson, recording a threesome made up of her husband Alex, Tom Dorsey—former leader of Ma Rainey's Wildcat's Jazz Band and future legend of gospel—and songster Tampa Red: 'Selling That Stuff.' . . . [She] says her one talent was for recognizing that if she didn't like it, it would sell." Blackwood, 49. For more on Dickerson, see Alex van der Tuuk, "Aletha Dickerson: Paramount's Reluctant Recording Manager," accessed July 24, 2020, http://www.vjm.biz/new_page_18.htm.

7. Suisman, *Selling Sounds,* 219; Paige McGinley, *Staging the Blues: From Tent Shows to Tourism* (Durham, NC: Duke University Press, 2014), 54. For more on Rainey's life and career, see Sandra R. Lieb, *Mother of the Blues: A Study of Ma Rainey* (Amherst: University of Massachusetts Press, 1983); and Angela Davis, *Blues Legacies and Black Feminism: Gertrude "Ma" Rainey, Bessie Smith, and Billie Holiday* (New York: Vintage, 1999). On Ethel Waters's vocal aesthetics, see Rosetta Reitz, liner notes for *Ethel Waters, 1938–1939: The Complete Bluebird Sessions,* Foremothers Vol. 6, RR 1314, Rosetta Records, 1986. For more on Rainey's set spectacle as well as Smith's visual aesthetics, see McGinley, *Staging the Blues.* For more on Mamie Smith's costumes, see David Wondrich, *Stomp and Swerve: American Music Gets Hot, 1843–1924* (Chicago: Chicago Review Press, 2003).

8. AnneMarie Cordeiro includes ads for Geeshie Wiley and Elvie Thomas's Paramount sides in her dissertation on Wiley's music. See "Are You Satisfied? Paramount: The Popular Race Record" advertisement, June 1930, and "New Blues" mid-1930s advertisement, "Race Records," Artophone Corporation, September 15, 1930, in AnneMarie Cordeiro, "Geechie Wiley: An Exploration of Enigmatic Virtuosity" (MA thesis, Arizona State University, 2011), 118–122. For more on Paramount's final years of operation, see Alex van der Tuuk, *Paramount's Rise and Fall: A History of the Wisconsin Chair Company and Its Recording Activities* (Denver: Mainspring, 2003), 149–190.

9. On Bessie Smith's late career, see Chris Albertson, *Bessie* (New Haven, CT: Yale University Press, 2003). On Rainey's late career, see Lieb, *Mother of the Blues.* On Waters, see Ethel Waters, *His Eye Is on the Sparrow: An Autobiography,* with Charles Samuels (New York, NY: Da Capo, 1992). While Blind Lemon Jefferson and Blind Blake found success on Paramount,

Patton, House, and James were largely lionized in the wake of their Paramount recording careers, belated fandom and adulation emerging out of the 1960s blues revival led by white, transatlantic collectors and archivists.

10. Scott Blackwood, "Last Kind Words," liner notes for *Rise and Fall, Volume 2*; Tammy Kernodle, "Having Her Say: The Blues as the Black Woman's Lament," in *Women's Voices across Musical Worlds*, ed. Jane Bernstein (Boston: Northeastern University Press, 2003), 216–218. Memphis Minnie is by far the most famous female guitarist of the blues era. She began recording with her second husband, Joe McCoy, in 1929. See Paul Garon and Beth Garon, *Woman with Guitar: Memphis Minnie's Blues* (San Francisco: City Lights Books, 2014); and Sonnet Retman, "Memphis Minnie's 'Scientific Sound': Afro-Sonic Modernity and the Juke Box Era of the Blues," *American Quarterly* 72, no. 1 (March 2020): 75–102. The conversations regarding Wiley and Thomas' exceptionalism are passionate, detailed, and compelling. I've been in the room for some of them and respect and value this turn toward old-school Black women's sounds in the world of white male critics. See "Exploring the Rise and Fall of Paramount Records," roundtable event featuring Jack White, Greil Marcus, Scott Blackwood, Dean Blackwood, Adia Victoria, and the author, Yale University, October 28, 2014.

11. Wondrich, *Stomp and Swerve*, 123; L. V. Thomas, interview by Robert Mack McCormick, Houston, Texas, June 20 and November 2, 1961, as quoted in Oliver and McCormick, *Blues Come to Texas*, 75. Oliver and McCormick's research reveals that the "first place [Thomas] worked at was Sandy Point [Texas] where she commenced in 1908 a career of nearly thirty years playing" (75). "To get your life means," Jafari Allen argues, "to recover something that you profoundly need—perhaps parts of yourself, gathered together for once." Jafari Allen as quoted in Aimee Cox, *Shapeshifters: Black Girls and the Choreography of Citizenship* (Durham, NC: Duke University Press, 2015), 234.

12. For the slim details pertaining to Thomas's and Wiley/Scott's respective lives, see Sullivan, "Ballad of Geeshie and Elvie." See also L. V. Thomas, interview by Robert Mack McCormick, Houston, Texas, June 20 and November 2, 1961, as quoted in Oliver and McCormick, *Blues Come to Texas*, 75.

13. Sullivan, "Ballad of Geeshie and Elvie."

14. Michelle Alexander, *The New Jim Crow: Mass Incarceration in the Age of Colorblindness* (New York: New Press, 2012); Ruth Wilson Gilmore, *Golden Gulag: Prisons, Surplus, Crisis, and Opposition in Globalizing California* (Berkeley: University of California Press, 2007); Naomi Murakawa, *The First Civil Right: How Liberals Built Prison America* (New York: Oxford University Press, 2014). See also Ava Duvernay, dir., *13th* (Kandoo Films, 2016).

15. Wondrich, *Stomp and Swerve*, 123; Heather Love, *Feeling Backward: Loss and the Politics of Queer History* (Cambridge, MA: Harvard University Press, 2009), 4, emphasis in the original; Kara Keeling, *Queer Times, Black Futures* (New York: New York University Press, 2019), 145–176.

16. L. V. Thomas reflects on her collaboration with Wiley in the 1961 interview with her conducted by Robert Mack McCormick. L. V. Thomas, interview by Robert Mack McCormick, Houston, Texas, June 20 and November 2, 1961, as quoted in Oliver and McCormick, *Blues Come to Texas*, 75.

17. Janet Schultz (daughter of Paramount executive Alfred Schultz) as quoted in van der Tuuk, *Paramount's Rise and Fall*, 187. Elizabeth Freeman, *Time Binds: Queer Temporalities, Queer Histories* (Durham, NC: Duke University Press, 2010), xi. On the closing of the Grafton plant, see also Blackwood, "Out of the Anonymous Dark," *Rise and Fall, Volume 1*. Bryan Wagner, *Disturbing the Peace: Black Culture and the Police Power after Slavery* (Cambridge,

MA: Harvard University Press, 2009), 57. On the racial demographics and population of Grafton circa 1930 as well as the travel arrangements made by Paramount for its African American artists, see van der Tuuk, *Paramount's Rise and Fall*, 157. Wagner's provocative argument about ethnographic blues performances hinges on his theory of Blackness and statelessness as being inextricably linked to one another. He compellingly considers "the mnemonics that enabled informants to sing themselves from incapacity into hypothetical existence. Black singers," he continues, "were able to invent a perspective from which people without perspective could begin to speak only because their music allowed them to proceed as if such things were possible even when they were not. The music's capacity to convey hypothetical experience—experience that could be imagined but not known and felt but not named—was celebrated by collectors who took its artifice for authentic self-expression. The authenticity that these collectors thought they had found was nothing more than the residue from personification, the trace left by the outlawed speaker whose humanity is continually staked on its invisibility in political society. Writing the history of black authenticity, it follows, means thinking backward through the equation that would make this political invisibility into cultural property." Wagner, *Disturbing the Peace*, 57. But the point that I'm making here diverges from his to the extent that what I am arguing for is a way to conceive of Geeshie Wiley and L. V. Thomas's performances as pushing beyond the realm of "perspective," "invention," and "personification," as, in short, constituting a performance dwelling that rejected the limitations of "political society" even as it remained "invisible" to it. Elizabeth Freeman, *Time Binds: Queer Temporalities, Queer Histories* (Durham, NC: Duke University Press, 2010).

18. Artists who have covered "Last Kind Word Blues" include David Johansen and the Harry Smiths, C. W. Stoneking, Dex Romweber (featuring Jack White), and the Kronos Quartet. Roots music artist Rhiannon Giddens, a former member of the Carolina Chocolate Drops, was the first African American artist to record a cover of "Last Kind Word Blues."

19. Sullivan, "Ballad of Geeshie and Elvie"; Petrusich, *Do Not Sell*, 37.

20. Blind Lemon Jefferson, "Wartime Blues," *Rise and Fall, Volume 1*; Zora Neale Hurston, "Characteristics of Negro Expression," in *The Jazz Cadence of American Culture*, ed. Robert O'Meally (New York: Columbia University Press, 1998). The floating verses "drink muddy water" and "sleep in a hollow log" appear in other blues. For instance, one of the songs included on the 1987 Rosetta Records collection *Jailhouse Women's Blues*, entitled "Ricketiest Superintendent," recorded in the 1930s at the infamous Mississippi Parchman prison, contains these same lyrics. The "war" in "Wartime Blues" is one that we, in the jook joint with Lemon, will recognize as being both internal and external—a mighty struggle within that pushes our hero to the edge of the river of his own despair in one verse and that, in another, causes him to long to *be* a train, an engine of modernity that might "shine a light" in his lover's brain, only to discover that this propulsive machine has crashed.

21. Geeshie Wiley and Elvie Thomas, "Last Kind Word Blues," *Rise and Fall, Volume 2*. "Last Kind Word Blues" lyrics, https://genius.com/Geeshie-wiley-last-kind-word-blues-lyrics. Kernodle traces the blues woman's lament from "regionalized traditions of the shout, ballad, work song, field holler, and instrumental music." Tammy Kernodle, "Having Her Say: The Blues as the Black Woman's Lament," in *Women's Voices Across Musical Worlds*, ed. Jane Bernstein (Boston, MA: Northeastern University Press, 2003), 217. I'm relying on the Genius website version of lyrics here as it's one of the most credible lyrics transcription sites. However, several scholars have transcribed Wiley and Thomas's lyrics in recent years and offer varied readings of key verses. In "Unknown Bards," Sullivan makes important breakthroughs in his

analysis of Wiley's use of folk vernaculars (which he first discovered while working as a fact-checker for Marcus's work on Wiley), including the title's reference to "kind," which, he explains, "she doesn't mean . . . like we do; she doesn't mean 'nice.'" John Jeremiah Sullivan, "Unknown Bards," in *Pulphead: Essays* (New York: Farrar, Straus and Giroux, 2011), 259. See also Greil Marcus, "Who Was Geechie Wiley? The First and Last Kind Words from a Ghost of the Blues," *Oxford American,* Summer 1999; Marcus, *Three Songs, Three Sings, Three Nations* (Cambridge, MA: Harvard University Press, 2015), 58–105. See also Cordeiro, "Geechie Wiley," 59–60.

22. Cordeiro, "Geechie Wiley," 62, 61. Cordeiro describes the blues ballad as a genre of music born out of its British antecedent, malleable with a three-line stanza structure and an often loose, subjective narrative sequence.

23. Critics have disagreed about this line of the song in particular. Marcus maintains that Wiley sings here, "I can stand right here / See my face from the other side," while Cordeiro, Sullivan, and others have transcribed the line as "See my baby" or see my "brownie from the other side." Sullivan, "Unknown Bards," 260. Rhiannon Giddens's 2015 cover goes with "see my babe," as does the aforementioned Genius website transcription. Rhiannon Giddens, "Last Kind Words," *Tomorrow Is My Turn,* Nonesuch Records, 2015. "Last Kind Word Blues," Genius https://genius.com/Geeshie-wiley-last-kind-word-blues-lyrics. Gayle Wald hears the same, but in this case, I hear what Marcus hears. Author's conversation with Gayle Wald, February 2017.

24. Marcus, *Three Songs,* 81.

25. Katherine McKittrick, *Demonic Grounds: Black Women and the Cartographies of Struggle* (Minneapolis: University of Minnesota Press, 2006), 5; Sullivan, "Unknown Bards," 260. McKittrick's work builds on the theories of Sylvia Wynter, Toni Morrison, Edouard Glissant, Judith Butler, and others. Sarah Haley, *No Mercy Here: Gender, Punishment, and the Making of Jim Crow Modernity* (Chapel Hill: University of North Carolina Press, 2016).

26. McKittrick, *Demonic Grounds,* xvii; Haley, *No Mercy Here,* 198, 26. Ensnared in the "dangers of Jim Crow public life," which "were grave," Haley argues, "black women were subject to arrest for any infraction of political etiquette or for simply being in public" (45).

27. Sylvia Wynter, "Beyond Miranda's Meanings: Un / Silencing the 'Demonic Ground' of Caliban's Woman," in *Out of the Kumbla: Caribbean Women and Literature,* ed. Carole Boyce Davies and Elaine Savory Fido (Trenton, NJ: African World Press, 1990), 364.

28. Sullivan, "Ballad of Geeshie and Elvie."

29. Sherrie Tucker, "Big Ears: Listening for Gender in Jazz Studies," *Current Musicology,* nos. 71–73 (Spring 2001–Spring 2002): 375–408. Writing in 1935, Hurston, the folk purist, argued that "there never has been a presentation of genuine Negro spirituals to any audience anywhere. What is being sung by the concert artists and glee clubs are the works of Negro composers or adaptors based on the spirituals." Zora Neale Hurston, "Spirituals and Neo-spirituals," in *Negro: An Anthology,* ed. Nancy Cunard (New York: Continuum, 1934), 224.

30. Robert "Barbecue Bob" Hicks, "Motherless Child Blues" (1927).

31. Paul Oliver, *Songsters and Saints: Vocal Traditions on Race Records* (New York: Cambridge University Press, 1984), 126. Cordeiro calls "Pick Poor Robin Clean" a "guitar rag," a genre of music featuring "a steady oscillating bass with a syncopated melody." She compares Wiley and Thomas's recording to works by Robert Johnson, Charley Patton, Blind Blake, and other ragtime guitarists. Cordeiro, "Geechie Wiley," 50–51.

32. The transcription is taken from WeenieCampbell.com, and I believe it is slightly more accurate than Oliver's deciphering of the lyrics. "Geeshie Wiley and Elvie Thomas

Lyrics," WeenieCampbell.com, April 21, 2006, http://weeniecampbell.com/yabbse/index.php ?topic=2269.0. Likewise, various critics read the lyric "having a family" differently. Pop historian Elijah Wald and others refer to blues musician Luke Jordan's 1927 recording of the song as including the lyrics "having your family." Elijah Wald, "Pick Poor Robin Clean (Larry Johnson)," Old Friends: A Songobiography, June 6, 2016, http://www.elijahwald.com /songblog/pick-poor-robin/.

33. Sullivan, "Ballad of Geeshie and Wiley."

34. For more on the coon song tradition, see Lynn Abbott and Doug Seroff, *Ragged but Right: Black Traveling Shows, Coon Songs, and the Dark Pathway to Blues and Jazz* (Jackson: University Press of Mississippi, 2012). See Brooks, *Bodies in Dissent,* 214–226. The mystery of this song's meaning persists among blues aficionados and historians. Wald places "Pick Poor Robin Clean" firmly in the tradition of the dozens, speculating that "picking poor robin may be similar to the French 'Alouette,' which uses the metaphor of picking feathers from a bird as a stand-in for disrobing a woman." Wald, "Pick Poor Robin Clean." See also Elijah Wald, *Talking 'bout Your Mama: The Dozens, Snaps, and the Deep Roots of Rap* (New York: Oxford University Press, 2014), 45. Oliver and McCormick's work refers to "Pick Poor Robin Clean" as a "gambling song." Oliver and McCormick, *Blues Come to Texas,* 75. See also amateur blues fans' discussions about the song at WeenieCampbell.com: "Geeshie Wiley and Elvie Thomas Lyrics." The *Chicago Defender* advertised Luke Jordan's 1927 version of the song on Victor Records, announcing that the "other side of the record carries 'The Traveling Coon.'" "Pick Poor Robin Clean," Victor Records ad, *The Chicago Defender* December 3, 1927.

35. Kip Lornell, *Virginia's Blues, Country, and Gospel Records, 1902–1943* (Lexington: University Press of Kentucky, 1989), 108–109. Lornell notes that "little is known of Jordan's life beyond the most basic facts. He was born on January 28, 1892, possibly in Campbell or Appomattox County. By his late teens, Jordan had moved into Lynchburg, where he remained until his death on June 25, 1952. Jordan is still remembered by black musicians in Lynchburg as a unique and forceful guitarist. Moreover, he had the reputation as a problem drinker and an expert angler who never held down a regular job. His 'signature' songs were 'Cocaine Blues' and 'Church Bells Blues,' which some local blues musicians still perform." Cordeiro observes that the two versions of "Poor Robin" are "quite similar, although the fidelity of Jordan's Victor recording is higher, his guitar accompaniment is less dense, and he sings solo." Jordan, she argues, "lacks the intensity of the two women who really exercise their sense of rhythm in this rag." Cordeiro, "Geechie Wiley," 57. See also Elijah Wald's discussion of Jordan's version as well as the late contemporary blues revivalist Larry Johnson's version of the song. Wald, "Pick Poor Robin Clean."

36. Ralph Ellison, *Invisible Man* (New York: Vintage, 1995), 193. Thomas notes, "I was the one who started calling [Wiley] 'Geechie'—I just picked that name for her." See L. V. Thomas, interview by Robert Mack McCormick, Houston, Texas, June 20 and November 2, 1961, as quoted in Oliver and McCormick, *Blues Come to Texas,* 75.

37. Ralph Ellison, "On Bird Watching," in *Living with Music: Ralph Ellison's Jazz Writings,* ed. Robert O'Meally (New York: Modern Library, 2002), 75–76. Henry Louis Gates Jr. reads Ellison's use of the song in this second context as a "twofold" parody "involving a formal parody of the melody of 'They Picked Poor Robin' as well as a ritual naming, and therefore a troping, of an action 'observed from the bandstand.'" The signifying riff in "Robin" functions "as 'something that gives any orchestra a great background,' by which [Jelly Roll] Morton means 'what you would call a foundation,' 'something you could walk on.'" Henry Louis Gates Jr., *The Signifying Monkey* (New York: Oxford University Press, 1988), 105. Oliver and

McCormick's research notes that "Picked Poor Robin Clean" was "known in isolated instances in Oklahoma, Texas, and North Carolina." Such a point would confirm both Oklahoma native Ellison's familiarity with the song as well as Thomas and Wiley's. Oliver and McCormick, *Blues Come to Texas,* 295.

38. Haley, *No Mercy Here,* 220, 212.

39. Recall that Thomas, we know for sure, was a teenage inmate in Texas's Harris County Jail in 1910, but for what reason we do not know, and Wiley's potential criminal record is a source of even greater mystery as a result of Sullivan's discovery of the 1931 death certificate of her husband, Thornton, which states that he had died, according to his brother, at the hands of Lillie Mae (Geeshie) Scott, from a "stab wound in between collarbone and neck." Sullivan, "Ballad of Geeshie and Elvie." Kali Gross, *Colored Amazons: Crime, Violence, and Black Women in the City of Brotherly Love, 1880–1910* (Durham, NC: Duke University Press, 2006), 77. Gross speculates that such "illegal acts may indicate a broader resentment towards the prolonged denigration of their womanhood" (77).

40. Haley, *No Mercy Here,* 3, 6.

41. Danielle Goldman, *I Want to Be Ready: Improvised Dance as a Practice of Freedom* (Ann Arbor: University of Michigan Press, 2010), 27, 22.

42. Lindsay Reckson, *Realist Ecstasy: Religion, Race, and Performance in American Literature* (New York: New York University Press, 2020).

43. Haley, *No Mercy Here,* 230. For Haley's engagement with Wynter's theories of the demonic and her brilliant reading of the Parchman Penitentiary women's blues song "Go Way Devil," see 230–231.

44. Gerard Ramm, oral presentation at University of California, Berkeley, fall 2015.

45. Samuel Charters, "Rosetta and the Parchman Women's Blues," *Living Blues,* January/February 2006, 68. But as Reitz, Haley, Wagner, and other scholars insist and reveal, the Parchman women's material was not ersatz; they had their own songs to sing. "It would be," says Rosetta Reitz in a letter to her coproducer Cheri Wolfe, "a marvelous correction of much of the one-sided view we have of this music when it is spoken of as coming from cotton fields, as though the implication has been, those songs were men, as though women weren't even in those fields and of course, we know better; or prison songs are assumed to be male." Rosetta Reitz to Cheri Wolfe, August 28, 1986, Box 5, 1316, Rosetta Reitz Papers, David M. Rubenstein Rare Book and Manuscript Library, Duke University.

46. Rosetta Reitz as quoted in Charters, "Rosetta and the Parchman Women's Blues," 71; Rosetta Reitz, liner notes for *Jailhouse Blues,* Rosetta Records, 1987. In a letter to coproducer Patti Carr Black, director of the Mississippi State Historical Museum and the Department of Archives and History, Reitz explains the reasons why she insisted on using the title *Jailhouse Blues* for the collection. "First of all," she argues, "it's powerful and it tells what the album is about. It is also a reverberation of and a historic tribute to Bessie Smith, who sang a strong song by that name. And Dinah Washington sang the same song by that name. And Mamie Smith sang another version with the same title. Elvis Presley sang Jailhouse Rock [*sic*] which comes from these blues.... I can appreciate your position, sitting in an historical museum, this title might sound too vernacular. But for me, sitting in New York City and going into the Tower Record stores . . . where I see how the album will be competing, I of course, want the 'jazzier' title." Rosetta Reitz to Patti Carr Black, June 22, 1987, Box 5, 1316, Rosetta Reitz Papers.

47. Haley, *No Mercy Here,* 245. Michael Denning argues that in the era of the 1920s global working people's vernacular music craze, "recorded improvisation was a new form of reification." Michael Denning, *Noise Uprising: The Audiopolitics of a World Musical Revolution*

(London: Verso, 2015), 206. Reitz contends that the Parchman Penitentiary women prisoners' songs were "sung for their own survival and their own pleasure." Rosetta Reitz to Cheri Wolfe, August 28, 1986, Box 5, 1316, Rosetta Reitz Papers. For more on jailhouse women's blues, see also Mike Daley's reading of the work of Mattie May Thomas, one of the artists included on vol. 2 of 2005's *American Primitive* CD anthology. Mike Daley, "Mattie May Thomas, Prewar Blues Mystery Woman," *MapleBlues,* November 2016, clipping, Herbert Halpert 1939 Southern State Recording Expedition, AFC 1939 / 005 File, American Folklife Center, Library of Congress, Washington, DC.

48. Van der Tuuk, *Paramount's Rise and Fall,* 151. Haley, *No Mercy Here,* 245.

49. Says Thomas, "We'd alternate our singing—she'd sing one, I'd sing one, and each of us would bass for the other." L. V. Thomas, interview by Robert Mack McCormick, Houston, Texas, June 20 and November 2, 1961, as quoted in Oliver and McCormick, *Blues Come to Texas,* 76.

8. "Slow Fade to Black"

1. Felicia R. Lee, "Two Artists Salute a Legacy," *New York Times,* June 14, 2012; BRIC TV, "Slow Fade to Black: Caught in the Act," YouTube video, 7:39, posted August 6, 2012, https://www.youtube.com/watch?v=ne_r06NMqrk.

2. Joseph Roach, exchange with the author, 1999; Toni Morrison, *Beloved* (New York: Vintage, 2004), 308.

3. Lee, "Two Artists Salute a Legacy"; BRIC TV, "Slow Fade to Black"; Linda Dahl, "The Ones That Got Away," in *Stormy Weather: The Music and Lives of a Century of Jazz Women* (New York: Limelight Editions, 1989).

4. Silvia Spitta, "On the Monumental Silence of the Archive," in "On the Subject of Archives," ed. Marianne Hirsch and Diana Taylor, special issue, *emisférica* 9, nos. 1–2 (Summer 2012), http://www.hemisphericinstitute.org/hemi/es/e-misferica-91/spitta.

5. Sweet Honey in the Rock, "I Remember, I Believe," in "Sweet Honey in the Rock in Performance," *Talk of the Nation,* NPR, November 10, 2005, http://www.npr.org/templates /story/story.php?storyId=5007357.

6. BRIC TV, "Slow Fade to Black"; Sweet Honey in the Rock, "I Remember, I Believe."

7. Sweet Honey in the Rock, "I Remember, I Believe." Weems as quoted in Lee, "Two Artists Salute a Legacy."

8. Lee, "Two Artists Salute a Legacy." Tubman's famous quote is taken from Harriet Tubman to Sarah Bradford, in *Scenes in the Life of Harriet Tubman,* 1868, as quoted in "Harriet Tubman Myths and Facts," Bound for the Promised Land: Harriet Tubman, Portrait of an American Hero, accessed July 27, 2020, http://www.harriettubmanbiography.com/harriet -tubman-myths-and-facts.html: "There was no one to welcome me to the land of freedom. I was a stranger in a strange land; and my home, after all, was down in Maryland, because my father, my mother, my brothers, and sisters, and friends were there. But I was free, and they should be free."

9. Cassandra Wilson, "Acknowledgement," *Loop,* Fall 2016, 11–14.

10. Cassandra Wilson, *Coming Forth by Day,* Legacy Recordings, 2016. See also John Leland, "Going Home with Cassandra Wilson; Jazz Diva Follows Sound of Her Roots," *New York Times,* March 7, 2002. Jazz studies awaits a great, full-length exploration of Wilson's marvelous and varied career.

11. While curating and performing in a series of events at the nation's premiere art institution, Julia Bullock laid out a direct set of aims that she intended to address head-on in her work: "the marginalization and exploitation of women and minority groups; exoticism and appropriation; segregation, lack of access, and cultural exclusion; objectification in the visual arts, and the ways in which I, as a performer, can shift the perspective from object back to subject; and providing a voice for beings and stories that have been made silent." The potent realization of such goals, however, demanded an imaginative yoking together of what remains in the archive and what, as Bullock crucially asserts, she might body forth as a vocalist and performer. Julia Bullock, "On Her MetLiveArts Residency and Presenting 'History's Persistent Voice,'" Met, September 13, 2018, https://www.metmuseum.org/blogs/now-at -the-met/2018/julia-bullock-metlivearts-history-persistent-voice. Director Peter Sellars also observes that Bullock is "moving the whole art form into a new relevance, both by completely rehabilitating the existing repertoire and by commissioning a set of things that need to exist." Sellars as quoted in Zachary Woolfe, "'This Is Who We've Been Waiting For': A Diva on the Precipice," *New York Times,* October 25, 2019.

12. Corinna da Fonseca-Wollheim, "A Haunting Tribute to Josephine Baker Arrives at the Met Museum," *New York Times,* January 17, 2019. Many thanks to Lucy Caplan for her assistance with arrangements to attend the dress rehearsal for *Perle Noire* on January 15, 2019, at the Metropolitan Museum of Art. The critical work on Baker's performance politics is voluminous. See, for instance, Mae Gwendolyn Henderson, "Josephine Baker and *La Revue Negre:* From Ethnography to Performance," *Text and Performance Quarterly* 23, no. 2 (2003). See also Daphne Ann Brooks, "The End of the Line: Josephine Baker and the Politics of Black Women's Corporeal Comedy," *The Scholar and the Feminist Online* 6, nos. 1–2 (Fall 2007 / Spring 2008), http://sfonline.barnard.edu/baker/brooks_01.htm. Bullock's residency also featured her curation of programs focusing on "Langston Hughes in song" and a performance of the German opera *El Cimmaron,* the story of the Cuban fugitive from slavery Esteban Montejo.

13. Saidiya Hartman, *Wayward Lives, Beautiful Experiments: Intimate Histories of Social Upheaval* (New York: Norton, 2019), 17. Hartman calls these kinds of experiments exercises in "recogniz[ing] the obvious, but that which is ceded: the beauty of black ordinary, the beauty that resides in and animates the determination to live free, the beauty that propels the experiments in living otherwise. It encompasses the extraordinary and the mundane, art and everyday use. Beauty is not a luxury; rather it is a way of creating possibility in the space of enclosure, a radical art of subsistence, an embrace of our terribleness, a transfiguration of the given. It is a will to adorn, a proclivity for the baroque, and the love of *too much*" (33).

14. Jamila Woods, *Legacy! Legacy!,* Jagjaguwar, 2019. See also Jon Caramanica, "For Jamila Woods, History Is Today's Inspiration and Tomorrow's Blueprint," *New York Times,* May 15, 2019. See also Wood's 2020 single, "Sula," released on the first anniversary of Toni Morrison's passing which pays homage to the protagonist of the author's 1973 Black feminist classic novel of the same name. Another 2019 release, *Silences,* by contemporary avant-garde blues musician Adia Victoria, works the speculative angles of the archive as well. In November 2019, Victoria discussed the inspiration for her work in an in-studio interview at Los Angeles's NPR station, KCRW. There, Victoria said, "I wonder what it would sound like if Billie Holiday got lost in a Radiohead song?" As DJ Anne Litt notes, "*Silences* takes its title from the 1962 book of the same name, by first-wave feminist Tillie Olsen, a reflection on the yawning void in artistic canons that came with excluding women from serious consideration." Anne Litt, "Morning Becomes Eclectic: Adia Victoria," KCRW, November 4, 2019,

https://www.kcrw.com/music/shows/morning-becomes-eclectic/adia-victoria. See also "Exploring the Rise and Fall of Paramount Records," critical listening event with Adia Victoria, Jack White, Greil Marcus, Scott Blackwood, Dean Blackwood, and Daphne Brooks, Yale University, October 28, 2014.

15. Daphne Duval Harrison, *Black Pearls: Blues Queens of the 1920s* (New Brunswick, NJ: Rutgers University Press, 1988). Hazel Carby, "It Just Be's Dat Way Sometime: The Sexual Politics of Women's Blues," in *Unequal Sister: A Multicultural Reader in U.S. Women's History*, ed. Ellen Carol DuBois and Vicki Ruiz (New York: Routledge, 1990), 238–249; Angela Davis, *Blues Legacies and Black Feminism: Gertrude "Ma" Rainey, Bessie Smith, and Billie Holiday* (New York: Vintage, 1999). See also David Wondrich's fine reading of Mamie Smith's "Crazy Blues" breakthrough. David Wondrich, *Stomp and Swerve: American Music Gets Hot, 1843–1924* (New York: Chicago Review Press, 2003), 207–214.

16. Daphne A. Brooks, *Bodies in Dissent: Spectacular Performances of Race and Freedom, 1850–1910* (Durham, NC: Duke University Press, 2006), 207–280. See also Lynn Abbott and Doug Seroff, *Ragged but Right: Black Traveling Shows, Coon Songs, and the Dark Pathway to Blues and Jazz* (Jackson: University Press of Mississippi, 2012); Abbott and Seroff, *The Original Blues: The Emergence of the Blues in American Vaudeville, 1899–1926* (Jackson: University Press of Mississippi, 2017).

17. George Walker, "Two Real Coons," *Theatre,* supplement, 1906.

18. Wondrich, *Stomp and Swerve,* 213. For a first-hand account of the "Crazy Blues" recording session and the electrifying success of the record, see Perry Bradford, *Born with the Blues: The Salty and Uninhibited Autobiography of One of the Greatest of the Old-Time Jazz Pioneers* (New York: Oak Publications, 1965), 114–129. See also Abbott and Seroff's discussion of Smith's success. Abbott and Seroff, *The Original Blues,* 268–269. "Mamie Smith and the Birth of the Blues Market," *All Things Considered,* NPR, November 11, 2006, https://www.npr.org/2006/11/11/6473116/mamie-smith-and-the-birth-of-the-blues-market.

19. In her epic Great Migration novel, Toni Morrison illuminates the volatile connections between anti-Black violence in the 1910s, African American protest politics, and the birth of the blues. See Toni Morrison, *Jazz* (New York: Vintage, 2004), 53–54. Wondrich, *Stomp and Swerve,* 208.

20. Wondrich, 210. Bradford, *Born with the Blues,* 118. Bradford adds that "Mr. Hager got a far-off look in his eyes and seemed somewhat worried, because of the many threatening letters he had received from some Northern and Southern pressure groups warning him not to have any truck with colored girls in the recording field. If he did, Okeh Products—phonograph machines and records—would be boycotted." Bradford, 118.

21. Daphne A. Brooks, "100 Years Ago, 'Crazy Blues' Sparked a Revolution for Black Women Fans," *New York Times,* August 10, 2020. For a history of racial segregation in popular music culture, see Karl Hagstrom Miller, *Segregating Sound: Inventing Folk and Pop Music in the Age of Jim Crow* (Durham, NC: Duke University Press, 2010). See the Fred Moten trilogy, Consent to Not Being a Single Being: *Black and Blur, The Universal Machine,* and *Stolen Life* (Durham, NC: Duke University Press, 2017). Black press outlets touted the success of "Crazy Blues" for having sold "a million dollars worth of records." *Chicago Defender* as cited in Abbott and Seroff, *The Original Blues.* Blues historian Elijah Wald reminds that record sales numbers from this period were less than accurate. But he argues that "when anyone talks about a record in the teens or twenties selling a million copies, what they mean is lots and lots." Author's Interview with Elijah Wald, July 31, 2020.

22. "Pace & Handy," *Chicago Defender,* July 31, 1920.

23. Abbott and Seroff, *The Original Blues*, 267-271. My thanks to Caryn Ganz for her terrific feedback on my study of "Crazy Blues."

24. Wondrich, *Swerve and Stomp,* 211. Bradford, *Born with the Blues,* 125. Wondrich, *Swerve and Stomp,* 212.

25. For more on interracial politics between Asian Americans and African Americans in the early twentieth century, see Mary Lui, *The Chinatown Trunk Mystery: Murder, Miscegenation, and Other Dangerous Encounters in Turn-of-the-Century New York City* (Princeton, NJ: Princeton University Press, 2005). On African American ideas about racial "otherness" in the early twentieth century, see Stephanie Batiste, *Darkening Mirrors: Imperial Representation in Depression-Era African American Performance* (Durham, NC: Duke University Press, 2012). See also Erika Lee, *At America's Gates: Chinese Immigration during the Exclusion Era, 1882–1943* (Durham, NC: University of North Carolina Press, 2003); and Beth Lew-Williams, *The Chinese Must Go: Violence, Exclusion and the Making of the Alien in America* (Cambridge, MA: Harvard University Press, 2018).

26. Adam Gussow, "'Shoot Myself a Cop': Mamie Smith's 'Crazy Blues' as Social Text," *Callaloo* 25, no. 1 (2002): 8–44.

27. Ann Powers: *Good Booty: Love and Sex, Black and White, Body and Soul in American Music* (New York: Dey St., 2017), 74–75.

28. On the history of the 1919 racial massacres that swept across the United States that year, see for instance, David Krugler, *1919, The Year of Racial Violence: How African Americans Fought Back* (New York: Cambridge University Press, 2015). Cameron McWhirter, *Red Summer: The Summer of 1919 and the Awakening of Black America* (New York: St. Martin's Griffin, 2012).

29. Author's interview with Elijah Wald, July 31, 2020. On Mamie Smith's success on the blues circuit, see Abbott and Seroff, *The Original Blues*, 267–271.

30. Jayna Brown has shown us the reach of these sensational aesthetic intimacies between Black and white women performers, boldly recuperating this lost history of "love and theft" between Black women who danced, sang, composed music, and played instruments in the early twentieth century and white women performers such as Eva Tanguay, Fanny Brice, Mae West, and especially "big-boned" Jewish singer Sophie Tucker, "the last of the red hot mamas," women who were inspired, sometimes threatened by, and deeply desirous of the black women performers in their midst. "All of these [white] women," Brown argues, "learned their dances, including the shimmy, from watching Clara Smith and other black women performers on the [Theater Owners Booking Association] circuit through Chicago." Jayna Brown, *Babylon Girls: Black Performers and the Shaping of the Modern* (Durham, NC: Duke University Press, 2008), 213.

31. Hortense Spillers, "Mama's Baby, Papa's Maybe: An American Grammar Book," in *Black, White, and in Color: Essays on American Literature and Culture* (Chicago: University of Chicago Press, 2003), 203–229.

32. Valerie Smith, *Toni Morrison and the Moral Imagination* (New York: Blackwells, 2012); Gayle Wald, "Past Is Present," *Oxford American,* no. 18, Southern Music Issue, Winter 2016, 26, emphasis in the original.

33. Jon Pareles, "A Solo Spotlight for a Powerful Voice," *New York Times,* January 23, 2015; Randy Lewis, "Rhiannon Giddens Channels 'Voices That Need to Be Heard' on 'Freedom Highway,'" *Los Angeles Times,* February 26, 2017.

34. Pareles, "Solo Spotlight"; Dave Itzkoff, "Rhiannon Giddens Brings Diversity to Banjo Award," *New York Times,* September 11, 2016. See also Francesca Royster, "Can the Black Banjo Speak?," unpublished paper manuscript, October 2020.

35. Yunina Barbour-Payne invokes the term "Affrilachian" to describe the work of the Carolina Chocolate Drops and the group's sonic evocation of "an identity that encompasses multiple ethnic groups within the Appalachian region, particularly people of African descent." Barbour-Payne argues that, inasmuch as "Giddens embodies Affrilachia, her body transforms into a multifaceted catalyst through which individuals communicate their regional, racial, and national identity connections." Yunina Barbour-Payne, "Carolina Chocolate Drops: Performative Expressions and Reception of Affrilachian Identity," in *Appalachia Revisited: New Perspectives on Place, Tradition, and Progress,* ed. William Schumann and Rebecca Adkins Fletcher (Lexington: University of Kentucky Press, 2016), 43–58. For her part, Giddens has talked about her deep identification with her North Carolinian identity above all other formations, stating, "It's not so much that I'm black or I'm white or I'm Indian or whatever. I'm Southern. And furthermore I'm a North Carolinian." Malcolm Jones, "Patsy Cline, Alison Krauss, and Now . . . Rhiannon Giddens," *Daily Beast,* March 8, 2015, http://www .thedailybeast.com/articles/2015/03/08/patsy-kline-allison-krauss-and-now-rhiannon -giddens.html. Giddens and her fellow Chocolate Drops, Don Flemons and Justin Robinson, met in 2005 at the Black Banjo Gathering at Appalachian State and formed the group soon after, studying closely with their mentor, North Carolina Piedmont fiddler Joe Thompson. See Karen Michel, "Chocolate Drops Revive String-Band Sound," NPR Music, January 28, 2007, https://www.npr.org/templates/story/story.php?storyId=7054539.

36. Ann Powers, "First Listen: Rhiannon Giddens, 'Tomorrow Is My Turn,'" NPR Music, February 1, 2015, https://www.npr.org/2015/02/01/382372052/first-listen-rhiannon-giddens -tomorrow-is-my-turn; Rhiannon Giddens, liner notes for *Tomorrow Is My Turn,* Nonesuch Records, 2015; James Reed, "Rhiannon Giddens, 'Tomorrow Is My Turn,'" album review, *Boston Globe,* February 9, 2015; Pareles, "Solo Spotlight."

37. David Fricke, "Rhiannon Giddens' Old Time Religion," *Rolling Stone,* March 5, 2015; Lee Bidgood, "Three Solo Albums by the Original Chocolate Drops (Band)," review of *Tomorrow Is My Turn, Journal of Appalachian Studies* 21, no. 2 (2015): 285–288; Pareles, "Solo Spotlight."

38. Giddens, liner notes for *Tomorrow Is My Turn;* Susan Davis, "Rhiannon Giddens, American Angel: *Tomorrow Is My Turn,*" *American Music Review* 44, no. 2 (Spring 2015): 25–28; Pareles, "Solo Spotlight."

39. Giddens, liner notes for *Tomorrow Is My Turn;* Davis, "Rhiannon Giddens, American Angel."

40. Rhiannon Giddens, "Angel City," *Tomorrow Is My Turn;* Davis, "Rhiannon Giddens, American Angel."

41. Jones, "Patsy Cline"; Powers, "First Listen."

42. Rhiannon Giddens, "Black Is the Color," YouTube video, 3:56, posted October 5, 2015, https://www.youtube.com/watch?v=0Pg2lt8PmTA. In her liner notes, Giddens discusses how she "always loved best the west North Carolinian Sheila Kay Adams' version" of this song. Giddens, liner notes for *Tomorrow Is My Turn.* See also "Push It Further: Rhiannon Giddens Takes a Turn on Tradition," *Morning Edition,* NPR, February 10, 2015, http://www .npr.org/2015/02/10/384943903/push-it-further-rhiannon-giddens-takes-a-turn-on -tradition. Also in her notes for the album, Giddens thanks "the incomparable ladies— Nina, Odetta, Sheila, Peggy, Dolly, Patsy, Sister Rosetta Tharpe, Jean, Libba, Florence, Armentha and Deborah—who inspired me to make this record: if not for you, there'd be no me." Giddens, liner notes for *Tomorrow Is My Turn.* In the video, she holds "an actual Fisk Jubilee Singers songbook" from the archive. Giddens tells us that she "had this whole

story concocted in [her] head about [her] discovering this love story between two Fisk Jubilee Singers." Rhiannon Giddens, public conversation with Daphne A. Brooks and Brian Kane, November 15, 2018, Yale University Black Sound and the Archive Working Group event, Yale Oral History of American Music Archive, https://yale.app.box.com/file/560465460119.

43. Giddens, public conversation with Brooks and Kane.

44. Thomas F. Briggs, *Briggs' Banjo Instructor of 1855* (Bremo Bluff, VA: Tuckahoe Music, 1992).

45. Giddens, public conversation with Brooks and Kane, emphasis Giddens's.

46. The story of the Carolina Chocolate Drops' excavation of "Snowden's Jig," referred to by nineteenth-century blackface minstrel performer Dan Emmett and the Virginia Minstrels as "The Genuine Negro Jig" is a moving one. The reclamation of "Snowden" in the title of the song was the group's effort to pay homage to the early and influential African American string band, the Snowden Family Band. "We actually went to the grave of the patriarch of the family," says Giddens, "and played that tune. . . . It was a pretty deep moment." Giddens, public conversation with Brooks and Kane. For more on the Snowden family, see Howard L. Sacks and Judith Rose Sacks, *Way Up North in Dixie: A Black Family's Claim to the Confederate Anthem* (Urbana: University of Illinois Press, 2003).

47. Giddens, public conversation with Brooks and Kane; Terry Gross, "Rhiannon Giddens Speaks for the Silenced," NPR, *Fresh Air,* May 11, 2017, https://www.npr.org/2017/05/11/527911058/rhiannon-giddens-speaks-for-the-silenced. Giddens's passion for the banjo resulted in her taking a trip to Gambia "to study the akonting, a three-stringed, centuries-old West African ancestor of the banjo." Pareles, "Solo Spotlight"; Itzkoff, "Rhiannon Giddens Brings Diversity." There, though, she ended up deepening her interest in minstrel banjo as she realized, "I wanted to go to the Caribbean. I wanted to go to early banjo." Giddens, public conversation with Brooks and Kane.

48. Giddens, public conversation with Brooks and Kane, emphasis Giddens's. See, of course, Eric Lott's classic meditation on minstrelsy. Eric Lott, *Love and Theft: Blackface Minstrelsy and the American Working Class* (New York: Oxford University Press, 1995).

49. Giddens, public conversation with Brooks and Kane, emphasis Giddens's. For more on the history of the banjo, see Robert B. Winans, *Banjo Roots and Branches* (Urbana: University of Illinois Press, 2018).

50. Giddens, public conversation with Brooks and Kane.

51. Wald, "Past Is Present," 26. Wald points out that a "bill of sale she discovered during her research was the sorrowful inspiration for 'At the Purchaser's Option,' her wrenching song about the buying and selling of enslaved children without regard for kinship relations" (28–29).

52. Gross, "Rhiannon Giddens Speaks."

53. Giddens, public conversation with Brooks and Kane.

54. Gross, "Rhiannon Giddens Speaks"; Toni Morrison, public reading of *Beloved* at U.C. Berkeley, Fall 1987. Morrison made this remark on more than one occasion during public events about her work. See also Africans in America, Part 1: "The Terrible Transformation," PBS website, https://www.pbs.org/wgbh/aia/part1/1narr3.html for use of this formulation. In her conversation with *Fresh Air*'s Terry Gross, Giddens breaks into a spontaneous verse of "Underneath the Harlem Moon" and rolls out a series of elegant and varied vocal inflections and phrasings that recall Ethel Waters's 1933 hit version of that song. Giddens notes that she performs the song with Waters's added lyrics.

55. John Jeremiah Sullivan, "Rhiannon Giddens and What Folk Music Means," *New Yorker,* May 13, 2019. The performance was in Sing Sing prison.

56. Sullivan, "Rhiannon Giddens."

57. Giddens, public conversation with Brooks and Kane, emphasis Giddens's.

58. Jewly Hight, "'Songs of Our Native Daughters' Lays Out a Crucial, Updated Framework for Americana," First Listen, NPR Music, February 14, 2019, https://www.npr.org/2019/02/14/693624881/first-listen-our-native-daughters-songs-of-our-native-daughters. See Our Native Daughters, *Songs of Our Native Daughters,* Smithsonian Folkways, 2019. The album features original tracks by all four musicians that focus on the historical challenges, triumphs, and emotional complexities of historically rooted Black womanhood across the centuries. Giddens wrote liner notes for the album and compiled a "further reading" bibliography. Sullivan, "Rhiannon Giddens."

59. Will Hermes, "Valerie June and the Intersectional Protest Folk LPs Defining Nu-America," *Rolling Stone,* March 8, 2017; Ann Powers, "First Listen: Valerie June's *Pushin' against a Stone,*" NPR Music, August 4, 2013, https://www.npr.org/2013/08/04/207916507/first-listen-valerie-june-pushin-against-a-stone; Jem Aswad, "Countrified Darling Valerie June's Soulful *Pushin' against a Stone* Will Snag Awards, Sell Tote Bags," *Spin,* August 12, 2013; Edith Zimmerman, "Williamsburg-Appalachia-Country-Blues Goes Pop," *New York Times,* August 16, 2013.

60. Ken Tucker, "Singer-Songwriter Valerie June Draws on Her Southern Roots in 'The Order of Time,'" *Fresh Air,* NPR, April 3, 2017, https://www.npr.org/2017/04/03/522455171/singer-songwriter-valerie-june-draws-on-her-southern-roots-in-the-order-of-time.

61. Valerie June, "Love You Once Made," *The Order of Time,* Concord Records, 2017; Hermes, "Valerie June and the Intersectional Protest LPs Defining Nu-America"; Shamira Muhammad, "Organic Moonshine Roots Music and Fela Kuti: An Interview with Valerie June," Africa Is A Country website, November 21, 2013, https://africasacountry.com/2013/11/organic-moonshine-roots-music-and-fela-kuti-an-interview-with-valerie-june.

62. Andy Gill, "Album Review: Valerie June, Pushin' against a Stone," *Independent* (UK), May 10, 2013; Marissa Moss, "Valerie June: Why the Brilliant Folk Artist Doesn't Write Protest Songs," *Rolling Stone,* March 21, 2017.

63. Valerie June, public conversation with the author, November 8, 2017, Yale University Black Sound and the Archive event; Jewly Hight, "Review: Valerie June, 'The Order of Time,'" First Listen, NPR Music, March 2, 2017, https://www.npr.org/2017/03/02/517916942/first-listen-valerie-june-the-order-of-time.

64. Edith Zimmerman, "Williamsburg-Appalachia-Country-Blues Goes Pop," *New York Times,* August 16, 2013; Will Hermes, review of *Pushin' against a Stone,* by Valerie June, *Rolling Stone,* October 18, 2013.

65. Emerson Hockett was known for promoting one of Prince's earliest live shows as well as Bobby Womack and other soul and R&B artists. Says June of her father's untimely passing at the age of sixty-three, "I come from a singing family. We held hands in a circle around him and sang songs from our childhood. We sang songs we used to sing at church and songs we used to sing to get through the hard work days. I was holding my father's hand when I felt his spirit leave his body." Valerie June, "The First Time I Lost a Parent," *New York Times,* March 7, 2017.

66. In a 2017 interview at the Rock and Roll Hall of Fame, June listed the following figures as her "biggest inspirations": "I love Oprah. I love Michelle Obama. Thich Nat Hanh. Gandhi. Martin Luther King Jr. John Lennon. Rumi. Frida Kahlo. Pink Floyd. Paulo Coelho.

David Bowie. Wendell Berry. Joan of Arc. Basquiat. Syd Barrett. Zora Neale Hurston. Alan Lomax. Nirvana. All old time blues and country singers. Elvis. Tina Turner. Fela. Nick Drake. Karen Dalton. Tom Waits. Mother Theresa. Willie Nelson. Carl Sagan. Bob Marley. Josephine Baker. Etta James. Esther Hicks. Stevie Nicks. Kahlil Gibran. So so so many more. I like to stay inspired!" Songwriting influences include, for her, Leonard Cohen, Neil Young, Dolly Parton, Tracy Chapman, Joanna Newsom, and Carole King. "Interview with Valerie June," Rock and Roll Hall of Fame, February 2, 2017, https://www.rockhall.com/interview -valerie-june. See also June's discussion of favorite vocalists (e.g., Newsom, Nicks, Dolly Parton, Nina Simone, and Karen Dawson). Ilana Kaplan, "Valerie June Talks about Loss, Love and *The Order of Time*," *Nylon*, March 23, 2017.

67. June, public conversation with the author. June adds an anecdote that resonates with L. V. Thomas's golden years profile, noting, "I have friends who say that she had guns on her, even in church. She would not be crossed."

68. June, public conversation with the author.

69. In her magisterial reading of legendary Cuban vocalist Celia Cruz, Vazquez describes how "Cruz would often save her signature 'Bemba Colora' as the encore an audience had to deserve. . . . We remained because she remained." Alexandra T. Vazquez, "What She Brought with Her," NPR Music, September 9, 2019, https://www.npr.org/2019/09/19/759195256 /what-she-brought-with-her.

70. My thanks to Valerie June for sharing this recording during our publication conversation at Yale in November 2017. Jessie Mae Hemphill was the niece of Mississippi blues musician Rosa Lee Hill, another June influence. Hemphill launched her major recording career in the 1980s when she released her first full-length album, *She-Wolf*, on the French label Disque Vogue in 1981. She released over a dozen albums through the early 2000s and passed in 2006. Wikipedia, s.v. "Jessie Mae Hemphill," last modified March 16, 2020, https://en.wikipedia.org/wiki/Jessie_Mae_Hemphill. The oral history recording is courtesy of Valerie June Hockett.

71. June, public conversation with author.

72. Says June, "So if you wan[t] to get mystical, we can go for a long time because my mind is in that place." June, public conversation with the author. See also Charles Chesnutt, *The Conjure Woman Tales* in *Charles Chesnutt: Stories, Novels, and Essays* (New York: Library of America, 2002); and Zora Neale Hurston, *Mules and Men* (New York: Amistad, 2008).

73. Moss, "Valerie June"; Geoffrey Himes, "Valerie June Wants to Be Set Free," *Paste*, March 17, 2017. Geoffrey Himes adds that "June says she once got lost for hours in Oklahoma City's American Banjo Museum, amazed that the banjo has taken so many forms and has been used in so many genres over the decades. She saw 10-string banjos, electric four-string banjos, even bass banjos. If an instrument so rooted in American history could shrug off all assumptions about how it looked and how it sounded, why not her?"

74. June, public conversation with the author.

75. Sylvia Wynter and Katherine McKittrick, "Unparalleled Catastrophe for Our Species? Or, to Give Humanness a Different Future: Conversations," in *Sylvia Wynter: On Being Human as Praxis*, ed. Katherine McKittrick (Minneapolis: University of Minnesota Press, 2014), 45.

76. June, public conversation with the author.

77. Dan Hyman, "From Kickstarter to Critical Acclaim: The Genre-Bending Music of Valerie June," *Elle*, March 13, 2017; Hight, "Review: Valerie June;" *NPR Music*, March 2, 2017; Hermes, review of *Pushin' against a Stone*; Hua Hsu, "Valerie June's Music Is a Reminder That Life Goes On," *New Yorker*, May 3, 2017; Hight, "Review: Valerie June."

78. "When Valerie June Writes Music, It Begins with a Voice in Her Head," NPR, *Weekend Edition Saturday,* March 25, 2017, https://www.npr.org/2017/03/25/521135413/when-valerie -june-writes-music-it-begins-with-a-voice-in-her-head; June, interview with the author; Thom Duffy, "Singer-Songwriter Valerie June Closes Out a Successfully Genre-Mashing, Globe-Circling 2017," *Billboard,* December 19, 2017; Moss, "Valerie June"; "Interview with Valerie June," Rock and Roll Hall of Fame.

79. Mark Lomanno, "Enunciating Power and Ex . . . Plosive Time: Cécile McLorin Salvant's 'Woman Child' and Silence Undone," *Ethnomusicology Review* 21 (March 18, 2014), https:// ethnomusicologyreview.ucla.edu/content/enunciating-power-and-ex%E2%80%A6plosive -time-c%C3%A9cile-mclorin-salvant%E2%80%99s-%E2%80%9Cwoman-child%E2%80%9D -and-silence-0; Nate Chinen, "Cécile McLorin Salvant: The Ghost Writer," *JazzTimes,* February 3, 2018.

80. Margo Jefferson, "The Trolley Song—25 Songs That Tell Us Where Music Is Going," *New York Times Magazine,* March 9, 2017; Ben Ratliff, "A Singer Is a Big Part of the Picture," *New York Times,* December 6, 2013; Lomanno, "Enunciating Power"; Chinen, "Cécile McLorin Salvant: The Ghost Writer."

81. "Jazz Singer Cécile McLorin Salvant Doesn't Want to Sound 'Clean and Pretty,'" *Fresh Air,* NPR, November 4, 2015, https://www.npr.org/2016/01/01/461503555/jazz-singer-c -cile-mclorin-salvant-doesnt-want-to-sound-clean-and-pretty; Sonnet Retman, "Ho-de-ho-de-ha, ha! Ha!': How Blanche Calloway Swings" (unpublished manuscript, April 2019); Nate Chinen, "Cécile McLorin Salvant Wields Her Power, Drawing from Her Album 'For One to Love,'" *New York Times,* August 26, 2015; Fred Kaplan, "Cécile McLorin Salvant's Timeless Jazz," *New Yorker,* May 22, 2017; Brad Farberman, "Cécile McLorin Salvant: Fire & Ice," *JazzTimes,* January 24, 2012. Of her influences, Salvant has said, "I say that all of these people I carry with me have influenced me. It would be hard to pin it down to even 20 people. They're like companions and sometimes I feel like I can never be lonely because I have all these beautiful artists with me that have changed my life." Charles Waring, "Dreaming Big—Cécile McLorin Salvant Talks to SJF," *Soul and Jazz and Funk,* September 25, 2017, https://www.soulandjazzandfunk.com/interviews/dreaming-big-cecile-mclorin-salvant -talks-to-sjf/. See also Ben Ratliff, "A Young Vocalist Tweaks Expectations," *New York Times,* November 2, 2012.

82. Alan Lomax, "Preface to the 1993 Edition," in *Mister Jelly Roll: The Fortunes of Jelly Roll Morton, New Orleans Creole and "Inventor of Jazz"* (Berkeley: University of California Press, 2001), xi.

83. Elijah Wald and I agree that "Murder Ballad" clocks in at "roughly 100 lines of lyrics." Wald email to the author, September 22, 2020. Lomanno, "Enunciating Power"; Cécile McLorin Salvant, "John Henry," *WomanChild,* Mack Avenue Records, 2013. "In language as raunchy as the life in this city of pleasure," observes Lomax, Morton's Library of Congress recordings "portrayed its streets, bars, neighborhoods, customs, and celebrations, depicting the rich background out of which jazz grew." Lomax, "Preface," xi.

84. Nate Chinen, "Wild Women Don't Worry: Cécile McLorin Salvant's Politics of Desire" (paper presented at the Museum of Pop Culture Annual Pop Conference, Seattle, WA, April 26, 2018). See also Nate Chinen, *Playing Changes: Jazz for the New Century* (New York: Pantheon, 2018), ix–xi.

85. Will Hermes, review of *Dreams and Daggers,* by Cécile McLorin Salvant, in "15 Great Albums You Probably Didn't Hear in 2017," *Rolling Stone,* December 19, 2017.

86. Nina Simone, "Mississippi Goddam," *In Concert,* Phillips Records, 1964.

87. Chinen, "Cecile McLorin Salvant: The Ghost Writer"; Ratliff, "Young Vocalist Tweaks Expectations"; Tom Vitale, "The Vast, Versatile Range of Cécile McLorin Salvant," *All Things Considered,* NPR, November 18, 2017, https://www.npr.org/2017/11/18/561380228/the-vast-versatile-range-of-c-cile-mclorin-salvant; "Salvant Doesn't Want to Sound 'Clean and Pretty'"; Cécile McLorin Salvant, "You Bring Out the Savage in Me," *WomanChild;* Cécile McLorin Salvant, "Si j'étais blanche," *Dreams and Daggers,* Mack Avenue Records, 2017.

88. "Authentic Early Jazz, from a 23-Year-Old Womanchild," *All Things Considered,* NPR, June 3, 2013, https://www.npr.org/2013/06/03/188394005/authentic-early-jazz-from-a-23-year-old-womanchild; Lomanno, "Enunciating Power"; Chinen, "Cécile McLorin Salvant Wields Her Power"; David Hadju, "And Look—She's a Star! Cécile McLorin Salvant Has a Repertoire Twice as Long as Most Singers," *Nation,* December 26, 2017.

89. My thanks to Lauren Jackson of the University of Chicago for this generative observation about the intersections between "doing time" and "spending time." For more on temporality in Salvant's repertoire, see Lomanno, "Enunciating Power."

90. Ralph Ellison, *Invisible Man* (New York: Vintage, 1995), 441, 443.

91. Philip Lutz, "Cécile McLorin Salvant: True Character," *Downbeat,* June 10, 2018; Hermes, review of *Dreams and Daggers;* Waring, "Dreaming Big."

92. Chinen, "Cécile McLorin Salvant Wields Her Power." Chinen observes that McLorin Salvant is "a stealth subversive, working within a recognizable framework in ways that feel ecstatic and unbound" Chinen, *Playing Changes,* ix–x.

93. Fred Kaplan, "Cécile McLorin Salvant's Timeless Jazz." On her early interest in Billie Holiday's phrasing, see "Salvant Doesn't Want to Sound 'Clean and Pretty.'" On her skills as an actress, see Lutz, "Cecile McLorin Salvant."

94. Jefferson, "Trolley Song."

95. Abbott and Seroff, *Ragged but Right,* 52; Brown, *Babylon Girls,* 56-91; Fred Kaplan, "Cécile McLorin Salvant's Timeless Jazz."

96. Abbott and Seroff, *Ragged but Right,* 22–23. Camille Forbes, *Introducing Bert Williams: Burnt Cork, Broadway, and the Story of America's First Black Star* (New York: Civitas Books, 2008). Abbott and Seroff, *Ragged but Right,* 52–53.

97. Bert Williams, "Nobody," *The Early Years, 1901–1909,* Archeophone Records, 2004; WNYC, "Cécile McLorin Salvant, 'Nobody,' Live on Soundcheck," YouTube video, 3:42, posted July 24, 2013, https://www.youtube.com/watch?reload=9&v=8kxDdkphgwQ.

98. Ted Gioia, liner notes for McLorin Salvant, *WomanChild.* On this her second album, she takes on a number of songs long left behind. In addition to taboo numbers like "You Bring Out the Savage in Me," which had not been recorded since 1935 by Valaida Snow, and the folk ballad "John Henry," Salvant covers 1930s Haitian poet Ida Salomon Faubert's poem "Le front caché sur tes genoux." "Salvant Doesn't Want to Sound 'Clean and Pretty.'" Her 2015 album, *For One to Love,* features a cover of the 1963 knee-jerk gender politics pop hit, the Burt Bacharach-penned "Wives and Lovers," which she takes on as well in a bid to explore the genre of the sexist song. See "Salvant Doesn't Want to Sound 'Clean and Pretty'"; Gioia, liner notes for *WomanChild.* I borrow the "doubleness" formulation from Brian Kane, *Hearing Double: Jazz, Ontology, Auditory Culture* (New York: Oxford University Press, forthcoming).

99. Bernice Johnson Reagon, liner notes for *Jailhouse Blues,* Rosetta Records, 1987. Reagon continues by adding that "whatever the motivation, we owe a debt to these women." Blues scholar Samuel Charters further speculates that the women prisoners of Parchman

may have pieced together their music from their own forced labor "with the windows of their sewing room open" and picking up the work songs and rhythms of the men in the field. For more on Reitz and Reagon's *Jailhouse Blues* project, see Chapter 3.

100. Sarah Haley, *No Mercy Here: Gender, Punishment, and the Making of Jim Crow Modernity* (Chapel Hill: University of North Carolina Press, 2016), 45.

101. Jelly Roll Morton, "The Murder Ballad," 1938, AFC 1938/001, original recording housed at the American Folklife Center, Library of Congress, Washington, DC, https://www .loc.gov/item/afc9999005.5948. See, for instance, Jelly Roll Morton, "The Dirty Dozen," also recorded during his Library of Congress sessions, in which he declares, "so I had a bitch/wouldn't fuck me 'cause she had the itch/Yes, she's my bitch/Oh yo' mammy don't wear no drawers." "'The Dirty Dozen,' Jelly Roll Morton," Genius, accessed July 27, 2020, https://genius.com/Jelly-roll-morton-the-dirty-dozen-lyrics; Jelly Roll Morton, "The Dirty Dozen," 1938, https://www.loc.gov/item/afc9999005.5949/. My thanks to the members of Yale's Black Sound and the Archive Working Group and especially to Ambre Dromgoole, Clara Wilson-Hawken, and Chloe Swindler for their excellent and resourceful research on "Murder Ballad" for our February 2018 workshop with Cécile McLorin Salvant. For more on Morton and his game-changing career, see Lomax, *Mister Jelly Roll*. See also William J. Schafer, *The Original Jelly Roll Blues* (London: Flame Tree, 2008); Howard Reich and William Gaines, *Jelly's Blues: The Life, Music, and Redemption of Jelly Roll Morton* (New York: Da Capo, 2003); and James Dapogny, *Ferdinand "Jelly Roll" Morton: The Collected Piano Music* (Washington, DC: Smithsonian, 1982). See also Bryan Wagner, *Disturbing the Peace: Black Culture and the Police Power after Slavery* (Cambridge, MA: Harvard University Press, 2009), 51–56.

102. Cécile McLorin Salvant, "Wives and Lovers," *For One to Love,* Mack Avenue Records, 2015; "Salvant Doesn't Want to Sound 'Clean and Pretty.'"

103. Jefferson, "Trolley Song"; Matt Jacobson, conversation with the author, May 2017; Cécile McLorin Salvant, "If a Girl Isn't Pretty," *Dreams and Daggers.*

104. Cécile McLorin Salvant, "Wild Women Don't Have the Blues," *Dreams and Daggers.* Haitian literature scholar Shanna-Dolores Jean-Baptiste calls Faubert "one of Haiti's first feminist and queer writers." Shanna-Dolores Jean-Baptiste, email to the author, September 26, 2018. Jack Halberstam, "Wildness, Loss, Death," *Social Text* 32, no. 4 (121) (Winter 2014): 138, 147. See also Tavia Nyong'o, *Afro-fabulations: The Queer Drama of Black Life* (New York: New York University Press, 2018); "'Wild Women Don't Have the Blues,' Ida Cox," Genius, accessed July 27, 2020, https://genius.com/Ida-cox-wild-women-dont-have-the-blues-lyrics; "'You Bring Out the Savage in Me,' Valaida Snow," Genius, accessed July 27, 2020, https:// genius.com/Valaida-snow-you-bring-out-the-savage-in-me-lyrics; Lomanno, "Enunciating Power"; Jean-Baptiste, email to the author. See also Omise'eke Natasha Tinsley, *Thiefing Sugar: Eroticism between Women in Caribbean Literature* (Durham, NC: Duke University Press, 2010).

105. Roseanne Vitro, "An Interview with Cécile McLorin Salvant," *JazzTimes,* January 20, 2016. See also Lutz, "Cécile McLorin Salvant"; and Fred Kaplan, "Cécile McLorin Salvant's Timeless Jazz."

106. Chinen, "Wild Women Don't Worry."

107. Louis Maistros, "These things may not be right, but they are true," https:// louismaistros.livejournal.com/47509.html.

108. Brent Edwards, "Louis Armstrong and the Syntax of Scat," *Critical Inquiry* 28, no. 3 (Spring 2002): 647.

109. Vitro, "Interview with Cécile McLorin Salvant"; Edwards, "Louis Armstrong," 649. See also Brent Edwards, *Epistrophies: Jazz and the Literary Imagination* (Cambridge, MA: Harvard University Press, 2017), 27–56.

110. She takes us to and through the kind of place that queer Black feminist critic Kara Keeling describes in her captivating reading of Donna Summer's 1977 disco manifesto, which, as she argues, "transform[s] the sound and feel of disco and with it, the rhythms and gestures of gay and trans* desire and comportment." Kara Keeling with Jacqueline Stewart and Daphne Brooks, "The Combahee River Mixtape" (lecture, University of Chicago, September 2017). Here as well Keeling cites Jon Savage, whose observations about temporality and sonic performance are provocative. Savage argues that, "within its modulations and pulses, ["I Feel Love"] achieves the perfect state of grace that is the ambition of every dance record: it obliterates the tyranny of the clock—the everyday world of work, responsibility, money—and creates its own time, a moment of pleasure, ecstasy and motion that seems infinitely expandable, if not eternal. Jon Savage as quoted in Keeling, "Combahee River Mixtape."

111. Waring, "Dreaming Big."

112. Hortense Spillers, "Mama's Baby, Papa's Maybe: An American Grammar Book," in *Black, White, and in Color: Essays on American Literature and Culture* (Chicago: University of Chicago Press, 2003), 203–229; Christina Sharpe, *In the Wake: On Blackness and Being* (Durham, NC: Duke University Press, 2016); Hartman, *Wayward Lives, Beautiful Experiments*. My great thanks to Ed Arrendell and Cécile McLorin Salvant for their generosity in sharing a recorded live performance of *Ogresse* with me.

113. Farberman, "Cécile McLorin Salvant"; Ratliff, "Young Vocalist Tweaks Expectations"; Chinen, "Cécile McLorin Salvant: The Ghost Writer." Adds Salvant, "Abbey Lincoln is a singer who greatly influenced me in her choice of repertoire, because it's not always about 'This man loves me' or 'He doesn't love me' or 'I'm gonna cry.' She had this conscious choice to think about repertoire in a different way." Faberman, "Cécile McLorin Salvant."

114. Cecile McLorin Salvant, *Ogresse* lyric book (Copyright Cecile McLorin Salvant, 2018). Hortense Spillers, "Mama's Baby, Papa's Maybe," 229, emphasis in the original.

115. Cecile McLorin Salvant, *Ogresse* lyric book. MOCA, "Wangechi Mutu + Santigold, 'The End of Eating Everything,' Nasher Museum at Duke University," YouTube video, 3:40, posted March 21, 2013, https://www.youtube.com/watch?v=wMZSCfqOxVs. The *Ogresse* lyrics booklet includes Salvant's own drawings which daringly engage blackface caricature. Two chansons included in the song cycle push this trope with cannibalistic imagery. For more on Salvant's drawings, see Brittany Spanos, "Dig Deep: An Interview with Cecile McLorin Salvant," *Rookie*, October 19, 2015, https://www.rookiemag.com/2015/10/cecile -mclorin-salvant-interview/. See also Kyla Tompkins, *Racial Indigestion: Eating Bodies in the 19th Century* (New Yok: New York University Press, 2012).

116. Cecile McLorin Salvant, *Ogresse* lyric book. Stefano Harney and Fred Moten, *The Undercommons: Fugitive Planning and Black Study* (Autonomedia, 2013).

117. See June Jordan's famous mantra, "who in the hell set things up this way" in her classic "A Poem About My Rights." June Jordan, "A Poem About My Rights." June Jordan, *Directed by Desire: The Collected Poems of June Jordan* (Copper Canyon Press, 2007), 309–310.

118. Sings Ogresse, "C'est très simple à faire / 700g de chair / fraîche de paysan . . . 100g de beurre" (It's very simple to do / 700g of flesh / fresh peasant / 100g of bacon / 50g of butter / 60g of onions / 1000g mushrooms / 30g of flour / 1 bottle of red wine / 1 bouquet garni). Cecile McLorin Salvant, *Ogresse* lyric book.

119. Toni Morrison, *A Mercy* (New York: Vintage, 2008), 107.

120. Jack Halberstam, "Wildness, Loss, Death," *Social Text* 32, no. 4 (121): (Winter 2014): 141, 147.

121. Spillers, "Mama's Baby, Papa's Maybe," 229, emphasis in the original. Adds Alex Weheliye, "Claiming and dwelling in the monstrosity of the flesh present some of the weapons in the guerilla warfare to 'secure the full cognitive and behavioral autonomy of the human species,' since these liberate from captivity assemblages of life, thought, and politics from the tradition of the oppressed and, as a result, disfigure the centrality of Man as the sign for the human." Alexander Weheliye, *Habeas Viscus: Racializing Assemblages, Biopolitics, and Black Feminist Theories of the Human* (Durham, NC: Duke University Press, 2014), 137.

122. Toni Morrison, *Paradise* (New York: Alfred A. Knopf, 1997), 264. Toni Morrison, *Beloved* (New York: Vintage, 2004), 308.

123. Halberstam, "Wildness, Loss, Death," 141, 147.

Epilogue

1. Greil Marcus, *The Old, Weird America: The World of Bob Dylan's Basement Tapes* (New York: Picador, 2011), 2.

2. Marcus, 2.

3. Marcus, xx, xxiii, xxii; Greil Marcus, *Invisible Republic: Bob Dylan's Basement Tapes* (New York: Henry Holt, 1997).

4. Marcus, *Old, Weird America*, 70.

5. Bob Dylan and the Band, "Bessie Smith," *The Basement Tapes*, Columbia Records, 1975.

6. See Peter Viney, "'Bessie Smith': Notes," The Band's fan website, accessed July 29, 2020, http://theband.hiof.no/articles/bessie_smith_viney.html.

7. Marcus, *Old, Weird America*, 67.

8. Scholarship on *Lemonade* and Beyoncé's repertoire has proliferated since the premiere of her self-titled, first visual album, *Beyoncé* in 2013 and is now plentiful. See, for instance, *The Beyoncé Effect: Essays on Sexuality, Race and Feminism*, ed. Adrienne Trier-Bieniek (New York: McFarland and Company, 2016); Omise'eke Natasha Tinsley, *Beyoncé in Formation: Remixing Black Feminism* (Austin: University of Texas Press, 2018); Kevin Allred, *Ain't I A Diva: Beyoncé and the Power of Pop Culture Pedagogy* (New York: The Feminist Press at CUNY, 2019); *Queen Bey: A Celebration of the Power and Creativity of Beyoncé Knowles-Carter*, ed. Veronica Chambers (New York: St. Martin's Press, 2019); *The Lemonade Reader: Beyoncé, Black Feminism and Spirituality*, ed. Kanitra D. Brooks and Kameelah L. Martin (New York: Routledge, 2019).

9. See LaKisha Simmons, "A Black Feminist Sense of Place on the Louisiana Sugar Plantations of Beyoncé's *Lemonade* and Carrie Mae Weems's The Louisiana Project," unpublished manuscript, September 2018. See also Patricia Coloma Penate, "Beyoncé's Diaspora Heritage and Ancestry in *Lemonade*," in *The Lemonade Reader*, ed. Kinitra D. Brooks and Kameelah L. Martin, 111–122; Michele Prettyman Beverly, "To Feel Like a 'Natural Woman': Aretha Franklin, Beyoncé and the Ecological Spirituality of Lemonade," in *The Lemonade Reader*, ed. Kinitra D. Brooks and Kameelah L. Martin, 166–182. Tyina Steptoe, "Beyoncé's Western South Serenade," in *The Lemonade Reader*, ed. Brooks and. Martin, 183–191. Saidiya Hartman, *Lose Your Mother: A Journey along the Atlantic Slave Route* (New York: Farrar, Straus, and Giroux, 2007), 6.

10. Simmons, "A Black Feminist Sense of Place," 3, 16, 7.

11. Katherine McKittrick, *Demonic Grounds: Black Women and the Cartographies of Struggle* (Minneapolis: University of Minnesota Press, 2006), xxiii.

12. Mary Pat Brady, *Extinct Lands, Temporal Geographies: Chicana Literature and the Urgency of Space* (Durham, NC: Duke University, 2002), 5–7.

13. Christina Sharpe, *In the Wake: Blackness and Being* (Durham, NC: Duke University Press, 2016).

14. Malcolm X as quoted in Beyoncé, *Lemonade* (Parkwood Entertainment, 2016). The X speech, which is sometimes referred to as "Who Taught You to Hate Yourself," was delivered in May 1962 in Los Angeles. mrholtshistory, "Malcolm X—On Protecting Black Women," YouTube video, 1:04, posted April 20, 2008, https://www.youtube.com/watch?v=6EIEKe8fVmg&t=4s.

15. On the cultural history of the 1927 flood, see Susan Scott Parrish's excellent study. Susan Scott Parrish, *The Flood 1927: A Cultural History* (Princeton, NJ: Princeton University Press, 2018).

16. Andy Horowitz, email to the author, October 19, 2018.

17. Lauren LaBorde, "Mapping the Louisiana Locations in Beyoncé's 'Lemonade,'" Curbed New Orleans, June 3, 2016, https://nola.curbed.com/maps/beyonce-lemonade-louisiana-filming-locations. See also Speedy, "Louisiana Locations in Beyoncé's 'Lemonade' Visual Album," Hot 107.9, April 27, 2016, http://1079ishot.com/louisiana-locations-beyonce-lemonade/. Several fan sites identify the parking garage as on Carondelet in the Central Business District of New Orleans. Horowitz notes that the garage in question "is on the even number side of the block. But there is an easy fix here, since in New Orleans, anyone would refer to 'the 800 block of Carondelet.'" Horowitz, email to the author.

18. Andy Horowitz, *Katrina: A History, 1915–2015* (Cambridge, MA: Harvard University Press, 2020), 123.

19. Marcus, *Old, Weird America,* 70.

ACKNOWLEDGMENTS

In many ways, this book had its beginning out on a vista in 1956 (captured in the opening-page images of these *Liner Notes*). My aunt Lodell Matthews (1917–2009) was the first member of our immediate family to escape the Jim Crow South and settle in northern California during World War II. She worked the shipyards with my Uncle Ernie and eventually took jobs in the houses of prominent professors at the University of California, Berkeley, exceeding the already crucial role of domestic worker to become a fellow traveler and a valued and respected interlocutor in some of these households.

The image of my Aunt Lodie standing beside Margaret Marston and looking out across the Colorado River region came to me too late to discuss with her in 2009. After her passing that year, Marston's grandson Jeff and his family sought me out at Princeton University and shared photographs and memories of her role in their lives. He also tipped me off to more photographs included in the papers of his grandfather, the historian Otis R. Marston, which are held at the Huntington Library in Pasadena. I lingered on two images—one of Lodie still and enraptured, standing side by side with an older white woman, their backs to the camera and looking out into the great wide open, and another with Lodie front and center, dressed smartly in outdoors wear with sleeves rolled up and holding a beverage of some sort, out perhaps on some adventurous archaeological dig with white folks off in the background. In these two photographs, I saw something instructional, something that communicated to me the sum of all that I'd also always recognized as lying at the very heart of Black women's musicianship and sonic cultures: vision and excavation.

Could I tell a story of Black women and popular music culture that could account for the depths of their creative and intellectual thought; their hopes, dreams, and aspirations; something that summed up the feeling I get when I look at that image of Lodie spanning the horizons? And could I, likewise, tell a story of Black women musicians' serious labor and the digging that these artists have always done in their music to "speak the unspeakable," to document the past, to recuperate the forgotten, to scrutinize the complexities of past and present conditions with attention and care? Lodie was the brave example that always framed

this book's principal ideals, and for these reasons I've dedicated it to her and to my mother, Juanita—but more about her later.

At Harvard University Press, I have benefited greatly from the ferociously cogent and creative vision of my editor, Sharmila Sen, as well as associate editor Heather Hughes and the entire production team for this book, including Angela Piliouras, Kate Brick, and Stephanie Vyce. I'll always remain indebted to Lindsay Waters for first championing this project, and I extend my thanks as well to assistant editor Joy Deng.

The archivists who helped me on my own many digs deserve my deepest gratitude. They shared with me resources, rare materials, tips, and advice that, in some cases, utterly transformed the direction of this book. To the librarians, curators, research staffs and assistants based at the following institutions—the essential workers in our scholarly lives—I owe my steadfast thanks: the marvelous Melissa Barton, Nancy Kuhl, and the staff at Yale University's Beinecke Rare Book and Manuscript Library; the great Karl Schrom, Suzanne Lovejoy, and the staff at Yale University's Irving S. Gilmore Music Library; Steven Fullwood, Alexsandra Mitchell, and the staff at the Schomburg Center for Research and Culture; DeLisa Minor Harris and the staff at Fisk University's John Hope and Aurelia E. Franklin Library, Special Collections; the staff at the Arthur and Elizabeth Schlesinger Library on the History of Women in America at the Radcliffe Institute for Advanced Study; the staff at the Rubenstein Rare Book Library at Duke University; Wayne Winborne and the staff at the Institute of Jazz Studies at Rutgers University; the staff at the George A. Smathers Library at the University of Florida, Gainesville; the staff at Princeton University's Firestone Library, Special Collections; Brenda Nelson-Strauss and the staff at Indiana University's Archives of African American Music & Culture; the staff at the American Folklife Center at the Library of Congress; Lynn D. Abbott at Tulane University's Hogan Jazz Archive; and Lauren Onkey and the staff at the Rock and Roll Hall of Fame Archives.

Thank you to the graduate student assistants who tirelessly supported my archival research: Marcie Casey, Nikolas Sparks, Chloe Swindler, and Clara Wilson-Hawken, and enormous thanks to my undergraduate research assistants, Mila Rostain and especially Paloma Ortega.

My great thanks to all of the individuals and institutions who assisted with providing the images for this book and so much more: the dazzling Marsha Music; the warm and generous Tom Martin; Balbi A. Brooks; the indefatigable Elijah Wald (a one-man archive unto himself!); Peter J. Blodgett at the Huntington Library; Elise von Dohlen; Frank Matheis; Paddy Bowman; Howie Movshovitz; Larry Ryckman; Jon Freeman and Jerry Portwood at *Rolling Stone*; Jessica Tubis at the Beinecke Rare Book and Manuscript Library; the legendary Lorraine O'Grady; Laura Lappi; the pioneering Cynthia Dagnal-Myron; Marc Glassman; Tad Hershorn at the Institute of Jazz Studies; Farah Griffin and Herb Jordon at the Mary Lou Williams Foundation; Todd Harvey at the American Folklife Center, Library of Congress; the kind and generous Rebecca Reitz; Barbara Weinberg Barefield; Jonathan Silin and the Estate of Robert Giard; Hope Ketcham Geeting and Elizabeth Dunn at the Rubenstein Rare Book Library, Duke University; the endlessly invaluable Nona Willis Aronowitz; Joi Gresham and Julie McGarvie at the Lorraine Hansberry Literary Trust; Eli Attie; the wise and supportive Greil Marcus; Jim Linderman; Robert Crumb; Lora Fountain and Agence Lora Fountain; Joyce Lee at the *Houston Chronicle*; Robin Wartell; Amy Pennington-Lee; Rebecca Mecklenborg at the Jack Shainman Gallery; Lee Nisbet at Nasher Museum of Art; Kaitlyn Donaldson at the Lorain Historical Society; Daniela Lopez Amezquita at the International Center of Photography; the warm and charitable Ed Arrendell; Rai Howell; Maria Ehren-

reich at Mack Avenue Records; R. John Williams; Kay Peterson at the Smithsonian Institution; Zachary Haas at Yale Music Library; and David McClister.

Many thanks to the institutions who have generously funded this project: the Radcliffe Institute for Advanced Study, the Schomburg Center for Research in Black Culture, and the American Council of Learned Societies.

Through the years, I've benefited from the insightful feedback that I've received after every single lecture that I've given on this research. Among the scholarly and artistic communities who have engaged my work, I'd like to especially thank the generous faculty, the brilliant students, and the helpful staff at the following institutions: the University of California, Berkeley (especially its Black Room Collective and the Department of Theater, Dance, and Performance Studies); UCLA's Center for the Study of Women; the University of Chicago; Northwestern University; New York University's Department of Performance Studies; the University of Southern California; Brown University; the University of Washington, Seattle; the Radcliffe Institute for Advanced Study; Harvard University; the University of North Texas; Clemson University; Washington University; the University of Virginia, Charlottesville; Duke University; the Rock and Roll Hall of Fame's "American Masters" series; Rutgers University; the University of Georgia, Athens; Cornell University; the University of Massachusetts, Amherst; Wesleyan University; Columbia University; the University of Toronto; York University; Indiana University; Aoyama University, Tokyo; Stanford University; Dartmouth University; the New Museum; Salisbury University; St. Louis University; Binghamton University; McGill University; Barnard College; the University of Miami; the National Humanities Center; Santa Clara University; McMaster University; Stony Brook University; the University of Michigan; Bennington College; Amherst College; Tulane University; the University of Roehampton; and the University of Oxford. Eleven years—a lot of places and people. It's all made the difference with this work.

Thank you to my supportive colleagues and staff at Princeton University—Naomi Murakawa, Nicole Shelton, Stacey Sinclair, Wendy Belcher, Judith Weisenfeld, Shirley Tilghman, Eric Quinones, Emily Thompson, Michael Wood, Simon Gikandi, Keith Wailoo, Alison Isenberg, Scott Burnham, Dionne Worthy, and the late and wonderful Richard Okada.

I'm grateful to my Yale colleagues in all five of my units—the Department of African American Studies, the Program in American Studies, the Program in Women's, Gender & Sexuality Studies, the Program in Theater and Performance Studies, and the Department of Music—and especially Roderick Ferguson, Jacqueline Goldsby, Crystal Feimster, Aimee Cox, Tavia Nyong'o, Marc Robinson, Emily Greenwood, Vanessa Agard-Jones, Jafari Allen, Michael Veal, Lisa Lowe, Laura Wexler, Michael Denning, Elizabeth Alexander, Jonathan Holloway, Steve Pitti, Alicia Schmidt-Camacho, Mary Lui, Glenda Gilmore, Emily Bakemeier, George Chauncey, Ron Gregg, Karin Roffman, Caleb Smith, Dani Botsman, Joanne Meyerowitz, Gary Okihiro, Ana Ramos-Zayas, Sally Promey, Greta LaFleur, Inderpal Grewal, Dan HoSang, Albert Laguna, Zareena Grewal, Erica James, Gerald Jaynes, David Blight, Ed Rugemer, Kobena Mercer, Michael Warner, Charles Musser, Eli Anderson, Thomas Allen Harris, and Nicholas Forster. To my brilliant graduate and undergraduate students, thank you for your fearlessness, your passion, your dedication, the risks that you take that move me to leap with you. To our marvelous staff—particularly Jodie Stewart-Moore, Lisa Monroe, Jasmine Williams, Edith Rotkopf, and Vanessa Epps—thank you for creating a workable universe in which we've been able to thrive and do our work.

A very special thanks to my colleagues who inspired me in crucial ways and who steered me forward with this project: Hazel Carby, Joseph Roach, Robert Stepto, and Valerie Smith. And

enorm

ous thanks to Greil Marcus for his assistance with multiple facets of this project, for the early invitation to listen to Mamie, and for his intellectual generosity and collegiality. Special thanks as well to Dean Blackwood and Scott Blackwood for inviting me to listen along with them to the Paramount Records archive and to go on an extraordinary trip with the records.

Thank you to the artists who've shared their time, their work, and their wisdom with me: Cecile McLorin Salvant, Valerie June, Carrie Mae Weems, Wangechi Mutu, Rhiannon Giddens, Jack White, Chuck Lightning, Nate Wonder & the Wondaland Arts Collective. And a special thanks to the great Ralph Lemon for asking me a question that set me off and running.

Conference meetups, late-night bar exchanges, feeling meditations by text and email, and winding phone conversations on stolen weekend afternoons: the people who have thought alongside me through the evolution of this project have been willing to kick it every which way and in all sorts of contexts, at all times of the night and at the top of the day. For that I'm so grateful. My great thanks to the interlocutors all around—mentors and former students, colleagues and friends—who've moved me and inspired this project in numerous ways: Badia Ahad, Danielle Bainbridge, Kevin Beasley, Lauren Berlant, Andie Berry, Lileana Blain-Cruz, Nicholas Boggs, Mary Pat Brady, Jennifer Brody, Adrienne Brown, Jayna Brown, LaMarr Bruce, Lucy Caplan, Nate Chinen, Joshua Clark Davis, Kameron Collins, Huey Copeland, MR Daniel, Ann DuCille, Nadine and Jacqueline and the Easton Nook family, Erica Edwards, Nadia Ellis, Ian Finseth, Gisele Fong, Lynne Foote, P. Gabrielle Foreman, Chandra Ford, Caryn Ganz, Eric Glover, Matt Guterl, Sarah Haley, Alicia Hall-Moran, Hunter Hargraves, Shay Harris, Saidiya Hartman, Scott Herring, Ellie Hisama, Anna Marie Hong, Briallen Hopper, Andy Horowitz, Branden Jacobs-Jenkins, Lauren Jackson, Reginald Jackson, Shanna-Deloros Jean-Baptiste, Meta Jones, Ralina Joseph, Robin Kelley, Claudia Mitchell Kernan, Tammy Kernodle, Roshy Kheshti, Rachel Lee, Nancy Levene, David Levin, EngBeng Lim, Eric Lott, Emily Lutenski, Kim Manganelli, Jesse McCarthy, Paige McGinley, Uri McMillan, Nick Mirzoeff, Brandi Monk-Payton, Madison Moore, Peyton Morgan, Wesley Morris, Harryette Mullen, Mark Anthony Neal, Debbie Nelson, Azusa Nishimoto, Lara Pellegrinelli, Richard Pettengill, Sonya Posmentier, Gerard Ramm, Guthrie Ramsey, Connie Razza, Lindsay Reckson, Chandan Reddy, Gracie Remington, Francisco Robles, Tricia Rose, Francesca Royster, Janet Sarbanes, Leo Saks, Scott Saul, Barbara D. Savage, Darieck Scott, Nayan Shah, Melanie Masterson Sherazi, P. A. Skantze, Marti Slaten, Werner Sollors, Gustavus Stadler, Jason Stanyek, Jonathan Sterne, Jennifer Stoever, John Jeremiah Sullivan, Brian Sweeney, big bro Greg Tate, Lisa Thompson, Salamishah Tillet, Dean Toji, Sherrie Tucker, Deborah Vargas, Shane Vogel, Elijah Wald, Alex Weheliye, Harry Weinger, David Wondrich, Richard Yarborough, Patricia Ybarra, and the fearless students in my Yale 2008 undergraduate seminar on Black women and popular music culture.

A number of distinct and vibrant groups helped to bring my work to life. Thank you to the early aughts feminist rock critic "girl group" undercommons cofounded by Daphne Carr and Jason Gross and held down on the regular by Amy Phillips, Kandia Crazy Horse, Caryn Brooks, Sara Marcus, and Zoe Gemelli. And thank you to the freedom-fighting campers as well as my pioneering colleagues at Willie Mae Rock Camp for Girls, among them Karla Schickele and Hanna Fox.

I'm grateful to Princeton University for the funding to convene the Black Feminist Sound Studies faculty seminar in 2013 that enabled me to bring around the table Farah Griffin, Gayle Wald, Salamishah Tillet, Nina Eidsheim, Mendi Obadike, Emily Lordi, and Imani Perry. My great thanks to that special group where crucial ideas took flight.

At Yale, the most electrifying collaboration for me has come in the form of the Black Sound and the Archive Working Group (affectionately known as "BSAW"). A good portion of this book would not exist without this ensemble. To my cofounder and codirector of BSAW, Brian Kane, a huge thanks for conspiring with me, and to our awesomely creative faculty and student members, particularly Sophie Abramowitz, Ambre Dromgoole, Tobi Kassim, John Klaess, Shayne McGregor, Brian Miller, Liana Murray, Jocelyn Proietti, Nicholas Serrambana, Chloe Swindler, and Clara Wilson-Hawken—my great thanks.

Columbia University's Jazz Studies Working Group has, likewise, nurtured my spirit and opened up wide vistas of possibility for me. Without this group as well, portions of this book would have never seen the light of day. To its ensemble of prodigious thinkers—among them, Farah Jasmine Griffin, Robert O'Meally, Brent Hayes Edwards, Fred Moten, Diedra Harris-Kelley, Maxine Gordon, Robin D. G. Kelley, Jason Moran, Vijay Iyer, Imani Owens, Krin Gabbard, George Lewis, Michael Veal, as well as Yulande McKenzie-Grant for her kind administrative support—I owe so much for encouraging renegade and inspiring Black Study.

For coming on twenty years now, the institution formerly known as the Experience Music Project Museum (now called the Museum of Pop Culture) has hosted an annual pop music conference in Seattle that has played host to a generation's worth of scholars, journalists, musicians, and grassroots activists and creatives on an annual basis. EMP (as we'll always refer to it) remains the beloved site of deeply vibrant conversation, generative critical thought, ardent wonk battles, and moving and affectionate remembrances. Two decades in, we are family. Among the regulars who have pushed me, challenged me, laughed and cried with me, and wrestled and danced with my ideas are Eric Weisbard, Ann Powers, Greil Marcus, Robert Christgau, Gayle Wald, Sonnet Retman, Alexandra Vazquez, Jack Halberstam, Josh Kun, Tavia Nyong'o, Jason King, Daphne Carr, Carl Wilson, Maureen Mahon, Karen Tongson, Christine Balance, Michelle Habell-Pallan, Evelyn McDonnell, R. J. Smith, Joshua Clover, Elijah Wald, Jody Rosen, Oliver Wang, Ken Wissoker, Holly George-Warren, Grace Hale, Douglas Wolk, Jack Hamilton, Summer Kim—and I know there are others—two decades' worth. My great thanks to the fam.

A community of people have delivered light, wisdom, and hope while I've worked through the years on this project. To David Swerdlick and Asila Calhoun, Eileen Swerdlick and Steven Swerdlick, Nicole King and Brett and Isaac St. Louis; to dear Fred Moten, Tera Hunter, Tamsen Wolff, Joshua Guild and Carla Shedd, Jack Halberstam and Macarena Gomez-Harris, Josh Kun, Jonathan Flatley and Danielle Aubert, Glenda Carpio, Ginger Nash, Niko Addis, and Max Clayton and Molly Clayton—thank you for everything.

And to the people who have lived with this project up close in more ways than they even know—the magnificent Alexandra Vazquez; the mighty and astonishing Kathryn Lofton; the dazzling Sonnet Retman and Curtis Bonney; the fearless Leigh Raiford and Michael Cohen; the loving Harriet Chessman and Bryan Wolf; and the beautiful and invaluable ensemble: Allegra, James, Madeleine, and Noah Gibbons-Shapiro—the gratitude runs so deep. I also owe an enormous debt to two scholarly legends and superheroes, Farah Jasmine Griffin and Gayle Wald—not only for the beauty of their friendship but for the care, vision, and brilliant feedback that they've given to me about my work. Farah flat out invented a universe for so many of us to do this work, and Gayle dramatically expanded the playing field. Is there a book without them?

Likely not. This is true as well with regard to the remarkable Carole Hall, who swooped in and delivered some keep-it-real editorial insight. Nate Jung picked up the baton and was

the best late-inning interlocutor a writer could ask for. Thank you for the deep nuts-and-bolts thinking.

To Amy DePoy, a huge thanks for her razor-sharp and resourceful research assistance. And to Van Truong, thank you for your care and creativity, your tireless focus, and your generous support in multiple phases of this project; and thank you for your friendship.

Two other beloved fellow travelers made all of the difference in how I've approached my work for years now. To Kara Keeling and Jackie Stewart, thank you for the solidarity and the Combahee sisterhood. As the Queen would say, "you're all I need to get by."

Thank you to the Brooks family and thank you to the Jacobsons for always grounding me. To Jerry Jacobson, thank you for your enormous heart, your deep ethical kindness, and your felt engagement with my work. And to my mother, Juanita Kathryn Watson Brooks, thank you for the unconditional love, care, and belief in me, and thank you for the moving stories that widened my view of your world and enabled me to hear history in a different register. Your bravery in living a free life is a secret history of hope.

Finally, to Matthew Frye Jacobson—for reading damned near everything, for the endless conversations, for the bottomless laughter, for the archive that is music, for likely a thousand home-cooked meals, and for a partnership that entails looking seriously and soberly every day at our history of right now and trying to leap through it—thank you for this privilege. Don't jinx it.

This book has been written in memory of my Aunt Lodie as well as a number individuals who broadened my thinking and enlivened my imagination in numerous ways: my late father, Nathaniel Hawthorne Brooks, Sr.; Lindon Barrett; Rosemary George; Richard Iton; Jose Munoz; and Cheryl Wall. What an utter gift to have learned so much from each of them. Determined to pass it on . . .

CREDITS

Illustrations

205 Rosetta Reitz Papers, David M. Rubenstein Rare Book & Manuscript Library, Duke University. Used by permission of Rebecca Reitz.

210 Courtesy of Nona Willis Aronowitz.

217 Courtesy of Nona Willis Aronowitz.

237 Photo by Gin Briggs, courtesy of the Lorraine Hansberry Literary Trust, LHLT.org.

240 Photo by David Attie. Courtesy of Eli Attie.

247 Courtesy of Nona Willis Aronowitz.

255 Photo by Michael Ochs Archives via Getty Images.

255 Photo by Michael Ochs Archives via Getty Images.

259 Photo by Gin Briggs, courtesy of the Lorraine Hansberry Literary Trust, LHLT.org.

259 Courtesy of Nona Willis Aronowitz.

262 Film still from Rhiannon Giddens's "Black Is the Color" video (2015). Dir. Peter Zavadil.

270 From the collection of Jim Linderman.

285 Photo by Michael Ochs Archives via Getty Images.

287 Courtesy of Peter Whelan.

290 Photo by and courtesy of Eilon Paz from the book *Dust and Grooves: Adventures in Record Collecting*.

292 Copyright ©Robert Crumb, 1999.

293 Copyright ©Robert Crumb, 1999.

300 Photographer: Fred Bunch_HP / ©Houston Chronicle. Used with permission.

304 Courtesy of Robin Wartell.

319 Paint on vinyl record and gelatin silver print, edition 1/3, 23×29 inches (58.4×73.7 cm). Collection of the Nasher Museum of Art at Duke University. Museum purchase, 2009.3.1. © Carrie Mae Weems. Courtesy of the artist and Jack Shainman Gallery, New York. Photo by Peter Paul Geoffrion.

321 © Carrie Mae Weems. Courtesy of the artist and Jack Shainman Gallery, New York.

322 © Carrie Mae Weems. Courtesy of the artist and Jack Shainman Gallery, New York.

324 Courtesy of Juanita Kathryn Watson Brooks.

324 Courtesy of the Lorain Historical Society in Lorain, Ohio.

338 Courtesy of Marsha Music.

338 Courtesy of Marsha Music.

344 Getty Images.

346 Courtesy of Marsha Music.

367 Victor Records.

373 © Carrie Mae Weems. Courtesy of the artist and Jack Shainman Gallery, New York.

386 Apeda Studio, [Mamie Smith], 1920–1924. International Center of Photography, Gift of Daniel Cowin, 1990 (1500.1990).

388 Photo by and courtesy of David McClister.

407 Photo by Paul Natkin / Getty Images.

408 Photo by Ebet Roberts / Getty Images.

411 Ebru Yildiz / *The New York Times* / Redux.

415 Photo by Mark Fitton / © Mack Avenue Music Group.

429 Courtesy of the artist, Gladstone Gallery, New York and Brussels, and Victoria Miro, London. Commissioned by the Nasher Museum of Art at Duke University, Durham, NC.

430 Courtesy of Cécile McLorin Salvant.

436 Film still from Beyoncé's *Lemonade* (2016). Dir. Kahlil Joseph, Beyoncé Knowles, and Melina Matsoukas.

436 Film still from Beyoncé's *Lemonade* (2016). Dir. Kahlil Joseph, Beyoncé Knowles, and Melina Matsoukas.

436 Film still from Beyoncé's *Lemonade* (2016). Dir. Kahlil Joseph, Beyoncé Knowles, and Melina Matsoukas.

437 Film still from Beyoncé's *Lemonade* (2016). Dir. Kahlil Joseph, Beyoncé Knowles, and Melina Matsoukas.

439 Film still from Beyoncé's *Lemonade* (2016). Dir. Kahlil Joseph, Beyoncé Knowles, and Melina Matsoukas.

439 Film still from Beyoncé's *Lemonade* (2016). Dir. Kahlil Joseph, Beyoncé Knowles, and Melina Matsoukas.

440 Film still from Beyoncé's *Lemonade* (2016). Dir. Kahlil Joseph, Beyoncé Knowles, and Melina Matsoukas.

440 Film still from Beyoncé's *Lemonade* (2016). Dir. Kahlil Joseph, Beyoncé Knowles, and Melina Matsoukas.

441 Film still from Beyoncé's *Lemonade* (2016). Dir. Kahlil Joseph, Beyoncé Knowles, and Melina Matsoukas.

443 Reuters / Reuters Photographer—stock.adobe.com.

445 Film still from Beyoncé's *Lemonade* (2016). Dir. Kahlil Joseph,
 Beyoncé Knowles, and Melina Matsoukas.

445 Film still from Beyoncé's *Lemonade* (2016). Dir. Kahlil Joseph,
 Beyoncé Knowles, and Melina Matsoukas.

Text

The Introduction includes text first published in "Janelle Monae" and "Bessie Smith,"
Women Who Rock, Volume 1, ed. Evelyn McDonnell (New York: Hatchette Books, 2018)
and builds on ideas first published in "Open Channels: Some Thoughts on Blackness,
the Body, and Sound(ing) Women in the (Summer) Time of Trayvon," *Performance
Research* 19, no. 3 (2014): 62–68.

The preface to Side A and Chapter 4 continue discussions presented in "The Write to
Rock: Racial Mythologies, Feminist Theory, and the Pleasures of Rock Music Criticism,"
Women and Music: A Journal of Gender and Culture 12 (2008): 54–62.

The text of "'Drag 'Em': How Movement Shaped the Music of Mary Lou Williams,"
NPR Music, September 2019, https://www.npr.org/2019/09/14/758077669/drag-em
-how-movement-shaped-the-music-of-mary-lou-williams, is reprinted in Chapter 1
with minor edits.

Portions of Chapter 2 were first published as "Sister, Can You Line It Out?: Zora Neale
Hurston & the Sound of Angular Black Womanhood," *Amerikastudien / American
Studies* 55, no. 4, (2010): 617–627.

The text of "Drenched in Glory: How Aretha Gave Voice to Embattled Black Women—and
Transformed a Nation," *The Guardian*, online edition, August 17, 2018, informs Chapter 4.

The preface to Side B includes text first published as "The Beautiful Struggle," *New Inquiry*,
July 22, 2019.

Chapter 7 includes text first published in "See My Face from the Other Side: Freedom Is
a Blues Woman's Prerogative," *Oxford American Magazine, Southern Music Issue* 95
(Winter 2016): 130–141.

Chapter 8 builds on ideas first discussed in "100 Years Ago, 'Crazy Blues' Sparked a
Revolution for Black Women Fans," *New York Times,* August 10, 2020; "This Voice Which
Is Not One: Amy Winehouse Sings the Ballad of Sonic Blue(s)face Culture," *Women and
Performance: a journal of feminist theory*, March 2010, and "1920, August 10: Mamie Smith
becomes the first black woman to make a phonograph record: A New Voice of the Blues,"
A New Literary History of America, eds. Greil Marcus and Werner Sollors (Cambridge,
MA: Harvard University Press, 2009), 545–550.

INDEX

Archive(s) (*continued*)
61, 89–90; problems of, 268; record keeping as, 104; Reitz and, 166, 167, 172, 174, 188, 192, 195; as repertoire, 120–121, 129; songs as, 116, 142; of sound, 28; taste-making by, 57, 58; Thomas and, 277, 278, 353; time and, 58; Washington and, 200; Wiley and, 277, 278, 301–302, 353; Willis's, 250–251; witnesses in, 83. *See also* Collectors; Curation; Curator(s); Historical memory; Things

Archive(s), Black, 4, 52–54, 89–90, 119–122, 159–160, 310–316, 377–393, 396–399, 400–403, 413–414

Archive(s), queer, 271–272, 275, 281, 312, 353; Lesbian, 305–306

Archivist(s), 267, 387; Black women musicians, 183; Giddens, 387–410; Hopkins, 87; Hurston, 148–158; June, 399–410; Knowles, Beyoncé, 439, 442; lost blues women, 266; Odetta, 160; Reitz, 195; Salvant, 412–431. *See also* Curation; Curator(s); Historians

Argue, Darcy James, 412, 426

Armstrong, Lil, 183, 189

Armstrong, Louis, 42, 424

Arrangement, 8, 13–16, 24, 25, 32, 90, 183, 320, 354, 358, 372, 383, 413, 438

Arrangers: cultural performers as, 13; Hurston as, 159; René Marie as, 25

Art, Black feminist speculative, 315. *See also* Kay, Jackie; Speculative; Weems, Carrie Mae; *individual artists*

Art, visual, 9, 14, 34, 48, 112, 122, 181, 191, 192, 201, 202, 376, 427, 429, 434, 437. *See also* Knowles, Beyoncé; Monáe, Janelle; Mutu, Wangechi; Weems, Carrie Mae.

Artists, Black: disappearance from public sphere, 317; exploitation of, 94; lack of exposure to, 286; limitations imposed on, 381; profiles of, 215; recording industry and, 333–334

Artists, Black women, 315; access to liner notes, 7; as archives, 4, 35; as critics, 67; culture industry's relation with, 43–45; documentation of, 35; as drivers, 101; feminism and, 167; as historians, 183–184; invisibility of,

27–28; knowledge about, 35; modern art made by, 17; negation of, 57; observations by, 108; perceptions of, 30; popular music culture and, 4, 55–57; racism and, 182–183; relationship with world, 29; role of in modern art, 27; as sociocultural intellectuals, 35; subcultures forged by, 44; white vocalists and, 178. *See also* Blues women; Labor, intellectual; Musicians, Black women; Vocalists, Black women; *individual artists*

Artists, B-side, 265

Artists, queer / gender-nonconforming, 12, 297, 298, 423. *See also* Queerness; *individual artists*

Ashford, R. T., 337

Audience: musicians' relation with, 185, 397–399, 407–409, 414–416, 420–425; women in, 199. *See also* Fans

Auerbach, Dan, 402

Aura, myth of, 31, 32

Austin, Lovie, 15, 91, 183, 350

Authenticity: correlated with economic failure, 279; Hurston's preoccupation with, 130; music writing and, 60; as nationality, 303. *See also* Primitivism

Author, death of, 263

Automobiles. *See* Cars

Automotivity. *See* Cars

Aznavour, Charles, 390

Baartman, Sarah, 263

Bacharach, Burt, 422

Bacon, Francis, 191–192

Baez, Joan, 392

Bailey, Mildred, 75

Baker, Josephine, 39, 375–376, 416

Baldwin, James, 10, 24, 68, 75–76, 219, 220, 222, 230–231, 238

Balliett, Whitney, 189

Bambara, Toni Cade, 105, 246

Bancroft, Anne, 219

Bangs, Lester, 9, 143

Banjo, 389, 394–396, 398, 406–407, 426

Baraka, Amiri (LeRoi Jones), 27, 59, 74, 75, 77, 78, 88, 105, 211, 308

Barclay, Dorothy, 250

Barnicle, Mary Elizabeth, 136, 152

Barrett, Lindon, 19–20, 21, 37, 89, 313

Barthes, Roland, 425

Basement Tapes, The (Dylan), 432–435

Basquiat, Jean-Michel, 123

Battle, Joe Von, 326, 337, 346; photograph of, *338. See also* Record shops

Battle, Shirley Von, 326; photograph of, *338. See also* Record shops

Battle Philpot, Marsha. *See* Music, Marsha; Record shops

Bay, Mia, 7

Bearden, Romare, 51, 201

Beasley's Music Store, 336, 341, 342, 343. *See also* Record shops

Bechet, Sidney, 327

Benjamin, Walter, 30, 31, 39, 275, 307

Bennett, Lerone, Jr., 74

Bentley, Gladys, 186

Berger, Maurice, 320

Berlant, Lauren, 342–343

Berry, Chuck, 98, 101

Berry, Elizabeth Mendez, 81, 82

Beyoncé. *See* Knowles, Beyoncé

Birmingham School, 44

Black, Patti Carr, 202, 204

Black aesthetics, 73

Black alterity, 358

Black Arts movement, 75, 78

Black Cognition, 35, 38–39

Blackface minstrelsy, 30, 83, 283, 361–362, 419; "Crazy Blues" and, 383; emergence of blues music and, 379–381; Giddens and, 394–396; "Pick Poor Robin Clean," 361–363; rewriting, 382. *See also* Vaudeville

"Black Is the Color" (song), 392–393

Black Lives Matter, 399

Black Marxism (Robinson), 18

Blackness: collectors' fascination with, 281–282, 283, 284–285, 286, 290; fade into, 370; modernity and, 18–23, 27; New Orleans and, 440; as polyvalence, 357

Black Odyssey, A (O'Meally), 51

Black Patti Records, 286–287, 288

Black Power, 70, 71, 73, 78, 336. *See also* Civil Rights movement; Lincoln, Abbey

Black radical tradition, the concept of, 8, 29, 244, 357, 363, 413

Black Rock Coalition, 38

Blacks, The (Genet), 231

Black sound, the concept of, 4, 12, 20, 21, 35, 40, 46, 68, 78, 79, 105, 129, 131, 132, 140, 141, 143, 144, 150, 195, 264, 285, 326, 394, 402

Black studies: modernity and, 18; Morrison and, 40; Moten's versioning of, 21–22; music as, 119; music criticism and, 35, 38, 41; new blues criticism and, 308; right to obscurity in, 39

Black Swan Records, 286, 350

Blackwood, Dean, 278, 283, 286

Blackwood, Scott, 278, 283, 317

Blesh, Rudi, 310

Bloch, Ernst, 211

"Blue Monk" (Monk), 103–104

Blues, 49; alternative history of, 12; artists' indebtedness to pioneers, 15; autobiographical *I* of, 51; Ellisonian reading of, 104; emergence of, 379–381; emphasis on male musicians, 351; euphemisms in, 50; exploitation of, 245; feminist reading of, 168; Hansberry on, 231–232; Hurston's ethnography and, 131–132; mobility and, 16; mood and, 106–111, 132; mothers in, 360; presumptions about, 173–174; produced by men for white market, 173; recording of, 61; romanticization of, 281, 282, 380; sexism in, 172; sexuality and, 50, 167, 173, 401; sexual metaphors in, 50; white artists, 381; white colonization of, 3; white masculinist aural gaze and, 280; white men's rediscovery of, 297. *See also* Country blues; Criticism, new blues; Jook; Music, Black; Reitz, Rosetta; *individual artists*

Blues, women's, 352; focused on Great Migration, 162 (*see also* Railroad songs); presumptions about, 173–174; prison songs, 182, 201–204, *203*, 366, 368, 420, 421; railroad blues, 177, 196; record label devoted to, 162 (*see also* Reitz, Rosetta; Rosetta Records)

Blues feminist ideology, 401

Blues People (Jones), 59, 75, 78, 105

Blues record culture, 325–347. *See also* Collectors; Phonograph; Record shops

Blues romanticism, 286

Blues studies, recuperative turn in, 170. *See also* Reitz, Rosetta; Rosetta Records

Blues travelers, 100. *See also* Mobility

Blues women: Black feminist approach to music of, 355; lament tradition, 356; "Last Kind Word Blues," 277, 284, 301, 355–358, 391; legacy of, 378, 379; narratives of women's sexuality, 198; Paramount and, 350; at Parchman Penitentiary, 366–368; practice of freedom, 365; queer archival research in history of, 305; romanticization of, 296, 297; unearthing of recordings of, 47–48. *See also* Musicians, Black women; *individual artists*

Blues women, lost, 266; approaches to study of, 296 (*see also* Marcus, Greil; McCormick, Robert "Mack"; Sullivan, John Jeremiah); collectors and, 281; desire to remain lost, 275–276; Hemphill, 404–406; photographs and, 275; photographs of, *269*, 271–272, 276, 303, 304; primitivist romance mythologies of, 281, 282; queer archiving and, 281; white critics' fascination with, 279. *See also* Collectors; Musicians, Black women; Paramount Records; Thomas, Elvie / L. V.; Wiley, Geeshie

Blues women sabotage, 364

Boas, Franz, 141

Bob Marley and the Wailers, 70–71

Bodies: Black, 126; blues women's, 358; control of, 63; Hurston's use of, 155–160; as narrative device, 127; Reitz note on, *188*; women confined to, 121. *See also* Agency; Medium; Phonography; Sexuality

Bogan, Lucille, 167, 181

Boggs, Nicholas, 34

Bogle, Donald, 178

Bonham, John, 442

Bon Jovi, Jon, 57

Botkin, Ben, 146

Boyd, Valerie, 130

Bradford, Perry, 333, 334, 380–381, 383, 384

Brady, Mary Pat, 438

Briggs, Thomas F., 394

Brody, Jennifer, 192

Brooks, Gwendolyn, 75

Brooks, Juanita Kathryn Watson, 48, 266; childhood of, 323, 330, 331, 339–341, 342 (*see also* Jim Crow; Record shops); experience of music, 345; listening practices of, 343; photograph of, *324*; records and, 324–325. *See also* Texarkana

Brown, Adrienne, 152, 153

Brown, Anne, 1

Brown, Jayna, 27, 385, 419

Brown, Lois, 83

Brown, Sterling, 88, 337

Brownstein, Carrie, 39

Brown Sugar (Bogle), 178

Bruno, Giuliana, 13

Bryant, Beulah, photograph of, *182*

B-side artists, 265

B sides, 45

Bullock, Anna Mae (Tina Turner), 1, 63

Bullock, Julia, 375, 377

Burnett, T Bone, 390, 391, 392

Burnham, Dorothy, 226

Burnham, Louis, 226–227

Burton, Antoinette, 268, 318, 330–331

Bussard, Joe, 287–290, 359; photograph of, *290*

Butler, Judith, 264, 279

Butler, Octavia, 314, 322

Campt, Tina, 263

Canon, 31, 96, 57–59, 60, 140, 163, 172, 180, 194, 276, 302, 385, 401–402, 414; canonized, 310–317; canonizing, 116, 140

Capitalism: feminist critique of, 258, 364; racial, 19, 234, 244 (*see also* Slavery); Robinson's critique of, 18; Willis on, 244

Captivity: self-making practices and, 19. *See also* Enslaved people; Labor, Black; Slavery

Carby, Hazel, 35, 44, 251, 379

Carolina Chocolate Drops, 388, 390, 394. *See also* Giddens, Rhiannon

Cars: Black women artists and, 101; commonwealth car, 153; female drivers, 99; Hurston and, 129, 130, 150–155; as instrument of mediation, 150–151; as sexual innuendo, 150; vulnerability in,

152; Williams and, 97–100. *See also* Mobility

Carter, Betty, 418–419

Carter, Nell, photograph of, *182*

CAUSE (magazine), 183

Celebrity, Black, 72–73, 209, 218–219, 271, 322, 385

Chain-gang slavery, 158

Chassanoff, Alexandra, 318

Chesnutt, Charles, 407

Chicago Defender (newspaper), *367*, 381

Chicago Sun-Times, 70

Childress, Alice, 102, 106

Chinen, Nate, 411, 412, 416, 424

Chitlin' Circuit, 91, 97, 271, 333, 361, 381

Christgau, Robert, 59, 60, 63, 143

Christian, Barbara, 12, 96, 251, 254

Church, African American, 52, 140–141, 145, 196–197, 201, 297, 303, 339, 341; Valerie June's background in, 402–403, 408–409

Cinema, African American experience of, 325

Circum-Atlantic theory, 79

Citizenship, Black women's, 11, 25

Civil Rights movement, 70, 224–226, 227; Black celebrity and, 218–219; Burnham in, 227; Fahey and, 284. *See also* Black Power; Hansberry, Lorraine; King, Martin Luther, Jr.

Class struggle, 44

Cleveland Plain Dealer, 59

Cline, Patsy, 391

Collaboration, 280; antagonistic, 51

Collectors, 266, 272, 308–309, 323; desire to contextualize, 294–295; early, 282; fascination with Blackness, 281–282, 283, 284–285, 286, 290; fascination with obscurity, 281–282; female sexuality and, 287; neocolonial rhetoric of, 278; Petrusich on, 291, 294–295, 300; primitivist romance mythologies of blues and, 281, 282; racial romanticism of, 294; Reitz as, 169–170, 176; relation with records, 286; sense of righteousness, 289; *78 Quarterly*, 286–288; treatment of African Americans, 284–286, 289, 301, 309; troubling, 281; unearthing of blues women's recordings and, 47–48; Wiley and Thomas and, 278–279. *See also*

Blues women, lost; Bussard, Joe; Criticism, new blues; Crumb, R.; Fahey, John; Fans; Hoarding; McCormick, Robert "Mack"; Petrusich, Amanda; Records

Colored American (magazine), 84–85

Coltrane, John, 53–54, 117

Combahee River Collective statement, 246

"Come Sunday" (song), 41, 108, 109–110

Commonwealth car, 153

Congress of American Women, 166

Conquergood, Dwight, 140

Consumer Guide, 63

Consumerism/consumption, 17, 244; Hansberry's critique of, 258

Consumers: Black record, 333–345; women, 234, 253; young, 334

Cooper, Bradley, 432

Cordeiro, AnneMarie, 357, 361

Corse, Carita Dogget, 146

Cotten, Elizabeth, 196, 391, 404

Counterdivas, 418–419, 428

Country blues, 351

Cox, Aimee, 332, 353

Cox, Ida, 17, 176, 198, 423

Craft, 13, 20, 31, 99, 267, 280; Mamie Smith's, 387; Mary Lou Williams's, 15–16, 90, 99; Rosetta Reitz's, 165–166, 172, 176, 196, 200; Toni Morrison's, 326; Valerie June's, 204. *See also* Musicians, Black women; *individual artists*

Crawley, Ashon, 120

"Crazy Blues" (song), 3, 61, 333–334, 336, 380–381, 382, 399; curation by, 385; lyrics, 383–384

Creem (magazine), 70

Crenshaw, Kimberlé, 249

Crisis, responding to, 365

Critic(s): Black women musicians as, 95; Hansberry and, 229–232; job of, 38; Morrison as, 327; presumption about what counts as, 61; racial and gender biases among, 69; Reitz as, 165, 172, 181–183, 186, 195, 201; relation with artist, 61, 80–81; role in shaping cultural imaginary of Black women's sonic cultures, 47; troubling, 281; unearthing of blues women's recordings and, 47–48

Critic(s), Black: Hansberry on, 231; role of, 81. See also *individual critics*

Critic(s), Black feminist, 227. See also *individual critics*

Critic(s), Black music: necessity and responsibility of, 77, 78–79. See also *individual critics*

Critic(s), Black women: artists as, 67; in sixties and seventies (*see* Dagnal-Myron, Cynthia; Garland, Phyl; O'Grady, Lorraine); as writers, 70–71. See also *individual critics*

Critic(s), cultural studies, 44

Critic(s), feminist cultural, 242. See also *individual critics*

Critic(s), male: approach of, 195; Reitz and, 189

Critic(s), music: impact of, 207; radicalism in, 74; Williams's view of, 94–95. *See also* Writing; *individual studies*

Critic(s), queer woman-of-color, 212. *See also* Hansberry, Lorraine

Critic(s), white, fascination with marginalized / disappeared, 279

Critic(s), white feminist, 62, 69. See also *individual critics*

Critic(s), women, 208. See also *individual critics*

Critic(s), women music, 248. See also *individual critics*

Criticism: alternative, 35; as art, 81; collaborative, 295; exclusion of Black women in, 7, 20; Frankfurt School, 37, 39; Hurston's, 137–145; importance of, 80–81, 82; music as, 36; racism in, 7, 20, 230–231; sexism in, 7, 20, 229, 230–231; shifting critical viewpoint in, 73; task of, 80, 186; white control of, 77–78; as world-making, 81

Criticism, Black feminist music, 65. See also *individual critics*

Criticism, music: Black feminist thinking and, 8; Black radical tradition and, 8; Black Studies and, 35, 41; counterhistory of, 5; elision of Black women musicians in, 20; new ways of doing, 48; white male dominance of, 34–35, 36. *See also* Writer(s), music; *individual critics*

Criticism, new blues, 290, 307; fetishization of relics, 306; need for Black study of, 308; on Paramount Records, 366. *See also* Collectors

Criticism, rock, 68, 211. *See also* Criticism, music

Crosthwait, Jimmy, 284

Crumb, R., 277, 290–291, *292–293*, 294, 300, 309, 323, 355. *See also* Collectors

Cullingham, James, 290

Cultural amnesia, 65

Cultural change, Black women musicians and, 15

Cultural front, 32

Cultural hybridity, recognition of, 33

Cultural labor, Black, 3. *See also* Labor, Black

Cultural memory, Black feminist, 12, 134, 378

Cultural performers, 13

Cultural politics, Black, 249

Cultural radicalism, 243–245

Cultural studies critics, 44

Culture: counterhistory of, 5; possibility of, 35

Culture, Black: ethnographers' presumptions about, 282; intersection with sound technologies, 20; problem in interpretation of, 295; as revolutionary rejoinder to modern, 19

Culture, blues record, 325–347. *See also* Collectors; Phonograph; Record shops

Culture, pop: Black women artists and, 4, 39, 55–57; community founded on, 82; counterhistory of, 47; curatorial turn in, 374; racism in, 242; segregation of, 3; sexism in, 242; white patriarchal hegemony in, 47

Culture, women's, 342–343

Culture industry: Black women artists and, 43–45; critique of, 37. *See also* Recording / music industry

Culture makers, 2–5, 14

Culture-making, modernity and, 19

Cunard, Nancy, 141

Cuney-Hare, Maude, 67, 77

Curation: 4, 13; Black women musicians and, 16, 23; "Crazy Blues" and, 383, 385;

Electric Lady, The (Monáe), 111. See also Monáe, Janelle

Ellington, Duke: Black, Brown and Beige, 108; "Come Sunday," 41, 108

Ellis, Nadia, 362

Ellison, Ralph, 41–42, 43, 59, 61, 68, 87, 100, 264, 358, 441; "On Bird, Bird Watching & Jazz," 363; Black radical tradition of, 363; on historical time, 272; Invisible Man, 41–42, 308, 362, 363, 417; on Jackson's "Come Sunday," 109–110; "Little Man at Chehaw Station," 33–34; on "Picked Poor Robin Clean," 362–363; "As the Spirit Moves Mahalia," 110

Elusiveness, 143, 274. 276. See also Blues women, lost; Fugitivity

Emancipation project, Black feminist, 369–372

Emerson, Victor, 3

Emotion, archive of, 315, 397

End of Eating Everything, The (Mutu), 427, 429

Eng, David, 275, 300

Engh, Barbara, 114, 121

Ensemble, 10, 275–276

Enslaved people: music from, 394; recuperating humanity of, 389. See also Captivity; Labor, Black; Slavery

Ephemera, 313, 316, 370. See also Things

Epistrophies (Edwards), 36

Erotic, 246. See also Sexuality

Eroticism, public, 63. See also Sexuality

Ertegun, Ahmet, 58

Ethnography: presumptions about Black culture and, 282; signifying, 131. See also Hurston, Zora Neale; Lomax, Alan; Lomax, John A.

Euphemisms, in blues, 50

Evans, David, 404, 405

Everett, Dorothy, 176

Experimentalism, B sides as sites of, 45

Exploitation: abolishing, 45; of Black music, 78, 242, 245, 381, 442

"Fact of a Doorframe, The" (Rich), 190

Fahey, John, 117, 283–286, 289–290; neocolonial rhetoric of, 278; In Search of Blind Joe Death, 289–290; treatment of African Americans, 301. See also Collectors

Fans, 282; Black, 334; Black women musicians and, 280; Reitz, 197; of soul, 76; views of female, 59. See also Audience; Collectors

Farmer, Ashley, 316

Farm Security Administration, 201, 202

Faubert, Ida, 423

Feather, Leonard, 6, 94, 116

Federal Theatre Project (FTP), 136

Federal Writers Project (FWP), 145, 151, 154, 155–159. See also Hurston, Zora Neale

Feist, 207

Felski, Rita, 113–114

Feminine mystique, 199

Feminine Mystique, The (Friedan), 166

Feminist music critics, 248. See also individual critics

Feminist scholars, Black. See Scholars, Black women

Feminists / feminism: awakening of consciousness, 228; Black women artists and, 167; blues feminist ideology, 401; de Beauvoir, 227; Faubert, 423; homosexuality and, 235

Feminists / feminism, Black, 8, 22, 27–28, 212, 229, 280, 315–316; approach to blues women's music, 355; Black feminist critics, 227 (see also individual critics); Combahee River Collective statement, 246; cultural memory of, 378; emancipation project, 369–373; intellectual history in sound, 4; Lemonade, 435–445; literature / cultural criticism by, 246 (see also individual artists; individual writers); model of formalistic philosophizing, 40; need for, 35; Ogresse and, 425; sidelining of, 434; Willis and, 249

Feminists / feminism, queer Black, 234. See also Hansberry, Lorraine

Feminists / feminism, second-wave, 165, 208, 212; affinities between Black and white feminist culture writing, 209; conflict in, 218; debates about sexuality, 252–254; Friedan, 166; race and, 213,

Quality, 58

Queer archives, 271–272, 281, 305–307, 312, 353

Queer Black feminism, 234. *See also* Hansberry, Lorraine

Queer ethics of historical practice, 275

Queer/gender-nonconforming artists, 12, 297, 298, 423. See also *individual artists*

Queerness: Hansberry's, 234–236, 250; in "The Murder Ballad," 415, 424; Rainey and, 351. *See also* Lesbianism/lesbians; Sexuality

Queer sociality, 12, 354–355

Queer theorists: Black, 269; Ferguson, 222, 235–236, 238, 263; Love, 275, 353; Muñoz, 211, 316, 423

Queer woman-of-color critique, 212. *See also* Hansberry, Lorraine

Race records, 326, 334, 335, 339, 379; labels, 329; market, 351, 360; production for white market, 173; racially exploitative practices, 291; white subjectivity in, 296–297. *See also* Collectors; Paramount Records; Record shops

Race relations, 340, 379. *See also* Jim Crow; Racism; Segregation; White supremacy

Racial/economic justice, 91. *See also* Civil Rights movement

Racism, 379; Black women artists and, 182–183; in criticism, 7, 20, 230–231; in culture industries, 242, 333; feminism and, 218; in popular press, 233; Salvant's material and, 416; in white-owned record stores, 339. *See also* Jim Crow; Race relations; Segregation; White supremacy

Radano, Ron, 67

Radical History Review (journal), 271, 306

Radicals/radicalism, 74, 243–245

Radical tradition, Black, 8, 29, 244, 357, 363, 413

Radios, 343

Railroads, 177. *See also* Great Migration

Railroad songs, 156–159, 160, 177, 196

Rainey, Ma, 10, 378; career of, 350–351; Reitz on, 178, 181

Raisin in the Sun, A (Hansberry), 214, 218, 219, 220, 223, 224, 231, 235, 238. *See also* Hansberry, Lorraine

Ramm, Gerard, 302, 366

Rap wars, 360

Reagon, Bernice Johnson, 202, 372, 421

Rebellion/revolution, 8, 272, 295, 382, 387

Reckson, Lindsay, 365

Record collectors. *See* Collectors

Recorders, Black women as, 32–33. *See also* Phonography

Recording devices, 146. *See also* Phonograph

Recording/music industry: Black artists and, 333–334; "masters" in, 56; neglect of Black market, 339; racism in, 3, 333, 339; transformation of, 69; Williams on, 94–95. *See also* Culture industry; Labels, record; Paramount Records; Race records; Rosetta Records

Records, 281; archival polyphony of, 335; Black women as, 32–33; early, 282; in *Jazz*, 328; long-play, 6; production of, Reitz on, 197; purchased by Black girls, 332; value of, 282. *See also* Collectors; Phonograph; Phonography; Race records; Things

Record shops, 323, 336–347; Angelou and, 344–345; Beasley's Music Store, 341, 342, 343; Black, 316; Joe's Record Shop, 326, 337, *338*, 345–347, *346*; listening booths, 341–342; Marsha Music and, 326, 337, 345–346, *346*; Melrose Record Shop, 344–345; photographs of, *338*, *346*; racism in, 339; Satellite Record Shop, 337; white-owned, 339

Redmond, Shana, 25, 112

Reggae, 71

Reid, Vernon, 39

Reitz, Rosetta, 46–47, 64, 125, 161–206, 421; album titles, 177; archives and, 166, 167, 172, 174, 188, 192, 195; background, 165–167, 169–170; blues, presumptions about, 173–174; blues activism, 199; blues philosophy, 168; career, 161; as

Roxon, Lillian, 62–64, 69, 70
Royster, Francesca, 112
Russell, Michele, 256

Said, Edward, 186
Salsburg, Nathan, 294
Salvant, Cécile McLorin, 49, 377–378, 412–431; as actor, 416–417, 423–424; as archivist, 420–426; background, 416–417; critics on, 414–416; on dreams, 425–426; *Dreams and Daggers*, 417; "The Murder Ballad," 414–416, 421–425; "Nobody," 420–421; *Ogresse*, 426–431, *430*; photographs of, *411*, *415*; rewriting of songs by, 413; as songwriter, 426–430; sonic aesthetics of, 419; vocal virtuosity, 419–420. *See also* Archivist(s)
Sanchez, Sonia, 104
Sanneh, Kelefa, 60
Santigold, 427
Satherley, Art, 339
Satire, racial, 290
Saunders, Gertrude, 61
Savage, Barbara D., 7
Scatting, 424–425; temporal, 424–425
Schneider, Jake, 286
Schneider, Rebecca, 121
Scholar and the Feminist Conference, 252–254
Scholars, Black women, 18, 21. *See also* Hartman, Saidiya; Hurston, Zora Neale; Morrison, Toni; Spillers, Hortense
Science fiction, 115. *See also* Monáe, Janelle
Scott, A. O., 80
Scott, David, 21
Scott, Esther Mae, 15–16, 23, 24, 29, 33
Scott, Jane, 59
Scouts, 331, 337, 339, 348, 349, 351
Scruggs, Mary Elfrieda. *See* Williams, Mary Lou
Searching, 390
Second Sex, The (de Beauvoir), 227–228
Sedgwick, Eve, 7
Segregation, 361; Black women's radical perseverance and, 202; Brooks's experience of, 340–341, 342; Hurston's field

work and, 153. *See also* Jim Crow; Racism; Violence, state
Seiler, Cotten, 99, 101
Self-making, 319, 378, 212; by Black women vocalists, 252–256; captivity and, 19
Serialization, 236, 238
Sermons, 138
78 Quarterly (magazine), 286–288
78 rpm record collectors. *See* Collectors
Sexism: in blues / jazz, 172; in criticism, 229, 230–231; in popular culture industry, 242; women's culture and, 342–343. *See also* Misogyny
Sex Pistols, 248, 249
Sexual autonomy, 235–236
Sexual identity, Hansberry's, 234–236. *See also* Lesbianism / lesbians; Queerness
Sexual innuendo, 313
Sexuality: Black women and, 253–256, 286–287, 313; blues and, 50, 167, 173, 198, 401; collectors and, 287; feminist debates about, 252–254; Hansberry and, 234–236; homosexuality, 234–236; in "The Murder Ballad," 415, 424; rock and, 246. *See also* Lesbianism / lesbians; Pleasure; Queerness; *Queer entries*
Shadow books, 120, 144
"Shake That Thing" (song), 126
Shange, Ntozake, 251
Shapeshifting, 332
Sharp, Dee Dee, 317–318
Sharpe, Christina, 426
Sheppard, Ella, 67
Shevey, Sandra, 62, 69
"Shipwreck Blues" (song), 49–51
Simmons, LaKisha, 326, 437
Simone, Nina, 1, 17, 52, 57, 214, 389, 390, 391, 392, 441, 443
Singers. *See* Vocalists, Black women; Voice; *Artist(s) entries; Musician(s) entries*
Singing, 129. *See also* Vocalists, Black women; Voice; *Artist(s) entries; Musician(s) entries*
Siren song reference, 111
Siren trope, 113–114
Skantze, P. A., 117, 120
Slaten, Marti, 153

Warner, Michael, 44
"Wartime Blues" (song), 148–149, 356
Washington, Booker T., 84–85
Washington, Dinah, 74, 195, 200, 417; Reitz on, 178, 181, 187, 198–201
Washington, Salim, 53
Watermelon Woman (film), 315
Waters, Ethel, 125, 126, 196–198, 351
Watson, Arthur, 340
Watson, Gertrude Graham, 340
Weems, Carrie Mae, 48, 49, 263, 315, 316–322, 374, 375, 437; *Ode to Affirmative Action*, 317–318, *319*; *Slow Fade* concert, 369–373; *Slow Fade to Black*, 320, 322, *322, 373*; *Who, What, When, Where*, 319–320, *321*
Weheliye, Alexander, 20–21, 118, 159
"We Hitch Our Wagons" (*Mademoiselle*), 215. *See also* Hansberry, Lorraine; *Mademoiselle* (magazine); Willis, Ellen
Wein, George, 163; photograph of, *182*
Wells, Ida B., 384
Wenner, Jann, 57, 58, 64
Westbrook, Halona Norton, 14
Wheatley, Phillis, 314
Wheatstraw, Peetie, 41
Whelan, Pete, 287
"When the Levee Breaks" (song), 442
White, Georgia, 195, 198
White, Jack, 283, 441, 442
White, Simone, 27–28
White masculinist aural gaze, 280
White noise supremacy, 9
White supremacy, 225, 361. *See also* Jim Crow; Segregation; Violence, state
Wildness, 423, 428–430, 431. *See also* Halberstam, Jack
Wiley, Geeshie, 47–49, 266–267, 271, 272, 273, 325; archive of, 277, 353; biographical details, 297, 353; Black feminist approach to music of, 355; career of, 351–353; collectors and, 278–279; critical language surrounding music of, 278; incarceration and, 295, 366; "Last Kind Word Blues," 355–358, 391; liner notes on, 278; Marcus's focus on, 301–302; "Motherless Child Blues," 359–360;

obscurity/elusiveness of, 274, 278, 301, 351–352; at Paramount, 348–350; Petrusich on, 295; "Picked Poor Robin Clean," 361–365, 366; practice of freedom, 365; reissues of recordings, 278; resuscitation of, 278–279; Sullivan and, 272, 273–274, 277–278, 284, 295, 296–298, 305, 353, 362. *See also* Blues women, lost
Wilkerson, Isabel, 263
Williams, Alexia, 407
Williams, Bert, 379, 382, 383, 416, 418, 419–420
Williams, John, 97
Williams, Mary Lou, 15, 23, 24, 29, 33, 45, 46, 64, 67, 69, 90–102, 115, 374–375, 377; ambivalence toward popular, 94; cars and, 97–100; commitment to racial and economic justice, 91; "Drag 'Em," 97, 100; *Embraced*, 94; interviews, 99; as jazz historian, 91; jazz tree illustration, 91, *93*; *A Keyboard History*, 99; on music industry, 94–95; "Nightlife," 97, 100–101; sexual assault, 97; as theorist, 95–96, 101; travel of, 96–100; writings of, 91, 92, 94
Williams, Mayo, 286, 339
Williams, Sherley Anne, 314, 322
Willis, Ellen, 47, 63, 64, 69, 207, 208, 241–251; "After the Flood," 257; archives of, 210, 250–251; background, 208, 213–214; Black cultural politics and, 249; Black feminism and, 249; "But Now I'm Gonna Move," 242; on capitalism, 244; contradictions of, 241; feminist theories, 246–247; freedom and, 243, 244; Hansberry and, 209–211, 212, 213–215, 217, 218, 249, 257–260; image of, 216; impact of, 217, 248; intersectionality of, 249; on Joplin, 254; *Mademoiselle* article, 209, 213–214; on mass art, 242; photographs of, *210, 217, 247, 259*; pleasure and, 243, 244, 245–246; on punk, 247–248; rebellion of, 216; repertoire, 218; review of *For Colored Girls*, 260; on "Send Me to the Electric Chair," 257; serialization by, 236; "Sisters under the